THE BRITISH LIBRARY STUDIES IN MEDIEVAL CULTURE

The Lindisfarne Gospels
Society, Spirituality and the Scribe

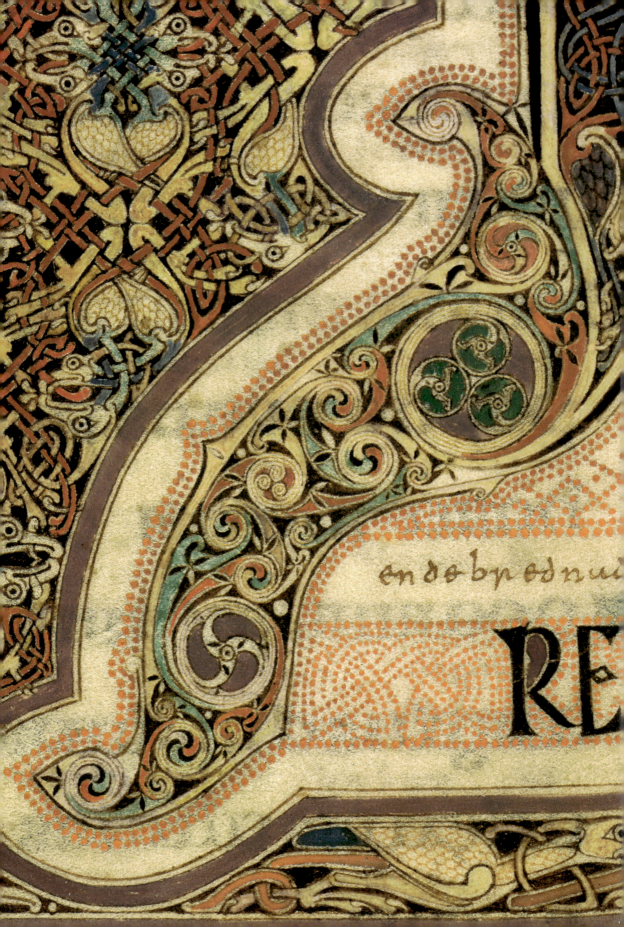

THE LINDISFARNE GOSPELS

Society, Spirituality and the Scribe

Michelle P. Brown

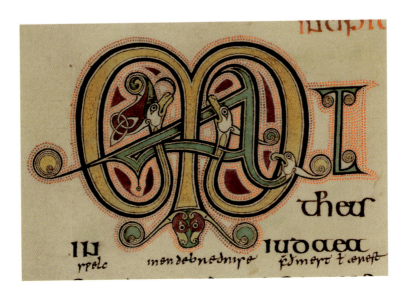

UNIVERSITY OF TORONTO PRESS

2003

'For God and Saint Cuthbert'

Text © 2003 Michelle P. Brown
Illustrations © 2003 The British Library Board
and other named copyright holders

First published 2003 by
The British Library
96 Euston Road
London NW1 2DB

Typeset in Columbus by
Norman Tilley Graphics, Northampton
and printed in Great Britain at the
University Press, Cambridge

Published in North America in 2003 by
University of Toronto Press Incorporated
Toronto and Buffalo

ISBN 0-8020-8825-2 (cloth)
ISBN 0-8020-8597-0 (paper)

National Library of Canada Cataloguing in Publication

Brown, Michelle P.
 The Lindisfarne Gospels : society, spirituality and the scribe / Michelle
P. Brown

Includes bibliographical references and index.
ISBN 0-8020-8825-2 (bound). – ISBN 0-8020-8597-0 (pbk.)

 1. Lindisfarne Gospels. 2. Illumination of books and manuscripts,
Anglo-Saxon – England – Holy Island (Island). 3. Illumination of books and
manuscripts, Medieval – England – Holy Island (Island). 4. Bible. N.T. Gospels –
Illustrations. I. Title.

ND3359.L5B76 2003 745.6'7'0942889 C2003-901717-6

Contents

Acknowledgements

It has been a tremendous privilege and a joy to work with this remarkable manuscript. I have tried to remain true to the spirit that informed those who made and used it, and to those who have helped to preserve it and to give it voice over the centuries.

This book has been a challenging one to write. The circumstances surrounding its production have meant that it seeks to accomplish three purposes simultaneously: to provide the technical detail required of a facsimile commentary, to provide the first full monographic account of one of the world's great manuscripts which is geared to the needs of the scholarly community; and, in recognising that the Lindisfarne Gospels are of interest to a broader audience than many such monuments, to open up the research accordingly to the informed general reader. Each constituency of readers may therefore, in the course of reading my text, experience a sense of frustration when the needs of another are being addressed. I can only apologise and crave their forebearance. To the general reader I would simply say that complexity need not be a threat to understanding, or faith. Often apparent simplicity and true comprehension come from a distillation of sophisticated information and applied technique, in this case generated by academic research. To the academic I would suggest that, in my opinion, professionalism need not unduly obscure or restrict comprehension nor dull enthusiasm.

My work would not have been possible without the support of a great many people, the litany of whose names would require lengthy recitation. I extend to them all my heartfelt thanks. Special mention must, nonetheless, be made of my debt of appreciation towards the following:

To the late Julian Brown who taught me so generously and who did so much, along with the rest of those who worked on the first facsimile from 1956 to 1960, to open up the study of the Lindisfarne Gospels; to Janet Backhouse, my predecessor as Curator of Illuminated Manuscripts at the British Library, who ensured that the manuscript was increasingly interpreted for as wide an audience as possible; to the British Library management for allowing me release from some of my duties for six months in order to write this book; to Professor Warwick Gould and colleagues at the School of Advanced Studies of the University of London for appointing me as a visiting Research Fellow for the period in question and for hosting a one-day colloquium on the Lindisfarne Gospels which I organised on 11 January 2002; to Catherine Atkinson and the relevant committee at Re:source who kindly arranged for me to receive an award under the Sharing Museum

Skills Millennium Award scheme that allowed a six-week secondment to the Special Collections Department at the University of London Library; to Emma Robinson, the University Librarian, and her colleagues in Special Collections (especially Helen Young and Judith Etherton) who all made me feel so very welcome during this time, and in the general course of my career as a reader in the remarkable palaeography collections; to Manfred Kramer and all those with whom I have collaborated so enjoyably at Faksimile Verlag and Print und Art, and those who produced the replica binding (André Glauser and Peter and Michael Shorer); to Professor Robin Clark and the members of the Raman laser project at The British Library and the Christopher Ingold Chemistry Laboratories, University College London, especially Katherine Brown and David Jacobs (British Library) who undertook the work on the manuscript; to Gordon Gallacher and Bob Martin for life-saving technical assistance; to Satwinder Sehmi, Anne Heywood, Canon Martin Kitchen, Professor Richard Kelly, Maria Pechnig, Ciaran Quinn, Janet Stephens and Peter Moran for their kind support; to my colleagues at the British Library, especially Laurence Pordes who undertook the photography, conservation staff (notably David French and John Mumford), members of the Western Manuscripts Department (notably Alixe Bovey, Greg Buzwell, Justin Clegg, Jacqui Hunt and Pam Porter) and to John Goldfinch of the Rare Books Department.

Special thanks go to the Publications staff (notably Lara Speicher and Kathleen Houghton), all those involved in production (Alicia Correa, Helen Kemp, Norman Tilley, Ella Whitehead), and especially David Way without whose staunch support, vision and friendship this work would not have been possible.

I should like to express my warmest thanks to those colleagues and friends who have so generously read and/or commented on aspects of the work: Carol Farr, David Ganz, Tim Graham, Nancy Netzer, Roger Norris, Éamonn Ó Carragáin, Andy Orchard, Jane Roberts, Colin Tite, Chris Verey, Niamh Whitfield, Sue Youngs, and my dear father, Andrew Whelan. Any errors of fact or opinion have been perpetuated inadvertently or against their better judgement.

I have spent much life-enhancing time in north-east England, as well as in many of the other areas mentioned within these pages. I should like to convey my thanks to the people of the region, and especially to those who live and work on Holy Island and those who experience a sense of renewal and refreshment of spirit in that special place.

Throughout my work on this challenging project I have felt myself surrounded and supported, as ever, by the love of my family and friends (some thankfully still living and some gone before, notably my dear mother) and I wish them all to know how greatly I value them. The loyalty, good-natured tolerance and profound love of my husband Cecil have sustained me in this endeavour, as in all I do.

Pax.

Dr Michelle P. Brown October 2002

List of Plates and Figures

Frontispiece
Lindisfarne Gospels (Cotton MS Nero D.iv), f. 139r, detail from the Luke incipit page

Title page
Lindisfarne Gospels (Cotton MS Nero D.iv), f. 18v, detail

Figures

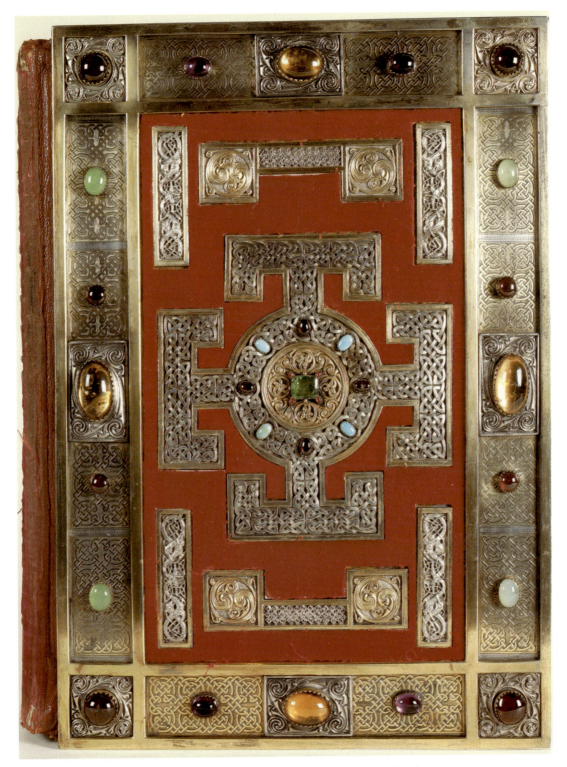

Pl. 1. Lindisfarne Gospels (BL, Cotton MS Nero D.iv), 1853 treasure binding, upper cover.

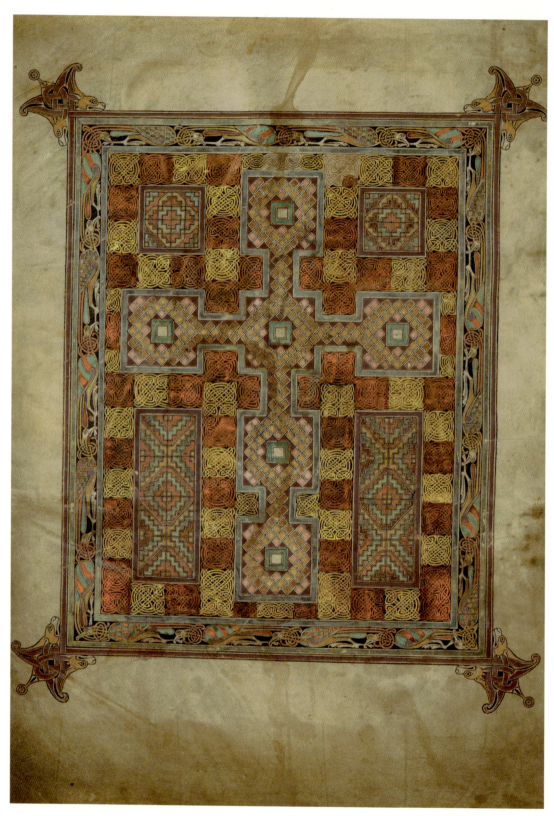

Pl. 2. Lindisfarne Gospels (BL, Cotton MS Nero D.iv), f. 2v, Prefatory cross-carpet page.

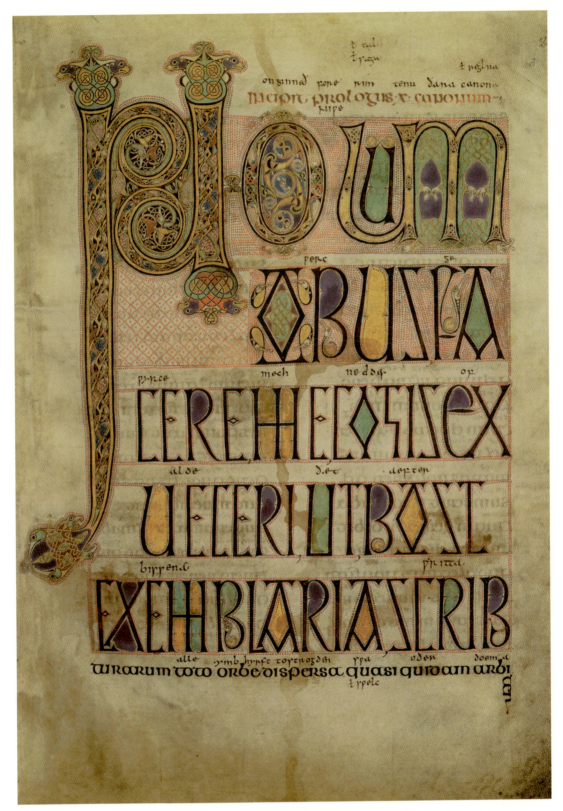

Pl. 3. Lindisfarne Gospels (BL, Cotton MS Nero D.iv), f. 3r, Jerome, Novum Opus Preface incipit page.

Pl. 4. Lindisfarne Gospels (BL, Cotton MS Nero D.iv), f. 5v, Jerome, Plures Fuisse Preface.

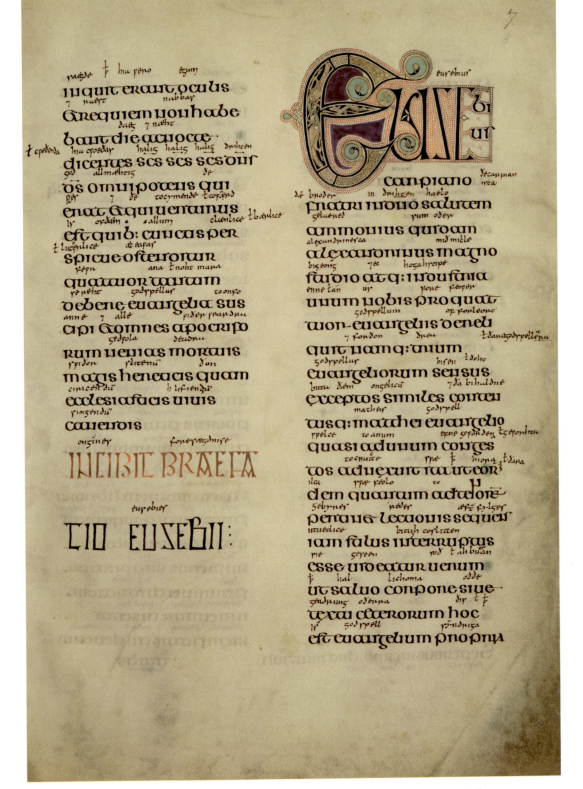

Pl. 5. Lindisfarne Gospels (BL, Cotton MS Nero D.iv), f. 8r, Eusebius-Carpiano Preface.

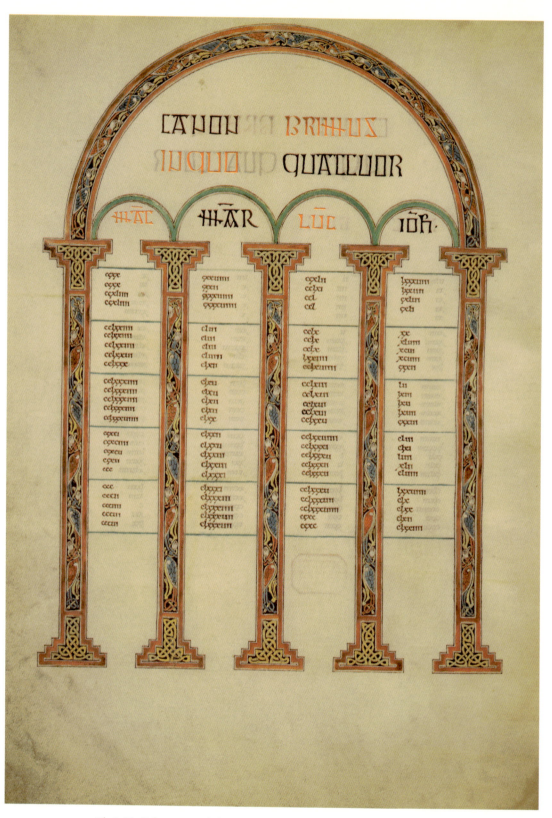

Pl. 6. Lindisfarne Gospels (BL, Cotton MS Nero D.iv), f. 10v, Canon Tables.

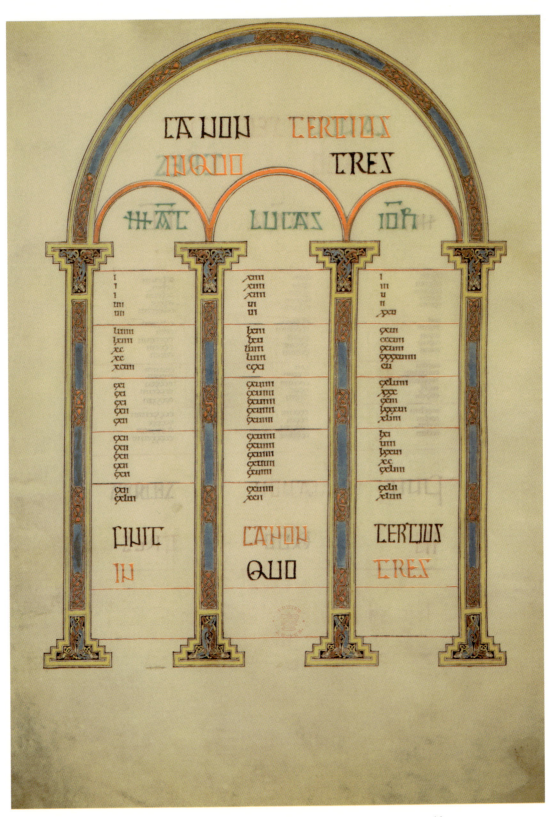

Pl. 7. Lindisfarne Gospels (BL, Cotton MS Nero D.iv), f. 12r, Canon Tables.

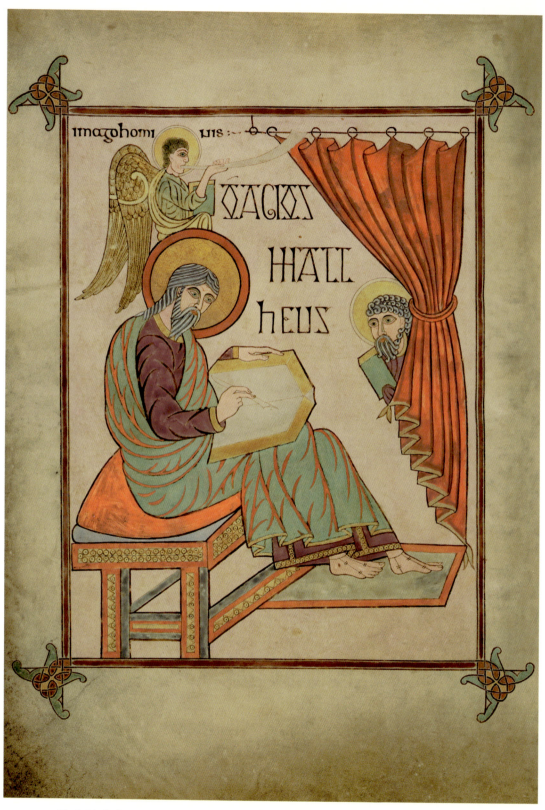

imagohomi nis ꞓ

ϽAꞓIϽS
HATT
heus

Pl. 8. Lindisfarne Gospels (BL, Cotton MS Nero D.iv), f. 25v, Matthew evangelist miniature.

(b)

(a)

Pl. 9. (a) Lindisfarne Gospels (BL, Cotton MS Nero D.iv), f. 26r, back-drawings for the Matthew carpet page; (b) Lindisfarne Gospels (BL, Cotton MS Nero D.iv), f. 25r, back-drawing showing the original design for a larger corner-piece to the Matthew evangelist miniature.

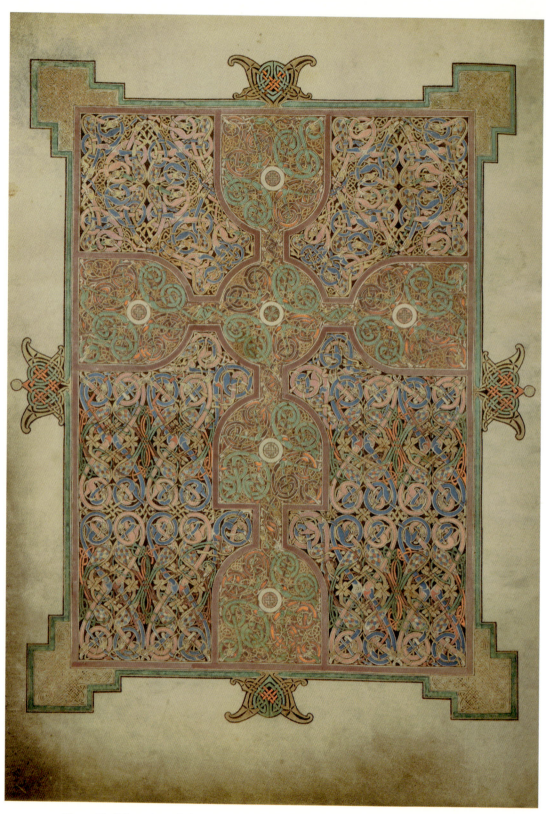

Pl. 10. Lindisfarne Gospels (BL, Cotton MS Nero D.iv), f. 26v, Matthew cross-carpet page.

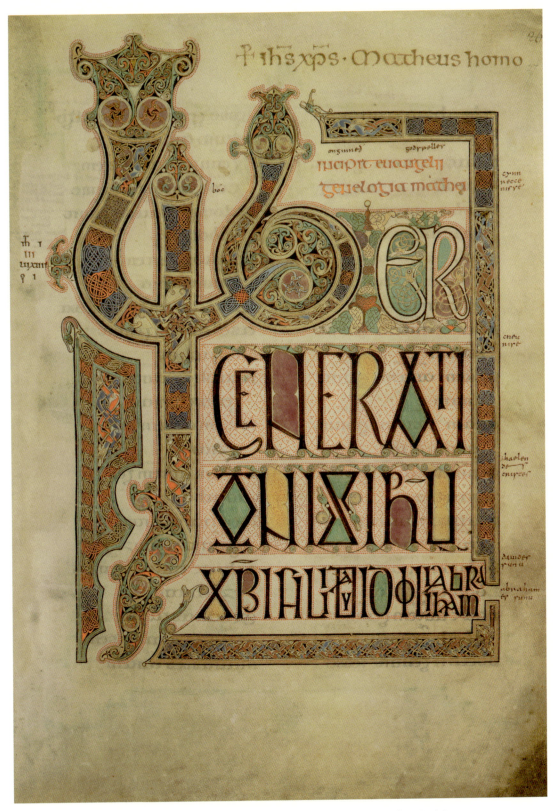

Pl. 11. Lindisfarne Gospels (BL, Cotton MS Nero D.iv), f. 27r, Matthew incipit page.

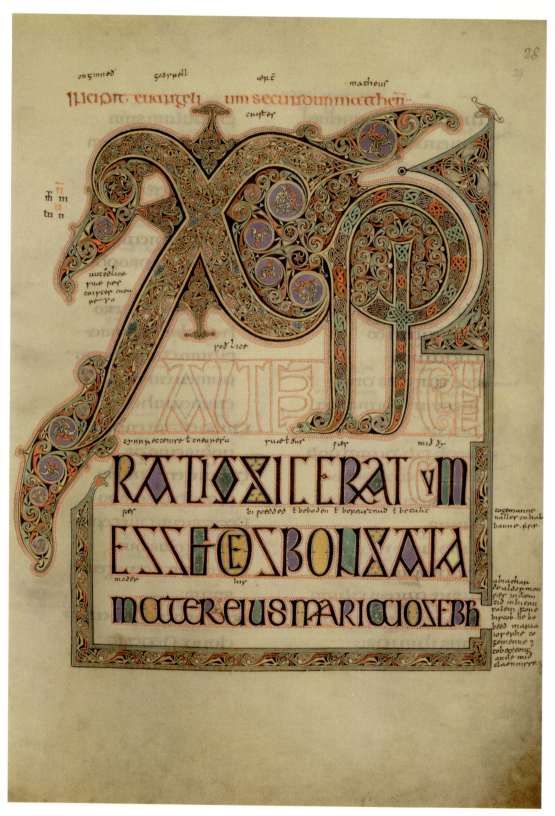

Pl. 12. Lindisfarne Gospels (BL, Cotton MS Nero D.iv), f. 29r, Chi-rho page.

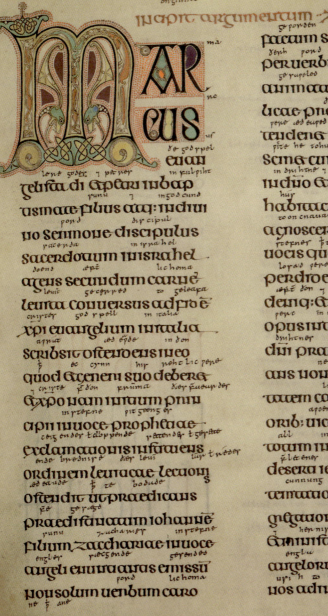

Pl. 13. Lindisfarne Gospels (BL, Cotton MS Nero D.iv), f. 90r, Mark prologue.

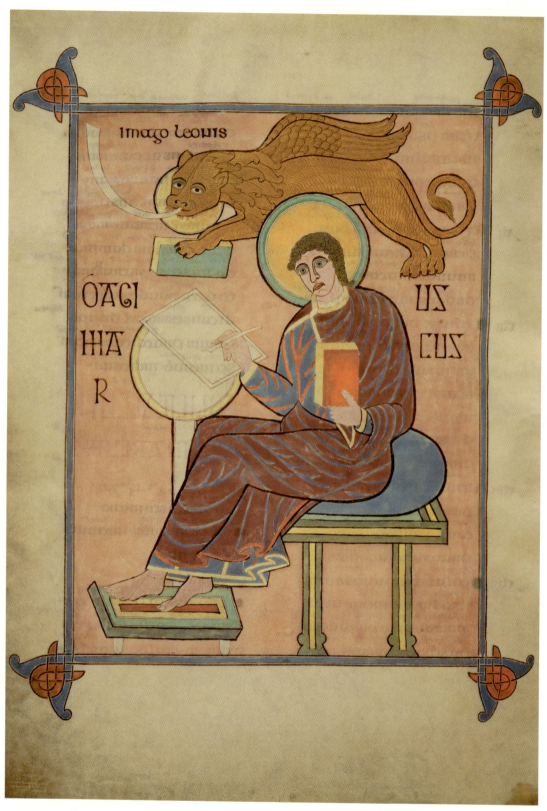

Pl. 14. Lindisfarne Gospels (BL, Cotton MS Nero D.iv), f. 93v, Mark evangelist miniature.

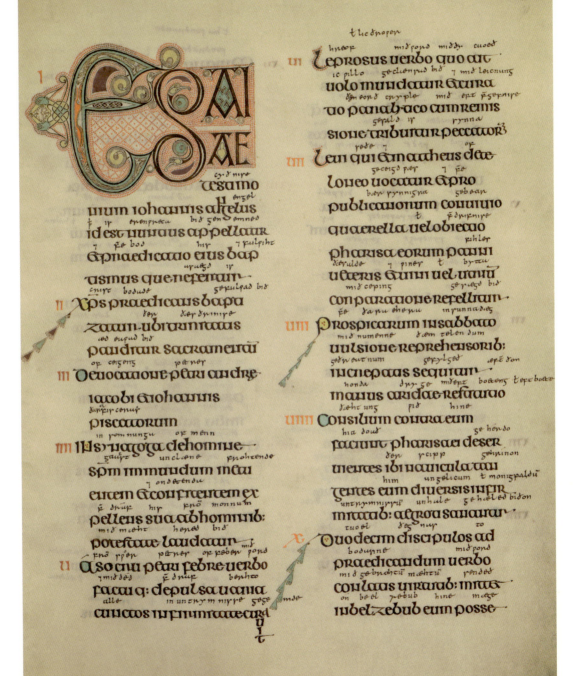

Pl. 15. Lindisfarne Gospels (BL, Cotton MS Nero D.iv), f. 91r, Mark capitula.

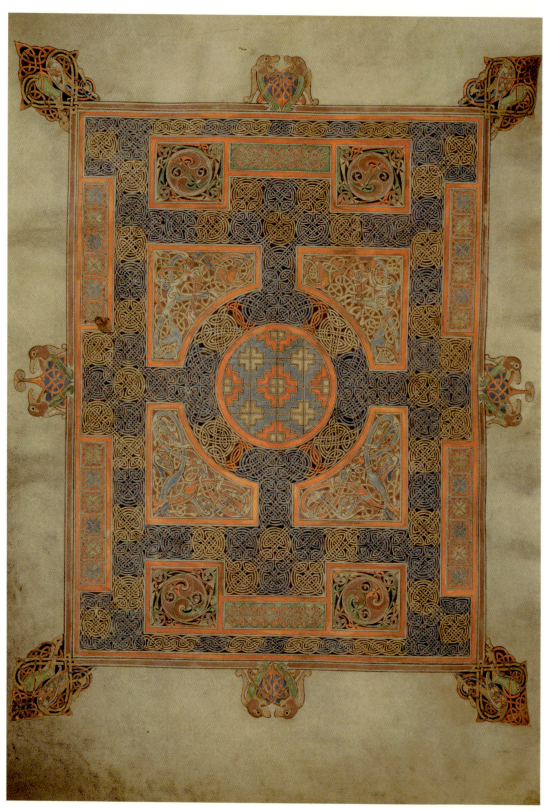

Pl. 16. Lindisfarne Gospels (BL, Cotton MS Nero D.iv), f. 94v, Mark cross-carpet page.

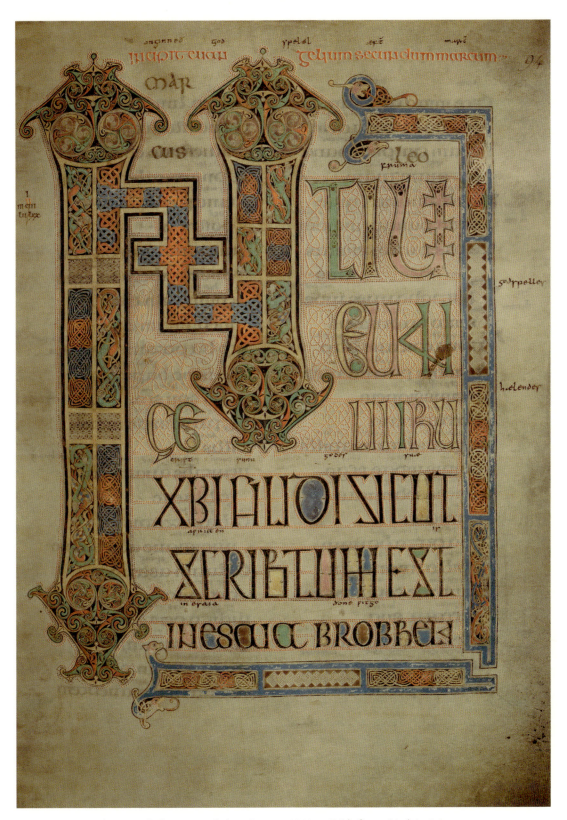

Pl. 17. Lindisfarne Gospels (BL, Cotton MS Nero D.iv), f. 95r, Mark incipit page.

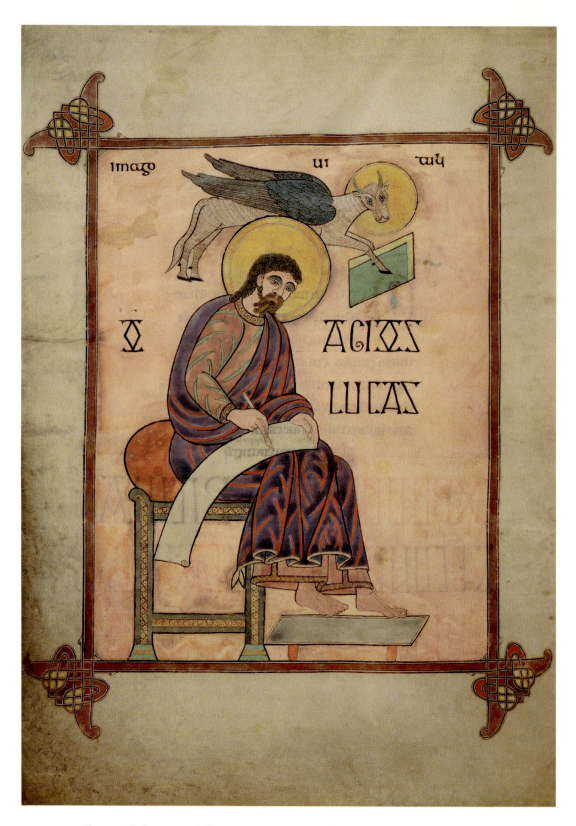

Pl. 18. Lindisfarne Gospels (BL, Cotton MS Nero D.iv), f. 137v, Luke evangelist miniature.

(a)

(b)

Pl. 19. (a) Lindisfarne Gospels (Cotton MS Nero D.iv), f. 137r, stylus under-drawing by the
original scribe for the display rubric to the Luke capitula explicit, with rubric as painted by the
rubricator above; (b) Lindisfarne Gospels (Cotton MS Nero D.iv), f. 93v, guidenotes used when
planning the layout of the decoration, the 'MR' at the lower left indicating that the image
was to be of St Mark and the 'd', above to its right, meaning 'depingendum' ('to be painted').

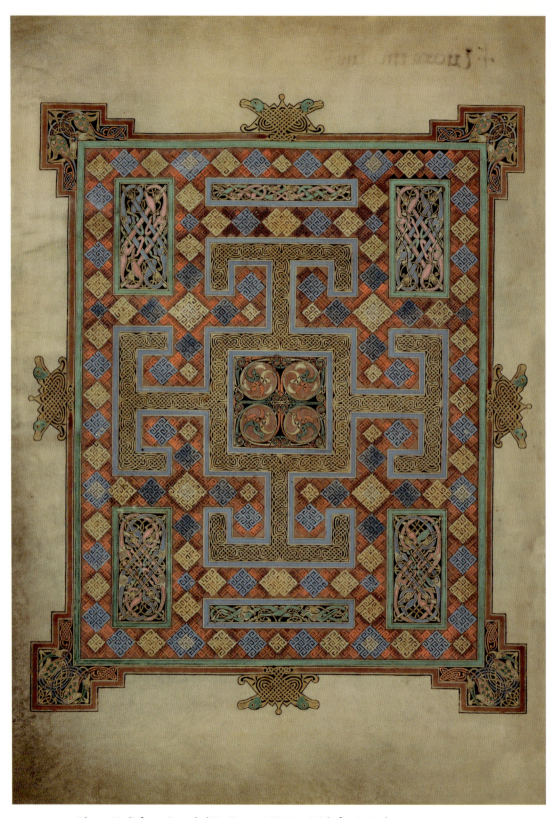

Pl. 20. Lindisfarne Gospels (BL, Cotton MS Nero D.iv), f. 138v, Luke cross-carpet page.

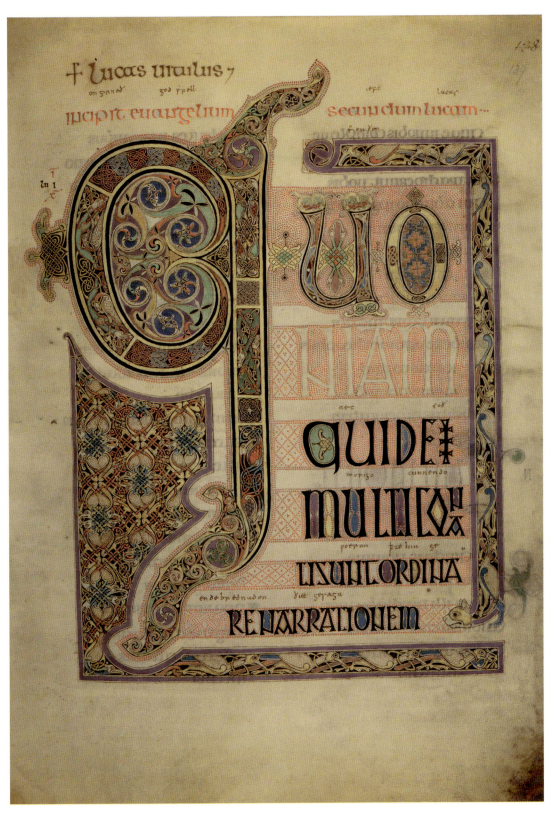

Pl. 21. Lindisfarne Gospels (BL, Cotton MS Nero D.iv), f. 139r, Luke incipit page.

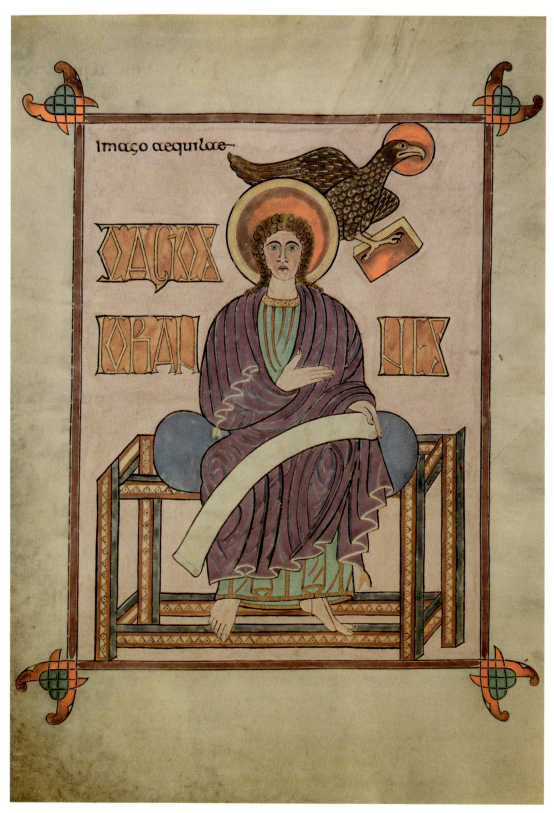

Pl. 22. Lindisfarne Gospels (BL, Cotton MS Nero D.iv), f. 209v, John evangelist miniature.

Pl. 23. (a) Lindisfarne Gospels (BL, Cotton MS Nero D.iv), f. 94r, compass and grid marks and lead point drawings on the back of the Mark carpet page; (b) Lindisfarne Gospels (BL, Cotton MS Nero D.iv), f. 2v, detail of unfinished section at the head of the prefatory carpet page.

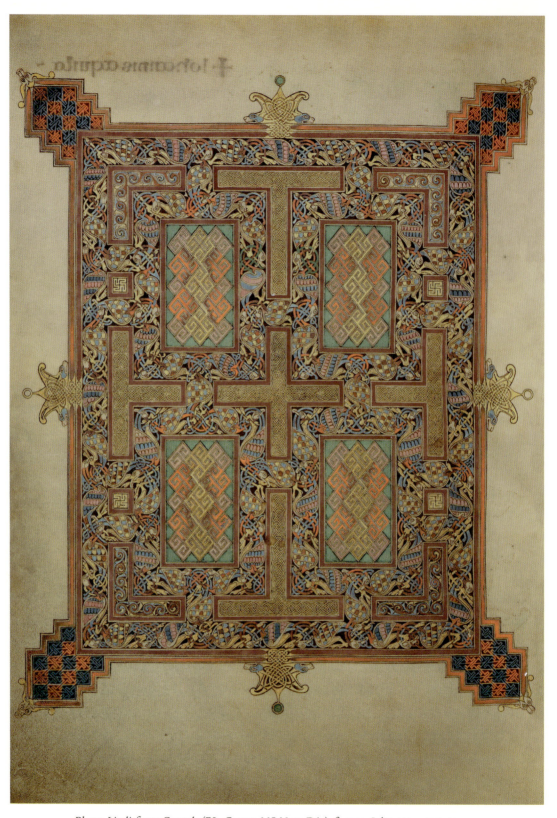

Pl. 24. Lindisfarne Gospels (BL, Cotton MS Nero D.iv), f. 210v, John cross-carpet page.

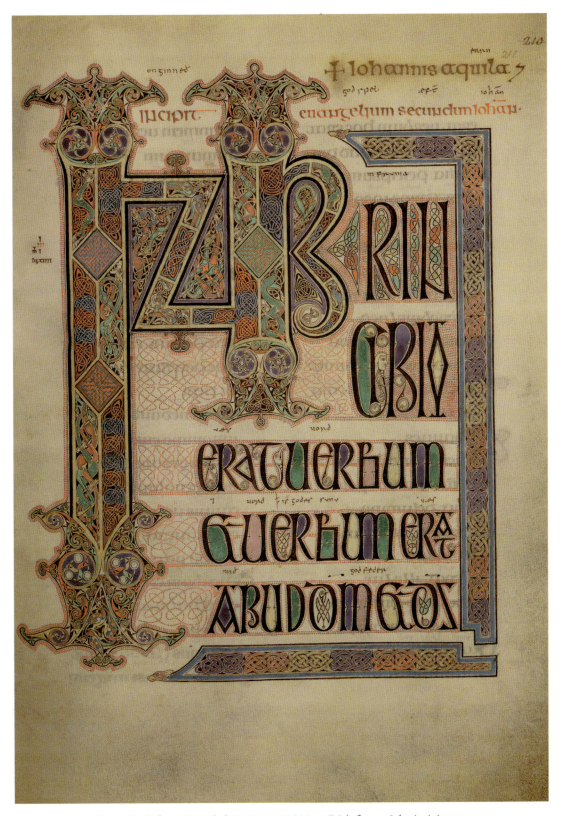

Pl. 25. Lindisfarne Gospels (BL, Cotton MS Nero D.iv), f. 211r, John incipit page.

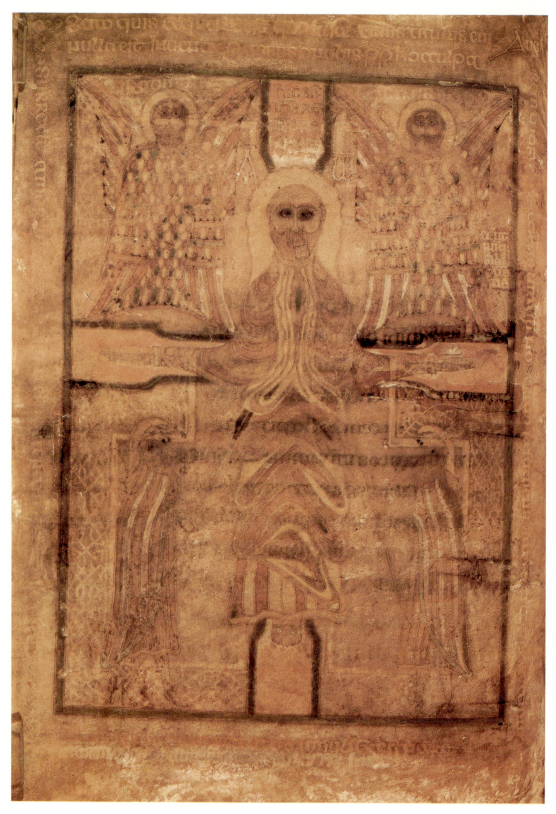

Pl. 26. The Durham Gospels (Durham MS A.ii.17), Crucifixion, f. 38³b.
(Reproduced by kind permission of the Dean and Chapter of Durham Cathedral)

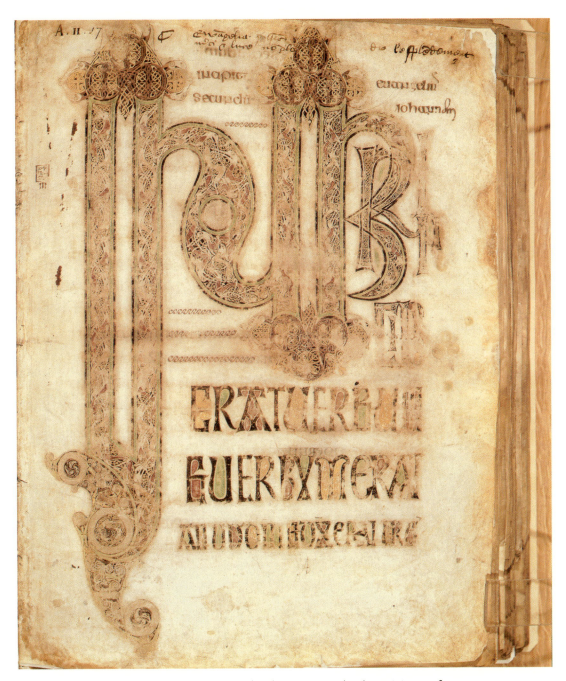

Pl. 27. The Durham Gospels (Durham MS A.ii.17), John incipit page, f. 2r.
(Reproduced by kind permission of the Dean and Chapter of Durham Cathedral)

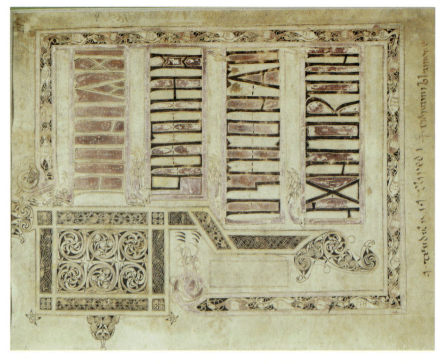

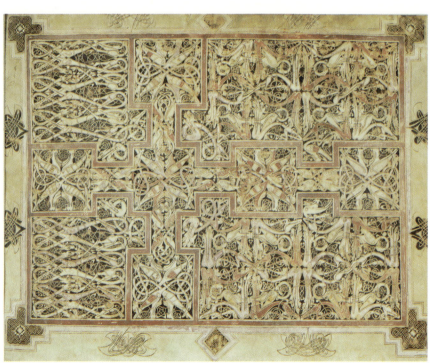

Pl. 28. The Lichfield Gospels (MS s.n.), pp. 220–1, Luke carpet page and incipit page. (Reproduced by kind permission of the Dean and Chapter of Lichfield Cathedral)

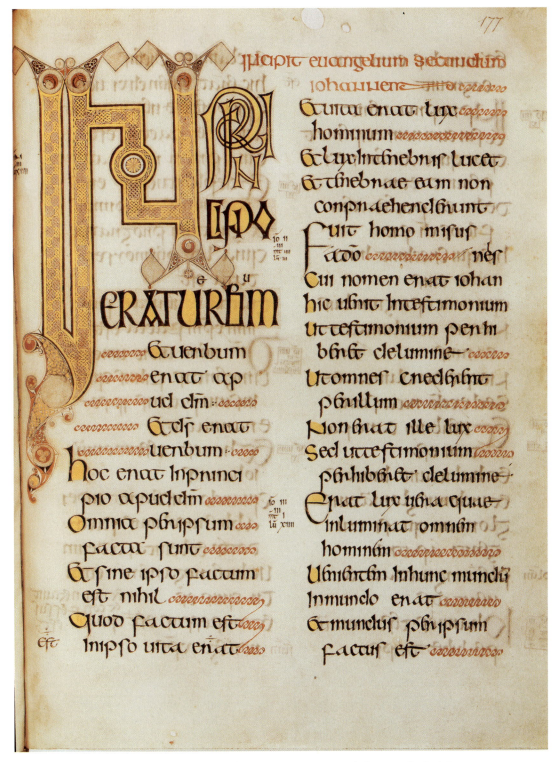

Pl. 29. The Echternach Gospels (Paris, BNF, MS Lat. 9389), f. 177r, John incipit page.
(Photo: Bibliothèque nationale de France)

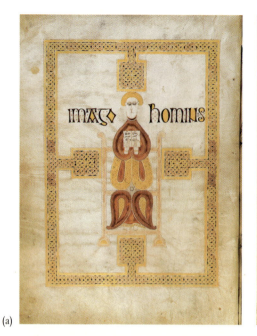

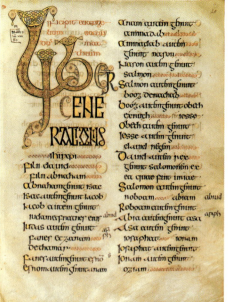

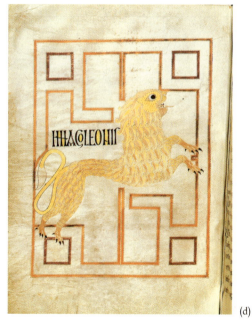

Pl. 30. The Echternach Gospels (Paris, BNF, MS Lat. 9389): (a) f. 18v, Matthew miniature;
(b) f. 20r, Matthew incipit page; (c) f. 19r, Chi-rho page; (d) f. 75v, Mark miniature.
(Photo: Bibliothèque nationale de France)

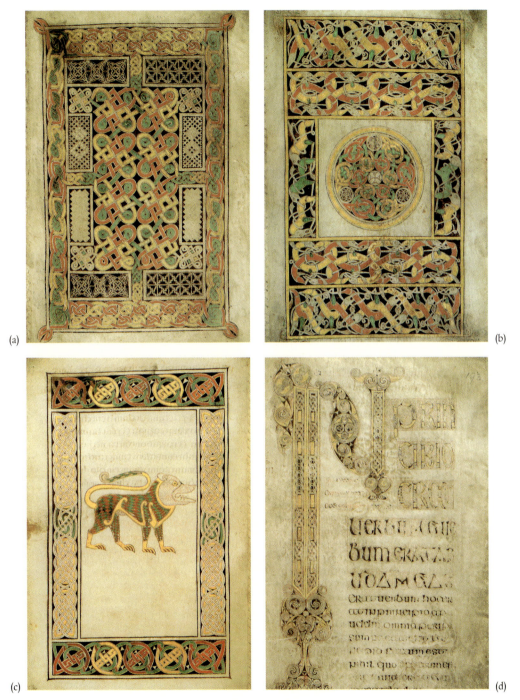

(a)

(b)

(c)

(d)

Pl. 31. Book of Durrow (Dublin, Trinity College Library MS 57): (a) and (b) ff. 125v, 192v, carpet pages; (c) f. 191v, John miniature (not the usual order of symbols); (d) f. 193r, John incipit page. (Photo: courtesy of the Board of Trinity College Dublin)

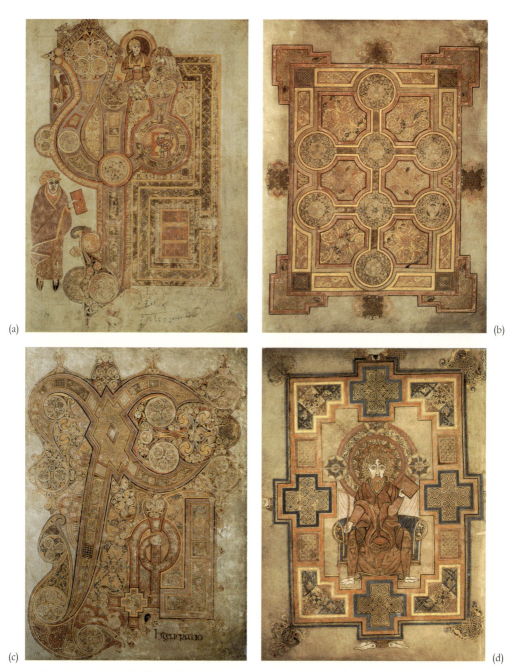

Pl. 32. The Book of Kells (Dublin, Trinity College Library MS 58): (a) f. 29r, Matthew incipit page; (b) f. 33r, carpet page; (c) f. 34r, Chi-rho page; (d) f. 291v, John miniature.
(Photo: courtesy of the Board of Trinity College Dublin)

INTRODUCTION

Setting the scene

The 'Lindisfarne Gospels' form one of the great landmarks of human cultural achievement. This remarkable volume is a Latin Gospelbook made in Britain some time around 700, after the twilight of the Roman world and at the dawn of the early Middle Ages. It features an energetic and sophisticated new style of art which fuses Celtic, Germanic and Mediter-ranean forms in a visual manifestation of a vibrant new culture sometimes termed 'Insular' (of the islands of Great Britain and Ireland). It is one of the most famous items in the national collections held at the British Library.[1]

What is it that makes this book so special and entices successive generations to con-template its mysteries? Its pages exude a passion, an energy and a thoughtful, receptive commitment to an earnestly held purpose, a higher ideal, which speaks of the very best of human aspiration. Books are about people. They can embody many different aspects of human activity – intellectual, literary, spiritual, ideological, artistic, historical, political and economic. They are portals into past lives, facilitating that vital organic communion between past, present and future. Whenever one such witness survives the ravages of time and the vagaries of fortune it presents a valuable testament. When such a survivor has come through comparatively intact and still preserves its brilliance its voice can be particularly eloquent. The enthusiasm and skill of the Lindisfarne Gospels' maker is a constant source of inspiration, the technical and artistic refinement a cause of wonderment, enquiry and admiration. The volume's decoration conjures up a world in which the old order was giving way to the new, an uneasy, restless time during which one of the great shifts in world history was taking place and cultures were metamorphosing and melting into one another, giving birth to new identities. There are echoes of the vigour of prehistoric societies – Celts, Picts and the Germanic/Scandinavian peoples – whose secrets are shrouded in the mists of time and are still being yielded up to the archaeologist's trowel, and of encoded symbolism and ostentatious visible consumption of wealth. There are, woven into its pages, testimonies to the learning and culture of the Graeco-Roman world, of early Byzantium, papal Rome, Lombardic and Ostrogothic Italy and Frankish Gaul. The

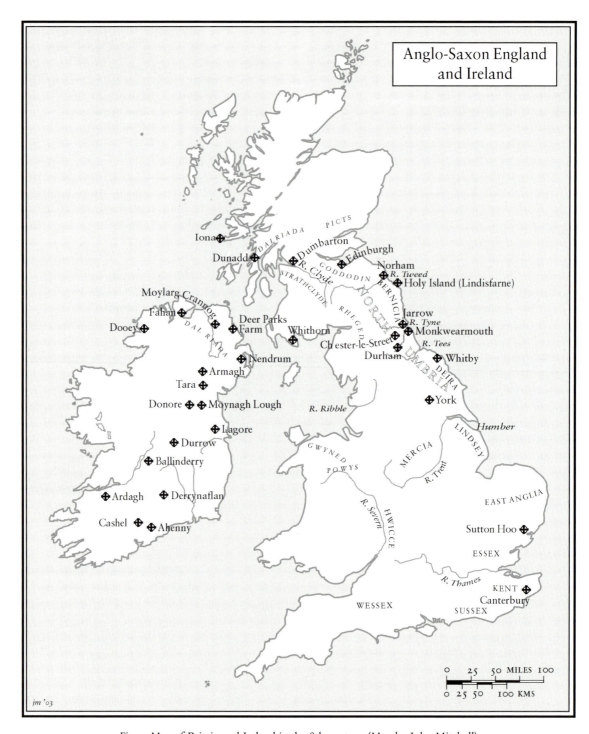

Fig. 1. Map of Britain and Ireland in the 8th century. (Map by John Mitchell)

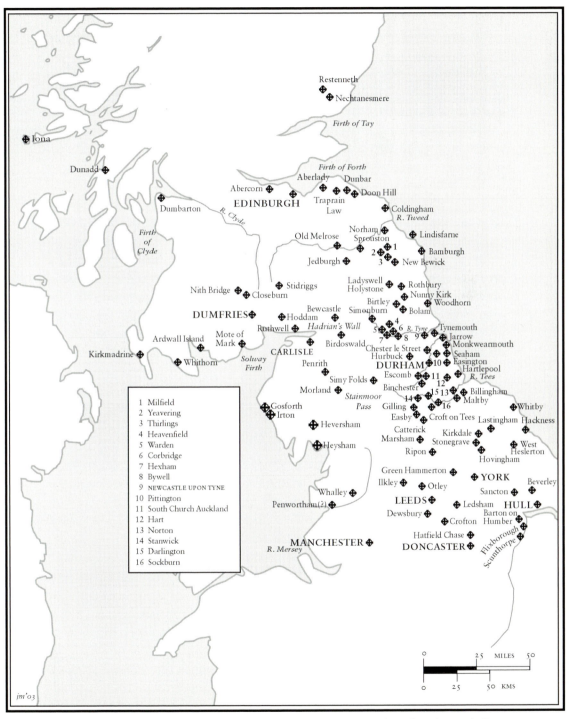

Fig. 2. Map of Northumbria in the 8th century, after Hawkes, 1996. (Map by John Mitchell)

1 Milfield
2 Yeavering
3 Thirlings
4 Heavenfield
5 Warden
6 Corbridge
7 Hexham
8 Bywell
9 NEWCASTLE UPON TYNE
10 Pittington
11 South Church Auckland
12 Hart
13 Norton
14 Stanwick
15 Darlington
16 Sockburn

pivotal role of the Middle East, of Jerusalem, Palestine and Coptic Egypt (home of the ascetic desert fathers, the 'hard men' of the early Christian Church) is acknowledged and celebrated within its pages too.

The language in which the Lindisfarne Gospels were first written is Latin, the volume being a valuable early witness to St Jerome's 'Vulgate' version, but the display script on its decorated incipit pages opening each Gospel, and the inscriptions accompanying its compelling depictions of the evangelists, draw not only upon the capital letters of ancient Roman inscriptions (such as those found in the vicinity of Hadrian's Wall) but upon Germanic runes and Greek letter-forms. Between the lines of its text are tiny glosses, a word-by-word translation of the Latin into Old English, added by a priest named Aldred around the 950s–960s, and representing an important landmark in the early English language. This was a culture which had achieved its own distinctive identity but which emphasised its place within the wider world.[2]

The circumstances of its production have the power to intrigue. How, and why, did one person invest so much sustained effort into producing such an encyclopaedic masterpiece? What was the artist-scribe's life like? What must it have been like to try to claw back enough time and energy to undertake this body-racking, muscle-aching, eye-straining task in a hut somewhere on the seaboard of north-west Europe with the wind and the rain and the distraction of a beauteous Creation all around? What other duties filled the day: the monastic round of the divine hours (perhaps as many as eight religious services throughout each day and night); the need to prove humility by manual labour, from milking cows to brewing ale or forging metalwork; the requirements of daily prayer and study (some scope for scribal feats of heroism there); the forty days in the wilderness of physical deprivation and penance for Lent; the joys of high days and holy days; the constant intercessions for living and for dead and against the threat of famine, plague and pestilence, and of all-too-frequent military confrontations; apprehension concerning all these dangers to your own and kindred communities and to the surrounding countryside which harboured your flock, which was in constant need of your pastoral care as well as your 'physick' and humanitarian aid? In such an environment the scribe takes up quill and brush as the armament in his spiritual struggle – the equivalent of St Cuthbert doing battle with his demons on his island retreat, on behalf of all Creation. Above all, this book is the physical expression of a devout, deep spirituality, transcending any formalistic religiosity, in which one individual creature endeavours its utmost to seek union with his/her maker through a labour of love, a quest which answers a deep-rooted human need. These are some of the reasons why we still feel drawn to the Lindisfarne Gospels.

The volume became a jewel in the crown of the foundation collections of the newly established British Museum in 1753, having belonged to a great seventeenth-century antiquarian and parliamentarian, Sir Robert Cotton (d. 1621). It carries the press-mark 'Cotton MS Nero D.iv', indicating that it was the fourth volume on the fourth shelf in the

book-press surmounted by a sculptural bust of the emperor Nero in Cotton's library at the Palace of Westminster (within what are now the Houses of Parliament). Cotton was responsible for preserving the majority of books which have survived from Anglo-Saxon England although sadly some, including the Beowulf manuscript, were badly damaged in a fire in 1731.[3] Not only has the volume survived in a remarkably fine state of preservation, it was originally made with exceptional care and high quality materials. This has always been a special and treasured book, accessible to only a few but admired by many. If it is to continue to exist in its fine state, while continuing to engage audiences at a wide variety of levels, in the present and the future, we must keep finding ways of making it accessible other than by direct handling. The decision to undertake a new, state-of-the-art facsimile with Faksimile Verlag is a very important step in this process and is, in itself, a landmark in the history of book production. This, and the other forms of outreach which it has facilitated, will allow more people than ever before to explore and interact with this fascinating masterpiece.

Like most of the great monuments of human endeavour, whether books, artworks or archaeological sites such as the Valley of the Kings and Sutton Hoo, the Lindisfarne Gospels repays revisiting. Each generation comes to it with new questions, new perceptions and new technologies. The first attempt to provide a full facsimile of the manuscript was undertaken by Urs Graf Verlag from 1956 to 1960, with a massive accompanying commentary volume written by a scholarly team which included my own mentor and friend, the eminent palaeographer Professor Julian Brown.[4] This is now an extremely rare publication. Although it was itself an important landmark in facsimile production, it does not possess the advantages of the modern 'fine art facsimile', being largely in black and white and conveying limited information concerning the codicology and physicality of the book as an object. Nor does it serve to impart the original intention of weaving text, script and decoration into a seamless, homogenous fabric in which ornament and colour are used throughout to clarify the sense and use of the text. In short, it is not a 'museum quality' replica. Likewise the commentary, while representing the best scholarly and scientific methods of analysis of the day, which have helped to shape and to stimulate the pursuit of subsequent knowledge, now needs to have its findings reappraised, carried forward in the light of intervening research and set within a fuller historical and cultural context, acknowledged as a great desideratum to date.

It is, therefore, with the greatest respect to the work of my forebears that I have undertaken a new commentary volume, of which this is the second and major part. For the sake of the historical record it may be useful to set this work in context. A first, extrapolated, descriptive volume has been issued with the facsimile (for ease of consultation in tandem),[5] but in an attempt to make as much information available to as wide an audience as possible it was decided to issue the expanded commentary (the present volume, which incorporates much further research) as a stand-alone monograph as well as issuing it to facsimile

subscribers. It is also planned to release a full electronic facsimile in the future, which this volume can accompany. This new departure in facsimile publication, a result of collaboration between the British Library, Faksimile Verlag and the author, is designed to increase access and to maximise the potential of the emerging interface between printed and electronic publication and image articulation.[6] To acknowledge and celebrate the high esteem in which Cotton MS Nero D.iv is held in the north-east of England, copies of the facsimile are being presented to Durham Cathedral and to the people of Holy Island (to be retained at their Heritage Centre). A major exhibition on the volume and its times will also be staged at the British Library to mark the launch of the new facsimile. It is hoped that these combined efforts will serve fittingly to celebrate this particular stage in the 'life history' of one of the world's great books.

The scholarly team working in the 1950s concluded that the Lindisfarne Gospels were made at the monastery of Lindisfarne on Holy Island, a tidal island which is accessible from the mainland for part of each day, off the coast of the Anglo-Saxon kingdom of Northumbria in north-east England. The Gospelbook is traditionally associated with the cult of St Cuthbert, an Anglo-Saxon nobleman (for whom some claims of Irish ancestry have traditionally been advanced) who was a member of the monastic community there and its bishop at the time of his death in 687. Cuthbert won renown even during life for his ascetic lifestyle, his preaching and his teaching by example, all seasoned with a diplomatic political acumen – 'as wise as serpents and as gentle as doves' (Matthew 10.16). Bede wrote of him (*Historia Ecclesiatica* IV.27–8):

> He used mainly to visit and preach in the villages that lay far distant among high and inaccessible mountains, which others feared to visit and whose barbarity and squalor daunted other teachers ... he taught others to do only what he first practised himself. Above all else, he was afire with heavenly love, unassumingly patient, devoted to unceasing prayer, and kindly to all who came to him for comfort ... His self-discipline and fasting were exceptional and through the grace of contrition he was always intent on the things of heaven. Lastly, whenever he offered the sacrifice of the Saving Victim of God, he offered his prayers to God not in a loud voice but with tears welling up from the depths of his heart.

It was concluded in *Cod. Lind.* that this prestigious book was made at Lindisfarne as part of the preparations for the translation of Cuthbert's relics to a feretory (shrine) above ground, to the right of its high altar, in 698.[7]

From the end of the eighth century this vulnerable island fell prey to Viking raids and during the ninth century the community left the island, staying for a while at Chester-le-Street (a fort on an old Roman road), before finally settling at nearby Durham, where the cult of St Cuthbert continued to form the focus of devotion at the famous cathedral of the prince-bishops of Durham (see fig. 36). It has been assumed that the volume was seized by King Henry VIII's commissioners at the time of the Dissolution of the Monasteries in

the 1530s and brought to London because of its jewelled binding. This is now lost, its current treasure binding being a mid-nineteenth-century fabrication donated by Bishop Maltby of Durham, perhaps as part of a 'contest' for ownership of the cult between Anglicans and Catholics, hotly debated at the time.[8] Evidence reviewed in chapter two of the present volume suggests that this view of the book's provenance can be challenged, however. In the mid-tenth century, whilst the book was at Chester-le-Street, it was glossed between the lines in Old English by Aldred, a member of the community who became its provost. This work, which Aldred saw as the completion of the book, means that the Lindisfarne Gospels contain the earliest surviving translation of the Gospels into the English language, as well as the original text. In a colophon Aldred associated his work with that of those whom the community thought had originally made the Lindisfarne Gospels. Eadfrith, Bishop of Lindisfarne (698–721) was accredited with writing and decorating the volume; his successor as bishop, Aethilwald, was said to have bound it; and an anchorite named Billfrith was commissioned by him to make the metalwork which adorned it. In *Cod. Lind.* this team was accepted and it was assumed that Eadfrith undertook the work before assuming the busy role of bishop in 698. Two other books were associated with the Lindisfarne scriptorium: the Durham Gospels (Durham, Cathedral Library, MS A.II.17) and the Echternach Gospels (Bibliothèque Nationale, Paris, MS lat. 9389) and these were ascribed to another artist-scribe, termed the 'Durham-Echternach Calligrapher', thought to be an older member of the Lindisfarne scriptorium and to have made the Echternach Gospels at the time that the Lindisfarne Gospels were being made and the Durham Gospels afterwards, but in an 'old-fashioned' style (palaeographically and perhaps textually). This contorted chronology, devised to accommodate conflicting aspects of the evidence, and the 'fixed point' of 698, have distorted subsequent discussions of the period and of the relative chronology of its artefacts, as have nationalistic or regional allegiances which have coloured scholarship on the subject.[9]

Lindisfarne was founded in 635 by St Aidan as part of the monastic federation (*parochia/paruchia*) of the Irish St Columba (Columcille). It was therefore originally linked, however loosely, to other Columban houses such as Iona and Durrow (and, from the ninth century, Kells) and was intended to carry the process of conversion to Christianity into the pagan Anglo-Saxon kingdom of Northumbria. A relationship with two great books associated with the cult of St Columba, the Book of Durrow and the Book of Kells (Trinity College Dublin, MSS 57 and 58), has been acknowledged, Durrow being considered earlier (later seventh century, post 660s) and Kells later (eighth century, some seeing it as c.800, others closer to 750 because of palaeographical similarities to the Lindisfarne Gospels). Suggestions of place of origin for all these important Insular manuscripts have varied from Iona, Ireland and Scotland to Northumbria. In recent years the reliability of Aldred's colophon has been questioned, as has a Lindisfarne origin for the Lindisfarne Gospels and their close associates, with Ireland or an Insular foundation on the Continent and the

romanising twin monasteries of Wearmouth/Jarrow in Northumbria being suggested as alternative production centres.[10]

These great masterpieces of early medieval book production are encyclopaedic in their cultural and visual references and can be all things to all people. The culture they represent has often been termed 'Insular' ('of the islands') in order to convey its widespread currency. In some cases, such as that of the Lindisfarne Gospels, such a fusion of diverse elements drawn from all areas of a multi-cultural society may have been intentional on the part of the makers. For modern scholars the temptation is to isolate those features redolent of a particular culture or region with which they are concerned, sadly often at the expense of a balanced consideration of the whole. The collision between the traditions of the early 'Celtic' (or perhaps more properly in this context 'Columban') and 'Roman' Churches which resulted in the famous synod held at St Hild's double monastery at Whitby in 664, at which St Wilfrid won the day in favour of Rome, has perhaps been seen as too much of a divide between the two camps, significant though it undoubtedly was. The rift (and the schism it threatened) was healed fairly quickly, if not easily, thanks largely to the reconciliation undertaken by figures such as St Cuthbert, Bishop Ecgbert and Abbot Adomnán of Iona. Nonetheless, there remains a tendency for much modern nationalism to be projected backwards into a period which was notable for its ability to merge elements from the Celtic, Germanic, Graeco-Roman, and Christian Orient cultures to give birth to a new order in Europe: the early Middle Ages. The Lindisfarne Gospels stand at the crossroads of the transition from the ancient to the medieval world, and their exuberance and accomplishment convey the passion and enthusiasm that their makers felt in the face of such a challenge. The apostolic mission had reached the farthest ends of the known world (this presaging in the Christian view the end of this world and coming of the next), where a Christian people carried the Word of God still further northwards while showing the old centre, the Mediterranean, that they were no provincial outpost, but the champions of a new order. The text of the Lindisfarne Gospels explodes into a triumphant celebration of the best of all cultures, as its letters grow to occupy the whole page – literally the Word made flesh, or rather the Word made word.

My research to date has suggested that a Lindisfarne origin for the volume can be reasserted and that Eadfrith's *floruit* coincides with other historical and stylistic evidence suggestive of its date and place of origin, making it possible that he may indeed have been its maker or commissioner. However, the dating and relationship to other works need to be revised and the historical context for production more fully assessed. The picture which emerges is one in which Bishop Eadfrith and the Lindisfarne community were actively collaborating with other centres, such as Wearmouth/Jarrow, throughout the first quarter of the eighth century, to maximise the benefits of a new culture which was fully integrated into the Christian Oecumen (an eternal fellowship transcending individual traditions) and which celebrated a new confidence and acknowledged all of its formative influences.

In this they were matched by certain figures in the Irish Church, such as Adomnán, who shared something of these eirenic reconciliatory views. 'Celtic' did not preclude 'Roman', or vice versa, except in the mind of a few die-hard scholars, then as now. Such spiritual ambitions need also to be seen against the backdrop of contemporary society and politics, with the bishopric of Lindisfarne playing an important role in ensuring a measure of unification within the northern territories traditionally held by the Picts and the British kingdoms of Strathclyde and Rheged, which had been annexed by Anglo-Saxon Northumbria or which needed to be diplomatically stabilised as neighbours. Expressions of cultural unification within the embrace of Mother Church were desirable at a number of levels.

Around 705 an anonymous monk of Lindisfarne wrote the first *Life of St Cuthbert*. His bishop, Eadfrith, swiftly commissioned the most famous scholar of the age, Bede, from the twin monastery of Wearmouth/Jarrow, to rework the *Life* and to help shape the cult to a new purpose. Bede's verse *Life* of Cuthbert, begun within a few years of the anonymous *Life*, was revised by Bede to produce a tighter structure, suited to meditation, during the second decade of the eighth century. This was followed by his prose *Life*, finished around 721, a decade before his completion of the *Historia Ecclesiastica Gentis Anglorum* (*The Ecclesiastical History of the English People*). The second and third decades of the eighth century were thus crucial in determining the future complexion of Northumbria and in establishing the rallying points for its identity.[11] It is surely significant that during the first quarter of the eighth century, as we shall see, other major cults were taking shape along similar lines: Stephen of Ripon wrote a life of St Wilfrid and indicates that a book commissioned by him was seen as a focus of his cult at Ripon; Adomnán, Abbot of Iona (who visited Northumbria and who was working to bring the Irish Church, and his own more stubborn community, into line with more 'universal' practices), was penning his life of St Columba, who was himself celebrated as a scribe and whose cult came to feature a vast number of prestigious books, from the Cathach of Columcille to the Books of Durrow and Kells. Which of these prominent cults was taking shape first is difficult to determine, but they are likely to have sparked off one another and perhaps engendered a sense of competition. The anonymous author of the first *Life of St Cuthbert* was probably taking his cue from a pre-existing Irish hagiographical tradition, which during the seventh century had produced works such as the *Vita I* of St Brigid of Kildare (perhaps by Aileran the Wise of Clonard, d. 665), a *Vita II* of Brigid by Cogitosus, and a tripartite *Life* of St Patrick by Tírechán,[12] as well as from the earlier lives of the Egyptian desert fathers and St Martin of Tours, and from Roman biographical traditions. The Irish works had served a useful function as propaganda for the competing claims of the metropolitan churches of Armagh and Kildare and the adoption of the genre in early eighth-century Northumbria may, at one level, have served a similar purpose. Cogitosus mentions the bejewelled tomb of St Brigid of Kildare, and a later witness (Giraldus Cambrensis, writing in the late twelfth

century) records that a fantastically intricate illuminated manuscript was one of the wonders of her shrine,[13] indicating that there was already an Irish background for this sort of focused cult with visible treasures, including books. A similar phenomenon occurred at the end of the twelfth century when many established cults, including that of St Cuthbert, erupted into a flurry of hagiographical and artistic activity stimulated by competition generated by the recent martyrdom of Thomas Becket, which sent Canterbury soaring to number one as the English pilgrim destination of choice.

The translation of the relics in 698 has been seen as the chronological focus for activity surrounding the cult of St Cuthbert and the production of associated works, despite the fact that the earliest accounts indicate that this was not a great planned event. At Bishop Eadberht's behest Cuthbert's remains were being gathered in along with others on the island, a wooden box (the coffin, which still exists and is displayed in the Cathedral Treasury in Durham) having been made to contain his exhumed remains, and only when these were found to be incorrupt – the highest sign of holiness – were they given additional prominence and developed into the focus of a cult under the auspices of the next two bishops, Eadfrith (698–721) and Aethilwald (c.721–40). The remains of these three influential bishops joined Cuthbert in his reliquary-tomb and the names of the two latter were subsequently associated with the making of the Lindisfarne Gospels by the community of St Cuthbert. The '698' scenario does not suggest a prolonged period of planning and labour, of the order required to produce the Lindisfarne Gospels, preceding the translation of the saint. I would suggest that the later period, coinciding with Eadfrith and Aethilwald's times as bishops of Lindisfarne, is more likely to have led to the making of the Lindisfarne Gospels and, as we shall see, a consideration of the historical and stylistic contexts leads me to favour a planning and production date within the period c.710–25 (most probably c.715–20).

Around 710, following the death of St Wilfrid, that flamboyant and abrasive champion of 'romanitas' (pro-Roman feeling), a book of splendid appearance in its lettering and ornament, written in gold on purple pages and enshrined within a jewelled case – heralded as a new marvel in Britain when Wilfrid presented it to Ripon in the 670s – was apparently a focus of attempts to establish a rival cult of St Wilfrid at Ripon.[14] Perhaps it was at this time that the need for a similar contribution to the shrine of St Cuthbert was deemed necessary in the form of the Lindisfarne Gospels. But whereas this crucial visible relic of St Wilfrid, the champion of the Roman order, summoned up the might of Rome, that of St Cuthbert, the great figure of reconciliation between the Celtic, British and Roman traditions, proclaimed a new sense of drawing upon the best of the various cultures of the past to celebrate a new culture of the future in which all would find a place. In this sense it acts as a visual equivalent of Bede's *Historia Ecclesiastica*. Another of the great monuments of Northumbrian art, the Franks Casket, which has stylistic affinities with Cuthbert's coffin, likewise brings together scenes from Germanic (Weland the Smith and the enigmatic tale

of 'Ægili', either a Germanic hero or even possibly, as suggested by David Howlett, Achilles), Roman (Romulus and Remus, founders of Rome, suckled by the she-wolf), Judaic (the sack of Jerusalem by Titus) and Christian (Adoration of the Magi) lore in a manner which reconciles the past and human traditions of identity and origin with a Christian eternity.[15]

Given that the manuscript known as the 'Lindisfarne Gospels' is thought to have been associated with the island of that name from at least the early seventeenth century, our voyage of exploration should perhaps begin with a consideration of the history of the region of Northumbria, especially during the seventh and eighth centuries, and of the role played by the monastery established on Holy Island. For those eager to learn more concerning the Lindisfarne Gospels I would urge that they contain their impatience and join this journey to familiarise themselves with the society and environment which gave it birth. Only by so doing can we begin to understand how and why it came into being.

Notes

1 Where it is usually on display to the public, free of charge, seven days a week, in the British Library's 'Treasures Gallery' at St Pancras, London.

2 Some of the terminology relating to book production may be unfamiliar to non-specialists. As a starting point, and in order to see what I mean by certain terms, I would recommend the consultation of my own handbooks: M. P. Brown, *A Guide to Western Historical Scripts from Antiquity to 1600*, 1990; M. P. Brown, *Understanding Illuminated Manuscripts. A Guide to Technical Terms*, Malibu and London, 1994. For a basic introduction to Insular and Anglo Saxon manuscripts, see M. P. Brown, *Anglo-Saxon Manuscripts*, London, 1991.

3 Archbishop Matthew Parker was the other greatest single early collector of books from Anglo-Saxon England. On Sir Robert Cotton's library, see Tite 1993.

4 T. D. Kendrick *et al.*, *Evangeliorum Quattuor Codex Lindisfarnensis* (facsimile, 2 vols, Olten and Lausanne 1956–60), henceforth *Cod. Lind.*

5 M. P. Brown 2002.

6 The photography was undertaken by a senior photographer in the British Library, Laurence Pordes, in accordance with usual approved in-house procedures and without disbinding the volume. The subsequent electronic articulation of images and the colour balancing, the latter taking at least two days for each major decorated folio, was undertaken at the British Library alongside the manuscript by members of Faksimile Verlag, Print und Art and British Library staff (principally myself). This book and other projects benefit greatly from the facsimile images.

7 On relic translations, see Heinzelmann 1979 and Angenendt 1994. The site of the tomb was probably on the left when viewed from the nave (on the celebrant's right) to judge from the position of a pilgrim passage in the Norman ruins of Lindisfarne Priory.

8 See also the discussion in chapter two. See also Bailey 1989.

9 *Cod. Lind.*, pp. 102–3, where Julian Brown's discussion of the respective chronology is constrained by consideration of the art historical sequence proposed by Bruce Mitford. See also Verey *et al.* 1980, p. 46 where Brown acknowledges that he was inclined to take a different view of the respective chronology of the volumes in question.

10 See Ó Cróinín 1982 and 1984; O'Sullivan 1994; Dumville 1999.

11 For this and the following, see M. P. Brown 2000.

12 Howlett 1998a.

13 See, for example, the discussion in M. P. Brown 2002a.

14 Stephanus, *Life of Wilfrid*, ch. 17.

15 This early eighth-century whalebone casket, which may have served as a reliquary, features Latin and Old
 English inscriptions in display capitals reminiscent of those of the Lindisfarne Gospels; British Museum,
 MME 1867, 1–20; see Webster and Backhouse 1991, no. 70. Alcuin's correspondence includes a rebuke
 (letter 124) to the brethren of a monastery for their fondness for secular songs which were sung alongside
 Christian ones. See Whitelock 1979, no. 194. This was thought to be Lindisfarne, but this has been
 challenged by Bullough 1993.

CHAPTER ONE

The genesis of the Lindisfarne Gospels

Lindisfarne and its book: the historical context

The timeless and evocative tidal isle known as Holy Island, or Lindisfarne, sits as if moored to the coast of Northumbria amid the wild North Sea. Twice a day it seems to set sail as the tides close and the island retreats into its own private world. As the waters ebb the poles, or 'waymarks', emerge to flag the natural safe-track across the treacherous sands which is the traditional path, still preferred by many latter-day pilgrims. Gradually the modern causeway with its made-road surfaces, like the back of a sea serpent, and the island stirs itself to receive the day's flood of visitors. They are lured there by its association with a vibrant tradition of Christian spirituality, by the mysterious natural beauty of the place, by the rugged profile of its castle which appears as if carved from its rocky outcrop, by its flora and fauna and by its history, which, although also rich in many other ways, is dominated by the cult of St Cuthbert and by its reputation as the probable place of genesis of one of the world's most famous books, the Lindisfarne Gospels.

Always a valuable natural harbour and blessed with the ability to support a community with the fruits of land and sea, the island would always have been a focus for human habitation.[1] As a geographical feature it ensured the presence of an extensive and unusually rich estuarine and wetland environment. Along with the Farne Islands, with their seabird and seal colonies, the area is a veritable cornucopia of natural resources and appears to have attracted human exploitation from as early as the Mesolithic period.[2] Not much is known of Holy Island's prehistory, but the outcrop of the castle mound (see fig. 3a), stranded within an otherwise low-lying landscape, and echoed only on the horizon by the rocks capped by Bamburgh Castle (see fig. 4), high-seat of the Anglo-Saxon royal house of Bernicia, sited some dozen miles away on the mainland, is always likely to have attracted human attention as a symbol of power or worship.

By the time that Bede was writing his *Historia Ecclesiastica* (referred to henceforth as *HE*) it was known as 'insula Lindisfarnensis' or 'ecclesia Lindisfaronensis', 'the island/church of the Lindisfaran', 'Lindis' being the same element as the early name for the kingdom of

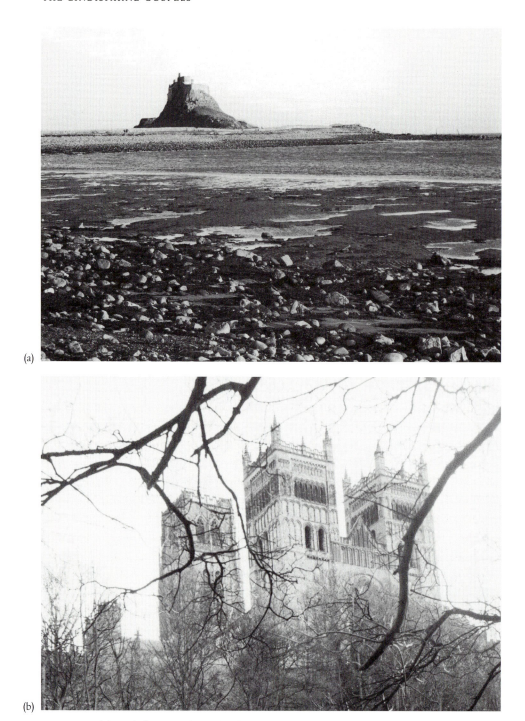

Fig. 3. (a) Lindisfarne Castle, Tudor fort remodelled by Lutyens, seen from the harbour; (b) Durham Cathedral. (Photos: the author)

14

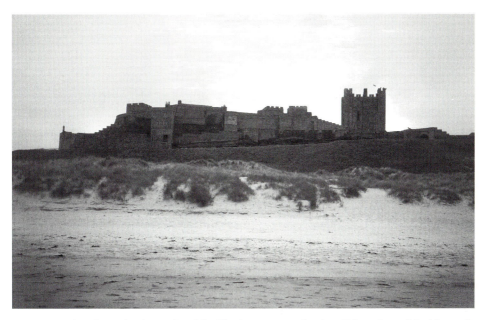

Fig. 4. Bamburgh Castle, the medieval fortifications occupy the site of the palace of the kings of Bernicia, seen from the beach from the direction of the Farne hermitage. (Photo: the author)

Lindsey in north Lincolnshire, 'faran' meaning 'travellers' and the final element deriving from 'eg', island.[3] The place-name would therefore mean the island of the people who travelled from, or to, Lindsey, if Ekwall was correct in dismissing medieval explanations of the name as variations on a stream name 'Lindis', or 'the recess by the Lindis' (*per* Symeon of Durham), and subsequent interpretations, including 'Lindis' = flats, 'farn' = small fragment, 'ee' or 'eae' = island.[4] Bede also gives us (*HE* III.63) an earlier name, 'Metcaud', which may be related to the Irish 'Inis Metgoit'. We do not know the source of Ekwall's proposed derivation of 'Lindisfarne'. It may be an allusion to the shared ethnic origins of the Anglian peoples of Northumbria and of the kingdom of Lindsey (lying between the river Humber and the major estuary known as the Wash). The southern Northumbrian royal house of Deira certainly pursued political interests in Lindsey and Edwin of Northumbria was its political overlord. It may have arisen from some secondary settlement pattern, or from an offshore trading outpost linked in some way to the more southerly territory. It may be significant that the conversion of Lindsey, with its key ecclesiastical centre at Peterborough (Medeshamstede), was commenced by Paulinus as part of his northern mission (launched from Canterbury where the Roman mission led by Augustine had established its centre in 597) and later largely consolidated by missionaries from Lindisfarne. Such links might also help to explain the high frequency of artefacts of medieval Celtic origin in Lindsey.[5]

The island emerged onto the historical stage during the latter part of the sixth century, when, so the *Historia Brittonum* (ch. 63), a ninth-century Celtic compilation attributed to a monk named Nennius, suggests, it was something of a focus of British alliances against the growing power of the Anglo-Saxons, a grouping of pagan Germanic peoples of German, Frisian and southern Scandinavian origins who came to England as mercenaries, settlers and conquerors from the fifth century onwards.[6] Hussa, a grandson of Ida, the latter said to be the first king of Anglo-Saxon Bernicia, is thought to have taken refuge from the British leader Urien on Holy Island during his ultimately successful push-back against the British.[7] The island would thus have become the property of the Bernician royalty during their conquest of the region in the sixth century and, along with other prominent landmarks such as Bamburgh and the high-status settlement below Yeavering Bell (which can also be clearly seen on the landward horizon), may have served as visible centres of their power. The northern Northumbrian Bernician house had a turbulent history punctuated by power-struggles both with their indigenous British neighbours, notably the ancient kingdoms of Rheged (focused upon part of south-western Scotland and Cumbria), Strathclyde (the Clyde basin and south-western Scotland) and of the Goddodin (around Edinburgh) and even Wales, with the Picts and with other Anglo-Saxon powers such as the Deiran dynasty in southern Northumbria (which included York) and the ambitious, thrusting Midland kingdom of Mercia. The various branches of the Bernician house (which on occasion intermarried with its Pictish and British counterparts) also competed violently with one another, occasioning several dynastic crises. The history of the conversion to Christianity of this important region was inextricably linked, as elsewhere in Europe, to the fortunes of the great as well as the good.

The reign of King Edwin (617–33), which Bede celebrates as a golden age, witnessed the introduction of Christianity, so Bede alleges, to the region by Paulinus, a follower of St Augustine who had been sent by Pope Gregory the Great to the Kentish royal seat at Canterbury in 597. Paulinus' entrée to Northumbrian society was guaranteed, as had been Augustine's in Kent, by the marriage in 625 of a Christian princess to a pagan king, in this case Princess Aethelberg of Kent to Edwin of Deira, as his second wife (his first having been a Mercian). It should be remembered, however, that such missions were aimed primarily at the new Germanic ruling classes. As elsewhere in Britain there would have been varying measures of earlier Christian survival inherited from the period of the Roman occupation and preserved by the British Church, one focus of which may have been Carlisle, at the other end of Hadrian's Wall, a possible candidate for the original home of St Patrick, the 'Apostle of Ireland', who joined other Christian clerics in Ireland (such as Palladius who had been sent there by Pope Celestine in 431 to minister to those already of the Christian faith).[8] The patterns of ecclesiastical interaction and allegiance operating in Britain and Ireland were evidently complex from the start. During the fifth century British missionaries such as St Ninian, based at Whithorn ('Candida Casa', the 'White House') in

what is now south-west Scotland, and St Kentigern (or Mungo) at Glasgow, did much to sustain and to spread Christianity in northern Britain and Pictland. An *eccles-* place-name (derived from the Latin *ecclesia*), lying inland from Bamburgh on the middle Tweed (Eccles, near Coldstream), may signify an earlier Christian presence in the vicinity of Holy Island itself.[9] Ireland also began to play a significant part in the process in the sixth century with the mission of St Columbanus to the Continent and the *peregrinatio* ('voluntary exile for Christ') in 563 of an Irish royal prince, St Columba, to Iona – a Hebridean island off the coast of Argyllshire in western Scotland. Columba and his followers subsequently founded numerous monasteries on the mainland, as well as houses in Ireland such as Durrow, Derry and (from the early ninth century) Kells. Lindisfarne was to be one such foundation, part of the monastic federation (*parochia*) of St Columba.

This is, of course, a drastic over-simplification of an extremely difficult set of issues. One point which it raises immediately is that determining the appropriate use of the terms 'Celtic' and 'British' is complicated. In the context of this volume I propose to use 'British' when speaking of the native population and Church in Britain in the Roman and post-Roman period (which remained largely Celtic in ethnicity but was culturally romanised to varying degree) and during the establishment of the Anglo-Saxon kingdoms which came to be known as England (broadly, therefore, the first to tenth centuries). In this sense 'British' is the same as 'Welsh' (from Old English *Wealas*, 'stranger'), the name used by the Anglo-Saxons to denote the indigenous Celtic population of Britain. This came to be applied particularly to Wales which, unlike the other British kingdoms, managed to resist absorption into early Anglo-Saxon England. The obscure origins of the Picts in the North may have predated the influx of Celtic peoples into Britain and Ireland during the Iron Age (from at least the sixth century BC onwards). Irish (*Scotti*) settlers in the West of Scotland challenged Pictish supremacy and, following the eventual merger of their respective kingdoms in the ninth century, gave their name to the other kingdom which avoided English rule during the Middle Ages – Scotland. I shall therefore use 'Celtic' generically when speaking of the legacy of the Celtic Iron Age (especially in respect of art) and also specifically when referring to the distinctive culture and traditions of the Christian Church in Ireland which developed there between the fifth century and the time of its increasing rapprochement with the mainstream influence of the Church of Rome and its satellites during the eighth century (which some might term its 'reform'). It should be borne in mind, however, that its traditions were also espoused, in varying measure, in other areas where its clergy were active, notably parts of Scotland, Man, South West Wales, Cornwall, Brittany, and other ultimately Irish foundations in England and on the Continent.

The foundation of Lindisfarne came about as a direct result, according to Bede, of the contest for the Northumbrian kingship.[10] Bede's hero, the Christian King Edwin, was killed in battle at Hatfield/Hadfield in 632/3, some six years after his baptism by Paulinus

at York. An alternative account of his earlier conversion in Nennius' *Historia Brittonum* (ch. 63), at the hands of Rum (Rhun), son of the British King Urien of Catreath and Rheged, following the baptism of his daughter Eanfled, alerts us to early competing claims between the various churches and clearly signals the political considerations of alliance and clientship underpinning much of the work of conversion. That Paulinus' centre of operations remained south at York may also imply that the reintroduction of Christianity to north-east England had not significantly advanced by the time of Edwin's death (*HE* III.2).[11] This despite Bede's claims that following Edwin's conversion Paulinus baptised many of the Bernicians in the River Glen below the royal assembly point at Yeavering, and the *Historia Brittonum*'s competing claims that in the forty days after Rum's alleged baptism of Edwin the British saint went on to baptise the whole Bernician race.

On Edwin's death Paulinus and the royal family fled to Kent and the reins of power in Northumbria soon passed to the northern Bernician house, its scions returning from exile in the Christian enclaves of Irish and Pictish Scotland. The affiliations they acquired in exile were to exert a profound effect on the history of Northumbria. With the eventual victory in battle of Oswald over Cadwalla at Heavenfield in 634 the 'Celtic' (or, more precisely, Columban) tradition of Christianity achieved a foothold in the region. In Bede's account of events (*HE* III.3) Oswald emerges as a new Constantine, assured of victory over the unholy alliance of the pagan Mercians and the Christian Cadwalla of Wales by his adoption of faith, symbolised by the wooden cross which became his standard and which he set up on the site of his victory at Heavenfield, thereby sowing the seeds of a Northumbrian preoccupation with the iconography of the Cross which would lead to the sculpting of free-standing stone crosses and to the great Old English epic poem, the *Dream of the Rood*. This event is presented in terms of Constantine's victory at the Milvian Bridge, viewed retrospectively as the decisive turning point in the fortunes of early Christianity and the springboard for its becoming the state religion of the late Roman Empire. It was to Iona, site of his own exile and education, that Oswald turned for spiritual support, no doubt accompanied by the secular political backing of the Irish kingdom of Dalriada which straddled the Irish Sea and in which Iona lay. Local resistance is signalled by the initial failure of the Columban mission, its first ambassador, the inflexible Corman, returning to Iona in dismay. Not so its next emissary, Bishop Aidan, who adopted a gentler, more persuasive tone and who arrived in 635 at the island stronghold given to the Columban *parochia* by King Oswald – Lindisfarne, a site reminiscent in so many ways of Iona itself.

Oswald's otherwise successful reign was beset by conflict with Penda of Mercia whose resistance to Northumbrian expansion culminated in Oswald's death at the Battle of Oswestry in 641, upon which Bernicia passed to his brother, Oswy. Oswald's relics were subsequently transported to Bardney in Lindsey (another intriguing link between the two areas; they were taken there by Oswald's niece, Osthryd, who was married to King

Fig. 5. Inner Farne hermitage, seen from Bamburgh Castle. (Photo: the author)

Ethelred of Mercia, see *HE* III.11–12) and his head-relic was taken to Lindisfarne where it was subsequently interred in Cuthbert's coffin, while other of his corporeal relics were taken to the citadel of Bamburgh, reinforcing the close connection between the cult and the royal house.[12]

The island was thus a possession of the Bernician royal house, bestowed upon its chosen vehicle for spiritual validation and support in establishing a stable society, the Irish-oriented 'Celtic' Church. The site of the wooden monastery which Aidan (635–51) and his successor Bishop Finan (651–61) constructed, in 'Scottish' (which at this period means 'Irish') fashion, and which was dedicated to St Peter (no anti-Roman feeling there), is thought to underlie the present remains of the later Norman Lindisfarne Priory, rather than the imposing outcrop occupied by the castle at the other end of the island. There is some slight suggestion, archaeologically, that the latter may have functioned as a defensive or symbolic site during prehistory,[13] and it may have retained some such significance in the Anglo-Saxon period, thereby symbolising in however basic a fashion the alliance of church and state. The donation of royal land, often featuring a defensible site such as a Roman fort (Reculver, Bradwell-on-Sea and Burgh Castle, to name but a few), is a feature of conversion in other Anglo-Saxon kingdoms. The fortunes of the religious community here would remain closely linked to those of its royal sponsors. It may be overstating the case somewhat to present Lindisfarne as the *eigenkirche* of the Bernician royalty, a Northumbrian Aachen or St Denis (the distinction of royal mausoleum being shared in any

Fig. 6. St Cuthbert's Isle (Hobthrush), the retreat in the bay adjacent to Lindisfarne monastery.
(Photo: the author)

case with Whitby), but such royal association undoubtedly played an important role in its subsequent prominence, as of course did the spiritual commitment and integrity of its early leaders. Bishop Aidan was a valued member of the royal household (*HE* III.6) and one of the many churches that he and his followers established in the region was that at Bamburgh. It was leaning against the outer timber walls of this church in the shadow of the royal citadel that Aidan eventually died.

Kings ever needed to be reminded of their Christian duties and encouraged to donate more resources and Aidan seems to have cultivated close relationships with Oswald's successors, Oswy of Bernicia and Oswin of Deira. In thanksgiving for divine aid in finally eliminating the dangerous pagan king, Penda of Mercia, in 655, Oswy made numerous donations of land to Lindisfarne, enabling it to extend the Columban *parochia* with its own network of daughter-houses. Six of these ten-hide donations (a hide being enough land to support a family) fell within Bernician territory and may have included Melrose, Coldingham, Norham, Abercorn and Gilling. Others followed and included some Pictish houses, Hartlepool, the anonymous monastery celebrated in the ninth-century poem *De abbatibus* by Aethelwulf,[14] Peterborough, Bradwell-on-Sea and Lichfield.

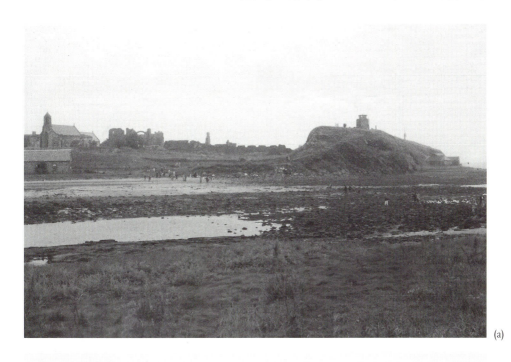

(a)

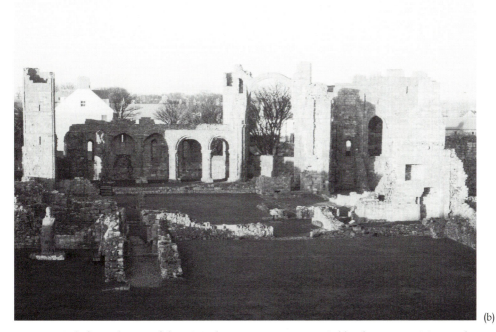

(b)

Fig. 7. Lindisfarne, the site of the original monastery, now occupied by the Norman Priory and parish church, with the ridge known as the Heugh on the right: (a) seen from St Cuthbert's Isle and (b) seen from the Heugh. (Photos: the author)

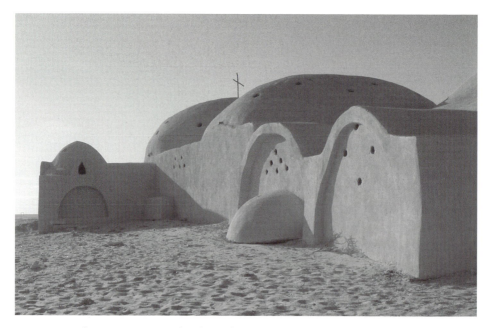

Fig. 8. 5th-century monastic church amidst the hermitages of the Wadi Natroun, Egypt.
(Photo: David Jacobs)

Lindisfarne Castle is essentially a sixteenth-century Tudor fortress romanticised in the early twentieth century by Sir Edwin Lutyens. It formed part of a re-fortification of the island as a supply base for the English navy, occupying as it does a strategic position in respect of northern England, Scotland and the Continent. The island would always have been a significant site militarily and economically, as well as being spiritually evocative and associated with a nearby grouping of islands, known as the Farnes, of the sort that exerted a powerful and deep-rooted pull on the Celtic imagination (see fig. 5). The Farne islands were to become a place of retreat for members of the Lindisfarne community, notably its saintly bishops who would conduct their feats of spiritual and physical endurance on behalf of humankind within direct view of the royal citadel of Bamburgh (like Lazarus at Dives' gate, a constant reminder to secular government of human suffering and of the divine will), as well as of Lindisfarne. The small islet, known as St Cuthbert's Isle (or 'Hobthrush', Thrush Island), within the bay adjacent to Lindisfarne Priory (see figs 6, 7a, 7b) provided a more immediate retreat within a monastery which favoured the eastern eremitic tradition of the desert fathers (see fig. 8).[15]

Another crucial aspect of Celtic monasticism, however, was its outreach to the world through preaching and mission and by functioning as a mirror of secular society, idealised and God-centred. As such, monasteries were not remote from society and played a variety of roles from open prisons (as part of the religious penitential component of the legal

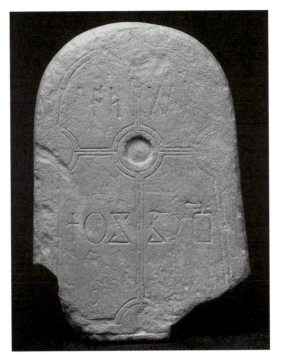

Fig. 9. Osgyth name-stone, marking the burial of a woman in the vicinity of Lindisfarne monastery, 7th–8th century. The name is given in runes (above) and Lindisfarne display capitals (below). Lindisfarne Priory Museum. (Photo: courtesy of English Heritage)

system in which not only fines and penalties but an element of public penance were exacted for misdemeanours) to trading and manufacturing centres. They and their associated laypeople were, if you like, the early Christian Celtic equivalent of nucleated settlements or small towns. When the monks had to leave the island in the ninth century the 'people of St Cuthbert' went with them. A tradition has arisen which implies that, as at Mount Athos, women were not permitted on the island from the time of St Cuthbert. There is no evidence of this in the early record, and indeed material evidence such as the name-stone of the woman Osgyth who was evidently buried within the monastic enclave during the early eighth century would definitely contradict it (see fig. 9).[16] Aidan of Lindisfarne had bestowed the veil upon the first Northumbrian nun, Heiu of Hartlepool, and had persuaded Hild of Whitby to remain in her native region rather than pursuing her vocation in Gaul, and double monasteries of monks and nuns ruled by abbesses were a feature of northern Christianity (as in Gaul and at St Brigid's Kildare). The *vitae* of Cuthbert abound in instances of his friendship with and ministry to women. There was evidently no particular antipathy towards women in the Northumbrian Church. The tradition may have stemmed from St Cuthbert's condemnation of the monks and nuns of Coldingham for

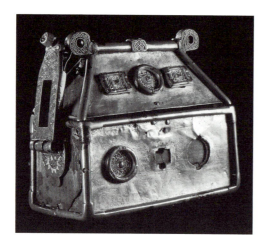

Fig. 10. Monymusk reliquary, front of a Pictish house-shaped reliquary, 8th century, perhaps resembling a church building (NMS, RMS RE 14). (Photo: courtesy of the Trustees of the National Museums of Scotland. © Trustees of the National Museums of Scotland)

their moral laxity and from the misogyny of his community at Durham during the Norman and Angevin periods.[17]

Excavations on the probable site of the monastery of Lindisfarne have been limited, owing to the presence of the later priory and church buildings and of the village itself. From what clues are given in the literary record (Bede's *HE* and the lives of St Cuthbert) and by analogy with Iona, the monastery is likely to have been contained within an earthwork bank (a *ráth* or *vallum*) which may have enclosed the area from the foreshore opposite St Cuthbert's Isle to the market place.[18] The layout of the village, and later medieval references to outlying chapels and burial grounds, would suggest that there may also have been an outer boundary earthwork extending further through the village to the line of what is now Marygate, thus the inner sanctum would be demarcated from the outer enclave in which more worldly domestic and industrial activities might be conducted.[19] Bede (*HE* IV.30) refers to an island hermitage (St Cuthbert's Isle) near to the monastery, within its 'outer precinct' which would tend to confirm such an arrangement: an inner sanctum within a bigger enclosure. The inner enclosure contained two churches, one built by Aidan and another by Finan, of wooden planks and thatch. Bishop Eadberht had the latter covered with lead plaques on its roof and walls, which must have given it an appearance resembling contemporary Insular metalwork house-shaped shrines, such as the Monymusk reliquary (see fig. 10) or the Abbadia San Salvatore shrine.[20] It is thought that the Norman Priory and the parish church (which may date from the late Anglo-Saxon period) reflect both the position of the original main church containing Cuthbert's shrine (in what is now the Priory, see figs 7a, 7b, 11) and the second church copying the double-church on an east–west axis arrangement of late seventh-century Jarrow (see fig. 12).[21] Or might Jarrow have copied Lindisfarne's layout for its two stone churches? More likely, perhaps, is that both centres were observing an arrangement already practised in the Christian Orient. The church buildings would have been surrounded by a burial ground

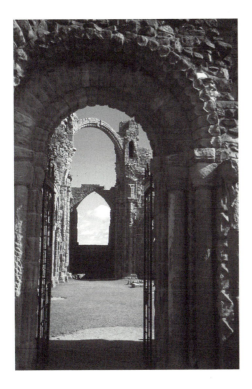

Fig. 11. Lindisfarne Priory, interior of the Norman priory built on the site of the early church. St Cuthbert's coffin stood on the floor to the left of the altar at the far end (now approached by a medieval pilgrim's passage). The Lindisfarne Gospels would probably have stood on the altar.

and literary sources refer to a dormitory and a guest-house. Excavations on the Heugh (see fig. 7a), a ridge sheltering the site from the estuary, have revealed a number of features which have been interpreted as a watchtower (from which the torches announcing the death of St Cuthbert on the Inner Farne hermitage were seen) and pilgrimage stations, including a cross-base. Another Anglo-Saxon cross-base occurs between the two churches (see fig. 13).

The marking of areas of a monastic enclave with high-crosses is a feature found in many Irish monasteries, including Iona, from the later eighth and ninth centuries onwards, but the Lindisfarne practice may predate this. The anonymous and Bedan *Lives* of St Cuthbert refer to the healing of a pilgrim who wore the shoes of the saint and who conducted a pilgrimage round (*turas*) of the 'places of the sacred martyrs', or (*per* Bede) 'the holy places'. This recalls traditional Irish practice, already observed before the early eighth century, and the more recent introduction of Roman stational liturgy.[22] There was a well-established Celtic and British tradition of inscribing pillars or slabs with crosses,[23] but the earliest reference in the written record to the raising of a free-standing stone cross is that which Bishop Aethilwald of Lindisfarne (d. 740) ordered to be made as his memorial. The grave of Bishop Acca of Hexham was likewise subsequently marked with tall stone crosses at head and foot (one of which survives at Hexham Abbey). Stylistically, there would appear to have been something of an earlier Patrician and Columban context, to judge from the

25

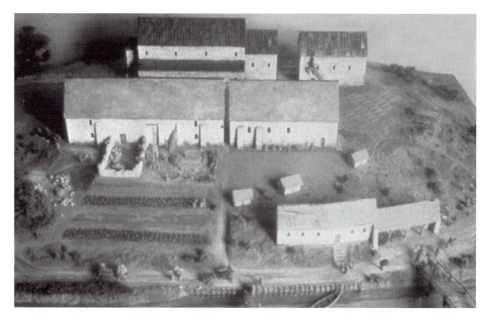

Fig. 12. Jarrow, model of the cœnobitic (communal) monastery as founded in 681; model, reconstructed following excavations directed by Rosemary Cramp. (Photo: courtesy of the Trustees of Bede's World and the Rector and Churchwardens of St Paul's, Jarrow)

stone slabs at Fahan and Carndonagh in Co. Donegal (close to Lough Foyle whence Columba set sail for Iona) which feature simple crosses which appear as if struggling to liberate themselves from the slabs of stone from which they are carved (see fig. 14). Later in the eighth century a full three-dimensionality would be achieved in the high-crosses at Ahenny in Munster (see figs 15, 16). The Co. Donegal slabs may date from as early as the seventh century (or the early eighth) but their artistic conception and carving technique are much simpler, and almost primitive, in comparison with the deep-relief and attenuated multi-sectioned cross shafts from Lindisfarne's northern outpost of Abercorn, near Edinburgh, and Acca's Cross at Hexham. The tradition of free-standing stone crosses may thus perhaps have reached maturity of conception at Lindisfarne, as part of the Columban tradition but perhaps also in specific recollection of King Oswald's wooden cross, raised at Heavenfield in emulation of Constantine, the first Christian emperor, and of the stational liturgy of the cross celebrated in Rome from the first quarter of the seventh century onwards.[24]

In accordance with this stage of development of the Irish-style 'Celtic' Church, centres such as these were monastic but their abbots were generally priested and often exerted authority over the bishops (although recent scholarship is beginning to ascribe more importance to the role of the bishops than was formerly allowed). Such an arrangement was geared to overcome the limitations of a non-urban, tribal territorialism and appears to

26

Fig. 13. Cross base lying between the two churches on Lindisfarne (now the sites of the Priory and parish church), 8th or 9th century. (Photo: the author)

have been indebted to the eastern ecclesiastical tradition. Irish bishops often exercised their diocesan function from monastic seats (or *civitates*, 'cities'), as had Pope Gregory the Great in Rome, who enjoined Augustine to do likewise at Canterbury.[25] This may also be indicative of ultimately eastern influence, such practices continuing to feature in the Orthodox Church, the Archbishop of Sinai also serving as Abbot of the Monastery of St Catherine, for example. At Lindisfarne the abbot was frequently also the bishop.[26]

Such a parochial function made Lindisfarne and its daughter-houses a valuable new feature of local government, as well as spiritual power-chargers for Northumbria's rulers. Many key members of these monasteries, both male and female, were increasingly drawn from the ranks of the aristocracy, and the royal house itself, further cementing the union. A rapprochement with the other major powers of northern Britain was also highly desirable at this stage in the kingdom's development. During the second half of the seventh century, however, the political stage was changing. Lindisfarne's own *parochia* had spread with the contributions of its personnel (such as Cedd, Chad and Diuma) to the conversion of Lindsey, Mercia and Essex, but the extended monastic model was increasingly ill-suited to the territorial and organisational needs of the Anglo-Saxon Church and state. The Roman Church was making significant headway in establishing a proto-parochial struc-

Fig. 14. Cross slab, Fahan, Co. Donegal,
7th or early 8th century. (Photo: the author)

ture, especially under the aegis of Archbishop Theodore from Tarsus, in modern Turkey,
who arrived at Canterbury in 667 along with Hadrian, a North African who had sub-
sequently been based in Naples and who, as abbot of St Augustine's Canterbury, assisted
Theodore in his ecclesiastical and educational development of the early English Church –
a truly cosmopolitan melting pot of people and influences.

Eastern influences have long been recognised in Insular religion, transmitted through
the writings of Church Fathers such as St John Cassian (a key figure in eastern monasticism
who died at Marseilles around 433) and St Pachomios,[27] and through liturgical and
devotional practices, thought perhaps to have been transmitted via post-Roman Gaul and
Iberia. There are also intriguing artistic influences, and perhaps transmission of techniques,
such as the eastern 'Coptic' form of sewing and binding preserved in the form of the St
Cuthbert Gospel (British Library, Loan MS 74, see fig. 17) which is suggestive of an actual
learning/teaching process. People travelled more at this time than we are inclined to think,
water being one of the main lines of communication, and there are elusive but intriguing
indications of visits to and from the East to these northern islands. There are references to
Coptic and Armenian monks preserved in the Irish litanies and to western pilgrims visiting
Jerusalem, the Levant and Egypt, while travel guides were in circulation in an Insular milieu
describing not only the holy places of Jerusalem, but the Egyptian monasteries of Nitria

Fig. 15. High Cross (South Cross), Ahenny, Co. Tipperary, 8th century. The damaged cap and bosses may recall reliquaries on a wooden and metalwork prototype (perhaps a processional cross, the Crux Gemmata), on which the design of the stone cross was based. (Photo: the author)

and Scetis.[28] One such guidebook was allegedly dictated to Abbot Adomnán (who initially recorded it on wax tablets and then transcribed it) on Iona by Arculf, a Frankish bishop returning from pilgrimage whose ship was blown off course, causing him to seek shelter at the abbey. The resulting account is known as Adomnán's *De locis sanctis* and was subsequently reworked by Bede as an aid to the spiritual journey (of mind and soul).[29]

As we shall see, the frequent visits paid by the Northumbrian clerical noblemen, Benedict Biscop, Ceolfrith and Wilfrid to Rome are ample testimony of links with that particular centre and with regions of France, Switzerland and northern Italy en route. Nor were such travels confined to men. Boniface wrote a letter in 747 to Archbishop Cuthbert of Canterbury advocating that he 'forbid matrons and nuns to make their frequent journeys back and forth to Rome. A great part of them perish and few keep their virtue. There are many towns in Lombardy and Gaul where there is not a courtesan or a harlot but is of English stock.'[30] Alliance and trade with southern England, Frankia, Rome itself and other cosmopolitan centres were also becoming increasingly important. Along with royal centres such as Bamburgh, monastic sites such as Monkwearmouth, Jarrow, Whitby and Lindisfarne are likely to have been the major focuses of communications and trade. Coin hoards, including one deposited on Holy Island,[31] are evidence of probable mercantile

Fig. 16. Detail of one of the Ahenny high crosses (North Cross), Co. Tipperary, 8th century. The ornament recalls that of the Lindisfarne Gospels and contemporary Irish metalwork. (Photo: the author)

activity, and St Willibrord, Apostle of Frisia, who trained at Lindisfarne and Ripon before spending a number of years in Ireland and then travelling to the Germanic homelands where he founded Echternach in Luxembourg as part of his mission, certainly permitted at least one of his monks to visit Holy Island (Bede, *Vita Cuthberti*, ch. 44). In the other direction Wilfrid and Acca of Hexham also visited Willibrord in Frisia, and trade between Frisia and Northumbria is likely to have cemented the missionary links.[32]

Following Bede's lead many historians have crystallised the essence of this shift in emphasis into a religious controversy between competing Celtic and Roman church traditions, culminating in the famous Synod of Whitby in 664. Bede's emphasis upon the issues of disparity in physical appearance in the method of tonsuring priests (symbolic of different practices of consecration) and of different observances in the dating of Easter are in one sense symbols of the fundamental issue of whether the English Church (and indeed Anglo-Saxon England itself) should favour an increasingly regional and peripheral stance or should embrace and help to develop the European mainstream and the universal Christian Oecumen. Such matters were of vital import in the development of the early Christian Church. The First Paschal Controversy had been one of the key issues addressed at the First Ecumenical Council of Nicaea in 325, as it raised the threat of schism, the great spectre at the Eucharistic feast of the early Church.[33] At even a purely pragmatic level such

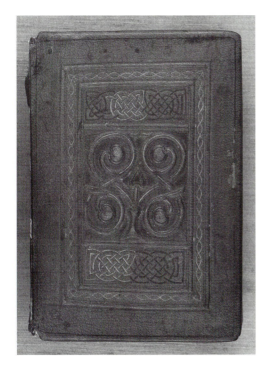

Fig. 17. Binding of the Cuthbert Gospel of St John (formerly the Stonyhurst Gospel, BL Loan MS 74), late 7th century. The book was found in the coffin of St Cuthbert in 1104 and retains its binding, the earliest to survive in the West, bound in 'Coptic' fashion. (Photo: courtesy of the Society of Jesus)

divergent practices carried greater political as well as theological and liturgical import than a modern audience might immediately perceive. Of course it was highly disruptive and irregular if the Bernician king, Oswy, and his Kentish wife, Eanfled, could not celebrate the greatest holy day in the Christian calendar together because they hailed from different church traditions, and striking differences of clerical appearance may not have helped to engender a spirit of ecumenism, but the far-reaching cultural and social impacts can only be guessed at. One recent event which perhaps helps to sharpen our perception of the extra-religious aspects of the problem is the dilemma faced by the European banking community upon the reception of Greece into the EU. Its banks naturally observe the Greek Orthodox calendar for their bank holidays and these of course do not correspond to those elsewhere in the European community, occasioning disruption and trading disadvantages. At the time of writing Greece has been given three years in which to come into line with EU practice.

Establishing a common observance for the dating of Easter carried many implications for the clerics of the day. The avoidance of schism was a particularly serious concern, and one of the factors which coloured England's relations with Rome during the period in question was the Monothelete controversy. In 679 Archbishop Theodore convened the Council of Hatfield which affirmed the faith of the English Church: that Christ had a fully human will, accompanied by human courage, thereby rejecting the Monothelete heresy

which denied him any such will as this would have brought him into conflict with the perfect divine will of which he partook. Pope Agatho sent a senior member of his household, John the Archcantor, to represent him at this council and he accompanied Benedict Biscop and Ceolfrith on their return journey from Rome to Northumbria, spending some time at Biscop's new foundation of Monkwearmouth instructing its brethren in the liturgy and chant of Rome. Hatfield was one of a number of European councils that prepared the way for the Sixth Ecumenical Council held in Constantinople in 681 which was convened to resolve this crisis which had divided the Church in East and West and which had led to the martyrdom of Pope Martin I (649–55) and his adviser, Maximus Confessor. The Council proclaimed that in Christ the divine and human wills were coherently united and that as Christ was incorruptible he never conflicted with the divine will. It was stressed that this incorruptibility lay in his conception, without corruption, from the Virgin Mary by the Holy Spirit. It is from the 650s on that we find the cult of the Virgin, and the veneration of the Cross upon which Christ displayed his will and courage, developing in Rome (from earlier eastern roots) and influencing its liturgy and art. It also became important to stress the unity of Christ's incarnation, from conception to crucifixion, which were thought to have taken place on the same date – 25 March, his conception and death occurring at the Spring equinox and his birth at the winter solstice (25 December) in accordance with the solar cycle upon which the Roman calendar was based.[34] Calendrical niceties carried significant connotations. It is probably not coincidental that in 681 the second of Biscop's twin monasteries, Jarrow, was founded – forming (with Monkwearmouth) two centres with their wills coherently united.

The beginnings of controversy over the Easter dating in Northumbria appear to have been initiated not by the English Wilfrid (who received his early training at Lindisfarne and who first visited Rome with the community's approval), but by Ronan, an Irish scholar who had studied in Gaul and Italy and who began, with the backing of the queen and Alchfrith the king's son, persuading his fellows to accept the Roman dating, bringing him into dispute with Bishop Finan of Lindisfarne (d. 661). That in Ireland itself a mixed practice prevailed before the Synod of Whitby may be deduced from the career of the Frankish Bishop Agilbert, missionary to Wessex in the mid-seventh century, who had earlier trained in the southern part of Ireland under teachers following the Roman reckoning of Easter. Around 630 a convention of Irish abbots at Columba's own foundation of Durrow had opted to follow the Roman Easter and soon after delegates from an Irish synod travelled to Rome to participate in the Paschal celebrations.[35] Henceforth the southern areas of Ireland observed what was perceived to be an international Christian convention. The background to, and the resolution of, the conflict focused upon the Synod of Whitby was evidently a complex one, not governed by the overly simplistic nationalistic complexion with which it has been imbued in modern scholarship in which 'Celtic' opposed 'Roman', and 'Roman' won.

Fig. 18. The Tullylease slab, Co. Cork, 8th century, commemorating an Anglo-Saxon, Berechtuine. The half-uncial script and the cross resemble those of the Lindisfarne Gospels. (Photo: the author)

At Whitby King Oswy used the occasion he had engineered to opt for a unified English Church and for the European mainstream in favouring the Roman case so adroitly argued by Wilfrid (playing his trump card of St Peter's control of the gateway to the heavenly kingdom) against the 'Celtic' (or rather the Dalriadan Columban) cause championed by Bishop Colman of Lindisfarne. Colman and some other representatives of the 'Celtic' Church in England (Celt and Anglo-Saxon alike) subsequently withdrew to Scotland and Ireland. They and others, such as the influential English Bishop Ecgbert who had travelled to Ireland on *peregrinatio* before the Synod of Whitby, founded 'English' centres such as 'Mayo of the English' and Inishbofin, which subsequently conformed to Roman usage, attracting further English recruits and numbering English bishops amongst its visitors during the eighth century. They may also have been involved with other centres associated with English names, such as Tullylease, Co. Cork (see fig. 18),[36] or with dedications to Colman, such as Tarbat (Ross and Cromarty) in Pictland. Nonetheless, those parts of the 'Celtic' Church which had not already done so also gradually adopted the Roman dating of Easter, renewing missionary efforts on the Continent and conducting their own internal spiritual reforms. In 686 the Abbot of Iona and biographer of St Columba, Adomnán, visited Jarrow where he accepted the Roman Easter (*HE* xv.21) and subsequently persuaded many Irish houses to do likewise (*HE* v.15). His own community of Iona remained

obdurate, however, only finally coming into line in 715/16 following the dedicated persuasion of the aforementioned Ecgbert, who was also instrumental in motivating Willibrord's mission to the Continent (*HE* III.4 and v.9, 22, 24) and who may have been crucial in encouraging the Pictish Church to align itself with Northumbria.[37] Ó Cróinín has argued that, as Ecgbert was based in Ireland, his initiatives (at least in relation to Willibrord's mission) should be viewed as Irish. That may be so, but Ecgbert evidently did not perceive this as restricting his relations with England. Perhaps the English foundations in Ireland, post-Whitby, should be viewed less as 'protest votes' and more as link mechanisms. The remainder of the Columban Church had adopted the Roman Easter by 772.[38] The potential schism was over. From the end of the seventh century onwards there are signs of a new eirenic atmosphere of reconciliation and collaboration pervading the thought of many of the leading ecclesiastical figures of Northumbria and Ireland who sought to celebrate their combined Roman, Eastern and Celtic legacies.[39] The leadership of the Lindisfarne community, post-Whitby, passed into the hands of members of the *parochia* of English birth, such as Eata (an original English pupil of Aidan's) and Cuthbert, formerly of the daughter-house of Melrose and, for a short and painfully divisive period following Cuthbert's death, was held by Wilfrid himself. Wilfrid's vision for the English Church was dynamic and outward looking, but not one that took account of the needs and sensitivities of those who might not fully concur.

Cuthbert therefore came to Lindisfarne in 664 with his abbot, Eata, from Melrose, presumably as a direct consequence of the Synod of Whitby. Colman's initial replacement, Tuda, an Englishman trained in the Roman tradition in the south of Ireland, was made bishop (at Colman's request, *HE* III.26) but died very soon after his appointment (with the result that for fourteen years, 664–78, the bishopric was vested in Hexham rather than Lindisfarne).[40] The abbacy, however, remained (again at Colman's request) within the Columban orbit, with Eata's transfer from Melrose. He and Cuthbert were stalwart representatives of the local Columban tradition, having been forced to leave Ripon shortly before 663 to make way for Wilfrid and his followers, but more inclined (and perhaps with less loss of 'face' to consider) than Colman and his party to work towards a constructive rapprochement with the Roman mainstream. The post-Whitby solution, where the important focus of Lindisfarne was concerned, therefore seems initially to have been a constructive compromise, allowing it and other key Columban houses such as Melrose, and Whitby itself, perhaps to retain something of their earlier allegiances while actively promoting the new order in Northumbria. The hand of Archbishop Theodore can perhaps be detected behind the subsequent shaping of the Lindisfarne bishopric. He is known to have visited the island on at least one occasion, at which time he dedicated the wooden church built by Bishop Finan to St Peter (Bede, *HE* III.25). Lindisfarne's relationship with Canterbury, and with York, should be kept in mind as another source of 'romanising' influence, alongside Wearmouth/Jarrow.[41]

Following Eata's lead, it is Cuthbert who emerges in Bede's narrative as the leading figure in the process of reconciliation and it was this role, along with his ability to combine the best of the Celtic ascetic tradition of spirituality, roving ministry and perceptible sanctity with the administrative acumen of the ecclesiastical infrastructure, which featured in the posthumous development of his early cult. Having trained at Melrose, Cuthbert held the posts of guest-master at Ripon and prior of Melrose and subsequently of Lindisfarne, where Bede tells us he instructed the brethren in the observance of regular discipline (*HE* IV.27), although in the prose *Vita Cuthberti*, ch. 16, he also says that up to the time of writing the monastic constitution of Lindisfarne remained, with Cuthbert's aid, as established under Aidan, indicating that any reform was far from extreme and that the Columban tradition continued to be respected and espoused. Cuthbert became Bishop of Lindisfarne in 685, under royal pressure, and died alone on his Farne hermitage in 687. His relics were brought back to Holy Island, despite his own wish to remain on his place of retreat, his 'gateway to resurrection',[42] and his reservations concerning the implications for his community of establishing a major cult.

In 698 Bishop Eadbert ordered his relics, along with those of other saintly members of the community, to be moved from the stone sarcophagus to the right of the altar at Lindisfarne and gathered up for greater veneration. Upon opening Cuthbert's tomb his remains were found to be miraculously incorrupt and plans were rapidly drawn up to make a greater event of the translation and to place his body in a wooden coffin occupying a central focal point on the floor of the sanctuary above the original tomb.[43] Bede (*HE* IV.30) tells us that eleven years after Cuthbert's death

> Divine Providence guided the community to exhume his bones … When they informed Bishop Eadbert of their wish, he gave approval and directed that it should be carried out on the anniversary of his burial … and when they opened the grave, they found the body whole and incorrupt … the brothers were awestruck, and hastened to inform the bishop of their discovery. At that time he was living alone at some distance from the church in a place surrounded by the sea … it was here that his venerable predecessor Cuthbert had served God in solitude for a period before he went to the Farne Island … having clothed the body in fresh garments, they laid it in a new coffin which they placed on the floor of the sanctuary.

No sign here of a major celebration of the translation (although 'surprise' is crucial), conducted during the penitential season of Lent and in the bishop's retreat. It is, none-theless, the translation of 698 which has come to be associated with the occasion of manufacture of the Lindisfarne Gospels as another visible focus of the cult of St Cuthbert. This conclusion was reached partly on the basis of the attempts of scholars during the twentieth century to make sense of the relationships and production sequences of artistic monuments of the period and largely upon the later history of the book, notably the colophon added around 950–70 by Aldred. In the course of the present discussion we shall consider some of the ways in which this assumption can be assessed.

The perceived opposition of the Celtic and Roman camps has dominated historical, theological and art historical debate relating to the period and has led to an overly polarised stance aggravated by modern perceptions of nationalism. Whitby did not occasion a wholesale English rejection of the 'Celtic' Christian past per se, nor a complete breakdown in communications. Neither did Celtdom harbour a pre-existing antipathy to the Roman tradition or a spirit of introverted isolationism from which England had to assert its independence, rather the contrary.[44] In correcting such preconceptions the pendulum of scholarly debate has swung somewhat too far in both directions and only now is it steadying to a more measured, balanced middleground.

Colman and Wilfrid, the key protagonists in the debate, may not have seen it this way, of course. Colman felt obliged to withdraw his labours and Wilfrid seems to have viewed his victory as bestowing a carte blanche to trample over the feelings and rights of those who stood in the path of his ambitious personal vision for the English Church. This was to bring him into conflict not only with the remaining representatives of the Columban tradition but with the kings of Northumbria, Archbishop Theodore and the ecclesiastical establishment. Nor were his activities confined to northern England or even to Gaul and Rome. His intervention in Irish politics as part of the succession crisis of the Frankish prince Dagobert has also recently emerged.[45] That Irish influence continued to be exerted in England is indicated by the Synod of Hertford of 672 at which enactments were passed concerning the 'orthodox' celebration of Easter and wandering clergy, and by the Council of Celchyth (Chelsea) which as late as 810 still considered it necessary to deny Irish clergy the right to exercise any spiritual authority in England.

The Northumbrian conflict with the forces of Mercia and of North Wales, and incursions into the territories of Northumbria's British, Pictish and 'Celtic' neighbours continued throughout the reigns of Oswald, Oswy and Ecgfrith. In 679 Archbishop Theodore negotiated a peace which acknowledged the independence of the kingdoms of Northumbria and Mercia. Henceforth Northumbrian ambitions south of the Humber were curtailed, forcing Ecgfrith to concentrate his attentions upon northward expansion, raiding Ireland, Dalriada, and Pictland, the latter leading to his death in battle in 685. He even launched hostilities in Ireland, but relations seem to have improved under his successors, notably Aldfrith (Oswiu's son by an Irish wife) who reigned from 685 to 705. Aldfrith was a ruler renowned for his learning – he had been educated in Wessex, Ireland and Iona – and seems to have adopted a more tolerant stance in respect of Northumbria's Celtic, Pictish and British neighbours and their religious traditions. Northumbrian ambitions henceforth generally concentrated upon maintaining the status quo in respect of their neighbours and in retaining control of what is now the Scottish Lowlands and Cumbria. They were largely successful in this, the area between Forth and Tweed remaining in Northumbrian hands until Lothian was ceded to Kenneth II of Scotland by the English king, Edgar, in the 970s, with the River Tweed finally coming to demarcate

the Anglo-Scottish border following Malcolm of Scotland's victory at Carham in 1018.[46]

With the accession of the Pictish King Nechtan in 706 Pictland had entered a new phase in its relations with Northumbria, conforming to the Roman Easter dating and seeking Northumbrian support in 'modernising' the Pictish Church (*HE* v.21).[47] In this it appears Nechtan may have been assisted by Bishop Ecgbert, the same Northumbrian ecclesiastic who had established an English community in Ireland, post Whitby, and who was instrumental in initiating Willibrord's mission.[48] The letter which he may have helped Nechtan to compose included a request to Abbot Ceolfrith of Wearmouth/Jarrow for stonemasons to instruct in church construction, indicating that by this time the essentially Iron Age timber construction techniques of hewn oak and reed thatch initially employed on Holy Island and its other foundations was being augmented, if not replaced, by the late Roman tradition of masonry. This had been reintroduced to England via Augustine's mission to Kent and, to Northumbria, via Gaulish masons imported during Ecgfrith's reign to construct two important new linked monasteries, Monkwearmouth and Jarrow, further south on Wear and Tyne. When the Northumbrian nobleman Benedict Biscop founded these two houses, in 674 and 681 respectively, it was with the assistance of a royal land grant of ninety hides;[49] some rate of inflation on the ten hides initially given to Lindisfarne and its satellites. Wilfrid likewise employed impressive stone construction techniques, 'more Romanum' ('Roman fashion'), at his key holdings such as Hexham and Ripon. Throughout the last quarter of the seventh century and the first half of the eighth the Northumbrian landscape became increasingly populated with worship sites, some, as Bede warns, sadly little more than the 'tax breaks' of the Northumbrian aristocracy.

Lindisfarne's land-holdings also grew dramatically during this period, Ecgfrith's donations including Carlisle and adjacent land, the Bowmont Valley and Cartmel.[50] Under the auspices of Ecgfrith and Archbishop Theodore of Canterbury the Church structure of Bernicia became organised around three key bishoprics, Lindisfarne, Hexham and the newly refounded Whithorn.[51] From its heartland of 'Islandshire', and adjacent 'Norham-shire', Lindisfarne controlled the Bernician littoral, its lands and foundations (such as Coldingham and Aberlady) lining the northern English seaboard as far as Abercorn, near Edinburgh on the Forth Estuary. Abercorn is dedicated to St Serf, a follower of Ninian, and it is thought that the church there may have been refounded from Lindisfarne in the seventh century. As part of the reforms following the Synod of Whitby, Archbishop Theodore had established Trumwine there as bishop of the Picts, but following his flight south after the Battle of Nechtanesmere in 685 (at which the Pictish King Brude defeated the Northumbrians) administration of the former see is thought to have passed to Lindisfarne and thence to Durham. Other of its major houses, including Norham and Melrose, lined the strategic Tweed Valley. This line may well have marked a traditional route of communication with the western coast of Scotland and with Iona itself. The rivers Tweed and Clyde come within around five miles of each other in the interior and would

have provided a valuable riverine communications route, along with the Forth/Clyde line. The ancient Roman road network also seems to have featured in the planning, with the early monastery of Melrose lying adjacent to a major Roman fort, Trimontium, at what is now Newstead (rather than modern Melrose itself, where the later abbey is sited) and near a Roman bridge, the footings of which can still be seen, carrying the region's main north/south road. Nor were Lindisfarne's holdings confined to the north. Some, such as Chester-le-Street, Gilling and Crayke, lay southwards and may have marked staging posts, or *mansiones*, en route to York, where the Bishop of Lindisfarne seems to have owned a residence from at least the late seventh century.[52]

Lindisfarne was a crucial lynchpin in Northumbria's political game-plan, not only ensuring its physical control of the northern half of the kingdom, but winning the hearts and minds of its multi-ethnic population. The visible remains of this northern Northumbrian spiritual hegemony survive in the sculptured monuments to be found from Abercorn, Aberlady and Jedburgh to Ruthwell, Bewcastle, Lowther and Hoddom, and find an echo in the Pictish Class II stones with their crosses and iconographies of Northumbrian derivation merging with the enigmatic ancient Pictish symbols. With its Celtic antecedents and its prominent role within the English establishment the 'community of St Cuthbert' was ideally placed to act as the regent of the north. Herein lay the roots of the later medieval development of the palatinate – the prince-bishops of Durham.

Such grandeur was yet to be fully realised. At the time that Bede was writing, Northumbria's 'Golden Age' was already past and the focus of attention and power had shifted southwards. But temporal power is not always a prerequisite of cultural achievement and it is in the period of comparative political ebbtide that Northumbria seems to have produced some of the greatest cultural statements of its legacy and identity. These came to embody that of early 'England' as a whole and included Bede's remarkable attempt to create a national history, the *Historia Ecclesiastica*, and the Lindisfarne Gospels.

Were the Lindisfarne Gospels made at Lindisfarne?

From the foregoing it will be apparent that, even with its traditions of asceticism and spirituality and its leanings towards aspects of eremitic monasticism, Lindisfarne was no remote bastion of otherworldliness. This was no Skellig Michael (although the Inner Farne hermitage performed something of that function, see figs 5, 175). Rather, like Columba's Iona, its parent house, it was strategically sited, both geographically and politically, to exert the maximum amount of authority over the kingdoms to which it ministered, and their ruling elites. This, coupled with an indefatigible commitment to preaching tours and pastoral care for ordinary rural communities, no matter how inaccessible, and to teaching and exhortation by example – in short the visible living out of faith – ensured its success.

Lindisfarne was a powerful and wealthy house. Cuthbert's own 'Achilles heel', as he

himself admitted, was the temptation of worldly riches, presumably reflecting his own spiritual dilemma as an ascetic called upon to lead a powerful monastic federation (a dilemma similar to that faced later by St Francis and the mendicants). If it lacked the initial advantages of the bounty bestowed upon subsequent Northumbrian foundations, such as Wearmouth/Jarrow and Hexham, it rapidly attracted further endowments and gifts and these are likely to have grown considerably following its establishment as a major cult site after Cuthbert's death and the formalisation of his cult after the translation of his relics in 698. During the eighth century we find it becoming a refuge for kings 'in clericatu', retreating from the world into monastic life (voluntarily or under duress), such as King Ceolwulf of Northumbria (729–37), a benefactor of Lindisfarne who continued to exert a major influence in dynastic politics from his base there from his first stay with the community in 731 until his death in 762.[53] It was to King Ceolwulf, then possibly resident at Lindisfarne, that Bede addressed the preface to his *Historia Ecclesiastica* in which he drew specific note to his reliance upon the testimony of the Lindisfarne community for information relating to St Cuthbert, in whom Ceolwulf must already have shown a notable interest.[54] This displays an intriguing link in Bede's own thinking between his work on the *Vita Cuthberti*, composed for Lindisfarne's former bishop, Eadfrith, and the *Historia Ecclesiastica*, seemingly produced for a kingly patron with a specific devotion to Lindisfarne.

Holy Island was also, as Cuthbert had feared, a potential sanctuary for political activists such as the royal pretender Offa, who around 756 was dragged from the church by pursuers who also imprisoned Bishop Cynewulf at Bamburgh, presumably for defending the right to sanctuary.[55] It would have offered rich pickings to anyone who dared to transgress its ancient rights, and in 793 those who so dared descended upon the island from its vulnerable seaward side – the Vikings. These were probably not the Danish warbands who would take over much of England, including Northumbria, during the course of the ninth century, but given the pattern of raiding around the northern isles of which the sack of Lindisfarne formed part, the 'White Strangers' (or 'fair-headed'), the Norwegian Vikings who would establish themselves in Ireland, the Highlands and Islands and Cumbria.[56]

The shock-waves of such pagan desecration reverberated around Christendom, sounding the death-knell of 'the age of the saints'. An emotive letter of sympathy thought perhaps to have been despatched in 797 to Hygebald, Bishop of Lindisfarne, by the prominent English intellectual Alcuin from Charlemagne's court (no paragon of abstention itself) is tinged by the sorrowful suggestion that such horrors had been called down upon the brethren by their departure from earlier ideals of asceticism. [57]

Let there be no doubt then that Lindisfarne would have commanded the physical resources necessary to produce a masterpiece such as the Lindisfarne Gospels. That such a major centre would have needed a full complement of scriptural and liturgical texts and that these would have included tomes tending towards the higher echelons of book production is likely, to say the least. Its roots within the Columban tradition would probably

have fostered an appreciation of the book arts, Columba himself enjoying fame as a scribe and his own subsequent cult featuring an extensive complement of book-relics, including the Cathach of Columcille, the Book of Durrow and the Book of Kells. One of his successors, Abbot Dorbene of Iona, who was elected in 715, was likewise renowned as a scribe. Adomnán tells us that at Iona, which would have operated a rule of life similar to that introduced at Lindisfarne by Aidan,[58] the brethren were grouped into three categories: 'the seniors',[59] older brothers, employed mainly in religious services and in copying Scripture (which is likely to be of relevance when considering the stage of life in which the maker of the Lindisfarne was working); 'the working brethren',[60] dedicated to manual labour; and 'the juniors', pupils and novices.[61] All the brethren were expected to engage in prayer, meditation and manual labour,[62] and a task such as making the Lindisfarne Gospels would have embodied all three.

It has generally been assumed that, if indeed Eadfrith were the artist-scribe of the Lindisfarne Gospels, he would have had to undertake the work before assuming the busy role of bishop in 698. The foregoing would indicate that within the Columban tradition (and elsewhere if the case of Cassiodorus, himself a scribe, is anything to go by) such important scholarly tasks of transmission were more likely to be entrusted to older, more eminent members of the community, including founders and abbots. Adomnán tells us himself in the colophon to his *De locis sanctis* that he had undertaken the work despite being incredibly busy in accordance with his high office, observing that 'which I have written down in what is a poor style of words, despite being surrounded on every side by almost insupportable labours, ecclesiastical problems, and duties that called for my attention'.[63] If you want something done, ask a busy person! More importantly, as O'Loughlin observes, *De locis sanctis* was written with a very definite purpose related to 'salvation'.[64] Bede was quick to perceive that potential and reworked the text himself in relation to his exegetical work on the sacred sites, *De Templo* and *De Tabernaculo*. It is, therefore, not unlikely that work upon an extraordinarily high status book probably intended as a visible cult item, the writing of which would have been seen as an heroic feat of scriptural transmission, preaching and eremitic devotion in its own right, should have been entrusted to the most important member of the community – its bishop – even if the endeavour did consequently take longer to complete. In fact it was never fully completed, something preventing its maker from completing the very final elements of the decoration and rubrication, some of which were left unfinished in respect for an individual who was already likely to have achieved saintly status himself, like Bishop Eadfrith.

Bede refers to Lindisfarne as a centre of learning and requested of Bishop Eadfrith, in the preface to his prose *Vita Cuthberti*, that his name be inscribed upon the roll of the Lindisfarne 'liber vitae' ('Book of Life') which would have been kept on the altar for the liturgical inclusion of the names it contained within the community's intercessions (the names did not need to be read out during the liturgy – the very presence of the book

upon the altar meant that all the names therein could be simultaneously evoked by it).[65] However, there is no evidence of a major library resource of international stature being available at Lindisfarne, such as that constructed by Benedict Biscop and Ceolfrith at Wearmouth/Jarrow, although it has been said of the anonymous author of the first life of St Cuthbert, a member of the Lindisfarne community, that he 'was familiar with the books of a well-stocked library and knew the scriptures well'.[66] Such libraries would always have been a rare commodity and, if their custodians were so inclined, they could serve readers outside the host communities. They could also disappear almost without trace. If Alcuin is to be believed, even given the luxury of poetic licence, York also possessed an impressive and well-stocked library by the late eighth century and yet none of its volumes can be securely identified amongst the depleted ranks of the surviving books of the Insular world. Likewise, Bishop Acca of Hexham is said by Bede (*HE* v.20) to have assembled 'a most numerous and notable library', which remains unrepresented in the surviving corpus of Insular books. Lindisfarne, however, has left no clues in the historical or artefactual record hinting at a role as a major intellectual centre. Its reputation lay more within the realms of faith and any high-grade books which it possessed are likely to have primarily reflected such preoccupations. Given what is known of the books associated with the cults of both Columba and Wilfrid, a prestigious Gospelbook is likely to have been a prerequisite of the cult of St Cuthbert at Lindisfarne.[67] The historical and cultural profile of that centre would suggest that any such cult book would be likely to acknowledge and celebrate both the Celtic antecedents of the house, its contemporary role in Anglo-Saxon England as effective regent of the multi-ethnic region of northern Britain and its place in the universal Christian ecumen.

The Lindisfarne Gospels certainly fit such a context on all counts, but can we be *positive* that the book was actually made at Lindisfarne? The answer has to be no. Like the majority of its peers, the volume contains no original colophon stating where or when it was made, or by whom. It does, however, contain such a colophon added in the third quarter of the tenth century by Aldred, who subsequently became Provost of the Community of St Cuthbert at Chester-le-Street and who seems to have ensured his entrance into this prestigious house, the descendant of Lindisfarne as *caput* (head) of the *parochia*, by glossing some of its key Latin works in the Old English vernacular. Such an addition cannot be taken simply at face value; it needs to be assessed in relation to other evidence and the motives of its compiler duly considered. That having been said, provenance history – in effect the reconstruction of the biography of the book – is usually accepted by scholars as a valuable and influential evidential component in determining its probable place of origin. Thus David Dumville is able to write of the Book of Kells, which similarly lacks a secure statement of origin, that 'a wide variety of other types of evidence conspires to place the "Book of Kells" within a margin of chronological error around AD 800. Given the provenance, a Columban house in the Gaelic world is the natural scholarly first port of call

(a)

(b)

Fig. 19. The 'Tara' or Bettystown Brooch, Irish, 8th century (NMI R 4015): (a) front and (b) back.
(Photo: courtesy of the National Museum of Ireland)

and is by no means incredible.'[68] The same might justifiably be said of the Lindisfarne Gospels around 700–25, and Lindisfarne would qualify as such as house, its claims being reinforced by its tenth-century provenance within its relocated community.

An assessment of the book's circumstances of production has to consist of a balanced evaluation of a range of evidence, from the internal components of the work and their affiliations to its historical and cultural context, judged against the contextual raft of scholarship at any given time. The motives and methodologies of individual commentators and the perspectives of different disciplines have to be taken into account – they are an important part of what makes the artefacts of the past worthy of consideration in the present and an aspect of their continuing relevance. For such works can act as portals into past lives, and although we can never fully pass through these doorways to capture full historical veracity we can use them to explore the inter-relationships of past, present and future and, perhaps, thereby to gain a greater understanding of ourselves.

If scholarly consensus today favours Lindisfarne as the likely place of origin of Cotton MS Nero D.iv this was by no means always the case. As we shall see, Cotton knew that the volume had been associated with that described in the early twelfth century by the Durham historian, Symeon, as the book of St Cuthbert which was lost in the sea and

(a)

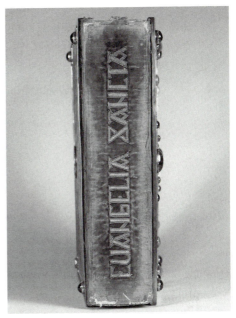

(b)

Fig. 20. Lindisfarne Gospels (Cotton MS Nero D.iv), the 1853 treasure binding:
(a) lower cover and (b) spine

recovered miraculously unharmed. In the early seventeenth century its owner Sir Robert Cotton referred to it as the 'Durham Book', noting the passage recounted by Symeon. Not until the nineteenth century did the great debate concerning the English or Irish origins of the Lindisfarne Gospels and other key representatives of the Insular style assume momentum, and this should be understood in the context of the contemporary socio-political background. The discovery of the 'Tara' brooch (see figs 19a, 19b, 111), one of the great masterpieces of Insular metalwork, on an Irish beach in 1850 and its subsequent publicisation, by the jeweller who had acquired it, at the Great Exhibition in London in 1851 (which probably inspired the creation of the Lindisfarne Gospels' current treasure binding, see pl. 1 and fig. 20), formed part of a growth in antiquarian interest in the early Middle Ages in Britain and Ireland. What is now termed 'Insular' art, as a means of signalling certain shared cultural elements throughout the group of islands in question during the sixth to ninth centuries (while simultaneously acknowledging distinctive regional features and dissimilarities), was initially perceived as either Irish or 'Hiberno-Saxon', i.e. under Irish influence even if made in Anglo-Saxon territory.

Shortly after the excitement occasioned by the Tara brooch and its discovery in Ireland, there was a flurry of activity surrounding the Lindisfarne Gospels.[69] In 1853 the octo-genarian Edward Maltby, Bishop of Durham, obtained the permission of the Trustees of the British Museum (much to the dismay of the Keeper of Manuscripts, Sir Frederic

Madden) to have the volume rebound in a replacement treasure binding.[70] That same year it was agreed by the Surtees Society, convening in Durham Castle under the auspices of its first patron, the said Edward Maltby, to publish an edition of the Latin and Old English texts of the Lindisfarne Gospels (or 'Durham Book' as they alternatively referred to it), along with the gloss and variant readings of the Rushworth (or Macregol) Gospels, an Irish Gospelbook also glossed in English during the tenth century. Why this sudden peak in interest in the volume in the north-east? Richard Bailey has given a lively account of the way in which the relics of St Cuthbert featured in the struggle to achieve de facto Catholic emancipation in the region.[71] Despite the grant to Catholics of freedom to worship in 1791 tensions continued. Bishop Maltby became embroiled in the dispute. In 1851 (17 January) *The Times* published his letter to the Archdeacon of Lindisfarne instructing him to deter his flock from 'Romish' practices, such as the worship of images. This provoked much debate and ill-feeling, including the publication of an anonymous pamphlet (accredited in a manuscript note on the British Library's copy to Revd McRogerson of Minsteracre), entitled 'Protestant Aggression. Remarks of the Bishop of Durham's Letter to the Arch-deacon of Lindisfarne', by 'a Catholic clergyman resident within the diocese of Durham', which rebuked him in the strongest terms.[72] Maltby's decision to put his personal mark, and that of Durham Cathedral, upon the Lindisfarne Gospels, in the form of the new binding, may have been connected to this debate, either as an attempt to soften the perception of his antipathy to the cult or as a reinforcement of the Anglican 'ownership' of it in the face of competing Catholic claims.

The work of the Surtees Society can also be interpreted, in part, in this light. The Society was established in 1834, 'having for its object the publication of inedited manu-scripts, illustrative of the intellectual, the moral, the religious, and the social condition of those parts of England and Scotland, included on the East between the Humber and the Frith of Forth [*sic*], and on the West between the Mersey and the Clyde, a region which constituted the ancient kingdom of Northumberland'.[73] In the preface to the second part of their edition of the Lindisfarne and Rushworth Gospels, in 1861, the Society's agenda in this respect is made clear (p. vii): 'The object the Society proposes to itself in this under-taking is to give an exact representation of the most ancient and noteworthy monuments of the theological labours of our Teutonic forefathers.' It goes on to ascribe the making of the book to Eadfrith, prior to his elevation to the status of bishop in 698 and adds that 'the magnificent binding which was bestowed upon this unique volume by Æthelwold, Eadfrith's immediate successor in the see of Lindisfarne, has been worthily replaced within the last few years by the gorgeous covers which attract the attention of most visitors to the British Museum'.[74] The Secretary of the Society at this time was none other than James Raine who, in 1827, had so controversially opened the tomb of St Cuthbert in Durham Cathedral in order to establish the status and possession of his relics.[75] In the preface to part III (1863), p. ix, the Society states:

The Latin text, which is printed entire, is that of the Lindisfarne Book, containing the four Gospels in the Vulgate version, the oldest specimen existing of any portions of the Holy Scripture transcribed by a native of Britain [and pushed Eadfrith's work back into the lifetime of St Cuthbert, stating that it] was the work of Eadfrith, bishop of Lindisfarne, and was undertaken by him in honour of St Cuthbert, in the life-time of that eminent man, but not completed till some years after his death, which took place in AD 687.

The picture which emerges is one of the Lindisfarne Gospels being utilised, or rather appropriated, as part of a campaign to demonstrate the English (and Anglican), as opposed to the 'Celtic' (or Catholic), contribution to the evangelisation of northern Britain. At a time when Catholic emancipation was a burning issue in the region, it gives one pause to recall, as the anonymous author of the pamphlet censuring Maltby was quick to point out, that the effects and implications of the Irish famine of 1845–8 were becoming all too apparent.

Other authors who included the volume in their discussions, such as J. O. Westwood who had published images from it in 1843–5, likewise accepted the veracity of Aldred's colophon and ascribed it to Lindisfarne, but in 1913 (the year of the wave of strikes in Ireland led by James Connolly and the growing threat of rebellion) a growing perception of the Irish primacy of the style led R. A. S. MacAlister to be the first to question the colophon seriously and to claim the volume as a ninth-century Irish product.[76] The debate sharpened in 1947 when F. Masai published his 'Essai sur les origines de la miniature dite irlandaise', reasserting the Anglo-Saxon contribution. The nationalistic gloves were off and discussion of the book history of the period has been tinged ever since with the partisanship it engendered. With its 'secure' Lindisfarne origins, Cotton Nero D.iv became somewhat pivotal in attempts to claim the style for England. Foremost in this campaign was T. D. Kendrick whose *Anglo-Saxon Art to AD 900* of 1938 sought to redress the balance and who, followed by Rupert Bruce-Mitford (heavily influenced by his own archaeological involvement in the early seventh-century Anglo-Saxon ship-burial mound at Sutton Hoo), was concerned with demonstrating the presence of the Hiberno-Saxon style in England and its indebtedness to Anglo-Saxon and other Germanic metalwork. The Urs Graf facsimile (*Cod. Lind.*) of the Lindisfarne Gospels, in 1956–60, conducted under Kendrick's general editorship and with the art historical discussion by Bruce-Mitford, heavily favoured an English context for this and related volumes, identifying Lindisfarne as the production centre of the Lindisfarne, Durham and Echternach Gospels, its scriptorium dominated by two master-scribes, Bishop Eadfrith and an artist-scribe, who was perhaps his mentor, identified by Julian Brown and termed 'the Durham-Echternach Calligrapher'.[77] In his accompanying discussion of the palaeography, codicology and textual history of the Lindisfarne Gospels, Julian Brown made a major contribution to the study of early medieval palaeography, laying the foundations for his analysis of the Insular system of scripts which was the first coherent attempt at its interpretation, but any notes of caution

he expressed as part of the construction of this particular orthodox edifice of scholarly opinion were lost in the overall confidence of the editorial team. *Cod. Lind.* nonetheless stands as an enduring monument to innovative scholarship and as a benchmark in the analysis of an individual manuscript. Christopher Verey's work on the Durham Gospels, in a facsimile of 1980 and in subsequent articles, did much to explore further the relationships between these books (including his important identification of the same correcting hand in both the Lindisfarne and Durham Gospels) and to reaffirm the existence of an influential scriptorium at Lindisfarne.[78] This assumption has remained generally accepted, if not unchallenged, ever since, but landmarks of scholarship such as these should become part of a continuing dialogue and dialectic. That is their purpose.

In the course of the debate the origins of some of the greatest treasures of Irish metalwork, such as the Tara brooch and the Ardagh chalice, were also on occasion claimed for 'England' because of their close stylistic relationships to manuscripts such as the Lindisfarne Gospels. Archaeological discoveries made during the later twentieth century have fortunately returned sanity to the debate, demonstrating that the style was something of a shared, multi-cultural vocabulary which could be employed both in Britain and Ireland. Manufacturing debris found at Irish sites such as Lagore Crannog have clearly shown it in practice there and the royal fortress of Dunadd at the heart of Irish Dalriada in Scottish Argyll, with which Columba's mission was so intimately involved, has yielded vital evidence of the mixing and matching of Celtic, Germanic and Pictish stylistic elements in metalwork made there between the sixth to eighth centuries.[79] Dáibhí Ó Cróinín reintroduced the evidence of metalwork to the discussion of manuscripts when demonstrating the fallacy of arguments claiming Anglo-Saxon England as the only route by which the influence of Germanic metalwork could have reached Insular scriptoria, by discussing Irish historical contacts with Frankia (in which the romanophile Wilfrid played a significant part) and the initial Irish impetus to the Frisian mission of St Willibrord.[80] Given these facts and the protracted interaction between Ireland and the Continent in the wake of missions such as those of Columbanus and Fursey, not to mention Irish participation in the intellectual life of the Carolingian Empire, arguments favouring Irish cultural isolationism must surely be considered specious.

In attempting to restore perspective, the pendulum has however perhaps swung once again too far in one direction. Attempts to advance a lesser-known Irish monastic site, Rath Melsigi, as a major production centre for volumes associated with Echternach, such as the Echternach Gospels, which, on the basis of the association of this volume with the Durham and Lindisfarne Gospels by the editors of their respective facsimiles, might imply that the whole group should be seen as Irish, have gone too far and have failed to receive general credence in their entirety (if not in their detail) as they have overstated the case.[81] Bede (*HE* v.9–11) tells us that the origins of Willibrord's mission lay in Ireland and was instigated by Ecgbert (638/9–729), an English bishop pursuing monastic exile there. Bede also

says (*HE* III.27) that during a plague which struck Ireland in the 660s Ecgbert was at a monastery called Ráth Melsigi, but there is no reason to think that he need have remained there until Willibrord left for Frisia in *c*.690. Ecgbert's arena of operations seems to have been a broad one.

Willibrord was also following in the footsteps of Bishop Wilfrid of York, who had been the first Insular cleric to preach in Frisia in 678/9 (Stephanus, *Life of Wilfrid*, chs 26–8), under whom Willibrord had served at Ripon and who continued to take an interest in the latter's work.[82] The background to the mission was a mixed one and need not have precluded participation by personnel recruited from England as well as from Ireland and on the Continent, the mission only flourishing after Frankish conquest of part of the region (Bede, *HE* V.10). The identification of two Echternach scribes named in charters as Virgilius and Laurentius as Irishmen (Virgilius being equated with the Irish name Fergal) has been inflated to support the concept of a primary Irish character for the early Echternach foundation and its scriptorium, yet there is no evidence to support this assertion.[83] Likewise, much has been made of the presence of Old Irish glosses in an Echternach book, yet Old English and Old German glosses are also to be found in another of its volumes.[84] What the Echternach perspective has demonstrated is that an 'Insular' scriptorium could draw upon the many different traditions available to it, in varying measure for various projects, and that such multi-cultural centres could act as two-way streets for the transmission of influences. That some related books, such as the Augsburg Gospels, are now thought to have been made in an Irish orbit serves, like the archaeological evidence, to demonstrate the shared currency of 'Insular' book production.[85] Nancy Netzer has made a valuable contribution to the debate by exploring the historiography of the subject and the motivation underlying various bibliographical contributions, and by demonstrating the long-term interaction of Irish, English and Continental personnel in the scriptorium at Echternach.[86]

In the course of these deliberations the origins of other important volumes have also been discussed, notably the Book of Durrow, the Book of Kells and the Cambridge-London Gospels (Cambridge, Corpus Christi College, MS 197B and British Library, Cotton MS Otho C.v). Those favouring a Northumbrian origin for the Lindisfarne Gospels and its closest relatives have all too often taken correspondences of stylistic details with these other works to suggest that they were all made in England. Those who view the Books of Durrow and Kells as Irish, whether made in Ireland itself or at Irish Iona or its orbit, have frequently made the opposite assumption that all are in effect Irish products. Detailed work on the individual volumes is, however, increasingly indicating a stylistic currency throughout what has been termed the 'Irische schriftprovinz',[87] which incorporated Ireland, northern Britain and Northumbria and Insular centres on the Continent. My own work on similar problems besetting discussion of manuscripts made south of the Humber in the eighth and ninth centuries, with Canterbury and Mercia serving as the two opposed poles

in this context, has likewise shown a dispersal and evolving set of inter-relationships across what I have termed the Southumbrian 'schriftprovinz'.[88]

Recent trends in scholarship are also moving away from the traditional linear approach to stylistic development. Julian Brown's approach to the Insular system of scripts and its development favoured a two-phase approach, with the rapprochement of older Insular and Italian influences (of which the Lindisfarne Gospels are the prime example) marking the transition from Phase I to Phase II.[89] He was the first to acknowledge, however, the formative nature of the Irish contribution and that, especially in Ireland, Phase I was not uniformly replaced by Phase II features. This is of particular relevance when considering the place of works usually considered early on stylistic grounds, such as the Book of Durrow, which is generally considered to be of seventh-century date, but for which a ninth-century dating has also been proposed.[90] Styles of decoration and script do not 'progress' relentlessly in levels of sophistication or refinement. One of the closest relatives of the Lindisfarne Gospels, British Library Royal MS I.B.vii, which is thought to have been made a little later somewhere in Northumbria and which used the same core textual archetype, is decidedly old-fashioned in its 'Style II' animal ornament and its use of display capitals of North Italian or Merovingian inspiration and belongs to an earlier stage in decorative evolution where its zoomorphic ornament, its initials and its technique are concerned, but in other palaeographical respects it seems decidedly later. The palaeographical similarities between the Lindisfarne Gospels and the Book of Kells led Julian Brown to seek to associate them more closely in terms of date and place of production, favouring Kells' manufacture in an unidentified Pictish scriptorium sometime in the mid-eighth century, rather than the consensus view of Iona or Ireland around 800.[91] If the Book of Durrow can be variously dated from the seventh to the ninth centuries, one wonders why it should be deemed necessary to telescope the chronological sequence of related works to within half a century. That having been said, a departure from a fixed point of c.698, as attributed to the Lindisfarne Gospels, for production of some of the key works would help to relax the temporal tension somewhat.

Patrick McGurk's discovery of the proximity of the textual relationship between the prefaces of the Book of Durrow and of the Book of Kells certainly adds considerable force to the suggestion that they were produced in the same tradition, and possibly (although not necessarily) in the same scriptorium, which most scholars would see as either Iona or a Columban house in Ireland.[92] Dáibhí Ó Cróinín's ingenious attempts to associate the Echternach Gospels and the Cambridge-London Gospels with the Augsburg Gospels, on palaeographical grounds, and to locate them all at Ráth Melsigi have been challenged by Nancy Netzer's proposal of a more organic multi-cultural composition of the Echternach scriptorium as it developed, with English and Continental scribes participating in its work following an initial primarily Irish phase of the scriptorium.[93] In identifying Ecgbert and an English foundation in Ireland, Ráth Melsigi (Co. Carlow?), as the guiding force behind

Willibrord's mission, Ó Cróinín sought to claim the mission for Ireland and to exclude Northumbrian participation, but we have seen that Ecgbert by no means distanced himself from Northumbrian affairs, encouraging the Pictish Church to ally itself with Northumbria, rather than perpetuating its affiliations with the Columban federation, and intervening personally to persuade Iona finally to adopt the Roman Easter dating. Once again the regional spheres of operation may be seen not to have been mutually exclusive. Work on the Cambridge-London Gospels has likewise shown that although one scribal hand may be related stylistically to those of Irish scribes at Echternach, others (represented mainly in the charred remains of the London portion of the volume, damaged by fire in 1731) are much closer to the stage of development represented by the Lindisfarne Gospels and that the textual evidence also supports a closer relationship with the Lindisfarne and Durham Gospels than with the Echternach Gospels and products of the Echternach scriptorium.[94]

When all is said and done, would it be surprising for books made in Northumbria before and after the Lindisfarne Gospels to exhibit relationships in a number of ways with books made elsewhere within the Columban *parochia*? On the contrary, it is surely to be expected.

The Lindisfarne Gospels share a particular connection, other than the stylistic ones, with the Durham Gospels.[95] They share a correcting hand, as Christopher Verey showed,[96] and I would go on to suggest that Durham was corrected in two stages by this hand, once independently and then with direct reference to the new text and layout embodied in the Lindisfarne Gospels. This, and their shared provenance within the community of St Cuthbert (which can be seen from inscriptions to date from at least as early as the mid-tenth century), along with their close palaeographical and art historical links, is as good an indication as we are likely to retain that they came from the same place. The third volume in the traditional grouping, the Echternach Gospels, is somewhat harder to place. Julian Brown ascribed it to the same scribe as the Durham Gospels, although the text is written in a different grade of script – set minuscule rather than the half-uncial of Durham and Lindisfarne.[97] This was attributed to the need to write Echternach quickly (698 again being seized upon as an historical focus, this time the ceremonies surrounding the foundation of Willibrord's new monastery at Echternach). Lapses into minuscule letter-forms at line endings in the Durham Gospels provided some scope for the comparison of hands, as did the opening page of the Echternach Gospels which is written in half-uncial. It is arguable whether the identity of hands can be sustained. I personally do not find the identification fully convincing. Likewise, in art historical terms, there are dissimilarities of approach to set against perceived similarities. In particular, the Incipit pages and the minor decoration of the Echternach Gospels lack the distinctive Germanic animal interlace and zoomorphic letter terminals found in both the Durham and Lindisfarne Gospels, and indeed in the Book of Durrow. Instead the Echternach artist favoured an abstract repertoire of Celtic curvilinear ornament, interlace and geometric motifs. The penwork of this ornament is highly distinctive and features extremely fine lines for spiralwork and cross-hatching,

Fig. 21. BL, Add. MS 30850, ff. 5v–6r, Chi-rho page from a Visigothic manuscript, a Mozarabic Antiphonal with neumatic musical notation, Spain, 11th century. The fine linear hatching of the ground recalls the penwork of the Echternach Gospels and Insular metalwork.

reminiscent of Visigothic manuscript art or of fine metalwork engraving (see fig. 21).[98] The surviving parts of the Durham Gospels do not include evangelist miniatures, preventing comparison with the distinctive terrestrial symbols of Echternach where, as in the Book of Durrow and the Cambridge-London Gospels, full-length evangelist symbols occur, rather than accompanying their scribal human counterparts as in the Lindisfarne Gospels (see pls 8, 14, 18, 22, 30, 31 and figs 22a, 22b, 23).

The Echternach Gospels used a version of the 'Vulgate' text including an admix of 'Old Latin' elements (as did the Book of Durrow, both of them linking it to Columban prefatory material) and was subsequently corrected in its margins to the 'Irish/Celtic' mixed text (a Vulgate/Old Latin mixture characterised by some scholars as 'Irish' or 'Celtic' because of the frequency of certain readings within books from that background and because of the distinctive 'Celtic' inclusion of prefatory lists of Hebrew names). The Durham Gospels feature a 'mixed Italian' text (again, a mixture of Vulgate and Old Latin readings, but one characterised by scholars as 'Italian' because of the frequency of certain readings in books of that origin) and the Lindisfarne Gospels a Vulgate (with a comparatively low frequency of Old Latin intrusions) with Jerome's prefaces.[99] Simplistically this might suggest a somewhat closer association for the Echternach Gospels with the Columban tradition than

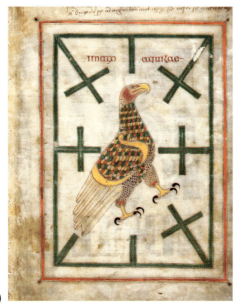

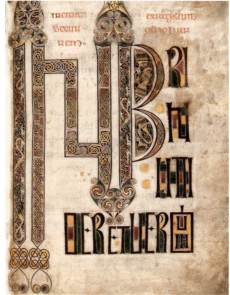

(a)

(b)

Fig. 22. The Cambridge-London Gospels:
(a) (Cambridge, Corpus Christi College, MS
197B), ff. 1v–2r, St John evangelist miniature
and incipit page; (b) BL, Cotton MS Otho C.v,
f. 27r, Mark miniature. Northumbrian, first
half 8th century. (Photos courtesy of the
Master and Fellows, Corpus Christi College,
Cambridge and of the British Library Board)

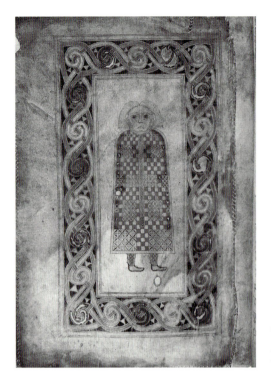

Fig. 23. The Book of Durrow (Dublin, Trinity College Library, MS 57), f. 21v, Matthew miniature. (Photo: courtesy of the Board of Trinity College Dublin)

with that represented by either the Durham or Lindisfarne Gospels (certainly than with the latter). Durham, Durrow and Echternach, however, all feature 'mixed' texts. The question is one of degree and of regional frequency of variant readings and of the comparative levels of distillation of Jerome's revised Vulgate text from the various mixed recensions which were widely circulated), but one cannot preclude a scenario in which more than one text type was available or favoured in a particular community or that one textual tradition might be replaced or supplemented by another. Indeed, the practice of correction throughout the wider group would suggest that different 'editions' were actively collated against one another. On balance however, in my opinion, the Echternach Gospels can be less firmly linked to the Lindisfarne Gospels and its place of production than may the Durham Gospels. Even if Ráth Melsigi has failed to win credibility as the site of a major scriptorium, it has served as a timely reminder that there are other unidentified scriptoria to be taken into account, in Ireland, England and on the Continent.

Ireland has not been the only alternative place of origin suggested for the Lindisfarne Gospels. Wearmouth/Jarrow has also been advanced as a possibility, notably by William O'Sullivan and David Dumville.[100] Julian Brown's work on both the script and text of the Lindisfarne Gospels, and the art historical contribution by scholars such as J. P. Nordhagen, Rupert Bruce-Mitford and George Henderson, had already signalled a number of intriguing

associations between Lindisfarne and the three great Bibles made at Wearmouth/Jarrow for Abbot Ceolfrith prior to his departure for Rome in 716.[101] I would suggest that, as with the Ireland/England debate, there has been too rigid a perception of 'Celtic' versus 'Roman' in respect of the relationship, or rather failure to acknowledge a direct relationship, between the monasteries of Lindisfarne and Wearmouth/Jarrow. In my paper which formed the Jarrow Lecture 2000 I sought to begin to rectify this perception, indicating some ways in which these centres can be seen to have co-operated, in keeping with the historical context already adduced above, which led me to suggest that the Lindisfarne Gospels were made at Lindisfarne during a period (c.710–21) when Bishop Eadfrith and Bede seem to have been actively collaborating in determining the future direction of the cult of St Cuthbert as part of a broader religious and political agenda for both northern Britain and England in general.[102]

A scenario for production: the collaboration between Lindisfarne and Wearmouth/Jarrow

The other focal point which dominates discussions of book production in Northumbria is the scriptorium shared by the twin centres of Monkwearmouth and Jarrow (see figs 12 and 28). Here there are two principal landmarks which have been established in scholarship for its activity: the three great Bibles commissioned by Abbot Ceolfrith sometime before he departed to retire to Rome in 716 (an event recounted with considerable pathos by Bede, a member of the community who probably played a leading role in the impressive editorial team which undertook this herculean labour) and the publishing campaign which had come into being by the mid 740s to disseminate the writings of Bede, who even so soon after his death in 735 was rapidly en route to becoming the best-selling author of his day (see fig. 104).[103] The history of these monasteries and the known passion of their founding fathers, Benedict Biscop and Ceolfrith, for things Roman have led to them being viewed as something of an island of *romanitas* in a Hiberno-Saxon sea. The books which they are known or thought to have made are characterised by an orderliness, clarity and regularity of appearance which has been construed as reflecting the influence of earlier models from Italy. This should not be taken, however, as meaning that they did not tolerate other styles within the scriptorium, as I have suggested elsewhere.[104] The personnel recruited to man these new houses in the later seventh century would have been drawn, in part, from existing houses and Bede (*Vita Cuthberti*, ch. 6) tells us, for example, that Sigfrith, a priest of Jarrow, trained at Melrose and knew St Cuthbert. Other members of Lindisfarne's *parochia* may also have served at Wearmouth/Jarrow or have had dealings with those more southerly houses.[105] In his preface to the *Vita Cuthberti* Bede tells us that he was commissioned to write it by Bishop Eadfrith of Lindisfarne, to rework an earlier life written by one of the Lindisfarne brethren, and that during its composition Herefrith, a

Fig. 24. The Burchard Gospels (Würzburg, Univ.-Bibl., M.P.Th.F.68), f. 164v, 6th-century Italian Gospelbook with late 7th or early 8th-century Wearmouth/Jarrow annotations (see especially top left) concerning the liturgy for the Good Friday Passion. (Photo: courtesy of Würzburg, Univ.-Bibl.)

priest of Lindisfarne, came to peruse the draft which was eventually submitted by Bede for approval by the Lindisfarne community.

William O'Sullivan and David Dumville have taken such contacts to argue that the Lindisfarne Gospels were actually written at Wearmouth/Jarrow, Dumville associating the volume with the development there of a distinctive minuscule script as part of the publication of Bede's works during the middle years of the eighth century. Conversely, there is an insurmountable degree of dissimilarity which likewise separate it from known Wearmouth/Jarrow products. It also enjoys equally close relationships with books of the Columban and Echternach traditions (and in the latter I include the Echternach Gospels as a major influence, whether or not that book was actually made by Insular personnel in Echternach, or brought there from another Insular house). There is also overwhelming art historical evidence for its grounding within the Columban and 'Celtic' traditions and of the eager reception of its modifications to that shared stylistic vocabulary in Ireland and Scotland during the eighth century.[106] Is it not, therefore, more tenable to see the manufacture of the Lindisfarne Gospels as taking place at Lindisfarne during a period when it was concerned with consolidating its traditional relationship with its 'Celtic' past and developing its growing rapprochement with the English mainstream Church, including romanising centres such as Wearmouth/Jarrow?

These twin-houses furthermore possessed a library that must have been the envy of any religious. The textual influence of books thought to have formed part of this library can be detected in a number of other works, such as BL Royal MS 1.B.vii, the St Petersburg Gospels, the Gotha Gospels and the Burchard Gospels (see figs 24, 25, 26, 27), but these are not therefore considered to be Wearmouth/Jarrow products, but rather to have gained access to models from its library. The same can be said of the Lindisfarne Gospels, the archetype for the main text of which (though not for the Canon Tables and evangelist miniatures) seems to have been a southern Italian Gospelbook from the Wearmouth/Jarrow library. Like the other books cited above, which subsequently used an exemplar with the same text type, the Lindisfarne Gospels do not need to have been made at Wearmouth/Jarrow because of the previous ownership of one of its models, which appears in any case to have enjoyed quite a wide circulation. If scribes could travel, so could exemplars and textual and stylistic influences. To isolate any such particular features and to ignore other components present in the Lindisfarne Gospels, which point away from Wearmouth/Jarrow towards strong 'Celtic' and other Mediterranean sources of inspiration and to the artefactual remains from Lindisfarne itself, would be to perpetuate an over-selective and potentially biased approach to this complex situation.

So, let us consider some of the complexities of the evidence and of the historical context for the relationship between Lindisfarne and Wearmouth/Jarrow, to see where they lead. This will inevitably be a personal interpretation based upon a balance of probabilities, as have been all other discussions of the Lindisfarne Gospels and its origins.

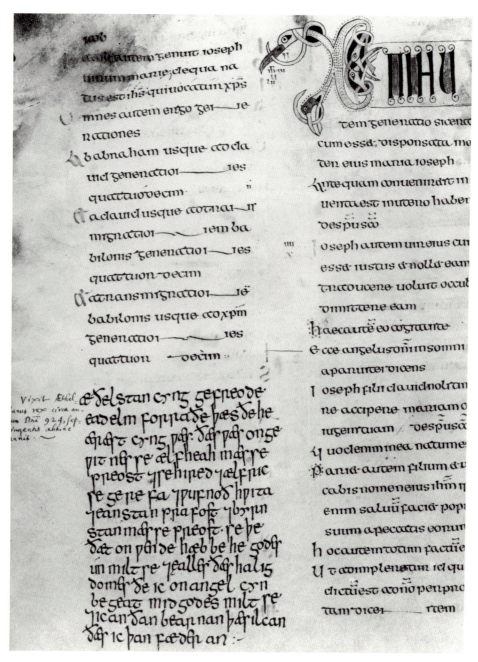

Fig. 25. BL, Royal MS 1.B.vii, f. 15v, Chi-rho from Matthew's Gospel, Northumbrian, second quarter of 8th century, with manumission document (bottom left) added in Old English in the tenth century under King Athelstan.

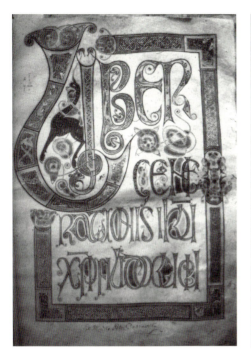

Fig. 26. The St Petersburg Gospels
(St Petersburg, State Library, Cod. F.v.I.8),
f. 18r, Matthew incipit page. (Photo:
St Petersburg, State Library)

Fig. 27. The Gotha Gospels (Forschungs-
bibliothek, Gotha, Cod. Memb.I.18), f. 126r,
Luke incipit. (Photo: Forschungsbibliothek,
Gotha)

Wearmouth/Jarrow, their approach to books and their cultural influence on the cult of St Cuthbert

In the *Lives of the Abbots of Wearmouth and Jarrow* Bede gives us an indication of something of the initial impact upon visual and book culture of Benedict Biscop's new foundations: Monkwearmouth, established at the mouth of the River Wear in 674 and Jarrow on the Tyne, in 681 (see figs 12, 28, 29a–c):[107]

> he brought back many holy pictures of the saints to adorn the church of St Peter he had built:
> a painting of the Mother of God, the Blessed Mary Ever-Virgin, and one of each of the twelve
> apostles which he fixed round the central arch on a wooden entablature reaching from wall to
> wall; pictures of incidents in the gospels with which he decorated the south wall, and scenes
> from St John's vision of the apocalypse for the north wall. Thus all who entered the church,
> even those who could not read, were able, whichever way they looked, to contemplate the dear
> face of Christ and His saints, even if only in a picture, to put themselves more firmly in mind
> of the Lord's Incarnation and, as they saw the decisive moment of the Last Judgement before
> their very eyes be brought to examine their conscience with all due severity.

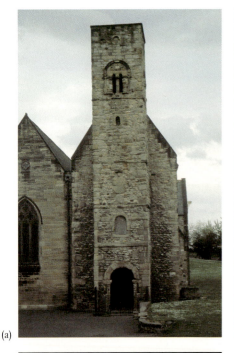

(a)

(b)

Fig. 28. St Peter's, Monkwearmouth: (a) tower (the two lower stages); (b) porch with zoomorphic carvings; (c) interior west wall of nave, from Benedict Biscop's original foundation of 674; (d) St Paul's Jarrow, exterior wall with masonry and stained glass windows of the easternmost church of the original foundation of 681. (Photos: the author)

(d)

(c)

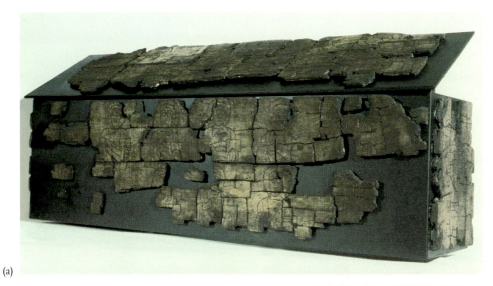

(a)

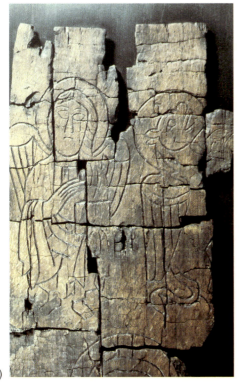

(b)

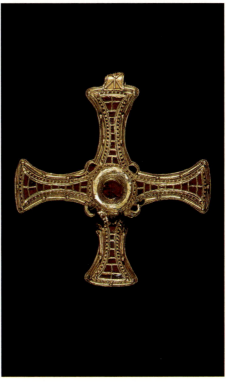

(c)

Fig. 29. (a) The coffin of St Cuthbert (Durham Cathedral Treasury), Lindisfarne, 698;
(b) detail of its evangelist symbols; (c) St Cuthbert's pectoral cross, gold, garnets and
shell, discovered in his coffin, Anglo-Saxon, second half of 7th century.
(Reproduced by kind permission of the Dean and Chapter of Durham Cathedral)

It may be that we retain some recollection of these images which Benedict brought back from Rome in 679–80 to adorn the church at Monkwearmouth in the figures engraved on the wooden coffin of St Cuthbert, with its Virgin and Child, its Apostles and the angels and evangelist symbols of the Last Judgement (see figs 29a–b).[108] He also came back with 'a great mass of books of every sort', the first and foremost of the benefits which Bede records that he bestowed upon his foundation. On his next and fifth journey to the eternal city, around 685, Benedict returned with:[109]

> a large supply of sacred books and no less a stock of sacred pictures than on previous journeys. He brought back paintings of the life of Our Lord for the chapel of the Holy Mother of God which he had built within the main monastery, setting them, as its crowning glory, all the way round the walls. His treasures included a set of pictures for the monastery and church of the blessed apostle Paul, consisting of scenes, very skilfully arranged, to show how the Old Testament foreshadowed the New. In one set, for instance, the picture of Isaac carrying the wood on which he was to be burnt as a sacrifice was placed immediately below that of Christ carrying the cross on which He was about to suffer. Similarly the Son of Man up on the cross was paired with the serpent raised up by Moses in the desert.

Thus the images which covered the walls of the churches at Monkwearmouth and Jarrow served as visual summaries of aspects of Scripture and of the relationship between the Old and New Testaments, illustrated by means of didactic typology.[110] The integral nature of the two Testaments is a subject to which I shall return when discussing the production of scriptural books at Wearmouth/Jarrow and Lindisfarne.

Benedict Biscop's library had been founded at least as early as his third trip to Rome from England around 671, during which he also collected books in Gaul:[111]

> He brought back a large number of books on all branches of sacred knowledge, some bought at a favourable price, others the gift of well wishers. At Vienne on the journey home he picked up the books he had left there in the care of his friends.

So Benedict collected books from Italy, where he may also have acquired Byzantine tomes, from Gaul and presumably also from southern England, bearing in mind that he served for a time as abbot of St Augustine's Abbey in Canterbury where the school of Theodore and Hadrian flourished.[112] On one of his journeys to Italy he was accompanied by Ceolfrith, later commissioned by him to found Jarrow. Benedict had decreed that, following his death, the library he had amassed for the instruction of the two communities should be conserved and kept as a whole.[113] Upon assuming the abbacy of both foundations, bringing them ever closer as a unit, Ceolfrith not only observed this behest but set about expanding the libraries of both houses:[114]

> He doubled the number of books in the libraries of both monasteries with an ardour equal to that which Benedict had shown in founding them. He added three copies of the new translation of the Bible to the one copy of the old translation which he had brought back from Rome. One of these he took with him as a present when he went back to Rome in his old

Fig. 30. Fragment probably from another of the Ceolfrith Bibles (BL, Add. MS 45025, the Middleton leaves), f. 2v, Wearmouth/Jarrow, before 716.

Fig. 31. The Codex Amiatinus (Florence, Biblioteca Medicea-Laurenziana, MS Amiatino 1), f. V, Ezra miniature, one of the Ceolfrith Bibles, Wearmouth/Jarrow, before 716. (Photo: Florence, Biblioteca Medicea-Laurenziana)

age, and the other two he bequeathed to his monasteries. For eight hides of land by the River Fresca he exchanged with King Aldfrid, who was very learned in the scriptures, the magnificently worked copy of the Cosmographers which Benedict had bought in Rome.

This passage gives some insight into the value of books as commodities at the time: the land exchanged represented the livelihoods of at least eight families, and its riverside location probably rendered it even more valuable. The total land-holdings of the combined communites of SS Peter and Paul at the time when Ceolfrith set off for Rome in 716 was one hundred and fifty hides – the value of some nineteen such books.[115] The libraries of Wearmouth/Jarrow may have represented their most valuable financial asset, as well as their spiritual and intellectual mainstay. We can only speculate on the comparative value of the three massive single-volume Bibles (pandects) produced for the abbot which were formed of some 1,550 calfskins each.[116] The pandect which accompanied Ceolfrith on this final journey has of course survived in the form of the famous Codex Amiatinus (see figs 31, 121) and fragments from one of the others have resurfaced, some discovered by Canon Greenwell as binding fragments (now British Library, Add. MS 37777) in a Newcastle antique shop and presumably representing one of the volumes retained by the communities. Other pieces (now British Library, Add. MS 45025, see fig. 30, and Loan MS 81) may also relate to this copy which seems to have been donated by King Offa later in the eighth century to Worcester, where it was already thought to have been made in Rome.[117]

Indeed, Amiatinus, the dedication inscription of which had been tampered with, was only recognised as having an English association in the late nineteenth century (and indeed it was not until the twentieth that it was acknowledged as the work of actual Englishmen), so 'romanising' is its style.[118] One of these volumes was seen by Alcuin, who refers to it in verse, and may have stimulated his own influential edition which resulted in the single-volume Alcuin Bibles produced by the Tours scriptorium during the second quarter of the ninth century for dissemination throughout the Carolingian Empire.[119] We should not underrate the importance that was attached to access to books at this period. When we talk glibly of exemplars consulted or of 'influences' we are talking about real people exchanging or making available valuable and prized commodities, and about an underlying web of human relationships, be they personal or political in character.

The cultural and political import of Ceolfrith's tangible statement of conformity with the ideas and taste of the Mediterranean world has been acknowledged, and elsewhere I have suggested that the letter of thanks from the Pope sent to Ceolfrith's successor, Hwaetberht, signifies the entry of the communities into the 'comitatus' of St Peter.[120] However, there is another, and for Ceolfrith and his brethren, deeper meaning to such a gesture. Ceolfrith's pandects represent not simply a culturally and politically motivated antiquarian essay in facsimilising a book or books made in early Christian Italy, such as the *Codex Grandior* or the *Novem Codices* (written at Cassiodorus' monastery during the sixth century) and perhaps a Neapolitan Gospelbook, some of which may have been included in the Wearmouth/Jarrow libraries. Rather, they represent a further contribution to the complex processes of translation and editing which extend through many stages, including a translation of the Old Testament into Greek, the Septuagint, through the translations into Latin from Hebrew and Greek by St Jerome to Cassiodorus' own editions of Jerome's pre-Vulgate Hexaplaric recension (thought perhaps to have been his *Codex Grandior*, which Ceolfrith brought back from Rome), Jerome's Vulgate (possibly Cassiodorus' 'smaller pandect' to which he refers to his *Institutiones*) and Cassiodorus' 'Old Latin' standard copy of scripture, the *Novem Codices*. For Ceolfrith desired to create a monumental single volume which stressed the integral, complementary nature of the Old and New Testaments.[121]

When Ceolfrith, self-styled in his dedication page as 'abbot from the ends of the earth', set off for Rome with his tribute to the papacy he was proclaiming his people's role in the apostolic mission. Not only had the holy Word been preached in the farthest corners of the earth, the newly won people of God were able to make an active contribution to its dissemination, worthy of the traditions of the Church Fathers. This essay in book production was no antiquarian feat, designed merely to impress and to gain status (although these were probably welcome bonuses), it symbolised the fulfilment in the West of Christ's commission to his disciples to take the Good News ('Gospel') throughout the world, an achievement which was to herald the very coming of the kingdom of God.

Another welcome by-product of Ceolfrith's embassy, which he so sadly did not live to complete in person, would perhaps have been an *apologia* on behalf of the people of England, and Northumbria in particular, for the persistent squabbles and recalcitrance in enacting papal *dicta* which had accompanied the turbulent career of that erudite prince of the church, Wilfrid, and his expulsions from office by king and prelate alike. In recent years the papacy had been forced to listen to the complaints of both parties, time and again. England was in need of powerful advocacy if the phenomenal achievements of the preceding century and more were not to be tarnished. It transpired that a book served, and served well, as the ambassador of the English nation.

The early cult of St Cuthbert and its historical context

How did the cult of St Cuthbert feature in such attempts to locate and integrate England within the early Christian world view? An assessment of the political situation in Northumbria can help us to answer this question. Wilfrid is often seen as the champion of *romanitas* in England, closely followed in Northumbria by Benedict Biscop and Ceolfrith. Monkwearmouth and Jarrow were inextricably caught up in the discord that his ambitions provoked. Wilfrid represented a threat to the royal and aristocratic property-owning interest groups of the North, as well as to the religious foundations which were forced to keep him friendly by subsuming their land-holdings within his own. If ever there was a 'troublesome priest' this was it, and we know too well the fate which was to befall another – Becket. In 687–8, following Cuthbert's death, Wilfrid administered the see of Lindisfarne, engendering a period of bitterness of which Bede can scarcely bring himself to speak.[122] Wilfrid was expelled from office in 691 and excommunicated in 703, causing him to travel to Rome to appeal, whence he returned, vindicated, in 705. The first *Life* of St Cuthbert was composed by an anonymous monk of Lindisfarne sometime between 691–705.[123] It records that, by 705, the Celtic Columban foundation of Lindisfarne had already adoped the primarily Benedictine Rule favoured at Wearmouth/Jarrow (even if aspects of earlier Columban tradition introduced by Aidan, such as the inclination towards an eremitic component, continued as well) and this period seems to have inaugurated a closer collaboration between these focal Northumbrian houses. There are ample indications that the cult of St Cuthbert was being actively promoted, not only by Lindisfarne, but by the Bernician royal house.[124] The political implications of such cults have been well rehearsed, and indeed sadly we still see them subverted on occasion in the service of political and financial interests in the present. From the time of the anonymous *Life* onwards it is possible to detect another, more laudable, trend, however: that of promoting Cuthbert as a figure of reconciliation and a rallying point for the reformed identity of Northumbria and of England. His successors as bishop, Eadberht and Eadfrith, also appear to have enjoyed something of this role and to have actively promoted it. Eadberht's

translation of Cuthbert's incorrupt body in 698 took place in a time of uncertainty and trauma. Continuing tension and a preoccupation with reform seem to have thrown Lindisfarne and Wearmouth/Jarrow into closer alliance. The Cuthbert Gospel, thought perhaps to have been included in the coffin in 698, is written in the characteristic uncial script which is taken as a hallmark of Biscop's twin foundations and is thought perhaps to represent their gift to the newly established cult. No less significant a contribution were the verse and prose reworkings of the anonymous *Life* by Bede, commissioned by Bishop Eadfrith of Lindisfarne, which earned the Jarrow scholar, at his own request, a place in the 'liber vitae' of Cuthbert's community.[125]

Alan Thacker has concluded that Bede wrote his prose *Life of Cuthbert* partly to update the Lindisfarne one and partly to harness the Cuthbertine cult to new concerns, namely 'Bede's attempted reform of the spiritual life of his people by means of a rejuvenated church', ambitions shared by Lindisfarne and by a substantial sector of the Northumbrian ecclesiastical establishment.[126] Even after his death in 709/10 Wilfrid continued to pose a potential challenge to such aspirations of reconciliation. His biographer, Stephanus, informs us that Wilfrid's abbots and followers continued to fear their enemies and reveals an attempt to promote a cult of St Wilfrid, perhaps to rival that of Cuthbert.[127] Stephanus' *Life of Wilfrid* used the anonymous *Life of Cuthbert* as a model and Wilfrid's cult was claiming miracles to vie with the efficacy of Cuthbert's relics and their propensity for healing and protecting. In chapter 17 of the *Life of Wilfrid*, which deals with the foundation of Wilfrid's church at Ripon in 671–8, Stephanus writes (after a recollection of a time at which the kings were in accord with Wilfrid and accorded him, and his, deference):[128]

> Our holy bishop adorned the house of God even further with a marvel of art hitherto undreamt of: he had written, for his soul's good, a book of the Gospels, done in letters of purest gold on parchment all empurpled and illuminated, and had ordered jewellers to make a case for them, also of the purest gold and set with precious gems. All these treasures and several more besides are kept in the church to this day as a memorial to him. His remains are here and his name is constantly remembered in the monks' daily prayer.

In the next chapter Wilfrid restores a child to life, the most Christ-like of miracles, and in subsequent chapters the military successes of the reign of King Ecgfrith and Queen Aethilthryth who 'were both obedient to Bishop Wilfrid in everything' are recounted in biblical terms.[129]

Stephanus' work was finished around 720.[130] This was shortly before Bede's prose *Life of St Cuthbert* (completed *c*.721) and after the anonymous *Vita* and Bede's verse version. Hagiography was evidently an important component in establishing Northumbiran identity at this period.

The translation of 698 has been seen as the chronological focus for activity surrounding the cult of St Cuthbert and the production of associated works. I would suggest however that the later period, coinciding with Eadfrith's time as bishop of Lindisfarne, was equally

defining and merits consideration in this respect. Following Wilfrid's death, around 710, a book of splendid appearance in its lettering and ornament and enshrined within a jewelled case was apparently a focus of attempts to establish a cult of Wilfrid at Ripon. It may have been at this time that the need for a similar contribution to the shrine of St Cuthbert was deemed necessary, in the form of the Lindisfarne Gospels.

Script as icon: the book as teacher, preacher and cult focus

The Columban background to the traditions of the Lindisfarne community would already have imbued in it a heightened appreciation of the importance of books and their power as symbols. But whence did their forebears and their competitor Wilfrid derive the idea of the symbolic efficacy of sacred text? Some of the Mediterranean background has been discussed above. Empurpled volumes penned in chrysography (writing in gold ink) were known from fifth- and sixth-century Byzantium and Italy (e.g. the fragment of the Codex Palatinus, British Library, Add. MS 40107, made in northern Italy during the fifth century, or the sixth-century Greek Codex Purpureus, British Library, Cotton MS Titus C.xv), and it may be that he had his volume made in Italy or by Italian scribes, hence its acclaim as a new phenomenon in England (see fig. 32).[131] The Prologues to the Old and New Testaments in the Codex Amiatinus are written on purple vellum, although the script is in yellow ink emulating chrysography, which could not perhaps be technically produced at Wearmouth/Jarrow although gold leaf was used there (for the capitals supporting the arcades of the Codex Amiatinus' Canon Tables and for an initial in leaves from a Gospel-book now appended to the Utrecht Psalter). The mosaics of Ravenna depict treasure bindings (the Christ Pantocrator of S. Apollinare in Classe holds one, as does a clerical member of Justinian's entourage in S. Vitale, see fig. 33) and the bejewelled, sealed book features here and in other early Christian works, such as the fifth-century chancel arch mosaic of Sta Maria Maggiore, where it is enthroned alongside the *crux gemmata* and symbolises the divine Wisdom, which is Christ, as a hidden mystery concealed beneath the letter of Scripture (see 1 Corinthians 1.24 and 2.6–7).[132]

Such sacred book-icons were presumably important not only as a focus of devotion and as a pilgrim-magnet, but could play a vital role in the legal system, as a guarantor of oath-swearing (as on the Bible in modern courts of law) and as a physical symbol of the saint's protection when sanctuary was being sought, a phenomenon which Cuthbert was well aware would plague his community.[133] Nonetheless, books did not apparently feature in the cults of the saints of Italy and Gaul (other than those with Insular connections) which inspired both Wilfrid and his followers and the monks of Lindisfarne. They did, however, enjoy a special role in Ireland, with which Wilfrid had political dealings, despite his championing of the Roman cause at the Synod of Whitby, and whence Lindisfarne traced its origins as a member of the Columban *parochia*. The potent relics associated with the

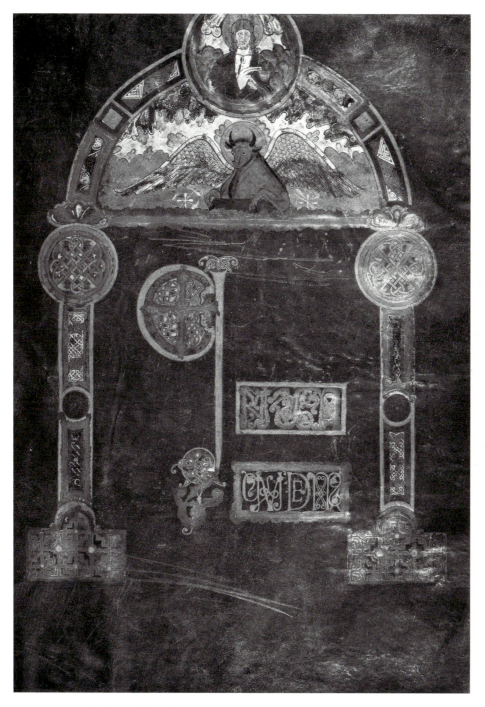

Fig. 32. The Royal Bible (BL, Royal MS 1.E.vi), f. 43r, Luke incipit page, an example
of gold and silver script on purple pages, Canterbury, c.820–40.

Fig. 33. Christ Pantocrator, mosaic, S. Apollinare in Classe, Ravenna, 6th century, a jewelled cover adorns the Book of Life (this figure may have inspired that in the Royal Bible, fig. 32). (Photo: the author)

cult of St Columba were not his corporeal remains or burial place, but his clothing and books 'in his own handwriting' (an emphasis perhaps echoed in the later medieval librarian of Durham's attributions of certain volumes as 'de manu bedae', 'in the hand of Bede').[134] Even during Cuthbert's lifetime his belongings are represented as extensions of his own miracle-working person, such as his belt which cured Abbess Aelfflaed and which calls to mind that enshrined in the eighth-century Irish Moylough Belt-Shrine.[135] Such portable relics, suitably enshrined, served a valuable function when carried in progress around the saint's patrimony, to reinforce the *parochia*'s claims to authority and property tenure. Indeed, the carrying strap on the Lough Kinale Book-Shrine has led to the suggestion that it may have been carried on circuit on religious occasions (see fig. 34).[136] On such occasions, and in other religious processions during the liturgy or when placed upon the altar or a shrine as a focus of worship, such books needed to impress. In addition to the Irish book shrines there was also a tradition of adorning the covers of Gospelbooks with precious metals and jewels (see figs 35, 36). An emphasis upon the miraculous powers of the goods of saints is also reflected in the practice of the desert fathers, such as St Anthony, who distributed belongings on their deathbeds, but the site of whose graves remained concealed.[137] The cult of St Cuthbert, and the nascent cult of Wilfrid, may therefore have combined the Gaulish and overseas Celtic practice (as with the cult of St Fursey at Péronne) of displaying the tomb and accompanying it by more flexible and portable relics in the Celtic tradition.[138]

The Irish cult of St Brigit may have done something similar. A seventh-century biographer of the renowned foundress of Kildare, Cogitosus, writes that her remains were splendidly displayed in a bejewelled tomb beside the high altar.[139] The account given by Giraldus Cambrensis, in his *Topography of Ireland* of *c.*1187, refers to a Gospelbook he saw at the shrine which was of such miraculously intricate workmanship that you would think it 'the work of an angel and not of a man' and which has been assumed to be of the Insular

68

Fig. 34. Lough Kinale book shrine, upper cover, Irish, late 8th century (NMI). (Photo: National Museum of Ireland)

period.[140] Like Lindisfarne, Kildare was assiduous in promoting its royal connections (especially with royal women, who also figure in Cuthbert's *Lives*), reflected in its de luxe religious objects, and the sanctity of its leading spiritual head. This was consolidated by a programme of hagiographical writing – by 850 at least three *Lives* of Brigit, two in Latin and one in the vernacular, may have been produced, paralleling the three *Lives* of St Cuthbert.[141] Similarly, at the time that the anonymous writer was compiling Cuthbert's first *Life*, Adomnán was composing his *Life of St Columba*.[142]

The Cathach of Columcille (a Psalter attributed to the hand of St Columba, see fig. 37) and other cult items such as the Book of Durrow and the Book of Kells may have served a similar symbolic and protective function for Columba's cult (see pls 31, 32).[143] The Cathach, for example, was carried into battle by its hereditary keepers to ensure their victory (hence its name, which means 'Battler').[144] Some such books continued to be displayed and shown to the visitor, such as that seen at Kildare by Giraldus Cambrensis in the late twelfth century. But it is an amazing thought that, within a generation of their manufacture and sometimes perhaps from the point of completion, some of these stunning Insular scriptural manuscripts would never actually have been seen, but would have been enshrined as powerful embodiments of divinity – the impetus behind their making being akin, at one level, to that of the sculptural details of the later Gothic cathedrals, of which so much would only have been shared by God and the craftsperson he inspired.[145] The metalwork book-shrine made in Ireland during the late eighth century and recently found in Lough Kinale, Co. Longford (see fig. 34), was not designed to open, implying that the knowledge that it contained a sacred book was enough to ensure its efficacy, just as the Cuthbert Gospel of St John hidden from view in the coffin would have continued to fulfil its sacred function (see fig. 17).[146] It may have been out of sight, but the community apparently continued to preserve the copy of St John's Gospel said to have been owned by Cuthbert's preacher, Boisil, as one of its relics and it is likely that the presence of a similar

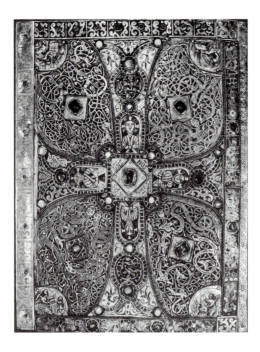

Fig. 35. Lindau Gospels Treasure binding (New York, Pierpont Morgan Library), lower cover, Continental in Anglo-Carolingian style, early 9th century. (Photo: New York, Pierpont Morgan Library)

Gospel within the coffin was known as a feature of the cult during its early stages.[147] The Cuthbert Gospel seems to have been contained within a leather or linen pouch or satchel, recalling the tooled leather satchel of fifteenth-century date which contained the Book of Armagh (now preserved at Trinity College, Dublin).[148] Such satchels are often mentioned in Irish literature as containing books or relics, such as that which Adomnán tells us contained a hymnal written by Columba which was lost in a river for several months, after which the book-cum-relic was found incorrupt.[149] Later, in the twelfth century, the Cuthbert Gospel was hung, as a special honour, around the necks of visiting dignitaries.[150] That such practices existed earlier is demonstrated by Alcuin's condemnation, addressed to the Archbishop of Canterbury, of the popular practice of wearing saints' bones and Gospel texts, presumably for their protective, talismanic merits.[151]

The wearing of sacred texts is an ancient practice, manifest for example in the Judaic wearing of phylacteries (Deuteronomy 6.8). The Gospel of St John was considered particularly efficacious in Christian circles. John of Salisbury claimed that St Cuthbert cured a man by laying a copy of John's Gospel on him and during the Middle Ages its incipit 'In the beginning was the Word, and the Word was with God, and the Word was God' was often worn around the neck as a protective charm.[152] St Augustine even records the belief that these words could cure headaches.[153] Yet the special import of this non-synoptic Gospel extended beyond the merely apotropaic (protective). St John is symbolised by the eagle, an identification discussed by commentators such as Augustine, Gregory and Bede, for his spirit flies directly to the throne of God for inspiration. The 'disciple whom Jesus

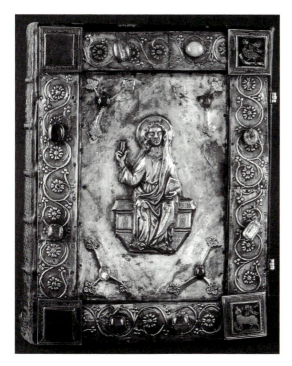

Fig. 36. Carolingian Treasure Binding (BL, Add. MS 11848), upper cover, Gospelbook, Tours first half of 9th century.

loved' evoked a special proximity to the person of Christ and an insight into the divine will. Lections from his Gospel featured at key points in the liturgy, including the masses for the sick and dying. It would thus have lent itself particularly well for pastoral work in the field, perhaps explaining why it sometimes circulated as a separate volume, reflected in the difference in textual exemplars used for John in Insular Gospelbooks such as the Durham, Cathedral Library, MS A.II.16.[154] It is also bound with the mass text and related material in the Irish Stowe Missal (see fig. 83).[155] Sister Benedicta Ward has commented on the special place which this Gospel occupied in the religious life of the period. It was the text which Cuthbert and his master, Boisil, studied together in the last week of the latter's life, for it contained 'the simple things of "the faith that works by love"' (Galatians 5.6). It was also an apt focus for meditation for one about to leave this life, and Bede likewise chose to devote his last days to the task of translating it into the vernacular, that its benefits might be more widely enjoyed.

Boisil's copy of John is said by Bede to have been written on seven quires, symbolising the week of study, paralleling the biblical account of the time taken for the Creation. The Cuthbert Gospel is written upon twelve quires, this number symbolism invested with connotations of discipleship. This raises the intriguing possibility of the existence of a concept of 'sacred codicology' in which theological symbolism might be embedded within the actual structure of books, a phenomenon already recognised in relation to Insular metalwork structures.[156] Bede certainly applied such principles to the text itself,

Fig. 37. The Cathach of Columcille (Dublin, Royal Irish Academy, s.n.), f. 12v, Irish, late 6th or early 7th century. (By permission of the Royal Irish Academy © RIA)

when he recast his *Lives* of St Cuthbert in forty-six chapters in reference to the number of years taken to build the Temple, to the age of Adam and to the period of gestation. Forty-six was the time needed to create the perfect human and was therefore apt for his account of the formation of the ideal saint.[157] The Cuthbert Gospel of St John may have been interred with the saint in recollection of Boisil's book.[158] The practice of burying books with the dead is an ancient one, if rare within the Christian tradition. The ancient Egyptians interred their deceased with a copy of the Book of the Dead, to ease their passage to the afterlife, and the tradition seems to have been perpetuated in Christian Coptic Egypt, to judge by the fourth- or fifth-century Coptic Psalter (see fig. 38) discovered supporting the head of a young girl in a shallow grave in the modest cemetery of Al-Mudil (some 40km north-east of Oxyrhynchos).[159]

In addition to books attracting such attention as potent relics, scribes themselves might also be imbued with miraculous powers. This is not surprising when they happened to be saintly figures such as Columba, but the ninth-century poem *De abbatibus*, by Aethelwulf, which refers to a daughter-house of Lindisfarne, records that the relics of the accomplished Irish scribe, Ultán, were also wonder-working.[160] Speculation has abounded as to where Ultán was based and whether any surviving works might be attributable to him, but he is perhaps of greater value as a literary topos, attesting to the concept of the saintly scribe.[161]

Leslie Brubaker has suggested that relics fulfilled a similar role in the West to that of sacred images in the East. She writes that 'Intercession, for the Byzantines, was a primary function of the sacred image: the image channelled prayers to God, and God's goodwill back to the individual or community. The needs of western Christians for intercession and protection – for access, in short, to divine power – were channelled into relics of saints rather than images of them.'[162] The illuminated Insular Scriptural manuscript could perform such a function in both forms, as icon and as relic.

In 1104 the body of St Cuthbert was translated once more to a new shrine at the East end of Durham Cathedral, inaugurating a new era for his cult and for the fortunes of the

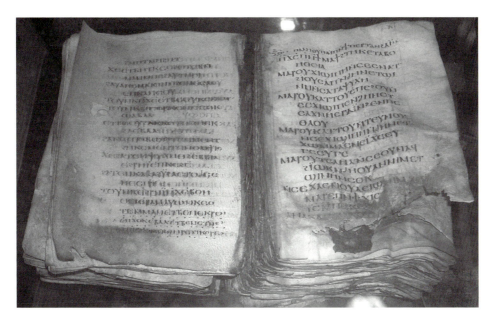

Fig. 38. Cairo, Coptic Museum, MSS Library, No. 12488, Psalter found supporting the head of a young Coptic girl in a grave at Al-Mudil, Egypt, 4th–5th century. (Photo: Cairo, Coptic Museum)

north-east. The coffin was opened to reveal the still incorrupt saintly remains and, during his sermon at the translation ceremony a triumphant Bishop Flambard elevated a small book found within the coffin for the edification and veneration of the congregation – probably the Cuthbert Gospel of St John.[163] Some fifty years later (1153 or 1154) William Fitzherbert, archbishop of York, repeated Flambard's actions, but this time it was a copy of the *Vita Cuthberti* which was displayed, the power of the saint assuming the healing and protective role traditionally ascribed to the Gospel.[164] In considering these works, the Cuthbert Gospel, the Lindisfarne Gospels and the early *Lives* of St Cuthbert, and also the great Ceolfrith Bibles, we can begin to perceive some of the ways in which the Insular world, and Bede's Northumbria in particular, moulded western perceptions of the book and of how it might function as an instrument and channel of faith.

Numerous relics were found interred with St Cuthbert when the coffin was opened in 1104 and again by the Cathedral librarian, James Raine, in 1827, and by Canon Greenwell in 1899.[165] Of these only the gold and garnet pectoral cross (see fig. 29c) and the Gospel of St John, along with some opulent textiles (for which those that survive may be replacements) are considered to have formed part of the original deposition.[166] Inclusion of the cross and the book was particularly apt, not only in signifying Cuthbert's role as bishop and as teacher and preacher, but as the ultimate symbol of orthodox Christianity. The fear of idolatry enshrined in the second commandment was bequeathed by Judaism to the

Fig. 39. Mosaic, the Orthodox Baptistry, Ravenna, 5th century. The Gospelbook,
Cross and Throne serve as symbols of the Godhead. (Photo: the author)

other monotheistic religions of the Word. From its inception Islam fostered the use of
sacred calligraphy in a religious context to avoid such dangers. In the early Christian
Church images had already assumed an iconic status as focuses of veneration, which,
as John of Damascus indicates, might be misinterpreted as the objects of worship. Yet
even during the state-sponsored iconoclasm in eighth-century Byzantium under Leo the
Isaurian, certain symbols could be used as an alternative to figural representation. Thus the
Cross and the Book became acceptable symbols of orthodox Christianity and can be seen
occupying the throne and the altar in the fifth-century Orthodox Baptistry in Ravenna
(see fig. 39).[167] In the 720s the iconoclast party erected a tablet above the great gate of the
imperial palace in Constantinople, recording the substitution of a Cross for the figure of
Christ, which read:[168]

> The emperor Leo and his son Constantine
> Thought it dishonour to the Christ divine
> That on the very palace gate he stood,
> A lifeless, speechless efigy of wood.
> Thus what the Book forbids they did replace
> With the believer's blessed sign of grace.

74

The Council of Nicaea of 787, supporting attempts by the Empress Irene to restore images, likewise stated that:[169]

> We therefore follow the pious customs of antiquity and pay these icons the honour of incense and lights just as we do the holy gospels and the venerable and life-giving cross.

Thus the practice of portraying the Godhead by means of abstract or symbolic substitution was reinforced within the Christian tradition from an early date. The *crux gemmata* ('jewelled Cross') and the Gospelbook serve as the embodiment of Christ in the mosaics of Ravenna, they are encountered enshrined with Christ's faithful minister, St Cuthbert, and they combine in an electrifying symbiosis in the magnificent diptychs of cross-carpet page and decorated incipit in the Lindisfarne Gospels, where, I would suggest, the crosses and adorned words embody the Godhead and we are presented with the physical embodiment of the Word.

Secular authorities were quick to avail themselves of such potent symbolism. Constantine stressed that his authority was based upon the sign of the cross, in the name of which he triumphed at the Milvian Bridge (echoed in the Jarrow cross-slab with its 'hoc signum' inscription, emphasising the triumph of the Cross over death) and the mosaics portraying the Emperor Justinian and his entourage at S. Vitale, Ravenna, feature a shield (the shield of faith) bearing a Chi-rho-headed cross and a Gospelbook in a jewelled cover (see fig. 33). Christ of the Last Judgement is likewise depicted at S. Apollinare in Classe, and elsewhere, holding the Book.[170] The Church was quick to represent the advantages of such tools to the aspirational dynasties encountered in north-western Europe and a major achievement accredited to St Augustine following his conversion of King Ethelbert of Kent and his court was the commital of the ruler's lawcode to the safe-keeping of writing.[171] Augustine is even said, by Bede, to have devised written Old English for the purpose.[172] A newly converted Anglo-Saxon ruler thereby seems to have been seeking to associate himself with Christian culture, and the ultimate Judge, and to use writing to bolster his role as an heir to the authority of his late Roman precursors. Such developments are likely to have been indebted to heightened perceptions of the authority of the written word in the context of conversion and liturgy. The earliest extant Anglo-Saxon charters are written not in variants of the late Roman cursive secretary, as seen on the Continent, but in stately, high-grade uncials, of the sort usually reserved for religious texts.[173] In 735 Boniface would send a letter from the Germanic mission-fields to Abbess Eadburh of Minster-in-Thanet in Kent requesting that she have written for him a copy of the Petrine Epistles penned in gold (which he sent her for the purpose as it was such a valuable commodity) to impress the natives.[174]

To the Celtic and Germanic peoples of north-western Europe, with their sophisticated oral societies, their abstract and symbolic art, their love of words and their proto-literate writing systems (ogam and runes) geared for commemorative and talismanic purposes, the

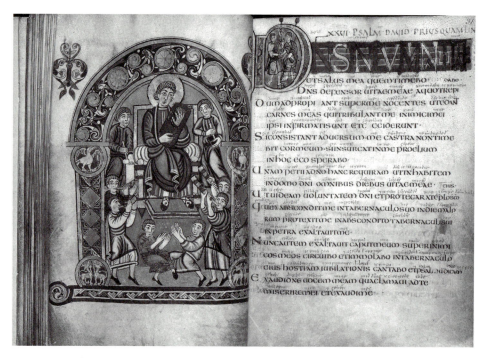

Fig. 40. The Vespasian Psalter (BL, Cotton MS Vesp. A.i), ff. 30v–31r, King David and his musicians; opening of Psalm 26, with historiated initial 'D' depicting David and Jonathan, Kent, c.720–30, with Old English gloss added at Canterbury in the second quarter of the 9th century.

book presented itself as the new symbol of ultimate, divine authority.[175] What more natural than that they should seek to adorn it with the ornamental repertoires which for centuries had conveyed signals of wealth, status and power through the visible consumption of resource embodied in the metalworker's art.[176] In Byzantium honour had been paid to the Word of God by writing it in letters of gold and silver upon purple-stained parchment, but in Insular books the Word assumes iconic status, the sacred incipits and monograms of its Gospelbooks growing to occupy the entire page as vehicles of *contemplatio* intimately combining word and image. The modest initials of sixth- and seventh-century Italy and of Merovingian Gaul, with their crosses, birds and fishes, do not begin to approach the level of adornment accorded to the Word in an Insular context.[177] Nor is it surprising that the historiated, or story-telling, initial should have made its first known appearance in Insular books: the Vespasian Psalter, a Kentish work of around 730, and the St Petersburg Bede, written at Wearmouth/Jarrow around 746 (see fig. 40).[178] What more intimate visual symbiosis of text and image could there be, and what greater mutual validation? As we shall see, the intimacy extends in far subtler ways throughout Insular Christian images, revealing a level of inter-textuality founded upon a wealth of scriptural and exegetical

76

sources and multivalent levels of 'reading' from which our sophisticated electronic age might well learn.

The freedom to explore such relationships in the west was to some extent established by Pope Gregory the Great, although debate concerning the role and acceptability of images continued, especially in the Carolingian orbit. Around 600 Gregory wrote to Bishop Serenus of Marseilles, censuring his destruction of images on the basis that:[179]

> It is one thing to adore a picture, another to learn what is to be adored through the history told by the picture. What Scripture presents to readers, a picture presents to the gaze of the unlearned. For in it even the ignorant see what they ought to follow, in it the illiterate read.

Gerald Bonner has stressed the importance of the priestly and pastoral roles for Bede.[180] The fusion of these with the monastic discipline may have fostered his enhanced perception of the function of books as pastors. The peripatetic ministry of Cuthbert was also important to Bede. Books were similarly peripatetic, and at a time when church buildings and a parochial structure were in such early stages of development sacred texts might act as focal assembly points (as did the 'field' or 'preaching' crosses). Cassiodorus felt that they could also act as teachers. In his *Institutiones* he observes that the *antiqui* could found schools with oral instruction, while for the *moderni* books must suffice instead of teachers.[181] His plans, under Pope Agapetus, to found schools in Rome having been confounded, the monastery known as the Vivarium which he established on one of his estates was to serve in the production of such long-distance teachers. Some of them travelled as far as Northumbria to fulfil their vocation. George Henderson has suggested that the image which once accompanied an inscription known to have adorned Pope Agapetus' library in Rome depicted him seated amongst 'holy men' represented as 'fictive books stacked in a fictive bookcase'.[182] Within this tradition Bede's literary pastoral ministry reinforces the concept of the scholar-priest, informed and inspired by Scripture and by the Church Fathers in the form of the books which were their voices and adding to their number the instructors which were his own literary works. Bonner comments that 'what was essential was transmission, and that was what Bede understood himself to be providing'.[183] His works on grammar, chronology and the like were designed primarily to equip priests with the skills necessary for the salvation of souls, their own and others. His biblical commentaries extended this process to comprehension, stressing the importance of *meditatio* (prayerful reading and meditation upon Scripture) which can lead to *contemplatio*, a revelatory glimpse of the vision of God to come.

Perhaps meditation upon God revealed in his Word, as an anticipation of seeing him in his heavenly glory, similarly applied to the production and observation of the intricate decorated incipit openings of works such as the Lindisfarne Gospels. If so, the decorated Scripture is the Insular world's most complex and sacred image, or semi-abstract symbolic *figura* (symbolic representation), of the Godhead and Lindisfarne's carpet pages labyrinths

of prayer, prefiguring the devotional pavement-mazes of Chartres and other of the Gothic cathedrals by half a millennium or more.[184]

Notes

1 Higham 1986, p. 27.
2 Excavations at Nessend Quarry have revealed evidence of flint working over an extended period from *c.*8000 to 1500 BC, commencing before the island became partially separated from the mainland. See Cambridge 1988, p. 22. For a fuller discussion of the Nessend excavations, and of the early monastic and other early medieval occupation sites on the islands, see O'Sullivan and Young 1995.
3 Ekwall 1936, pp. 284–5.
4 Hull 1927.
5 I am indebted for this information to Susan Youngs, British Museum, pers. comm. On the origins of the Insular style in East Anglia, see Henderson 1999.
6 David Dumville has, however, given a salutary warning concerning the historical reliability of this material for the earlier period to which it pertains, see 'The Origins of Northumbria: some aspects of the British background', in Dumville 1993, no. III, p. 9.
7 Higham 1986, p. 259.
8 According to Prosper of Aquitaine, *Chronicon*, ch. 1307; see also Dumville 1984, pp. 16–17; Bourke 1993, p. 4.
9 Higham 1986, p. 276.
10 See Bede, *HE* III.1–3; for a summary general discussion, see Higham 1986, pp. 280–1. I would suggest that Bede, in assuming this role as the chronicler of the conversion and in his construction of the summary of his own oeuvre (in the form of the bibliography of his works which he appended to his *Historia Ecclesiastica*) is assuming the role of a latter-day Eusebius, and also perhaps of St Jerome.
11 York remained the power-base for the Northumbrian Deiran dynasty and it was of course intended, as part of Pope Gregory's plans for the re-conversion of Britain, that a second metropolitan see be re-established there as well as at Canterbury.
12 See Thacker 1989, pp. 103–24.
13 O'Sullivan and Young 1995.
14 See Symeon of Durham. T. Arnold 1882–5, I, pp. 265–94, printed the text of *De abbatibus* and suggested that the monastery in question was at Crayke, a property of Lindisfarne's near York, a suggestion followed by Lapidge 1996; see also Campbell's edition of 1962 (see Aethelwulf). Perhaps this ninth-century piece was composed in connection with the brief sojourn of the community of St Cuthbert at Crayke? On Lindisfarne's landholdings in general, see Craster 1954 and Higham 1986.
15 The influence of the eastern desert fathers upon the early Insular Church has long been recognised. Some foundations, such as Skellig Michael with its grouping of individual beehive cells, may even have adopted a semi-eremitic lifestyle in which the monks lived as individual hermits, coming together for services, in accordance with the semi-eremitic *lavras* of Syria and Palestine. Most monasteries, however, adopted a more communal, coenobitic lifestyle but acknowledged the role of hermit or anchorite as a higher monastic calling which some of its members espoused. On Celtic monasticism, see, for example, Walsh and Bradley 1991. On the influence of eastern monasticism see, for example, Telepneff 1998.
16 The Osgyth stone is one of a number of name-stones of the period, probably used to mark graves, and is on display in the Lindisfarne Priory Museum.
17 See Aird 1998 and Marner 2001.
18 On this, and the following details suggested by excavation, see O'Sullivan and Young 1995.
19 On the layout of Celtic monasteries see, for example, Herity 1983.
20 See Youngs 1989 nos 128–9.
21 O'Sullivan and Young 1995.
22 Ó Carragáin 1987, 1994 and forthcoming; Herity 1989, pp. 53–4. The passage in the anonymous *Life* occurs in ch. 4 and the Bedan metrical *Vita Prima*, 45.

23 See, for example, their use in a pilgrimage context in Herity 1989.

24 Annotations added at Wearmouth/Jarrow to the Italian Burchard Gospels include, at the beginning of the Passion (John 18.1), 'in ebd. maiore feria vi ad Hierusalem legitur passio dni' ('in holy week on Friday at Jerusalem the Passion of the Lord is read'), noting the Good Friday station as part of a list of the stations kept at Wearmouth/Jarrow and indictating a familiarity with such liturgical practices in contemporary Northumbria. I am indebted to Éamonn Ó Carragáin for this information. For further discussion on the implications of the veneration of the Cross, see the discussion of the cross-carpet pages in the Lindisfarne Gospels, below. The bases of several crosses have been found in the vicinity of Lindisfarne Priory and have been interpreted as possible stational crosses, see O'Sullivan and Young 1995.

25 Bede, *Vita Cuthberti*, ch. 16; see Colgrave 1940, pp. 206–8. See also Ó Cróinín 1995, p. 166. For eastern parallels for this practice, especially in Egypt, see Telepneff 1998.

26 Telepneff 1998, p. 14.

27 See, for example, Telepneff 1998, pp. 14–15 and 22; see also Chadwick 1961.

28 See Telepneff 1998, p. 14; Plummer 1925, pp. 54–75; Atiya 1967, pp. 55 ff. Telepneff and Atiya are inclined to over-estimate the reliability and extent of the sources. See also the more measured discussion in Wilkinson 1977.

29 Adomnan, *De locis sanctis*.

30 Talbot 1954, p. 133; Mitchell 2001, p. 173.

31 O'Sullivan and Young 1995.

32 Higham 1986, pp. 302–3.

33 Duke 1932, p. 93.

34 For a full discussion see Ó Carragáin forthcoming. I am deeply indebted to Éamonn Ó Carragáin for sharing this information with me prior to publication, and for much valuable and stimulating discussion. On the councils, see Haddan and Stubbs 1871, III, pp. 146–8; Cubitt 1995a and b. On the cult of the Virgin and on its artistic manifestation see, for example, Chavasse 1958, pp. 375–402; Nordhagen 1977; Nilgen 1981; Clayton 1990; Belting 1994. For a summary of the calendrical matter, see Talley 1986, esp. pp. 96–7.

35 See Stenton 1971, pp. 120, 122 and Fisher 1973, p. 82. See also Bede, *HE* III.2.

36 Tullylease includes, as part of a group of sculptures, a slab with a cross and inscription in 'Phase II' half-uncials recording Berechtuine (Old English Beorhtwine), which is thought to date to the eighth or ninth century. Its form of cross, with chalice-shaped terminals, is similar to that encountered on some of the Lindisfarne name-stones and on the Matthew carpet page of the Lindisfarne Gospels. This need not imply any direct relationship, and certainly does not establish Tullylease as an English foundation, but does indicate, once again, a shared cultural context. See M. P. Brown 1989 and Henderson and Okasha 1992.

37 See Thomas 1992, p. 14, where he suggests, following Duncan, that Ecgbert composed the letter from King Nechtan to Abbot Ceolfrith of Jarrow in 713–14.

38 Duke 1932, p. 138; Skene 1886–90, pp. 287–9.

39 See the discussion by Thomas Charles-Edwards 2000, p. 342, of Adomnán's policy of integrating Columba and his *parochia*'s traditions with those of the broader ecumen, on his friendship with Abbot Ceolfrith, and on what he also presents as an 'alliance' between Lindisfarne and Wearmouth/Jarrow. For further implications of the existence of such a 'middle party', see Ó Carragáin forthcoming.

40 See Stenton 1971, p. 124 and Fisher 1973, p. 84.

41 See Bischoff and Lapidge 1994, p. 133, n. 1 and pp. 158–60, where it is suggested that Abbot Hadrian of Canterbury, who had been based in the Neapolitan region, may have been the source of the southern Italian Gospelbook, containing Neapolitan pericopes, which served as the main textual exemplar for the Lindisfarne Gospels and which was also consulted at Wearmouth/Jarrow. There are, however, as we shall see, other aspects of the textual and codicological evidence which would tend to indicate that the exemplar did come via Wearmouth/Jarrow.

42 On the spirituality of 'places of resurrection', see Sheldrake 1995, pp. 54–6 and 64.

43 Farmer 1983, p. 262.

44 A note of caution needs to be exerted here, however, in respect of the 'British' Church, in Wales in particular.

45 Ó Cróinín 1984.

46 Duke 1932, pp. 106–7.

47 Columban influence in Pictland seems to have suffered as a result. The eleventh-century Irish Annals of Tighernach record that in 717 the family of Iona was expelled 'across the back of Britain' by King Nechtan. See Duke 1932, p. 110.

48 Thomas 1992, p. 14.

49 Higham 1986, pp. 288–9; Hart 1975, documents 144, 145.

50 Higham 1986, p. 289; Hart 1975, documents 146, 139, 147.

51 Higham 1986, p. 305.

52 Craster 1954, 183.

53 Higham 1986, pp. 290–1, 293. For a discussion of the manifestation of this phenomenon in Ireland, see Bhreathnach 2001. The presence of a royal resident evidently impacted upon the lifestyle of the community, as indicated by Ceolwulf's demand that in future they should drink wine. Such departures from their previous lifestyle of Colman's day, acclaimed by Bede, *HE* III.26, for its austerity and piety, probably contributed to the decline in standards lamented by Alcuin, letter 124. Whitelock 1979, no. 194.

54 Bede completed his work on the *Historia Ecclesiastica* in 731.

55 Cambridge 1988.

56 See, for example, Dumville 1997, pp. 4–7; Crawford 1987; Ritchie 1993; for the material remains, see Shetelig 1940–54; Wamers 1983.

57 Whitelock 1979, no. 194. But see Introduction, note 15, above, in which the attribution for one of Alcuin's letters to Lindisfarne is qualified. His other letters to Hygebald reveal his horror at the attack.

58 As discussed above, Lindisfarne seems to have continued to embrace aspects of its earlier Columban lifestyle, such as the eremitic retreat, even after the 'regular' reforms to monastic life introduced by Cuthbert along Wearmouth/Jarrow lines.

59 Adomnán, *Life of St Columba*, 2.45; see Duke 1932, p. 69.

60 Adomnán, *Life of St Columba*, 3.24; see Duke 1932, p. 69.

61 Adomnán, *Life of St Columba*, 1.2–3 and 3.22; see Duke 1932, p. 69.

62 Such as metalworking, which is specified; Adomnán, *Life of St Columba*, 2.30; see Duke 1932, p. 69.

63 O'Loughlin 1992, p. 37; Adomnán, *De locis sanctis*, 3, 6. 4–5.

64 O'Loughlin 1992, p. 37.

65 It duly appears within the pages of the Durham *Liber Vitae* (British Library, Cotton MS Domitian A.vii), a ninth-century volume which has been claimed both as a Lindisfarne and as a Wearmouth/Jarrow product. See Hamilton Thompson 1923 and M. P. Brown 1989.

66 Marsden 1995, p. 78.

67 Aethelwulf's *De abbatibus* applauds the patronage leading to the replacement of existing Gospelbooks with even better versions.

68 Dumville 1999, p. 62.

69 On the discovery of the 'Tara' brooch, see Whitfield 1974.

70 See the discussion of this binding in chapter 4, below.

71 Bailey 1989, pp. 231–46.

72 See Anon. 1851.

73 See Surtees Society 1854–65, vol. 389 (1861), 'Report for the year 1861', p. 3.

74 See Surtees Society 1854–65.

75 See Bailey (preface, part II, 1861, p. viii) 1989.

76 MacAlister 1913, p. 299.

77 *Cod. Lind.*

78 Verey 1989 and 1999.

79 Youngs 1989; Campbell and Lane 1993.

80 Ó Cróinín 1984.

81 Ó Cróinín 1982, 1984, 1989. Dumville gives a useful review of the evidence, 1999, pp. 84–101, where, on the role of Ráth Melsigi, he concludes on p. 87 that 'As a source of manuscripts or missions, Ráth Melsigi is a recent academic phantom'.

82 Bede, *HE* v.11 tells of Wilfrid consecrating a member of the Frisian mission, Swithberht, as bishop in

England in 692/3. For a discussion of this, of related evidence and of the implications concerning the composition of the Echternach scriptorium, see Dumville 1999, pp. 89–101. Netzer and Dumville have both argued for an English contribution to book production at Echternach during the eighth century; to quote Dumville on the early stages of the Frisian mission, 'Input to the mission from England, though not necessarily from Northumbria, may therefore be allowed as a possibility.' Dumville 1999, p. 92. McKitterick has also added a valuable insight from a Frankish perspective which again supports the concept of a multi-cultural scriptorium; see, for example, McKitterick 1985, 109–15, and 1991.

83 Ó Cróinín 1984; refutation by Dumville 1999, p. 91.

84 Ó Cróinín 1989a, pp. 135–43 and 319–22, and 1984, p. 29, n. 1; see discussion by Dumville 1999, p. 90, n. 144.

85 Ó Cróinín 1988, 1989.

86 Netzer 1989, 1989a, 1994, 1996.

87 See T. J. Brown 1982 (reprinted in Bately *et al.* 1993).

88 M. P. Brown 1996 and 2001b.

89 T. J. Brown 1982 and 1984.

90 William O'Sullivan 1994a, questioned the dating of Durrow although part of his argument seems to be based on the misapprehension that the Turin Gospels, with which he draws analogies, were painted in one campaign when in fact it actually seems to be an earlier volume which underwent repainting during the ninth century. The stylistic parallels for the Book of Durrow, especially with metalwork, would still tend, nonetheless, to favour an earlier dating.

91 T. J. Brown 1971; for more recent scholarship on the Book of Kells, see O'Mahony 1994.

92 Fox *et al.* 1990, esp. the contribution by P. McGurk.

93 Ó Cróinín 1984; Netzer 1989, 1994.

94 For the various aspects of the debate, see Ó Cróinín 1982, 1984, 1988 and 1989; Netzer 1989 and 1994; Verey 1999; M. P. Brown forthcoming b.

95 Verey *et al.* 1980. See the discussion in chapter three, below.

96 Verey *et al.* 1980, pp. 74–6.

97 See T. J. Brown on script in *Cod. Lind.*

98 For an example of such fine linear hatching in Visigothic manuscript art, see British Library, Add. MS 30850, f. 6r.

99 This is a simplified outline. For the intricacies of the text types see chapter three, below.

100 O'Sullivan 1994; Dumville 1999.

101 Nordhagen 1977; Henderson 1987, 1993. For an interesting recent appraisal, see O'Reilly 2001.

102 M. P. Brown 2000. See also Charles-Edwards 2000.

103 See, for example, Wood 1995 and Parkes 1982.

104 M. P. Brown, forthcoming b.

105 Dumville 1999, pp. 74–5.

106 See chapter five, below.

107 Bede, *Lives of the Abbots of Wearmouth and Jarrow*, ch. 6, see Farmer 1983, pp. 190–1.

108 See Battiscombe 1956.

109 Bede, *Lives of the Abbots*, ch. 9; see Farmer 1983, p. 194.

110 That is, demonstrating the way in which the Old Testament prophesied and prefigured the New Testament by means of parallels, such as King David being a type/prefiguration of Christ.

111 Bede, *Lives of the Abbots*, ch. 4; Farmer 1983, p. 188.

112 Farmer 1983, pp. 29–30.

113 Bede, *Lives of the Abbots*, ch. 11; Farmer 1983, p. 196.

114 Bede, *Lives of the Abbots*, ch. 15; Farmer 1983, p. 201.

115 Farmer 1983, p. 36.

116 *Ibid.*

117 For the Codex Amiatinus, see Alexander 1978, no. 7. For a brief discussion of the surviving remnants of the Ceolfrith Bibles and the Worcester connection, see Webster and Backhouse 1991, pp. 122–3, and, especially for the Offa connection, M. P. Brown 1996, p. 166 and Marsden 1998. On Ceolfrith's

commission, see Wood 1995.

118 De Rossi 1888, pp. 1–22. For a summary of the issue, see Bruce-Mitford 1967 and Nordhagen 1977.

119 Alcuin's *Carmen* 69 quotes the couplet above Amiatinus' Ezra miniature as part of his description of a Bible punctuated *per cola et commata*, like the Ceolfrith pandects, which he may have seen. See Corsano 1987, pp. 3–4 and 20–2.

120 Wood 1995; Brown forthcoming b; Brown forthcoming a.

121 Perhaps based upon the Vulgate version contained in Cassiodorus' nine volumes, of which a fossilised recollection may be preserved in the possible ninefold sections of work by seven different scribes in the Codex Amiatinus. Farmer 1983, p. 35; E. A. Lowe 1960. On these recensions see Marsden, 1995, 1995a.

122 Thacker 1989, pp. 103–24 at p. 116.

123 *Ibid.*, p. 116; Berschin 1989, pp. 95–102; Lapidge 1989, pp. 22–96.

124 Thacker 1989; Marner 2001.

125 This may have commenced a long period of mutual commemoration which makes it so difficult, from content, to determine whether the surviving mid-ninth-century *Liber Vitae of Durham* (BL, Cotton MS Domitian A.vii) was in fact written, in its gold and silver characters, at Lindisfarne/Norham or Wearmouth/Jarrow. See M. P. Brown 1989, pp. 151–63 at p. 162; Gerchow 1987, pp. 140–93.

126 Thacker 1989, p. 119.

127 Stephanus, *Life of Wilfrid*. Whitelock 1955, no. 154. Also edited by W. Levison in *Mon. Germ. Hist., Script. Rer. Merov.*, VI. For a reappraisal of the identity of Eddius Stephanus as Stephen of Ripon, see Lapidge 1999.

128 Stephanus, *Life of Wilfrid*, ch. 17, p. 124.

129 *Ibid.*, ch. 19, p. 125.

130 Farmer 1983, p. 10, dates Stephanus' work to around 720; Whitelock 1955, p. 752, places it soon after Wilfrid's death in 709.

131 For Add. 40107, see CLA 2.**, p. 17.

132 O'Reilly 2001.

133 Bede, *Vita Cuthberti*, ch. 37 in Farmer 1983, p. 91.

134 Farmer 1987, p. 96; Lawlor 1916, 241–443; M. P. Brown 1989, p. 153. On attribution to Bede, see also Marsden 1998 and Bullough 1998.

135 Bede, *Vita Cuthberti*, ch. 23 in Farmer 1983, pp. 72–3. Youngs 1989, no. 47.

136 Kelly 1994, pp. 280–9. On religious circuits and their context, see Herbert 1988.

137 Thacker 1989, p. 109.

138 Farmer 1987, p. 173. M. P. Brown 2001a.

139 Bhreathnach 2001.

140 O'Meara 1982. M. P. Brown forthcoming d.

141 Bhreathnach 2001.

142 Thacker 1989, p. 112.

143 Dublin, Royal Irish Academy, MS s.n.; Dublin, Trinity College, MSS 57 and 58; Alexander 1978, nos 4, 6 and 52.

144 Dublin, Royal Irish Academy, MS s.n.; CLA 2.266.

145 Michael Clanchy makes a similar point in Mostert 1999, p. 11.

146 For some useful general remarks on Irish book-shrines, see Ó Floinn in Ryan 1983, p. 61. One metalwork shrine, that of the Gospelbook known as the Domnach Airgid ('silver Church or shrine', its name derived from a shrine of that name given by St Patrick to St MacCairthainn of Clones), made in the late eighth–ninth century and further adorned in the fourteenth, was found to contain its book, which had been folded over to fit into the reliquary which had obviously been designed for other relics. The symbolic presence of the manuscript, rather than regard for its physical identity, was evidently the priority here. See Ryan 1983, no. 85.

147 Marner 2001.

148 Ryan 1983, no. 86; for the account of the pouch in St Cuthbert's coffin, see Marner 2001, and Tudor 1989, pp. 447–68 at p. 460.

149 Ryan 1983, p. 50.

150 Tudor 1989, p. 460.

151 Marner 2001.

152 *Ibid.*

153 Migne 1844–64, vol. 87, cols 527–9.

154 CLA 2.148; Alexander 1978, no. 16. See M. P. Brown forthcoming b and Verey 1999, pp. 327–35.

155 Dublin, Royal Irish Academy, MS D.II.3; CLA 2.268; Alexander 1978, no. 51.

156 M. P. Brown 1993; David Howlett's recent work is yielding increasing evidence of the use of sophisticated compositional structures, many of them numerically based and with scriptural authority. See, for example, Howlett 1998.

157 Berschin 1989, pp. 95–102 at pp. 99–100.

158 Bede, *Vita Cuthberti*, ch. 8 in Farmer 1983, pp. 53–4. See M. B. Brown 1989, pp. 151–64 at p. 153.

159 Now in Cairo, Coptic Museum, MSS Library, no. 12488; see Gabra 1993, pp. 110–11.

160 Aethelwulf, *De abbatibus*, ch. 8, pp. 20–3. See M. P. Brown 1989, p. 157.

161 Nees 1993. Ultán need not, in any case, have been working locally for his prized relics to be venerated in Northumbria. One famous scribe of that name, for example, was Ultán moccu Chonchobair who composed hagiographical narratives concerning St Patrick and St Brigid of Kildare during the seventh century; see Howlett 1998a, p. 23.

162 See Brubaker 1995, p. 11.

163 Bonner 1989a. See also G. H. Brown 1996; Marner 2001. The St Cuthbert Gospel was formerly known as the Stonyhurst Gospel and is currently on loan to the nation via the British Library (Loan MS 74); CLA 2.260 and 2.187; T. J. Brown *et al.* 1969.

164 Marner 2001.

165 Discussed by Bailey 1989, and for a discussion of other aspects of the relics, see other contributions to part 3 of Bonner *et al.* 1989. For a fuller examination of the relics, see Battiscombe 1956.

166 The wooden portable altar seems to have received its metalwork embellishment during the eighth century and to have been deposited in the coffin thereafter.

167 Chrysos 1999.

168 Ayerst and Fisher 1977, p. 102; M. P. Brown 2000, p. 2.

169 *Ibid.*, p. 103.

170 On a similar theme, see McKitterick 1995.

171 The Textus Roffensis is Rochester, Cathedral Library, MS A.35; see Webster and Brown 1997, pp. 219–20. For a translation of extracts from its text, see Whitelock 1979, no. 29.

172 Bede, *HE* II.5; see Whitelock 1979, no. 151, p. 664. For the full text, see Colgrave and Mynors 1969.

173 See, for example, BL, Cotton MS Augustus II. 2 and II. 29, on which see Webster and Backhouse 1991, nos 27 and 28 and Webster and Brown 1997, pp. 220–1.

174 Whitelock 1979, no. 172.

175 M. P. Brown 1998a.

176 See Webster and Brown 1997, pp. 211–12, 232–3, 240.

177 M. P. Brown, forthcoming a and the discussion of display script in chapter 4, below.

178 BL, Cotton MS Vespasian A.i and St Petersburg, Public Library, Cod. Q.v.I.18, see Alexander 1978, nos 29 and 19; CLA 2.193, II.1621. See also Wright 1967.

179 See Ayerst and Fisher 1977, pp. 101–2; Chazelle 1990, 138–53.

180 Bonner 1989. See also G. H. Brown 1996.

181 Fridh 1973, 3.5.3, 3.9.1, 3.31.4, 4.51.2, 7.15.1, 8.14.2, 8.25.1, 11.1.19. See Stansbury 1999, p. 60.

182 O'Reilly 2001; G. Henderson 1993, p. 85.

183 Bonner 1989a, p. 387.

184 There is also some general cultural analogy with the Buddhist mandala as a vehicle of meditative prayer.

CHAPTER TWO

The Lindisfarne Gospels: the biography of the book

Provenance: what does the later history of the Lindisfarne Gospels reveal?

The Lindisfarne Gospels are a Latin Gospelbook made in the Insular world some time in the late seventh or early eighth centuries, this author favouring production at Lindisfarne, *c.*710–25. There is no conclusive evidence of where the book was made and clues, but little definitive proof, as to its whereabouts between the mid-tenth and the early seventeenth centuries. It is thought to have accompanied the displaced community of St Cuthbert, in celebration of whose cult it was probably made, to its other major homes at Chester-le-Street and Durham. By the early seventeenth century it was in London, passing from one Robert Bowyer to Sir Robert Cotton and, with the rest of his collection, thence to the British Museum and to the newly formed British Library in 1973, where it remains known as Cotton MS Nero D.iv.

Books of this period seldom tell us when or where they were made, or by whom. An occasional colophon containing a dedication to, or an entreaty of prayer for, named individuals sometimes provides a valuable clue,[1] but by and large encountering one of these manuscripts is like meeting someone with amnesia who cannot readily reveal their origins. In order to discover such secrets it is necessary to find out all one can of the individual standing before you, and to piece together clues about their preceding life history. In artefactual terms these biographical details are termed 'provenance'.

The provenance evidence for the Lindisfarne Gospels is confused, confusing and often contradictory. Like a detective story, the plot weaves in and out. Some clues will be 'red herrings', others may point to a conclusion which is then challenged by further details. I have tried to present as many of the alternatives as possible and have indicated which I consider the most likely. It remains, however, for the readers to serve as the jury in reaching their own conclusions, but first they must be patient and review the evidence.

Fig. 41. Image of the Last Judgement, with Viking-like warriors (Lindisfarne Priory Museum), Lindisfarne, 9th century. (Photo: courtesy of English Heritage)

The community of St Cuthbert: from Lindisfarne to Durham

It will be helpful to set out what we know concerning the life history of the Lindisfarne Gospels within the historical context. The volume was apparently with the community of St Cuthbert at Chester-le-Street around 950–70 when it was glossed in Old English and given a colophon naming those who were thought to have made the book originally – evidence traditionally cited in favour of a Lindisfarne origin – by a priest named Aldred. It is assumed to have accompanied the monks on their travels in search of a new home after they were forced to leave Lindisfarne because of Viking attacks. The vulnerable island jewel of Lindisfarne was the first victim of Viking raids on Britain in 793 (see fig. 41). This was reported as a violent and bloody outrage which shook contemporaries and was lamented in Alcuin's correspondence and verse (with a wistful note that its downfall may have been occasioned by lapses from its earlier standards of excellence). The early monastic community never fully recovered from the blow, and the number of monks within a progressively secular community remained as low as two or three until the Benedictine reforms of the later tenth century. Initially some treasures, including Aidan's early wooden church building, were evacuated north to Norham under Bishop Ecgred (830–46), pursuing the old links with other monasteries that were part of the *parochia* of St Columba.[2] Ecgred also translated the bodies of Cuthbert and King Ceolwulf there, making it temporarily the *caput* of the see.[3] The Durham *Liber Vitae*, probably started in the 840s and incorporating earlier material, might conceivably have been written by a member of the community at this time, either at Lindisfarne or Norham, as a means of physically transporting the commemoration of the community's former worthies and benefactors between the two centres.

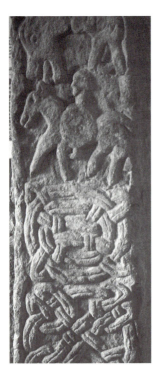

Fig. 42. Cross shaft commemorating one Eadmund, Chester-le-Street (Anker's House Museum), late 9th–10th century. King Eadmund visited the shrine there in 945, but this sculpture is probably earlier. (Photo: the author, with kind permission of the Vicar and Churchwardens of St Mary and St Cuthbert, Chester-le-Street)

By 875 these bloodthirsty attacks are thought to have become unbearable and a permanent Viking military presence had descended upon Tyneside. It should be noted, however, that Lindisfarne itself is significantly further north than Tyneside and that the community's 'wanderings' in fact took them ever closer to the lion's den. The community left the island in 875 and embarked on a nomadic period, taking the relics of St Cuthbert with them.[4] The sources tell of St Cuthbert appearing in a vision to King Alfred in his hiding place in Athelney marshes, at the nadir of his guerrilla warfare against the Danes, and intervening in the election of the new Viking leader, Guthred, with whom he could subsequently treat. This particular episode is in the *Historia de Sancto Cuthberto*, either as an eleventh-century interpolation into a narrative derived essentially from the mid-tenth century or part of an integral eleventh-century composition. It recounts that Abbot Eadred of Carlisle, who had joined the community of St Cuthbert during its travels, redeemed a young Dane, Guthred, from captivity and presented him to the Viking forces as a successor to their recently deceased leader, Halfdene.[5] If the *Historia* was correct in this, then the community's intervention in northern politics would certainly have eased relations with Wessex and Guthred's coinage indicates that he acknowledged Alfred as his overlord.[6] These events are probably to be connected with the community being granted the old Roman fort on a prime line of communication at Chester-le-Street by Guthred in *c*.883 (see fig. 42),

interpreted by Higham as the establishment of a crucial ecclesiastical buffer-zone between the two Northumbrian kindoms of Bernicia (which remained under English rule) and Deira (under the Danes).[7] At the same time Guthred bestowed upon the community all the land between Tyne and Wear, including the properties formerly held by Wearmouth/Jarrow. This homecoming did not mark the end of the Viking threat to the community, however. In 918, following the victory of King Regnald of Norway over combined English and Scottish forces at Corbridge, one of his followers, Onalafbald, seized the territory between the rivers Eden and Wear, entered the church at Chester-le-Street and swore on Thor and Odin his enmity to Bishop Cuthred and the community. The *Historia de Sancto Cuthberto* (par. 23) gleefully records that this action provoked his own death.[8] The episode serves to indicate that local Viking interests continued to be constrained by the presence of the community of St Cuthbert within their midst.

During the preceding eight years in the wilderness, Symeon of Durham (in his history of Durham composed around 1104–9 when the shrine of St Cuthbert had been re-established in the new cathedral) tells us that Bishop Eardulf of Lindisfarne and Abbot Eadred of Carlisle attempted at one point to set sail for Ireland from the mouth of the Derwent, in Cumbria.[9] Carlisle was among Lindisfarne's major landholdings and the community may have wished to join with members of other of its key houses before leaving the area. Alternatively, the journey may have been intended as one in which the Bishop of Lindisfarne and his community visited their satellites in person to explain the need for their relocation and to ensure their continued authority in those traditional holdings – an authority ensured by the ritual progress of the relics of St Cuthbert which accompanied them. The *Historia de Sancto Cuthberto* tells how God thwarted them by washing St Cuthbert's book overboard, of his ensuing instruction to one of the bearers of the coffin, Hunred (see fig. 43), to go and search for it in the treacherous quicksands of the Solway estuary (see fig. 44), and of its recovery, miraculously undamaged by its trial by water. According to Symeon's embroidered account of the episode, the relics were then taken to the ancient monastery of Whithorn before travelling for a short four-month sojourn at Crayke in Yorkshire, a property of Lindisfarne's situated only ten miles or so north of York.[10] After the intervention in Guthred's career, St Cuthbert and his community moved northwards, to Chester-le-Street (883–995) where Aldred probably glossed the volume around 950 (and certainly before 970).

The legends associated with this period (as compiled by Symeon of Durham) present it, I suggest, in terms of biblical history. Moses (Cuthbert, embodied by his relics) and the Israelites ('the people of St Cuthbert') wander in the wilderness in search of a new promised land (ultimately to be Durham – their new Jerusalem) and survive trials such as the crossing of the Red Sea and the parting of the waves (the loss overboard of St Cuthbert's Book amid waves of blood red) with Aethilwald's cross raised before them in emulation of Moses' raising of the brazen serpent – a type of Christ's triumph over death

Fig. 43. Hunred retrieving the Lindisfarne Gospels from the sands of the Solway estuary, from a memorial window, St Mary and St Cuthbert, Chester-le-Street. (Photo: the author, with kind permission of the Vicar and Churchwardens of St Mary and St Cuthbert, Chester-le-Street)

on the cross. This is partly literary and theological convention, but it also suggests another interpretation. The route taken is one which embraced not only some of the most import-ant early houses of the Lindisfarne *parochia* within its most northerly reaches, but one which acknowledged its Irish origins and the contribution made by Ninian and Columba to the conversion of Scotland and northern England, and turned from them towards the south, the new focus of power. The carrying of relics bears all the hallmarks of an ecclesiastical progress, a ritual procession around a church's landholdings with relics to authenticate and confirm its continued authority in those areas, a role which the Book of Kells also seems to have performed within the Columban *parochia*.[11] Bernicia was no longer the major political player it had been, although it still needed to be harnessed to ecclesi-astical concerns. For a Church to flourish in what was now Anglo-Danish territory it needed to be closer to the seat of power and its rulers. The route therefore followed the line of what seem, from the *parochia*'s earlier landholdings, to have been *mansiones* or staging posts en route to York, held by the community. Communications were maintained with the Anglo-Saxon royalty and its anti-Viking resistance, now centred upon Wessex, and it is the community of St Cuthbert which appears to have orchestrated the take-over bid by a Danish candidate sponsored by itself and by the West Saxon royal house, with whom Alfred would be able to treat.[12] In some sense the community of St Cuthbert was

Fig. 44. The sands of the Solway estuary (seen from the southern shore), where the Book of St Cuthbert was found after having been washed overboard, according to Symeon of Durham. (Photo: the author)

a contributory architect of the Danelaw and may have formed a strategic ecclesiastical buffer-zone within it, helping to contain the Danelaw within a pincer movement of southern and northern territories still in English hands.

The reference in Aldred's colophon to all the saints whose relics 'are' on Holy Island indicates that the community continued to value its former home and to retain a connection with it, as indeed was still the case in the later Middle Ages. When Bishop Aldhun relocated the see to Durham in 995 he still styled himself 'Bishop of Lindisfarne'.[13] The impressive assemblage of sculpture dating to the ninth and tenth centuries which is preserved in the Priory Museum on Holy Island is as rich as that from any major ecclesiastical site of the period and, along with archaeological excavations of settlement sites on the island of similar date,[14] indicates that Holy Island remained an important focus and religious centre with an associated population. The *caput* may have moved further south but the *parochia* probably still existed and embraced its traditional northern outposts.

In 995 further Scandinavian threats caused Bishop Aldhun to move the community southwards to Ripon for about four months, before finally settling at the readily defensible site of Durham, probably as part of the fortification of the site for his own purposes by Earl Uhtred.[15] In 1069 Bishop Aethelwine once again felt the need to evacuate St Cuthbert's body, this time to escape the vengeance of another ruler of Viking descent, William the Conqueror, during the 'Harrowing of the North'. The refugee monks took what they could in the way of relics with them, but many of the 'precious ornaments' they had left in the church at Durham were pillaged by the Normans and were never retrieved.[16] The monks returned in 1070, but to a new regime headed by King William's new bishop, a Lotharingian named Walcher. In 1083 Durham was refounded as a showpiece of the Anglo-Norman Church, its 'secular' clergy being ousted in favour of Benedictine monks. At the same time a priory was established at Lindisfarne, as a dependency of Durham, by

Bishop William of St Calais (Carilef). The intention would seem to have been, as a priority, to emphasise the link between Durham and its Lindisfarne origins and to establish the legitimacy of Norman ecclesiastical succession as guardians of the patrimony of St Cuthbert. In 1093 the foundation stone of the new cathedral at Durham was laid and in 1104 work was sufficiently advanced for the shrine of St Cuthbert to be rededicated at its east end. Lindisfarne and the origins of the cult continued to be of importance to the community.[17]

As we have seen, Symeon of Durham recorded that a book associated with St Cuthbert jumped ship when the community left Lindisfarne, rather than be taken by them to Ireland (their first choice as refuge and ultimate source of the Columban foundations), miraculously survived, and could still be seen in Durham. It has been assumed that this book was the Lindisfarne Gospels, without proof and without any corroborative water staining.[18] There is no identifiably specific reference to the Lindisfarne Gospels in medieval records of Durham's property but a Durham inventory of 1367 records that a book of St Cuthbert which was saved from water (per Symeon) was kept in Lindisfarne, a dependency of Durham's. There is no proof that this was the Lindisfarne Gospels, but if it were then it was possibly not at Durham throughout the Middle Ages as is usually claimed. I shall return to this question shortly.

Aldred's gloss and colophon

The main evidence traditionally cited in support of production at Lindisfarne is a colophon and interlinear continuous gloss translating the original Latin text into Old English (see fig. 45a). This is the oldest extant English-language version of the Gospels and was added to the volume around 950 by a priest named Aldred who seems to have been a member of the community of St Cuthbert at Chester-le-Street. Aldred had achieved the important position of provost by 970, when he added a colophon on f. 84r of the *Durham Ritual* (Durham, Cathedal Library, MS A.IV.19, see fig. 45b). This records that he was writing in the tent of Bishop Aelfsige of Chester-le-Street (968–90) pitched at Oakley Down in Dorset, the colophon including mention of the moon phase and other calendrical details which suggest the date of 970. The Ritual's colophon may be translated from Old English as:

> Aldred the provost wrote these four collects at Oakley, to the south of Woodyates, among the West Saxons, on Wednesday, Lawrence's feast day (the moon being five nights old), before tierce, for Ælfsige the bishop, in his tent.[19]

Elsewhere in the Ritual Aldred's hand probably added collects for St Cuthbert and an interlinear gloss to the bulk of the book – an early tenth-century West Saxon Latin collectar. There has been considerable palaeographical debate about whether some or all of these additional elements in the *Durham Ritual*, and the gloss by an Aldred in the

Fig. 45. (a) The Lindisfarne Gospels (BL, Cotton MS Nero D.iv), f. 259r, the end of the book, with the 'colophon group' of inscriptions added by Aldred in the 950s or 960s; (b) The Durham Ritual (Durham MS A.IV.19), f. 46v, Wessex, 9th century, with gloss added by Aldred in 970. (Reproduced by kind permission of the Dean and Chapter of Durham Cathedral)

Fig. 46. The Durham Gospels (Durham MS A.II.17), f. 106r, fragment of a Gospel written in uncial script from Wearmouth/Jarrow, appended to the Durham Gospels, c.700, with marginal inscription by Boge, 10th century. (Reproduced by kind permission of the Dean and Chapter of Durham Cathedral)

Lindisfarne Gospels, can be associated with a single hand.[20] In an essay first published in 1943 one of the subject's leading authorities, Neil Ker, argued that, despite apparent differences in appearance, all these elements were by one scribe, Provost Aldred of Chester-le-Street, even if conducted at different stages in his career.[21] It was accepted that the Lindisfarne Gospels gloss was stylistically the earliest stage, this assumption being reinforced by Aldred's reference to himself in its colophon as 'priest', an office usually generally assumed at or after the age of thirty, and its implication that in adding the gloss Aldred was facilitating his entry into the community. Accordingly, a date of c.950 has generally been accepted for his glossing of the Lindisfarne Gospels. The identification of the glossator of the Lindisfarne Gospels as Aldred the Provost, who later glossed the Ritual, precludes his being the Bishop Aldred of Chester-le-Street (d. 968) referred to in the priest Boge's inscriptions in the Durham Gospels (Durham, MS A.II.17, f. 106r, see fig. 46).[22]

In an attempt to site his work within a tradition embracing the original production of the Lindisfarne Gospels, Aldred named three earlier members of the community as the book's makers and their names, if taken at face value, suggest a Lindisfarne origin as part of the cult of St Cuthbert. Scholars would not usually accept an inscription added some two hundred and fifty years after manufacture as reliable or conclusive evidence alone

of origins, but those inclined to accept it have also argued, in different ways, in favour of contextual, historical, palaeographical and archaeological evidence supporting a Lindisfarne origin.[23] The reliability of Aldred's colophon statement about manufacture was first questioned by R. A. S. MacAlister when he claimed it as a ninth-century Irish work.[24] This was rebutted by G. Baldwin Brown and his acceptance of the colophon was repeated in *Cod. Lind.* and by most other commentators. It has subsequently been challenged again by W. O'Sullivan, D. N. Dumville and L. Nees.[25] Nees is the only commentator to have backed his suspicions with a proper discussion of the colophon as a historical document.[26] He suggests that Aldred manufactured the colophon in order to stress his own role as the fourth in a quartet of 'makers' of the book, as a reference to the four evangelists and to the continuing process of evangelistic transmission of the Gospels, this 'quadriga' reflecting other symbolic quartets such as the four elements, the four rivers of Paradise, the four cardinal virtues, the ages of man and the four compass directions. His choice of the three other 'evangelists' was guided, so Nees maintains, by the references to the two bishops in the works of Bede and by the inclusion of Billfrith's name in the list of anchorites in the Durham *Liber Vitae* (BL, Cotton MS Domitian A.vii, f. 18r, see fig. 47).[27] This does not explain why the otherwise unknown Billfrith should have been chosen and identified as a metalworker. He occurs as number twenty-one in the list of anchorites on f. 18r, separated by nineteen intervening names from that which may refer to Bishop Aethilwald, also an anchorite, who was thought to have commissioned him and perhaps implying an intervening time lapse. This does not explain why a metalworker should have occurred to Aldred as one of the quartet. Nor does it explain why a 'random' name should have been selected from a list of anchorites as opposed to another ecclesiastical category, nor why Aldred did not preserve the spelling adopted in the *Liber Vitae* if it was indeed his source (Aldred uses two 'l's rather than the one that appears there).

It therefore remains possible that Aldred was drawing upon an earlier source (or sources) and incorporating it into his colophon. This may, as we shall see (see the discussion of the original binding in chapter four, below), have taken the form of an inscription upon a metalwork cover or shrine, or an earlier written account which might even have been included in the volume itself, like the anonymous account of the 'wanderings' of the community which was included in Durham's 'Liber Magni Altaris'. The latter (or the 'liber de reliquiis' attached to St Cuthbert's shrine, which some scholars think may have been the same volume)[28] may even have been the Lindisfarne Gospels, which seems once to have included extraneous matter to judge from the codicological evidence.[29] Any such earlier nucleus for the contents of Aldred's colophon proper would not necessarily have come any closer to relating fact concerning the circumstances of the book's manufacture, but the likelihood of its existence does support the contention that there was a pre-existing tradition within the community with which Aldred subsequently associated himself. I have sought to demonstrate within this present work that the historical and contextual circum-

Fig. 47. The Durham *Liber Vitae* (BL, Cotton MS Domitian A.vii), f. 18r. The name 'Bilfrith' occurs at the head of the second column of names of those whom the community remembered in prayer, written in gold and silver (the silver has oxidised, impairing the original elegance).

stances for the production of the Lindisfarne Gospels independently suggest that they were likely to have been made at Lindisfarne during the period of the floruits of the bishops whose names continued to be associated with the book by tradition.

Nees points out that the context of extant colophons and dedication inscriptions points to the ninth or tenth centuries as the time at which Aldred's colophon is likely to have been composed and highlights the possibility of the particular influence of dedications in books presented by King Athelstan to the community of St Cuthbert in the 930s.[30] The practice of applying such inscriptions to books certainly increased somewhat in that period, but is not unknown earlier. Ceolfrith's dedication inscription in the Codex Amiatinus is one such example, as is the colophon copied from an earlier exemplar into the Echternach Gospels. Original colophons also occur prior to the ninth century, such as the behest to 'ora pro uuigbaldo' (pray for Wigbald) in the late eighth-century Barberini Gospels.[31] There is no doubt that Aldred actually compiled the colophon as it now appears on f. 259r of the Lindisfarne Gospels, and he was probably doing so within a tradition of Carolingian and tenth-century English practice, but again it cannot be proved that part of his text was not based upon earlier material. The language and layout of Aldred's compilation would tend to suggest that this was indeed the case. Its layout is curiously erratic, with Aldred glossing his own text for the 'Five Sentences' and adding marginal inscriptions (the 'litera pandat' and the verse concerning his parentage), and includes indentation of the lines mentioning the manufacturing team. Indentation was an established form of indicating quotation.[32] Another prominent feature of the inscription is that its major component parts, the clauses of the 'Five Sentences' and the incipit of the colophon proper, are marked by large crosses of the sort that often mark the beginnings of inscriptions on metalwork and stone, which could reflect a source. A linguistic feature might also suggest that the colophon was not a single, new composition. The name of Bishop Aethilwald is given in different ortho-graphical forms: Eðilvald and Oeðilvald, and on f. 89v it takes the form 'Æðilwald', with an 'e' caudata and a 'wyn'. This might indicate that Aldred copied the name from various sources as well as using the form with which he was familiar. Likewise, the name Billfrith differs from the 'Bilfrith' in the Durham *Liber Vitae*, whence Nees argues that he derived the name, and Eadfrith also occurs therein with the spelling 'Eatfrith'. The inclusion of Latin elements within the Old English text ('hoc evangelium deo', 'lindisfearnensis æcclesiæ' and 'construxerunt vel ornaverunt') might also reflect the copying of parts of the text from another source. Furthermore, Jane Roberts has suggested to me that there may be a previously unnoticed poetic verse embedded within the part of Aldred's 'colophon group' concerning the manufacturing team. It is as if he were reworking an earlier verse, amplifying and extending it to include the passage relating to himself and thereby cor-rupting the poetic form.[33] On balance the evidence conspires to suggest that Aldred was adapting an earlier source or sources for his statements concerning the 'makers' of the Lindisfarne Gospels. Aldred may have thereby effectively destroyed an earlier vernacular

verse naming the makers of the Lindisfarne Gospels. He does, however, preserve or possibly compose some Latin verse as part of the 'colophon group'. Next to the original explicit to the Gospel of St John on f. 259r he has written:

> + Lit(er)a me pandat
> sermonis
> ministra
> Omnes alme
> meos fratres
> Voce salvta: [34]

In this verse writing is acclaimed as the servant of speech. The statement concerning Aldred's parentage likewise takes the form of a Latin rhyming couplet indicating that Aldred himself harboured aspirations as a poet. These verses are nearly hexameters. The insertion of 'fida' before 'ministra' and of a word of one long or two short syllables before or after 'fratres' would make them scan (I am deeply indebted to Andy Orchard for this suggestion).

Aldred's continuous interlinear gloss in Old English between the lines of the original Latin manuscript is written in the Northumbrian dialect. A further Anglo-Saxon translation is preserved in the form of later (twelfth-century) manuscript copies and is known as the West Saxon or Wessex Gospels, being written in the West Saxon dialect. Another gloss, added during the tenth century to an early ninth-century Irish Latin Gospelbook, the Macregol Gospels, by two hands, thought to be those named in annotations as Owun and Farmon, a priest from Harewood (West Yorkshire, or near Ross-on-Wye or Lichfield),[35] relies upon Aldred's gloss, or a shared source, and is in the Mercian dialect.[36] The Lindisfarne Gospels may contain the earliest extant translation, but we know that work on disseminating the biblical texts in the vernacular had commenced earlier. Bede was engaged in translating St John's Gospel, for the good of his soul and those of all people, on his deathbed (dictating to an assistant) in 735. The Vespasian Psalter (BL, Cotton MS Vespasian A.i, see fig. 40), a Kentish work of around 730, was also given an interlinear Old English gloss during the second quarter of the ninth century (probably at Canterbury by one of the scribes who also worked on the Royal Bible, BL, Royal 1.E.vi, some time between 820 and 840).[37] The spirit of evangelisation that engendered such an openness to spreading the Word by any means was very different to the official intolerance encountered by Wycliffe and Tyndale in the late Middle Ages.

This work may have been Aldred's way of establishing his credentials and making a contribution to the community which he seems only recently to have joined. He glossed Matthew, Mark, Luke and the beginning of John in a neat, tiny pointed cursive hand using black ink. From 5.10, and in mid verse, John's Gospel is glossed in the same hand, but using red ink. The Prefaces are also in red, up to the beginning of the 'Plures Fuisse', as are some further glosses added to Matthew. There are also a few additional glosses in red on f. 140v

(Luke 1). The change in ink may simply have resulted from some unpredictable change in Aldred's circumstances, or it may be that he decided to accord John's Gospel the particular distinction that it often seems to have attracted, especially in the context of the cult of St Cuthbert (who studied it with his master, Boisil, and who was interred with a copy of it), by glossing it in a higher grade ink. It is tempting to wonder whether Aldred's model for the gloss on John might even have been indebted, if only in part, to the translation to which Bede devoted his last days on earth and that the red ink might honour such a source. Boyd outlined the sources to which Aldred may have had access,[38] including Bede's Old and New Testament commentaries and his homilies upon the Gospels. However, in his 'gloss 62' (John 19.38) Boyd notes that Aldred glossed the passage 'post / .i. est in die examinis iudicii. Districti iudicis. ðus beda ðe bróema bóecere cuéð'[39] ('thus said Bede, the famous scribe'), and states that 'It has proved impossible to pin down the precise reference in Bede. Aldred may have derived his explanation from Bede's *Explanatio Apocalypsis*.[40] The great value of this marginal explanation is that Aldred confirms Bede as one of the sources of his scholarship.'[41] Might this, alternatively, represent a Bedan gloss on his otherwise lost translation of John's Gospel, signified by the use of red ink? Later in the Middle Ages de luxe volumes would often be ruled in red or purple ink as a sign of status, and the popular expression 'red-letter day' derives from the practice of grading liturgical feastdays by the use of different coloured inks in calendars. Aldred might then have gone on to gloss the ancillary, prefatory texts and have decided to make a few additions to Matthew and Luke, correcting/supplementing his initial gloss and still using his red ink.

Aldred seems to have been building a reputation as a glossator/translator and his hand can also be observed, as we have seen, in the *Durham Ritual* (see fig. 45b)[42] where he glossed some of the collects interlinearly and added red initials to the text, and in Latin glosses to Oxford, Bodleian Library, Bodley 819 (see fig. 48), a late eighth-century copy of Bede's commentary on the Proverbs of Solomon written at Wearmouth/Jarrow (which probably passed to the community as part of its absorption of Wearmouth/Jarrow's properties in the late ninth-century).[43] He emerges as something of a champion of the written English vernacular in northern England at a time when it was being reintegrated into the new, unified England. This process had been initiated by Alfred and considerably forwarded by his successors, Athelstan effectively reclaiming the north. It was not, however, an inevitable one and encountered much opposition. At around the time that Aldred was glossing the Lindisfarne Gospels Eric Bloodaxe (d. 954), ruler of Viking York, was advancing his 'kingdom' in Northumbria. Alba (Scotland) and Strathclyde also posed a threat to English control of the north. The community of St Cuthbert seems to have been 'doing its bit' to keep the region 'English' and the promotion of Old English may have been part of this. The use of the vernacular would also, of course, have served to further enhance the popularity and accessibility of the cult of St Cuthbert and to strengthen Christianity in the region. The visits of kings Athelstan and Edmund to the shrine of St Cuthbert over the

Fig. 48. Oxford, Bodleian Library, Bodley MS 819, ff. 28v–29r, Bedan exegesis, Wearmouth/Jarrow, late 8th century, with gloss by Aldred. (Photo: The Bodleian Library, University of Oxford)

preceding decades can also be viewed in the light of fostering the process of reintegration and may have helped to stimulate Aldred to perpetuate King Alfred's agenda of translation as an essential adjunct to unification and national spiritual wellbeing and an earlier Insular tradition of glossing texts (see fig. 49). This may subsequently have been reinforced by Aldred's own visit to southern England as a scribal notary in the train of his bishop in 970, during which time they may have obtained the *Durham Ritual*, made in southern England earlier in the century, for the community.[44] Indeed, the visit may have been partly motivated by diplomacy to ensure the stability of the north, Bishop Aelfsige and Aldred accompanying Kenneth, King of Alba, to Wessex, perhaps as diplomatic mediators and presumably with the intention of safeguarding the community of St Cuthbert's interests in negotiations concerning the English/Scottish frontier zone.[45]

Boyd deduced, from the areas of interest evinced in Aldred's explanatory glossing of certain passages, that he was particularly concerned with issues of celibacy and simony and interpreted these as indicating that he was joining the community with a reforming celibate monastic agenda in mind.[46] Like most English monasteries at the time, that at Chester-le-Street would have been largely secular (Boyd suggested that it may have contained as few as two or three monks, and pointed out that its abbots were not monks from the time following the flight from Holy Island until the early eleventh century).

Fig. 49. Cambridge, Corpus Christi College, Parker Library MS 183, f. iv, Bede's Lives of St Cuthbert, Wessex, *c.*934. King Athelstan presenting this copy of his 'Lives' to St Cuthbert at Chester-le-Street. The Master and Fellow of Corpus Christi College, Cambridge.

According to Boyd, Aldred's 'colophon group' and parts of his gloss indicate that he may have had to purchase his ordination into the community, paying eight ores of silver for his induction (and glossing Luke's Gospel for the community), while he is at pains to point out that his other qualifications – his reputable parentage, his humility, his priestly status, his scholarship and his dedication to *opus dei* in the labour of glossing the Gospels – are in accordance with the Church's teaching which demanded that the Bishop ordain, freely, the worthy candidate. The additional, voluntary payment of four ores of silver which he makes, accompanying the glossing of John for his own soul's sake, along with the labour, perhaps served to demonstrate that he was transcending the simonaical demands of the contemporary episcopacy.

This raises the question of Aldred's background. Where had he acquired such high monastic ideals and the learning to back them? His command of the Northumbrian dialect of Old English would tend to suggest a northern birthplace and Millar has pointed to mistakes and variants in the gloss which he takes as indicative of a 'seepage up' of 'originally low status usages' which he interprets as exhibiting a familiarity with more recent, local linguistic trends.[47] He goes on to say that 'Before the Norman Conquest, the position of late West Saxon as Schriftsprache led to the at least partial submersion of most other written dialects at the time, except, as with the glosses to the Lindisfarne and

99

Rushworth Gospels and the *Durham Ritual*, where the primary purpose of the written product appears either to be for personal use only, or at the very least for a limited group.' Brunner, however, in a discussion of the frequent occurrence of variant linguistic forms in the Lindisfarne gloss, outlined two explanatory views. The first, favoured by Bouterwek, Waring and Skeat, was that the gloss was by two or more scribes who spoke different dialects, a theory belied by the palaeography which indicates one hand only. The second view, favoured by the palaeographers (including Maunde Thompson, Warner, Ker and Brown), that it was written by one scribe who spoke 'a language admitting many variants in its morphology'.[48] This supports the possibility that, although Aldred's gloss is essentially his own composition, written directly into the Lindisfarne Gospels and based upon its text, he also consulted one or more pre-existing translations and preserved their linguistic and orthographic forms alongside those of his own sections. Aldred's approach to language and its variant forms was as fluid as his approach to script, his hand, as analysed by Ker, exhibiting an exceptionally wide range of letter-forms and styles, again perhaps reflecting in part the influence of his exemplars.

So it would appear that Aldred's gloss was the work of someone from Northumbria for local use, composed directly for the Lindisfarne Gospels and written in it by one hand (Aldred's) familiar with writing both Old English and Latin in both cursive minuscule and half-uncial,[49] but perhaps with reference to some previously translated matter. It represents a statement of local identity in the face of Scandinavian incursion against a backdrop of attempts to reassert an English identity throughout England. As Millar states, 'It is unfortunate that because of the unsettled environment of the North of England at this time, our first inklings that something "odd" was happening to the nature of English comes from texts, such as the gloss to the Lindisfarne Gospels, which originated in a part of the North which exhibits both then and now a lesser Scandinavian influence (to the extent of being readily classified as a Secondary Contact dialect), and which were written by older, probably conservative, men who had a considerable grounding in the South-Western Schriftsprache.'[50] Aldred thus emerges as a scholar who was familiar and in tune with the aims and linguistic background of the West Saxon educational and religious revival, and who was applying it to the needs and traditions of his native Northumbria. The community of St Cuthbert, with its key role in the ecclesiastical and political life of the area, was an obvious base from which to pursue such an agenda. Another indication of Aldred's background is gained, as Ross noted, from the disagreement of proper names in the original text of the Lindisfarne Gospels and its gloss, leading him to conclude that Aldred was consulting one or more other texts as well, these exhibiting affinities with forms in manuscripts of the 'Celtic' family.[51] Another possibility is that Aldred was consulting other pre-existing translations of the Gospels into the vernacular (such as that already mentioned, by Bede) which, like Owun and Farmon's gloss to the Macregol Gospels, had been based upon other Insular texts of the Latin Gospels. In any case, Ker

was of the opinion that Aldred's work in the Lindisfarne Gospels was essentially his own composition and that this was his first attempt to write it down as he went through the manuscript, as certain errors have occurred specifically because of the layout of the original Latin text in Lindisfarne.[52]

If standards at a house as important as Chester-le-Street may have been considered lax by the time that Aldred glossed the Lindisfarne Gospels as part of his reception into the community, where else might he have trained beforehand? At the period in question the most likely options are outside Northumbria and the Danelaw in southern or western England, or on the Continent. His hand occasionally admits features of caroline minuscule, such as the caroline 'a' in the 'allum' of the third line of the part of the colophon naming the manufacturing team and the previously unnoticed possible caroline question mark (*punctus interrogativus*) ending its tenth line, 'and (I) Aldred, unworthy and miserable priest?'. Such features are in accordance with the early influence of caroline on the hands of those working in 'reforming' circles in the mid-tenth century, prior to its fuller introduction as part of the Benedictine reforms of the 970s onwards.[53] Boyd saw Aldred as joining the community in the 960s, during the reign of the pro-monastic reform monarch, King Edgar (959–75) and this may have been the case. It may be that Aldred was 'planted' specifically in his native region as part of an attempt to address such issues of reform in one of the most powerful houses in the north, in which case he may even have been 'sponsored' by one of the great tenth-century reformers, such as Dunstan (who became Archbishop of Canterbury in 959), Aethelwold (who became Bishop of Winchester in 963) or Oswald (who became Bishop of Worcester in 961 and Archbishop of York in 971), or, as suggested above, encouraged by contact with one of the West Saxon royal visitations of the north from Athelstan's time onwards. Ker's palaeographical assessment of the development of Aldred's hand is a persuasive one, and his work on the Lindisfarne Gospels at the time of his entry into the community was certainly conducted some time before he became its provost, by 970. Even if he undertook his gloss during the 960s as opposed to the 950s he would still have been in the front ranks of the monastic reform movement and a valuable northern ally for the reforming Church and Monarchy.[54]

The importance of spoken language (the vernacular) is emphasised in the opening phrase of the colophon, where writing is acclaimed as the servant of speech and where Latin interacts with Old English, a reference to the oral/scribal processes of Gospel transmisson and also to Alfred's educational agenda and its emphasis upon the vernacular. Aldred's work on Lindisfarne has been conducted with tremendous care and is presented both stylistically, and in the colophon, as a formal contribution. His hand is an elegant, pointed Anglo-Saxon minuscule, occasionally exhibiting half-uncial features (especially when he adds words in Latin, as on the colophon page, where the 'Five Sentences' give the impression of having been copied from an Insular half-uncial model, and when he seems to be copying some of the original scribe's letters as a pen-trial on f. 121r). It exhibits little

sign of the influence of caroline minuscule and its confident cursive nature supports the conclusion that Aldred's is a hand that was probably used to penning documents and which was adapting itself for the purposes of glossing. The half-uncial elements may simply reflect the visual influence of the Lindisfarne Gospels themselves upon Aldred's hand during his glossing work, or may indicate that he was also used to writing a more formal 'old fashioned' book hand into which he nonetheless introduced 'modern' caroline features. The recording of the names of others associated with what must have been a greatly treasured and venerated relic in its own right would not have been undertaken lightly and is probably to be viewed in the nature of an official statement by the community of St Cuthbert on the presumed origins of the Lindisfarne Gospels.[55]

Transcription and translation of Aldred's 'colophon group'

The colophon and other inscriptions by Aldred on f. 259r (termed collectively 'the colophon group' by *Cod. Lind.*)[56] may be transcribed as follows:

> ðe ðrifalde 7 ðe anfalde god ðis godspell/ aer vorvlda gisette
> + Trinus et unus d(eu)s evangelium hoc ante / saecula con stituit
> ærist avrat of mvðe crist(es)
> + Matheus ex ore c(h)r(ist)i scripsit
> of mvðe petres avrat
> + Marcus ex ore Petri scrips(it)
> of mvðe paules avrat
> + Lvcas de ore Pauli ap' scrips(it)
> in deigilnisi l̄ i(n) f(ore)esaga siðða rocgetede l̄ gisprant
> + Ioh(annes) in prochemio deinde eructavit
> word mið gode gisalde 7 halges gastes 'l̄ mið godes geafa| 7 halges gastes
> verbum d(e)o donante et sp(irit)v s(an)c(t)o scrips(it) | mæht avrát ioh(annes)'

> + Eadfrið biscop/b lindisfearnensis æcclesiæ
> he ðis boc avrát æt frvma gode 7 s(an)c(t)e
> cvðberhte 7 allum ðæm halgvm. ða. ðe / 'gimænelice'
> in eolonde sint. 7 eðilvald lindisfearneolondinga 'bisc(op)'
> hit vta giðryde 7 gibelde sva he vel cuðe.
> 7 billfrið se oncrę he gismioðade ða
> gihríno ða ðe vtan ón sint 7 hit gi<->
> hrínade mið golde 7 mið gimmvm ęc
> mið svlfre' of(er)gylded faconleas feh:,
> 7 [-ic] Aldred p(re)'s'b(yte)r indignus 7 misserim(us)?[57]
> mið godes fvltv(m)mę 7 s(an)c(t)i cuðberhtes
> hit of(er)glóesade ón englisc. 7 hine gihamadi:.
> mið ðæm ðríim dælvm. Matheus dæl
> gode 7 s(an)c(t)e cuðberhti. Marc(us) dæl.
> Ðœm bisc(ope/um?). 7 lvcas dæl ðæm hiorode

7 æht 'v' ora s[eo\'v']lfres mið tó inláde.:-
7 sci ioh(annes) dæl f(erore) hine seolfne / 'i(d est) f(eror)e his savle' / 7 feover óra
s[eo]'v'lfres mið gode 7 s(an)c(t)i cvðberhti. þ(et)te he
hæbbe ondfong ðerh godes miltsæ on heofnv(m).
séel 7 sibb on eorðo forðgeong 7 giðyngo
visdóm 7 snyttro ðerh s(an)c(t)i cvðberhtes earnvnga:,

+ Eadfrið, Oeðilvald, Billfrið, Aldred – hoc evange(lium) Deo 7 Cuðberhto constrvxer(vn)t
(ve)l ornavervnt:,

The final element seems not to belong with the rest of the text, repeating the names of the 'makers' within a Latin infrastructure. If this was copied from an earlier source it would have been enough to have provided Aldred with the names to which he appended his own and to have formed the core of his text.

Aldred is obviously struggling to fit everything he wishes to include into the ruled area and has to add some components of his text, including that concerning his lineage, in the margins. Adjacent to the display capitals of the original text 'Explicit Liber Secundum Iohanen', in the outer margin and preceded by a cross, are written the following verses in Latin:

+ Lit(er)a me pandat
sermonis
ministra
Omnes alme
meos fratres
Voce salvta:

This may be translated as: 'May the letter, faithful servant of speech, reveal me; greet, O kindly [book], all my brothers with thy voice.'[58] The subject may be intended to be either the text of John's Gospel, Aldred's gloss, or both.

(Signs of the Cross marking the beginning of each clause followed, in Latin, by the text known as the 'Five Sentences', which is of uncertain origin but may derive in part from the Plures Fuisse prologue, included in the Lindisfarne Gospels, commencing at f. 5v. These may be translated as:)

God, three in one, these Gospels have since [the dawn of] the age consisted of:
Matthew, who wrote what he heard from Christ;
Mark who wrote what he heard from Peter;
Luke, who wrote what he heard from the Apostle Paul;
John who willingly thereupon proclaimed and wrote the Word given by God through the Holy Spirit.[59]

There then follows:
(Sign of the Cross, followed in Old English by:)

Eadfrith, Bishop of the Lindisfarne Church, originally wrote this book, for God and for St

Cuthbert and – jointly – for all the saints whose relics are in the island. And Ethiluald, Bishop of the Lindisfarne islanders, impressed it on the outside and covered it – as he well knew how to do.[60] And Billfrith, the anchorite, forged the ornaments which are on it on the outside and adorned it with gold and with gems and also with gilded-over silver – pure metal. And (I)[61] Aldred, unworthy and most miserable priest? [He] glossed it in English between the lines with the help of God and St Cuthbert. And, by means of the three sections, he made a home for himself – the section of Matthew was for God and St Cuthbert, the section of Mark for the bishop[/s], the section of Luke for the members of the community (in addition, eight ores of silver for his induction) and the section of St John was for himself (in addition, four ores of silver for God and St Cuthbert) so that, through the grace of God, he may gain acceptance into heaven; happiness and peace, and through the merits of St Cuthbert, advancement and honour, wisdom and sagacity on earth.

(Sign of the Cross, followed by names in Old English, the rest in Latin:)

Eadfrith, Oethiluald, Billfrith, Aldred made, or as the case may be adorned/embellished [added beneath the line], this Gospel-book for God and Cuthbert.

Against the mention of his name in the first line Aldred tells us something of his parentage, adding in the margin the rhythmic couplet:

Ælfredi natus aldredus vocor: bon' mulieris filius eximius loquor

which I would translate as:

Aldred, born of Alfred, is my name: a good woman's son, of distinguished fame.

He glosses the reference to his mother with the words 'id est tilw'', *til wif* meaning 'good woman'.[62]

On f. 89v he added the following prayer in Old English:

Thou Living God, remember Eadfrith and Oethiluald and Billfrith and Aldred, a sinner; these four, with God, were concerned with this book.[63]

Thus the four latter-day evangelists perpetuate the work of the Gospel writers in a line of transmission stemming from Christ, the Holy Spirit and the chief Apostles, Peter and Paul.

Tradition concerning the making of the Lindisfarne Gospels: who were Eadfrith, Aethilwald and Billfrith?

Aldred's colophon, as we have seen, attributes manufacture of the volume to three figures: the writing (and by implication the decoration) to Eadfrith, Bishop of Lindisfarne (698–721; the binding (sewing and covering) to Aethilwald, Bishop of Lindisfarne (721–40); the metalwork cover (a treasure binding or book-shrine) to Billfrith the Anchorite. We have seen that the colophon needs to be handled with caution, but it remains likely that he was drawing upon earlier material associating these names with the book, so it is relevant to

assess what we know of the lives of these figures who assumed such a prominent place in the tradition of the community of St Cuthbert.

Eadfrith seems to have succeeded to the see at the death of his predecessor, Bishop Eadbert, on 6 May 698, not long after the translation he had arranged on 20 March of the body of St Cuthbert to a wooden coffin placed above ground near the high altar at Lindisfarne. Eadbert's own body was placed beneath it in Cuthbert's former tomb, presumably at the behest of his successor, Eadfrith, who is likely to have been greatly involved in the translation ceremony and in the subsequent presentation and custodianship of the cult site (and the administration and distribution of associated relics).[64] Florence of Worcester says that Eadfrith succeeded in 698, to be followed on his death by Aethilwald, Abbot and priest of Melrose, in 721 and Symeon likewise ascribes to him a twenty-two-year episcopate.[65] During this time he restored the Inner Farne hermitage, asked an anonymous member of the community to write the first *Life* of St Cuthbert, around 705, and commissioned Bede to rewrite a second prose *Life* of St Cuthbert which was completed and dedicated to Eadfrith shortly before the latter's death in 721.[66] Eadfrith undertook to have Guthrith the sacrist enter Bede's name in the Lindisfarne register, or 'liber vitae', and in return Bede promised him a copy of his earlier verse *Life* of St Cuthbert.[67] During the reign of Osred (705–16), Eanmund consulted Eadfrith on the foundation of an unknown daughter monastery of Lindisfarne, celebrated in a ninth-century poem by Aethelwulf, *De abbatibus*, and home of the miracle-working Irish scribe it immortalised, Ultán.[68] Eadfrith sent a priest there to help set up and instruct the community.[69] It has also been suggested that Aldhelm was addressing Eadfrith ('Ehfrid') in one of his letters, but this was doubted by the editor of the correspondence.[70] If this were the case, however, it would provide valuable further evidence of Eadfrith of Lindisfarne's connections with pupils of the 'school' of Theodore and Hadrian, including Aldhelm and Bede.[71] Eadfrith's name is probably that recorded (as 'Eatfrith presbiter') on f. 18v of the mid-ninth-century Durham *Liber Vitae*, in a list of 'abbots of the grade of priest', and perhaps also on f. 20r where 'Eatfrith' appears in a list of abbots.

Florence of Worcester gives the dates of Aethilwald's episcopate as 721–39 and Symeon gives 724–40.[72] The Laud MS of the Anglo-Saxon Chronicle (MS E) places his death in 737. Bede says, in the summary at the end of the *Historia Ecclesiastica* (HE v.22), that Aethilwald was bishop in 731 and the continuation of this text gives his death in 740;[73] at HE v.12 he says that he had been Abbot of Melrose. At the time that the anonymous *Life of St Cuthbert* was written (c.699–705) he was prior of Melrose and is described as an eye-witness to miracles performed by St Cuthbert (HE iv.4) and by the time of Bede's prose *Life* (completed 721) he was abbot (prose *Life*, ch. 30).[74] In order to have been a priest, ordained at thirty at the earliest, by around 700 he would need to have been born by at least c.670, making him at least fifty when he became bishop. Previously it has been argued that Eadfrith and Aethilwald could not have worked on the Lindisfarne Gospels in their busy

mid-life, but only before they achieved major ecclesiastical positions at the end of the seventh century.[75] The present author, however, sees the special dignity of working on such an important project (in this particular context) as an honour which would have been bestowed at a more advanced stage in an ecclesiastical career. This, along with the slightly unfinished nature of the original act of making, and the following stylistic and textual reappraisal of its chronological relationship to the other books with which it was traditionally associated (and dated to c.698), supports a later, eighth-century date for its manufacture. In the latter scenario, work was left just unfinished at Eadfrith's death and the work of assembling the book and binding it was bequeathed to the successor to the episcopal dignity, Aethilwald.

If neither of the bishops undertook the work themselves but were nonetheless responsible for ordering it, then a broad dating of 698–740 is suggested. This would remain the case even if other 'senior' members of the community, other than the bishops themselves, were physically involved in production. If the reliability of the colophon as historical evidence is questioned, such a dating would still nonetheless accord with the historical and stylistic contexts for production. The stylistic affinity with the coffin of St Cuthbert, with a fixed manufacturing date of 698, would tend to suggest a date for the Lindisfarne Gospels earlier in this date range rather than later and, along with the name-stones marking burials on Lindisfarne and the pectoral cross of St Cuthbert, which seems to have been interred with him, serve to identify Lindisfarne as the site with the closest artefactual context for the manufacture of the Lindisfarne Gospels (see figs 9, 29a–c, 91).

Further references to Aethilwald may be preserved in connection with his making of a stone cross to his own memory.[76] This, along with the cross which was set up at Hexham by Bishop Acca and is still preserved there, gives the earliest recorded example of the raising of a stone high cross in Britain and Ireland (although there was an earlier Insular tradition of inscribing crosses upon pillars or slabs, and the profiles of the crosses are already liberating themselves from the stone of the seventh- or early eighth-century slabs at Fahan and Carndonagh in Co. Donegal, see fig. 14). Upon the death of Bishop Acca of Hexham, in 740, two stone crosses were likewise set up in his memory, one at the head of his grave and another at the foot, one of which may still be seen in Hexham. This practice may have been indebted to the influence of the stational liturgy of the cross, which as we have seen was known in Northumbria by the early eighth century, and may also have had a particular resonance for the region in recalling the wooden cross erected on the battle site at Heavenfield by King Oswald in 634 (Bede, *HE* III.2). This act, and the battle itself, was imbued (certainly in Bede's account) with the historical analogy with the victory of Constantine, the first Christian emperor, at the Milvian Bridge. Constantine, whose mother, Helena, was accredited with the discovery of the True Cross in the Holy Land, had himself a specific connection with the region, having been proclaimed emperor while at York in 306. All in all, the symbolism of the Cross was historically, as well as spiritually

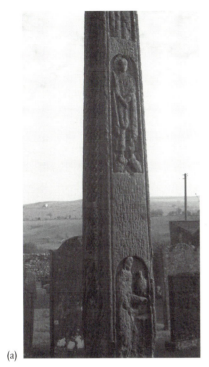 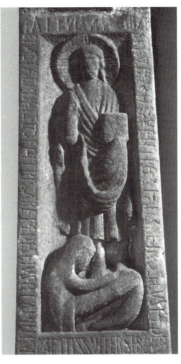

(a) (b)

Fig. 50. (a) The Bewcastle Cross, 8th century, with the figure of the patron at the foot, a worn
runic inscription, Christ between the beasts (and John the Baptist above); (b) detail of the
Ruthwell Cross, 8th century, depicting Christ and Mary Magdalene, drying his feet with her hair.
Both feature runic inscriptions, accompanied by Roman capitals in the case of Ruthwell which
also carries excerpts from the Old English poem 'The Dream of the Rood'. (Photos: the author)

and liturgically, particularly apt for a Northumbrian audience. Aethilwald's cross accom-
panied the community on its travels and was finally transported to Durham. It may be what
Leland saw in Durham Cathedral's churchyard in 1538 and described as: 'a crosse of 7 fote
longe, that hath had an inscription of diverse rowes yn it, but the scripture cannot be read.
Sum say that this crosse was brought out of the holy chirch yarde of Lindisfarn isle.'[77] This
sounds not unlike a shorter or damaged version of the Bewcastle or Ruthwell cross (see fig.
50a–b) with their runic inscriptions, and may be of relevance in a consideration of their
dating and cultural affiliations.

Aethilwald may also have been responsible for compiling an abbreviated version of the
Psalms, in Latin, referred to in a rubric accompanying a breviate psalter in the Book of
Cerne, a Mercian prayerbook of c.820–40. An acrostic poem in the same volume, mention-
ing an 'Aetheluald episcopus' has also been argued by some to have been composed about
Aethilwald of Lindisfarne,[78] although if that is so then the Mercian version is likely to have
been reworked, probably with reference to his namesake, Bishop Aethelwald of Lichfield

(818–30).[79] Aethilwald of Lindisfarne might also have been the owner or compiler of a hymnal, the 'Ymnarius Edilwaldi', a copy of which was in Fulda during the sixteenth century.[80] This may have been influenced by a hymnal which Bede says, in the list of his works which he appended to the *Historia Ecclesiastica*, that he had compiled. Aethilwald's name may also be recorded in the Durham *Liber Vitae* on f. 18r where an 'Oethiluald presbiter' (Cuthbert's successor on Farne?) heads a list of anchorites, a calling not unknown to the bishops of Lindisfarne, Eadberht, and Cuthbert himself, having espoused it.

Both Eadfrith and Aethilwald rapidly achieved saintly status within the community. Symeon tells us that their bones, along with Eadberht's, were taken with the community when they left Holy Island in 875.[81] They may, like Eadberht's, have even been deposited formerly in Cuthbert's tomb. They were certainly reported to have joined Cuthbert in his coffin by the time that it was opened in 1104.[82] A custodian of the shrine, Alfred Westou, who was active under Bishop Eadmund (1020–42) and into the time of Bishop Aethelwine (1056–71), acquired Billfrith's bones for Durham, along with those of Bede and Cuthbert's teacher, Boisil, as stated in a list of relics composed between 1104 and the mid-twelfth century.[83] An early twelfth-century Anglo-Saxon poem, *De situ et reliquiis* (also known as 'Durham'),[84] mentions all these important figures, but omits Billfrith. This might imply that his fame, ensured by Aldred's colophon, was unknown at that time, although Westou was sufficiently aware of his importance to have sought out his relics. The impression is that the community had preserved some recollection of his fame, presumably because of its tradition concerning his role in adorning the Lindisfarne Gospels. The possibility of the core of the colophon, naming the makers, having been derived from an inscription on a metalwork shrine is considered in the discussion of the binding in chapter four, below.[85]

As an anchorite, or hermit, Billfrith might be expected to have left little mark on the historical record, and this is indeed otherwise the case. His name occurs in a list of anchorites in the Durham *Liber Vitae* (f. 18r), made initially at Lindisfarne or Norham (or less probably Wearmouth/Jarrow, although it includes material relating to all of these communities) around 840, by which time Billfrith was evidently deceased. Aldred's colophon gives no indication of when Billfrith may have contributed his metalwork to the adornment of the Lindisfarne Gospels, but Symeon, quoting a source probably other than the colophon itself (perhaps the same source, such as a metalwork inscription or earlier written account of community history, that provided some of the core matter for Aldred's colophon), says that he was commissioned by Bishop Aethilwald to produce it.[86] This implies that they were contemporaries, intent upon further honouring and embellishing a Book of St Cuthbert (presumably the Lindisfarne Gospels) after its production. In order to get round the chronological disjuncture presented by their adherence to a dating of *c.*698 for Eadfrith's and Aethilwald's work (relying on Aldred and disregarding Symeon), the contributors to *Cod. Lind.* suggested that 'Billfrith's metalwork was an afterthought, carried out a generation or so after the book was originally bound in leather'.

I favour the view that, if these figures were in fact associated with the making of the Lindisfarne Gospels, Eadfrith either commissioned another 'senior' member of the community to undertake the work or, equally plausibly, that he wrote and illuminated it himself around 710–20 as his own form of eremitic retreat (resembling the anchoritic retreats of St Cuthbert and Bishop Eadbert). The artist-scribe's death (in 721 if he was in fact Eadfrith) would have meant that some minor work was left unfinished as it was viewed as his particular *opus dei*, contributing to his own acclaim as a saint, and it was therefore deemed inappropriate that others should work on it, apart from the rubricator who had to add what was necessary in order to make its text usable. Under such circumstances it would have been appropriate that Aethilwald, Eadfrith's successor as bishop and a book-producer in his own right, should have been entrusted with the task of binding the book. Billfrith might then, or subsequently, have been instructed to adorn it with metalwork covers or plaques or to enshrine it in a *cumdach* (book shrine). The metalwork context extends from the 670s, when Wilfrid's book in its jewelled shrine was presented to Ripon, until the late Middle Ages. As we shall see, Irish cumdachs of the late eighth-century onwards provide a particularly good context and many of them carry inscriptions naming those responsible for making, commissioning and enshrining the books that they contained. If Billfrith did indeed supply metalwork embellishment it may have carried a litany of names, including his own, to which Aldred added himself.

It remains the case that the names cited by Aldred in his colophon correspond in terms of their floruits to the stylistic and historical context which I propose for the origins of the Lindisfarne Gospels. Rather than being constrained by the dates suggested by the colophon, an independent assessment of the evidence can be found to concur with it: 721 need not be a hard and fast end-date for the work. The rubrication and correction of the volume postdated the disappearance of the artist-scribe in the final stages of illumination and so would the act of binding and any metalwork adornment. The close stylistic relationship with the one dated artefact of the period, the coffin of St Cuthbert, made at Lindisfarne for the translation of 698, would tend to pull the dating of the manuscript back towards 700 rather than propelling it further towards 750, as some scholars might wish. The dating of around 710–25, proposed here, is tenable and the names cited in the colophon correspond chronologically to such a dating. If Aldred did concoct them he must have been either a good historian or a remarkably 'good guesser' to have hit upon names which mesh in their historical inter-relationships and which concur with the stylistic and historical contexts.

The brethren of Lindisfarne do not seem to have been easily deterred in their subsequent attempts to preserve the early history of their foundation. Eadberht virtually enshrined the wooden church in sheets of lead, and the original wooden church of Aidan, which may even have been itself enshrined within this larger church (like the Holy Sepulchre), was physically moved to Norham in the ninth century.[87] The sculpted cross

erected by Bishop Aethilwald around 740 was also taken with the community, along with Cuthbert's coffin and associated relics, when it was displaced by Viking attacks later in the ninth century.[88] Preserving the recollection of association with important figures within the history of such cult-orientated communities seems to have been an important feature and may have some bearing upon the ascription preserved in the colophon. Such relics and, as Rosemary Cramp has suggested, the distinctive nature of their Insular ornament, continued to serve as a rallying point for identity in the north-east into the twelfth century.[89] Indeed, they continue to do so today.

Symeon of Durham and the Lindisfarne Gospels

In his *Historia Dunelmensis Ecclesiae,* composed c.1104–9, the Durham monk and historian, Symeon, shows that he may have been familiar with the Lindisfarne Gospels and Aldred's colophon when he wrote:

> … Eadfridi videlicet venerandae memoriae episcopi, qui hunc in honorem beati Cuthberti manu propria scripserat, successoris quoque ejusdem venerabilis Ethelwoldi, qui auro gemmisque perornari jusserat, sancti etiam Bilfridi anachoritae, qui vota jubentis manu artifici prosecutus, egregium opus composuerat. Erat enim aurificii arte praecipuus.[90]

This may be translated as:

> … Bishop Eadfrith, of holy memory, who had written it with his own hand in honour of the blessed Cuthbert; and the venerable Æthelwald his successor, who ordered it to be adorned with gold and precious stones; and St Billfrith the anchorite, who, obeying with skilled hands the wishes of his superior, achieved an excellent work: for he excelled at the goldsmith's art.[91]

It is interesting that Symeon adds to the knowledge imparted by Aldred's colophon the details that Eadfrith had written the volume with his own hand ('manu propria scripserat'), rather than commissioning it, and that Aethilwald, on the contrary, ordered Billfrith to produce metalwork for the binding or book-shrine rather than personally engaging with work on the book. The latter detail runs counter to the specific statement by Aldred that Aethilwald bound the volume himself and that Billfrith adorned either this, or a relic box, with metalwork and jewels. Nor does Symeon refer to Aldred or his gloss. Symeon is also the only source indicating that Billfrith's metalwork was added early on, rather than merely at any time before Aldred's gloss. The impression is that Symeon was also familiar with the tradition surrounding how a book associated with St Cuthbert's cult was originally made, also preserved in Aldred's colophon added to the Lindisfarne Gospels. However, he had either merely absorbed and slightly garbled the outline of the colophon's statement, rather than the detail, or he had recourse to a piece of information, written or oral, within the community other than the Lindisfarne Gospels themselves. If such a tradition was in circulation and picked up on by Symeon, it could of course have existed

prior to Aldred's time and simply have been ascribed by him to what was then viewed as the best candidate for manufacture by the venerable named team, or have been specifically associated with the book itself by an inscription on extraneous leaves, now lost, or an inscription on a metalwork shrine. The colophon alone is not proof of the original circumstances of manufacture, but may be treated as corroborative, if not conclusive, evidence.

Symeon was also responsible, in the same work, for linking the tradition of a book made by Eadfrith, Aethilwald and Billfrith with that of a book associated with Cuthbert's cult, which had survived trial by water. He recounts the community's period of wandering (II.11) which is taken verbatim from the 'Anonymous Miracles and Translations', a text written in a volume known as the 'Liber Magni Altaris' kept chained to the high altar at Durham (perhaps also to be associated with a Gospelbook, the 'liber de reliquiis', and perhaps even identifiable as the Lindisfarne Gospels). In II.12–13, however, he relies upon an unknown source (perhaps more material bound into the 'Liber Magni Altaris'/'liber de reliquiis'?) and it is here that the passage concerning the Lindisfarne Gospels occurs, the statement concerning the making of the volume being preceded by a tale demonstrating its miraculous nature. The passage tells of the attempted flight to Ireland, during which a storm arose, with waves of blood-red which washed the saint's Gospels overboard. The band of refugees returned to shore and the whereabouts of the volume was revealed in a vision to one of their number, Hunred. The passage goes on:

> Itaque pergentes ad mare, multo quam consueverat longius recessisse conspiciunt, et tribus vel eo amplius milliariis gradientes, ipsum sanctum Evangeliorum codicem reperiunt, qui ita forinsecus gemmis et auro sui decorem, ita intrinsecus literis et foliis priorem praeferebet pulchritudinem, ac si ab aqua minime tactus fuissett ... Porro liber memoratus in hac ecclesia quae corpus ipsius sancti patris habere meruit, usque hodie servatur, in quo nullum omnino, ut diximus, per aquam laesionis signum monstratur. Quod plane et ipsius sancti Cuthberti, et ipsorum quoque meritis qui ipsius libri auctores extiterant, gestum creditur, Eadfridi videlicet venerandae memoriae episcopi ...[92]

This may be translated, as in *Cod. Lind.*, as:

> Accordingly they go to the sea and find that it had retired much further than it was accustomed. And after walking three miles or more [towards the sea] they find the sacred manuscript of the Gospels itself, exhibiting all its outward splendour of jewels and gold and all the beauty of its pages and writing within, as though it had never been touched by water ... Further, the above-mentioned book is preserved to this day in this church which is honoured by the possession of the holy father's body and, as we have said before, no sign of damage by water is visible in it. And this is believed to be due to the merits of St Cuthbert himself and of those who made the book, namely, Bishop Eadfrith of holy memory ...

It has been assumed that his citation of the Lindisfarne Gospels' colophon indicates that this is the book to which Symeon refers. Trial by water is a hagiographical device also

encountered in material relating to St Columba and to St Margaret of Scotland whose sanctity similarly embraces their books and preserves them from damage when submerged in water.[93] It is common in the cults of Insular saints for their possessions to take on their miracle-working attributes (such as St Cuthbert's belt which, we are told in his *Life*, cured Abbess Aelflaed).

So, Symeon's account tells us that a book associated with the same manufacturing team as that outlined in Aldred's colophon (minus Aldred and with some variation of detail), and therefore presumed to be the Lindisfarne Gospels, was kept in the same church as St Cuthbert's body, i.e. Durham Cathedral, when Symeon was writing his history in the opening years of the twelfth century. His emphasis upon it being in *the* church where Cuthbert's *body* was kept might indicate, in view of subsequent references which cast confusion on the identity of the book and whether it was kept at Durham or Lindisfarne, site of the miracle-working tomb, that there was already something in the way of a rival claim to possession of a book renowned by tradition, as early as the beginning of the twelfth century. It is interesting that Symeon disregards Aldred's contribution, which might imply that he was not quoting directly from the colophon, that the sanctity accorded to St Cuthbert and to those who originally made the book in his honour was not deemed to extend to subsequent figures, or simply that he was irrelevant as his work on the Gospels was added subsequently to the events of the tale. The language Symeon uses to describe the volume – both its bejewelled exterior and beautifully executed pages and writing within – tends to suggest that he had seen the volume himself, as does his assertion that it could still be seen to have been undamaged by water. But was the volume at Durham necessarily the one that was the subject of the 'trial by water' tale or just one that the community had later identified as that famous relic? Also, was the 'book overboard' necessarily the one traditionally ascribed to Eadfrith, Aethilwald and Billfrith, or could Symeon, the only source for the conflation, have merged two pieces of community folk-lore, and alighted, at the time of the revival of the shrine in the new cathedral at Durham, on one of the books it possessed as an appropriate vehicle for such corroborations of sanctity? We cannot be sure that this volume was the Lindisfarne Gospels.

As will be seen below, the shrine of St Cuthbert at Durham possessed a number of Gospelbooks in the later Middle Ages, several with metalwork adornments, and at least one book associated with the Cuthbertine cult was at Lindisfarne itself. In answer to the cry that there could be only one such cult book, it should be remembered that Durham Cathedral Library still contains three major Insular Gospelbooks (MSS A.II.10, A.II.16 and A.II.17, see pls 26–27 and figs 65, 71, 96, 107), that the cult of St Columba included many manuscripts, including the Cathach of Columcille (Royal Irish Academy, s.n., see fig. 37), the Book of Durrow (TCD, MS 57, see pl. 31 and fig. 23) and the Book of Kells (TCD, MS 58, see pl. 32) and that later hagiography ascribed three hundred water-resistant books to the hand of Columba.[95] Let us avoid treading the same path as recent attempts to ascribe

the Book of Kells to the rival cult of Brigid at Kildare, without any corroborative evidence, simply because Giraldus Cambrensis saw a book there in the late twelfth century which was so intricate in its workmanship that it appeared to be the 'work of angels' and there could be only one such book![96]

Symeon was writing with the community's current agenda in mind. The passage relating to the book of St Cuthbert which he inserts into his narrative, from whatever source(s), was probably designed less to record 'known' fact than to convey several salient points relating to the community's history which had led them to the greatness of Durham. As we have seen, the displacement of the community and the patterns of its 'wanderings' have been presented as a result of attack and insecurity causing them to flee from their island base in the far north-east of England. However, a more subtle interpretation can be placed upon Symeon's account, in which the migration of the community can be seen as an attempt to move away from a venerable, but by now remote, focus (Holy Island) to somewhere more in the political/economic/cultural mainstream. The episode recounting the loss of a prized relic/book may be intended to show that, although the ultimate foundation focus of the community had been Columban Ireland and Scotland, the decision was taken in the mid-ninth century (with divine prompting) to shift the focus from Columba, and from Ninian's British/Scottish mission,[97] and turn towards the south, at the same time reaffirming the community's ancient affiliations and primacy throughout the north. There is some evidence to suggest that Crayke had been a traditional ecclesiastical staging post, or *mansio*, en route from York to Lindisfarne. Chester-le-Street, likewise, may have had some earlier connection with the community.

By moving southwards to these centres, the community was not in fact primarily fleeing from the Viking threat, but rushing to embrace its challenges. The reference to Cuthbert appearing in a vision to the West Saxon King Alfred when the English resistance movement was at its lowest ebb, hiding out in the Athelney marshes, and conferring legitimacy upon a new more acceptable, Viking leader, Guthred,[98] may signal the community's decision to engage with their new political overlords (both Viking and West Saxon). This would have enabled them to play an important role in the conversion of the new pagan settlers and to ensure that Cuthbert's patrimony was not only retained but extended and enriched in the 'new age'. Having settled at Chester-le-Street, with Guthred's blessing and the subsequent favour of the West Saxon monarchy (the shrine being visited, honoured and enriched by King Athelstan, for example, in 934 (see fig. 49); King Edmund also visited the shrine in 945), the community were given the properties lying between the rivers Tyne and Wear that had formerly belonged to Wearmouth/Jarrow.[99] The See of Lindisfarne was also retained, being extended at the same period by merging with that of St Wilfrid's important centre, Hexham. Our monastic refugees actually made an astute series of moves, as Symeon may be at pains to point out by his careful manipulation of material in his account. In view of such a possible authorial agenda it behoves us to treat

the details it contains with great care and to beware of taking them at face value as simply as detailed an account as he could muster – *caveat lector* ('reader beware')!

A book thus becomes the symbol of this significant set of decisions, which Symeon is obliquely ascribing to his predecessors in the community and by means of which they were to come at last to Durham. Its cathedral was entering a new golden age at the time when Symeon was writing and he perceived that it was in the community's interests to emphasise legitimacy and links with a former golden age – one during which St Cuthbert's cult was established and celebrated by the manufacture of a great cult book the making of which was attributed to some important figures in the early history of the community, Eadfrith, Aethilwald and Billfrith, whose relics had followed Cuthbert's to Durham and were there celebrated for their sanctity. Symeon and his brethren had evidently rescued and re-interpreted what they could by way of community tradition relating to such a book and had identified it with one that was available in Durham during the early twelfth century. This may have been the Lindisfarne Gospels or, given the inconsistencies of detail between its colophon and Symeon's reporting of the tradition, another of the many great books known to have been associated with Cuthbert, such as the Durham Gospels. There were certainly other Gospelbooks with jewelled covers attached to the shrine from earlier dates, such as British Library, Cotton MS Otho B.ix (a Carolingian Gospelbook sadly damaged in the Ashburnham House fire in 1731) which was one of two Gospelbooks with treasure bindings presented by King Athelstan in the 930s.[100]

If we need to exert such caution in interpreting Symeon's account, we need be similarly circumspect in our acceptance of the veracity of Aldred's colophon and its ascription of origins. Such evidence cannot be taken at face value, but it is an important part of the provenance history of the manuscript and needs to be addressed in the light of other evidence concerning origin, namely a discussion of the historical context for production and an appraisal of the book's relationship to other surviving remains of the period. The discussion of such evidence in the present volume tends to suggest that the details contained within the colophon could be correct.

Back to Lindisfarne?

The medieval library catalogues of Durham that have survived contain no specific mention of the Lindisfarne Gospels.[101] This is not unusual, for certain liturgical books would be kept not in the library, but in the sacristy or the treasury, for use in services and/or as relics or cult items in their own right. However, it is not immediately apparent in the early twelfth- and early fourteenth-century relic lists either. Around two thirds of the surviving library books which can be shown to have been owned by Durham are also not listed in the catalogues, which were never meant in any case to be comprehensive. A perusal of Watson's *Supplement* to Ker's *Medieval Libraries of Great Britain* will show that ten pages of

Fig. 51. The Tiberius Bede (BL, Cotton MS Tiberius C.ii), f. 5v, Southumbria (Canterbury?), *c*.825. The opening of Book I of Bede's *Ecclesiastical History of the English People*.

entries represent extant manuscripts still owned by Durham Cathedral Library, and eight pages those which were at Durham during the Middle Ages but are now elsewhere.[102] If, as seems most likely, the Lindisfarne Gospels did remain at Durham it was either so important that it was not worth mentioning, or the references are too curt to permit a specific identification. Alternatively, the contents of the Lindisfarne Gospels as they appear today may once have been supplemented by other matter which would correspond to one of the documentary references. This possibility will be explored further in chapter four, below.

However, as already noted, one of a series of booklists in medieval inventories of Lindisfarne Priory, dating to 1367, refers in a list of books 'in the Abbey' to 'the book of St. Cuthbert which fell into the sea ('qui demersus erat in mare'). The Durham historian Raine went on to suggest that this book was also that referred to as 'one book of the evangelists', kept in the church, in a Lindisfarne inventory of 1348; as 'one book of the gospels', kept in the church, in the 1416 inventory; and as one of '2 copies of the Gospels, with gilt backs (*tabul*)', kept in the church, in the 1533 inventory.[103] Ker accepted the Lindisfarne Gospels as being at Lindisfarne in 1367, although he also lists them under Durham.[104] In A. G. Watson's *Supplement* to Ker, Lindisfarne's ownership is rejected in favour of Durham, and the only book ascribed to Lindisfarne, erroneously, is a copy of Bede's *Historia Ecclesiastica*, British Library, Cotton MS Tiberius C.ii (see fig. 51), which

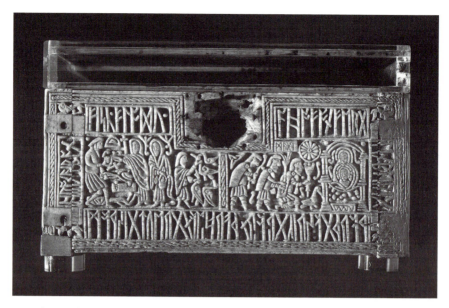

Fig. 52. The Franks Casket (BM, MME 1867, 1-20, 1), whalebone casket, perhaps a reliquary, front panel showing Weyland the Smith (left) and the Adoration of the Magi (right), Northumbrian, 8th century. The scenes are drawn from world history and mythology and are identified by inscriptions in Roman capitals and runes. Like Bede's *History* and the Lindisfarne Gospels, it celebrates earlier cultures and assimilates them into a Christian present. (Photo: courtesy of the Trustees of the British Museum)

was made at Canterbury in the early ninth century and includes a correction probably copied from an exemplar which has led to the Lindisfarne mis-attribution.[105] It cannot be proved that all or any of these inventories necessarily refer to the Lindisfarne Gospels, but that of 1367 would appear to relate to the volume that Symeon described which in turn related to Aldred's colophon. We have otherwise to consider that more than one volume was thought by the community of St Cuthbert to have been made by Eadfrith, Aethilwald and Billfrith or, as seems likely, that more than one volume associated with St Cuthbert was thought to have survived submersion in the sea. It is also possible, as we have seen, that Symeon has conflated two separate pieces of community history and assigned them to one book. If both references are to the same book, however, and if that book was indeed the Lindisfarne Gospels, it was evidently in Durham during the early twelfth century and at Lindisfarne by 1367. This may seem surprising: Holy Island is in an exposed location, as the Viking raids had demonstrated all too well, and political instability during the fourteenth century, with conflicts and raids between the Scots and English, would have ensured that it remained vulnerable. Lindisfarne Priory was refounded in *c*.1082, on the site of the original monastery, and later became a cell of Durham.[106] Attempts were made to

re-establish the tomb of St Cuthbert on Holy Island as a 'tourist attraction' for pilgrimage and offerings. Nonetheless, Durham was the prime focus of the cult of St Cuthbert and it is difficult to imagine its powerful prince-bishops and other prelates agreeing to send one of the most valuable and prized cult items elsewhere, and especially to such a vulnerable location, even if the priory's fortifications were being reinforced and its guest quarters enlarged during the fourteenth century.[107]

It is salutary, however, to note that, until Durham felt the need to reshape the Cuthbertine cult in order to compete with those of Thomas Becket and Godric of Finchale from the 1170s onwards, miracles of healing ascribed to Cuthbert took place not at Durham but at the site of his tomb on Holy Island or of his death at the Inner Farne hermitage. Although leading ecclesiastics would visit Cuthbert at Durham, the populace at large was not welcomed there before the late twelfth century. This was especially true of women, a major pilgrimage constituency, who were denied access to the cathedral precinct at Durham and, even after the Galilee Chapel was built to accomodate them as part of the cult's reform, could not even glimpse the site of the shrine at the east end from afar.[108] It was therefore in Durham's interest to retain a cult interest in Lindisfarne itself.

That manuscripts prized by Durham could stray is, however, amply demonstrated by the eight pages of Durham manuscripts now owned by other repositories,[109] which include the *Liber Vitae* once kept on Durham's high altar,[110] and the Gospelbook donated by King Athelstan (British Library, Cotton MS Otho B.ix) which was attached to the shrine, both of which had been acquired by Sir Robert Cotton by 1621, from unspecified sources.[111] These need not, however, have strayed at the time of the Dissolution. The author of the *Rites of Durham,* writing at the end of the sixteenth century (1593), recalled the *Liber Vitae* being kept on the high altar, for use in daily commemoration of benefactors.[112] He likewise refers to 'a marvelous faire booke which had the Epistles and Gospells in it' which was carried in procession for use in the High Mass. This cannot be the Lindisfarne Gospels unless the Epistles were at one time added to it, and it is unlikely that a book of such antiquity would be readily understandable for use in services; the *Liber Vitae*'s contents could be symbolically included by its very presence, without the names having to be read out from its antiquated scripts. He also refers to 'the booke of the 4 Evangelists which fell into the sea'. This may indicate that the volume inventoried at Lindisfarne in 1367 had returned or, more likely, corroborates the theory that more than one book was connected with this legend at different times, for the *Rites of Durham* goes on to indicate that it contained 'the reliques jewels ornaments and vestments that were given to the church by all those founders'. This is therefore probably the 'Liber Magni Altaris', the locked book kept chained to the high altar, or the 'liber de reliquiis' (unless they are one and the same) which may be the volume that appears in the inventory of the shrine of St Cuthbert at Durham in 1383 as 'item iv'.

In 1383 Richard de Segbruck, the keeper (*feretrarius*) of St Cuthbert's shrine at Durham listed books associated with the shrine, eight of which contain Gospel texts. This list

occurs in Durham, Cathedral Library, MS B.II.35 and includes the following entries which might be applicable to the Lindisfarne Gospels and which may be translated as:[113]

 i) Item … a Gospelbook adorned with silver and gold, with an image of the Trinity on one side/cover.

 iii) Item a book of St Cuthbert. I. With the texts of the Gospels.

 iv) Item a Gospelbook adorned with gold with a gilded crucifixion, with many evidences and monuments.[114]

Several of these had metalwork embellishments. Numbers i, iii and iv in the list might conceivably refer to the Lindisfarne Gospels. We do not know that Billfrith's metalwork included a depiction of the Trinity, as described in the first item, indeed such an iconography is only likely, by analogy, to have been produced in northern Europe after c.800, so this is possibly one of the Gospels with treasure binding known to have been presented by King Athelstan. The description of item iii is minimal, but it is not unknown for a work to be so well known that it is given only a brief identification, in this case a 'Book of St Cuthbert'. It is noteworthy that this item is not distinguished by a treasure binding, let alone one associated in community tradition with the work of Billfrith. We cannot know if the Lindisfarne Gospels was this book, or whether it was definitely at Lindisfarne or Durham during the Middle Ages. It is worth noting, however, that the entries which might conceivably refer to the Lindisfarne Gospels in Segbruck's list might equally apply to any of the other three great Insular Gospelbooks which are still in Durham's possession. These include the Durham Gospels (DCL, MS A.II.17), referred to in an inscription of c.1500 as 'de le splendement', i.e. located in the cathedral's library 'strongroom', the Spendement, although Alan Piper implies that it may earlier have been one of the books of the shrine.[115] Others are MS A.II.10 and MS A.II.16 (thought to have come from Wearmouth/Jarrow and possibly to be the Gospelbook referred to in the 1392 Spendement inventory as 'de manu Bede', which Piper suggests may have been removed from the shrine after Bede's relics were translated thence to the Galilee Chapel in 1370).[116]

Item iv has not been identified as the Lindisfarne Gospels as they contain no trace of such ancillary material or use. This reference may be worthy of reappraisal, however. There are a number of discreet pieces of codicological evidence in the Lindisfarne Gospels which would tend to indicate that this immaculate seeming volume once contained numerous insertions or inter-leavings. Concealed within the gutter of the volume are several areas of discoloration (see for example ff. 257–8). These may assume the form of narrow vertical bands of brown staining. The sharp edges of these stains suggest the presence of vellum guard-strips. They do not correspond with the volume's quiring and are more likely to have protected the backs of tipped-in items. In one area (the gutter of f. 152) offsets of script and of green pigment would imply that text ornamented with green initials and titles was for some time adjacent to the Lindisfarne Gospels' pages. Other ink offsets can be found in the gutter of ff. 257–8 and there are traces of a hole with ferrous surround at the

Fig. 53. Lindisfarne Gospels (BL, Cotton MS Nero D.iv), f. 199r, traces in the gutter of offsets from other manuscript materials bound into the book at some point, along with ferous stains (left head and margin) from a metalwork object kept within it.
(Detail also shown in colour, see fig. 86a)

119

head of the gutter of ff. 254–6 which may indicate an iron clip or tack of some sort attaching whatever left the ink offset on the succeeding folios. One particularly curious offset gives the distinctive appearance of brown ferrous corrosion (in the gutter of ff. 198v–199r, see figs 53, 86a). Its profile is long and angular, with a ring-shaped head. The effect is one of a pointed metal implement, perhaps a book-marker (an 'aestel' such as that mentioned in King Alfred's Preface to his translation of the *Cura pastoralis*?), or a knife or some such symbolic item of the sort sometimes attached to authenticate and solemnise medieval documents.[117] Its placing in the volume may be significant as it marks the Crucifixion narrative in St Luke's Gospel. Might it even have been associated with a relic of the Crucifixion, perhaps even of the Cross itself, enshrined in metalwork? Many such relics must have been lost and Bede preserves a reference to one such in his quotation of a letter from Pope Vitalian to King Oswy of Northumbria with which were sent gifts, including, for Oswy's queen, 'a cross made from the [iron?] fetters of the blessed Apostles Peter and Paul with a golden key' (Bede, *HE* III.29).

Incredible as it may seem, the pristine appearance of the Lindisfarne Gospels may once have been marred or, in the eyes of its medieval owners, enhanced by the insertion of extraneous items: the monuments and evidences representing the key benefactions to the Community of St Cuthbert. A later owner, perhaps Sir Robert Cotton, may have seen fit to tidy the volume up by removing any such insertions. The Lindisfarne Gospels may indeed have been the 'liber de reliquiis' of Segbruck's list and of the Account Rolls, which is thought by some scholars to have been the 'Gospels which fell into the sea' which until the late sixteenth century (according to the author of the *Rites of Durham*) was still at Durham and which may also be synonymous with the 'Liber Magni Altaris' which he says was chained to its high altar. If so, it would at one time also have contained an anonymous account of the miracles and wanderings of the community of St Cuthbert, records of grants and other benefactions to the community, and perhaps even some of the bestowed objects themselves, along with other material relating to the early history of the community which may have been used by Aldred and Symeon.[118]

Several of the early manuscripts at Durham are known to have contained records relating to the properties and history of the community of St Cuthbert which seems to have preferred to enter documents into blank spaces in its most prized books rather than retaining them as charters. [119] Three such books have survived: British Library, Cotton MS Otho B.ix, the Gospelbook presented to the community by King Athelstan; British Library, Cotton MS Domitian A.vii, the Durham *Liber Vitae*, probably made by the community around 840 (see fig. 49); and Cambridge, Corpus Christi College, MS 183, an early tenth-century southern English copy of Bede's *Lives* of St Cuthbert, thought to have been presented to the community by Athelstan in the mid-930s (see fig. 47).[120] The endowments entered within them indicate what sort of records may have been added to a fourth volume, the 'liber de reliquiis', mentioned by Segbruck and the Account Rolls as a decorated

Gospelbook with a gilded crucifix set on the outer binding, which had been used (especially during the tenth and eleventh centuries) for the extensive recording of property transactions, benefactions and relics bestowed upon the community since its foundation. The codicological 'archaeology' of the Lindisfarne Gospels indicates that it may have been this book. It might, therefore, be expected to have included a reference to itself and to any treasure binding/shrine. Such earlier sources, including a tradition concerning the original circumstances of manufacture of the Lindisfarne Gospels and the names of its makers/commissioners, may have been consulted by Aldred when composing his colophon and have been embedded therein. Alternatively, Aldred's colophon might be seen in the context of this drive to add records based on earlier community lore to the pages of their most cherished books, which may have played a role in the solemnisation of any such transactions (for example, by an agreement at the altar involving swearing or attestation upon books or other relics). In either case it remains likely that Aldred's new composition contained an earlier core deemed to have been legitimised by tradition.

Together these books would have provided a source of information when the community felt the need to express its traditions as written history during the tenth and eleventh centuries, an impetus partly propelled by their lack of formal documentary records in the face of a legal system which relied increasingly upon the value of written evidence at law. A similar fate may have befallen one of the great Ceolfrith Bibles. Fragments of one of the two pandects given by Abbot Ceolfrith to St Peter's, Monkwearmouth, and St Paul's, Jarrow, were discovered in the same context (of reuse as estate documents connected to Wollaton Hall, Nottinghamshire) as some charters recording grants to Worcester Cathedral. These later instruments were laid out in a large, bi-columnar format corresponding to the distinctive *mise-en-page* of the Ceolfrith Bibles. Medieval sources tell us that a great Bible, thought to have been made in Rome (bearing in mind that the Codex Amiatinus, Ceolfrith's complete surviving Bible, was also considered an Italian work until the late nineteenth/early twentieth centuries), was presented by King Offa to Worcester in the late eighth century and that during the Middle Ages it was enshrined upon the high altar and used to contain key records of the community's properties and rights.[121] The Lindisfarne Gospels may have done the same for the community of St Cuthbert.[122]

The dissolution of the monasteries

Lindisfarne Priory was dissolved in 1537 and no account of the procedure survives, in contrast to Durham Cathedral Priory, which was dissolved in 1539 but continued to serve as the Anglican cathedral, with more of its library and treasures intact than most English monasteries. The *Rites of Durham* relates the visitation by the King's commissioners, Leigh, Henley and Blythman, but makes no reference to books.[123] It has been assumed that the 'skilfull lapidaries' accompanying them would have dismantled the Lindisfarne Gospels'

metalwork if it was in Durham, or sent the whole volume to London. There are, however, no firm indications that the volume or its metalwork went to either the Jewel Tower or the Royal Collection, as booty or book. John Leland visited Durham at the time of the Dissolution and mentions books seen by him there, but nothing corresponding to the Lindisfarne Gospels.[124] There certainly seem to have been some attempts on the part of the community to preserve some of their treasures, notably Cuthbert's relics, also sometimes referred to as 'St Cuthbert's treasure', and there is a legend which relates that between 1537 and 1542 these were reburied somewhere near the west end of the cathedral and the secret of their whereabouts entrusted to three Benedictine monks, each successive generation.[125] Sir Walter Scott makes reference to this tradition in *Marmion* (ii.14):

> He chose his lordly seat at last
> Where his Cathedral huge and vast
> Looks down upon the Wear.
> There deep in Durham's Gothic shade
> His relics are in secret laid,
> But none may know the place,
> Save of his holiest servants three,
> Deep sworn to solemn secrecy,
> Who share that wondrous grace.

Similar attempts to safeguard a treasure such as the Lindisfarne Gospels, wherever it was at the time of the Dissolution, or during previous times of danger, could just as well have led to its alienation and journey to the south. Likewise, there are records of Durham books being removed by various members of its personnel at different points in its history, including 'J. Kempe episcopo london' (1421–5). A specific link, not only to London but to the Tower of London itself, where the Lindisfarne Gospels are known to have been by 1605, is provided by one of the most eminent of the prince-bishops of the Palatinate of Durham, Anthony Bek, a wealthy and flamboyant cleric who was at one time both Archdeacon of Durham and Constable of the Tower of London and whose immense personal treasure at the time of his death, in 1311, included items culled from the Palatinate. Bek's 'goods, chattels, treasure, gold and silver, jewels and precious stones' were thereupon seized by the king. If any of Bek's possessions were kept at the Tower they may have remained there.

Many of Durham's books remained within what became at the Reformation the Anglican Cathedral. The author of the *Rites of Durham*, writing at the end of the sixteenth century, refers to many of its most important books as if they were still there, notably the *Liber Vitae* and the 'Liber Magni Altaris', although he may be reminiscing. The remainder of the century witnessed many upheavals, including the Northern Rebellion, during which such important volumes may have been removed to safety. We know that the former was then somehow alienated and travelled south, becoming Cotton MS Domitian A.vii. If, as

the codicological evidence suggests, the volume known as the Lindisfarne Gospels was in fact that referred to as the 'Liber Magni Altaris' and/or the 'liber de reliquiis', it too may have come south only shortly before it was first recorded in 1603/5 in Bowyer's possession in London, rather than at the Dissolution or earlier.

The later history of the manuscript

Our knowledge of the Lindisfarne Gospels' history during the later Middle Ages and the Tudor period is reliant upon the testimony of scant and largely illegible physical marks left on the volume by later readers and owners. These are the forensic clues which may help to piece together a picture of its whereabouts and who it encountered. The volume contains several inscriptions by both early and later medieval and modern hands. What are these and what can we make of them?

Miscellaneous early annotations

The Lindisfarne Gospels is a remarkably 'clean' book, by any standards, and does not seem to have attracted many of the casual scribbles or more purposeful annotations of readers until the later Middle Ages (and even thereafter only sparingly). This might imply that access to the volume was limited, or that its magnificence was in itself a sufficient deterrent to scribblers. That an impressive visual appearance was not alone a guarantor of inviolability is demonstrated by the eleventh-century Viking Ringerike style beast and the name 'Pogo' scratched into one of the purple pages of the Royal Bible from Canterbury (British Library, Royal 1.E.vi, f. 30v).[126]

Some insertions to the text were marked and supplied, by the original scribe, and are signalled by an '?' in the margin adjacent to the omission, matched by a straight-backed 'ð' followed by the insertion. These are placed as discreetly as the spacing would allow and follow usual Insular practice. See, for example, f. 109v. On f. 249v a textual insertion added as a run-over above the top line of the right-hand column is marked with a curved diagonal line above a point, at both the end of the top line and the beginning of the suprascript insertion. The hand appears to be that of the original scribe.[127]

In the gutter of ff. 134v–135r lies what may be a rare remnant of the marking up for binding. A Roman numeral 'u' flanked by medial points is written on f. 134v and paired with a similar 'ui' between points on f. 135r. The heavy wedges to the minims suggest an early, Insular, date (and are in keeping with the style of the original half-uncial script). The ink is tonally midway between the black of the original text and the brown of Aldred's gloss. These marks occur at a quire break (between quires 17 and 18) and so are likely to relate to the arrangement of the quires for binding purposes. They appear to be isolated

within the volume, however, rather than part of a systematic programme. Another slight possibility is that they relate, unusually, to the process of 'imposing' the text (i.e. establishing the disposition of words copied from an exemplar upon the page), for it is notable that at this point, from ff. 134v–136r, the text appears somewhat compressed.

Other marks which might conceivably have been added to serve a codicological, assembly function at some point include a tiny, shaky mark resembling an Arabic figure '3', inscribed in brown ink beneath the left-hand column of f. 159r, and a small, shaky 'c' in the lower gutter margin of f. 184v.

It may indeed have been during the original production, or soon after, that a drypoint 'x' was inscribed in the margin beside the 'pater noster' (Matthew 6.9), f. 37r beside line 21 in the intercolumnar margin, and beside 'scitis quia post biduum pascha fuit ...' (Matthew 26.2), f. 80v beside line 19 in the outer margin, marking the passage in which Christ warns the disciples that, after the Paschal feast, he will be seized and crucified, a Roman pericope beginning 'Scitis quia post biduum', read in the Lateran during Holy Week.[128] These discreet crosses were supplemented, probably contemporaneously, by formal Latin crosses in heavy black ink. Julian Brown saw no reason to associate them with the original hand or that of the rubricator.[129] However, the Echternach Gospels have grand marginal crosses to mark the Magnificat and Benedictus and there is no reason why they should not be seen as (near) contemporary. Another contemporary annotation would appear to be the triangle of points above a virgula (comma) which marks the passage concerning the Resurrection on Easter Sunday on f. 255v and which may even be by the hand of the original scribe.

At the foot of the left-hand column on f. 97v is inscribed, in pale brown ink, what looks like a tall 'a' followed by an 'eth', by an Anglo-Saxon hand. The character of the letter-forms and the roughness of their execution is such that they could date to any time between the eighth and eleventh centuries. The hand does not closely resemble Aldred's (although he does occasionally use a tall 'a', e.g. on f. 130r).

At the head of f. 122r, at the top right-hand corner and partially trimmed, is an alphabetic pen-trial, of which the letters 'abcd' survive, in half-uncial script. The brown ink of these resembles that used by Aldred, although the letter-forms are not those of his gloss. They may represent an attempt on his part to copy the letter-forms of the original text.

A brown cross added in the gutter margin beside the penultimate line of f. 212r (next to 'miserunt iudaei ab') looks like Aldred's ink.

Aldred's gloss aside, he was probably also responsible for the tiny pen-trials consisting of dots and 's' shapes, e.g. at the upper right of f. 56r, and for the ink tracing of the calf symbol of St Luke which overlies the original leadpoint back-drawing on f. 137r (see fig. 54). He may also have copied the interlace motif at the head of the initial 'I' on f. 203v onto the preceding verso (f. 202v), copying it a little clumsily from the show-through on

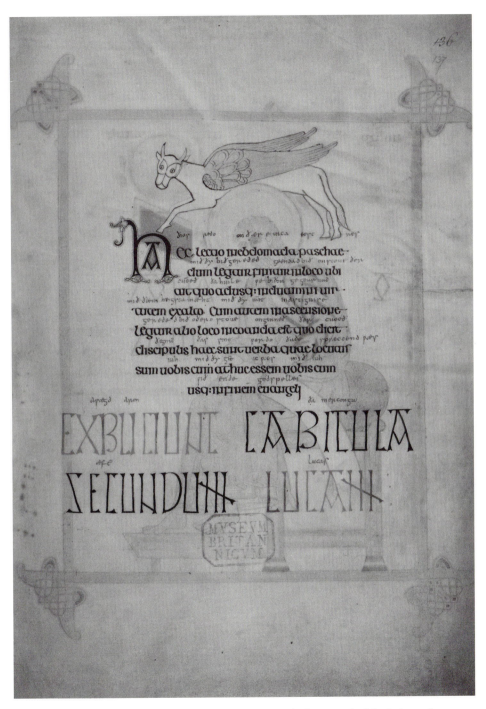

Fig. 54. Lindisfarne Gospels (BL, Cotton MS Nero D.iv), f. 137r, end of the Luke prefaces, with the drawing for the calf on the next page traced over the top in ink by Aldred.

f. 203r. He also added a rather clumsy circle surmounting a cusp at the head of the first line of display script on the Matthew Incipit page (f. 27r).

The spillage of red/orange pigment on ff. 141v–142 probably relates to Aldred's secondary glossing in red ink.

The Lindisfarne Gospels contain some twenty-seven instances of hardpoint marks (usually 'x' shaped) in the margins which appear to mark pericopes (lections).[130] Most Gospelbooks which have seen any actual use during the celebration of the Mass will contain some such discreet markings to assist in the location and punctuation for oral delivery of such passages. It is not possible to date the marks per se, but, as demonstrated in *Cod. Lind.*, they appear to be by more than one hand (some are rougher and doubled, for example), probably added to over a period of time, and to have marked passages which correspond to pericopes in Frere's Standard Gospel-series, other than those which correspond to later Roman pericopes.[131] The lections marked (see Appendix 1) generally correspond to the more important feastdays of the liturgical year. For the Temporale, or Proper of Time, these include Christmas, Epiphany, Easter, Ascension, Pentecost, with only four marking minor items. For the Sanctorale, or Proper of Saints, they include the feasts of Septem Fratres, Peter and Paul (and the Nativity of a Pope), Michaelmas, Stephen, Marcellus and Mark or Clement, Nativity of John the Baptist, Vitalis, John the Evangelist, with two of these also possibly relating to the celebration of St Cuthbert's feastdays at Durham as they correspond to two of three lessons used in his Votive Mass which was celebrated on most Thursdays, although the two other lessons associated with Cuthbert's Masses are unmarked.[132] The inference from these marks is that the Lindisfarne Gospels featured only occasionally in services during the Middle Ages, and generally for only the more important high days and holy days of the year, with some possible specific use in connection with the cult of St Cuthbert, but not consistently in accordance with the usage of Durham Cathedral.

Later medieval and modern additions and annotations

Paper slips carrying bibliographical references have been added, a usual British Museum practice, on the nineteenth-century vellum flyleaves at the front of the volume.

The recto of the post-medieval flyleaf preceding f. 1 is inscribed '323' at its head, relating to Sir Robert Cotton's ownership (see below).

On f. 1r, a post-medieval flyleaf (see fig. 55), is a characteristic Cottonian contents list, probably written by a calligrapher whom Sir Robert may have commissioned to inscribe his most prized books, rather than the usual contents lists supplied by Richard James (1592–1638), Cotton's librarian. It reads:

Fig. 55. Lindisfarne Gospels (BL, Cotton MS Nero D.iv), f. 1r, the Cottonian contents list, early 17th century.

Elenchus Contentorum in hoc Codice./
Quatuor Evangelia Latine, ex translatione B. HIERONIMI. cum –
Glossa Interlineata Saxonice/a. Canonibus EUSEBII. et eiusdem ad eos
Præfatione. Cum argumentis pariter et Capitulis Lectionum. Quo tem-
pore, et quorum opere, Completum fuerit hoc opus docet narratio ad finem
apposita. qu' ex parte sic habet. EADFRITH. OETHILWALD. BILFRITH.
ALDRED. hoc Evangelium Deo et CUTHBERTO Construxerunt: Ex qui-
bus verbis facile intelligamus eundem hunc Codicem esse de quo tot mira-
cula recitantur in Cronicis et Annalibus Dunelmensis Ecclesia.

This outlines the contents, accurately, and refers to the colophon at the end naming the makers, observing that from the same it is easy to tell that this is the miraculous book referred to in the Chronicles and Annals of Durham Cathedral. Cotton obviously thought that he had made the association with Durham, rather than having received it as a known Durham book. The inscription which he added in his own hand next to a corresponding reference in a collection of medieval material relating to Durham, also in his collection (Cotton MS Titus A.ii, f. 29v, see below) and still in that city as late as 1576, likewise indicates Cotton's pride in having ascertained the Durham connection himself.

Next to the heading is added the later Cottonian pressmark 'Nero D:4:' (see below). At some point after this was written ink was spilled on f. 1v and the resultant stain shows through onto f. 1r and offsets onto f. 2r. The first of a series of British Museum ownership stamps occurs on this folio, with another of its stamps, 'Museum Britannicum', starting another and probably earlier sequence from f. 2r.

On f. 2r a small 'c' has been written in the lower left-hand corner. On f. 2v what may be a medieval hand has written 'sjoha ...', presumably referring to St John, to the left of the righthand cornerpiece. 'Cap: 3 ...' is also inscribed at the mid-head of the page and presumably relates to the entry in the 1621 catalogue of Sir Robert Cotton's collection (see below) which also mentions 'Capite 32'. At the middle of the top edge of the page is inscribed the name of Robert Bowyer, now invisible but read in the 1950s as 'Rob. Bowyer', under ultra-violet light. This has been assumed to be an ownership inscription by Bowyer himself, but there appears to be something more, now illegible, written above and to the left of the name, and it is possible that this inscription, which is stylistically similar to Robert Cotton's own hand, was written by Cotton himself and relates to his acquisition of the volume from Bowyer (see below).

On f. 9, following the explicit of the Eusebian Preface, a hand of probable sixteenth-century date has written in an English cursive script 'Thys byk his sir/sys s/p' and on the next line 'hy hy h h h' (transcribed in *Cod. Lind.* as 'Thys byk hys ussys *per* hyly h h h'). 'Hy' was, coincidentally, the medieval name for Iona, whence Lindisfarne was founded, but the trailing off of the inscription thereafter would suggest that this is not a full word or a formal ownership inscription, but merely a pen-trial (random words or letters written to

test a freshly cut nib before using it to write formally) and perhaps, given the possible reading of 'thys byk his sirys' or 'sire's', that it was written by a youth trying his hand in his father's book.

On f. 45v a hand of probable seventeenth-century date has written 'in nescitis' in the outer margin. The same hand is likely also to have inscribed a marginal asterisk on f. 60v, 'manno viro' on f. 140v and the intercolumnar corrections to Aldred's gloss on f. 248v. The rough but faint diagonal lines in grey/green ink which may be intended to mark passages, e.g. on f. 85v line 6 (intercolumnar), are also possibly by this hand.

On f. 144v, in the gutter margin beside line 7, a skeletal 'N', of the sort commonly used as a 'nota' symbol during the thirteenth and fourteenth centuries, is added in leadpoint, indicating that the volume was being actively consulted at this time, if not systematically so, as this is an isolated occurrence.

On f. 211r, the great incipit page of St John's Gospel, there are a number of inscriptions, perhaps indicating that this important opening was frequently accessed or displayed. In the outer margin, to the right of the upper section of the border of the decoration, are several hardpoint inscriptions. The most prominent of these is an attempt to copy the angled end of the border at the top of the display panel, its interlace having been emulated so determinedly that its impression appears throughout the following three folios. Above this a heart-shaped interlace motif is inscribed, with an 'x' and a 'chy' or 'thy' at its foot (both perhaps referring to Christ) and a crossed tironian 'et' surmounted by an abbreviation bar for 'etiam' beneath the 'x'. Beneath these, to the right, appears 'us', written larger and probably by a different hand. Set above all of these is similarly inscribed 'thos t[8]', the first element of which probably denotes 'thomas' and the second a 't' followed by an 'er' or 'ur' abbreviation symbol. The letter-forms of all of these scribblings suggest a late medieval or sixteenth-century date. In the lower margin, to the right, there appears to have been a faint inscription in ink or metalpoint. This is now no longer visible, even with ultra-violet or infra-red light, and was already 'almost invisible even under ultra-violet light' in the 1950s when work was under way on *Cod. Lind.*[133] Traces of the inscription may be seen in a photographic reproduction of the folio (see fig. 56) published in 1873–83 by the Palaeographical Society.[134] The editors, E. A. Bond and E. Maunde Thompson, recorded their reading of it as 'Thomas Turner semel …' and described it as of sixteenth-century date. The 'Thomas' element can be discerned in the reproduction, but the rest requires the eye of faith and the 'Turner' cannot be proved. In a footnote to *Cod. Lind.* mention was made of William Turner, Dean of Wells (d. 1568), a native of Northumberland born at Morpeth, whose widow possessed some Anglo-Saxon books, although it is acknowledged that Turner is a common name and no connection can be assumed.[135] Tite took issue with the reading, dismissed an alternative suggestion that 'Thomas Tempest' was a possibility, and indeed questioned whether the second element was actually a surname at all.[136] It is difficult to interpret 'semel' without the remainder of its context, but its usual meanings

Fig. 56. Lindisfarne Gospels (BL, Cotton MS Nero D.iv), f. 211r, detail of the faded 'Thomas Turner' (?) inscription at the foot of the page, from the plate in the *Palaeographical Society: Facsimiles of Manuscripts and Inscriptions*, First Series (London 1873–83).

include 'with, together, once, first'. The inscription extended for a further line, but was illegible by the time of publication. The recurrence of the name Thomas may mean that this relates to the hardpoint inscription higher up the page. Stylistically they could be of fifteenth- or sixteenth-century date. There is no mention of a 'Turner' or 'Thomas T …' in the list of monks of Durham listed as 'Donors, Scribes and Other Persons concerned before 1540 with the Books recorded …' in Andrew Watson's *Supplement* to Ker.[137]

On f. 259v (see fig. 57), a blank page at the end of the medieval part of the volume, in the lower left-hand quarter of the page, is inscribed 'Jhn' (John or Johannis), written lightly with a thin pen and with an extremely exuberant flourishing of the 'J' at its head. This is also of probable sixteenth- or seventeenth-century date. On the lower outer edge of this page is written '19/48 17/8' (the / in each case signifying 'or') followed by a small superscript 'ii'. The figure 7 has been transformed to an 8. Beneath this the same hand goes on to add '19/4 1 1 n(?)p'. In both of these the '9' can also be read as '4' (in the first in its medieval looped form), but any attempt to read a date commencing '14 …' would be foolhardy. Another unverifiable possibility is that the numbers represent chapter and verse numbers of the Gospels (similar to annotation at the foot of f. 38v of the Durham Gospels). The hand appears to be post-medieval. At the top left-hand corner of the page an eighteenth-century hand has written 'Cons fol. 258', the 'fol.' having been written over an

Fig. 57. Lindisfarne Gospels (BL, Cotton MS Nero D.iv), f. 259v
later pen-trials on the back of the final page.

earlier foliation statement and followed by '256' which is scored through. The first foliation probably relates to the period of ownership by the Cotton family and the second, which commonly features in Cottonian manuscripts, was probably added shortly before or after the collection passed to the newly established British Museum in 1753.

Wanley, in the report on the collection of 1703, gave the Lindisfarne Gospels' foliation as '254'.[138] A usual British Museum foliation statement has been added in pencil on the final, nineteenth-century flyleaf, reading '259 fols J/F W April 1884. Ex P.S.S'. This indicates that the manuscript was refoliated and checked by members of staff (with those initials) of the Department of Manuscripts of the British Museum Library in 1884. This refoliation, in pencil, runs throughout the volume and replaces an earlier ink foliation of probable eighteenth-century date, which only ran from 1 (the recto of the first carpet page) to 258. This change was made to allow the seventeenth-century flyleaf carrying the contents note by the Cottonian librarian to be foliated as f. 1, British Museum practice having been to foliate any leaf carrying writing. The '256' on f. 259v, scored through in the eighteenth century, was presumably an earlier miscount and does not relate to a foliation sequence.

A curious red paper star, of the sort formerly accorded to schoolchildren as a reward for their scholarly prowess, has been pasted into the lower gutter margin of f. 101. A similar star is used to mark the opening of Genesis 43.25 on f. 63v of British Library, Cotton MS Claudius B.iv, the Aelfric Hexateuch, another important Anglo-Saxon manuscript.[139] This was probably made at St Augustine's, Canterbury during the second quarter of the eleventh century. Difficult though it is to credit, these days when we are more codicologically sensitive, these appear to be related to the selection during the nineteenth century of folios to be illustrated in a proposed guidebook to the British Museum collections.

Chapter numbers have been added at certain points in the margins of the Lindisfarne Gospels. In *Cod. Lind.* those on ff. 34r, 121r–129r and 143r–200r (consisting of 'Cap.' followed by a number)[140] were identified as written by the Anglo-Saxonist Laurence Nowell. This was not the Dean of Lichfield, as stated in *Cod. Lind.*, but a scholar (1530–c.1570) who served as tutor to the household of Sir William Cecil (1563–7).[141] His work in the field, mostly undertaken in the 1560s, included the *Vocabularium Saxonicum* (now Oxford, Bodleian Library, MS Selden Supra 63 (S. C. 3451)) which included 170 words culled from the the Lindisfarne Gospels gloss, followed by the reference 'Lind.' and with some twenty-five further words now only found in the Lindisfarne Gospels.[142]

Less formally written chapter numbers in the margins of John's Gospel (ff. 213v–257v) were identified as being written by the anonymous hand that wrote a transcription of the Lindisfarne Gospels' Gospel of St John in BL, Royal MS 1.B.ix (see fig. 58), from the collection of John Theyer (1597–1673) of Cowper's Hill, Gloucestershire.[143] On ff. 4v–54r of that volume the transcriber gives parallel texts of St John's Gospel from the Lindisfarne Gospels (rectos) and from Purvey's revision of the Wycliffite version (versos). From the

Fig. 58. BL, Royal MS 1.B.ix, ff. 4v–5r, 16th or early 17th-century transcript of Matthew's Gospel (gloss) from the Lindisfarne Gospels (right)

style of script, which is difficult to evaluate palaeographically as the copyist was attempting to convey the appearance of the original scripts used in his models, the transcriber was probably working during the later sixteenth or first half of the seventeenth century. This little paper volume bears considerable signs of wear and tear in the form of extensive ink smudges of the sort associated with printer's models. On f. iv there are offsets in red crayon which read 'COD SAX' and 'CUT WIDE', above what appears to be an addition sum. This may have been related to use by a printer or binder, perhaps more probably the latter as there are no signs of printers casting-off marks. One possibility is that it was prepared in connection with the earliest edition of the Gospels in Old English (*The Gospels of the fower Evangelistes*, London, 1571), by John Day assisted by John Foxe and at the instigation of Matthew Parker, Archbishop of Canterbury. A note on f. 5r of British Library, Harley MS 3449, an account by the late seventeenth–early eighteenth-century scholar George Hickes (author of the *Old English Thesaurus*) of previous scholarly work on the Lindisfarne and Rushworth (Macregol) Gospels, indicates that Lindisfarne was consulted in connection with Day's *The Gospels of the fower Evangelistes* rather than the West Saxon Gospels (as mis-identified by Bishop Ussher). It also notes that a transcription was prepared by one 'MN' in connection with William Camden's anonymous *Remaines of a Greater Work concerning Britaine* (1605). Only the Lord's Prayer was printed by Camden, who states that he saw Lindisfarne when it was already in the possession of Robert Bowyer. The work by Thomas Marshall for his polyglot edition of the 'Gothic' and Saxon Gospels (*Observationes in Evangeliorum Versiones perantiquas duas, Gothicas scil. et Anglo-Saxonicas*, 1665) is also referred to and is another possible source of the Lindisfarne transcript, Marshall stating that he saw the volume. However, if the work was undertaken for Day's or Marshall's work (the transcription in the latter seemingly being based on the former) they did not employ it as part of their printed editions, which do not concur with Aldred's version. Royal MS 1.B.ix may have been made in connection with one of these projects, but it is wisest to leave the matter open, pending further research.

The chapter numbers added to the Lindisfarne Gospels by the hand of Royal MS 1.B.ix and by Nowell were both subsequently trimmed by a binder, perhaps at the behest of Sir Robert Cotton who frequently had his books rebound, many still containing notes of instruction to the binder.[144] The transcriber was therefore at work before Cotton had the Lindisfarne Gospels rebound, and perhaps during or just before its period of ownership by Bowyer. The copy in silver of Cotton's arms, set inside the upper board as part of the new 'treasure binding' of 1853, is the same as the motif that Cotton had tooled on his bespoke bindings (for example, the Cottonian metal-clasped binding of Cotton MS Vespasian A.i; see fig. 59) and may indicate that the Lindisfarne Gospels were contained in an early seventeenth-century Cottonian binding that was replaced in 1853 to make way for Bishop Maltby's gift of a new treasure binding.

It is apparent, from the foregoing, that the Lindisfarne Gospels were being consulted by

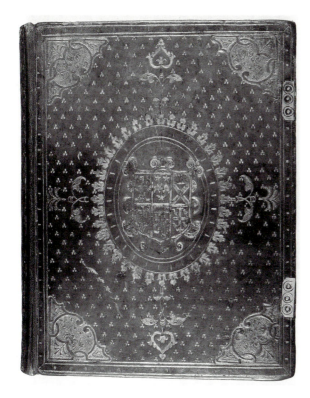

Fig. 59. Example of a Cottonian binding, early 17th century, on the Vespasian Psalter (BL, Cotton MS Vespasian A.i). Cotton may have had the Lindisfarne Gospels rebound in similar fashion.

scholars who had a particular interest in Anglo-Saxon language and history during the formative period following the establishment of the post-Reformation Anglican Church, when its association and continuity with earlier, vernacular English religious culture was being stressed. It seems to have been selectively consulted, however, and it is perhaps noteworthy that it does not feature more prominently in projects conducted by the circle of Archbishop Parker, although John Joscelyn did include twenty-two words from Aldred's gloss in his Old English word lists (Lambeth Palace Library, MS 692, f. 12r)[145] and, as we have seen, it may have been consulted by Day and Foxe. We do not know where or in whose collection the Lindisfarne Gospels were when consulted by these scholars. The volume may already have been in the south, or they may have travelled north to consult it. Other scholars known to have consulted it would have done so after it entered the collections of Robert Bowyer and then Sir Robert Cotton.

The volume was owned by the bibliophile Robert Bowyer (Clerk of the Parliaments, 1609–21, and Keeper of the Records in the Tower of London) by 1605 and it has been assumed that he received it from his father, William Bowyer, Keeper of the Records in the Tower of London, who was deceased by 1576,[146] his son Robert coming into the post himself in 1604.[147] William Bowyer was a bibliophile and owned at least two important

Anglo-Saxon manuscripts, the Abingdon manuscript of the Anglo-Saxon Chronicle (British Library, Cotton MS Tiberius B.i) and Cotton MS Otho B.ii + Otho B.x, a copy of the Old English *Pastoral Care*, as recorded by John Joscelyn in the first of his two lists of ancient manuscripts and their owners, compiled around 1566 (in British Library, Cotton MS Nero C.iii, f. 208r).[148] There is, however, no reference to the Lindisfarne Gospels being in William Bowyer's collection (which is not surprising as Joscelyn's list was specifically of historical texts) and there are no Durham connections for these other manuscripts in the possession of the Bowyers and therefore no evidence that (unlike Sir Robert Cotton) they were acquiring from a Durham nucleus, by whatever means. If it was Dissolution spoil, as is so often stated but without authority, it would probably have gone to the Royal Library (also now in the British Library, and which surprisingly contains only two books known to have been owned by Durham), its biblical text, glossed in English, being the sort of work that Henry VIII seems to have selected for retention.[149] If its supposed treasure binding was the reason for its seizure, as claimed, that would have gone to the Jewel House at the Tower of London but the book itself to the Royal Library, not to a private individual, unless of course the Bowyers were able to salvage the book there for themselves without declaring it.

The only conclusive provenance evidence after the tenth century occurs in 1605 when the volume was in the hands of Robert Bowyer. We know of his ownership from the now almost invisible inscription of his name at the head of f. 2v of the Lindisfarne Gospels and from the first printed reference to the manuscript, by William Camden in *Remaines of a greater work concerning Britaine*. This work carries a dedicatory epistle to Sir Robert Cotton of 1603 which may indicate that the work was undertaken in this year and that Bowyer already owned the Lindisfarne Gospels in 1603, and on p. 15 Camden printed the Lord's Prayer as translated 'about the yeare of Christ 700, found in an ancient Saxon, glossed *Evangelists* in the hands of my good friend M. Robert Bowyer, written by Eadfride the eight Bishop of Lindisfarne [*sic*]'.[150]

The manuscript subsequently belonged to the great antiquary and parliamentarian Sir Robert Cotton (1571–1631) who, along with Archbishop Matthew Parker, was responsible for saving much of the early book heritage of Britain. The Lindisfarne Gospels are more correctly known professionally by the press-mark in his collection as Cotton MS Nero D.iv. Along with one of the surviving primary copies of Magna Carta they were one of the foremost jewels in the crown of his collection. In a catalogue of his collection handwritten largely in 1621, partly by Cotton himself, and now BL, Harley MS 6018 (see fig. 60), the Lindisfarne Gospels are described on f. 119v in Sir Robert's hand as '323. Textus Evangeliorum pulcherimus ab Eadfrido postea Lindisfarnensis Episcopo circa annum Christi 660 scriptus et Saxonica Lingua per Aldredum presbiterum interlineatus. De istius libri amissione in mare et miraculosa inuentione extat narratio in historia Dunelmensi. Capite 32.'[151] The number '323' accords with that inscribed on the recto of the flyleaf

Fig. 60. BL, Harley MS 6018, f. 119v, Cotton catalogue, 1621, with the entry for the
Lindisfarne Gospels (no. 323) in Sir Robert's own hand.

preceding f. 1 (see above) and is the early Cottonian press-mark which preceded the
rearrangement of Cotton's library in which items were kept on presses surmounted by
busts of the Roman emperors and royal ladies and in which the Lindisfarne Gospels
acquired its current press-mark. Cotton MS Nero D.iv (as inscribed on f. 1r) was thus the
fourth book on the fourth shelf in the press surmounted by the bust of the Emperor Nero.
Among additional matter at the rear of the Harley 6018 catalogue are a number of
references to loans of books by Cotton to Robert Bowyer (on ff. 148v, 154v, 158r, 158v).
On f. 158r is a note written by Cotton, around 1613, of:

> Books that I had myself of Mr. Bowier.
> Orosius in Saxon Foll. – Foll.
> Beda de Ratione Temporum in parchment. – Foll.
> Flores Historiarum in parchment. Foll. – Foll.
> Saxon Gospels a fair Book. – Foll.
> A Book of verses and Poems that was John Ball. 8.[152]

The 'Saxon Gospels' are thought to have been the Lindisfarne Gospels. A further note on
f. 154v indicates that all, save these fair Gospels, were acquired by way of exchange of
books. Sir Robert made one further reference to the Lindisfarne Gospels himself, in the
form of a cross-reference equating them with the volume which Symeon said was washed

Fig. 61. BL, Cotton MS Titus A.ii, f. 29v, Durham anthology with Sir Robert Cotton's
marginal note relating to the Lindisfarne Gospels.

overboard, which he wrote on British Library, Cotton Titus A.ii, f. 29v (see fig. 61), a
fourteenth-century volume including Durham chronicles. Inscriptions added to the volume
by the Durham antiquary Christopher Watson indicate that it was in his possession as late
as 1576. Some Durham material was evidently still travelling south late in the sixteenth
century. Could some of this material have been associated with the Lindisfarne Gospels
when it came into Cotton's (or Bowyer's) possession, perhaps even bound into the book
itself?

There are no indications that the Lindisfarne Gospels ever left the Cotton collection
thereafter, even on loan. The historian Sir James Ware gave a summary of their origins and
contents in a notebook (now Oxford, Bodleian Library, MS Rawlinson B.484 (S.C.11831),
f. 39v) but seems to have consulted the collection *in situ*.[153] However the volume came into
Bowyer's hands, it is fortunate that this national treasure did not leave the country during
the Reformation and that it did not subsequently stray while on loan (unlike another great
book from Cotton's collection, now known as the Utrecht Psalter).

The Cotton Collection was subsequently bequeathed to the nation by Sir Robert's heirs
in 1702. The Lindisfarne Gospels fortunately survived the fire which destroyed or damaged
a significant part of the Cotton collection in 1731, whilst it was stored in Ashburnham
House, Westminster. It subsequently became one of several important private collections

(known as 'the foundation collections') which formed the basis of the first national museum, the British Museum, founded in 1753.[154] These collections have been held intact for the nation, and in trust for the global community, since that time. In 1972 the British Museum Library was identified as one of the components of the new British Library, which was established in 1973 by Act of Parliament (The British Library Act).

Such then is the evidence concerning provenance. When I began this account of the 'life' of the Lindisfarne Gospels I warned the reader that, as in the biography of a person, the evidence would be complex, varied, fragmentary and, on occasion, apparently contradictory. Some details formerly presented as 'facts' have been questioned. Some probabilities would tend to preclude other possibilities. Some points have to remain open or highly speculative. I have endeavoured to give an even-handed account of such evidence as survives and have indicated the conclusions that it suggests to me. I hope that the reader has been given adequate information, presented in impartial enough a fashion, to form an opinion too.

Exhibiting the Lindisfarne Gospels

Since the foundation of the British Museum in 1753, the Lindisfarne Gospels have left the security of the national collections only five times: evacuation during World War II in 1939; in 1961 the volume was displayed, for only a few weeks, at the Royal Academy, Burlington House as part of the exhibition 'Treasures from Trinity College, Dublin', in order that it might be seen for the only time alongside the Book of Kells and the Book of Durrow; in 1987, when it was briefly displayed in Durham Cathedral Treasury in honour of the anniversary of St Cuthbert's death (687) and briefly laid upon his tomb; in 1996 when it was exhibited alongside other material of the Golden Age of Northumbria, in an exhibition of that name at the Laing Gallery to mark Newcastle's hosting of Visual Arts UK; in 2000, when it was again exhibited at the Laing to mark the millennium. The political lobby for restitution of the Lindisfarne Gospels and its development as a totemic icon and rallying point for regional identity are relatively recent phenomena. Such lobbies have tapped into the very real affection and respect felt for the volume within the region. Other voices have been raised against the suggestion that the Lindisfarne Gospels should leave the British Library for anything other than individual special loans, which have to be extremely limited on conservation and security grounds. There are many good reasons for safeguarding the integrity of the national collections and the purpose-built British Library building provides a suitable long-term context for the preservation, interpretation and security of such a fragile and valuable work. Whatever one's point of view, the principle of 'inter-generational egality' dictates that no single generation should unduly jeopardise the long-term preservation and appreciation of such a global treasure in the service of its own agendas.

The Lindisfarne Gospels are usually displayed in the British Library's 'Treasures Gallery'. Here their pivotal role in the early history of Christianity and their preservation of the earliest English language translation of the Gospels can be appreciated in relation to some of the earliest extant papyri of the Gospels, the Codex Sinaiticus, the Alcuin Bibles, Wycliffe and Tyndale's English translations and the King James Authorised Version. Nowhere else would this be possible. They can also be understood in relation to the history of art, displayed near other landmarks of British art, such as the Benedictional of St Aethelwold, the Luttrell Psalter and the Sherborne Missal. Their historical and cultural roles are further enhanced by the frequent presence in the same gallery of the Anglo-Saxon Chronicle and Beowulf. The Lindisfarne Gospels may be more fully explored by visitors in the form of the 'Turning the Pages' system in the adjacent IT gallery.

The Lindisfarne Gospels have always assumed a prominent position within the library's exhibition galleries at the British Museum and in the Treasures Gallery of the new British Library building. They are now displayed and stored in optimum conditions in accordance with the most stringent security and preservation guidelines concerning environmental conditions. The exhibition cases and galleries have been specially constructed to meet these requirements and the conditions are achieved and monitored by sophisticated computerised plant. The British Library operates a rotation and substitution policy in respect of its internal exhibitions, with key treasures which have to be on 'permanent' exhibition to the public having their pages turned regularly to limit the exposure of any specific opening.

Facsimiles and reproductions

The first reproduction of the Lindisfarne Gospels was a manuscript copy of the Luke evangelist miniature and incipit page, along with a collage of script specimens from throughout the volume's text and gloss (now British Library, Stowe MS 1061, ff. 42–6, see fig. 62), made in the eighteenth century and gathered together by Thomas Astle as part of a volume of specimens of script and illumination in the course of work on his *Origin and Development of Writing* (1784, in which it appears as engravings, pls 14 and 14a).[155] Engravings of the four evangelist portraits were published in Joseph Strutt's *Horda Angelcynnan; or a Compleat View of the Manners, Customs, Arms, Habits, Etc. of the inhabitants of England* (1775–6), III, pls XXIII–XXVI. In his discussion of the Lindisfarne Gospels as part of 'a short account of the rise and progress of the art of design in England' he states confidently of the Lindisfarne Gospels' evangelists:

> In these rude and ancient delineations, we find no great idea of grace, nor the least mark of genius: besides the evident disproportion (as every figure, did he stand up, would be considerably too tall) the drapery is very stiff and unnatural, and the perspective of the stools or chairs which they sit upon extremely deficient; yet, on the whole, these designs are not

Fig. 62. BL, Stowe MS 1061, f. 44r, handmade facsimile of parts of the Lindisfarne Gospels'
scripts, in a collection assembled by Thomas Astle in the 18th century.

absolutely devoid of merit, especially if they are considered (as surely they ought to be) as the first dawning of the art amongst our Saxon sires (p. 181).[156]

An interesting comment upon the development of aesthetics and connoisseurship! He also went on to misinterpret the colophon, asserting that the book was written by Eadfrith but illuminated by Billfrith. The incipit page of Matthew was engraved in Madden and Shaw's *Illuminated Ornaments of the Middle Ages* (1833). A conflation of extracts from the manuscript (the head of St Matthew from f. 25v, the initial 'M' on f. 90, a rearranged version of Matthew 5.2–3 from f. 34, an extrapolated alphabet and part of the colophon on f. 259), was reproduced by J. O. Westwood in *Palaeographia Sacra Pictoria* (1843–5), part of pl. no. 45 and ff. 25v and 94v (a text page, one carpet and two incipit pages) in his *Facsimiles of the Miniatures and Ornaments of Anglo-Saxon and Irish Manuscripts* (1868), pls XII–XIII. Part of the Chi-rho page was illustrated in the first part of the text edition published by the Surtees Society in 1854. Folios 34, 27, 210v, 211 and 139 were reproduced by the Palaeographical Society in *Facsimiles of Manuscripts and Inscriptions*, Series I (1873–83), I, pls 3–6. Westwood (1843–5) misascribed the ornament to Aethilwald and was followed in this by Bond, Thompson and Warner in the Palaeographical Society publication, who erroneously summarised the colophon as 'the MS. was written by Eadfrith, Bishop of Lindisfarne (A.D. 698–721); that the ornamentation was added by Ethilwald, Bishop of Lindisfarne (A.D. 724–740); that Billfrith the Anchorite worked the jewelled covers; and that Aldred the Priest added the gloss.', mistaking Aethilwald's role and dates. They go on to state that Aldred's 'own handwriting' occurs in the gloss to John and in some corrections to Matthew', i.e. they take those in red to be Aldred's and imply (wrongly) that the rest were written by someone else, although composed by Aldred.

Other individual folios have appeared in various publications since. In 1923 the Trustees of the British Museum published a partial facsimile with three colour plates and thirty-six black and white, with an introduction by E. G. Millar, *The Lindisfarne Gospels* (1923) and in 1953–60 a full monochrome facsimile, with the major illuminated folios in colour, was published by Urs Graf. *Evangeliorum Quattuor Codex Lindisfarnensis* was edited by T. D. Kendrick, T. J. Brown, R. L. S. Bruce-Mitford, H. Roosen-Runge, A. S. C. Ross, E. G. Stanley and A. E. A. Werner in 2 vols (Olten and Lausanne, 1956 – facsimile, and 1960 – commentary). Janet Backhouse wrote two popular books on the Lindisfarne Gospels (1981 and 1995) and selected a postcard pack: these have done a great deal to make the manuscript better known to the public. The British Library also published a video, 'The Lindisfarne Gospels', and a new video is currently planned to coincide with the exhibition in 2003. The Lindisfarne Gospels were one of the first treasures of the British Library to be mounted on its award-winning 'Turning the Pages' interactive system, produced by means of digital imaging and animation techniques, which give the viewer the sensation of physically turning the pages on screen of some thirty folios of the manuscript. The system was initially reserved for use in the annexe to the 'Treasures' gallery in the new

British Library building at St Pancras when it was opened in 1998. It was subsequently made available at several heritage points in the north-east of England (enabled by the British Library in partnership with the Association of North-Eastern Councils) to celebrate the millennium in 2000 and was that same year published as an affordable CD-Rom.

For the historical record it may be useful to give a note of the form of this current episode in the Lindisfarne Gospels' history. The British Library, Faksimile Verlag and the author of the present volume have worked together to make a new fine-art facsimile of museum surrogate quality available as part of the present project. A first, extrapolated descriptive volume accompanies the facsimile and its contents are largely contained, and considerably amplified upon, in the present volume. We have sought to make the latter available as cheaply and widely as possible, issuing it as an independent monograph as well as distributing it to facsimile purchasers, marking a new departure in the democratisation of facsimile production by making the accompanying scholarship so widely available. It is planned to issue a full electronic facsimile in the near future, with which this volume can also be used. An exhibition, to be marked by the publication of a popular booklet, is planned at the British Library to accompany the formal presentation of copies of the facsimile and this accompanying volume to the British Library, and then (by the British Library and Faksimile Verlag jointly) to Durham Cathedral and the Lindisfarne Heritage Centre in May 2003. We hope thereby to make the Lindisfarne Gospels accessible, in an appropriate form which will permit the continued preservation of the manuscript itself, to as wide a global constituency as possible, in accordance with the principles of transmission which inspired those who first undertook its manufacture.

Notes

1 Gameson 2001a.

2 See *Hist. de Sancto Cuthberto*, ch. 9; R. S., 1, p. 201; Johnson-South 2002.

3 Craster 1954, p. 187, *Hist. De Sancto Cuthberto* (par. 9).

4 According to the *Hist. de Sancto Cuthberto*, the Cuthbertine in the *Historia Regum* and Symeon. On relic translations, see Heinzelmann 1979 and Angenendt 1994.

5 Craster 1954, p. 178. It has also been suggested (Johnson-South 1992 and 2002) that, if the passage is viewed as integral, the whole of the *Historia de Sancto Cuthberto* was composed at Durham during the second half of the eleventh century, based partly upon local traditions and partly on records contained within the community's service books, such as the Durham *Liber Vitae* and the 'Liber Magni Altaris' or 'liber de reliquiis', one (or both) of which I will suggest may have been the Lindisfarne Gospels.

6 Craster 1954, p. 189.

7 Higham 1993, p. 183.

8 Craster 1954, p. 191.

9 The southern shore of the Solway estuary was lined by the western extremities of Hadrian's Wall and included a number of points from which it would have been possible to set sail amidst the perilous sand-banks and quicksands, such as Bowness-on-Solway, the second largest fort on Hadrian's Wall, which stands at the westernmost tip of the southern shore, or the neighbouring Drumburgh. Almost opposite on the northern shore are the centres of Ruthwell and Hoddom, with their rich Anglian sculptural remains, representative of English control of this part of Rheged. If the community of St Cuthbert was not actually

intending to relocate to Ireland, a journey along the Solway to such outlying centres and to Whithorn, Ninian's ancient British monastery, refounded as an English bishopric in 731 under Pechthelm but which by this period may have come under Lindisfarne's aegis, may have been planned. Lindisfarne had held ecclesiastical sway over much of northern Britain since the late seventh century. If its centre of operations was to relocate considerable diplomacy would be required, within the *parochia* and amongst its neighbours, if that primacy was to be retained.

10 Symeon of Durham, *Hist. Dunelmensis*, chs x–xiii; pp. 56–69.

11 See the discussion of the later medieval provenance of the Book of Kells in Fox *et al.* 1990.

12 Craster 1954; Higham 1986, 1993.

13 Craster 1954, p. 192.

14 O'Sullivan and Young 1995.

15 Craster 1954, p. 196.

16 Higham 1993, p. 246.

17 For the later history of the community, see for example, Bonner *et al.* 1989; Aird 1998; Marner 2001.

18 Minor water staining has occurred on a few leaves at the head of the volume and is consistent with a leak from above while the volume was stored upright on a shelf, a storage practice which usually postdates the fifteenth century. Some early commentators made much of this staining, taking it as corroborative evidence for this being the book to which Symeon was referring. Surely the point of its miraculous survival should be that it would have sustained no such blemishes?

19 T. J. Brown 1969a, p. 24.

20 T. J. Brown 1969a, pp. 23–42.

21 Ker 1943.

22 Verey *et al.* 1980, p. 35.

23 See, for example, the arguments advanced in *Cod. Lind.* and in the first chapter of this present volume.

24 MacAlister 1913, p. 299.

25 Baldwin Brown 1921, pp. 337–41; *Cod. Lind.*; W. O'Sullivan 1994; Dumville 1999; Nees forthcoming.

26 See Nees forthcoming, where he states that the scholarly choices 'are not simply between accepting or disregarding the evidence of Aldred's colophon. The evidence needs to be investigated. Prior to this he cites a statement in my Jarrow lecture (M. P. Brown 2000), 'To dismiss Aldred's colophon out of hand is to challenge the value of provenance evidence as a whole, something which may be done when there is good reason, but which is counter-productive as mere iconoclasm.' The context in which he cites me seems to suggest that I was tacitly accepting the colophon, which was not the case. Later in his own text he says 'In comparison to other important early manuscripts with impressive illumination, its [the Lindisfarne Gospels'] early history is more secure than many … The manuscript known as the Lindisfarne Gospels was in the possession of the community of St Cuthbert by the mid-tenth century, as we know from Aldred's colophon, and that colophon's claims for its early history must have been thought at least credible, and support a view that the manuscript had already been in the possession of the community of St Cuthbert for a considerable, if indeterminate time.' This is, of course, what I meant when I said that to discount the value of the colophon (regardless of its claims concerning the original production of the book) as provenance evidence, linking the book to the community of St Cuthbert from quite an early stage, that is the tenth century, was not consistent with usual scholarly approaches.

27 At the end of his examination Nees adds 'The story that Aldred tells of its early history could actually be true, could reflect a remarkably accurate oral tradition, although without the evidence of the colophon it seems to me that on grounds of script and decoration scholarship would put the manuscript later, not in the first but in the second quarter, even toward the middle of the eighth century.' See Nees forthcoming. While agreeing with much of this conclusion I have presented my evidence in the present work for seeing the stylistic context, as well as the historical context, as favouring a dating somewhere between 710 and 725, with the lections marked suggesting that the layout may have been determined around 715.

28 Craster 1925 identified the 'Liber Magni Altaris' with the 'liber de reliquiis', remarking that a notary writing at Durham in 1433 states that he was shown 'various writings concerning the condition of the cathedral church', entered in an ancient hand near the middle of a book kept on the high altar (the 'Liber Magni Altaris') and that around the same time passages from the same book were copied into Cotton ms

Claudius D.iv, notably those on ff. 94v, 95v and 96r–97v. It can be deduced thereby that the added matter within the 'Liber Magni Altaris' included the *Chronica monasterii Dunelmensis* which extended the *Historia de Sancto Cuthberto* to the reign of William I and attempted to place information concerning the community's possessions within a historical context. I am deeply indebted to Simon Keynes for drawing my attention to this information. The unlikelihood of such a substantial chronicle being entered into a Gospelbook such as we know the 'liber de reliquiis' to have been, inclines him against identifying the references to this and the 'Liber Magni Altaris' as appertaining to the same book. It is worth adding, however, that marginal notes probably added to Cotton MS Claudius D.iv in the sixteenth century (such as that on f. 94v) say that grants made by kings Edward the Elder and Athelstan during the early tenth century were confirmed on the 'Liber Magni Altaris', indicating that this volume was of an earlier date. The parallels for the writing of documents into books to confirm their legitimacy and for guaranteeing legality by swearing upon a book all point to such a book containing a sacred text. The likelihood is, therefore, that the 'Liber Magni Altaris' was a Gospelbook which predated 900. This could have been the Lindisfarne Gospels. For an analagous inscription recording the names of those probably associated with the making and owning of the Stockholm Codex Aureus, see Gameson 2002; see also p. 267, n. 26 below.

29 See the discussion of later medieval provenance, below.

30 See Nees forthcoming.

31 The identity of Wigbald has not been established, but F. Henry intriguingly proposed an identification with a contemporaneous Bishop Hygebald of Lindisfarne, see Alexander 1978. On colophons in general, see Gameson 2001a.

32 E. A. Lowe 1928.

33 This previously unnoticed feature was pointed out to me by Jane Roberts, to whom I am deeply indebted for sharing her thoughts and preliminary text. If she is correct only one word needs to be altered in order to make an original metre scan. It is not possible to cite further details here, prior to her work for publication.

34 This may be translated as: 'May the letter, faithful servant of speech, reveal me; greet, O kindly [book], all my brothers with thy voice.'

35 Proximity to Chester-le-Street would favour the former location and the use of the Mercian dialect the latter. Farmon was assisted, or possibly sponsored, by Owun who is also named in the inscription. See Ross 1979 and 1981 and Breeze 1996. See also Coates 1997, who argues for a location for Harewood near Lichfield.

36 A synoptic edition of both glosses and of the Latin text of the Lindisfarne Gospels is given by Skeat 1871–87. Skeat considered that Owun and Farmon's gloss was based upon the Latin version of the Vulgate in the Lindisfarne Gospels as well as the original text of the Irish Gospelbook he was glossing, implying that he was consulting the Lindisfarne Gospels itself. This hypothesis might repay closer investigation and testing. Aldred's gloss may, in any case, have been available in another form.

37 M. P. Brown forthcoming c; Budny 1985.

38 Boyd 1975, pp. 56–7, where he lists Aldred's possible sources as Jerome's *Liber interpretationis hebraicorum nominum*, his *Commentarii in Esaiam, in Ezechielem, in Euangelium Matthaei, in iv epistulas Paulinas (ad Galatas, ad Ephesios, ad Titum, ad Philonem)*, his homilies and perhaps his correspondence; Pseudo-Jerome, *Interpretatio alphabeti Hebraeorum*, and *Commentarius in Euangelium secundum Marcum*; Augustine's exegesis on the Gospels, such as his *De sermone Domini in monte, Tractatus in Euangelium Ioannis* and his *De consensu Euangelistarum*; Isidore's encyclopaedia, *Etymologiarum sive Originum* and perhaps his *De ortu et obitu Patrum*; Gregory the Great's *Moralia sive Expositio in Iob, Homiliae in Ezechielem, Homiliae in Euangelia* and his *Registrum epistularum*; Pseudo-Chrysostom, *Opus imperfectum in Matthaeum*; Bede's Old Testament commentaries, including his *In Samuelem prophetam allegorica expositio, In Esdram et Nehemiam prophetas allegorica expositio, In librum patris Tobiae allegorica expositio* and his New Testament *In Marcum et Lucam expositio, Super Acta Apostolorum expositio, Explanatio Apocalypsis* and *Homeliarum euangelii libri ii*.

39 The Toronto database of Old English has 'cuæð' as the final word here, which is to be preferred.

40 In which Bede on Revelations 1.7 writes: 'In eadem illum forma videntes judicem potentem, in qua velut minimum judicaverunt, sera semetipsos poenitentia lamentabunt.'

41 Boyd 1975, p. 52.

42 On the Durham Ritual, see T. J. Brown 1969a; Ker 1943; Temple 1976, no. 3.

43 CLA 2.235.

44 T. J. Brown 1969a; Ker 1943.

45 Miles 1898, p. 247–50. King Edgar appears to have ceded Lothian to Kenneth, perhaps to ensure an amenable balance of power in the north.

46 Boyd 1975, pp. 4–5, pp. 8–10 (gloss to Matthew 1.18, concerning celibacy), 'to take care of, by no means to have as wife' and 'Abiathar the leader (?) was at that time High Priest in Jerusalem. He entrusted Mary to Joseph to take care of, and to deal with in purity'; pp. 22–3 (gloss to Matthew 7.6, concerning abuse and reform), 'those are the pearls, those are the commandments of the Gospel. ante porcos before swine, those are the fatted swine, those are the men in holy orders and the good men and the proud men. They despise the commandment of God and the Gospel'; pp. 24–31 (glosses to Matthew 10.8 and 10.14, concerning simony). 'He said to the apostles and bishops foremost after him. You received orders gratis; give [them] gratis without any price to those who are worthy in learning and in habits and in purity and in virtues and in health of body. For the bishop must test and teach the priest eagerly, unless he has learnt beforehand' and 'A bishop is commanded to receive a newly-arrived priest, and to consecrate him quickly. Let him teach him first and eagerly prove him and ask those who know him what kind of a man he is … [and] examine his doctrine unless he have a good person who will bear witness for him.'

47 R. Millar 2000, p. 61.

48 Brunner 1947–8, p. 32.

49 For Aldred's cursive, see, for example, the foot of f. 248v between the columns, and for his Latin in a higher grade script, see the foot of f. 251r and the 'Five Sentences' component of the colophon on f. 259r.

50 R. Millar 2000, p. 47, n. 17.

51 Ross 1979 and 1981. See also Breeze 1996.

52 Ker 1957, p. 216, where he writes: 'That the gloss was actually composed by Aldred and copied directly into this manuscript is suggested by such an eye-error as "ðaðe" glossing 'quinque', f. 174 (where "quin" is at the end of a line), which has been corrected to "fifo".'

53 Dumville 1993a.

54 The impact of the continental Benedictine reform movement appears to have begun to exert a limited influence upon some individual English ecclesiastics from the 930s onwards. Glastonbury and Abingdon witnessed the establishment of regular monastic communities during the 940s–50s, and Winchester, Canterbury and Worcester retained traditions of learning even prior to their reform. Might such a centre have nurtured the vocation and education of Aldred during his priesthood?

55 This need not preclude Nees' suggestion that Aldred has composed his colophon with a view to incorporating points of contemporary relevance, placing himself in the line of evangelistic transmission. See Nees forthcoming.

56 See the excellent and full treatment of the language of the 'colophon group' by Ross, Stanley et al. in Cod. Lind. The transcription above varies somewhat from theirs, but only in small details, such as the possibility of a caroline question mark (punctus interrogativus) following Aldred's statement of humility. I am also extremely grateful to Jane Roberts for showing me her transcription prior to publication.

57 The question mark (punctus interrogativus) has not formerly been noted.

58 Translation partly based upon that in Cod. Lind., Bk II, p. 10. See also the suggestion for the restoration of the hexameters, p. 66, above.

59 This is the translation given in Cod. Lind., Bk II, p. 10, but the following has kindly been made available to me by Jane Roberts and is closer to Aldred's own translation:
'+ God, three and one, established this gospelbook before the world.
+ Matthew wrote from the words [lit. mouth] of Christ.
+ Mark wrote from the words [lit. mouth] of Peter.
+ Luke wrote from the words [lit. mouth] of Paul the apostle.
+ John thereafter poured forth 'in the beginning'; he wrote the word given by God and the holy spirit.'

60 The wording is evocative of the decorative treatment of the binding of the St Cuthbert Gospel and its unusual sophisticated 'Coptic' sewing technique.

61 The reference to the first person singular is erased, presumably to depersonalise the character of the

inscription, or because it conflicted with the use of the third person singular in the remainder of the text.

62 *Cod. Lind.*, p. 10; T. J. Brown 1969a, p. 24.

63 A better sense of which may be 'were devoted to this book'.

64 Bede, *Vita Cuthberti*, chs 57–8; see Colgrave 1940, pp. 290–6.

65 *Florence of Worcester*, ed. Thorpe 1848, pp. 45, 50; Symeon of Durham, *Hist. Dunelm. Eccles* (henceforth HDE), bk I ch. 11; R. S., I, p. 37.

66 Bede's *Prose Life*, ch. 56; Colgrave 1940, pp. 60–2 and 142–6.

67 Colgrave 1940, p. 146.

68 Arnold 1882–5, tentatively identified this house as Crayke; Symeon of Durham, HDE, R. S., I, p. 270.

69 Aethelwulf, *De Abbatibus*, ch. 5, ed. Campbell 1967; Symeon, HDE, R. S., I, p. 270. On Ultán see Nees 1993.

70 See T. F. Tout, *Dictionary of National Biography*, 16, 1888, pp. 306–7; Ehwald 1919, pp. 486–7.

71 See Bischoff and Lapidge 1994, pp. 520, 527.

72 *Florence of Worcester*, I, p. 54; Symeon of Durham, HDE, I.12; R. S., I, p. 39.

73 Bede, ed. Plummer 1896, I, p. 362.

74 Colgrave 1940, pp. 116 and 254.

75 *Cod. Lind.*, pp. 12–13, 19.

76 Symeon, HDE, I.12; R. S., I, p. 39.

77 Toulmin-Smith 1907, p. 74.

78 Dumville 1972.

79 M. P. Brown 1996, pp. 131–5 and 143–5.

80 E. Bishop 1918, pp. 192–7; M. P. Brown, *op. cit.*

81 Symeon, HDE II.6; R. S., I, p. 57.

82 Miracle 7; R. S., I, pp, 252, 255.

83 Battiscombe 1956, 'Historical Introduction', pp. 113–14. Westou was a colourful character who claimed that he regularly had occasion to trim the nails and beard of St Cuthbert, whose corporeal remains were still, according to him, regenerating, the sale of these trimmings representing a further source of pilgrim revenue.

84 R. S., I, pp. 221–2.

85 See also G. Henderson 1987 and Ó Floinn 1994.

86 Symeon, HDE II.12; R. S., I, pp. 67–8.

87 Cramp 1989, p. 218.

88 On the Aethilwald cross, see Bonner *et al.* 1989, pp. 223–5, 228.

89 Cramp *et al.*, 1989, pp. 220–1.

90 Symeon, HDE, bk II, ch. xii; R S, 75, I, p. 68.

91 As in *Cod. Lind.*

92 Symeon, HDE, bk II.11.

93 Forbes-Leith 1896, p. 11; Gameson 1996; Bray 1992.

94 Kelly 1994.

95 Stokes 1890, p. 176.

96 Giraldus Cambrensis, *Topographia Hibernica*, chs 71–2, pp. 84–5.

97 Hence the Whithorn reference, it also being likely that Lindisfarne had enjoyed relations with this bishopric after its refoundation under the Northumbrian Bishop Pechthelm and that the Bishop of Lindisfarne might also have overseen the area after the extinction of the see, Bishop Heathored, *c.*821–30, seeming to have served for a time as bishop of both. See Miles 1898, p. 220. The evidence for this is, however, ambiguous.

98 Guthred was the community's own favoured candidate, a Danish Christian convert who was redeemed from servitude by Eadred, Abbot of Carlisle, and presented to the Viking army at Oswindun by Bishop Eardulf of Lindisfarne. See Duffus Hardy 1873, p. xxv.

99 This probably accounts for the presence of a number of manuscripts thought to have come from these important centres in the Durham Cathedral Library, and for the 'de manu bedae' ('by the hand of Bede'), identifiers inscribed in them by one of its medieval librarians.

100 Ker 1957, no. 176; Bonner 1989, p. 390.

101 These are printed by Raine 1838; see also Mynors 1939, pp. 2–4 and 9–11; Ker 1941, p. 38, and Watson 1987, p. 18.

102 See Alan Piper's contribution to Watson 1987, pp. 18–34.

103 Raine 1852, pp. 93–125.

104 Ker 1941, p. 119.

105 Watson 1987. See also M. P. Brown 1996, pp. 164–77 and Brown and Farr 2001, pp. 280–2.

106 Raine 1852, pp. 73–146; Hamilton Thompson 1949; Knowles and Hancock 1953, p. 69.

107 Cambridge 1988.

108 See V. Tudor 1989, esp. pp. 456–8; see also Marner 2001.

109 Watson 1987, pp. 18–34.

110 *Rites of Durham*, 1902, p. 16; Ker 1941, no. 147.

111 Ker 1941, no. 176.

112 *Rites of Durham*, 1902, pp. 16–17.

113 The list is printed by Fowler 1899, pp. 425–40. Other of the items have been identified with other books, or do not correspond at all with anything that might be the Lindisfarne Gospels.

114 The 'liber de reliquiis', printed in *Account Rolls* II, pp. 425–35 at p. 432, which is possibly to be identified with the 'Liber Magni Altaris' containing the Miracles, which was chained to the high altar.

115 Piper 1978, p. 237.

116 *Ibid.*

117 Clanchy 1993.

118 The latter certainly made use of the account of the wanderings as well as other unidentified matter and Aldred may perhaps likewise have derived an earlier tradition concerning the makers of the original book itself from amongst these addenda.

119 I am deeply indebted to Simon Keynes for making available his notes concerning the community of St Cuthbert and its records, made in connection with his work on the British Academy Corpus of Anglo-Saxon Charters, in progress.

120 See Keynes 1985; Thompson 1923; Rollason 1989.

121 Webster and Backhouse 1991.

122 Craster 1954, p. 199 points to the *Historia de Sancto Cuthberto* and the *Liber Vitae* also being treated in the manner of cartularies, with diocesan documents recorded in them, after the see had moved to Durham.

123 *Rites of Durham*, pp. 102–3.

124 Leland 1774, p. 41.

125 *VCH*, 1905, I, p. 250.

126 See Temple 1976, pl. 172.

127 See the discussion of the corrections in chapter four, below.

128 Frere 1930–5, Early Gospel-series, 96.

129 *Cod. Lind.*, p. 42.

130 *Cod. Lind.*, pp. 42–3.

131 *Ibid.*; Frere 1930–5, Standard Gospel-series, pp. 29–58.

132 See Hohler 1956.

133 *Cod. Lind.*, p. 25.

134 Palaeographical Society, 1873–83, Vol. II, pl. 6; see also E. G. Millar 1923, p. 8.

135 *Cod. Lind.*, p. 25, n. 7.

136 Tite 1997, p. 438, n. 22.

137 Watson 1987, pp. 84–100.

138 See the entry in Tite's edition of Smith's Catalogue of the Cotton Collection, Tite 1984.

139 Illustrated in colour in M. P. Brown 1991, p 54.

140 These may be compared with Nowell's transcripts, now British Library, Add. MSS 43703–10, e.g. Add. MS 43703, ff. 132v, 158r, and identical chapter numbers added to a late twelfth-century manuscript of the Wessex Gospels, of particular relevance in connection with Aldred's gloss and similarly cited in the *Vocabularium*, now Oxford, Bodleian Library, MS Hatton 38, e.g. ff. 12v, 41v.

141 See C. Berkhout in Damico 1998, pp. 3–17.

142 Marckwardt 1948, p. 24, and 1952.

143 Warner and Gilson 1921, p. 11.

144 Tite 1993.

145 See Graham 2000, p. 126, n. 89 and p. 135. For Anglo-Saxon manuscripts owned by the Bowyers, see Ker 1957, nos 175, 191, 224 and 309. A note by Lambarde in British Library, Add. MS 43707, f. 49r, indicates that Nowell had access to William Bowyer's collection, which may be of relevance, but it cannot be proved that this was where he consulted the Lindisfarne Gospels in the 1560s.

146 Historical Manuscripts Commission, 11th Report, App. 7, p. 139.

147 Calendar of State Papers, p. 178.

148 See Graham and Watson 1998.

149 See Ker 1985, p. 467.

150 *Cod. Lind.*, p. 26.

151 This may be translated as '323. A Gospelbook beautifully written by Eadfrith, afterwards bishop of Lindisfarne, around AD 660 and interlinearly translated into the Saxon language by Aldred the priest. It is of this book, lost in the sea and miraculously found, that the history of Durham speaks. Ch. 32.'

152 Tite gives this date, Tite 1993, 1997; *Cod. Lind.* gave 1609–14.

153 I am indebted to Colin Tite for this, and for much invaluable discussion.

154 Tite 1993; E. G. Millar 1973.

155 See Webster and Backhouse 1991, no. 83c.

156 He also drew attention, on p. 189, to the account of the Lindisfarne Gospels in the 'History of the Cotton Library', prefixed to the catalogue (Thomas Smith, *Catalogue of the Manuscripts in the Cottonian Library, 1696*, Tite 1984, pp. 46–51, and also in the preface to the catalogue of the Royal manuscripts (David Casley, *A Catalogue of the Manuscripts of the King's Library. An Appendix to the Catalogue of the Cottonian Library*, 1734, pp. xii–xiii and pl. XIIIc, a script specimen). These make fascinating reading and cast light upon the attitudes to the book and its age in their respective periods, but do not add to knowledge concerning its provenance. John Selden also discussed the volume in the preface to his *Historiae Anglicanae Scriptores* x, 1652. Thomas Smith adds his own comment on the aesthetics of the illumination, stating that '... the figures seem crude compared with those of today, lacking brightness, elegance and symmetry. The art of painting was not so far developed at that time, although in the smoothness of their parchment, the outline of letters and the beauty of their handwriting the Anglo-Saxons cannot be judged inferior to the most cultivated ages' (p. 49). Perceptional values certainly change from age to age.

CHAPTER THREE

Enshrining Scripture:
the text of the Lindisfarne Gospels

Collations, transcriptions, glossaries and printed editions

There is a large body of published work on the Latin and Old English texts of the Lindisfarne Gospels. Those cited here are intended to show some of the landmarks which have occurred in the process of making the text more widely known.

1. In the mid-sixteenth century John Joscelyn recorded twenty-two words from the Lindisfarne Gospels' gloss in his Old English word lists (Lambeth Palace Library, MS 692, f. 12r).

2. Laurence Nowell's inclusion of words from Aldred's Old English gloss in his *Vocabularium Saxonicum* of the 1560s (Bodleian Library, MS Selden Supra 63).

3. Anonymous sixteenth- or seventeenth-century transcription of Aldred's Old English gloss to St John's Gospel, paralleled with Purvey's version of the Wycliffite version, in BL, Royal MS 1.B.ix (see discussion above and fig. 58).

4. Richard Bentley's (d. 1742) collation of the Latin text, designated 'Y', for his unfinished edition of the New Testament in Greek and Latin, in Trinity College, Cambridge, MS B.17.14 (see Wordsworth and White 1889–98, pp. xv–xxvii).

5. Latin text and Old English gloss first printed by J. Stevenson (vol. I) and G. Waring (vols II–IV), *The Lindisfarne and Rushworth Gospels*, Surtees Society (1854–65).

6. Latin text and Old English gloss, plus marginalia, printed by W. W. Skeat, *The Holy Gospels in Latin, Anglo-Saxon, Northumbrian and Old Mercian Versions* (1871–87). This continued the work commenced on an edition of Matthew's Gospel in the Anglo-Saxon and Northumbrian versions by J. M. Kemble and C. Hardwick (Cambridge, 1858).

7. Collated by G. M. Youngman for J. Wordsworth and H. J. White, *Nouum Testamentum … secundum editionem Sancti Hieronymi: pars prior – Quattuor Euangelia* (1889–98), designated as 'Y' (p. xiv). Omits the Capitula Lectionum preceding each Gospel and indicating when lessons from each should be read.

8. In 1891 Dom. G. Morin published and discussed the 'quasi capitulary'.

9. A. S. Cook edited *A Glossary of the Old Northumbrian Gospels (Lindisfarne Gospels or Durham Book)*, 1894.

10. In 1908 Dom. J. Chapman printed a table combining the capitula lectionum and quasi-capitulary of the Lindisfarne Gospels, British Library, Royal MS 1.B.vii and the Burchard Gospels.

11. In 1914 De Bruyne collated the capitula, classifying them as part of his 'family C'.

12. Matthew 6.20–34 printed by Chadwick, Judge and Ross (1934).

13. A parallel edition was published by H. Sweet in *A Second Anglo-Saxon Reader* (1st edn, 1887, 2nd edn, revised by T. F. Hood, 1978, pp. 143–71) of glosses to Matthew 6 from Aldred's gloss to the Lindisfarne Gospels and Farmon and Owun's gloss to the Rushworth Gospels, Bodleian Auct.D.2.19. The former is described as Northumbrian, *c*.950–70 and the latter as tenth-century Mercian.

14. Latin text discussed extensively in *Cod. Lind.*, 1955–60. An 'Index Verborum Glosse-maticus', being an index of the words (or 'linguistic forms') of the Old English gloss, along with the Latin words which they are used to gloss, and the corresponding chapter and verse of the Gospels in which they appear, was edited by Alan S. C. Ross and E. G. Stanley (based upon the MA theses of D. E. Chadwick, C. O. Elliott, N. L. Haddock, Betty Hill and R. G. Price) in the *Cod. Lind.*, 1960, Bk II, pp. 45–160. They also provided an alphabetical list of Latin words, with their glosses (pp. 161–76) and Tables by means of which chapter and verse could be located in the facsimile, correlating them with folio and column numbers (pp. 49–56).

15. Patrick McGurk included the Lindisfarne Gospels as no. 22 in his *Latin Gospel Books from AD 400 to AD 800*, 1961.

16. In 1969 Regul published and discussed the prologues.

17. Christopher Verey identified the same correcting hand at work in both the Lindisfarne and Durham Gospels in his commentary accompanying a facsimile of the latter (1980, pp. 74–6), the text of which was extensively discussed and collated.

18. Partially collated by Bonifatius Fischer, *Die lateinischen Evangelien bis zum 10. Jahrhundert*, 1988–91 (*Aus der Geschichte der lateinischen Bibel*, 13, 15, 17, 18, Matthew 1988, Mark 1989, Luke 1990, John 1991), designated as 'Ny'. For his select collations of the Lindisfarne Gospels, see the final column of the Text Table in Appendix 2, on the CD-Rom.

The place of the Lindisfarne Gospels in the dissemination of Scripture: the background

The Lindisfarne Gospels have long been taken to be a good textual representative of the Gospel section of a Latin translation of the Christian Bible (incorporating both the Old and New Testaments) now known as the 'Vulgate'. This was one of several projects to

produce reliable editions of the components of the Bible, based variously upon earlier Hebrew, Greek and Latin texts, undertaken by St Jerome in the later fourth and early fifth centuries.[1]

Those unfamiliar with the methodology of textual scholarship might assume that the earlier the copy of a text, the closer it will be to the original author's version. Given the vagaries of processes of transmission in the pre-print age, and the problems of ensuring faithful copies free from scribal errors of reading and copying or of subsequent editorial interventions, this need not necessarily be the case. No two scribes can write identical copies, even in the most organised of manuscript 'publishing' campaigns. Age does not alone guarantee authenticity or purity of text. Sometimes all the available manuscript copies of a text need to be compared, and their inter-relationships assessed, in order to gauge what the author's original version of any passage was likely to have been.

Christianity is a religion of the Word which nonetheless has had also to rely, especially in its early stages, upon oral tradition – what people told one another, in Aramaic, Hebrew, Greek and then the Latin and vernacular languages. Written testimonies and individual books (or groups of books) of the Bible initially circulated as informally produced pamphlets on papyrus and parchment and it was not until 'official' attempts to gather them together, to assess their validity and 'codify' them as complete bodies of work of a 'canonical' (or approved) nature that complete Bibles were produced. The earliest were the fourth-century Greek copies – the Codex Sinaiticus and the Bibles known to have been commissioned (but thought now to be lost) by the Emperor Constantine who had recently converted to Christianity, ultimately leading to its acceptance as the state religion of the late Roman Empire. The early Church councils played an important part in this process, which was a gradual one. An earlier campaign to likewise codify the Hebrew Bible (the Old Testament) had led to the production of a Greek translation/edition, now known as the Septuagint, in Alexandria in the late third century BC, this being one of several Greek versions subsequently in circulation.[2] Jerome was a Latin speaker and, by the time he came into papal service, there were many different Latin versions circulating throughout the Empire's territories.[3] The variants were generally small differences in wording, spelling and punctuation, but these could be significant. These versions are generally grouped under the heading 'Old Latin', and were also known as 'vulgata' or vulgar/vernacular.[4] Jerome sought to purge the Latin text of its errors and variants, with reference to the Greek versions. He subsequently went on to return to the Hebrew in his attempts to get as close as possible to the original meaning.[5] Although Jerome had been commissioned to produce a new Latin 'Vulgate' by Pope Damasus, since there were (as Jerome tells us in his 'Novum Opus' prefatory letter addressed to Pope Damasus) almost as many versions as codices,[6] his work did not supplant the earlier rescensions and in many copies his 'Vulgate' and Old Latin readings became blended, producing many different 'mixed' texts. Other early Christian authors also undertook their own editions.[7] By the time that 'the Vulgate' came

to be printed much work was necessary on the part of Church councils and editors to decide on its form, as devised by Jerome, which itself varies according to the edition. Regaining the original text therefore becomes a complex process of distillation.

In their attempts to regain Jerome's original work on the Vulgate, modern textual scholars (such as Wordsworth and White, and Fischer) have compared and collated the texts of a vast body of manuscript copies and have grouped them into families on the basis of their variant readings.[8] As a result, the texts of the Codex Amiatinus (a complete Bible) and of the Lindisfarne Gospels are thought to represent particularly good early copies which may be relatively close to Jerome's Vulgate version. They seem to have been based upon a southern Italian Gospelbook and a variety of other exemplars (including some which had been copied and edited at Cassiodorus' sixth-century Italian monastery, the Vivarium) which were in turn edited at Wearmouth/Jarrow to produce what is known as the 'Italo-Northumbrian' family of texts. Other copies of the Gospels copied by Insular scribes employ a plethora of versions, the product of numerous exemplars and of local interventions in the course of copying and correcting. Most of these might be classified as 'mixed' texts, although they may exhibit a greater or lesser degree of agreement with what has come to be known as the Vulgate. Scholars have tended to group them into 'mixed Italian' or 'mixed Irish/Celtic' families on the basis of their variant readings and the prefatory matter which accompanies the Gospels (with the inclusion of prefatory lists of Hebrew names, for example, being a particularly 'Irish/Celtic' feature), and on the supposed origins of their exemplars. It should be remembered that these classifications have been applied by scholars in an attempt to impose order on what was evidently a very fluid and organic process of textual transmission. 'Mixed' texts incorporate Vulgate readings, in varying levels of frequency. It can be difficult to know which variants are significant and which incidental.[9]

Most Insular Gospelbooks are therefore technically of the 'mixed' variety. It is certainly not the case that the Vulgate was accorded primacy or that the history of Insular Gospelbook production was a quest to achieve a textual purity embodied by Jerome's Vulgate version. That having been said, Insular scribes and scholars do exhibit an interest in comparative readings and a respect for copies of texts which were ultimately associated by tradition or inscription with venerated figures in Church history, such as Jerome. The texts of the Codex Amiatinus and what may be parts of the other (now fragmentary) Ceolfrith Bibles, the Gospelbooks made at Wearmouth/Jarrow (the Cuthbert Gospel of St John and the fragments appended to the Durham Gospels and the Utrecht Psalter) and of the Lindisfarne Gospels (which seem to have been copied largely from the same southern Italian Gospelbook archetype) incorporate fewer variants from the Vulgate (as defined by printed editions which have themselves relied upon such manuscripts to establish their readings, thereby necessitating a rather circular approach) than other Gospelbooks made in Britain, Ireland or Insular centres on the Continent.

Jerome's Vulgate edition was not promulgated as an 'authorised' version.[10] Even when such landmarks in textual dissemination have occurred they are not always uniformly adopted. There is an innate conservatism which often manifests itself in such matters, and which may be particularly strong when there is a marked element of orality involved. One has only to consider the many printed editions of the Christian Bible in use at the present to begin to appreciate this.

Biblical texts usually circulated as individual books or as groups (e.g. the Pentateuch, the first five books of the Old Testament). Single-volume Bibles – pandects – were exceptions, usually linked to major editorial campaigns and/or representing consciously devised landmarks in dissemination, such as the programmes of codification and circulation of texts associated with the state sponsorship of Constantine and Charlemagne, and with the monastic initiatives of Cassiodorus and Ceolfrith. In compiling them a number of different exemplars would be used for their component parts, of heterogenous provenance. Such Bibles might be made for reference (as Ceolfrith intended the two pandects he left for Wearmouth and Jarrow to be), or as exemplars for copying, to ensure some measure of uniformity (as in the case of the Tours Bibles and perhaps in the case of Gospelbook exemplars disseminated from Wearmouth/Jarrow).

Free from the confines of labelling of orthodoxy, the early rescensions of either principal text strand could be modified or glossed as need dictated, Gregory the Great stating, in his *Moralia in Job*, that he had used Jerome's text as his basis but had no hesitation in varying it in accordance with the Old Latin where this accorded with his own moral and ascetic interpretation (e.g. 'unto us is born a saviour' instead of Jerome's 'unto you', Luke 2.11).[11] Such an approach, as well as the familiarity of tradition and orality, may have played a role in determining some of the places where the Lindisfarne Gospels departs from the Vulgate text of its main exemplar. Another important factor to bear in mind is the influence of the performance of the liturgy itself. De Hamel has suggested that the dissemination of the 'Vulgate' version favoured in what is known as the 'Italo-Northumbrian' family of texts may have had a lot to do with its use within the reformed liturgy introduced under Roman influence and practised at Wearmouth/Jarrow and other Northumbrian centres from the late seventh century onwards.[12]

Some of the Lindisfarne Gospels' variant readings may represent those with which their scribe was familiar prior to his obtaining a new exemplar which was a comparatively good representative of Jerome's version of the Vulgate. The influence of another rescension can also be seen in the arrangement of the Lindisfarne Gospels' sixteen-page Canon Tables and perhaps in some of its textual variants. This was the New Testament edition by Victor of Capua (*c.*547) which conflated readings from a Vulgate version of the four Gospels to form a Gospel harmony (or diatessaron, not an influential text until the central Middle Ages). Such a text is to be found in the form of the Capuan Codex Fuldensis, which was probably in England during the early seventh century.[13]

Wearmouth/Jarrow and the Ceolfrith Bibles

Another early Christian biblical editor of note was Flavius Cassiodorus (*c.*485–580), a Roman Senator of Squillace who served under the Ostrogothic ruler, Theodoric, but who retired in the face of the Byzantine wars to found a monastery on his estate, known as the Vivarium (named for the fishponds which were a feature of its civilised lifestyle). A key figure in the establishment of an approach to biblical studies founded upon the syllabus of the liberal arts, and an influential advocate of responsible copying and dissemination of texts, his textual intervention was more concerned with the form and mechanics (orthography, latinity) of the text, than with its actual revision. His own exegetical works take the Old Latin as their basis, his 'Novem Codices' or nine-volume copy of this text being prepared as his own working copy. He was also responsible for producing an illustrated one-volume Bible – the *Codex Grandior*, a copy of which Ceolfrith is thought to have brought back from Rome to Wearmouth/Jarrow – the Old Testament of which was based upon Jerome's earlier Hexaplaric version, based on the Septuagint. The Gospels in the *Codex Grandior* are thought to have been the Vulgate and the rest of the New Testament probably Old Latin. Cassiodorus also produced a smaller one-volume Bible ('pandectam … minutiore manu') which was Vulgate throughout. That the pandect brought by Ceolfrith to Wearmouth/Jarrow was the *Codex Grandior*, rather than Cassiodorus' smaller pandect, is indicated by Bede's reference to a picture of the Tabernacle which he had seen, and which was copied in the Codex Amiatinus (ff. 2v–3r), corresponding to one which Cassiodorus said he had included in the *Codex Grandior*.[14]

However, the editors/makers of the Codex Amiatinus did not use the Hexaplaric text (Jerome's revision of the Old Latin on the basis of the Hexaplaric Septuagint) of the *Codex Grandior* but substituted a primarily Vulgate version of the text. It is possible that reference was made to Cassiodorus' smaller pandect, although there is no firm evidence that there was a copy of this in Northumbria (Bede simply saying that Ceolfrith added three pandects to the one he brought from Rome), and an analysis of Amiatinus indicates that its component texts are likely to have been compiled from a variety of sources.[15]

Its Gospels relate to those in the Lindisfarne Gospels (which include feasts thought to relate to the Naples area, whence the source for both seems to have originated).[16] In Amiatinus the Gospels are preceded by a Majesty miniature,[17] the Novum Opus, Canon Tables on seven pages, then the Plures Fuisse, the Gospel prefaces (argumenta) partly edited to agree with early Irish versions,[18] and Capitula Lectionum (which agree with the Lindisfarne Gospels; the lists of Neapolitan feasts are, however, omitted).

The varied textual affiliations of the Codex Amiatinus, which has, in the absence of fuller evidence, to be taken as representative of the other two Ceolfrith Bibles, indicate that, rather than undertaking a direct copy of any one of Cassiodorus' major oeuvres, as has often been suggested, the scriptoria of Wearmouth/Jarrow conceived of a major

editorial project which would locate them within the prime lines of transmission of the sacred texts. They may have been inspired to produce uncharacteristic and ambitious single volume Bibles in emulation of the *Codex Grandior*, and they may have made reference to this, and to any other of Cassiodorus' biblical works that they possessed, but as one of a number of sources. Amiatinus was not an antiquarian facsimile of an Italian pandect (such as Cassiodorus' smaller pandect), or even an adaptation of the textual form of one earlier edition into the codicological format of another (e.g. a reworking of Cassiodorus' *Novem Codices* in the single-volume format of the *Codex Grandior*), but an active, dynamic work of scholarly compilation and emendation. The Ceolfrith Bibles were in themselves a 'new edition' (see figs 30, 31, 121). They represented a version of the Vulgate, and indeed are still viewed as good early witnesses of such a text, but they achieved this by a complex process of excavation, compilation and interpretation, working from a number of sources in emulation of, and probably with reference to, Jerome's own process of distillation from a plethora of varying sources from different 'vulgata' traditions. It is not surprising that the Ceolfrith pandects should exhibit the influence of work undertaken on individual books by the leading scholar of the day, Bede, who was undoubtedly a driving force behind the enterprise initiated by his beloved abbot, Ceolfrith (see Meyvaert 1976 and Marsden 1995, 1995a and 1998).

The famous 'Ezra' miniature in the Codex Amiatinus (f. V recto, see fig. 30a)[19] should perhaps be read less, as some commentators have suggested,[20] as an image of Cassiodorus, adapted with reference to the great preserver of the Judaic Scriptures, Ezra the scribe, but as a homage to the continued process of rediscovery and emendation of sacred text, continually inspired by the Holy Spirit, in which the Ceolfrith Bibles played a significant role. The bookcase, or *armarium*, containing its nine volumes simultaneously makes reference to Cassiodorus' work but labels them in an arrangement that does not accord with the clues given in *Institutiones*, his 'manual', to the organisation of his actual *Novem Codices*. Instead the labelling makes reference to book titles favoured by other writers, such as Augustine:[21] the number nine symbolically represents the *Novem Codices*, while the labelling indicates that they were part of a fluid, living tradition. That the image of Ezra is likely to have originated at the Vivarium is reinforced by Cassiodorus' *Institutiones* (5.22, 12.3), in which he gives various lists of the sacred books and refers to an image of the Tabernacle and to diagrams of the arrangements of the biblical books, all of which are perpetuated in the Codex Amiatinus. This is an important, if apparently minor, adjustment to perception of the image, for it indicates that Cassiodorus and those responsible for the Ceolfrith Bibles were not attempting to provide an 'authorised' edition, but an authoritative one, drawing and improving upon the best sources they could find in order to carry forward the process of revelation and understanding of the divine Word. It would have been anathema to them to view their work as the 'last word' – the process of transmission and exploration was a divinely inspired one, which had to be perpetuated.

Fig. 63. Lindisfarne Gospels (BL, Cotton MS Nero D.iv), f. 205v, erased decorated initial 'M'
(faintly visible beneath the two upper capital lines) in the prefatory matter to one of the
Gospels, the function of which was originally misunderstood by the artist-scribe who
then replaced it with a smaller minor initial (bottom left).

This is significant when we consider the relationship of the Lindisfarne Gospels to the
Ceolfrith Bibles, their closest textual relatives, and to other Insular Gospelbooks. Are the
Lindisfarne Gospels themselves a 'facsimile' of the Gospels component of the Ceolfrith
Bibles, or of the Italian, possibly Neapolitan, Gospelbook which was the source for this
part of their texts – as one author has recently put it 'a complete sixth-century Gospel
book in disguise'?[22] Should 'achieving' close proximity to Jerome's Vulgate necessarily be
considered as an evolutionary advancement against which other texts should be measured?
The answer on both counts is no.

As we shall see, the Lindisfarne Gospels' unique arrangement and decorative enhance-
ment of prefatory matter seems to have been constructed in order to emphasise Jerome
as the ultimate authority for its particular version of the Vulgate text, and to stress the
function of the Eusebian Canon Tables which he espoused as a means of navigating and
comprehending the inter-relationships of the four Gospels (see pls 2–7). The Lindisfarne
Gospels preserves the recollection of its principal textual exemplar, which was probably a

southern Italian Gospelbook which came via Wearmouth/Jarrow or was one of their scriptoria's copies of it, including some distinctive matter relating to Italian liturgical feasts (of probable South Italian/Neapolitan character) which were probably retained as a means of enhancing the perceived authority of an exemplar from an 'exotic' background, the books of which were venerated because of its importance within the early Christian tradition. Changes which he made to his decorated initials suggest that the artist-scribe did not really understand them and did not fully grasp the way in which the lections for the feasts related to their accompanying rubrics, associating the latter with the following rather than the preceding texts and having to erase the large initials he had drawn once he realised his mistake (see fig. 63).[23] If such features were retained despite being unfamiliar (or, presumably, useful), either it was important to signal that such an 'exotic' exemplar had been consulted, or its integrity was being preserved through respect, even if some of its prefatory texts were redundant.

The Lindisfarne Gospels can, therefore, be seen on one level as a conscious statement of Italian textual influence and of affiliation with Jerome's version of the Vulgate, but they are not exclusively a copy of a single source, even for the texts, let alone for the highly individual decoration which, amongst other innovative features, represents the most ambitious attempt to articulate text by the ornamentation of script at text breaks that the world had seen and which may be discerned (from the discussion of layout and technique in chapter four and of the hierarchy of decoration in chapter five, below) to have been the result of innovative, original planning of layout on the part of its artist-scribe (see fig. 64). In this respect its closest relatives within the Insular corpus would appear to be the Book of Durrow and the Book of Kells (see pls 31, 32).

An important aspect of the Vulgate tradition which, although obvious, is worth remembering here, is that Jerome's work essentially represents a systematic attempt to translate and revise Scripture in the vernacular (the 'vulgar' language of common currency). We are used, when considering the medieval West, to defining 'vernacular' as ostensibly 'not Latin', or more correctly as not one of the 'linguae sacrae' (i.e. Hebrew, Greek or Latin, the languages used in the transmission of the sacred texts of the Judaeo-Christian tradition). This shift in perception of the status of Latin (the basis of the emergent 'romance' languages) owed a great deal to Jerome and to Popes Damasus and Gregory the Great in their promotion in the west of Latin versions of Scripture and in raising 'vulgar' Latin to literary heights.[24]

The interaction between literacy and orality is important here. The prefaces to the Gospels known as the Monarchian prologues (which summarised conventional wisdom concerning the authorship of the four Gospels), which are embedded in the argumenta preceding each of the Gospels in Lindisfarne, reinforced the idea of committing oral tradition to writing, stating as they do the authority from whom each evangelist heard their Gospel – thereby supporting Jerome's campaign to translate into the vernacular, as part

Fig. 64. Lindisfarne Gospels (BL, Cotton MS Nero D.iv), f. 253r,
text page showing layout of minor initials.

of this line of initially oral transmission. Indeed, most people's knowledge of Scripture throughout the Middle Ages would continue to be oral and visual, rather than written. This might relate to the inclusion in the Lindisfarne Gospels' Matthew miniature of the inspiring or dictating figure (see pl. 8). According to the Monarchian prologues Matthew heard his Gospel from Christ. One level of reading of this part of the Lindisfarne Matthew image might therefore support an identification of the figure behind the curtain with Christ who simultaneously conveys the interpreted meaning of the Old Testament. This would accord with other layers of multivalent interpretation which I have proposed in chapter five, below, for this miniature.[25] This relationship is emphasised further in the Touronian Vivian Bible (or 'First Bible of Charles the Bald') of 845 which contains a miniature (Paris, Bibliothèque Nationale de France, MS lat. 1, f. 3v) illustrating the inception and diffusion of Jerome's Vulgate in which he is shown as an author, teacher (of male and female pupils) and distributor of copies of his work which fill the churches.[26] This also depicts an *armarium* containing earlier written authorities, as does the Amiatinus Ezra miniature (see pl. 30a) which I have in turn related to the Lindisfarne Gospels' enigmatic figure behind the curtain.[27] The Vivian Bible also contains an image of King David composing the Psalms by dictating them to scribes – another important iconography relating to the inspired transmission of text which finds precursors in two English manuscripts of eighth-century date, the Durham Cassiodorus and the Vespasian Psalter. An appreciation of the Vulgate tradition as part of a continuing process of interaction with orality and with transmission in the vernacular might conceivably have had some bearing on contemporary work to translate Scripture into the English vernacular, signalled by Bede's translation work on John's Gospel, which would lead eventually to Aldred's gloss. The latter opens his colophon on f. 259r of the Lindisfarne Gospels with a Latin synopsis of the Monarchian prologues outlining the process of transmission, which he translates into Old English (see fig. 45a). In associating himself with the names of the three figures to whom the making of the volume is ascribed, Aldred presents himself as the fourth evangelist,[28] John, beloved of Christ, and places himself, and the English language, within that direct line of transmission from the divine to humankind.

Julian Brown pointed out that the Lindisfarne Gospels' evangelist miniatures contain Greek inscriptions, but written in Latin characters with some Latin endings, and commented that this could be a local innovation.[29] If so, this would parallel its approach to the fusing of roman capitals and runic features for the display script used here and for the Gospels opening display pages and incipit/explicit rubrics. There may also be an implicit intention of thereby symbolically placing the English vernacular in the tradition of translation, from Greek, to Latin, to English, and/or the route of transmission of Scripture from its ultimate sources (the evangelists and their sources of inspiration outlined in the Monarchian prologues), through the Greek, Latin and English (/Germanic) speaking worlds. The script used would thus visually convey the babble of tongues of the Tower of

Babel, reconciled and made mutually intelligible by the power of the Holy Spirit, as at Pentecost, and by the sending out of the Apostles to the farthest corners of the earth to preach the Gospel.[30] In these islands, thought then to be the utmost extremities of the known world, this apostolic process had reached fruition.

The subsequent Vulgate tradition

If the Lindisfarne Gospels represent a particular moment of celebration of Jerome's version of the Vulgate, it was not a frozen one. The complex interaction of textual rescensions continued and it would appear that in some Insular Gospelbooks there was either a tradition of adapting texts of one sort to another, perhaps more familiar or used form, or perhaps of even turning these volumes, by correction against another version, into partially 'parallel' or comparative texts for study purposes.[31] Many 'mixed' texts continued to be copied and were, themselves, subject to further admixture from other versions of the Latin Gospel texts.

Alcuin of York, the English scholar who was so valued by Charlemagne and made Abbot of Tours (796–804), used both the 'Mixed Italian' and 'Italo-Northumbrian' traditions which were familiar to him in England when himself undertaking a single-volume revision of the Vulgate Bible, which he completed in 800. In this he engaged in a process of scholastic correction, replaced Jerome's Hebraicum Psalter with the Gallicanum, based upon the Hexaplaric Greek, and added verse prologues and colophons. That he is likely to have been influenced in this by the Ceolfrith Bibles is indicated by the fact that he appears to have seen one of them at York, for his *Carmen 69* quotes the inscription surrounding the Codex Amiatinus' Ezra miniature. [32]

Alcuin's was not the only version in use in an early Carolingian context. The Court School drew heavily upon the English experience and Theodulf of Orléans upon the Mixed Spanish tradition of his homeland when preparing his revised text. Abbot Maurdramnus of Corbie also undertook a six-volume revision of the Bible, in the course of which some of the earliest experiments in devising a suitable script for rapid copying and ease of legibility – caroline minuscule – occurred.[33] But by the end of the ninth century the Alcuinian rescension was becoming the norm throughout much of Europe, its rate of penetration elsewhere being commensurate with that of Carolingian influence and Church reform generally. Although not officially promoted as an 'authorised' version, it progress-ively assumed something approaching the status of one and exerted significant influence upon subsequent transmission. It was to form the basis of the scholastic tradition of the twelfth-century 'Paris Bible' and thereby of the exegetically based studies conducted at Paris University.[34] This is not the place to embark upon a summary of the transmission of biblical texts during the High Middle Ages, but should serve merely to give a rudimentary indication of where the Lindisfarne Gospels stands in the broad picture. As noted above,

the Lindisfarne Gospels contributed also to another major strand of transmission, the emergence of a new vernacular Bible, with the addition of Aldred's gloss – the earliest surviving example of the Gospels in the English language.

The Lindisfarne Gospels as a witness to the Vulgate

The Gospel text of the Lindisfarne Gospels thus presents us with what its makers, and modern scholarship, understood to be one of the earliest and best witnesses to St Jerome's Vulgate version of the Gospels, and belongs to what is known as the 'Italo-Northumbrian' textual family.

Anglo-Saxon England seems, on the basis of the surviving evidence, to have received its knowledge of the Latin Gospels via three routes: the 'Italian Mixed' tradition, associated with the Augustinian mission based at Canterbury and St Wilfrid's 'romanising' activities; the 'Mixed Irish/Celtic' which had grown up in the Celtic Church (which also evinces familiarity with the other traditions); and the Italo-Northumbrian editorial drive focusing, for the Gospels, upon Jerome's Vulgate version and emanating from Wearmouth/Jarrow. Given that the process of transmission was an organic and dynamic one, no single tradition assumed primacy, possibly not even in the key scriptoria with which they were associated. As with most matters appertaining to the Insular environment, permeation, imagination and synthesis are paramount, and we attempt an over-rigid classification and distinction at our peril. One feature which was appreciated within this fluidity was authority, in terms of a respect to be accorded to key figures within the Christian tradition (be they the early Church Fathers, or fathers of Christianity within the Insular milieu, such as Columba and Augustine of Canterbury).

Jerome himself was well aware of the emergent medieval creative tension between 'traditio' and 'innovatio' and was at pains to justify and document his own editorial processes, as outlined in the 'Novum Opus' open letter to Pope Damasus (see pl. 3). Bede was equally sensitive to such needs, especially as, like Jerome, he attracted significant controversy and criticism for presuming to make an active contribution to textual transmission and criticism. His letter, or 'apologia', to Bishop Acca of Hexham concerning his commentary on Luke, is a moving plea for understanding on the part of a scholar who is evidently hurt, and somewhat bemused, by the misunderstanding by others of his purpose and of his own heightened perception and comprehension of the tradition within which he is actively working.[35] He writes that in those who translate, expand or humbly copy Scripture the Spirit continues to work, as in the biblical authors who were first inspired to write them.[36] Perhaps only those who had devoted their lives to becoming, simultaneously, a living ark of Scripture and a vessel capable of emptying itself completely in order to be filled with the Spirit, could fully sympathise with his vision and working methods,[37] then as now. Bede was part of a living tradition, in which the inspiration accorded others

needed to be valued and duly acknowledged and engaged in a symbiotic relationship with the inspiration of the contemporary writer. The popular epithet of 'the father of English History' accorded to Bede pays tribute to aspects of his methodology which have informed the discipline of history writing. One of these is the recognition of the need to verify, assess and record sources, whether primary or secondary – a significant contribution to the development of footnoting and bibliography.

That Celtic ecclesiastics were similarly aware is adequately conveyed by the emphasis placed upon the event which triggered St Columba's influential *peregrinatio* (or voluntary exile for Christ) – the charge of plagiarising a version of the Psalter from St Finian of Moville, which is said to have led to one of the biggest blood-baths in early Irish history, the Battle of Cul Dremne, the charge probably acting as a pretext for the playing out of dynastic politics, Columba being a prince of the powerful Uí Neíll. During the sixth century, Jerome's Bible was introduced to Ireland by Finian of Moville, probably via Italian sources. Columba was thus claiming credit for the introduction of a new textual rescension as his work, indicating the prestige attached to such work of scholarly transmission. Columba laying claim to Hieronymic tradition might explain the use of versions of the Vulgate Gospels text in the Book of Durrow, where they are combined with prefatory matter of Irish/Celtic character.[38] The Vulgate was not widespread in Ireland, however, until the tenth century. Instead a family of texts developed combining elements from the Old Latin and Vulgate traditions, which has been characterised as the 'Irish' or 'Celtic' mixed text.[39] A particularly distinctive feature of the prefatory matter of this textual family was the inclusion of the 'glosses on Hebrew Names'.[40] Jerome had composed a 'Liber de Nominibus Hebraicis', inspired by the work of Philo and Origen, which explained the meaning of the Hebrew Names in both Testaments.[41] This presumably influenced the Irish 'Hebrew Names'. The Old Latin featured Græcised versions of these names, but Jerome brought them into line with Hebrew originals (rabbinic tradition included the practice of expanding upon the exegetical meaning of such names and related to this pronunciation was a major concern, given the absence of vowels from Hebrew script). There are no lists of Hebrew names in the Lindisfarne Gospels.

The comparatively high frequency of colophons within manuscripts with Celtic affiliations, and some of their Anglo-Saxon counterparts, might be connected to the impulse to declare authority by association with named individuals. The Book of Durrow combines its version of the 'Vulgate' Gospels with Irish prefatory matter accompanied by a Columban colophon, its arrangement being closely related to that of the Book of Kells.[42] The Echternach Gospels contain, as the primary text (not the corrections), another version of the Vulgate Gospels (generally similar to that in the Lindisfarne Gospels but not close enough to suggest a shared exemplar), with punctuation *per cola et commata* and a colophon, possibly by Cassiodorus, saying that it had been copied from one corrected against a copy owned by Jerome and subsequently in the library of Eugippius, Abbot of Lucullanum near

Naples. These are combined with Irish, Columban prefaces which are again related to those in the Book of Kells.[43]

Seen in this context, the Lindisfarne Gospels, with their textual and stylistic affiliations, becomes less an attempt to 'facsimilise' an Italian copy of Jerome's Vulgate, than a sophisicated attempt to celebrate and document a particular authority. They do not now contain an original colophon, other than that added by Aldred which might itself be seen as a later statement of credentials within the Cuthbertine tradition, but the distinctive arrangement of prefatory matter which is distinguished, along with the opening suites of the Gospels themselves, by the greatest concentraton of decoration, declares unequivocally their affiliations with St Jerome (see pls 3–5). This should not be viewed simplistically as a declaration of *romanitas*. Columba's close connections with the Hieronymic tradition have already been mentioned. Rather it should be seen as an attempt to draw even closer to the authority of this renowned figure because of his seminal role in the universal dissemination of Scripture. This was in no guise the property of any localised tradition.[44]

The Vulgate Gospels text used in the Lindisfarne Gospels is encountered in several works in uncial script by the Wearmouth/Jarrow scriptoria – the Ceolfrith Bibles, the Cuthbert Gospel of St John (Stonyhurst Gospel), the Utrecht Psalter fragments and the fragments of Luke appended to the Durham Gospels (see figs 17, 30, 31, 46, 65, 121).[45] As we have seen, a Vulgate text is also found in the Echternach Gospels which have copied a colophon stating that the ultimate source was owned by Jerome and was subsequently in the vicinity of Naples. It is tempting to think of this as the elusive source of the Lindisfarne Gospels' text, with its Neapolitan feasts (as indeed Julian Brown suggested in *Cod. Lind.*), but the lack of close correpondence between their Gospel texts would tend to argue against this, as also does the absence from the Lindisfarne Gospels of the prized colophon linking the work back to Jerome, an association not readily relinquished, one might imagine. The feasts are omitted in the Echternach Gospels, but this would have occurred because they ally their Vulgate text to a prefatory suite of the Irish/Celtic tradition. The Lindisfarne Gospels, on the other hand, extend the Jerome association and the authority of their source by adopting a prefatory suite celebrating the Jerome/southern Italian links. Did they copy the texts of this suite and their arrangement directly from an exemplar, or is this an original compilation?

In the Lindisfarne Gospels the prefatory matter is arranged as follows: Jerome's Novum Opus; his Plures Fuisse; the letter of Eusebius to Carpianus; the Canon Tables; Mt Gospel preface (the Argumenta); Mt Gospel chapter lists; Feasts. Each of the other Gospels is also prefaced by the appropriate Argumenta, chapter lists and feasts (see pls 3–5). The prefatory matter is similar, in part, to that of the Codex Amiatinus, but is elevated to a status commensurate with introducing a Gospelbook rather than for inclusion within a Bible. It does not, however, replicate Amiatinus faithfully in respect of prefatory matter (of which Lindisfarne contains more components) and it is unlikely to have been the direct model.

Fig. 65. The Durham Gospels (Durham MS A.ii.17), f. 2v. (Reproduced by kind permission of the Dean and Chapter of Durham Cathedral)

The Gospelbook used at Wearmouth/Jarrow as an exemplar for that part of the Bible's texts is more likely to have been the source loaned out for consultation, especially given the logistics of copying from so large a tome as one of the Ceolfrith pandects. In order to ascertain the sort of prefatory matter that Wearmouth/Jarrow associated with the Gospels, it is instructive to consider the Burchard Gospels (Würzburg, Univ.-Bibl. M.P.Th.F.68), a sixth-century Italian Gospelbook to which prefaces were added at Wearmouth/Jarrow at the end of the seventh century (see figs 24, 72). These resemble those in the Lindisfarne Gospels, but omit the Canon Tables and the Neapolitan feasts and group the chapter lists for all four Gospels together, rather than placing them before each one as the Lindisfarne Gospels do. The book appears to have travelled to an Insular centre on the Continent during the eighth century, where Canon Tables were added. Wearmouth/Jarrow is known to have provided copies of Bede's work for use in the mission fields; presumably it supplied biblical, patristic and liturgical texts too, including second-hand ones.

Another Italian source of relevance to the Lindisfarne Gospels is the Codex Fuldensis. As we shall see, the Lindisfarne Gospels' Canon Tables on sixteen pages are related to those in the Capuan Codex Fuldensis (Fulda, Landesbibliothek, Bonifatianus 1, see fig. 66), a sixth-century southern Italian text being the New Testament edition by Victor of Capua (c.547), this copy possibly being made for Victor himself, perhaps at Capua where he was bishop (541–54), and subsequently belonging to Boniface (see fig. 66). It contains a Gospel harmony (or diatessaron, conflating passages from all four Gospels into a continuous text) based upon an essentially Vulgate Gospel text, similar to the version used in the Ceolfrith Bibles and the Lindisfarne Gospels.[46] Victor quoted Eusebius-Carpiano in his preface and prefixed an extract from the Novum Opus to the Canon Tables themselves. An echo of such preoccupations with the relationships between the four Gospels, the role of the Canon Tables and of explicatory introductory matter in clarifying and exploring this relationship, may be heard reverberating throughout the Insular Gospelbook tradition, not least in the Lindisfarne Gospels, where the decorative scheme is also placed at its service.

These surviving witnesses to the sort of Italian models known to have been available in an Insular orbit at around the time the Lindisfarne Gospels were made might imply that, like the Ceolfrith Bibles, they were drawing together features from at least two principal sources and harmonising them into a formal programme, impressively presented. This is not to say that any of the Italian volumes cited were actually consulted during the making of the Lindisfarne Gospels, or that there could not have been another exemplar which contained all of the Lindisfarne Gospels' textual features – given the low rate of survival of material of this period it would be rare and fortunate indeed to identify firmly one book which was the immediate exemplar for another 'survivor'[47] – but the balance of probability (always a capricious scale) would suggest that, like the other Insular books discussed, it was 'mixing and matching' to a certain extent, in order to achieve its own distinctive statement.

Fig. 66. Codex Fuldensis (Fulda, Landesbibliothek, Bonifatianus 1), ff. 5v–6r, a 6th-century southern Italian New Testament edition by Victor of Capua. Double page spread to show Canon Tables. (Photo: Hochschul-u Landesbibliothek Fulda/Bildarchiv foto Marburg)

The only book which substantially replicates both the Gospel texts and prefatory matter of the Lindisfarne Gospels, including the distinctive Neapolitan feasts, is British Library, Royal MS 1.B.vii (see figs 25, 67). Its Canon Tables are moved to the end of the prefatory sequence, however, and differ from those of the Lindisfarne Gospels, being contained on twelve pages, the 'shorter Latin series', rather than the Lindisfarne Gospels' sixteen.[48] This volume is either directly descended from the Lindisfarne Gospels or, if not, would suggest that there was a complete exemplar for much of the Lindisfarne Gospels, other than the

Fig. 67. BL, Royal MS 1.B.vii, f. 10v, Canon Table from a Northumbrian Gospelbook, first half of 8th century.

Canon Tables. Royal 1.B.vii is generally considered to have been made in Northumbria during the early eighth century. It contains a record of manumissions granted by King Athelstan in 924 and was said by Wanley to have been donated by him to Christ Church, Canterbury.[49] Northumbrian books had evidently reached southern England before Athelstan's visit to Chester-le-Street. Another book that closely echoes the Lindisfarne Gospels' textual arrangement is the later eighth-century St Petersburg Gospels (see figs 26, 68), which also differ in respect of the Canon Tables, in a fashion akin to Royal 1.B.vii (twelve pages and at the end of the sequence) and which omit the 'Neapolitan' feasts.[50] The Burchard Gospels, an Italian book to which prefatory matter was added at Wearmouth/Jarrow, resembles the Lindisfarne Gospels and these other volumes in its texts, but also omits the Canon Tables (which were subsequently supplied on the Continent)[51] and the feasts (see figs 24, 72).

Another volume which may be related to the textual stemma of the Lindisfarne Gospels is the Gotha Gospels (Gotha, Forschungsbibliothek, Cod. Membr.1.18, see figs 27, 69), which Nancy Netzer has identified as containing unusual textual features paralleled in the Lindisfarne Gospels and Royal 1.B.vii. These three volumes arrange their prologues in the order of Novum Opus, Plures Fuisse and Eusebius-Carpiano. Their capitula lectionum

168

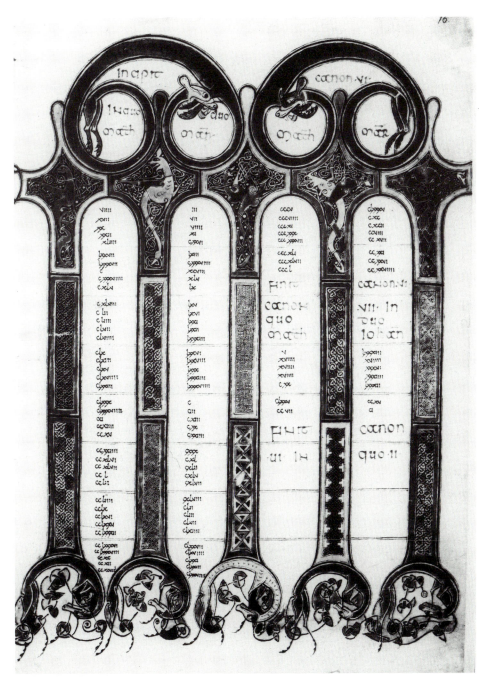

Fig. 68. The St Petersburg Gospels (St Petersburg, State Library, Cod. F.v.I.8),
f. 16r, Canon Table. (Photo: St Petersburg State Library)

Fig. 69. The Gotha Gospels (Gotha, Forschungsbibliothek, Cod. Memb.I.18), f. 118v, Luke prologue and capitula. (Photo: Forschungsbibliothek, Gotha)

agree, including the 'Neapolitan' Feasts, with chapter lists of De Bruyne's 'Family C' for Matthew, Mark and Luke.[52] In its actual Gospel texts, however, Gotha displays little correspondence to the Lindisfarne Gospels in its textual variants. If they were inspired by the same archetype for the arrangement of their prefaces, they do not both seem to have followed its Gospel texts. Nordenfalk attributed the provenance of the Gotha Gospels to Echternach and related their initials stylistically to those of the Trier Gospels, while Lowe ascribed it to Murbach, both favouring production in a continental centre under Insular influence.[53] Netzer did not, however, see it as closely related to the Trier Gospels, to which she ascribed an Echternach origin, preferring a Northumbrian origin on the grounds of its textual affiliations. Its style would tend to place it within the eighth century and later than the Lindisfarne Gospels. The decoration nevertheless has something of a Continental appearance to my eye and that, coupled with the provenance, suggests that it may be wise to conclude that the Gotha Gospels were the work of a scribe trained in Northumbria who may have been working either there or abroad.

The relationships between the Lindisfarne Gospels and these, its closest textual relatives, indicate that there is likely to have been a model at Wearmouth/Jarrow for the Lindisfarne Gospels' prefatory and Gospel texts and that this was reflected in the eighth-century Gospelbooks Royal MS I.B.vii, and the St Petersburg Gospels (and for the prefatory arrangement of the Gotha Gospels) but that it did not include Canon Tables which were supplied variously with reference to other sources (intriguing, as it contained both Eusebius-Carpiano and the Novum Opus, both of which deal with their use, implying that it had probably lost its set of tables before being consulted in Northumbria). In the Lindisfarne Gospels' case this was a volume containing the 'first larger Latin series',[54] which is generally found in the Greek Gospelbook tradition accompanied by the Eusebius-Carpiano preface.[55] These features are more likely, however, to have been derived from an Italian intermediary – something similar to the Capuan Codex Fuldensis.[56] Thus the available evidence would tend to suggest that the Lindisfarne Gospels' maker was consulting at least two major exemplars of probable Italian origin in order to achieve the desired arrangement.

The textual stemma suggested is of a southern Italian exemplar which became available at Wearmouth/Jarrow where it was edited and some of its prefatory matter reordered or discarded. This line of transmission was followed by the Burchard Gospels (a sixth-century Italian volume with substantial early eighth-century Wearmouth/Jarrow annotations) and the St Petersburg Gospels (perhaps made in later eighth-century Mercia, as its palaeography and decoration suggest). The unaltered southern Italian exemplar (or an unedited Wearmouth/Jarrow copy) subsequently became available to the makers of the Lindisfarne Gospels, and to those who made Royal I.B.vii (thought to be a slightly later Northumbrian work) and the Gotha Gospels (likewise probably a slightly later Northumbrian work).

All of these derivative volumes employ different sources to plug the gap in the original

exemplar which lacked its Canon Tables, and in the Lindisfarne Gospels' case this was a book closely resembling, if not actually, the Capuan Codex Fuldensis. Echoes of a 'Capuan' co-exemplar can also be detected in the Lindisfarne Gospels' Gospel texts, see Appendix 2 where the Codex Fuldensis ('Jf') is the closest known earlier source for some of the Lindisfarne Gospels' textual variants (e.g. Matthew 3.5; 3.9; 16.18; 27.29; Luke 6.37). On several occasions the Lindisfarne Gospels introduces its own unique textual variants (see the final column of Appendix 2). Some of these are explicable as slips or omissions during copying, but some are obviously intentional, such as the two variants in John 20.23 and 20.25 (see also Mark 2.13; Luke 6.35; 10.42; 24.10). The use of two major exemplars might also serve to explain the discrepancies which occasionally occur between the Lindisfarne Gospels' Canon Tables and the marginal numeration of Canon and section numbers (see Appendix 2, final column of the Text Table on the CD-Rom, and discussion under 'Canon Tables', below).

It should be noted that the marginal apparatus of the Lindisfarne Gospels (indicating the Eusebian sections into which the text was divided, the numbers of the Canon Tables they appeared in and any similar occurrences in the other Gospels) generally accords closely with its Canon Tables and that, contrary to the view sometimes stated that it would not have functioned well as a working volume and was merely for show, it would have functioned well both for reference and liturgical purposes. Even if, as the focus of a cult, it was not meant to be frequently used, its meticulous artist-scribe, who seems to have been so aware of the implications and responsibilities of participating in the transmission of Scripture, is likely to have done his best to ensure that it was as correct as possible in every way, to be pleasing to the Lord.

The Lindisfarne Gospels' textual stemma

The arrangement of prefatory matter preserved in the Lindisfarne Gospels, and its elevated status within the decorative programme, seems to have been constructed in order to

emphasise Jerome as the ultimate authority for its text, and to stress the function of the Eusebian Canon Tables which he espoused as a means of navigating and comprehending the inter-relationships of the four Gospels. Ironically, by the time this arrangement was encountered in an exemplar at Wearmouth/Jarrow the Canon Tables were already missing and had to be supplied with reference to other sources. Such Canon Tables were already augmenting and supplanting in importance the traditional Monarchian prologues, represented in the Argumenta preceding each Gospel in the Lindisfarne Gospels, and other texts emphasising the Gospel harmony, such as the diatessaron of Victor of Capua. Perhaps as part of a rationalisation of this process the Lindisfarne Gospels' maker placed the tables after the three prefaces (Novum Opus, Plures Fuisse and Eusebius-Carpiano) which justify and explain them, as well as the Vulgate version of the Gospel texts. Only then are we given the preliminary matter proper to each Gospel (Gospel prefaces/Argumenta and chapter lists/Capitula Lectionum), ahead of the opening of each individual Gospel, including some distinctive matter relating to Italian liturgical feasts (of probable S. Italian/Neapolitan character), probably retained as a means of enhancing the perceived authority of an exemplar.

The Lindisfarne Gospels can, therefore, be seen on one level as a conscious statement of Italian/Vulgate affiliation, but they are not solely a copy of a single source, even for their texts, let alone their highly individual decoration which uniquely elevates the prefatory matter to an homogenous, if still ancillary, status with the Gospels themselves. The visual appearance of the Lindisfarne Gospels is remarkably unified and sustained, creating a celebration of what was perceived to be the Hieronymic version of the Vulgate tradition, of the routes by which it had been transmitted, and of the complex inter-relationships between the four individual Gospels. Several sources were probably consulted and are paid homage to via visual and textual references, but more as part of a creative process, than one of straight copying. [57]

As perusal of the textual collations listed in the final column of the Text Table on the CD-Rom in Appendix 2 will show, the Lindisfarne Gospels' (Ny) highest rate of agreement in their variants are with the Codex Amiatinus (Na), then Royal 1.B.vii (Nr). For Matthew and Mark these volumes also agree closely with the first hand of the Northumbrian Durham MS A.II.16 (Nd and also, if somewhat less frequently, with its other two hands, Nef), for Luke with the Wearmouth/Jarrow leaves appended to the Durham Gospels, Durham MS A.II.17 (Nz), with the parts of Matthew and John contained in the Wearmouth/Jarrow leaves attached to the Utrecht Psalter (Nu), and for John with the St Cuthbert (or Stonyhurst) Gospel (Ns) with which Lindisfarne often agrees against the Codex Amiatinus. Other of the Lindisfarne Gospels' textual variants, where they depart from the Vulgate and its Wearmouth/Jarrow affiliations, find their closest parallels within works of the 'Irish/Celtic' mixed family and of earlier Insular traditions, such as the Bobbio Gospels in Milan, Ambrosiana I.61 sup. (from the Irish monastery of Bobbio

Fig. 70. BL, Cotton MS Tib.B.v, f. 76r, fragment of 8th-century Northumbrian Gospelbook,
with compressed script (10th-century Old English documents relating to Exeter
are entered in the blank spaces elsewhere on the leaf).

founded by Columbanus, Ji), the Irish Old Latin Codex Usserianus Primus (Xr), Durham
MS A.II.10 (Ee), which incorporates at least two text types, the 'Vulgate' Book of Durrow
(Ed) and Echternach Gospels (Ge), and the non-'Celtic' 'mixed Italian' Durham Gospels
(Ef).[58] The Lindisfarne Gospels seldom agree in any of their variants with the Book of
Kells (Hq). Other volumes displaying a comparatively high frequency of agreement with
some of the Lindisfarne Gospels' variants are the St Petersburg Gospels (Ec), Cambridge
Kk.I.24/BL Cot. Tib. B.v f. 26/BL Sloane 1044 f.2 (an eighth-century Northumbrian
Gospelbook related palaeographically to the Durham Cassiodorus, Eh) and the Barberini
Gospels (Ev) (see figs 70, 106, 132).[59] The Gotha Gospels (Gu) display some
correspondence with the Lindisfarne Gospels' variant readings, but do not enjoy anything
like as close a relationship to them as Royal 1.B.vii. Despite a similar arrangement of
prefatory matter there is not a high rate of correspondence in variant readings with the
Burchard Gospels (Jw). Although they feature a text belonging to the 'Irish/Celtic' family,
the Lichfield Gospels (Hl) exhibit a certain limited level of agreement with the Lindisfarne
Gospels' variants, but this may be due to a shared recollection of an earlier Columban
tradition (see pl. 28). There is no further textual evidence for the Lindisfarne Gospels

having served as a model for Lichfield in the way that the relationship between the decoration of the two volumes might lead one to expect.[60]

Those volumes exhibiting a particularly close textual relationship to the Lindisfarne Gospels, other than those attributable to Wearmouth/Jarrow, namely BL, Royal MS 1.B.vii, the St Petersburg Gospels and the Prefaces of the Gotha Gospels, are commonly ascribed origins in Northumbria or (in the case of St Petersburg) Mercia (although a continental origin for Gotha cannot be excluded). They need not have copied the same actual exemplar, but they do stem ultimately from a common archetype. A possible migration southwards of the text type may have been due to the distribution of other, lost, copies made in Northumbria or to the possibility that Mercian scribes may have trained in Northumbria. Royal 1.B.vii had certainly travelled south by the tenth century, when it was presented by King Athelstan to Canterbury, and one of the Ceolfrith Bibles seems to have been presented by King Offa of Mercia to Worcester in the late eighth century (see figs 25, 31).[61] Although the Lindisfarne Gospels seem to have exerted some influence in terms of design there is little evidence to suggest that they ever acted as a textual exemplar themselves,[62] as might be expected if they were relatively inaccessible and served primarily as the focal point of a cult with an occasional liturgical role on special feast-days.

The overall impression from the Gospel texts in the Lindisfarne Gospels is that they adhered quite closely to a South Italian or Wearmouth/Jarrow model. The text accords closely with the Ceolfrith Bibles but frequently departs from their edited version in favour of other Wearmouth/Jarrow Gospelbooks: the leaves appended to the Durham Gospels – which certainly belonged to the community of St Cuthbert by the tenth century and which might be a candidate as the exemplar (see fig. 46); leaves bound into the Utrecht Psalter (perhaps added to it by Sir Robert Cotton, or earlier at Canterbury); and the St Cuthbert (or Stonyhurst) Gospel which may have been donated to St Cuthbert's shrine as early as the translation of 698 and certainly before 1104 when it was found in his coffin. If more had survived of the two former Wearmouth/Jarrow Gospelbooks, it is likely that the Lindisfarne Gospels would agree with them more than with the Codex Amiatinus. Occasionally the Lindisfarne Gospels depart from this tradition and favour readings which find their closest parallels within what is likely to have been an earlier Columban tradition. The books which subsequently adhered most closely to the Lindisfarne Gospels' text, as well as to the arrangement of prefatory material (but not to the Canon Tables) are, as we have seen, Royal 1.B.vii, the St Petersburg Gospels and (in the case of its prefaces) the Gotha Gospels. Given the lack of availability to them of the Lindisfarne Gospels' Canon Table solution, the textual agreement is more likely to have stemmed from an ultimate common source, the southern Italian Gospelbook available at Wearmouth/Jarrow, and its copies rather than from a consultation of the Lindisfarne Gospels themselves. A 'Capuan' exemplar for the Lindisfarne Gospels' Canon Tables may also have exerted an influence upon its Gospel texts, to judge from a number of variants which find their earliest

Fig. 71. The Durham Gospels (Durham MS A.ii.17), f. 76r, final 4 lines of page, showing the common correcting hand of the Durham Gospels and the Lindisfarne Gospels (above penultimate line). (Reproduced by kind permission of the Dean and Chapter of Durham Cathedral)

correspondence in the Codex Fuldensis (Jf, see pls 6, 7 and fig. 66). There is also some agreement in the Lindisfarne Gospels with variant readings which find their earliest parallels within the Old Latin tradition or the Italian 'mixed' tradition. Several of the later seem to relate to volumes from northern Italy (Aquileia?) (Jj, Jm, Jz, Je, Jt, Jk).

The celebration of Jerome's Vulgate version in the Lindisfarne Gospels was capable of absorbing other favoured readings. Furthermore, in the Insular world the complex interaction of textual rescensions continued. Soon after production Royal 1.B.vii's Vulgate text was corrected to the Mixed Italian type, akin to that found in the Durham Gospels, which was also corrected soon after production to the Vulgate, as found in the Lindisfarne Gospels (probably in a second phase of correction conducted by the same hand that had provided corrections to its original text and which also corrected the Lindisfarne Gospels, see fig. 71). The implication is that the Durham Gospels were written and corrected, the correcting hand then worked on the Lindisfarne Gospels and returned to the Durham Gospels for a second campaign of correction in accordance with the Vulgate text of the Lindisfarne Gospels or its exemplar. This was not a systematic or comprehensive correction, unlike that of the Echternach Gospels which presented an essentially Vulgate text and was subsequently corrected in its margins to the 'Irish/Celtic' mixed text. As already noted, it would appear that there was either a tradition of adapting texts of one sort to another, perhaps more familiar or used form, or perhaps of turning these volumes, by correction against another version, into 'parallel' texts for study purposes (even if only for limited readings). Cassiodorus had pointed in his *Institutiones* to the importance of works being corrected against one another, the consensus of the voices of different

versions coming together to achieve a harmony (rather than supplanting or shouting down one another) and in this, as in so many aspects of book production and use, he is likely to have influenced Northumbrian scribes.[63] In their own limited fashion the corrections to the Insular Gospelbooks might in a sense be seen as the precursors within the early western monastic environment of the glossed and parallel text forms which were to prove so important in the subsequent study of the Bible in the Middle Ages and which had been introduced in Origen's six-column comparative Hexapla.

Prefatory matter

Given that there were so many different textual rescensions of the Gospels in circulation it is hardly surprising that the components and arrangement of the prefatory matter introducing them should also have varied considerably and likewise their marginal chapter divisions and prefatory capitula lists, marginal apparatus and Canon Tables. These elements have been arranged into groups or families by scholars seeking to impose some sense of order and inter-relationship.

We have seen that the Lindisfarne Gospels adopt a distinctive and particularly lengthy arrangement of prefatory matter, consisting of Jerome's Novum Opus; his Plures Fuisse; the letter of Eusebius to Carpianus; the Canon Tables; Matthew Gospel preface (the Argumenta); Matthew Gospel chapter lists; Feasts (see pls 3–5, 13, 15). Each of the other Gospels is also prefaced by the Argumenta, chapter lists and feasts.

The Lindisfarne Gospels' Argumenta belong to the Italo-Northumbrian family (as found in Amiatinus) and are from what is known as the 'Monarchian Prologues' group.[64] The Capitula Lectionum, or chapter lists (containing brief synopses of the subject matter of each of the chapters into which the Gospels were divided), occur at the beginning of each Gospel (88 in Matthew; 46 in Mark; 94 in Luke; 45 in John). They are identical in the Lindisfarne Gospels and Amiatinus (according to De Bruyne these capitula, like the simultaneous use of Eusebius-Carpiano, Novum Opus and Plures Fuisse, all first occurred in Northumbria and were classified by him as 'family C').[65] McGurk has pointed out that the use of the words 'capitula lectionum' in the rubrics shows that they were intended to serve as a liturgical capitulary, i.e. to assist liturgical lection (the readings used in church services).[66]

Its closest relatives in respect of the arrangement of its prefatory matter are:[67]

Royal 1.B.vii, which differs only in moving the Canon Tables to the end of the sequence and in the nature of its canon tables; likewise the Gotha Gospels (Gotha, Forschungs-bibliothek, Cod. Memb. 1.18). These are also the only witnesses other than the Lindisfarne Gospels that include the 'Neapolitan' feasts.

Würzburg, f. 68 (the Burchard Gospels), Wearmouth/Jarrow prefatory additions to a sixth-

century Italian Gospelbook, which omits the Canon Tables (subsequently added in an Insular centre on the Continent in the eighth century) and 'Neapolitan' feasts and ends its sequence with the Gospel chapter lists of all four Gospels.

The St Petersburg Gospels, F.v.I.8, which, like Royal I.B.vii and the Gotha Gospels, move the Canon Tables (which in all are arranged differently to the Lindisfarne Gospels) to the end of the sequence, but which also omits the feasts.[68]

The Lindisfarne Gospels, Royal I.B.vii, the Gotha Gospels and the St Petersburg Gospels belong to the same family of chapter lists (De Bruyne's family C – containing 88 chapters for Matthew; 46 for Mark; 94 for Luke; 45 for John), and are joined only by the Wearmouth/Jarrow fragmentary Gospels in Utrecht, which are incomplete and only contain those for Matthew, which are family C.[69] Royal I.B.vii differs in some minor details from the the Lindisfarne Gospels capitula. In the Gotha Gospels and the St Petersburg Gospels the divisions in the text do not consistently accord with the family of chapter summaries, however.

Gospelbooks from the eastern Mediterranean (Greek, Armenian, Coptic, Syriac and Georgian) were usually prefaced by a quire containing the letter of Eusebius to Carpianus and Eusebius' Canon Tables. Jerome prefixed the Canon Tables to his Vulgate edition. His letter to Pope Damasus (the Novum Opus) outlines the purpose and use of the Canon Tables, and explains his principles of textual revision. His Plures Fuisse preface, which often accompanied the Novum Opus, comments upon the four evangelists. It rendered the Monarchian prologue to each Gospel potentially superfluous. These Monarchian Prologues were attributed to Priscillian and were accompanied by chapter lists for each Gospel, but refer to the Old Latin, even though they are often present in Vulgate texts such as the Lindisfarne Gospels where they occur in the Argumentum preceding each Gospel. The prefatory matter in eastern and early uncial Gospelbooks is usually codicologically distinct, occupying separate quire(s), and the Gospels each have their own set of discreet quires (to emphasise that they were by different authors and were originally on separate rolls, or books).[70] The Lindisfarne Gospels and the Burchard Gospels are unusual in adopting this codicological arrangement. In the Lindisfarne Gospels the only overlap is that the end of Mark and some of Luke prefatory matter share a quire, but not the Gospels themselves.

The prototypical early Vulgate Gospelbook would open with the Novum Opus and Plures Fuisse, with a set of Canon Tables, and would precede each Gospel with the appropriate prologues and chapter lists. Additional texts, such as Eusebius-Carpiano, the Pseudo-Jerome preface 'Sciendum etiam' and Hebrew Names appear later and spasmodically.[71]

The Canon Tables

Canon tables indicate which passages are represented in which Gospels. The numbers in the tables should correspond to numbers written in the margins adjacent to the Gospel passages themselves (the 'section' or passage numbers for that particular Gospel and those for the places where they occur in other of the Gospels). This is a concordance system, devised by Eusebius of Caesarea (Constantine's 'court bishop', d. 338/9), in which the Gospels are divided into numbered sections and parallel readings from the four Gospels are displayed in cross-referential tabular form. Canon I lists passages which appear in all four Gospels and subsequent canons show the agreements between three Gospels (canons II-IV), then between any two of the Gospels (canons V-IX), and then passages unique to individual evangelists (canon X). There are ten tables in all, imbued with the perfection of Pythagorean number symbolism.[72] The numbering of the passages and the agreements listed can vary and Canon Tables have therefore been grouped by scholars into different types.

The Lindisfarne Gospels' Canon Tables are arranged on sixteen pages and are related, but not identical, to those in the Capuan Codex Fuldensis (Fulda, Landesbibliothek, Bonifatianus 1)[73] with its Gospel harmony based on an essentially Vulgate Gospel text, similar to the archetype for the Ceolfrith Bibles and the Lindisfarne Gospels (see pls 6, 7 and fig. 66).[74] Although Fuldensis would appear to contain a set of Canon Tables specifically adapted by Victor for use with his diatessaron and these differ from the Lindisfarne Gospels' in having varying orders of canon numbers, the total of references numbered in each canon differs only slightly and Patrick McGurk has therefore argued that Fuldensis does indicate that a sixteen-page Canon Table sequence, with variable details, was known in sixth-century southern Italy and is likely to have been the Lindisfarne Gospels' model for this feature.[75] The differences in the ordering of numbers are generally explicable by virtue of the fact that Victor seems to have numbered passages in his diatessaron and then arranged the numbers in the tables in the order they occurred in his text, rather than the order in which they are encountered in the Gospels themselves. The Lindisfarne Gospels, or their Canon Table exemplar, therefore may have converted a specialist set of tables for use in a Vulgate Gospelbook. This may account for some of the limited instances (some are obvious errors) where the marginal numbers in the Lindisfarne Gospels differ from those in its Canon Tables (see Appendix 2, col. 5, Mt CXCIIII; Mk LVIIII; Lk CCXII; Lk CCXLVII, Lk CCLXXIIII, Lk CCCXXVIII, which suggest that two systems have been used and reconciled, with the exception of these slips).

Sections for which several alternatives are listed in the Canon Tables are often only marginally annotated for one, without the alternatives (see, for example, Lk CCLXXXII, Lk CCLXXXV; Lk CCXC; Lk CCCXXXVI; Jn XLVI; Jn LVII; Jn CXC). Prior to this Carl Nordenfalk had declared the Lindisfarne Gospels to be the earliest surviving representative of the 'first

larger Latin Canon series', which had a sixteen-page arrangement and included Eusebius-Carpiano, a text which traditionally introduced Greek Gospelbooks. He favoured Ravenna as the possible origin of the group.[76]

It would appear, however, that the planner of the Lindisfarne Gospels located an unusual model for their Canon Tables – one which attracted no other surviving response in the Insular corpus and which either resembled the generous layout of the Codex Fuldensis and was consciously adapted, perhaps during the making of the Lindisfarne Gospels, or which had already been adapted and which probably derived from Italy. The textual variants in the final column of Appendix 2 include several instances (e.g. Mt 3.10–11; Mt 4.14; Mt 26.45, Lk 6.29) where the oldest known precursors include manuscripts from northern Italy (Aquileia?, the birthplace of Jerome), which may be relevant in this respect.

The Codex Fuldensis Canon Tables are arranged in four arcaded columns per page with simple coloured bands running through their heads, shafts and rectangular bases (see fig. 66). There is some rudimentary stippled decoration in their arches and linking the arcades to the titles above (these stippled triangular forms possibly recollect their linear counterparts in the Brescia purple Gospels, Brescia, Bibl. Quariniana, s.n., see f. 14, where they perform the function of architectural arcades which are made more explicit in Fuldensis by the rounded arcades below).[77] The Lindisfarne Gospels' tables extend and complicate the architectural allusion, providing a further containing arch for the titles at the top of the composition, adding stepped capitals and bases to the columns and filling them, the shafts and the outer arch with complex panels of interlace and zoomorphic decoration (see figs 6, 7). Angular display capitals are used for the table and column titles (capitals and uncials are used in Fuldensis). In the Lindisfarne Gospels the numbers are grouped in fives and set within coloured ruled horizontal lines. These may represent a recollection of the practice of setting Canon Tables in rectilinear grids, as in the Book of Durrow, which similarly groups the numbers in fives within ruled boxes.[78] This might imply that the designer of the Lindisfarne Gospels was consulting the Canon Table format more usually encountered in an Insular milieu and adapting them to an architectural sixteen-page sequence. Patrick McGurk and Nancy Netzer have drawn attention to the problems encountered by the makers of other Gospelbooks with an Insular background, such as the Augsburg Gospels, the Maaiseik Gospels, BL, Royal MS 7.C.xii and the Book of Kells, when putting together design solutions to the challenge of integrating more than one source for their Canon Tables.[79] The Lindisfarne Gospels' Tables appear more homogenous in their appearance and it is perhaps surprising that they do not seem to have exerted more of an influence on subsequent works. Perhaps, as other evidence also suggests, they were not accessible as an exemplar (a cult status taking them out of the orbit of the scriptorium). If they were copied from an exemplar pretty much as they stand, then this model also seems to have been out of circulation. Given survival rates, however, no firm conclusions can be drawn from this.

The Canon Tables of the Burchard Gospels are also on sixteen pages but these were added on the Continent, other than their first leaf which seems to have represented a first campaign (perhaps undertaken at Wearmouth/Jarrow) which was never completed, the continental scribes starting again from the beginning on the second folio of the quire and adding a final leaf to complete them. Nor do they correspond to the Lindisfarne Gospels in the contents between their tenth page (f. 6v) and their sixteenth (f. 9v). The intervening section corresponds to the Codex Fuldensis.[80] Again, there is no indication of a shared exemplar, but there are signs of an adaptation of the Codex Fuldensis version. This did not accord throughout with any such adaptation in the Lindisfarne Gospels.

The advantage of the sixteen pages was that this less compressed arrangement permitted a more logical and accessible arrangement of columns for cross-referential purposes. Even with ten tables, the Book of Kells' arrangement forces the reader to skip columns in order to find what a Eusebian section of choice corresponded to in the other Gospels in which it occurred. The Lindisfarne Gospels' layout is an elegant, leisurely solution to this problem of consultation, for its columns always scan across where necessary, even when a canon extends across several folios. In only one place has an error occurred to disrupt this. On f. 12v, which carries part of Canon 2, the name titles at the heads of the three columns, added by the rubricator, have been confused with those of Canon 3 on f. 13v and read Mt, Lk and Jn instead of Mt, Mk, Lk. A (near?) contemporary hand has corrected the error in suprascript minuscules. We cannot know for sure whether this solution was devised specifically for the Lindisfarne Gospels. However, the supposed lack of a set of tables within the main textual archetype, the failure to adopt the solutions favoured by other works which consulted said archetype, and the apparent conflation of references to a familiar grid layout and one featuring arcades on sixteen pages (encountered in a book thought to have been in England, the Codex Fuldensis, concerned with adapting them to a diatessaron which explored the relationship between the Gospels) would not preclude the Lindisfarne Gospels' solution from being a specially devised one. This would have been an appropriate solution for a Vulgate Gospelbook whose prefatory matter and decorative programme were at pains to emphasise Jerome's work and his espousal of Eusebius' Canon Tables as an essential adjunct. The authority of Jerome and of an exemplar(s) associated with southern Italy, and perhaps ultimately with Jerome's person, were also well served by such a set of solutions and implicit references.

Nordenfalk has pointed to Eusebius' intention that the Gospel harmony embodied in his canon tables should be 'a full epitome of the Holy Writ' and that 'in that capacity the canon-tables partook in the sacredness of the Holy Word which they prefaced, and made them entitled to an unusually splendid adornment of their setting that pleases the eye and more than anything else accounts for the wide distribution of Eusebius' invention and the tenacity with which it survived'.[81] He also ascribed to their architectural form a symbolic function, forming 'an impressive atrium at the entrance of the sacred text itself' – an

invitation and means of entering the Holy of Holies through an encapsulation of Christ's ministry which, I would suggest, parallels and complements the reading of the Matthew miniature.[82] We enter the entirety and meaning of the New Testament through the arches of the Lindisfarne Gospels' Canon Tables, as we do through the drawn-aside curtain and the book written by the evangelist-scribe in its Matthew miniature. These all invite us to partake of the Book itself which embodies the incarnate and risen Christ, just as all Creation is invited to partake of the eucharistic feast. This would again suggest that the Lindisfarne Gospels' impressive ornamental approach to its Canon Tables and their layout was a consciously devised one, as with its evangelist miniatures, rather than due merely to the incidence of copying an exemplar or exemplars.

The arrangement of the canons in the Lindisfarne Gospels' Canon Tables is as follows:

Folio	Page	Canon	Folio	Page	Canon
f. 10r	1	I	f. 14r	9	IV
f. 10v	2	I	f. 14v	10	V
f. 11r	3	I	f. 15r	11	V
f. 11v	4	II	f. 15v	12	VI
f. 12r	5	II	f. 16r	13	VII VIII
f. 12v	6	II	f. 16v	14	IX X Mt
f. 13r	7	II	f. 17r	15	X Mk X Lk
f. 13v	8	III	f. 17v	16	X Jn

Durrow and Echternach have Canon Tables, but in boxes, not the arcaded Antique type. The Lindisfarne Gospels are the oldest extant Insular Gospelbook to contain them and to elevate them to the status of a major decorative component; also probably the oldest to preserve the arrangement of complete if repetitive prefatory matter, especially in its inclusion of the Eusebius-Carpiano, explaining how to use the Canon Tables, which the Novum Opus also does (the Irish/Celtic family tending to prefer to use just this alone for such a purpose), and to elevate it to such high status within the decorative programme.[83]

Liturgical apparatus

In the Lindisfarne Gospels this takes the form of some liturgical rubrics in the Capitula Lectionum (similar occur in the Codex Amiatinus and Royal 1.B.vii); the Capitula Lectionum are followed by lists of feasts (curiously in the case of Luke these feasts precede the Argumentum and Capitula Lectionum), not given in liturgical order but in the order in which the corresponding pericopes (readings) occur (see figs 63, 64). These lists served no apparent practical purpose, as there is no indication to which pericopes the rubrics in the lists refer. They have therefore been termed a quasi-capitulary. Such a feature also occurs with variants in Royal 1.B.vii and, with Roman additions, was added by a

Wearmouth/Jarrow hand in the upper margins of the Burchard Gospels, along with crosses inserted in the text to mark the pericopes). *Litterae notabiliores* (enlarged letters in the text) in the Gospel texts in the Lindisfarne Gospels are given decorative emphasis subject to a liturgical influence whose nature is, according to the editors of *Cod. Lind.*, 'obscure and probably confused'. As we shall see, this was not the case.

The quasi-capitulary was identified by Edmund Bishop and Dom. G. Morin as being of Italian, Neapolitan origin (the main evidence for localisation to this region being the inclusion of the feast and vigil of St Januarius and the dedication of the basilica of St Stephen,[84] dating to the time of Pope Gregory the Great.[85] Dom. Chapman printed a table combining the capitula lectionum and quasi-capitulary of the Lindisfarne Gospels, Royal I.B.vii and Burchard in an attempt to regain something of the full character of the capitula lections and feasts in the S. Italian archetype.[86]

The only distinctive feasts are the dedication of the basilica of St Stephen, Januarius (both in Matthew, Januarius also in John), John the Baptist, Dedication of the Virgin, Laurence, Andrew, birth of SS John and Paul (Paul is a contemporary addition, possibly by another hand, on f. 208v), birth of St Peter, assumption of St John the Evangelist; feasts for the birth of a bishop, for the dedication of the basilica and the font. These latter might imply an episcopal connection for the archetype. This may have been one of the books brought from the Continent by Benedict Biscop and Ceolfrith, although other routes into the Wearmouth/Jarrow library are also possible. Both prelates had studied in Kent and were in communication with the Archbishopric of Canterbury, and Archbishop Theodore's close associate and co-teacher, Abbot Hadrian of St Augustine's Canterbury, had himself been based in Naples.

That the feasts were probably written in a minuscule script (half-uncial or a more cursive minuscule) in the archetype is indicated by the the Lindisfarne Gospels scribe's misreading of 'andreae' as 'ardreae' on f. 208r b20. This confusion could only have arisen by mistaking lower case 'n' and 'r'.

In the quasi-capitularies for Matthew, Mark and Luke, Aldred begins glossing the feasts before he realises what they are, then leaves them incomplete. The original artist-scribe himself does not appear to have realised that the reading for the birth of St Peter on f. 208r was part of the capitulary, as he copies the rubric in half uncials, rather than leaving a space for the capital inscriptions used for other such rubrics, and it is also left unnumbered and unglossed. The decorated initials which he supplied and then had to erase (see below and 'layout' in chapter four) likewise indicate his lack of familiarity with the contents of the quasi capitularies and that he was nonetheless seeking to integrate them into his homogenous and innovative decorative programme.

The Capitula Lectionum also includes specially rubricated readings for Easter, for the dead, for Quadragesima and for the birth of St Peter (which is not given marginal chapter numbers and which is left unglossed by Aldred).

Comparison of the rubrics in the Capitula Lectionum in the Lindisfarne Gospels, Amiatinus and Royal 1.B.vii further indicates, as already noted, that the maker of the Lindisfarne Gospels experienced some confusion concerning which Capitula they related to.[87] That for Lk cap. 57 (in red capitals: 'quod prope pascha legendum est'; also in Royal 1.B.vii) was interpreted as preceding cap. 58 (f. 136v) which then opens with a decorated initial, rather than concluding cap. 57. Lk, cap. 94 (f. 137r) is followed by the rubric 'Haec lectio in ebdomada paschae ...' (also in Royal 1.B.vii). Jn cap. 26 and 20 (f. 205v) are preceded by the rubrics: 'Legenda pro defunctis' and 'Legenda in quadragesima', whereas in Amiatinus (they are not in Royal 1.B.vii) they follow and are associated with cap. 25 and 19. Here the maker of the Lindisfarne Gospels realised that he was misunderstanding the rubrics and was in danger of perpetuating his mistake in Luke and consequently ignored the two quite elaborate decorated initials he had drawn for cap. 26 and 20 on f. 205v, replacing them with two smaller *litterae notabiliores*.[88] Amiatinus alone includes rubrics for Jn cap. 17 and Lk 89. The Lindisfarne Gospels and Royal 1.B.vii both follow Jn cap. 45 with the rubric 'quae lectio cum in natale sci. petri ...'. In *Cod. Lind.* Julian Brown concluded that they were all drawing upon the same archetype, which contained more rubrics than any one witness alone preserves, each approaching them in a partial, haphazard way, probably because of the confusing appearance of said archetype which may have been altered in an untidy fashion.[89] He went on to suggest that such alterations may have occurred in the course of converting a Gallican or Italian element into a Neapolitan capitulary.[90] This Neapolitan/S. Italian archetype is also thought to have contained (reconstructed by means of the Lindisfarne Gospels, Royal 1.B.vii, Amiatinus and Burchard) marginal rubrics for the pericopes (readings), quasi-capitulary lists, and untidy rubrics in the capitula lectionum. Confusion inherent in these already meant that they were no longer of practical use in locating the Gospel reading for the day and so they were not systematically copied or disentangled.

That this archetype is likely to have been owned by Wearmouth/Jarrow is further indicated (along with the signs of its consultation evinced in Amiatinus and in Burchard by Wearmouth/Jarrow hands) by the fact that Bede's Homilies show that he was also consulting a Neapolitan Gospel-lectionary and that such a system was in actual liturgical use at Wearmouth/Jarrow.[91] It seems unlikely, if not impossible, that they should have derived such a use from the Gospel volume (vol. 7) of Cassiodorus' Novem Codices, essentially a reference Bible, rather than from a Neapolitan/S. Italian Gospelbook (the absence of a proper liturgical index to the marginalia of which would have made it difficult to use), and this remains the likeliest candidate as an archetype for these features of the Lindisfarne Gospels' text. Retention of the rubrics to the capitula lectionum and the feasts in the Lindisfarne Gospels and Royal 1.B.vii suggest they adhered to an archetype, whilst Amiatinus and Burchard largely edit them out. Evidently the scribes of Wearmouth/Jarrow felt less constrained by a faithful adherence to the complete contents of this influential

Italian exemplar than did those who encountered it elsewhere, including Lindisfarne.

The Burchard Gospels, Royal 1.B.vii, the Gotha Gospels and the St Petersburg Gospels all have Eusebius-Carpiano (as well as other of the Lindisfarne Gospels' prefatory sequence features, in varying measure) suggesting that these were all to be found in the archetype and that the Lindisfarne Gospels have inserted Canon Tables (derived from another source) in a rationalised position, distinguished the matter which should preface the complete volume from that proper to each individual Gospel, and applied a decorative programme to consolidate and articulate the arrangement. Remains of the Neapolitan/S. Italian archetype's restrained decorative appearance (as reflected in the Wearmouth/Jarrow and 1.B.vii responses, with script and colour used to distinguish rubrics, but otherwise with only modest initials to articulate the major text breaks and *litterae notabiliores* the minor breaks) indicates how distinctively Insular and how innovative the Lindisfarne Gospels' contribution was in this respect and how it integrated Canon Tables from another source into an homogenous programme, which was also supplemented by evangelist miniatures (which do not occur in the other volumes descended from the archetype).[92] The decorative layout is new, even if the texts enshrined and celebrated the authority of Jerome's 'vulgata' edition and its southern Italian, and perhaps Capuan or northen Italian, intermediaries.

This being the case, were the evangelist miniatures integrated from another source? Were the Canon Tables likewise integrated, or were they a new compilation, conceived as part of the Lindisfarne Gospels' overall purpose and programme? The discussion of these in the chapter five, below, would tend to support the latter scenario. Like the rest of the Lindisfarne Gospels' programme, they were designed, in part, to explore issues of Scriptural transmission and authority, and, fundamentally, the relationship of the author, transmitter and 'reader'/viewer with the Divine.

Layout and its liturgical implications

The book is beautifully and thoughtfully designed and articulated, with a carefully planned layout of script and decoration designed not only to appear beauteous, but simultaneously dignified and exuberant. However, the apparent desire to retain certain components from the principal exemplar which were geared to its use in southern Italy, and perhaps reflected in certain liturgical practices revived in Northumbria, along with the addition of Canon Tables copied from a different source, have occasioned certain textual contradictions which have led some to suggest that the Lindisfarne Gospels would have functioned better as a conceptual and visual statement than as a working reference or servicebook. However, a closer examination of the textual components of the Lindisfarne Gospels has shown that it would have functioned well, if necessary, for both reference and liturgical purposes. There are some signs of subsequent liturgical use in services, but these are comparatively limited and tend to relate to the more important feast days in the

liturgical year, including some (but not all) of the feasts associated with the cult of St Cuthbert.[93]

The text is punctuated *per cola et commata*, as became the norm for Jerome's Vulgate, as also found, for example, in Amiatinus, the St Cuthbert Gospel and the Echternach Gospels. In this late Antique system of punctuation the length of the line serves to clarify sense and *sententia*, marking the pauses between verses and the sub-pauses within them. The resulting *mise-en-page* is extremely elegant and conducive to legibility, if extravagant of membrane.

Marginal roman numerals in red ink mark the chapter divisions (a red roman numeral with a bar above) and similar numerals mark the numbers of the Canon Table in which the passage appears (a red roman numeral usually without a bar above, although some occur) and a smaller hand marks the Eusebian sections of the various Gospels, corresponding to the numeration in the Canon Tables, with smaller roman numerals in text ink. These are in the hand of the rubricator, as are the headings and numbers in the Canon Tables.

The text is further articulated by the use of a programme of hierarchical decoration, with major decorated initials or monograms and display capitals for the Gospel incipits, the Chi-rho page and the Novum Opus which formally opens the book; minor decorated initials for the incipits of the other prefatory sections (Plures Fuisse, Eusebius-Carpiano, the Argumenta, Capitula Lectionum and feasts; rubrics, inscribed either in coloured angular display script (to mark the explicits/incipits of Gospels and for most of the liturgical rubrics in the capitulary), or gold (for the sacred names at the head of each Gospel incipit page) or red half-uncials, depending on function; small minor initials and *litterae notabiliores*, the decoration of which is varied according to function, occur throughout.

Minor initials in the Gospels are used to mark Eusebian sections and capitula (chapters): *litterae notabiliores* (enlarged letters) occur with coloured infill (usually green and yellow) and red dot outline (see figs 63, 64, 73). When the two types of text breaks coincide the *littera notabilior* is given an added contour line.[94] These seem to have a 'liturgical' function, marking pericopes, except in John where they are more common. Likewise, *litterae notabiliores* with whorls are significant in all save Luke, where they are common. This might imply the use of different models for the individual Gospels, or that such a practice was already fossilised in the exemplar.[95] However, it should be remembered that the artist-scribe of the Lindisfarne Gospels was adapting his text, copied primarily from one exemplar, to a decorative articulation reflecting text divisions related to its Canon Tables which were adapted from another source. The homogenous system of articulation which resulted, in which the hierarchy of text breaks is clearly shown and lections derived from several phases of liturgical development are integrated, is a remarkable one and represents a major contribution to book history. The background for this achievement lay within the earlier Insular tradition, from the early experiments with the use of decoration for textual articulation in the Cathach, Durham A.II.10 and the Book of Durrow, and would culminate

in the equally innovative response of the Book of Kells (see pls 31, 32 and figs 37, 96).[96]

Amiatinus, the Cuthbert Gospel of St John, the Utrecht fragment and Royal 1.B.vii all use red ink to mark capitula, whether by a punctuation mark, a *littera notabilior*, a few letters or a line, a practice probably derived from an Italian exemplar or a Wearmouth/Jarrow copy of one. Royal 1.B.vii does not follow the Lindisfarne Gospels in its method of textual articulation, nor precisely in its detail (i.e. in the liturgical rubrics inserted in the capitula lectionum and some of the pericopes marked), perhaps implying that they shared an ultimate exemplar, rather than enjoying a direct relationship.[97] Royal 1.B.vii also follows Wearmouth/Jarrow practice in marking pericopes by crosses formed either of solid lines or of points (seen also in Burchard, the Cuthbert Gospel of St John, the Wearmouth/Jarrow leaves appended to the Durham Gospels, and BL, Eg. 1046). Given Royal 1.B.vii's adherence to Wearmouth/Jarrow practices (it also begins each folio with a dedication cross inscribed in the top left of the page, in Wearmouth/Jarrow fashion) and its close relationship to the Lindisfarne Gospels, it would suggest that their shared model was associated with Wearmouth/Jarrow, either an Italian manuscript or, less probably, a Wearmouth/Jarrow copy of one (perhaps even the Gospelbook of which surviving leaves were appended to the Durham Gospels after that volume was damaged and which were certainly associated with it in the community of St Cuthbert by the mid-tenth century when both parts were inscribed by the same hand).[98]

Enlarged letters within the text also sometimes mark text divisions that do not correspond to a Eusebian section or a capitulum. Two are actually Eusebian sections but have not been given marginal numbers (f. 49v b21, Mt 12.24; and f. 249r a9, Jn 16.31). There are twenty-one instances of lections marked by an enlarged or decorated letter and most of these may be related to pericopes (lections) which occurred in either the Neapolitan/S. Italian quasi-capitulary (as preserved in the Lindisfarne Gospels itself) or in the marginalia of the Burchard Gospels added at Wearmouth/Jarrow and derived from the Roman lectionary, or others also taken from the Roman Gospel lectionary but not represented in Burchard (see figs 24, 72).[99] We do not know whether those related to the Roman lectionary also featured in the Italian archetype consulted by the maker of the Lindisfarne Gospels but did not feature in the quasi-capitulary (which seems unlikely), whether they were added to it later (probably at Wearmouth/Jarrow) or whether they were being incorporated independently from several sources during the production of the Lindisfarne Gospels. It may be that this systematic layout is indebted to codicological developments in Rome from around 650–700 when informal collections of liturgical texts and 'stage-directions' (*libelli*) began to be organised into books such as lectionaries, antiphonaries and sacramentaries. The Magnificat and Benedictus (Lk 1.46 and Lk 1.68, ff. 141v a19 and 142v a8) are also marked in the Lindisfarne Gospels and the closest analogy for this is in the Echternach Gospels. These are not liturgical lections but have an obvious resonance for the feasts of the Visitation and Candlemas (the Presentation in the Temple)

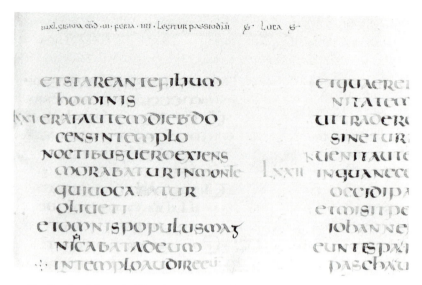

Fig. 72. The Burchard Gospels (Würzburg, Univ.-Bibl. M.P.Th.F.68), f. 130r, 6th-century Italian
Gospelbook with liturgical notes added at Wearmouth/Jarrow, late 7th or early 8th century.
(Photo: Würzburg, Univ.-Bibl)

which were among four 'Marian' feasts introduced into Roman usage by Pope Sergius I at
the end of the seventh century.[100] These resonant canticles were also sung every day in the
course of the monastic round, the Benedictus in the morning and the Magnificat in the
evening at Vespers. Jn 14.6b is also marked, for no apparent liturgical reason, and was
dismissed in the Urs Graf facsimile as probably 'purely capricious'.[101] However, Mk 14.21b,
Jn 3.3, Jn 12.16, Jn 12.47, Jn 12.48 and Jn 13.6b are also marked by enlarged *litterae
notabiliores* but were not noted in the Urs Graf facsimile.[102]

Jn 13.33 and Jn 4.5 are described in the Urs Graf facsimile as Roman pericopes for which
comparative evidence is of a later date than that ascribed to the Lindisfarne Gospels, but
they also occur in the Burchard Gospels' additions and in Royal MS I.B.vii. What is most
intriguing, however, is the Lindisfarne Gospels' inclusion of some lections of distinctively
Roman use (Mt 16.9 and Jn 7.37, ff. 129v a5 and 228r a11, see fig. 73) which were intro-
duced to the Roman liturgy later than those in Frere's Standard Gospel-series, possibly
even after the introduction of Stational Masses for the Thursdays in Lent were introduced
to Roman usage by Pope Gregory II (715–31).[103] These lections may have had a more
limited earlier life, but their inclusion within the original programme of textual articulation
of the Lindisfarne Gospels may provide valuable corroborative, if not actually conclusive,
evidence of a later dating for its production. They also indicate that the programme of
marking lections by means of enlarged or decorated letters was being developed in the
Lindisfarne Gospels, rather than being copied in its entirety from an exemplar; this being

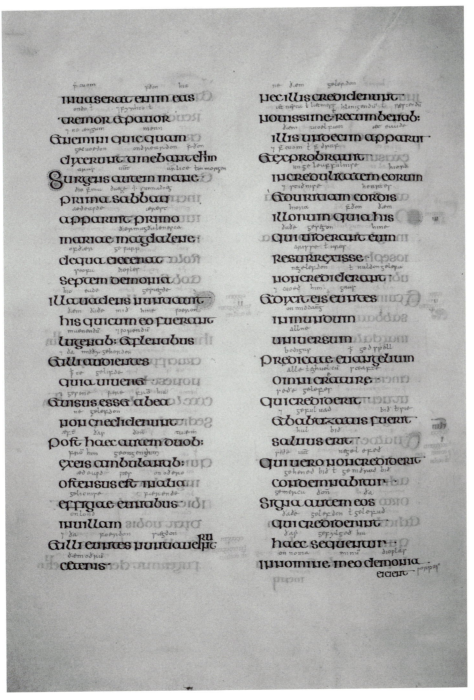

Fig. 73. Lindisfarne Gospels (BL, Cotton MS Nero D.iv), f. 129v, text page with minor initials marking text breaks, including some of the lections introduced into the Roman liturgy in 715.

in accordance with the Insular tradition as represented primarily by the Book of Durrow and the Book of Kells, both of which have strong affiliations with the Columban tradition. The additions to the Roman lectionary made during and after the time of Pope Gregory II are likely to have had an earlier background, but it remains significant that the lections marked in the Lindisfarne Gospels do not appear to have derived from a single source, or from purely Wearmouth/Jarrow or Columban practice, but to have represented a living and still growing tradition which was completely up to date.

One of the most striking instances of this form of decorative articulation occurs in one of the major decorated pages, the Chi-rho page (f. 29r, see pl. 12), Mt 1.18, which opens Matthew's narrative following the Genealogy of Christ. On this page one letter, the 'C' of 'Cum esset' (Mt 1.18b), is left uncoloured, the blank vellum surrounded with red dots causing it to leap out at the viewer. This feature was first noted by Julian Brown.[104] Various parts of Mt 1 featured in the lections for Christmas. The Matthean Genealogy of Christ was read during Matins on Christmas Day and before the Te Deum in the secular liturgy. The known Roman lections of Mt 1.18, however, all begin at 'Cum esset' rather than 'Christi autem' (which is included at the end of the Genealogy lection).[105] The passage commencing 'Cum esset' was the reading for the Vigil of the Nativity. The 'Christi autem' part of the text which precedes it, and which is marked by a major decorated monogram (the 'Chi-rho') on a scale commensurate with the Gospel incipits themselves, is also emphasised but seems not to have been a lection in widespread use. The only lection systems including a reading beginning 'Christi autem' are either northern Italian or Northumbrian annotations, added at Wearmouth/Jarrow to the Burchard Gospels, which are thought to represent an adapted Neapolitan system.[106] Nonetheless, the Chi-rho also features in the decorative programme of several other Insular Gospelbooks such as the Lichfield Gospels, the Barberini Gospels and the Book of Kells (see pl. 32c).[107]

The Chi-rho was probaby accorded this special dignity by virtue of its importance as a sacred name, representing Christ himself and serving as a potent symbol of his Incarnation. However, some Insular churches may actually have followed the northern/ southern Italian practice of beginning a lection with the 'Christi autem'. Conversely, its continued ornamentation within Insular books may represent a fossilised recollection of an earlier, obsolete liturgical practice associated with Italian centres which had produced some of the influential early Gospel exemplars which circulated in the Insular milieu. The maker of the Lindisfarne Gospels covered both options, choosing both to celebrate the early lection with an exuberant ornamentation of the 'Chi-rho' and to mark within the decoration of the page the lection for the Vigil of the Nativity which was rapidly becoming the norm within the Roman rite and which commenced at 'Cum esset'.[108] Here, as in other aspects of liturgical articulation, the Lindisfarne Gospels exhibit a concern to simultaneously enshrine significant parts of the text and to incorporate up-to-date Roman liturgical practices. Royal 1.B.vii, the Lindisfarne Gospels' closest relation in respect of its

response to a Wearmouth/Jarrow exemplar, accords the 'Christi autem' the status of being marked by a decorated initial and display script (although in a far more restrained fashion than in the Lindisfarne Gospels) but does not distinguish 'Cum esset'. This suggests that this is a feature that the Lindisfarne Gospels' artist-scribe is unlikely to have copied from its main textual exemplar, but to have consciously integrated into its layout with reference to other sources, some of them very recent.[109] The marking of alternative lections in this way, especially within a major display page context, remains a remarkable feature of the textual and decorative programmes.

Conclusions from the liturgical evidence

The foregoing discussion points increasingly away from the elaborate theory originally advanced by Chapman in support of the idea that the Lindisfarne Gospels is essentially a copy of the seventh volume of the *Novem Codices*, on inter-library loan from Wearmouth/ Jarrow.[110] It is highly unlikely that a study Bible such as Cassiodorus' *Codex Grandior* or the *Novem Codices* would have been adapted for liturgical use; the text would not in any case have been the Vulgate. Cassiodorus tells us in his *Institutiones* that his Gospel volume contained Canon Tables: these do not appear to have been present in the Lindisfarne Gospels' archetypal exemplar and were copied or adapted from another source. The feasts (copied variously in the Lindisfarne Gospels, Royal 1.B.vii, the Gotha Gospels and the feasts/lections added by a Wearmouth/Jarrow hand to the Burchard Gospels) suggest a southern Italian, possibly Neapolitan, origin for the main exemplar and the rubrics of the capitula lectionum and the way in which they have been misunderstood in the Northumbrian copies would suggest that the visual appearance of the exemplar was confusing in this respect and that it had probably been adapted and added to.[111]

Orthographical confusion of letter-forms suggests that the rubrics in the archetype were written in a minuscule script (half-uncial or a more cursive minuscule) which, if not familiar and one of the plethora of local derivatives of late Roman minuscules, might well have been misinterpreted by a Northumbrian scribe.[112] Marginal additions to the sixth-century Italian Burchard Gospels supplied at Wearmouth/Jarrow indicate that the elements of a Neapolitan Gospel-lectionary (of a sort in use prior to the reforms of Gregory the Great) derived from the 'archetype' were being applied to this fellow Italian manuscript along with Roman lections, but without any mention of peculiarly English saints. Such a lectionary is known from references in Bede's homilies to have been in use at Wearmouth/ Jarrow.[113] The Neapolitan lections were supplemented in Burchard with pericopes from the Roman lectionary (cited in *Cod. Lind.* as 'B rom') in use after the time of Gregory the Great and prior to reforms introduced by Gregory II shortly after he became pope in 715. These pericopes are also likely to have been present in the archetypal exemplar, whence they were derived by the Lindisfarne Gospels. It is as if the maker of the Lindisfarne Gospels were

continuing the process of integration of an early Italian rite and the Roman rite which had been commenced at Wearmouth/Jarrow. The process did not stop there.

Further lections formalised by incorporation into the Roman lectionary after 715 are also present in the Lindisfarne Gospels and, like the Echternach Gospels, they mark the Magnificat and Benedictus, which may be related to a new emphasis upon 'Marian' feasts introduced by Pope Sergius I (d. 701) at the end of the seventh century (likewise later emphasised by the Virgin and Child miniature in the Book of Kells). The Temptation (with its exegetical association with the Communion of Saints) is also marked by an initial and was to receive further emphasis in Insular usage, culminating in the full-page miniature of the Book of Kells. For what may have been extra-liturgical reasons the Lindisfarne Gospels also marks Jn 14.6b, Mt 26.2 and the Pater Noster (the two latter being marked by formal marginal crosses which may have been added later, but which resemble contemporary highlighting in the Echternach Gospels). They also mark, as we have seen, the lection for the Vigil of the Nativity at 'Cum esset' (Mt 1.18b), in accordance with current Roman usage.

The Lindisfarne Gospels use their programme of decoration to articulate the text in the ways outlined above, presenting a homogenous scheme which is nonetheless the result of influences which would appear to have been gleaned from several sources: an archetypal exemplar, supplemented with material also applied to Burchard at Wearmouth/Jarrow; material from subsequent Roman usage, including some formalised by papal introduction into Roman usage at the end of the seventh century and after 715, and some extraneous references. A dating around 715 or thereafter is strongly suggested, if not totally necessitated, thereby. Discreet marginal hardpoint markings added subsequently, probably at different times during the Middle Ages, indicate that the Lindisfarne Gospels was not used heavily in services, those markings which do occur generally indicating major feasts and some associated with St Cuthbert. The impression is that the Lindisfarne Gospels was designed to contain a living liturgical component, whether it was actually meant to be used or whether it was to be enshrined and commemorated as part of the overall intent of making we cannot know, and that it may subsequently have performed some liturgical or display function on the greatest of the Christian festivals and on some, but by no means all, of the feasts associated with the the cult of St Cuthbert.

That a luxurious volume such as the Lindisfarne Gospels should have perfomed a liturgical function, however limited, is significant in the face of scholarly sceptism as to whether such elaborately decorated books were ever actually meant to be used publicly, rather than being purely for display. Carol Farr has discerned similar tendencies in the Book of Kells, the full-page miniatures of which are increasingly being 'read' in relation to liturgical practices and exegetical sources.[114] She has pointed out, by way of analogy, that the highly illustrated Syrian Rabbula Gospels were made expressly for reading in the liturgy and that two Insular luxury Gospelbooks, the Barberini and St Petersburg Gospels,

contain marginal notations for lections.[115] She also cites Alcuin's prefatory poems for inclusion in ninth-century Carolingian Bibles which speak of the role of opulent manuscripts as ornaments of the Church and for reading aloud to the Church's community.[116] The evidence of the Lindisfarne Gospels would tend to support the conclusion that, although designed primarily for display in a cult context, it was important to the individual and community which made them that they should contain a commemoration of liturgical function, reconciling different Christian traditions in the same way as in their decoration,[117] and that they should (on occasion) actually fulfil a role in the public performance of the liturgy.

This tendency towards synthesis can also be observed in the Wearmouth/Jarrow campaign of editing Scripture enshrined in the Ceolfrith Bibles. Bede tells us that Benedict Biscop designed the customs of Wearmouth/Jarrow by merging elements from seventeen different customaries to form a new, unified one.[118] Neither Wearmouth/Jarrow or Lindisarne were in the business of 'facsimilising' or fossilising traditions; they were too busy contributing to a vibrant, living process.

The decorative programme of the Lindisfarne Gospels is not in any sense incidental, nor, by analogy with its closest textual relatives was it substantially derived from its textual exemplars. It is used to harmonise and dignify components from various scriptural and liturgical traditions and to celebrate one particular moment in the development of both within a book which, by its very nature, was intended to be a focus of veneration. The processes of transmitting and imbibing Scripture and of enacting it through public worship are offered up in the Lindisfarne Gospels as an act of prayer through the book's making and subsequent contemplation.

Notes

1 The subject of biblical transmission is a vast, complex and debated one. For good general introductions suited to this particular context see, for example, Lampe 1969; Marsden 1995; De Hamel 2001.

2 The Septuagint is traditionally viewed as the major translation of the Old Testament from Hebrew into Greek, commissioned around 250 BC by Ptolemy II, thought to be the founder of the great library at Alexandria. An addition to the original account by Aristeas adds that it was the work of seventy elders, working in seventy separate cells on an island in the harbour of Alexandria, which they found nonetheless to correspond due to the inspiration of the Holy Spirit. There is no 'authentic' witness to its text – rescensions were circulated by Hesychius and Lucian as well as Origen's Hexapla (Lampe 1969, p. 95; De Hamel 2001, pp. 17–18). Recognition of this led Jerome, in his revision of the Old Latin, to acknowledge the value of a new version direct from the Hebrew texts. This was very controversial, due to limited knowledge of Hebrew amongst other ecclesiastics, who could not evaluate the work themselves. Other Greek versions were also in circulation, including those of Aquila, Symmachus and Theodotion.

3 It may be useful to note, in respect of ensuing discussion of the iconography of the Lindisfarne Gospels' Matthew miniature and its decorative treatment of its prefatory matter, and of the Codex Amiatinus' prefatory gathering of tables and miniatures, that Jerome advocated 'tropology'. This is an approach in which the spiritual develops naturally out of the literal, which may be seen to relate to the Insular approach to exegesis and multivalent iconography. He related this to the two doors of the Temple (Ezekiel 41.23)

'which are the means of showing forth the mysteries of both Instruments', i.e. both Testaments, and both senses – being a search for higher meaning and spritual mysteries but founded on Scripture (Lampe 1969, p. 90). Jerome also advocated typology, the practice of identifying Old Testament symbolic precursors or 'types' for the New Testament (Lampe 1969, p. 91; De Hamel 2001, ch. 1).

4 The Old Latin version, commonly used in the West in Jerome's time and stemming from the Greek versions, notably of the Septuagint, was known as the 'editio vulgata' (Lampe 1969, p. 99). By the sixteenth century it was Jerome's new translation from the Hebrew that had acquired the name 'Vulgate', the Council of Trent according Jerome's version 'orthodox' status. We now understand the Vulgate to be Jerome's translation from the Hebrew books of the Old Testament Canon, except the Psalms; of the Hebrew and Aramaic of Esdras and Daniel, and the Greek parts of the latter and Esther; his translation from Aramaic of Tobit and Judith; Psalms of the Gallican version (rather than Jerome's Romanum, which probably represents an earlier Latin version, or his Hebraicum, based on Hebrew sources; the Gallicanum won widespread support in Gaul through the influence of Gregory of Tours and of Charlemagne and his circle); Wisdom, Ecclesiasticus, the Two Books of Maccabees and Baruch of the Old Latin version; Jerome's revised New Testament, conducted with reference to Greek sources, comprising work undertaken by himself on the Gospels and probably by an anonymous editor working in late fourth-century Rome for some or all of the rest of the New Testament (Lampe 1969, pp. 99–100, 108; De Hamel 2001, ch. 1).

5 Jerome (c.347–419/420), born at Stridon near Aquileia at the head of the Adriatic, first emerged onto the historical stage when he translated and continued the Chronicle of Eusebius (like Bede, he blended biblical editing, exegesis and history writing and had already embarked on all these spheres). He spent a period as a monk in Chalcis, studied in Antioch and Constantinople, then returned to Rome (where he had studied earlier) around 382 and became secretary to Pope Damasus who commissioned him to revise the Gospels in Latin, as there were so many versions in circulation. This was partly due to the varied routes and sources of transmission, partly to errors in translation and copying, partly to the inter-contamination of the individual Gospels. Jerome's emendation was carried out with the aid of 'ancient' Greek manuscripts, in an attempt to get closer to the archetypes. He may have extended this process to the rest of the New Testament. He also partially revised the Latin Psalter with reference to the Greek Septuagint (this is generally thought to be what is known as the 'Romanum', although some scholars view this as the basis of Jerome's revision). He also collated it against the Greek translation made from the Hebrew by the second-century Jewish scholar, Aquila. In 385 he left for Palestine, settling at Bethlehem. In the library at Caesarea he collated the Old Testament against the original copy of Origen's Hexapla, a version of the Bible laid out in six columns of Hebrew and Greek comparative texts and transliterations (Lampe 1969, pp. 83–4; De Hamel 2001, ch. 1).

6 Migne 1844–64 29, 526c; Lampe 1969, pp. 83–4.

7 St Augustine of Hippo, for example, also undertook a revision of parts of both Testaments, to improve the fidelity of the Latin to the Greek, favouring the Old Latin 'editio vulgata' over Jerome's use of the Hebrew. North Africa generally favoured the Old Latin tradition.

8 For an overview of such 'family' groupings, see the key to Appendix 2.

9 It would, under such fluid circumstances, be a nonsense to view the transmission of the biblical, or even just the Gospel, texts in the early medieval West as a struggle to achieve the primacy of Jerome's Vulgate. Mixed text families evolved in different areas, including the 'Mixed Italian' and 'Mixed Irish/Celtic' groups, as well as a distinctive Spanish family. It should also be noted that there are fewer differences between Jerome's and the Old Latin versions for the New Testament than for the Old Testament.

10 The earliest extant manuscript containing a 'Vulgate' version of the Gospels (and contemporary with Jerome) is St Gall, MS 1395, written in half-uncials, probably in Italy in the early fifth century.

11 Lampe 1969, p. 109.

12 De Hamel 2001, ch. 1.

13 McGurk 1961, p. 12; McGurk 1955, pp. 192–8; Lampe 1969, p. 115. For further details of the Codex Fuldensis, see p. 206, below.

14 Bede, *Historia Abbatum* 2.16, ed. Plummer 1956, 1, p. 379; Migne 1844–64, 94, 725a and 91, 454c; Cassiodorus in Psalms 15 (14), see Migne 1844–64, 70, 109a, b. Lampe 1969, p. 115 gives a useful bibliography for Cassiodorus (c.485–580) and for books thought to have come from his library (some

reached the Lateran and Ceolfrith obtained his copy of the *Codex Grandior* in Rome). See Fischer 1962, pp. 57ff. For a recent appraisal of the relationship of the Codex Amiatinus to works by Cassiodorus, see Meyvaert 1996. See also Corsano 1987, G. Henderson 1993 and Marsden 1995 and 1995a.

15 Lampe 1969, pp. 116–17. See especially the full discussion by Marsden 1995, ch. 5. See also Nees 1999.

16 Although Michelli 1999 has argued that one of the distinctive saint's feasts concerned of local 'use', Januarius, also featured in a church dedication at the Vivarium and suggested that the archetype for the Lindisfarne Gospels' text may therefore have originated there. The conjunction of Januarius and Stephen would still suggest Naples use, however, rather than that of the Vivarium.

17 There is some possibility that this may have originally formed part of the initial quire.

18 *Cod. Lind.*, p. 34. On the Argumenta see Regul 1969.

19 See Roth 1953, p. 37. For a thorough discussion of the issue, see Meyvaert 1996.

20 Courcelle 1948 (see transl. 1969, p. 379; Bruce-Mitford in *Cod. Lind.*, p. 148 and 1967; Michelli 1999.

21 Corsano 1987, pp. 15–16; Michelli 1999, p. 354.

22 See Michelli 1999, p. 357.

23 Discussed under layout in chapter four, below. As we shall see, a Neapolitan lectionary was in use at Wearmouth/Jarrow, but its Capitula Lectionum appears to have been unfamiliar to the artist-scribe of the Lindisfarne Gospels.

24 See M. P. Brown forthcoming c.

25 See also M. P. Brown 2000.

26 See McKitterick 1995, at pp. 50–1 and pl. 8.

27 M. P. Brown 2000.

28 See Nees forthcoming.

29 *Cod. Lind.*, p. 49.

30 See M. P. Brown forthcoming c.

31 Notably the Echternach Gospels which are consistently corrected against another version of the text throughout and the Durham Gospels, partially corrected against the Lindisfarne Gospels.

32 Alcuin's Carmina 69 quotes the couplet above Amiatinus' Ezra miniature as part of his description of a Bible punctuated *per cola et commata*, like the Ceolfrith pandects, which he may have seen. See Corsano 1987, pp. 3–4 and 20–2.

33 McGurk 1994, p. 2; on the introduction of caroline minuscule see, for example, Ganz 1990; McKitterick 1989.

34 For the foregoing, see Lampe 1969, pp. 133–42; De Hamel 2001.

35 For Bede's letter to Acca, see Farmer 1983.

36 M. P. Brown 2000, p. 14; Hurst 1960, prol. 93–115; Stansbury 1999, p. 72. On the early development of the concept of 'footnoting', see Grafton 1997.

37 M. P. Brown 2000, pp. 72–3.

38 See Verey *et al.* 1980, pp. 70–1.

39 Lampe 1969, p. 131.

40 These also occur in the Durham and Echternach Gospels. See Verey *et al.* 1980 and the discussions of Hebrew names by Patrick McGurk in Fox *et al.* 1990, and by Nancy Netzer 1994.

41 Lampe 1969, p. 100.

42 See P. McGurk in Fox 1990.

43 *Ibid.*

44 On the concept of 'local theology' see O'Loughlin 2000, pp. 8–9, 21–3 and Ó Carragáin forthcoming.

45 Also used by the hand responsible for John's Gospel in Durham MS A.II.16.

46 CLA 8.1196; McGurk 1961, p. 12.

47 On Italian volumes in England see, for example, Ganz 2002.

48 Nordenfalk 1938.

49 Alexander 1978, no. 20; Gameson 1994.

50 On the prefatory texts of the St Petersburg Gospels and their chapter divisions, see Bruno 2001.

51 Gameson 1994, p. 33, overlooks this fact and falsely attributes Burchard's Canon Tables to Wearmouth/Jarrow.

52 Netzer 1994, pp. 8 and 213, n. 63. McKitterick 2000, favours a Continental origin, however.

53 Nordenfalk 1932, p. 57, n. 1; CLA 8.1205; Alexander 1978, no. 27.

54 Nordenfalk 1938; Alexander 1978, no. 9.

55 Nordenfalk 1938; *Cod. Lind.*, p. 33.

56 McGurk 1955.

57 Least of all, as Bruce-Mitford suggested in *Cod Lind.* or, as Michelli restates, from the Gospel volume of the *Novem Codices*, which contained an essentially Old Latin rather than Vulgate text. See Michelli 1999, p. 257.

58 And the later Irish Rushworth or Macregol Gospels (Hr).

59 The Kentish Stockholm Gospels (Ea) and Royal Bible (BL, Royal 1.E.vi, Er), the Codex Bigotianus (Mercia or Kent, Eb) and the Breton Bodmin Gospels (Hx) and Oxford St John's College, MS 194 (c.900, Breton? Eo) also share a certain number of its variants, but these may not be of any great significance.

60 On two occasions when corrections are added later to the Lindisfarne Gospels (Matthew 26.39 and 27.32) they accord with readings shared by the St Petersburg Gospels, Codex Bigotianus and the Lichfield Gospels and with secondary corrections to the Echternach Gospels, but these would appear to be quite common variants.

61 Webster and Backhouse 1991, no. 87; Wood 1995; M. P. Brown 2001.

62 With the possible exception of consultation by Farmon whilst preparing his gloss of the Macregol Gospels in the tenth century, as discussed in connection with Aldred's gloss in chapter two, above.

63 See O'Reilly 2001, p. 17.

64 See McGurk in Fox *et al.* 1990, p. 34, Wordsworth and White 1889–98, p. 15. On the Argumenta, see Regul 1969.

65 De Bruyne 1931.

66 Fox *et al.* 1990, p. 34; Morin 1891.

67 See McGurk 1961, pp. 112–13.

68 On the Neapolitan Feasts see Morin 1891 and 1892.

69 McGurk 1961, pp. 113–15

70 *Ibid.*, pp. 6–7.

71 *Ibid.*, pp. 7–8.

72 See Nordenfalk 1992, p. 17.

73 CLA 8.1196; a sixth-century southern Italian text being the New Testament edition by Victor of Capua (547), this copy possibly being made for Victor himself, perhaps at Capua where he was bishop (541–54) and subsequently belonging to Boniface. See p. 155, above.

74 McGurk 1961, p. 12; McGurk 1955, pp. 192–8; Lampe 1969, p. 115; Köllner 1976, no. 1, pls 1–3.

75 McGurk 1955.

76 Nordenfalk 1938.

77 See Nordenfalk 1992, pl. VIII.2.

78 See McGurk in Fox *et al.* 1990, p. 55; it should also be noted that Nordenfalk 1992, p. 23, pointed out that such ruled boxes containing numerals in groups also occur in the early Greek Canon Table tradition, whence the Insular may derive.

79 See McGurk in Fox *et al.* 1990, pp. 52–7; see also Netzer on the beast Canon Tables in the Book of Kells, in O'Mahony 1994.

80 *Cod. Lind.*, pp. 33–4.

81 Nordenfalk 1992, p. 16.

82 Nordenfalk 1992, p. 30 and also p. 18; M. P. Brown 2000. See also the discussion of the Matthew miniature in chapter five, below.

83 See McGurk in Fox *et al.* 1990, p. 38. Royal 1.B.vii's tables and those added on the Continent to Burchard are similar, but probably relate more closely to a common archetype than to each other. CLA 9.1423a, b; Burchard's canons were added in an Insular centre on the Continent, during the early eighth century, not at Wearmouth/Jarrow as stated by Gameson 1994, p. 33.

84 *Cod. Lind.*, p. 35; however, Michelli has recently shown that there was also a church dedicated to St Januarius at the Vivarium but the conjunction with St Stephen would still suggest Naples; see Michelli 1999.

85 Gasquet and Bishop 1908, pp. 152–3; Morin 1891, 481–93, 529–37 – printed from the Lindisfarne Gospels and Royal 1.B.vii.

86 Chapman 1908, chs IV–VII, pp. 52–63. For a list of the liturgical rubrics of the capitula lectionum, see *Cod. Lind.*, p. 36.

87 *Ibid.*, pp. 35–6.

88 *Ibid.*, pl. 1 a–d.

89 *Ibid.*, p. 36.

90 *Ibid.*, pp. 36–7.

91 *Ibid.*, pp. 55–7; Morin 1892, pp. 316–26; Chapman 1908, pp. 65–77.

92 See the comparison of the Lindisfarne Gospels, Royal 1.B.vii and the Book of Kells in Farr 1997, pp. 82–5.

93 See 'Miscellaneous Early Annotations' in chapter two, above.

94 *Cod. Lind.*, p. 38.

95 For lists of the pericopes distinguished, see *Cod. Lind.*, pp. 36–43 and for an amplified listing, with some lections previously unnoticed, see the text table in Appendix 2, below.

96 For a discussion of some of the ways in which this phenomenon was further developed in the Book of Kells, see Farr 1997, pp. 42 ff., in which she outlines a close relationship between the *per cola et commata* articulation of a sixth-century Italian Gospelbook, British Library, Harley MS 1775, and the decorative layout of the Book of Durrow, on which subject we eagerly await further publication. She also compares and discerns a close relationship between the *per cola et commata* layout in the Lindisfarne Gospels and the punctuation and decorative articulation of the Book of Kells (see especially Farr 1997, App. 2.1).

97 For a comparative analysis of a limited sample of lections and their decorative treatment in the Lindisfarne Gospels, Royal 1.B.vii and the Book of Kells, see Farr 1997, App. 2.1.

98 *Cod. Lind.*, p. 46.

99 *Ibid.*, pp. 38–9. See Chavasse 1989 and 1993 and Atchley 1905.

100 See the *Liber pontificalis*, LXXXVI (Sergius), xiv, ed. Duchesne 1986–92, I, p. 376; transl. R. Davis 1989, pp. 86–7; see also Ó Carragáin, forthcoming. Carol Farr informs me, pers. comm., that the Magnificat and Benedictus are marked by enlarged initials in many Insular Gospelbooks, as is the Lord's Prayer, indicating that prayers and hymns within sacred text were often accorded special decorative treatment; I am indebted to Carol Farr for pointing out that the Magnificat is also marked in an early Italian Gospelbook, British Library, Harley MS 1775, f. 237r, and in Bodleian, Rawlinson G. 167, f. 3v, and that the Echternach Gospels contain a decorated marginal cross next to the Magnificat in Luke, f. 118r; see also Farr 1997.

101 *Cod. Lind.*, p. 39.

102 Further work will be required to establish their significance. Although there are no precise correspondences, the marking of lections in the following may be of relevance. I am deeply indebted to Carol Farr for making her notes on these lections available to me. Concerning Mk 14.21b, Christ's prediction of betrayal at the Last Supper: the Durham Gospels distinguishes Mk 14.24 with enlarged, decorated letters; the Echternach Gospels has marginal crosses inscribed next to Mk 14.18, 14.24 and 14.27; Royal 1.B.vii highlights Mk 14 with crosses and 'c's ('cantor'?) for reading the Passion antiphonally; Beissel 1907 indicates that Mk 14.21b is emphasised in the Spanish *Liber Comicus*; Greek Gospel lists of moveable feasts of the liturgical year give Mk 14.10–42 as the reading for Tuesday of 'Carnival Week'. Concerning Jn 3.3, in which Christ teaches Nicodemus that only through rebirth can the kingdom of God be seen: Greek Gospel lists for moveable feasts of the liturgical year give Jn 3.1–15 for the Thursday of Easter Week; Spanish Gospel lists (as preserved in Paris, BNF, MS lat 2171, containing seventh-century lections from Silos) give Jn 3.1–17 for the feast of the Invention of the Cross (3 May) and the Mozarabic Missal gives Jn 3.1–15 as the reading for the Vigil of Pentecost; Milanese Gospel lists give Jn 3.1ff as the lection for Holy Saturday Vespers in minor churches; Royal 1.E.vi marks the lection 'cotidiana' in the margin next to Jn 3.1; northern Italian and southern German Gospel lists (as in Munich, Clm 6224) give Jn 3.5 as the first reading at the font during the Easter Vigil; in the Ambrosian Rite Jn 3.1ff features for 'Fer. 2 ad Matutin'. For the 'Dominica de Lazaro': Wearmouth/Jarrow annotations in the Burchard Gospels mark Jn 3.1ff for 'Dom 2 Quadr Dom. 2. XL Paschae' and 'Oct. Pent. Octabas de Pentic.', perhaps indicating that the Nicodemus lection figured in emerging experimental stational liturgy in Northumbria. Concerning Jn 13.6b in which Peter asks Christ if he intends to wash his feet: Greek Gospel lists for moveable feasts mark Jn 13.3a–10 for

the washing of feet; Syrian Gospel lists likewise mark Jn 13.1ff; Gospel lists of Gregory the Great mark Jn 13.1ff for the foot washing at 'Coena Domini', without specifying a station; Milanese Gospel lists give Jn 13.4 for 'Sabb. Albis depos. in eccl. min.'; Gospel lists from northern Italy and southern Germany give Jn 13.4 for 'Coena domini ad Matutin'.

103 *Cod. Lind.*, p. 38. On Gregory II and the Thursdays of Lent, see Chavasse 1993; Lenker 1997; Ó Carragáin forthcoming. I am deeply indebted to Éamonn Ó Carragáin for his kind assistance in locating the following information concerning specific lections:

Mt 1.18b: Mt 1.18–21 appears regularly for the Vigil of Christmas from the seventh century onwards: Chavasse 1993, II, p. 38; Lenker 1997, p. 298. Also marked in the Burchard Gospels and Royal MS 1.B.vii.

Mt 16.9: not in Chavasse's index, which does have 16.1–2 and 16.13–19; Lenker 1997, p. 329, no. 178, gives Mt 16.16 as one of the possible lections for Wednesday of the eighth week after Pentecost.

Jn 4.5: not in Chavasse's index, which has 4.6–42 as a lection for Friday of the third week in Lent from the seventh century, as in Burchard (Chavasse 1993, II, p. 28). Lenker has Jn 4.5 as one of a list of lections 'in Quadragesima' in Royal MS 1.B.vii (p. 348, no. 403), and Jn 4.5–42 as a lection for Friday of the third week in Lent (p. 313, no. 86), as in Burchard, but also gives Jn 4.6–42 in many other MSS; Lenker has Jn 4–7 in a list of Lenten readings in the Durham Gospels (p. 348, no. 403).

Jn 7.37: Chavasse has Jn 7.32–39 as a lection for Monday in the fifth week in Lent, from the seventh century, as in Burchard; also Lenker, p. 315, no. 96, also in Royal MS 1.B.vii. Chavasse has Jn 7.40–53 as a lection for Thursday of the fifth week in Lent in the series Delta (after 750) and derivatives (Chavasse 1993, II, p. 28 and Lenker 1997, p. 315, no. 99).

Jn 13.33: Lenker has this as a lection for Wednesday of Holy Week (p. 317, no. 105, as in Burchard and Royal MS 1.B.vii. Chavasse has Jn 13.33–36 as a lection for Friday of the fourth week after Easter in series Delta (after 750) and derivatives (II, p. 30). Lenker has Jn 13.33–36 as a reading for Friday of the fourth week after Easter (p. 321, no. 131) in Cotton MS Tiberius A.ii etc. Lenker also has Jn 13.33–35 as a reading for a votive Mass for Thursday 'de caritate' (p. 383, no. 405) in eleventh-century missals.

Jn 14.6b: Chavasse has Jn 14.1–13 as a lection for SS Philip and James (II, p. 29) from the seventh century. Lenker has Jn 14.1 – as a reading for the sixth Sunday after Easter (p. 323, no. 140), as in Burchard and Royal MS 1.B.vii. Lenker also has Jn 14.1 – as a lection for 'cottidiana' in the Northumbrian-Neapolitan series (p. 350), as in the Durham Gospels. Lenker also has Jn 14.1–14 as a lection for SS Philip and James (p. 356, no. 35), as in Burchard.

104 *Cod. Lind.*, p. 40.

105 Bede's homily also begins at 'Cum esset', as do those of Alcuin and Paul the Deacon, and the pericope for the Vigil of the Nativity in the Carolingian Godescalc Evangeliary. See Farr 1997, p. 150.

106 Farr 1997, p. 150.

107 Carol Farr has suggested, pers. comm., that it may also represent the memorialisation of a venerable lection incipit which is being enshrined within these Insular Gospelbooks, if not actually celebrated. See Farr 1997, p. 150 and Farr (forthcoming, in Webster and Budny).

108 Frere's Early Gospel-series no. 272.

109 A late eighth- or early ninth-century Breton Gospelbook, the St Gatien Gospels (BNF, nouv. Acq. 1587, f. 2v), also features an incised 'x' marking the 'Cum esset' lection incipit in a text in which the 'Christi autem' incipit was the only one in this passage to be singled out by a decorated monogram of the 'Chi-rho'. See Farr 1997, p. 42. Here the earlier tradition was evidently still assuming primacy over the Roman liturgy in a Celtic context as late as the ninth century.

110 Scepticism was already expressed in *Cod. Lind.*, pp. 52–6; Chapman 1908, pp. 16–23.

111 On the Neapolitan feasts see, for example, *Cod. Lind.*; Gamber 1963; Lenker 1997.

112 Although short 'ſ' and 'n' can be confused even in half-uncial script.

113 Bede, *Opera Homiletica*, introduction by D. Hurst, p. ix.

114 Farr 1991, pp. 127, 129–31 and 1997, especially p. 42. On the background, see also Farr 1989 and 1994.

115 Cecchelli 1959, pp. 25–6; McGurk 1994, pp. 21–2; Gameson 1994, pp. 34–5.

116 Ganz 1994, pp. 55–6.

117 It may be relevant in this respect that the Stockholm Codex Aureus also marks a number of Greek lections in the decoration of its cross pages, perhaps as part of a similar gesture of ecumenical liturgical enshrine-

ment, commemorating venerable liturgies other than those celebrated locally. See also Farr 1997, pp. 42–3.

118 Bede, *Historia Abbatum*, ch. 11, ed. Plummer 1896, 1, pp. 374–5; Bede further explores Benedict Biscop's inclination towards diversity, *Opera Homiletica*, 1, homily 13, see CCSL 122, ed. Hurst 1955, pp. 93–4, transl., p. 132; see also Ó Carragáin forthcoming.

CHAPTER FOUR

Sacred codicology: the physical preparation, writing and binding of the Lindisfarne Gospels

The codicology of the Lindisfarne Gospels

The membrane and the preparation of the quires

Some one hundred and fifty large sheets of finely prepared calfskin (vellum) were used in the manufacture of the Lindisfarne Gospels. The sheets are remarkable for their quality and the relative scarcity of blemishes. Most Insular membrane of the period tends to be of a slightly more beige or yellow hue, is often thicker, and displays greasy, stiff and semi-transparent areas and, like its continental counterparts, will feature holes which occur during preparation as a result of imperfections in the skin (resulting from injuries, parasites and the like). The membrane used for formal works at particularly romanising centres, such as Wearmouth/Jarrow and Canterbury, is of generally higher quality, but sometimes reveals experimentation with late Antique/continental methods of preparation and codicological arrangement, as in the St Cuthbert Gospel, the Echternach Gospels and part of the Durham Gospels which are written upon membrane prepared in 'continental' fashion.[1] Perhaps by the time that the Lindisfarne Gospels were made Insular scriptoria, including Lindisfarne, had mastered improved manufacturing techniques themselves, allowing them to work more successfully within their indigenous codicological tradition following a period of experimentation with continental methods.[2] Alternatively, either the Echternach Gospels or the Durham Gospelbooks, or indeed both, may have been made in an Insular centre on the Continent or have incorporated prepared membrane as gifts from overseas communities. Boniface, for example, sent Abbess Eadburh of Minster-in-Thanet the gold required for the text written in chrysography which he had requested of her, indicating that physical resources could be contributed from a wide catchment area. The Lindisfarne Gospels engages in no such manufacturing experiments, adhering to the highest standards of Insular practice in maintaining a relatively consistent appearance between both hair and

200

flesh sides, and retaining quite a thick, suede-like nap. An additional whitening agent, such as chalk, may have been applied during manufacture of the vellum.

A great many skins must have been discarded, for this purpose, in order to attain such a consistent quality. Where blemishes do occur they are very discreet and sheets with larger holes are only used if holes can be hidden in the gutter. The implication is that only younger animals, perhaps yearling calves, were deemed suitable and that there was an extraordinarily large pool of skins from which to select. No single community, no matter how well endowed, could afford to generate so many skins at one time, so either a great many other landowners must have sold or donated resources to the project, or the skins were amassed on a more long-term basis, throughout the production campaign, which may have been in the order of five to ten years' duration. Lindisfarne was not, of course, reliant solely upon property close to the community itself. Its landholdings stretched from as far north as the Firth of Forth and to southerly estates such as Crayke and daughter-houses such as Hartlepool, and it might be expected that they could also have donated materials to such an exceptional enterprise.[3] Excavations on Holy Island in the late twentieth century revealed remains of a cattle-butchery site which was acclaimed in the press as the source of the membrane used in the Lindisfarne Gospels. However, the site was in fact associated with a settlement site in the sand-dunes not far from the north-eastern end of the causeway, known as Green Shiel, which seems to have been a Northumbrian secular settlement occupied during the second half of the ninth century.[4] It does, however, offer useful evidence of the island's suitability for animal husbandry. The tidal causeway and intermittent island status would also have facilitated the gathering together of an exceptionally large herd, if indeed some or all of the slaughtering took place on site.

Another exceptional feature of the construction of the volume is that the skins were arranged in such a way that the spine ridge runs across the open volume, horizontally, at approximately mid-page (see fig. 74), in order to minimise the disruptive effect of cockling to the appearance of the book and to the adhesion of the paint surface, which was thicker and denser in terms of the areas covered than other books of the period. The ambition of membrane is to return to the shape of the animal, unless kept at constant levels of temperature and humidity, hence the need for clasping mechanisms on medieval bindings. The extra measures taken in the manufacture of the Lindisfarne Gospels represent an exceptional and typically innovative approach to such a problem and are indicative of the extraordinary level of care taken in the production of a very special book.

The quires were generally arranged as eights (four bifolia, or full sheets of membrane, folded in half to form eight leaves), with hair facing flesh sides, and with hair sides generally on the outside of the quire, in accordance with usual Insular practice (as opposed to the continental practice of like facing like, because of the disjuncture in appearance between the two sides of the more thinly scraped skins).[5] Some of the major decorated pages, however, are inserted as singletons as they required greater time and effort in

Fig. 74. Lindisfarne Gospels
(BL, Cotton MS Nero D.iv),
f. 139r, the vellum sheets are
arranged so that the spine ridge
of the animal runs across the
pages horizontally at the same
place, minimising cockling.

production and drying when each new pigment was laid on and would have interrupted
the general sequence and rhythm of the work if they had been treated as an integral part
of the quire.

As already mentioned, the prefatory matter in eastern and western early uncial Gospel-
books is usually codicologically distinct, occupying separate quire(s), and the Gospels each
have their own set of discrete quires.[6] The Lindisfarne Gospels is unusual in the early
medieval western corpus in adopting this codicological arrangement (the Burchard
Gospels does so too, but that was, of course, an earlier Italian manuscript with later Insular
and Continental additions). In the Lindisfarne Gospels the only overlap is that the end of
Mark and some of Luke's prefatory matter (not part of the Gospel proper) share a quire.
Thus the distinct but inter-related witness of the four evangelists (a theme explored
throughout the text and decoration of the Lindisfarne Gospels) was a consideration which
also informed its physical manufacture at even the most fundamental levels, a phenomenon
which was probably stimulated by the influence of eastern traditions.

Collation of the Lindisfarne Gospels

The Lindisfarne Gospels consist of 259 vellum folios (including the Cottonian vellum flyleaf, f. 1). The present mid-nineteenth-century binding is discussed below (see pl. 1 and figs 20, 77). The interiors of its boards are lined with red leather doublures and into that inside the upper board is recessed a white metal plaque depicting the arms of Sir Robert Cotton (see fig. 75), probably copied from the former binding. Opposite is a gilt inscription recording the commissioning of the replacement treasure binding by Edward Maltby, Bishop of Durham, in 1853 ('Compact. Impens. Edw. Maltby. Episc. Dunelm. MDCCCLIII'). The doublures are backed with the first of a pair of nineteenth-century vellum flyleaves (this arrangement is repeated at the end of the volume). These are followed by two earlier vellum flyleaves, probably dating to a rebinding for Sir Robert Cotton in the early seventeenth century, the second of which (f. 1r, see fig. 55) carries a table of contents that refers to the manufacturing team identified in Aldred's colophon and to Durham tradition concerning the volume.[7] Cotton seems to have been particularly concerned with associating the Lindisfarne Gospels with the tradition, recounted by Symeon of Durham, of a book of St Cuthbert which miraculously survived immersion in the sea, perhaps reflecting some controversy concerning the popular identification of the book/relic in question. It has already been noted in the discussion o provenance, above, that both Durham Cathedral and Lindisfarne Priory seem to have laid claims to the possession of such a volume during the later Middle Ages.[8] Cotton frequently had such 'title-pages' added to his books, sometimes penned by his librarian and occasionally, when the item was considered by Cotton to be particularly important, as in the case of the Lindisfarne Gospels, by what appears to have been a more calligraphic and perhaps professional scribal hand.[9] The volume was subsequently foliated in ink, the 'Cons. Fol. 258' inscription on f. 259v being a British Museum 'in house' foliation statement of the sort current during the later eighteenth–nineteenth centuries, and a more modern British Museum pencil refoliation corrected this to include the Cottonian frontispiece, increasing the total to ff. 259.

The quires in the Lindisfarne Gospels are arranged as follows:

1^8 (ff. 2–8; wants 2, stub), 2^{10} (ff. 9–17; wants 10, stub), 3^8 (ff. 18–24; lacks 8, stub), 4^{10} (ff. 25–33; wants 9, stub, to accompany the carpet page on f. 26), 5^8 (ff. 34–41), 6^8 (ff. 42–9), 7^8 (ff. 50–57), 8^8 (ff. 58–65), 9^8 (ff. 66–73), 10^8 (ff. 74–81), 11^8 (ff. 82–9), 12^6 (ff. 90–94; wants 6, stub, which followed the carpet page), 13^8 (ff. 95–102), 14^8 (ff. 103–10), 15^8 (ff. 111–18), 16^8 (ff. 119–26), 17^8 (ff. 127–34), 18^{10} (ff. 135–43; wants 7, stub, to accompany carpet page), 19^8 (ff. 144–51), 20^8 (ff. 152–9), 21^8 (ff. 160–67), 22^8 (ff. 168–75), 23^8 (ff. 176–83), 24^8 (ff. 184–91), 25^8 (ff. 192–9), 26^8 (ff. 200–207), 27^{10} (ff. 208–16; wants 8, stub, to accompany carpet page), 28^8 (ff. 217–24), 29^8 (ff. 225–32), 30^8 (ff. 233–40), 31^8 (ff. 241–8), 32^8 (ff. 249–56), 33^4 (ff. 257–9; wants 1, stub; all gutters repaired).

Fig. 75. Lindisfarne Gospels (BL, Cotton MS Nero D.iv), Cotton's arms set inside the upper cover of the 1853 treasure binding and possibly copied from a previous Cottonian binding.

Dimensions, pricking and ruling

Dimensions of the cover: 372 × 265mm.

Dimensions of the page: 338–40 × 250mm.

Dimensions of the written space (text block): 232–7 × 185–8mm.

The text block is pricked and ruled, after the quires had been folded (the usual Insular practice, as opposed to that favoured on the Continent and in late Antiquity of pricking and ruling each bifolium before folding), in hardpoint containing a trace element of lead or silver, for double columns of twenty-four lines (see fig. 76).[10] The prickings for the horizontal lines are on the inner and outermost vertical lines. The carefully executed ruling does not run across the margins or intercolumnar space (unlike that of the Codex Amiatinus). An unusual, and extremely high-grade, feature is that the head-lines of the script have been ruled (although not pricked), as well as the base-lines, as in some examples of late Antique/early Christian formal volumes written in capital or uncial, bilinear script. The application of such a practice to an ostensibly lower-grade quadrilinear script (with ascending and descending strokes), such as half-uncial, is a reflection of the aspiration of such script to qualify as a similarly prestigious statement, as well as the nature of its models.

Fig. 76. Lindisfarne Gospels (BL, Cotton MS Nero D.iv), f. 42v, detail of the ruling for the text, conducted with a hard point which has left traces of lead (see especially end of line 4). This may be how the artist-scribe discovered the potential of the lead point for drawing.

As discussed below, it may have been during the course of ruling for the text with a stylus made of metal and incorporating silver or lead that the maker of the Lindisfarne Gospels became aware of its ability to produce a graphic line rather than the furrow produced when it was wielded with greater force. The introduction of a complex weave of ridges or furrows into the decorated areas of the Lindisfarne Gospels would have made it extremely difficult to apply the variety of pigments and ink details without them welling into the grooves, as ink sometimes did when words were written too closely to the ruled guide-lines.

Binding history

The original binding

Once the quires had been pricked and ruled, written upon and decorated, they were re-assembled, placed in order and sewn into a binding. The Lindisfarne Gospels is now sewn upon five cords, and the sewing holes would tend to suggest that this is likely to have been the original arrangement: sewing on supports with five sewing stations (the points at which the sewing needle penetrated the gutter of the quire to allow it to loop round the cord), kettle stitches (the long stitches which took the needle from the upper and lower

sewing stations to the endbands) and endbands (or headbands, additional cords at head and foot which were oversewn to consolidate the spine and prevent insect penetration). There are some small additional adjacent holes which suggest that the placing of the sewing stations was initially laid out with dividers.

There is no indication that the unsupported, 'Coptic', method of sewing, such as that employed on the St Cuthbert Gospel (formerly known as the 'Stonyhurst Gospel', see fig. 17), the earliest extant western binding, from late seventh-century Wearmouth/Jarrow, or on the Cadmug Gospels which accompanied Boniface on his mission was used here. Rather, in accordance with the more usual subsequent western practice, a supported form of binding seems to have been preferred, more akin to that of another extant early European binding, Codex Bonifatianus 2 (Fulda, Landesbibliothek, Codex Bonifatianus 2). This is a copy of the Leonine Epistles and Isidore's *Synonyma*, probably written at Luxeuil in the early eighth century, which bears the scars on its boards of the weapon which perpetrated the marytrdom in 754/5 of the missionary St Boniface, who is said to have attempted to shield himself with the book.[11] In this and in another book associated with Boniface, the Codex Fuldensis (Victor of Capua's Diatessaron),[12] as in subsequent western bindings, the quires were sewn onto a series of leather cords which were then threaded (or laced on) through holes drilled into wooden boards. The ends of the cords were often held in place by little wooden dowel pegs. These and the turn-ins of the leather covering placed over the boards were frequently concealed by a pastedown – a sheet of membrane, often part of an earlier manuscript (a significant part of our knowledge of early medieval books comes from such fortunate survivals), pasted to the board with cow-gum to tidy its appearance. The cords would have been of alum tawed (prepared sheepskin) and would have been threaded into channels cut through thick hardwood boards (to minimise insect incursion), over which a leather cover would have been moulded, also covering the spine which would have been consolidated and protected at head and foot by endbands (bound round with sewing, perhaps in a decorative multi-coloured pattern as on later medieval bindings), which may then have been embellished by tooling or by the addition of metalwork plaques.

The 'Coptic' form of unsupported binding relied upon the quires being held together by thread sewn with two interweaving needles, the ends of the threads then being laced onto the boards. This complex technique produced a very flexible structure which enabled the book to be opened wide, but it was perhaps less robust than the western supported method for larger volumes with heavy wooden boards, sometimes made yet weightier by metalwork embellishments. The eastern technique is known as 'Coptic' because of the high incidence of survival of bindings from the orbit of early Christian Egypt, but its use appears to have been quite widespread in the regions to the east and south of the Mediterranean.[13] So, either the eastern technique practised at Wearmouth/Jarrow was not known in the centre which produced the Lindisfarne Gospels or, as seems likely, it was not deemed appropriate for a larger volume.

Fig. 77. Lindisfarne Gospels (BL, Cotton MS Nero D.iv), jeweller's marks
from the 1853 treasure binding.

The nineteenth-century treasure binding, the earlier treasure binding and the Cottonian rebinding
In 1850 one of the great masterpieces of Insular metalwork, the 'Tara' (or Bettystown)
brooch (see figs 19, 111), was discovered on a beach in Co. Meath, Ireland. It was acquired
by a Dublin jeweller who manufactured a limited edition of replicas, exhibited at the Great
Exhibition held in the Crystal Palace, London, in 1851. The 'Tara' brooch is one of the
closest metalwork parallels to the decoration of the Lindisfarne Gospels and it may have
been seeing the replica that inspired the Bishop of Durham, Dr Edward Maltby, then in
his eighties, to engage in a personal act of piety in respect of the Lindisfarne Gospels,
offering to commission a treasure binding to replace Billfrith's metalwork adornment of
the volume as mentioned in Aldred's colophon (see pl. 1 and figs 20, 77).[14] This was to be
based directly upon the decoration within the manuscript. In 1853 the Trustees of the
British Museum agreed, in response to his request (March 1852), to rebind the Lindisfarne
Gospels at Maltby's expense. The work was commissioned of Messrs Smith, Nicholson and
Co. of Lincoln's Inn, London, at a cost of 60 guineas, and was carried out under the aegis
of Sir Frederic Madden, Keeper of Manuscripts at the British Museum, who appears to
have disapproved of the project, writing of it as 'a complete failure … The binding is
hideous, as it now stands, and the effect wretched enough to bring us into ridicule'.[15] No

Fig. 78. *Life of St Cuthbert* (BL, Yates Thompson MS 26), f. 77r, the opening of St Cuthbert's tomb, Durham, late 12th century.

record of the preceding binding was apparently kept. The modern binding has now entered into the history of the manuscript and excites a certain amount of public interest and affection in its own right. It warrants some attention as a landmark, along with the facsimiles of artefacts such as the 'Tara' brooch and the Alfred jewel produced during the nineteenth century, in the revival of antiquarian and archaeological interest in the remains of the 'Dark Ages'.

We do not know whether the metalwork embellishments ascribed to Billfrith the Anchorite consisted of plaques which adorned a leather binding, or of a case used to contain the book which may have been bound in a tooled leather binding over boards – perhaps a larger version stylistically, if not technically, of the surviving contemporaneous binding of the St Cuthbert Gospel (see fig. 17). This, as we have seen, consists of leather moulded over raised vine-scroll design attached to the underlying board, and interlace tooling of the leather, the structure being an 'unsupported' one employing what is known as 'Coptic sewing'.[16] For a volume as large as Lindisfarne a supported binding, with the quires sewn onto cords (a technique also attested from the eighth century West), would have been more suitable, as already noted. The reference in Aldred's colophon to Bishop Aethilwald impressing and covering the volume, as he knew well how to do, is intriguing in this respect. If it contains a germ of veracity it may be that Aethilwald was famed for having mastered such exotic binding techniques. The St Cuthbert Gospel is presumed to

have been a gift from Wearmouth/Jarrow incorporated into his coffin at the translation of 698. The coffin was opened at other times subsequently, before the little Gospel of St John was found lying on top of the inner coffin at the opening of the tomb in 1104 (see fig. 78), and it is even possible that a Wearmouth/Jarrow book could have been bound at Lindisfarne during the eighth century and later deposited in the tomb. Fragmentary mounts, some of which may have been attached to bindings, have been found in Viking graves, some adapted as jewellery, and three possible book mounts formed of double intersecting arced crosses (following the same geometric design principles as elements of Lindisfarne's cross-carpet pages) were excavated at Whitby. A substantial mount thought to have been made in eighth-century Ireland and depicting the Crucifixion (in a manner reminiscent of the Durham Gospels' Crucifixion miniature), found near Athlone, Co. Westmeath (the Athlone Crucifixion Plaque; see fig. 134) is thought perhaps to have adorned a book-cover.[17]

Stephanus tells us that Wilfrid's great purple and gold Gospelbook at Ripon was kept in a jewelled box and Lindisfarne may likewise have been stored in a book-shrine when not in use or with its pages displayed. The decoration of the Lough Kinale book-shrine (see fig. 34) is reminiscent of the great cross-carpet pages of Insular Gospelbooks such as the Lindisfarne Gospels and its dimensions are similar (being closest to those of the Echternach Gospels).[18] It dates to the second half of the eighth century and was probably made to house an earlier Gospelbook. It was not designed to open in order that the book might be consulted, but enshrined it as a relic. It had a carrying strap, perhaps indicating that it was carried on circuit (a display of the saint's relics throughout territories belonging to his or her community, to affirm possession and protection. The book it contained was not found. A metalwork fragment of another eighth-century book-shrine or binding was also recently discovered at Shanmullagh (Co. Antrim).[19]

Book-shrines of such an early date are rare, although several early Irish manuscripts were later enshrined in book reliquaries, such as the Domnach Airgid (the 'Silver Church or Shrine'), an eighth- to ninth-century reliquary in which a late eighth- or early ninth-century Irish Gospelbook was enshrined and which subsequently received further embellishment in the fourteenth and fifteenth centuries. That the reliquary was not originally designed for the book (and may have been designed as a box for other relics) is demonstrated by the way in which the manuscript had to be folded in order to be squeezed in, as the surviving fragments show.[20] Other examples include the twelfth- to fifteenth-century Shrine of the Book of Dimma,[21] the eleventh- to fourteenth-century Shrine of the Stowe Missal,[22] and the Soiscél Molaise, the shrine containing the Gospels of St Molaise (see fig. 79).[23] The main box component of the latter dates to the late eighth or early ninth centuries but its later embellishments include an early eleventh-century inscription in Old Irish which may be translated as: 'A prayer for Cennfailad, successor of Molaise who caused this shrine to be made for...+ and for Giolla Baithín, goldsmith, who made it.' This sort of

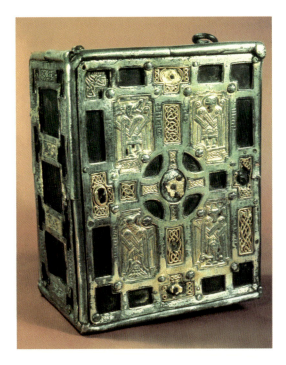

Fig. 79. The Soiscél Molaise (NMI R.4006), Irish book-shrine (to house a 'pocket' Gospelbook), late 8th–9th century, with 11th and 15th century refurbishments, general view including inscriptions and upper cover. (Photo: courtesy of the National Museum of Ireland)

formula, recording the names of those who commissioned and manufactured such shrines, or who were in some way associated with them, is common on Irish shrines from this period onward (the preceding examples all carry some such) and, in accordance with Insular epigraphic tradition, the components of the inscription are usually introduced by crosses (in the manner of charter subscriptions).[24] The shrine of St Patrick's Bell likewise carries a lengthy inscription in Old Irish: 'A prayer for Domhnall Ua Lochlainn who caused this bell to be made and for Domhnall, the successor of Patrick, with whom it was made and for Cathalan Ua Maelchallain, the keeper of the bell and for Condulig Ua hlnmainen and his sons who covered it.'[25] Such inscriptions often make reference to the person who made, or caused to have made, an object, the person(s) who subsequently contributed to the work or its adornment in some way and the person who physically made the metalwork. If there was any earlier basis to Aldred's colophon inscription, however he may have manipulated and adapted it to contemporary circumstances, might it have taken the form of an inscription on a reliquary associated with the Lindisfarne Gospels?

This would certainly help to explain the inclusion of the reference to Billfrith. Even if Aldred needed for reasons of analogy with the evangelists to include his name as one of four, Billfrith, although his name appears as one of a number of anchorites listed in the ninth-century Durham *Liber Vitae* (see fig. 47), does not seem to have been an obvious choice. As we have seen, he is number twenty-one in the list of anchorites on this page, and the spelling of his name differs from that employed by Aldred in having only one 'l'.

The selection of names and their specified relationships becomes more explicable if Aldred was adapting a metalwork dedication inscription and adding his name while drawing a parallel with the Gospel writers which is emphasised by the 'Five Sentences' discussing their natures and inspirations with which he precedes his version of the inscription adapted to include his own name in the litany.[26] The layout of the clauses naming the 'makers' of the Lindisfarne Gospels would accord with such an inscriptional formula, and the recitation of the litany of those involved – the maker or commissioner, his successor who bound the book and the anchorite/craftsman who made the metalwork that adorned it – are tantalisingly reminiscent of these Irish inscriptions which, although the surviving metalwork examples are later, may have had earlier precursors. The 'Or do …' ('a prayer for …') formula which commences such metalwork inscriptions certainly finds earlier Insular analogies in Irish funerary inscriptions upon grave slabs (such as those of eighth- to ninth-century date at Clonmacnoise). The latinate equivalent, 'Ora pro …' occurs in the context of Insular manuscript colophons, such as the 'Ora pro uuigbaldo' inscription at the end of the Barberini Gospels (Bibl. Apost. Vat., MS Barb lat. 570, see figs 99a, 132). The inclusion of the name of a metalworker in Aldred's colophon may thus remain one of the best indications that it was in some way indebted to tradition surrounding a piece of metalwork, perhaps a book shrine which he made and in which the Lindisfarne Gospels were once contained.

Prior to the Irish examples discussed above, there would appear to have been a tradition of enshrining books in eastern Christianity. This was an early forerunner of a flourishing medieval Coptic tradition of enshrining books in metalwork Gospel caskets.[27] These are usually embellished with crosses, reminiscent of carpet pages, sometimes accompanied by inscriptions, such as the extremely apt incipit of St John's Gospel – 'In the beginning was the Word …', emphasising that it was the embodiment of Christ through the Gospels that was being enshrined. The earliest extant example I know of is in the Coptic Museum in Cairo and comes from the treasure of Abraham, bishop of Hermonthis, dating to around 600. The simple but elegant silver box is inscribed with a gilded cross (recalling Segbruck's description of the 'liber de reliquiis' at the Durham shrine) (see fig. 80).[28] Coptic-style binding techniques were evidently transmitted to Northumbria, as the St Cuthbert Gospel demonstrates, so it is not unthinkable that book-shrines might also have been available as an inspiration. The Roman rite also indicates that the Gospelbook used during the liturgy was kept in a case and stored in a secure location between services.[29] As we have seen, following the death of St Wilfrid, around 710, a book of splendid appearance enshrined within a jewelled case – and heralded as a new marvel in Britain – figured in attempts to establish a cult of St Wilfrid at Ripon.[30] I have suggested that this may have provided a stimulus to the creation of a similar phenomenon for St Cuthbert's cult at Lindisfarne, in the form of the Lindisfarne Gospels.[31] Books enshrined in metalwork were evidently familiar in Northumbria and serving as cult focuses in the early eighth century and there

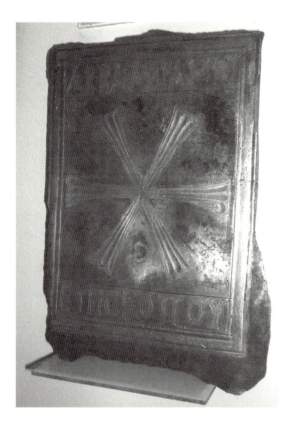

Fig. 80. Cairo, Coptic Museum, Silver book reliquary, from the treasure of Abraham, Bishop of Hermonthis, *c.*600. (Photo: Cairo, Coptic Museum)

is thus a secure historical and artefactual context for a possible metalwork inscription naming the manufacturing team of the Lindisfarne Gospels and their inter-relationships as preserved within Aldred's colophon, however he may have adapted it to his own contemporary agenda.

We cannot know when the Lindisfarne Gospels parted company with its metalwork ornaments. The Book of Kells was stolen from the church at Kells during the Middle Ages and was found abandoned in a ditch, its binding having been torn off, presumably because it was adorned with precious metals and perhaps jewels.[32] It is unlikely that a treasure binding was still intact when the Lindisfarne Gospels came into the possession of Sir Robert Cotton, but even if it were this may not have deterred this inveterate bibliophile from having the volume rebound in his own 'house-style'. Cotton frequently had his tomes rebound and several of his instruction notes to his binder survive on the flyleaves of volumes from his collection. The silver arms inserted into the inside of the upper board of the Lindisfarne Gospels' current binding represent Cotton's arms and were probably copied from the binding removed in 1853 (see fig. 75). This is therefore likely to have been a Cotton binding which would typically have consisted of brown leather over boards, tooled and gilded with a geometric design featuring his armorials, and held by a clasp at

the fore-edge. Such a binding is preserved on the Vespasian Psalter (BL, Cotton MS Vespasian A.i, see fig. 59). Cotton was prone to rearrange or 'improve' his books and if the Lindisfarne Gospels did contain Durham documents inserted in the midst of the text, he is likely to have ordered their removal.

Planning the layout: the technical innovation of the artist-scribe

When considering the way in which medieval scribes and artists planned their work it is important to remember that, although the processes involved in the manufacture of handwritten books are less 'mechanised' than those of printing, they had to impose their text (much as the printer) and work out how many words to the line and the page ahead of writing. The scribe would write one bifolium at a time, after they had been pricked and ruled, with the double sheet pinned or weighted to the writing slope. Once the bifolia were assembled into the folded quires the two pages adjacent to one another on the same side of the sheet during writing would perhaps form pages one and seven in an eight-leaf quire, the other folded sheets intruding between them. So, the text being written on a bifolium was seldom contiguous and, in order for the text to work, the number of words per page had to be established ahead of writing. This layout was usually established with reference to a model, usually another book known as the exemplar. As we have seen in the discussion of the text,[33] the main textual exemplar for the Lindisfarne Gospels, whether from southern Italy (as seems most likely) or a Wearmouth/Jarrow copy, was probably written in uncials, a script with a larger 'point size' than the Insular half-uncial used in the Lindisfarne Gospels. The stately nature of the Lindisfarne Gospels' script, its breadth and rotundity as well as some of its letter-forms, are indebted to the influence of uncial and this may have occurred for pragmatic as well as stylistic reasons. A change in script made it much harder to plan the layout of the work with reference to an exemplar in a different script. The ultimate example of such a problem is the relationship between the Utrecht Psalter (Utrecht, Universiteits-bibl., MS 32), an important and influential Carolingian book made in the region of Hautvilliers around the 830s, and the Harley Psalter (British Library, Harley MS 603, see fig. 81) which used it as its exemplar in the Christ Church Canterbury scriptorium in the early eleventh century.[34] The Utrecht Psalter employed the Gallicanum text of the Psalms, penned in formal rustic capitals. The Harley Psalter featured the Romanum text, then in use at Canterbury, written in a smaller script, an English caroline minuscule. Matters were rendered even trickier by the extensive programme of illustration and the difficulties of changing the words and size of script whilst trying to keep the text marching in pace with the illustrations. The project continued to exercise the scriptorium over the next two centuries, but in the process a great deal was learned concerning the technicalities and possibilities of book production.

In the case of the Lindisfarne Gospels, the artist-scribe seems to have adapted the formal

Fig. 81. The Harley Psalter (BL, Harley MS 603), f. 17r, Christ Church, Canterbury, early 11th century. Lead point was used for some of the under drawings, such as the hands of the demon (lower figure) seen here.

Insular book script with which he was familiar, half-uncial, to produce a more regular, larger script partly to allow for the absorption of the influence of the formal layout of an uncial model and partly to minimise the impact on textual imposition by the use of a different script. The other major factor was that the exemplar did not contain the canon tables or evangelist miniatures, which had to be absorbed into the arrangement, and, even more significantly, the maker of the Lindisfarne Gospels was attempting to produce a new programme of articulation of the text and its divisions by means of a sophisticated system of major and minor initials and *litterae notabiliores*.[35] The introduction of such an extensive decorative hierarchy into a text previously articulated largely by means of simple enlarged letters and rubrics distinguished primarily by the use of red would have had a substantial effect upon the process of planning the layout of the Lindisfarne Gospels' pages.

 The tool usually employed in the early Middle Ages to assist the planning of the layout of text and illumination was the hardpoint, usually a stylus, and the knife or awl for pricking. The hardpoint would produce a ridge and furrow effect, the motion of the stylus compared in Aldhelm's riddles to the action of the plough, which left a visible mark on both sides of the membrane or in the wax embedded in writing tablets which, like slate,

Fig. 82. The Stowe Missal (Royal Irish Academy, MS D.II.3), f. 12r, Irish, late 8th or early 9th century. The under drawing and ruling are in lead point. (By permission of the Royal Irish Academy © RIA)

Fig. 83. An early example of Insular script – extracts from the Psalms on one of the Springmount Bog Tablets (NMI, 4-1914.2), Irish, early 7th century. Wax tablets were also used for drafting text and trying out designs. (Photo: National Museum of Ireland)

bone or wooden motif-pieces, were used to sketch out designs (see fig. 83).[36] As the layout of books became ever more complex throughout the medieval period, with the introduction of parallel translations, wrap round commentaries and extensive cycles of illustration and decoration, artists and scribes experimented with different materials and techniques to produce a more flexible approach to layout. Leadpoint, crayon, chalk and ink applied with a thin pointed pen were all solutions adopted throughout much of Europe at various points during the twelfth to fifteenth centuries.[37] One of the many impressive and innovative aspects of the Lindisfarne Gospels was that its maker, intent upon producing a radically ambitious programme of interaction between text and illumination, turned his ingenuity to the methods and tools at his disposal to achieve the desired flexibility and non-intrusive character of design and layout.

Ruling was conducted with a hardpoint. This was metallic and has left discreet graphic marks in places (see, for example, f. 236r where the lines can be clearly seen as graphic marks which give some passages, e.g., f. 42v, col. 1, line 15, the appearance of proper lead-ruling, see fig. 76), indicating that it contained lead or silver. Because leadpoint was previously unknown at such an early date it was commonly assumed that, although the prickings visible on the unpainted sides of the carpet pages were an original part of the drafting process, the graphic lines of the drawings linking them were perhaps added by a later reader. They are, however, an integral element of the design process, and the clearly visible use of the same instrument for the ruling of the text, along with the elements of the original design which were drawn one way but changed during painting clearly show that these lead lines were original rather than later tracings (see pls 9, 23a).

The Florentine craftsman Cennino Cennini, writing his craftsperson's manual 'Il Libro dell'Arte' in the fifteenth century, gives instruction on 'how you should start drawing with a style and by what light', telling his reader to 'take a style [stylus] of silver, or brass, or anything else, provided the ends be of silver, fairly slender, smooth and handsome. Then

… run the style over the little panel [of wood or gessoed parchment treated with powdered bone] so lightly that you can hardly make out what you first start to do; strenthening your strokes little by little … let the helm and steersman of this power to see be the light of the sun, the light of your eye, and your own hand' and 'You may also draw, without any bone, on this parchment with a style of lead; that is, a style made of two parts lead and one part tin, well beaten with a hammer'.[38] This method of work seems close to that used some 700 years earlier by the artist-scribe of the Lindisfarne Gospels. Abbess Eadburh of Minster-in-Thanet is known to have owned a silver stylus at around this period,[39] and lead was widely available in north-east England, with red lead being used in the palette of the Lindisfarne Gospels as in many other Insular manuscripts, so there was no question about the technology being available. What was remarkable was that, during the making of the Lindisfarne Gospels, yet another outstanding technical innovation was introduced in order to enable the most sophisticated and aesthetically pleasing results.

The Lindisfarne Gospels is the first extant western manuscript to feature such leadpoint drawings (or at least the earliest example so far discovered). The use of lead for ruling manuscripts is usually ascribed to the late eleventh century and is thought to have been introduced into northern Europe via Iberia and southern France.[40] I have observed another early, and seemingly unnoticed, example of leadpoint, this time used for underdrawing, in the Stowe Missal (Royal Irish Academy, MS D.II.3, f. 12, see fig. 82), a late eighth- or early ninth-century Irish book. I have also observed its use, along with the usual hardpoint, for underdrawing in two early eleventh-century English manuscripts: the Aelfric Hexateuch (British Library, Cotton MS Claudius B.iv, see fig. 84) and the Harley Psalter (British Library, Harley MS 603, see fig. 81).[41] Every decorative element of the Lindisfarne Gospels (even small initials such as the 'p' on f. 24r) features drawings in this metalpoint, save the canon tables and the modest initial 's' of 'secundum' on f. 130r. So important were they that the 'fuit' of f. 139v is drawn on the other side, even though this is itself a decorated incipit page (see figs 85, 86).

Nor are these under-drawings, but are instead inscribed on the back of the page. This implies that the designs were worked out on the reverse and then somehow traced through, with guidance from prickings at cardinal points and by backlighting. This would imply the use of a transparent writing surface, perhaps of horn (known in an Islamic context) or glass of the sort which Bede tells us was introduced to Wearmouth/Jarrow by Gaulish glaziers, fragments of which (used as window glass and as millefiori rods used to decorate metalwork, see fig. 87) have survived from these sites.[42] Another possibility is that the vellum of the major decorated folios was stretched upon a frame and appropriately lit so that the design on the back could be drawn in ink and painted on the front, rather like an embroiderer's frame. A sloped angle would have been necessary if the ink was not to run even if the pigments could have been painted on vertically, with the membrane mounted in front of a window, like stained glass. We can, perhaps, come closest to

Fig. 84. The Aelfric Hexateuch (BL, Cotton MS Claudius B.iv), f. 144r, Canterbury,
early 11th century (unfinished). Some of the under drawings are in lead point.
The thick pigment layers rapidly obscure the drawings' details.

reconstructing the artist's method of work in another passage from Cennino Cennini's 'Il Libro dell'Arte'. This includes instructions on how to prepare membrane for use as a tracing paper (as well as how to manufacture it out of fish and plant glue), a technique more widely used in the Middle Ages for transferring or copying designs but not employed by the artist-scribe of Lindisfarne who was constructing his own designs rather than copying them.[43] The more relevant passage is that concerning 'How to work on silk, on both sides':

> If you have to do palls or other jobs on silk, first spread them out on a stretcher … take crayons … do your drawing … and if the same scene or figure has to be executed on both sides, put the stretcher in the sun, with the drawing turned toward the sun, so that it shines through it.

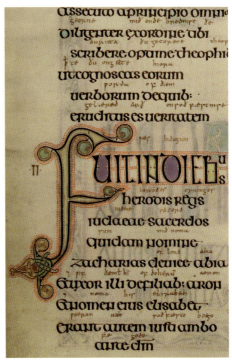

Fig. 85 (top left). Lindisfarne Gospels (BL, Cotton MS Nero D.iv), f. 139r, detail of the foot of the Luke incipit page, showing backdrawing for the initial 'F' on the other side of the page.

Fig. 86 (top right). Lindisfarne Gospels (BL, Cotton MS Nero D.iv), f. 139v, initial 'F' on the back of the Luke incipit page.

Fig. 86a (bottom left). Lindisfarne Gospels (BL, Cotton MS Nero D.iv), f. 199r, traces in the gutter of offsets from other manuscript materials bound into the book at some point, along with ferrous stains (left head and margin) from a metalwork object kept within it.

> Stand on the reverse side. With … your fine brush, go over the shadow which you see made by the drawing. If you have to draw at night, take a large lamp on the side towards your design, and a small lamp on the side which you are drawing, that is, on the right side, thus there might be a lighted taper on the side which is drawn on, and a candle on the side which you are drawing, if there is no sun. And if you have to draw by day, contrive to have light from two windows on the side with the drawing, and have the light from one little window shine on what you have to draw.[44]

Thus, by the simple expedients of mounting the vellum on a transparent writing slope or frame and of ensuring that there was a strong light source behind it and a weaker light source to his own back, the artist-scribe would have been able to follow his own drawings on the back of the sheet as he painted on its front. How he alighted upon this solution is another matter. Was it a known technique of which no earlier trace has survived in the record, or one of his own devising?

The compass and other layout marks on the carpet pages indicate that the metalpoint drawings were conducted directly onto the backs of these leaves (see pls 9, 23a and figs 85, 86). Designing in reverse would not have been too difficult here as the images can be read in reverse. For other pages, especially those featuring complex decorated script, it would have been very difficult to plan the layout back-to-front. One possibility (which I am indebted to the calligrapher Satwinder Sehmi for suggesting and trying out) is that a transfer technique may have been used. The design could have been drawn, right way around, on one sheet of vellum and this then placed on top of the reverse of the actual leaf to be painted and the top leaf burnished (rubbed) until the lead drawing offset onto the lower leaf. This might explain the somewhat blurred appearance of many of the lead lines.

The designs also show important signs of being devised *in situ*, further indicating that the metalpoint back-drawings are original. The foot of 'N' on the 'Novum Opus' page (f. 3, see fig. 88a) has more bird heads drawn on the back (f. 3v, see fig. 88b) than were actually used. The Matthew miniature was to have larger cornerpieces as drawn on its back (f. 25r, see pl. 9b) at the outer edge of the folio, which must have been somewhat wider originally, but the artist wisely refrained from thus unbalancing the composition when transferring it to the other side of the page (f. 25v) as the gutter margins were too narrow to accommodate the larger design. The back-drawing for the major decorated pages determines, along with the prickings, the overall layout of the design and the artist then concentrates on building up small sections or panels of ornament, especially of interlace, as if copying them from a motif-piece (see figs 90a–b). Once the layout and detailing is established, in accordance with well-comprehended geometrical principles (see fig. 89),[45] it is replicated elsewhere in the design without the detailed back-drawing and the pen-work is done free-hand with remarkable confidence and skill (see pls 9, 23). The deeper theological implications of this method of design, as well as its artefactual analogies, are treated within the discussion of design and painting technique in chapter five, below. This

is creative work-in-progress of an advanced type. No wonder it was achieved through the dedicated and sustained work of one individual as an integrated, inspired process.

The artist-scribe also appears to have written some guide-notes for himself when planning the work. Stylus inscriptions can be detected: on f. 23v (below the first line of the rubric and to the right), 'ex(...)'; on f. 91r (approx. 10mm above the initial in the first column), an uncial 'r' with abbreviation bar above; on f. 93r (in the margin to the right of the first line of the rubric in the second column), 'ext s', with two abbreviation bars, one above each word; on f. 93v (approx. 30mm right of the lowest point of the finial at the lower left-hand corner of the frame of the Mark miniature, see pl. 19b), 'd' with abbreviation bar above; on f. 137v (immediately left of the lowest point of the bottom left-hand finial of the Luke miniature), 'd' with abbreviation bar above. Julian Brown tentatively interpreted these as meaning *rubrica/rubricatio*, *explicit* and *explicit secundum*, and *depingendum* ('to be painted', with an evangelist portrait). He also thought he detected a faint stylus-inscribed 'mr' (*Marcus*) monogram in the bottom left-hand corner of f. 93v (see pl. 19b). These would have assisted the artist-scribe in the overall arrangement of the work when initially planning it on the blank sheets of vellum. Such guide-notes are known from the later Middle Ages but are not common at this early period and may once again represent a solution devised by this innovative artist to help him achieve his ambitious new layout, incorporating his decorative scheme when planning the imposition of the text onto the membrane.[46]

In one area we can observe the artist-scribe rethinking his layout, on f. 205v when planning the design of the openings of two *capitula* preceding St John's Gospel, capp. xvi and xx. Two large decorated initial 'M's each followed by a line of display capitals were originally drawn, leaving room for a rubric in the text half-uncial. These were subsequently erased (see fig. 63) and small enlarged initials with coloured infills, of the basic sort used to articulate the text throughout, were supplied by the same hand, followed by lines of his usual half-uncial text script (see pl. 19a). The rubricator subsequently painted in rubrics in his thin red epigraphic display capitals: 'Legenda pro defunctis' and 'Legenda in quadragesima'. A comparison with the texts of the Codex Amiatinus and Royal MS 1.B.vii reveal what has happened. The latter lacks these particular rubrics, but they are present in the former (Codex Amiatinus, f. 882r) where they mark the end of capp. xv and xix. The artist-scribe of Lindisfarne initially misunderstood the purpose of the rubrics in his exemplar and thought that they came before, rather than after, the readings in question. He therefore distinguished the wrong, following, passages by giving them large decorated initials. He evidently realised his mistake before painting these initials, erased them and redesigned the space.[47] He made the same error in respect of Luke, cap. lxxxviii which is introduced by a decorated initial and display capitals (f. 136r), preceded by a rubric 'quod prope pascha legendum est' in red half-uncials. Once again, the rubric relates to the preceding reading, cap. lxxxvii which is correctly indicated in Royal MS 1.B.vii (f. 83v). The

Fig. 87. Stained glass window, reconstructed as an evangelist figure, from the original easternmost church at Jarrow, 681. (Photo: courtesy of the Trustees of Bede's World and the Rector and Churchwardens of St Paul's, Jarrow)

(a)

(b)

Fig. 88. Lindisfarne Gospels (BL, Cotton MS Nero D.iv): (a) f. 3v, Back-drawing showing extra bird-heads originally planned for the foot of the 'N' of 'Novum Opus' on f. 3r; (b) the detail as painted on f. 3r (reversed for comparative purposes).

Fig. 89. Geometric design principles for the Lindisfarne Gospels carpet pages,
after R. L. S. Bruce-Mitford, *Cod. Lind.*

Lindisfarne artist-scribe had not yet realised his mistake. By the time he reached John's Gospel he had. This provides further evidence not only that the Lindisfarne Gospels were designed, written and painted primarily by one person, but that he was preserving prefatory matter from his exemplar concerning southern Italian lections with which he was not fully conversant, but which he considered important enough that he significantly corrected his own designs when he became aware of his misunderstanding. This detail provides further valuable corroboration, if any were needed, that the artist-scribe was devising his own decorative scheme, with its hierarchy of decorated initials, rather than copying these elements from an exemplar.

The innovative and creative artist-scribe of the Lindisfarne Gospels seems, however,

Fig. 90 (a). Bone motif piece (NMI E33:1385), Dooey, Co. Donegal, Irish 5th–6th century.
(Photo: National Museum of Ireland)

to have been working in something of a vacuum as his technical advances do not appear to have exerted a widespread influence.[48] This is consistent with the solitary, eremitic circumstances of production. Making the Lindisfarne Gospels was not a teaching exercise. There are nonetheless some indications of this unusual method of preliminary graphic drawing technique, rather than the common use of hardpoint, having a restricted impact consistent with subsequent general rather than detailed observation of the Lindisfarne Gospels itself or with an oral sharing of information. Prior to the experiments with layout, which included the use of leadpoint, in the Canterbury scriptorium during the early eleventh century (which I have already noted in connection with the production of the Harley Psalter and the Aelfric Hexateuch)[49] the only western manuscripts which exhibit something approaching the Lindisfarne Gospels' technique are, as we have seen, the Stowe Missal and also the Book of Kells, a Columban cult book made sometime between c.750–810, perhaps at Iona.[50] Neither adopt the complex method of back-drawing pioneered in the Lindisfarne Gospels, but the Stowe Missal displays leadpoint under-

224

Fig. 90 (b). Bone motif piece from Lagore Crannog (NMI W.29), Irish 8th–early 9th century.
(Photo: National Museum of Ireland)

drawings in one of its decorated incipit pages (f. 12r, see fig. 82), which also features a cat's body filled with birds, possibly inspired (directly or indirectly) by that of Lindisfarne's Luke incipit page (see pl. 21).[51] In its unfinished pages the Book of Kells demonstrates that some at least of its artists used a graphic medium for their preliminary under-drawings (but not back-drawings or leadpoint), in this case in pigment or finely applied ink.[52] In terms of its drafting technique, as well as in significant elements of its decoration (see the discussion of painting technique in chapter five, below) and script, the Lindisfarne Gospels finds its closest responses within the Irish or Columban context.

In conclusion, the maker of the Lindisfarne Gospels was extremely innovative technically, and artistically, and may have pioneered the use of leadpoint, the forerunner of the pencil, some three to four hundred years ahead of what was thought to be its introduction to Europe. Another radical innovation was the development of a transposed method of designing the decoration in flexible leadpoint on the reverse of the page to be painted, and of backlighting the sheet so that the design could be viewed from the side being painted

without losing the fine detailing when the first pigment layers were laid down, a technique still employed by modern animators who draw their cartoons on the reverse of the film so that the emulsion does not obscure the detail. If certain details no longer showed through effectively after the pigment was laid on, the artist could still have recourse to his drawings on the other side of the folio.

The unfinished areas of the work indicate that, although he came very close to doing so, the artist-scribe was unable to complete the last touches to his main work. These were left incomplete but the final essential stages of the project, adding the headings and numbers to the Canon Tables and supplying further rubrication and correction, were completed by the rubricator, whose hand was also responsible for the Gospel incipits/explicits. These are not always laid out or painted very successfully or evenly. Their comparatively inelegant appearance does not represent how the original artist-scribe conceived them, as can be seen from the under-drawings in hardpoint, probably drawn with a stylus, which he made on the pages and which were only partially followed by the rubricator. Here we see the artist-scribe working in a more conventional fashion when laying out his *mise-en-page*, supplying under-drawings for his letters in hardpoint on the side of the leaf on which they were subsequently painted, rather than favouring the leadpoint back-drawing technique which he used for the bulk of the layout and design process. A similar technique was used for laying out the square capitals for the display script of the Moutier Grandval Bible (British Library, Add. MS 10546, f. 402r), one of the great pandects made at Tours around the 830s, which are underdrawn in hard-point.[53] The style of explicit/incipit rubrics which close and introduce each Gospel, even as imperfectly executed by the rubricator, use capitals in epigraphic fashion, with a distinction between thick and thin strokes, finding an earlier model for its essential form in Italian books, such as the sixth-century Gospelbook which belonged to St Boniface, the Burchard Gospels, where they occur in alternate lines of red and black, as they sometimes do in Lindisfarne, and are accompanied by some basic colophon decoration consisting of red dots.[54]

The original under-drawings show the artist-scribe initially experimenting with script. This can be seen particularly well under raking light on f. 137r (see pl. 19a). Here lines relating to the under-drawing for the evangelist miniature on the other side of the foli (f. 137v) are used to guide the layout of the explicit, which is painted by the rubricator, but below the inscription may be detected the original stylus design of two wide lines on which the lettering is practised – partly in enlarged half-uncials of the sort used for the main text, but also in Roman capitals onto which angular rune-like features are grafted (a convention perpetuated by the rubricator in his display capitals).[55] The display script was obviously not being copied from an exemplar and was being intentionally composed with experimentation with a view to blending features from different script traditions, thereby establishing a stylistic statement of combined ethnicity.

Fig. 91. Name-stones used to mark graves within Lindisfarne's monastic precinct, late 7th–8th century (Lindisfarne Priory Museum). They carry crosses, some with terminals filled with interlace, and some have bilingual Old English/Latin inscriptions in runes, Roman capitals and half-uncial scripts (that commemorating 'Beanna' on the top left has a script very like that of the Lindisfarne Gospels and the others resemble the distinctive display capitals).
(Photo: courtesy of English Heritage)

The Word made word: the display script of the Lindisfarne Gospels

The distinctive display capitals developed in the Lindisfarne Gospels should be viewed not only in relation to manuscript art but also in the context of contemporary epigraphy, to which they are closely related. As we shall see, this provides valuable evidence of a proximity to features in other material from late seventh- to early eighth-century Lindisfarne and in centres under its aegis or within its orbit.

Rosemary Cramp has noted the Lindisfarne tradition of combining text and image, seen on Cuthbert's coffin and portable altar (namely the wooden core of a seventh-century piece which was subsequently adorned with metalwork and added to the coffin), on the name-stones and in the Lindisfarne Gospels' evangelist miniatures (see pls 8, 14, 18, 22 and figs 9, 29, 91).[56] Ray Page also commented on this phenomenon and added that the Northumbrian tradition (also observed on monuments such as the Ruthwell Cross and the Franks' Casket, see figs 50b, 52) of simultaneously featuring Roman capitals and runic letter-forms in inscriptions was an artificial feature probably devised in the scriptorium. He

Fig. 92. British Museum (MME 1986,4-6,18), Justinian I glass weight with bilingual Greek/Latin inscription, Constantinople? 527–565. (Photo: courtesy of the Trustees of the British Museum)

went on to associate the practice with the Lindisfarne scriptorium by virtue of the occurrence of the practice on the material remains from the island and in the Lindisfarne Gospels.[57] The Wearmouth/Jarrow scriptorium evinces no such tradition of runic display-lettering.[58]

The style of lettering was important. It needed to 'ring bells' in the audience's mind of both 'romanitas' and 'englishness'. A similar device had been employed earlier in Byzantium when the cohesion of the eastern Empire with its vestigial holdings in the west was emphasised by the occasional use of bilingual inscriptions in Greek and Latin, such as appears on British Museum, MME 1986, 4–6, 18 (see fig. 92), a Justinian I glass weight with bilingual inscription, probably made in Constantinople between 527–65. Such an impetus towards cultural integration may also have motivated the designers of Cuthbert's coffin to have parallel Latin and runic inscriptions carved for display to those visiting the shrine, and those who, like the Englishwoman 'Osgyth', had their names inscribed in both forms for posterity on their burial-stones at Lindisfarne (see fig. 9).[59] Numerous bilingual name-stones with Roman and runic lettering survive from Lindisfarne (eleven such stones have been found and are preserved in the Lindisfarne Priory Museum, see fig. 91) and

several from its daughter-house at Hartlepool. Some of the Lindisfarne name-stones, notably that commemorating 'Beanna' (see fig. 91, top left) also feature half-uncial script which is related to that of the Lindisfarne Gospels (the enlarged 'be' monogram which opens the inscription finding a particularly close parallel in Lindisfarne's beatitudes). This tradition of funerary monument incorporating a cross and epitaph has been traced by John Mitchell to possible origins in Lombardic northern Italy, with its influence being felt in late seventh- and eighth-century Northumbria (Lindisfarne, Hartlepool, Monkwearmouth, Jarrow, York and an outlier in Wales at Llanlleonfel), eighth- to ninth-century Ireland (Tullylease, see fig. 18 and Clonmacnoise) and in the southern Italian Duchy of Benevento (San Vincenzo al Volturno) during the ninth century.[60] The tradition is also found earlier in Coptic Egypt (see fig. 142). The epigraphic context of the Northumbrian name-stones (with a tradition of combined Latin/runic inscriptions represented primarily at Lindisfarne and its daughter-house, Hartlepool) and of the inscriptions on the Cuthbert coffin (made at Lindisfarne in 698) points to Holy Island and its orbit as the home of the Lindisfarne Gospels, as do other sculptural parallels for its decoration, discussed in the 'artefactual stylistic context' in chapter five, below. Lindisfarne therefore undoubtedly provides the best *in situ* context for aspects of the Lindisfarne Gospels' scripts and the way in which they seem to have been consciously combined to make cultural statements.

Although the designer of the the Lindisfarne Gospels consciously wished to allude to the vernacular tradition of runic script, he confined that reference to replicating angular stylistic features (which are heralded, to a lesser degree, in areas of the display scripts of the Echternach and Durham Gospels) rather than intruding actual runes, unlike his later counterpart in the Lichfield Gospels (see pl. 28).[61] Their inclusion in the latter, which in other respects accords with the Columban tradition and which exhibits a particularly close stylistic relationship to the decoration and script of the Lindisfarne Gospels, strongly suggests that it was, nonetheless, made in a monastic house within English territory and, given this conjunction of elements, probably in Northumbria.[62] Full runic inscriptions may have been acceptable in an epigraphic context, but in manuscripts they are alluded to, rather than replicated. If, as has been thought, the Lindisfarne Gospels were displayed at Lindisfarne, adjacent to Cuthbert's shrine, their use of a display script which successfully combined aspects of both letter-systems, sometimes in transliterations of the Greek, would have made a highly appropriate cultural statement of integration.

For the overwhelming impression that the Lindisfarne Gospels still convey is one not only of sublime artistry but of combined ethnicity. It has been said that acculturation assumes three forms: assimilation; emulation; synthesis.[63] I would suggest that in the Lindisfarne Gospels, as in the development of the cult of St Cuthbert and in Bede's *Historia Ecclesastica*, a prime motivation was to define what it meant to be Northumbrian, to be English, and to be a part of the Christian *œcumen*, encompassing the Italian, Byzantine, Coptic, Frankish, English, British, Pictish and Irish components of the universal Church.

As on the contemporary Northumbrian Franks' Casket (see fig. 52), the Hebraic, Roman and Early Christian past has been assimilated, emulated and synthesised with indigenous cultures and features drawn from specific traditions, local and exotic, to produce a new identity.

The Lindisfarne Gospels and the Insular tradition of display scripts

The function of display lettering (enlarged, upgraded or decorated letters, introduced by a major initial or monogram, which formally introduce a text), and of initials, is primarily one of textual articulation. It draws the reader's attention to significant breaks in the text, be they the openings of books, chapters, verses or liturgical lections. In Antiquity a scroll would generally contain a 'book' and would be appropriately labelled with a colophon stating its internal content. The codex, with its continuous text and potential for textual cross-referencing, demanded something more to assist the reader in navigating the text. Thus the enlarged initial letter and the rubric entered into the design of early codices,[64] along with some rudimentary ornament inherited from colophon decoration, often consisting merely of stippling, virgulae, minimal curlicues or hedera (ivy-leaves) in text ink or red (the use of which in such a context and in titles gave rise to the term 'rubric' from the Latin *rubrica*).[65] The use of colophon decoration to highlight significant elements may be seen in an Insular context in the Codex Usserianus Primus, a Gospelbook generally thought to have originated in Ireland during the late sixth or early seventh century.[66] Here it marks the transition from the Gospel of Luke to that of Mark, signalled by a Chi-rho and Alpha and Omega symbols contained, along with the explicit and incipit rubrics, within a box composed of colophon decoration (f. 149v).[67]

In the Rome of Pope Gregory the Great and in Merovingian Gaul rudimentary elements of decoration were added to the enlarged initial including crosses, fish and birds.[68] The origins of this phenomenon have commonly been attributed to scribes in the service of Pope Gregory around 600, but the practice of composing initials partly of zoomorphic forms may be seen to have had an earlier background in sixth-century Italian book production.[69] This may have been an indigenous development, or may have been indebted to earlier Byzantine or Ravennate elements of which evidence has not survived amongst the few extant illuminated books of the early Christian era.

In early Christian Ireland this principle was also warmly embraced. Motifs from indigenous Celtic La Tène art were applied as structural components of the initial and the process of calligraphic embellishment was extended to produce continuation lettering following the initial which diminished in size down to that of the text script, a phenomenon termed 'diminuendo' which may be seen in its boldest early form in the Cathach of Columcille (see fig. 37).[70] Whether this volume was made in the sixth or early seventh century, the practice is likely to have had something of an earlier background and its

appearance is perhaps best seen as part of the experiments with word separation and punctuation which took place in Ireland in response to the challenges of book production, of reading patterns geared primarily towards comprehension rather than public oration, and of learning Latin as a foreign language.[71] The mnemonic advantages of decoration as an aid to learning passages of text were to be acknowledged and exploited by the schoolmen of twelfth- and thirteenth-century France and they may also have occurred to the teachers of early monastic Ireland, with their ancient legacy of disciplined mnemonic oral tradition and of symbolic use of ornament.[72] The Psalms, for example, would have presented a particularly appropriate vehicle for such articulation assisted by ornament. Their verse form and sequential arrangement called for extra care and clarity in layout and certain of them warranted special note for liturgical usage, such as the 'three fifties', Psalms 1, 51 and 101, the incipits of which were singled out for particularly elaborate decoration in later Insular Psalters, as were other liturgical psalms on occasion.[73] The Psalms were also the lengthiest Christian text and they needed to be committed to memory by the aspiring religious. An essential part of the priestly training was the process of becoming 'psalteratus', being able to recite the Psalms from memory. The visual layout of the words on the page and the decorated script, which marked the key divisions, may have played an essential part in such a process.

Irish manuscripts from Columbanus' monastery of Bobbio (N. Italy) of the late sixth and early seventh centuries also exhibit signs of experimentation with the use of display script. The Milan Orosius (Milan, Bibl. Ambrosiana, D. 23. sup.) opens with an enlarged ribbon-like initial, drawn in outline as a skeletal or versal form, followed by a line of smaller but similarly drawn continuation lettering, before descending into the text script for its second line (f. 2).[74] Another Bobbio book (Milan, Bibl. Ambrosiana, S. 45.sup.), a copy of Jerome's *Commentary on Isaiah*, uses gradation of hierarchy of script and of scale to mark its incipit (p. 2), where a large initial 'N', featuring a cross-bar composed of two curvaceous fish, is followed by a slight diminuendo of the text script and is introduced by a titling rubric in enlarged rustic capitals followed by some colophon decoration.[75] The effect is reminiscent of the titling of Antique texts and also of the epigraphic tradition. In Roman monumental inscriptions the first line or lines would often be carved in a larger scale than succeeding lines, and on more portable items, such as the early Christian *ampullae* (small pilgrims' flasks) from Palestine, differing scales of inscriptions featured in the decorative scheme. In Late Antique books and painted inscriptions, such as those used as advertisements on the walls of Pompeii, hierarchies of scale of lettering and of grades of script may be observed articulating the openings of texts.

An appreciation of the diverse functionality of a hierarchical approach to script is apparent within the Insular system of scripts.[76] At the summit of the Insular hierarchy in its developed form during the late seventh to ninth centuries was display lettering. This might take the form of the high-grade square and rustic capitals of Antiquity, used for

Fig. 93. The Book of Armagh (Dublin, Trinity College Library, MS 52), f. 159v, initial with human head and calligraphic script by the Irish scribe Ferdomnach, Armagh, c.807. (Photo: courtesy of the Board of Trinity College Dublin)

rubrics or as the basis of ornamental display capitals, or to isolate sections of text (such as the prefatory matter penned in rustic capitals which precedes the body of the Vespasian Psalter).[77] The uncial, half-uncial and minuscule scripts used to write Insular books might also be elevated to display status by the inclusion of additional calligraphic details or virtuosity of penmanship to highlight passages of text, such as the display or capitular uncial used for the capitulae of the Codex Amiatinus, the display half-uncial used in the prefatory matter of the Book of Kells, or the flamboyantly calligraphic cursive minuscule with which Ferdomnach, one of the scribes responsible for the Book of Armagh (Dublin, Trinity College Library, MS 52, see fig. 93) opened his major sections of text. The use of graded and of calligraphically enhanced scripts, inherited from Antiquity and developed in an Insular context, would become a fundamental design feature of not only the manuscript but also the printed book, in which fonts and point sizes still fulfil a function of articulation.

No less significant was the Insular contribution of the great illuminated incipit page to the repertoire of medieval painting. This reached its zenith in the great Insular Gospel-books, where it formed an essential part of the programme of decoration.[78] Why should

232

major initials and display lettering have transcended their usual function to assume the role of works of art in their own right in this context? The key lies in the nature of the text and its use. The Gospels are the most sacred text of Christianity, a religion of the Word. The promulgation of the Gospels is the core function of the Church and was of paramount importance in the evangelising climate of the early Middle Ages. Boniface's correspondence with Abbess Eadburh of Minster-in-Thanet during the 730s, in which he asks her to send him a copy of the Epistles of St Peter written in gold to impress the natives, indicates that the visual power of the written word, the visible manifestation of the Christian faith, was still fully appreciated.[79] It is likely earlier to have made a similar impression upon the newly converted of the Celtic peoples and upon the Anglo-Saxons. Both societies possessed sophisticated pre-literate cultures, and indeed their proto-writing systems (ogam and runes) suggest that they had already formed a perception of the potency and potential of writing. They were also used to signalling status and power through visible ornament, notably metalwork, and to embedding symbolism, much of it religious, within such ornament. What could be more natural then, than to apply such a repertoire of decoration to the new medium of the book and, especially, to place it at the service of the Word of God.

Whatever the intermediate stages of experimentation, obscured in part by the fragmentary nature of the early evidence, it had become the practice by the mid-eighth century to adorn the opening of each of the Gospels with a decorative suite consisting of depictions of the evangelists, as portraits and/or in symbolic guise, perhaps accompanied by carpet pages, and of decorated incipits composed of initials and display script. Nowhere is the programme more harmoniously sustained than in the Lindisfarne Gospels. Here the incipits of each Gospel, along with the 'Chi-rho' initial page in the Gospel of St Matthew, are introduced by decorated initials or monograms which occupy about a third of the page and are followed by four to six lines of ornate display capitals contained within ruled horizontal lines and decorated bands and in diminishing scale (ff. 27r, 29r, 95r, 139r, 211r, see pls 3, 11, 12, 17, 21, 25). The rectilinear nature of the *mise-en-page* and the overall sumptuous effect is further enhanced by the script being contained within partial bar borders which extend around the sides of the page not already occupied by the initial and serve, with it, to frame the composition completely. The intricate ornament, combining Celtic La Tène spiraliform motifs and interlace, key and step patterns and zoomorphic elements, along with the bold display capitals with their coloured infills and stippled grounds, produces a strikingly opulent effect which links the incipit pages as seamless artistic diptychs with the facing cross-carpet pages. These openings thereby assume an iconic status in their own right, and I have suggested elsewhere that, along with the preceding evangelist miniatures, they form a sequential meditation upon the nature of Christ as variously conveyed by each of the Gospels and the symbolic portrayal of their authors which serve to express the different character of each Gospel and its encapsulation

of the complementary aspects of Christ's divinity and incarnation.[80] Thus the sacred nature of the Gospel text is celebrated artistically and elevated in status to an object of contemplation in its own right. It is the Word made word, as much an image of the Godhead as are the accompanying cross-carpet pages and the symbolic evangelist images, or as would be a figural image of the Crucifixion or Christ in Majesty.

Such a perception of the authority of the written word and its corresponding celebration could perhaps only have occurred in north-western Europe, in a climate of conversion and of nascent literary culture implanted in receptive cultural ground. The use of art and display was fostered here in an exuberant fashion. Whilst other monotheistic societies grappled with the implications of the anti-idolatrous third commandment (contributing to the rise of iconoclasm in Byzantium and to the similar response of sacred calligraphy in Islam, see fig. 94), the Church of the West took its cue from Gregory the Great's dictum that in images the illiterate read. Image and text thus complemented and mutually validated one another, and nowhere is this symbiosis more effectively achieved than in the display openings of the Insular Gospelbooks. The process of integration is carried one stage further in the Insular development (if not invention) of the historiated or story-telling initial, in which a letter contains an image germane to the text, the earliest extant examples of which appear to occur in the Vespasian Psalter, a Kentish product of the 720s–30s.[81] Here the surviving historiated initials introduce Psalms 26 (f. 31) and 52 (f. 53) with images of David and Jonathan and David as shepherd, respectively (see fig. 40). Another early historiated initial depicting Pope Gregory (although labelled by a later medieval hand as Augustine) occurs on f. 26v of the St Petersburg copy of Bede's *Historia Ecclesiastica,* made at Wearmouth/Jarrow in the 740s.[82]

The epigraphic root of the contained display panels encountered both in the 'Hiberno-Saxon' Gospelbooks and in the more overtly romanising works of Kent and of Wearmouth/Jarrow is graphically illustrated in the Trier Gospels, an Echternach product of the second quarter of the eighth century, where the archangels Michael and Gabriel, depicted in a manner reminiscent of classical winged victories, hold a plaque set upon a column.[83] This is inscribed with the incipit rubric of the Gospel of St Matthew, arranged in ruled bands like an Antique monumental inscription or diploma. This classicising rectilinear panelled approach to display lettering is most clearly reflected in early, eighth-century, manuscripts of the Southumbrian 'Tiberius' group, notably the Vespasian Psalter (see fig. 40), the Stockholm Codex Aureus (see fig. 153), the Blickling or Morgan Psalter and the Codex Bigotianus.[84] Here square capitals and some uncial letter-forms, either gilded or in colours, are often set against rigid panels with geometric parti-coloured grounds reminiscent of the *opus sectile* and coloured wall plaster of the Late Antique world, or of coloured window glass (see fig. 87). Some physical remains of this sort have been excavated, for example at Jarrow, the scriptorium of which employed a similar approach to its display script, as can be seen in the St Petersburg Bede.[85]

Fig. 94. Qur'an (BL, APA Or. MS 4945), f. 3r, decorated incipit page with interlace borders and frame 'escutcheons' (features also found in Insular manuscripts), from a 14th-century manuscript (1310) from Mosul, Iraq. Sacred calligraphy became a prominent feature of Islamic manuscript art. A similar phenomenon is encountered in the Lindisfarne Gospels' incipit pages.

The elaborate incipit pages of the Lindisfarne Gospels combine this romanising approach to panels featuring display capitals with a more calligraphic approach to letter-forms and overall design. The impact of Mediterranean works and influences can be detected here, as in other aspects of its text script, layout and textual exemplars. Another relevant aspect is the display captioning of the evangelist portraits, the angular capitals and syllabic layout of which are reminiscent, as are the figural forms, of the frescoes and icons of Rome, such as Sta Maria Antiqua, and Byzantium. The influence of more overtly romanising scriptoria such as Wearmouth/Jarrow is probably an element here, but it is only part of what is going on in the Lindisfarne Gospels. The exuberant ornamental openings, which are the epitome of the 'Insular' or 'Hiberno-Saxon' style, a heady cocktail of Celtic, Germanic and Mediterranean influences, are very different to the restrained, minimal classicism of any of the books thought to have been penned at Biscop's twin foundations, even those possible products which are not so overtly romanising.[86]

Lindisfarne's display capitals are drawn versal or skeletal forms. They adopt either a fluid, calligraphic form with zoomorphic, and in one case (f. 211r, see pl. 25) anthropomorphic, terminals and interlaced or other metalwork-like infills, or are drawn as angular black capitals. As discussed above, the manuscript display capitals assume the pronounced angularity of runic forms, clearly seen in the treatment of letters such as 'S', 'O' and 'M'. There is, as we have seen, an Insular tradition of mixing Roman capitals and runic letter-forms in epigraphic inscriptions, seen for example on the name-stones from Lindisfarne and Hartlepool and on the Cuthbert coffin, Ruthwell and Bewcastle Crosses and the Franks' Casket (see figs 29, 50b, 52, 91), where both scripts are used in parallel.[87] Greek characters also make an appearance in the display capital repertoire of the Lindisfarne Gospels, and also in the Cambridge-London Gospels (Cambridge, Corpus Christi College, MS 197B and British Library, Cotton MS Otho C.v) and British Library, Royal MS 1.B.vii, both Northumbrian works of the early eighth century (see figs 22, 25).[88] In the latter the designer has outwitted himself, replacing the Greek 'rho' in 'Christi' on f. 15v with a 'pi', thereby making a nonsense of his display panel (see fig. 25).[89] The same highly idiosyncratic feature also occurs, significantly, in the Macregol Gospels, made in early ninth-century Ireland (see fig. 95). Given the prominent nature of display lettering it is salutary to note how often mistakes seem to have been made: 'In principio eret [sic] verbum' on f. 2r of the Cambridge-London Gospels (see fig. 22); f. 22r of the Cutbercht Gospels (Vienna, Nationalbibl., Cod. 1224) where several lines of text have been omitted from the display lettering.[90] The consternation of the artist/scribes must have been considerable.

The rectilinear framed display capitals of the Lindisfarne Gospels proved influential in subsequent 'Hiberno-Saxon' Gospelbook production throughout the Insular world and well beyond its core period. This form of display panelling may be seen in the Lichfield Gospels, the St Petersburg Gospels (see pl. 28 and fig. 26), the Hereford Gospels (Hereford,

(a)

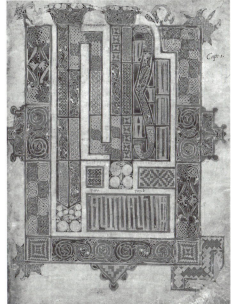

(b)

Fig. 95. The Macregol or Rushworth Gospels
(Oxford, Bodleian Library, Auct.D.2.19):
(a) ff. 126v–127r, John miniature carpet page
and incipit page; (b) f. 2v, Chi-rho page,
with Farmon and Owun's Old English gloss.
(Photos: The Bodleian Library, University
of Oxford)

237

Cathedral Library, MS P.I.2), the Rawlinson Gospels (Oxford, Bodleian Library, MS Rawl. G.167, see pl. 105), the St Gall Gospels (St Gall, Stiftsbibl., Cod. 51), the Macregol Gospels (see fig. 95), the Book of Kells (see pl. 32), the Garland of Howth (Dublin, Trinity College Library, MS 56), the St Gatien Gospels (Paris, Bibl. nat., nouv. acq. lat. 1587), the McDurnan Gospels (London, Lambeth Palace Library, MS 1370) and the Book of Deer (Cambridge, University Library, MS ii.6.32). Its use also extended to other texts, such as the Cologne Collectio Canonum (Cologne, Dombibl., Cod. 213) and the Stowe Missal and Gospel of St John (Dublin, Royal Irish Academy, MS D.II.3, see fig. 82) and the later Irish Psalters (Dublin, Trinity College Library, MS 50; British Library, Cotton MS Vitellius F.xi; Cambridge, St John's College, MS C.9).[91] The overwhelmingly 'Celtic' popularity of this style of framed display script is noteworthy, with some of the examples mentioned above (such as the St Petersburg Gospels and the Hereford Gospels) perhaps indicating its influence in western Mercia and the Welsh Borders too.

There is another principal form of display lettering which also enjoyed popularity throughout the history of Insular book production. This consists of an initial or monogram followed by a few lines of calligraphic display lettering, or even by angular display capitals of the Lindisfarne Gospels type, unframed and occupying only part of the page. Such treatment serves to illustrate how the calligraphic diminuendo lettering of the Cathach of Columcille (see fig. 37) evolved into the monumental display openings of the great Insular Gospelbooks. The process by which the enlarged initials of the Cathach and the early Bobbio manuscripts began to grow in stature and elaboration may be observed in Durham, Cathedral Library, MS A.II.10, where a large 'INI' monogram with stylised zoomorphic terminals to its cross-stroke is followed by a line of calligraphically drawn ribbon lettering which exhibits diminuendo (see fig. 96).[92] In the Book of Durrow (see pl. 31) and the Echternach Gospels (see pls 29, 30) the initials expand to occupy a quarter to a third of the page and become more elaborate in their decoration.[93] They are followed by three to six lines of display lettering in a mixture of calligraphic forms, emulating in drawn form the fluidity of the pen, along with the more static angular display capitals. Red colophon decoration is also used to emphasise the ground against which the lettering is placed and in Durrow this assumes a stippled form which serves to give the impression of formal bands. This gives a heightened impression of rectilinearity and formality, which is further enhanced in the Durham Gospels (see pl. 27) by its large angular black display capitals.[94] In the Lindisfarne Gospels these trends are refined and systematised. The stippled red grounds incorporate complex interlace and zoomorphic forms, even more reminiscent of the use of the stippling technique of Insular metalwork (such as the background to the inscriptions on the Irish Ardagh Chalice and on the Pictish bowls from the St Ninian's Isle treasure or the Pictish Monymusk reliquary, see figs 10, 97, 98) or the romanising geometric bands already mentioned in the context of Kentish and Wearmouth/Jarrow production.[95] Thus a technique which may have owed its origins in book form to the use

Fig. 96. Durham MS A.II.10, f. 2r, Mark incipit page, 7th-century Gospelbook (possibly Northumbrian) with an early example of a zoomorphic initial. (Reproduced by kind permission of the Dean and Chapter of Durham Cathedral)

Fig. 97. The Ardagh Chalice (NMI 1874:99), Irish, 8th century, with inscription, naming the Apostles, running around the bowl below the studded band and defined by a punched ground resembling the red dotted designs in the Lindisfarne Gospels. (Photo: National Museum of Ireland)

of colophon decoration in Late Antique books seems to have received a new impetus and interpretation under the stimulus of an indigenous form of decoration in another medium.[96]

It is tempting to view the developments in display layout as indicative of a progressive evolution with implications for relative chronology. Indeed, the growth in scale of the areas occupied by display lettering has been used traditionally to bolster the idea of a sequential development, which places the Book of Durrow early in the 'Hiberno-Saxon' group, in the seventh century. This may be the case, but it cannot be argued just from the display context, for the march towards full-page framed incipits was not an inevitable one. Smaller scale initials with unframed continuation lettering continue to be encountered throughout the eighth century in works such as the Maihingen Gospels (Schloss Harburg, Cod. I.2.4°.2), the Trier Gospels and the Cutbercht Gospels.[97] It should be noted, however, that these examples were all produced under Insular influence on the Continent, where it is likely that features introduced in the late seventh and early eighth century through works such as the Echternach Gospels continued to be utilised. They also occur, however in two of the books most closely related to the Lindisfarne Gospels or its archetype textually, BL Royal I.B.vii and the Gotha Gospels, both of which are generally thought to have been made in Northumbria (although continental origins have on occasion been postulated). In an internal Insular spectrum of development such features are perhaps still likely to be of an early date.

The fusion of Insular and Continental influences in European scriptoria have a further bearing upon a discussion of one more major category of display scripts, namely the intertwined lettering linked by biting beast heads and interspersed with other zoomorphic motifs which is characteristic of the Southumbrian 'Tiberius' group of manuscripts of the eighth and first half of the ninth century. Merovingian initials are characterised by their

Fig. 98. Edinburgh, National Museum of Scotland (NMS FC269), St Ninian's Isle bowl, with punched decoration, Pictish, 8th century. (Photo: National Museums of Scotland. © Trustees of the National Museums of Scotland)

incorporation of bird and fish elements. A perusal of Lowe's *Codices Latini Antiquiores* reveals that, as already mentioned above, there was a pre-existing sixth-century Italian tradition of such a practice. Its use was embraced in centres with early Insular connections, notably Luxeuil and subsequently Corbie, Laon and various German centres.[98] Their most evolved forms, however, do not occur until the second half of the eighth century, culminating in the multi-coloured outline capitals interspersed with animals and droleries (fanciful figures) as line-fillers and abbreviation strokes seen in the Gelasian Sacramentary (Vatican City, Bibl. Apost. Vat., Reg. lat. 316), the Sacramentary of Gellone (Paris, BNF, Cod. lat. 12048) and Augustine, *Quaestiones in Heptateuchum* (Paris, BNF, lat. 12168).[99] Such imaginative and whimsical motifs make an earlier appearance around 730 in the Kentish Vespasian Psalter, the earliest representative of the 'Tiberius' group. It may be that this was a southern English development, in keeping with the rise of the independent 'Anglian' beast motifs popular in Mercian art, coupled with some influence from the Continent moulding their use in book form. The mid-eighth-century Stuttgart Psalter (Stuttgart, Landesbibl., Cod. Bibl. 2°12), probably made at Echternach, exhibits a synthesis of Merovingian and Insular components of book production. Its initials feature the

characteristic Continental birds and fish, whilst its panelled bands of display script incorporate zoomorphic heads, foliate extensions and nascent intertwined letters and monograms.[100] The Cutbercht Gospels develop the blend further, later in the century. The introduction of beast heads as linking terminals to letters may once again have been an Insular invention introduced to the Continent, for it occurs in display lettering in the Lindisfarne Gospels (for example, ff. 5v, 211r, see pls 4, 25).

It is the Barberini Gospels (Vatican City, Bibl. Apost. Vat., Barb. lat. 570, see figs 99, 132) which effectively bridge the divide between the 'Hiberno-Saxon' approaches to display script, and that of their Continental offspring, with that of the early Tiberius group manuscripts.[101] Here the independent bird, beast, fish and anthropomorphic motifs which are interspersed in the bar panels of the Vespasian and Blickling Psalters are absorbed into lacertine display lettering set upon banded grounds following enlarged initials and monograms which, like their Hiberno-Saxon counterparts, grow to occupy half or more of the page. The gilding of the Kentish works gives way to a prominent use of purple as a panel ground, similarly redolent of imperial, Mediterranean connotations. Barberini has been variously claimed as a Southumbrian, Northumbrian and Continental product, with York sometimes being favoured as an appropriate compromise, precisely because it merges so many varied influences, but its use of display scripts is certainly closely related to that of the early Tiberius group manuscripts and seems fundamentally to have influenced that of the group's later members.[102] Prominent among these is the Tiberius Bede (BL, Cotton MS Tiberius C.ii, see fig. 51), from which the group takes its name.[103] Here the independent beast motifs seen earlier in the group appear within the initials, but the rectilinear bar panels sprout foliate or zoomorphic motifs at their corners and are filled with the sinuous lacertine display lettering, linked by biting beast-heads, seen in Barberini. Such features may also be observed in another, Mercian, member of the group, the Book of Cerne (Cambridge, University Library, MS Ll.i.10) which dates to the third or fourth decades of the ninth century.[104] This volume also employs angular red display capitals, reminiscent of those found in the evangelist miniatures of the Lindisfarne Gospels, to provide inscriptions as part of its own complex evangelist images (see figs 99b, 150). Like those in Lindisfarne, the Cerne evangelist inscriptions are redolent of the fresco and icon design of the Mediterranean world. The lacertine zoomorphic display panels of the Tiberius group are also paralleled in the Book of Kells (see pl. 32). This remarkable work is a veritable encyclopaedia of Insular art and the Tiberius group approach merges seamlessly with a baroque, flamboyant interpretation of the Hiberno-Saxon display opening. Kells also features the zoomorphic line-fillers and abbreviation symbols encountered in the late eighth- to early ninth-century members of the southern English Tiberius group. Unless it is to be seen as an isolated earlier manifestation of such features it would seem logical to view Kells as a product of similar date.[105]

Another important aspect of the Book of Kells, which is relevant to the present

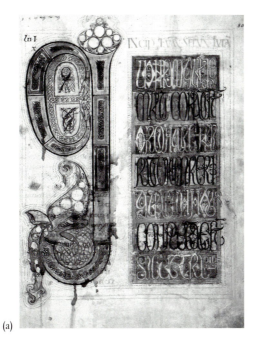

(a)

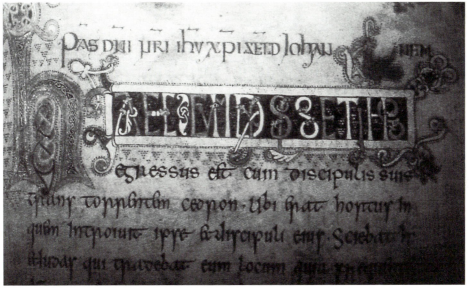

(b)

Fig. 99. (a) The Barberini Gospels (Biblioteca Apostolica Vaticana, MS Barb. Lat. 570), f. 80r,
Luke incipit page, Mercian? late 8th century (Photo: Biblioteca Apostolica Vaticana);
(b) The Book of Cerne (Cambridge, University Library, MS Lli.10), f. 32r, display script
introducing an extract from the Gospels, Mercian c.820–40. (Photo: courtesy of the
Syndics of Cambridge University Library)

discussion, is its extension of the practice of employing display script to highlight an increasing number of text breaks. These are further imbued with a hierarchical arrangement by virtue of the scale of the decorative display accorded them. This builds upon an approach to textual articulation which can be found amongst the earliest extant Insular books, such as the Codex Usserianus Primus, and which featured in the Columban tradition from the Book of Durrow onwards, the practice being significantly extended and formalised in the Lindisfarne Gospels.[106] In addition to the Gospel incipits the harmony of the Gospels is acknowledged in Lindisfarne by the application of a cross-carpet page and accompanying decorated incipit page to Jerome's 'Novum Opus' preface (ff. 2v–3, see pls 2, 3). This is rendered less formal than the actual Gospel incipits by the use of a smaller initial, by simpler angular display capitals with more modest stippled grounds and by the absence of framing panels. Other textual openings, such as the 'Plures Fuisse' preface, other prefatory matter and certain passages within the Gospel texts themselves are marked by enlarged initials followed by one or two lines of calligraphic continuation lettering set upon stippled grounds. In Kells, this practice is extended to a greater range of passages, which have been identified as liturgical lections, some of which attract a full-page decorative treatment.[107] Here display scripts play a crucial role in the overall articulation of the text and present a fossilised recollection of the liturgical use of the Gospelbook within a public context. In Kells the use of ornament as an essential component of both private *ruminatio* and impressive display to a wider community of readership can be seen in its fully developed form – a form commenced by the artist-scribe of the Lindisfarne Gospels.

The palaeography of the main text script

The text is written by one hand, with the exception of the textual apparatus, rubrics and some corrections which are by a hand known as that of 'the rubricator', who also undertook two campaigns of correction in the Durham Gospels (one before and one after he had gained access to the textual rescension used in the Lindisfarne Gospels).[108] His interventions in Lindisfarne consist of supplying the numbers and titles in the Canon Tables, the marginal systems of numerical annotation, chapter numbers and Eusebian sections, the rubrics (but not those in gold which are by the original artist-scribe, who also supplied the layout and sketches for the display rubrics in stylus, which were followed in part by the rubricator, but not always successfully – he seems to have been a competent scribe but no artist), the incipit/explicit inscriptions to the Gospels and corrections. Further corrections were added by Aldred and a few limited ad hoc insertions are by later hands.[109] The processes of rubrication and correction may have been undertaken by another hand as a matter of course (as a 'second pair of eyes', a common practice at this period), or because the maker of the Lindisfarne Gospels was not able to complete any or all of them himself as originally intended, as indicated by the unfinished details of the decoration. The

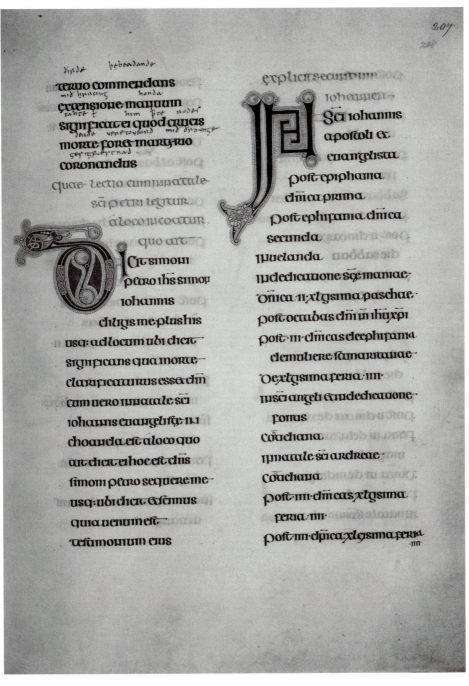

Fig. 100. The Lindisfarne Gospels (BL, Cotton MS Nero D.iv), f. 208r, text page from matter preceding John's Gospel which was not glossed by Aldred, giving an impression of the stately original appearance of the layout and script.

stylus sketches for the layout of the rubrics and their display lettering certainly indicate that the original artist-scribe intended to undertake the task himself (see pl. 19a).

The incomplete elements of the decoration were left unfinished, perhaps in respect of the character of the work as one person's *opus dei*, but if the book were to be considered complete, and to be usable (or complete as a liturgical and referential statement, even if primarily a symbolic one for the eyes of God rather than for the regular use of man), it would nonetheless have called for the Canon Tables to be completed and for marginal apparatus, rubrication and correction to be supplied.

The text script of the artist-scribe is a highly accomplished and calligraphic half-uncial. It is distinguished by its breadth and measured weight of aspect (perhaps best appreciated on f. 208r which contains prefatory matter which was not glossed by Aldred, see fig. 100) and by a rigorous adherence to a regular head and base-line, both of which are ruled – a rare feature. This regularity is further emphasised by the practice of extending head-strokes to link words, despite the adherence to the practice of word separation which was an important Insular contribution to book history originally developed in Ireland.[110] The version of this script used for the prefatory matter is lighter and more compressed in places (for example, ff. 136v–137r, 207r, see fig. 101) and might be termed 'capitular half-uncial'. This compressed aspect disrupts the broad regularity of the script and makes it a little closer in appearance to other eighth-century Northumbrian half-uncial hands, such as those of BL, Royal MS 1.B.vii (see fig. 25) and t;he Durham Cassiodorus. A similar variation in the character of the script as it appears in the biblical texts and as it appears in ancillary prefatory matter can be observed in the use of 'capitular uncial' for the latter in the Codex Amiatinus and 'capitular half-uncial' in the Book of Kells. The half-uncial script used for the feasts preceding Mark's Gospel on f. 93r of the Lindisfarne Gospels features a distinctive large 'b' with a second hooked bow at its head, in Greek epigraphic fashion, which may reflect an exemplar, and which is also found in the display script of the Incipit pages (including the nearby Mark Incipit, see pl. 17) and in passages of the main half-uncial text script (e.g. f. 235v and elsewhere in St John's Gospel). 'P' and 'h' also assume a hooked form, almost supplying a second bow, in the display script, again probably emulating Greek inscriptional forms.

Letter-forms are generally of half-uncial type but some have regular uncial variants: both round and tall 's' are used; round and tall 'd'; 'N' and 'n'; 'R' and 'r'; 'G' of the tailed variety, as practised in Wearmouth/Jarrow uncial, and flat-headed 'g'; 'y' may assume either a short, forked form, sitting upon the line, or may have a descender and its two branches curved to the right, and occasionally it takes a playful looped form in its descender; the distinctive half-uncial 'oc'-shaped 'a' is sometimes replaced by a thorn-like uncial 'A'. When compression is required, uncial 'N' can be raised above the line on its extended first leg (e.g. f. 250r a17), likewise 'R' (e.g. f. 255r b18). Uncial letters are frequently encountered in ligature, such as 'NT' (f. 258v, line one) and 'UR' (last line of the

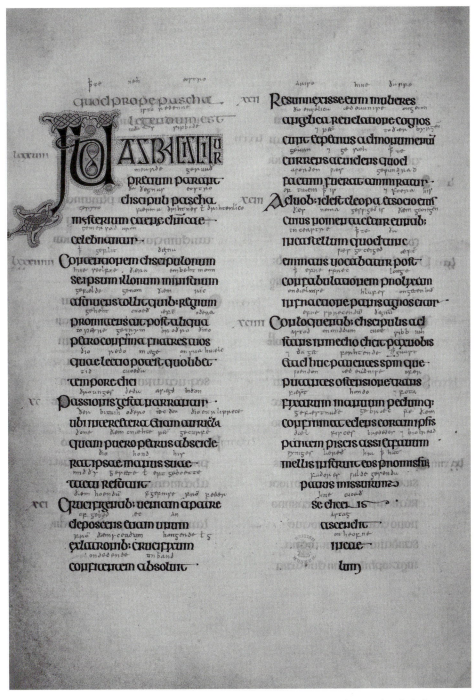

Fig. 101. The Lindisfarne Gospels (BL, Cotton MS Nero D.iv), f. 136v, the slightly compressed script ('capitular half-uncial') used for the matter preceding the Gospels.

Fig. 102. The Lindisfarne Gospels (BL, Cotton MS Nero D.iv), calligraphic space-saving endings to lines, after Millar, 1923.

first column, f. 91r), especially at line-ends – a distinctive feature of this particular scribe's modification of Insular half-uncial (see fig. 102) and one not typical of related works such as the Durham and Echternach Gospels. Such features may reflect the stylistic influence of an uncial exemplar. The same may be true of the monograms, a feature of Antique script and epigraphy, which adorn the display script of the Incipit pages and which appear occasionally within the text, such as the 'N' containing an 'o' and surmounted by an abbreviation bar denoting 'Non' (f.21r, the twelfth line of the first column).

More cursive minuscule letters also make a limited appearance, notably at line or page ends where space is at a premium or where an extra burst of calligraphic flair is indulged in, such as the tiny 'e's in ligature with the preceding letter, as in 'inpossibile' (fourth line of the second column, f. 141r) and 'uigilare' (line 19, first column, f. 93r), the cursive 'at' of 'praenunciat' (line 11, first column, f. 93r), the long 's'-shaped 'g' whose head enters into ligature with 'r' (line 21, second column, f. 21r), and the curved wavy line which denotes 'um' in 'peccatorum' (line 4, second column, f. 91r). Such incipient cursive features, here and in the Durham Gospels, enabled Julian Brown to perceive comparisons which led him to place the Echternach Gospels (see pls 26, 29, 30), written in a lower grade 'set minuscule' (with the exception of the opening folio of Matthew which is in half-uncial

similar to that of the Durham and Lindisfarne Gospels) within the Lindisfarne scriptorium
and to attribute both volumes to the same artist-scribe (named by him and Bruce-Mitford
'the Durham-Echternach Calligrapher').[111] Others have found the limited nature of the
palaeographical analogy difficult to sustain and have argued in favour of an origin for the
Echternach Gospels at Ráth Melsigi (Co. Carlow?) or Echternach in Luxembourg which
was founded by St Willibrord in 698, as part of a mission probably initially launched
from Ráth Melsigi with primarily Irish support and the backing of the Northumbrian
ecclesiastic exile Bishop Ecgbert.[112] That the recognition of a key Irish element in what was
formerly considered an Anglo-Saxon mission need not necessarily preclude a Northum-
brian contribution to the subsequent development of the Echternach scriptorium has been
ably demonstrated by Nancy Netzer.[113]

The most notable passage of calligraphic extravagance on the part of the the Lindisfarne
Gospels' scribe appears on f. 136v where the second column terminates in a triangular
diminuendo of calligraphic display half-uncial, its letters featuring extended cross-strokes
('N'), extended scrolled head-strokes ('s') and curvilinear distorted minims ('m'), remi-
niscent of that encountered later in the Book of Kells and the Book of Armagh (see pl. 32
and fig. 93). The Lindisfarne Gospels' scribe also likes to distort letters in order to wrap
them around others, such as the low-slung curved foot of 'l' which cradles an 'o' in the
final line of f. 146v, and the 'N' which raises itself on its extended first leg to stand above
its fellows in 'singula' at the end of f. 24r. He also likes to write letters in strings descending
vertically below the line, as with the 'uit' of 'curauit' at the end of the first column of
f. 91r. Single letters are also sometimes written as calligraphic subscriptions, such as the
two 'i's which sit extending downwards in ligature from the final minims of 'm' and 'h' in
'mihi' at the beginning of f. 147v. These glimpses of scribal exuberance indicate just how
much self-discipline, restraint and effort were required to sustain the incredible regularity
of the text script and indicate that the scribe was used to writing a less controlled half-
uncial and probably also a cursive minuscule script.

Punctuation

The Gospels are punctuated *per cola et commata*, as became the norm for Jerome's Vulgate
and as found in Amiatinus, the St Cuthbert Gospel and the Echternach Gospels. In this late
Antique system of punctuation the length of the line serves to clarify sense and *sententia*,
marking the pauses between verses and the sub-pauses within them.[114] The resulting *mise-
en-page* is extremely elegant and conducive to legibility, if profligate with the membrane
resource.

The prefatory material does not employ the *per cola et commata* system. Following the
rubrics and titles the more usual Insular system of *distinctiones* is used, in which the number
of points indicate the value of the pause.[115] One to three points are used, the final one
sometimes assuming the form of a *versus* mark or a 'z' shape.

Citation marks are written in the margins (see ff. 146r, 148v, 149r), in the form of a series of two points followed by a *versus* mark (touched in red), to mark quotations from other books of the Bible. This may be the earliest (extant) occurrence of such a practice within an Insular book. During the early eighth century, whilst composing his commentaries on the Apocalypse, Acts, Luke and Mark, Bede devised a system of citation, with the initial letter of the names of authors cited appearing in the margins adjacent to the passage quoted.[116] This practice, the origin of modern bibliographical footnoting/citation, assisted Bede in his attempts to vindicate his audacity in authoring new commentaries, which seems to have attracted adverse comment from some of his contemporaries, by pointing those less learned than himself towards his patristic sources. Lowe traced the marking of quotations, indicated by indentation or by 's' shaped *virgulae*, to late Antique and early Christian books, and showed that one surviving book containing such devices, a sixth- or seventh-century copy of a text by Ambrose (Boulogne-sur. Mer, Bibl. Mun., MS 32; CLA 6.734) was in England during the eighth century.[117] Bede may have been inspired by such systems, and perhaps even by the southern Italian Gospelbook which was also consulted by the scribe of the Lindisfarne Gospels who may have copied its citation marks into its margins. These marks appear to have been made by the original scribe but even if added by the rubricator are contemporaneous. They differ from the biblical citation marks found in Wearmouth/Jarrow books which employ a cross composed of four or five dots. If citation marks were not present in the exemplar, or even if they were (as suggested by their presence in another copy descended from the same textual archetype, the St Petersburg Gospels), their relevance to a contemporary audience is likely to have been due to Bede's adoption and extension of the practice during the first two decades of the eighth century and would tend to support the ascription of such a date to the Lindisfarne Gospels.

Abbreviations

Abbreviations are used sparingly, as befitted a formal copy of Scripture at this period.[118] Contractions, signalled by a horizontal abbreviation bar (occasionally doubled in red by the rubricator), are applied to some word endings (denoting final 'm' or 'n') where space-saving is in order and are used for the contractions for the *nomina sacra*: dns (dominus), ds (deus), spu sco (spiritu sancto), ihs xps (ihesus christus). Very occasionally a word or element may also be contracted with the use of a horizontal bar above, such as ni (nostri). Some other of the 'notae communes' of late Antiquity also occur, with b: for -bus and q: for -que. Tironian *notae*, the tachygraphic system devised by Cicero's secretary, Tiro, are generally avoided, despite their popularity in the Insular scriptorium, although his hooked 'h' for 'autem' appears (f. 146v, final line of second column) as does his back-to-front 'e' for 'eius' when it needs to be squeezed in (e.g. below the line on f. 256r a20). 'E' caudata is sometimes used. Stress marks or accents are occasionally placed above 'a' when it occurs

as a monosyllable joined to a following word and above 'o' when used as an exclamation or invocation (as in the evangelist miniature inscriptions, see pls 8, 14, 18, 22) and consist of a fine acute stroke.

Orthography

The orthography is good and suggests careful adherence to a good textual model. Monosyllables are generally, but not invariably, joined to the following word, a frequent Insular practice. Some orthographical variants occur: 'b' is preferred to 'p', as in 'scribtum'; 'p' is omitted from 'tem(p)tationem'; the second 't' of 'cottidiana' is often omitted. Single 's' sometimes replaces double 's' ('egresus' for 'egressus', f. 115r b20), again a common Insular feature. The scribe appears to have occasionally confused 'd' and 't' (misreading the script of his exemplar?), to have substituted 's' for 'd' ('assumit' for 'adsumit', corrected to 'assumpsit/adsumpsit', f. 33r a10) and 'i' for 'e' ('mercis' for 'merces', f. 154r b9 and f. 154v b16; 'remiseritis' for 'remiseretis', f. 257r a13; 'praecipit' for 'praecepit', f. 110r a19 and f. 110v a5; 'porrigit' for 'porriget', f. 168v a11) and 'a' occurs for 'ab', f. 154r a9. 'Iohannen' also occurs in place of 'iohannem', f. 216v a3, in accordance with Wearmouth/Jarrow practice and 'effetha' occurs instead of 'eppheta' (f. 110r a13). 'Et' sometimes replaces 'ad' as a unique textual variant (e.g., f. 200v b5). A confusion of 'r' and 'n', probably indicates misreading of a marginal note written in one of the continental post-Roman minuscules in the exemplar. A basic familiarity with Greek is signalled by the use of the Greek characters for the Chi-rho and the appearance of the Greek character for Latin 'f' within the display script of f. 27r, the Matthew Incipit page. This may betoken an appreciation of script as an indicator of cultural affiliation, rather than a working knowledge of the language, although Greek was certainly known by Northumbrian scholars such as Bede.[119]

Numerical annotation and corrections

The numbers in the Canon Tables were written by the same hand as those in the margins marking the Eusebian sections and the chapter numbers (which are in a thicker red ink), as a comparison of the letter forms and ink shows (e.g. the 'i' with bold head wedge and hairline serif at the foot; the 'x' with its descending foot terminating in a variable angular hook or a triangular serif with projecting lowest stroke; 'u' and 'i' in ligature; use of 'v' for 'u'). The letters also correspond to those in red for the chapter numbers and capitula lectionum and the abbreviation bars above them correspond to those in the rubrics. From this, Julian Brown concluded that they were all by the same hand.[120] On f. 239v one can clearly determine, from the arrangement and compression of the marginal numbers, that the number of the appropriate Canon Table was written first, then the section numbers for the Gospel in question and for corresponding passages in any of the other Gospels, then the Chapter number. On f. 240r it is possible to see how the rubricator spreads himself when supplying a Chapter number free from the constraints of any pre-inscribed section

numbers. In his extremely thorough analysis Julian Brown identified this hand as that which also supplied the rubrics and most of the corrections to the volume.[121] The stylistic comparison of the display lettering used as titles at the heads of the Canon Tables with that of the rubrics supports the conclusion that these too were the work of the rubricator. The layout and painting of the Canon Tables were, however, already completed by the original artist-scribe.[122]

The volume was carefully written and did not require extensive correction. The text scribe sometimes inserts omitted words between or below the line, or at line-ends, in a smaller and compressed version of his usual script, such as 'in templo' written in vertically descending characters after line 7 in the first column of f. 140v and 'nostris' added beneath the final line of f. 142v. This hand also adds some suprascriptions, such as 'a' above 'bartholomeum' in the first line of f. 100r. On f. 180r he has skipped a line from the exemplar and adds it using a run-over symbol. On the next line he carefully transforms an 'f' into a 'p' and also scores out an 'R' with a light diagonal line. Omissions in the text are occasionally marked by a 'ð' answered by 'ħ' accompanying the insertion in the margin (e.g. ff. 51r a10, 71v a4), a practice also observed in the Gotha and St Petersburg Gospels, so perhaps deriving from the textual archetype, and also in the Durham Gospels. *Signes de renvoi* consisting of an oblique stroke (like the accents used by the original scribe) with a point above are also used to mark omissions and transpositions (e.g. ff. 53v b19, 66r a4, 233v a17, 236v a14). A few corrections by erasure (which are difficult to date) also occur, such as the erased 'n' of 'loqueba(n)tur' in the second line of the second column of f. 97v.

A second, correcting hand added the lighter, compressed 'et pauli' to the feasts at the end of the penultimate line of f. 208v. This same hand may have been responsible for the suprascript insertion of a light minuscule 't' above 'cotidiana' in line 19 of the second column of f. 208r. This second hand undertook the bulk of the correcting (the original scribe having made some corrections as he went) and this was the hand identified by Julian Brown[123] as that of the rubricator.[124] Like the original scribe, he used expunctuation, insertion of letters above the word in question, sometimes marked by a point (which the original scribe also occasionally used, e.g. on f. 189v a10 and f. 248r a4) or contained within points. He occasionally also marked corrections by a light triangle of points, a feature also apparent in the Durham Gospels and identified by Verey as the same hand correcting both volumes (see fig. 71).[125] In general, the original scribe and the rubricator seem to have used the same, or similar, variant practices of correction, supporting the stylistic evidence that they came from the same scribal background, and probably worked in the same place.

In *Cod. Lind.*, Julian Brown identified two correcting hands other than that of the text scribe: that of the rubricator and that of Aldred.[126] The style of the former's hand and his occasional marking of corrections by a triangle of points can also be observed in the Durham Gospels (f. 6r lines 11–13; f. 56r line 16; f. 76r line 21; f. 81r lines 6–7; f. 88v line

5). On the basis of this, and on the close textual relationship of these corrections to the Lindisfarne Gospels, it was identified by Christopher Verey as the hand responsible also for correcting the Durham Gospels, or at the very least one from the same background, this serving to support the premiss that they were both made in the same scriptorium.[127] This was one piece of evidence cited in support of the suggestion, advanced primarily by Rupert Bruce-Mitford on art historical grounds, that Durham was the latest of the manuscripts which these scholars attributed to the Lindisfarne scriptorium, namely the Echternach Gospels, the Durham Gospels and the Lindisfarne Gospels. I would propose, however, that the same hand corrected the Durham Gospels in two phases: an initial correction after production and a later campaign of correction and punctuation after the textual rescension used in the Lindisfarne Gospels became available, and that the Lindisfarne Gospels could thus have been the later of the books to be produced.[128]

To recapitulate: if they were not actually made at the same place (which it is likely that they were on stylistic grounds) the Lindisfarne and Durham Gospels were certainly both available to the same person shortly after production. This hand painted the rubrics, partly following stylus drawings left by the original artist-scribe, and added the marginal apparatus for chapter numbers and Eusebian sections to the Lindisfarne Gospels. He also provided the numerical entries and decorative headings for its Canon Tables (which had been designed and painted by the original artist-scribe) and undertook a secondary correction of its text. The same person had undertaken an original correction campaign in the Durham Gospels and then appears to have returned to it, after his work on Lindisfarne, and to have emended and punctuated (*per cola et commata*) Durham's text in places to accord with that of Lindisfarne.

The place of the Lindisfarne Gospels within the 'Insular system of scripts'

The Lindisfarne Gospels' form of regular, canonical half-uncial script belongs to a type that E. A. Lowe called 'Insular majuscule', but was termed by Julian Brown 'reformed Phase II Insular half-uncial' as part of his innovative and influential analysis of the Insular system of scripts.[129] To summarise the place of the Lindisfarne Gospels within that system: Brown argued that, following their conversion to Christianity from the fifth century onwards, the Irish received a script known as cursive half-uncial, used by the educated reader of late Antiquity for annotation rather than by professional scribes.[130] Working from this basis they upgraded the script to produce a half-uncial similar to that of the late Roman script system, and downgraded it as a working minuscule script for more general purposes. What are thought to be the oldest extant Irish manuscripts (such as the Cathach, see fig. 37) employ cursive half-uncial, giving way to a minuscule which is written more quickly but features some higher grade letter-forms (sometimes termed 'hybrid minuscule'). The script of the Book of Durrow (see pl. 31) is more settled and approaches what might properly be

called Insular half-uncial, the most developed and regular form of which occurs in the Lindisfarne Gospels. Julian Brown saw this development, or 'reform' of earlier Insular half-uncial as being primarily influenced by the uncial script of Wearmouth/Jarrow and its Italian exemplars, the impact of which he detected in the hands of both the artist-scribe of the Lindisfarne Gospels and the Durham-Echternach Calligrapher. He considered the latter to be an older member of the Lindisfarne scriptorium but, influenced by Bruce-Mitford's views on ornament, argued that he wrote Durham and Echternach after the Lindisfarne Gospels had been made but in an older script style.[131] Others have suggested that Wearmouth/Jarrow experiments with minuscule script as part of the drive to 'publish' Bede's works from the 740s onwards provides a better context for the development of 'Phase II' half-uncial, David Dumville going so far as to suggest that the Lindisfarne Gospels may have been written at Wearmouth/Jarrow after 750, its reformed half-uncial being part of a systematic reform of the Insular script system which he alleges took place there.[132]

To my mind this is a contorted and restricted view of a more gradual and organic process. There are certainly points in the history of script when thoroughgoing reforms have been undertaken and promulgated within a short timespan, usually as part of a political and/or ecclesiastical imperative, such as the dissemination of caroline minuscule as part of a textual and religious programme of reform within the Carolingian Empire under Charlemagne,[133] or the reform of the Visigothic Church and its scriptoria under Carolingian influence after the reconquest of northern Spain,[134] or in response to fashion, commercial trends and international consumption such as that experienced within the sub-contracting stationers' shops of the European university towns in the thirteenth and fourteenth centuries.[135] I have even suggested elsewhere in this volume that during the early eighth century Wearmouth/Jarrow may have been circulating Gospelbooks in its distinctive uncial script as exemplars, as a means of transmitting what it considered to be more reliable forms of Jerome's Vulgate text. However, Julian Brown's useful categorisation of the development of Insular script into two major phases can be sustained without the need to envisage a programme devised by one influential centre, be it Lindisfarne or Wearmouth/Jarrow.

Julian Brown carefully traced the evolution of Insular half-uncial throughout the seventh century, with a progressive introduction of greater consistency and regularity, traceable throughout the pages of the Cathach, Durham MS A.II.10, the Book of Durrow and the Durham and Echternach Gospels (see pls 27, 29–31 and figs 37, 96). If any doubt be raised that an already well-developed half-uncial script was practised in a Columban milieu, consideration should be given to the 'in nomine' inscription with its rounded half-uncial characters, carved on a pebble (for votive purposes, or perhaps as a trial-piece, see fig. 103) excavated at the royal Dalriadan fort of Dunadd in Argyllshire, the regal power-base for the Columban mission.

Fig. 103. Pebble (NMS GP 219) inscribed 'in nomine' ('in the name of'), in half-uncial script, perhaps a devotional object or a scribal motif-piece, from the Irish ceremonial site of Dunadd in Dalriada, Argyll, Scotland, 8th century. (Photo: National Museums of Scotland. © Trustees of the National Museums of Scotland)

For Julian Brown, Phase II of this development was signalled by the adoption in the Durham and Lindisfarne Gospels, of a version of the script which exhibited the normalising influence and stately rounded aspect of Italian uncial script of the style practised in Rome. He observed the influence of this 'reformed' script in the hands of later volumes such as the Lichfield Gospels and the Book of Kells (see pls 28, 32), which he was inclined to date early in order to bring them closer to the 'absolute' finishing date of 698 for Lindisfarne's production. Similarly, he outlined the corresponding development of minuscule scripts, in their 'current', 'cursive', 'set' and 'hybrid' forms, throughout Britain and Ireland, again postulating a 'Phase II' which assumed several different forms according to region. Dumville has gone further, in the course of an attempt to dispel the idea of a Lindisfarne scriptorium, and suggested that Wearmouth/Jarrow was responsible for the wholesale 'Phase II' reform of the Insular system and that, as its distinctive Phase II minuscule seems to have evolved as part of a publishing campaign, identified by Malcolm Parkes,[136] to circulate the works of Bede in the mid-eighth century (see fig. 104), the reform of Insular half-uncial (of which the production of the Lindisfarne Gospel was an essential part) is likely to have occurred there at the same time, as such developments are, he would suggest, unlikely to have been protracted.[137] How then is one to account for the time lapse between its reform of high-grade book script by the introduction of italianate uncial around 700 and its completion of the process by a reform of half-uncial and minuscule around 740–60? It remains equally as likely that the campaign of book production employing minuscule script at Wearmouth/Jarrow, rather than the uncial which it reserved for sacred texts, was itself influenced by the earlier tradition of cursive minuscule scripts which are found in an Insular milieu from areas as diverse as seventh- to eighth-century Ireland, Continental mission centres such as Willibrord's Echternach and Columbanus' St Gall, the Canterbury school of Theodore and Hadrian, Boniface's south-western England and the Frisian mission-field, and is to be seen as part of the evolution of the genre into

Fig. 104. Bede, *Ecclesiastical History of the English People* (BL, Cotton MS Tib A.xiv), f. 26v, the third oldest copy to survive, minuscule script, Wearmouth/Jarrow, mid-8th century.

Fig. 105. The Rawlinson Gospels
(Oxford, Bodleian Library, Rawlinson
G.167), f. 1r, Luke incipit page, Irish,
second half of 8th century. (Photo: The
Bodleian Library, University of Oxford)

what has been termed 'Phase II'.[138] Did Wearmouth/Jarrow need half-uncial when it had
its own uncial for higher purposes and minuscule for others? If it did, there are, as we
shall see, better candidates as examples of what this may have looked like than the
Lindisfarne Gospels, which display little affinity with its codicological and artistic
traditions.

There was undoubtedly an earlier Insular tradition of half-uncial, and one that is well-
represented within books associated with the Columban *parochia*, which was stylistically
evolving towards a more formal, regular type throughout the seventh century and which
had achieved maturity by the time that the Durham Gospels was written (see pl. 27 and
fig. 71). If, as I have proposed, the Lindisfarne Gospels was made a little later, in the second
decade of the eighth century, 'Phase II' had already been achieved and its distinctively
overt response to the influence of uncial script should be seen as a further, rather exotic,
development which was a little aside from the mainstream and which thereafter exerted a
limited direct influence (over and above the general regularity of 'Phase II' half-uncial).
Such direct influence may be manifest in other books from the Columban federation such
as the Book of Kells (see fig. 148), while other areas were slower to evolve along similar
lines or, in the case of some Irish scriptoria, never did so and remained staunchly within
'Phase I'.[139] The Lichfield, Macregol and Rawlinson Gospels (see pl. 28 and fig. 105),
Lincoln College Oxford MS 92 (CLA 2.258, a fragment of Luke, now in the Bodleian),[140]

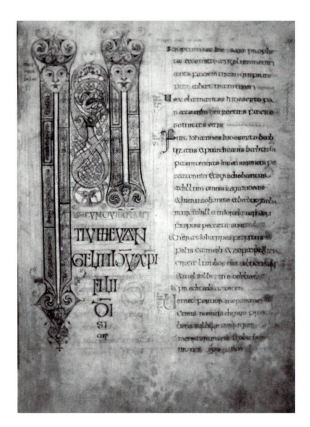

Fig. 106. The Barberini Gospels (Biblioteca Apostolica Vaticana, MS Barb. Lat. 570), f. 51r, Mark incipit page, with text script probably by a Mercian scribe trained in Northumbria or by a Northumbrian. (Photo: Biblioteca Apostolica Vaticana)

one of the scribes of the Cambridge-London Gospels and two of the scribes of the Barberini Gospels (see figs 106, 132) all favour a broad, regular half-uncial of mature 'Phase II' character. Others exhibit Phase II half-uncial scripts characterised by lateral compression and a less regular aspect with letters of differing heights and more fractured, angular strokes than the generous curves of the Lindisfarne and Durham Gospels. These include Royal 1.B.vii, the Gotha Gospels, the St Petersburg Gospels, the half-uncial hand of Durham MS A.II.16 (see figs 25–27, 107),[141] the Durham Cassiodorus, British Library, Eg. MS 1046,[142] and fragments of probable Northumbrian Gospelbooks such as those leaves from the same book which were appended to British Library, Cotton MS Tib. B.v, f. 76 (see fig. 70),[143] British Library, Sloane MS 1044,[144] and Cambridge University Library, MS Kk.1.24[145] (all of which have tenth-century Old English documents relating to Exeter written into their blank spaces, perhaps having been brought south by Athelstan or his successors). Several of these volumes (including Royal 1.B.vii, the Gotha and St Petersburg Gospels, all of which stemmed from the same textual archetype as the Lindisfarne Gospels) exhibit features associated with the Wearmouth/Jarrow scriptorium, such as a dedication cross at the top of each page of script and the marking of lections with a cross formed of

Fig. 107. Durham MS A.II.16, f. 37r, Northumbrian Gospelbook, mid-8th century. This section is by a scribe writing an uncial hand; other sections are by two scribes who wrote half-uncial scripts. (Reproduced by kind permission of the Dean and Chapter of Durham Cathedral)

points. If Wearmouth/Jarrow did practise a half-uncial it is perhaps more likely to have been of this second variety. The closest analogies for the more laborious, stately form encountered in the Durham Gospels and, in an even more grandiose form, in the Lindisfarne Gospels, lie within books associated within an eighth-century Irish or Columban orbit – within the background in which it was first developed.

Julian Brown's 'Phase II' of the Insular system of scripts retains its validity but should, I would suggest, be seen as the culmination of a process of growth and maturing in book production, stimulated by the increasing availability of earlier textual exemplars. These were brought to these islands by Roman and Frankish missionaries, by subsequent worthies of the Church such as Theodore and Hadrian, Wilfrid, Benedict Biscop, Ceolfrith and Acca, or shared between communities belonging to extended monastic families with houses on the Continent (such as Luxeuil, St Gall, Bobbio, Echternach, Utrecht, Salzburg and Fulda).[146] The stylistic influence of early Christian books exhibiting a regular layout and a generous high-grade uncial script played a significant role in this process and could, on occasion, stimulate a particularly faithful response, as in the uncial book production of the scriptoria of Wearmouth/Jarrow, some of the Kentish houses and Worcester.[147] Such

stimuli were coupled with an increasing confidence and evolution of earlier indigenous styles of script, decoration and codicological preparation. In terms of script, 'Phase II' would consist of the normalisation of high-grade uncials and half-uncials (with some regional variation) and, more importantly, of experimentation with a range of minuscule scripts of varying degrees of formality (current, cursive, set and perhaps hybrid) which were appropriate for a wide variety of purposes and which, by around 800, had achieved such status that they were even considered an appropriate vehicle for the Scriptures. Wearmouth/Jarrow's Phase II minuscule was one such experiment, but other equally successful ones were under way in Ireland, Mercia and Wessex and on the Continent where, in the circle of Charlemagne and Alcuin of York, they would culminate in the promotion of the multi-purpose caroline minuscule.

This level of maturity, which marks the next phase, was already being achieved by Insular scribes during the late seventh century and extended, to varying degrees depending on the historical circumstances of individual centres, throughout the eighth century. It was surely not the invention of any single scriptorium or individual, whether based at Lindisfarne or Wearmouth/Jarrow. The Lindisfarne Gospels represent a particularly successful fusion of these two complementary strands of development. The volume is an outstanding example of the matured Insular style of book production (favouring highly developed manifestations of its traditional half-uncial script, its Celtic/British and Germanic art forms and its processes of membrane preparation) which has nonetheless fully absorbed and assimilated the more recent injection (as part of a longer process of absorption) of Mediterranean textual, scribal and artistic influences. As such it is a precocious pinnacle within the development of 'Phase II', rather than its genesis.

The closest palaeographical relative to the Lindisfarne Gospels remains the Durham Gospels (see figs 65, 71).[148] It differs, however, in a number of respects. It has red running heads, unlike the Lindisfarne Gospels. It has alphabetic quire marks consisting of a letter flanked by a point and a versus mark on each side at the foot of the page (ff. 10v, 28v, 38$_4$-v, 75v), unlike the Lindisfarne Gospels, and is on coarser Insular membrane which does not approach the Lindisfarne Gospels in quality, holes in the vellum being patched and decorated with red dots (f. 74). Some of the membrane is prepared in accordance with Continental practice, with a marked distinction between hair and flesh sides. It is ruled for single bounding and horizontal lines, numbering twenty-one to twenty-two long lines rather than the Lindisfarne Gospels' double vertical and horizontal rulings for two columns of twenty-four lines (the *per cola et commata* arrangement of the Vulgate and the positioning of minor initials would have dictated this difference in the Lindisfarne Gospels). Durham's use of display half-uncial and its flamboyant calligraphic lapses into minuscule at line-ends are more reminiscent of the Book of Kells than of the Lindisfarne Gospels. Durham's black display capitals on f. 2r and its prefaces to Mark bear a resemblance to those of the Lindisfarne Gospels' incipit pages, including the incorporation of some Anglo-Saxon

angular runic stylistic features, but are unframed (see pls 3, 11, 17, 21, 27). Many of the red dots surrounding the display lettering on Durham's 'In Principio' page have faded almost to the point of invisibility and distort the overall appearance which would have originally provided a denser framework of stippling to the lines of script, making them appear less fluid than they now seem and more akin to the Lindisfarne Gospels' rectilinear approach.

The style of initials with zoomorphic terminals is closely related to that of the Lindisfarne Gospels, although in Durham they are produced calligraphically as part of the writing of the letters rather than planned, drawn and painted as in the Lindisfarne Gospels (except in the cases which occur as part of the Lindisfarne Gospels' display panels which are calligraphically penned in ink). The minor initials and *litterae notabiliores* in Durham feature more 'whiplash' terminals of the sort found in Irish and Echternach manuscripts than the limited examples encountered in the Lindisfarne Gospels. Neumes (an early form of musical notation encountered from the ninth century onwards) have been added between the lines of Durham on f. 74v, probably during the ninth or tenth centuries, marking the sung part of the beginning of Matthew's Gospel, the genealogy of Christ.[149] Lections in Durham are marked by light minuscule annotations surrounded by boxes in the margins ('de dedicatione', f. 21v; 'in cena domini', f. 27v; 'in natale domini', f. 72v), rather than being integrated into and signalled by the decorative hierarchy of initials as in the Lindisfarne Gospels. Durham's method of marking lections is also followed in Durham MS A.II.16. Some words in Durham's text are highlighted by red dots overlying the ink of the letters, such as 'sp(iritu)s', f. 6r, line 14. The half-uncial script of Durham is similar in ductus and letter-forms to the Lindisfarne Gospels, but the latter is more regular in its aspect, has a greater breadth and rotundity and introduces more uncial letter-forms. An interlinear correction by the scribe of Durham on f. 15r ('vobis mendar.') includes a cursive straight-backed 'd' written in New Roman cursive fashion, with the ascender rising on the left and descending on the right, leaving an open wedge at its head, an old-fashioned feature of minuscule script which finds Irish analogies. A straight-backed cursive minuscule 'd' with reversed ductus and open bow also occurs in Durham's running heads (f. 26v). The scribe of the Lindisfarne Gospels never allows his script to exhibit such extreme cursive features, even where he does occasionally downgrade at line-ends. Corrections in Durham are generally marked by three points arranged in a triangle (this being the work of the hand which also added some corrections to the Lindisfarne Gospels),[150] by a light chrisma or by a diagonal line or double line with a point above or below, linking insertions with their placing in the text, and occasionally (f. 67r) by a 'd' echoed by 'ħ' in the margin, as also occurs in the Lindisfarne Gospels.

Thus there are a number of palaeographical similarities between the Lindisfarne Gospels and the Durham Gospels, but also a number of differences, most of which would tend to indicate that Durham is somewhat closer to the Columban tradition and exhibits little of the Wearmouth/Jarrow influence apparent in the Lindisfarne Gospels. The same might be

said in terms of text. The Durham and Lindisfarne Gospels seem to have been in the same centre shortly after their production, as the same hand corrects both.[151] This scribe's work in Durham seems to have been undertaken in two campaigns, an initial correction and a later one made with reference to the Lindisfarne Gospels or their exemplar (and probably Lindisfarne itself as there appear to be a few corrections by his hand therein). Durham is damaged and is bound with fragments of a Gospelbook made at Wearmouth/Jarrow which fills part of its textual lacuna. That these were associated by the tenth century is indicated by the presence of inscriptions by a single hand, naming one 'Boge', in both sections (ff. 80, 80v and 106r, see fig. 46). Durham may have been made in another scriptorium of similar Columban background, such as Melrose, and subsequently joined the Lindisfarne Gospels, or, given their similarities, may represent an earlier phase of production in the same place – Lindisfarne.

Julian Brown thought that he had identified enough of a relationship between the minuscule 'lapses' of the Durham Gospels and the set minuscule script of the Echternach Gospels to suggest that they were the products of the same tradition of script. He also related this minuscule to that found in the Vatican Paulinus (Biblioteca Apostolica Vaticana, Pal. Lat. 235, see fig. 108) which he and Tom Mckay attributed to the Lindisfarne *scriptorium* and saw as representative of its more usual minuscule 'library' book production.[152] Even if, as seems likely, Durham and Echternach were not in fact by the same hand they certainly shared a common script background and the lapses at line-ends in Durham, and to a lesser extent in Lindisfarne, indicate that their scribes were familiar with the sort of cursive and set minuscule scripts which are given fuller reign in the Echternach Gospels. This need be interpreted as no more than the sharing of a common tradition which embraced parts of Ireland, Scotland, Northumbria and the Continental mission-fields at the time. The Vatican Paulinus could have been made at Lindisfarne, and is certainly how we can imagine one of its school books would have looked, but it need not necessarily have been. What is interesting to note is that in the Paulinus, as in many of the less formally produced non-scriptural Insular books, the work of several hands may be detected. It is quite rare for a book to be by one hand, let alone one as demanding as the Lindisfarne Gospels.

The use of exceptionally fine linear penwork, reminiscent of metalwork engraving techniques (and also encountered in Visigothic illumination, see fig. 21), in the incipit page ornament of both Durham and Echternach, and in the Durham Crucifixion miniature (see pls 26, 27, 29, 30), also provides a link between the decorative technique of the two volumes which reinforces their shared repertoire of Ultimate La Tène curvilinear ornament and interlace, although significantly Durham favours a Style II zoomorphic interlace of Germanic origins whilst Echternach avoids it.[153] The Echternach Gospels also relate, as might be expected, to subsequent works by the Echternach scriptorium, causing some scholars to maintain that the Gospelbook was also made there, or that it was an Irish

Fig. 108. The Vatican Paulinus (Biblioteca Apostolica Vaticana, MS Pal. Lat. 235), f. 8r, Paulinus of Nola, *Carmina*, early 8th-century Insular school book, possibly made at Lindisfarne. This style of minuscule script (top left) could be found throughout Ireland, northern Britain and the Insular mission fields.

product reflecting the origins of Willibrord's mission.[154] Others have pointed to a more mixed composition of the Echternach scriptorium in which Irish, Northumbrian and Frankish elements were represented and which would not preclude the Echternach Gospels being made by a Northumbrian, at home or abroad.[155]

Textually it is conceivable that Durham was made in the same place as the Lindisfarne Gospels, or in a closely related centre (such as Melrose?) and reflects the Columban tradition prevalent before a Vulgate exemplar from Wearmouth/Jarrow (either copied there or a southern Italian original) became available as the main exemplar for the Lindisfarne Gospels, bringing with it stylistic influences, and that Durham was subsequently corrected to reflect its impact. A close relationship is harder to maintain in respect of Echternach which itself relies on a Vulgate exemplar, different to that used by the Lindisfarne Gospels, and links it to Columban prefatory matter. The colophon copied into Echternach links the exemplar to southern Italy and ultimately to an association with Jerome himself. Given the importance attached to textual 'authority' and the association with prominent individuals manifest within the Insular tradition it is unlikely that the maker of the Lindisfarne Gospels would have preferred a different Vulgate exemplar to one connected to its 'author' himself if such was available within the scriptorium. On balance, I think it wiser to discuss Durham and Echternach individually, rather than necessarily as the products of the same hand (the 'Durham-Echternach Calligrapher'), and to note that the debate concerning their inter-relationships, and with the Lindisfarne Gospels, at the very least reinforces the conclusion that they all came from a shared background as the products of initially Irish foundations subject to increasing Anglo-Saxon and Mediterranean influences.

I have suggested that, rather than representing the norm as a high-grade Insular book-script, the Lindisfarne Gospels were a somewhat exotic exception, embodying a conscious classicism ostensibly as 'romanising' as the higher grade uncial scripts of Wearmouth/Jarrow and Kent, yet acknowledging and celebrating their indigenous palaeographical roots and the 'Celtic' contribution.[156] This 'reformed' script, with its stately aspect, the determined regularity and adherence to uniform head- and base-lines, the high frequency of uncial features and the layout *per cola et commata*, all redolent of the influence of Italian and Wearmouth/Jarrow influence, should perhaps best be viewed as standing aside from any evolutionary line. Any such 'evolutionary' interpretation should also be tempered by an acknowledgement that it is applied with the benefit of palaeographical hindsight and is unlikely to have been formalised and uniformly subscribed to by contemporary scribes. Celtic scribes in particular seem to exhibit a healthy lack of concern for phases and categories. Julian Brown's 'Phase I', the early developmental stage of Insular book production, was not replaced neatly by the more canonical 'Phase II', ushered in, so he suggested, by the innovations of Northumbrian scriptoria around 700. There was no conscious 're-tooling' on a production line to meet new specifications! In Ireland features of both phases may be mixed or may occur side by side throughout the eighth and

ninth centuries. This renders a primarily evolutionary stylistic arrangement of examples extremely dangerous. A book such as Durrow, which might appear to represent a less highly evolved form of script and ornament, need not *necessarily* be earlier in date (although, of course, it can be).

The script of the Lindisfarne Gospels did continue to exert an influence, however. British Library, Royal 1.B.vii exhibits a smaller and more compressed but still highly regular version of half-uncial, although its ornament is much more Germanic (its display script in particular resembles northern Italian and Frankish styles), modest and more 'old fashioned' in repertoire, scale and palette (see figs 25, 67).[157] As seen in the discussion of text, above, its maker had access to the same or a closely related textual exemplar as the Lindisfarne Gospels. Unlike the latter it preserves certain distinctive Wearmouth/Jarrow features, such as the inscription of a dedication cross at the head of each page and the marking of lections by a cross composed of four or five dots.[158] The Cambridge-London Gospels which are preserved in the form of Cambridge, Corpus Christi College, MS 197B and the badly damaged British Library, Cotton MS Otho C.v, contain a scribal hand which is reminiscent of that of the Echternach Gospels and of an Irish-trained member of the Echternach scriptorium, Laurentius.[159] However, they also contain a hand strongly exhibiting the Lindisfarne Gospels' palaeographical influence, reinforcing the strong art historical similarities which their evangelist symbols and decorated incipits share with both the Echternach Gospels and the Lindisfarne Gospels.[160] The Barberini Gospels contain two hands which employ a script similar to that of the Lindisfarne Gospels alongside two others, one of which appears by analogy to have belonged to a Mercian scribe.[161] The Lichfield Gospels contain a rather artificial, angular Phase II half-uncial as well as displaying considerable affiliations to the Lindisfarne Gospels' decoration.[162]

Perhaps the closest analogy to the Lindisfarne Gospels' stately, rounded script and more calligraphic display half-uncial, however, is to be found in the Book of Kells, in both the main text script and the calligraphic display variants of its prefaces (see fig. 148).[163] The similarities are so persuasive that Julian Brown argued that the two volumes were closer in terms of regional and chronological production than most scholars would accept, leading him to envision the production of Kells in an unspecified monastery in Scotland, perhaps in the mid-eighth century, a view which has not achieved currency.[164] Both books are likely to have been made as major cult items, widely renowned, of key houses within what started as the Columban *parochia* and it is perhaps therefore not so surprising that they should exhibit affinities without necessarily having been produced in the same scriptorium, or close dependencies, in a single developmental phase. If, as I suggest, the Lindisfarne Gospels were made at Lindisfarne, an important house hosting its own major cult and which continued to celebrate its Columban roots alongside its newer ecumenical affiliations, and completed in the early 720s this would in any case serve, for the squeamish, to narrow the chronological and ideological gap between these two great

monuments of the book arts. Their mutual stylistic relationship to a third, the Book of Durrow, which has been shown to be closely related textually to the Book of Kells, is also explicable in that it is another focal point within the cult of St Columba and was also made in a Columban house (see pls 31, 32). This may have been the same scriptorium which produced the Book of Kells (in which case Durrow is likely to have been the earlier of the two or one which had access to the same textual exemplar, containing unusual prefatory matter, as that used in the making of Kells). The Lindisfarne Gospels do not relate closely to either of these two great Columban books textually, but enjoys a palaeographical and art historical relationship with both, as well as to other works which are not closely related to them, including those made at Wearmouth/Jarrow.

The conclusion suggested is, once more, of a shared Columban heritage which the matter of the Lindisfarne Gospels are not afraid to integrate freely with other major influences, notably that of Wearmouth/Jarrow. On the basis of the historical and stylistic evidence, as well as that of provenance (with or without the statement concerning manufacture in Aldred's colophon) Lindisfarne remains the likeliest place to have fostered the fusion of such diverse influences at the time when it was building its reputation as a major pilgrimage centre and extending its influence throughout northern Britain.

Notes

1 T. J. Brown 1974. For the historical significance of codicological methods of preparation, see also M. P. Brown 1991a.

2 M. P. Brown 1991a.

3 See chapter one, above, for historical context.

4 O'Sullivan and Young 1995, p. 87.

5 T. J. Brown 1974.

6 This served to emphasise that they were composed by different authors, as they would originally have been written on separate rolls, or books. See McGurk 1961, p. 8.

7 Per Symeon of Durham.

8 See chapter two, above.

9 Tite 1993. The current, and previous, bindings and the various annotations and additions to the manuscript are discussed in chapter two, above.

10 T. J. Brown 1974.

11 Wilson 1961.

12 *Cod. Lind.*, pp. 84–7.

13 Needham 1979; Avrin 1991.

14 For a discussion of the background of ecclesiastical politics and the Anglican response to Catholic emancipation, see chapter one, above.

15 Backhouse 1981, pp. 90–1.

16 T. J. Brown 1969.

17 For some examples of mounts which may have been attached to bindings, such as one discovered in Phoenix Park, Dublin (National Museum of Ireland, P.782a), see Youngs 1989, no. 145. For the use of similar mounts on Codex Bonifatianus 1, see Wilson 1961. For the Whitby mounts, see Webster and Backhouse 1991, no. 107a. On the Athlone plaque (National Museum of Ireland R.554) see Youngs 1989, no. 133.

18 This was excavated in the 1980s in Ireland in Lough Kinale, Co. Longford. Kelly 1994.

19 On the Shanmullagh plate see Bourke 1998. The Loughtiniale shrine appears to have been forced open and lost in the lake, near a small crannog (an artificial inhabited island), perhaps during a Viking raid of 853.

20 Ryan 1983, no. 85, pls pp. 71 and 179.

21 *Ibid.*, no. 83, pl. p. 174.

22 *Ibid.*, no. 76, pl. p. 159.

23 *Ibid.*, no. 75, pl. p. 60.

24 Cennfailad became abbot of Devenish, in succession to its sixth-century founder, St Molaise, in 1001 and died in 1025, see Ryan 1983, p. 161.

25 The bell dates to sometime from the sixth to eighth century and the inscription dates its shrine to *c.*1100. Domhnall Ua Lochlainn was king of Ireland, 1094–1121, and Domhnall Mac Amhalgadha was bishop of Armagh, 1091–1105; see Ryan 1983, pp. 167–8.

26 Nees forthcoming, discusses the Carolingian and tenth-century English contexts for the inclusion of dedication inscriptions in books. These arguments would still prove valid in the context of Aldred's adaptation of an earlier metalwork inscription, in the Irish tradition, for use in a book. The alternative suggestion that he may have adapted an inscription within the book may find support from an inscription '+ Orate p(ro) ceolheard pr(esbyter) indas 7 ealhun 7 wulphelm auripex' on the first folio of the Stockholm Aureus. This was dated by Ker 1957 and Gameson 2002 to the tenth century and related by the latter to a new binding added after the book was ransomed from the Vikings in the mid-ninth century and preserving the names of the original makers or commissioners.

27 See, for example, the example dating to 1424 from Old Cairo, Church of the Virgin Mary, see Gabra 1993, pp. 84–5.

28 Exhibited in the upper galleries of the Coptic Museum, Cairo. See Gabra 1993, p. 46.

29 Andrieu 1948, p. 65.

30 Stephanus, *Life of Wilfrid*, ch. 17; Farmer 1983, p. 124. Whitelock 1979, no. 154. Also edited by W. Levison in *Mon. Germ. Hist., Script. Rer. Merov.*, VI.

31 M. P. Brown 2000.

32 Fox *et al.* 1990.

33 See chapter three, above.

34 Noel 1995; van der Horst 1996.

35 See T. J. Brown's discussion of layout in *Cod. Lind.* For the general context of *mise-en-page* and textual articulation, see Parkes 1987 and 1992. On decorative articulation in an Insular context, see Farr 1997, pp. 42, 50–56, 83–5 and *passim*. The practice of distinguishing key text breaks and 'rubrics', or matter relating to how to use or read the text, by the use of red pigment can be seen as early as the second millenium BC in ancient Egyptian texts and inscriptions.

36 Motif-pieces are discussed below, and in chapter five. On wax tablets see, for example, M. P. Brown 1994a.

37 M. P. Brown 1990, p. 4.

38 See Thompson 1960, pp. 5 and 7. Drawings made with such a style can, Cennini tells us, be easily erased using a piece of bread, see Thompson 1960, pp. 7–8.

39 On Eadburh's silver stylus, see Farmer 1987, p. 128.

40 M. P. Brown 1990, p. 4.

41 Temple 1976, nos 86, 64; Noel 1995. See, for example, the drawing of Satan's hand on f. 17v of Harley 603. There are also some traces of metalpoint underdrawings in a late tenth-century manuscript from Fleury illuminated by an Anglo-Saxon artist, British Library, Harley ms 2506 (see, for example, pp. 36v and 39v). Cynthia Hahn 1988 also noted the occurrence of leadpoint in Ottonian manuscripts. There were undoubtedly further early instances of its use. See also n. 50, p. 268, below.

42 Webster and Backhouse 1991, no. 105a and see also similar finds from Whitby, nos 107f–p.

43 Thompson 1960, pp. 13–14; Scheller 1995. I am indebted to Lillian Randall for drawing my attention to Cennini in this respect.

44 Thompson 1960, p. 106.

45 Stevick 1994.

46 Bill Schipper recently drew attention to previously unnoticed hard-point notes in the margins of the Benedictional of St Aethelwold, an Anglo-Saxon manuscript of around the 980s, relating to the liturgical arrangement of its texts, see Schipper 1994. David Ganz has also kindly drawn my attention to guide-notes to the artist in the late eighth-century Cologne, Dom. MS 83.

47 *Cod. Lind.*, pp. 7–8 and pl. 1; and the textual implications are discussed at p. 35.

48 Although, as we shall see, it may have been consulted by the artists of the Lichfield Gospels and the later Anglo-Saxon Copenhagen Gospels, and by the tenth-century glossator of the Macregol Gospels.

49 See above, p. 225.

50 A continental example of an underdrawing in metalpoint, probably made in northern France or Flanders during the second half of the eleventh century, is an unfinished sketch of an evangelist portrait on f. 27***verso of British Library, Burney MS 41. This seems to have been previously unnoticed. The decoration of the volume exhibits some Anglo-Saxon influence, somewhat in the style of the Jumièges Gospels. A further possibly early continental example of a lead/metalpoint sketch occurs on f. 55r of Brussels, Royal Library, MS 18383, the St Laurent Gospels from the Mosan region, thought to date from the first half of the eleventh century. However, the sketch is in an odd location, on a blank page facing an original evangelist miniature, and may be of later date. For a possible Ottonian example, see Green 1974, pp. 129–38. See also n. 41, p. 267 above.

51 See Alexander 1978, no. 51, pl. 217.

52 See Henry 1974, pls 24–5; see also Fox *et al.* 1990.

53 I am deeply indebted to Stan Knight for drawing this to my attention.

54 See De Hamel 2001, pl. 15.

55 On the relationship of text layout proportions to illuminations in a Carolingian context, see Harmon 1984.

56 Cramp 1989.

57 Page 1989 and 1995, pp. 316–17, 321–4.

58 One name-stone of the Lindisfarne/Hartlepool/Whitby type incorporating some runic elements (perhaps that of someone with affiliations with the Lindisfarne *parochia*) has survived from Monkwearmouth, although there is no evidence of the assimilation of such stylistic features into manuscripts known to have come from Wearmouth/Jarrow.

59 Page 1995, pp. 321–4.

60 Mitchell 2001, pp. 170–4; see also Okasha 1999; Karkov 1999; Henderson and Okasha 1992 and, above all, the careful discussion of the Northumbrian name-stones and their epigraphic context by John Higgitt in Cramp 1984, pp. 202–5.

61 Lichfield, Cathedral Lib., s.n.; Alexander 1978, no. 21.

62 Unless we are to assume that runes were used in English foundations in Ireland or Pictland.

63 Neuman de Vegvar 1987.

64 See, for example, the Codex Augusteus; Berlin, Deutsche Staatsbibl., lat. fol. 416 and Vatican City, Vat. lat. 3256.

65 Roberts and Skeat 1987; Nordenfalk 1951, pp. 9–20; T. J. Brown 1984. For the Codex Augusteus, see CLA 8.13. See also Parkes 1992, on rubrication.

66 Dublin, Trinity College Library, MS 55. For a stimulating discussion of the dating of this and other of the earliest extant Insular manuscripts, see Dumville 1999. His arguments would tend to push the chronology of these manuscripts prior to the seventh century, but the evidence advanced in support of a fifth-century dating and Continental origin for Usserianus Primus is extremely slight (see especially pp. 38–9). Recognition that the historical context does not preclude the origins of the 'Insular system of scripts' stemming from the fifth century does not mean of itself that the extant manuscripts need to be strung across the intervening centuries to fill the vacuum. More detailed work is undoubtedly needed in this area.

67 CLA 2.271; see also Alexander 1978, no. 1.

68 Petrucci 1971; Zimmermann 1916; Grabar and Nordenfalk 1957. See, for example, the copy of Gregory's *Regula Pastoralis* in Troyes, Bibl. Mun., MS 504; CLA 6.838.

69 See, for example, CLA 3.298, 3.347, 4.496, 11.646.

70 Dublin, Royal Irish Academy, s.n ; CLA 2.266; Alexander 1978, no. 4; Henry 1950, pp. 5–34.

71 Parkes 1987 and 1992.

72 Clanchy 1993, pp. 173–6. Hugh of St Victor, while advocating the mnemonic uses of manuscript decoration, saw it as an elementary or 'puerile' necessity and ascribed to it an origin in the schoolrooms of Antiquity, *ibid.*, p. 173.

73 Henry 1960, 23–40; McNamara 1973; M. P. Brown 1996.

74 CLA 3.328; Alexander 1978, no. 3.

75 CLA 3.365; Alexander 1978, no. 2.

76 M. P. Brown 1990; T. J. Brown 1982. See Dumville 1999, for a distinctive and, in places, contentious overview.

77 BL, Cotton MS Vespasian A.i; CLA 2.193; Alexander 1978, no. 29; Wright 1967.

78 For overviews, see Alexander 1978; Nordenfalk 1977; Henry 1965; G. Henderson 1987.

79 Whitelock 1979, no. 172.

80 See M. P. Brown 1996, pp. 88–9, 103–15.

81 British Library, Cotton MS Vespasian A.i. Also relevant in this context are what are likely to be even earlier examples of historiated initials in the Luxeuil lectionary (many thanks to David Ganz for bringing this to my attention) and the two initials depicting a man spearing a beast in Cambrai, Bibl. Mun., MS 470, CLA 6.740, which Lowe dates to the first half of the eighth century and ascribes to an Anglo-Saxon centre on the Continent.

82 St Petersburg, Public Library, MS Q.v.I.18; CLA 11.1621; Alexander 1978, no. 19; Wright 1967a, 91; Pächt 1962, p. 55. Patricia Stirnemann has also suggested an identification with Christ.

83 Trier, Domschatz, Cod. 61, f. 9; CLA 9.1364; Alexander 1978, no. 26; Netzer 1994.

84 For the Vespasian Psalter, see Wright 1967; for the Stockholm Codex Aureus, Stockholm, Royal Library, MS A. 135, see CLA 11.1642, Alexander 1978, no. 30, and Gameson 2002; for the Morgan Psalter, New York, Pierpont Morgan Lib.rary, MS M.776, see CLA 11.1661, Alexander 1978, no. 31; for the Codex Bigotianus, Paris, BNF, MSS lat. 281 and 298, see CLA 5.526, Alexander 1978, no. 34.

85 For the use of similar gilded capitals, in a more restrained context, at Wearmouth/Jarrow, see the Gospel-book fragments of similar date to the Ceolfrith Bibles, now in Utrecht, Universiteits-bibl., MS 32, CLA 10.1587. For the Jarrow excavations, see Webster and Backhouse 1991, no. 105 and also Cramp 1969 and 1975, and Cramp and Cronyn 1990.

86 For manuscripts possibly made at Wearmouth/Jarrow or a closely related centre which are less overtly romanising, such as perhaps the Durham Cassiodorus and Durham, Cathedral Lib., MS A.II. 16, see M. P. Brown forthcoming b.

87 For a discussion of this parallel tradition of lettering, see Page 1995, pp. 315–25.

88 See M. P. Brown forthcoming b.

89 See Webster and Brown 1997, pp. 245–6. On the knowledge of Greek in Anglo-Saxon England, see Bischoff 1966–81, II; Berschin 1980 and Bodden 1988.

90 For the Cambridge-London Gospels, see CLA 2.125, Alexander 1978, no. 12; for the Cutbercht Gospels, see CLA 10.1500 and Alexander 1978, no. 37.

91 Further details of all of these manuscripts are to be found in CLA and Alexander 1978.

92 CLA 2.147, Alexander 1978, no. 5.

93 CLA 2.273 and 5.578, Alexander 1978, nos 6 and 11.

94 CLA 2.149, Alexander 1978, no. 10; Verey *et al.* 1980.

95 For these and other relevant metalwork analogies, see Ryan 1983 and Youngs 1989.

96 See T. J. Brown 1984.

97 Further details of all of these manuscripts are to be found in CLA and Alexander 1978.

98 See, for example, CLA 4.497, 5.692, 6.765, 6.766, 7.852, 7.949, 8.1208, 10.1518, 11.1616, 11.1627.

99 CLA 1.105 and 5.618 and 5.630. For colour reproductions of relevant folios from the Gelasian Sacramentary and the Sacramentary of Gellone, see Verzone 1967, pp. 148 and 187.

100 CLA 8.1253; Alexander 1978, no. 28; Webster and Backhouse 1991, no. 128; Netzer 1996, pp. 119–26.

101 CLA 1.63; Alexander 1978, no. 36; Webster and Backhouse 1991, no. 160; M. P. Brown 2001; M. P. Brown and D. H. Wright forthcoming b.

102 See M. P. Brown 2001b.

103 CLA 2.191; Alexander 1978, no. 33; Webster and Backhouse 1991, no. 170; M. P. Brown 1996, pp. 169–78,

where it is discussed as a probable Canterbury product of the second quarter of the ninth century.

104 Alexander 1978, no. 66; Webster and Backhouse 1991, no. 165; M. P. Brown 1996.

105 For an exploration of this suggestion, see M. P. Brown 1994; see also Henry 1974 and Fox *et al.* 1990.

106 For the marking of lections and the development of the practice of marking them with decoration in the Insular corpus of manuscripts, see Farr 1997, especially pp. 15–17, 42–3, 46–50, 80–6, 117 and 120.

107 See Farr 1997. For the textual basis, see McGurk 1961. On the use of decoration as textual articulation, see also M. P. Brown 1996, pp. 68–128; Parkes 1992. See also Ó Carragáin 1994a.

108 Verey *et al.* 1980, pp. 38, 74–6.

109 There may also be a few random corrections by other Insular hands, such as the clumsy 'x' scoring through the 's' of *saecus*, with a heavy half-uncial 'c' written above, on f. 186r a11.

110 Parkes 1992.

111 *Cod. Lind.*, pp. 95–107.

112 Ó Croinín 1982 and 1984, 1989.

113 Netzer 1994.

114 Parkes 1992.

115 Parkes 1992.

116 Stansbury 1999.

117 Lowe 1928; Stansbury 1999a.

118 Lindsay 1963; M. P. Brown 1990; T. J. Brown 1984.

119 Bischoff 1966–81, II; Berschin 1980; Bodden 1988; G. Brown 1996.

120 *Cod. Lind.*, pp. 80–1. T. J. Brown also noted that the abbreviations used for the evangelist's names by this hand also corresponded, p. 80.

121 *Cod. Lind.*, pp. 78–81.

122 It should be noted that I have reappraised the relationship between the original artist-scribe and the rubricator here, from that given in part one of the facsimile commentary, M. P. Brown 2002.

123 *Cod. Lind.*, pp. 81–4.

124 It should be noted that I have reappraised the relationship between the original artist-scribe and the rubricator/corrector here, from that given in part one of the facsimile commentary, M. P. Brown 2002.

125 Verey *et al.* 1980, pp. 74–6.

126 *Cod. Lind.*, pp. 78–83.

127 Verey 1980 and 1999.

128 M. P. Brown 2000. Verey showed that the *per cola et commata* arrangement, which is not uniformly applied across all the books which feature it, and some of the textual corrections, are particularly close to the Lindisfarne Gospels and appear to be by the same hand which also added some corrections marked by a triangle of points in the latter. In the Durham Gospels facsimile (Verey *et al.* 1980, pp. 74–6) he in fact acknowledged that its correction could have been part of a later process, but did not pursue this line. He has now indicated to me, pers. comm., that his observations would not preclude my conclusion here.

129 CLA; T. J. Brown 1982; M. P. Brown 1989 and 1990.

130 T. J. Brown 1982.

131 See T. J. Brown on script in *Cod. Lind.*

132 O'Sullivan 1994; Dumville 1999.

133 See, for example, Ganz 1990; McKitterick 1989.

134 Walker 1998.

135 On university production see, for example, Bataillon *et al.* 1988.

136 Parkes 1982. The Moore Bede (Cambridge University Library, MS Kk.5.16, is considered to postdate the St Petersburg Bede of *c*.746. Given recent work by Bill Schipper on the layout of English vernacular manuscripts (see Schipper forthcoming), I wonder whether it might not, however, be closer to the original authorial layout of the text? It is laid out in single columns of long lines, like many later Anglo-Saxon vernacular compositions, unlike the St Petersburg Bede and British Library, Cotton MSS Tib. A.xiv and Tib. C.ii which are written in more formal cursive minuscule scripts arranged in two columns, more suited to presentation copies or a planned layout for wider dissemination than the original text written in simple single columns. We may investigate this possibility further.

137 Dumville 1999, which suggests many innovative and valuable ways of viewing the earlier stages of development of the Insular system of scripts but which becomes somewhat over-dogmatic in the process of its critical analysis of previous work when discussing 'Phase II'.

138 T. J. Brown 1982.

139 M. P. Brown 1989.

140 Noted by Julian Brown in *Cod. Lind.*, p. 89.

141 CLA 2.148b, that of John, CLA 2.148c is more akin to Lindisfarne's style.

142 CLA 2.194b.

143 CLA 2.190.

144 CLA 2.218.

145 CLA 2.138.

146 See, for example, Ganz 2002.

147 E. A. Lowe 1960; Petrucci 1971; M. P. Brown forthcoming a.

148 Verey *et al.* 1980; Verey 1989 and 1999.

149 This division may also be marked in the Lindisfarne Gospels by the blank vellum, red stippled defined, 'Cum' text break in the display script of the Lindisfarne Gospels' Chi-rho page. See the discussion of liturgical evidence in chapter three, above.

150 Verey *et al.* 1980, pp. 38 and 74–6.

151 *Ibid.*; Verey 1989 and 1999.

152 T. J. Brown and T. Mckay 1988, see pp. 8–9 for a discussion of the script.

153 See the discussion of zoomorphic ornament in chapter five, below.

154 Ó Cróinín 1982, 1984, 1989.

155 See Netzer 1989 and 1994.

156 M. P. Brown 1989 and 2000.

157 CLA 2.213; Alexander 1978, no. 20; Webster and Backhouse 1991, no. 84; M. P. Brown 1989 and 1990; Gameson 1994.

158 See chapter three, above. The dedication crosses are probably derived from Italian exemplars, such as a sixth-century northern Italian Gospelbook, Milan, Biblioteca Ambrosiana, Cod. C.39 inf., which features prominent Latin crosses in the top left of each folio; see De Hamel 2001, p. 13.

159 For the Cambridge-London Gospels see CLA 2-125. A fragment of its Canon Tables may survive in British Library, Royal MS 7.C.xii, ff. 2–3, see CLA 2.217. Ó Croinín 1989.

160 CLA 2.125; Alexander 1978, no. 12; Ó Croinín 1989, 1984; Webster and Backhouse 1991, no. 83; Netzer 1994; Verey 1999; Brown forthcoming b.

161 CLA 1.63; Alexander 1978, no. 36; Webster and Backhouse 1991, no. 160; M. P. Brown 1996, pp. 120–5, 167–78; Brown and Wright forthcoming.

162 CLA 2.159; Alexander 1978, no. 21; Webster and Backhouse 1991, no. 90.

163 Fox *et al.* 1990.

164 T. J. Brown 1971.

CHAPTER FIVE

The art of the Lindisfarne Gospels

The programme of decoration

When Giraldus Cambrensis wrote in 1187 of a Gospelbook he had seen at the shrine of St Bridget in Kildare, he was so struck by the intricacy and sophistication of its illumination that he described it as being, so one might think, the work not of men but of angels.[1] This famous quotation might well be applied to the Lindisfarne Gospels, one of the world's most famous and beautiful books.

The art of the Gospels is the epitome of the 'Insular' or 'Hiberno-Saxon' style produced in the British Isles and Ireland during the sixth to ninth centuries. This reflected the cultural and ethnic diversity of these islands, blending influences from Celtic, Pictish, Germanic, Anglo-Saxon and Mediterranean art (including Roman, Italo-Byzantine, Byzantine, Syriac, Armenian and Coptic traditions).[2] This process of synthesis was long lived and can be observed from the seventh century in the finds associated with the manufacturing processes of metalwork at the fort of Dunadd, the ceremonial focus of kingship rituals in the Irish kingdom of Dalriada in western Scotland (see fig. 109).[3] Likewise, the Mote of Mark, a fortress near Dumfries in the British kingdom of Rheged which seems to have passed into English hands, has yielded archaeological evidence of metalworking in which British, Celtic and Anglo-Saxon styles coincide.[4] Yet nowhere are these elements so masterly synthesised and sustained as in the Lindisfarne Gospels, an aesthetic encyclopaedia of the Post-Roman world.

The evangelist portraits, in which the Gospel writers are depicted as scribes accompanied by their identifying symbols – the man (Matthew), the lion (Mark), the calf (Luke) and the eagle (John) – feature the bearded figures of Byzantine art for Matthew and Luke and the 'Roman' youthful unbearded figures of Mark, and of John, the disciple whom Christ loved, who fixes the viewer with a challenging unwavering gaze (see pls 8, 14, 18, 22). These remind us of the frescoes, panel paintings and mosaics of early Christian art and

Fig. 109. Stone motif-piece with design for a brooch (RMS GP 218, National Museums of Scotland), from the Irish ceremonial site of Dunadd in Dalriada, Argyll, Scotland, 8th–9th century. Principles of such metalwork design resemble those used in the Lindisfarne Gospels. (Photo: © Trustees of the National Museums of Scotland)

are imbued with an iconic quality.[5] Their iconography, especially that of the St Matthew miniature with its mysterious figure peeping from behind the curtain, offers a compelling insight into the theology of the period and the exegetical world of scholars such as Bede.[6]

Just as complex in their invocation of the mysteries of Christianity are the five carpet pages (a device of probable Coptic derivation) with their embedded cross motifs (see pls 2, 10, 16, 20, 24 and figs 110, 115).[7] These are paired with the facing incipit pages, with their magnificent decorated initials and panels of display script, which commence each Gospel, and with the prefatory letter addressed by St Jerome to Pope Damasus. They are adorned with a vibrant menagerie of birds and beasts, who are distant relatives of the fauna of eastern hunting scenes in ivory and silk, and still closer cousins of the more naturalistic inhabitants of the vine-scroll motif (symbol of Christ's eucharistic sacrifice) lately imported from Mediterranean climes to the moorlands of Northumbria (see figs 113, 114). In the Lindisfarne Gospels the forms of the letters of sacred text and the crosses of the carpet pages become themselves the vine, inhabited by a throng of living creatures partaking of their sustenance. These creatures' forms are interwoven in rhythmic inter-lacing patterns interspersed with curvilinear trumpet spirals and pelta (a crescent with a cusped interior curve, derived from the profile of an ancient Greek shield) motifs derived from Celtic La Tène art, which had originated in the Iron Age and still enjoyed currency in Celtic Christian art. Parallels for such features are to be found in masterpieces of metalwork such as the Irish 'Tara' (or Bettystown) brooch and Ardagh chalice and the treasures of the Anglo-Saxon Sutton Hoo ship burial (see figs 19, 97, 111, 112). They also adorn the carvings of the early Irish high crosses (notably those at Ahenny near Cashel (see figs 15, 16) and the St John's Cross on Iona) and the Tullylease slab (see fig. 18), as well as Pictish sculptures and metalwork (some of the Meigle stones, especially no. 5, the

Fig. 110. Gnostic papyrus (Oxford, Bodleian Library, MS Bruce 96), Upper Egypt,
5th–6th century, with decorated cross introducing the text – the forerunner of the carpet page.
(Photo: The Bodleian Library, University of Oxford)

Aberlemno Churchyard slab and the silver bowls from the St Ninian's Isle Treasure) and
other Insular manuscripts, such as the Durham and Echternach Gospels, the Lichfield
Gospels, the Book of Durrow and the Book of Kells (see pls 27–32).[8] This wealth
of decoration enriches the underlying structure of the decorated letter-forms, with their
Roman, Greek and Germanic runic features, which convey the major openings of sacred
text. The letters have exploded across the page in a riot of ornament, themselves assuming
the status of icons and invoking the presence of Christ within the mystery of Scripture.
Such pages are indicative of the changes in thought that transformed the world of late
Antiquity into that of the Middle Ages.[9]

The programme of decoration extends to the architectural arcades, again replete with a
wealth of abstract and zoomorphic detail, which call to mind the entrance to the chancel,
the Holy of Holies, and which frame the Canon Tables (see pls 6, 7),[10] themselves an
embodiment of Christ's mission conveyed in symbolic numeric guise.[11] The same orna-
mental repertoire enlivens the major and minor initials which mark important sections in
the text. This programme of employing decoration to articulate text divisions is extended
to even the smallest initials and *litterae notabiliores* (enlarged letters) which mark chapters,
the Eusebian sections listed in the Canon Tables and the readings (lections or pericopes)
used in the liturgy, partly as practised in the centre in which the Lindisfarne Gospels was
made, seen and occasionally used. The text script, an elegant and calligraphic half-uncial,
is in itself a work of art.

Fig. 111. Detail of the 'Tara' or Bettystown Brooch (NMI R 4015), Irish, 8th century. (Photo: National Museum of Ireland)

Fig. 112. The Sutton Hoo shoulder clasps (BM, MME 1939, 10-10, 4,5), Anglo-Saxon, early 7th century. (Photo: courtesy of the Trustees of the British Museum)

Design, painting technique and materials

An important aspect of probable Wearmouth/Jarrow influence is the use in the Lindisfarne Gospels of an extended palette of Mediterranean derivation (as found in the Codex Amiatinus, and also in the Kentish Vespasian Psalter, see figs 30, 40), rather than the more restricted palette encountered in some other Insular works, such as British Library, Royal MS I.B.vii, the Durham and Echternach Gospels and the Book of Durrow. These latter feature red, green and yellow, which I have suggested may be indebted to the traditional

275

Fig. 113. Coptic stella with eagle, cross and vine-scroll, 5th–6th century, Egypt. BM, EA 618.
(Photo: courtesy of the Trustees of the British Museum)

(a)

(b)

Fig. 114. (a) Fragment of an altar screen or shrine with inhabited vine scroll, Jedburgh Abbey Museum, Northumbrian, 8th or 9th century. (Photo: Crown Copyright, reproduced courtesy of Historic Scotland); (b) inhabited vine scroll, Jarrow, late 7th century. (Photo courtesy of the Trustees of Bede's World and the Rector and Churchwardens of St Paul's, Jarrow)

palette of books decorated in Coptic Egypt (see fig. 115) and Merovingian Gaul (see pls 26, 27, 29–31 and fig. 116).[12] In one place, the bow of 'd' in line 4 of the Lindisfarne Mark incipit (f. 95r, see fig. 117), the artist-scribe may even have been attempting to enhance the palette further by layering washes of blue and mauve. Such experiments were subsequently carried to extremes in the Book of Kells, where the palette is considerably extended by the ambitious layering of pigments and by the use of superimposed dots and other devices for optical mixing. Poor pigment adherence may have resulted but is more likely to have been caused by the systematic washing of each page by an over-zealous later binder (see pl. 32 and fig. 118). The Lichfield Gospels also employ a technique of layered washes in order to extend the range of their extremely limited palette in which an organic purple pigment and whites predominate, almost as an extended meditation upon Bede's exegetical equation of shades of purple and white with the aspirations of the Just (see pl. 28).[13]

Another interesting aspect of the Lindisfarne Gospels is that they display the use of gilding. This Mediterranean feature of the book arts is encountered extensively in southern English de luxe manuscripts of the eighth and ninth centuries (such as the Vespasian Psalter, the Stockholm Codex Aureus and the Royal Bible, see figs 32, 40, 153), but its earlier introduction to England may even have been marked by the gold and purple tome commissioned by Wilfrid in the 670s, probably in Italy, which Stephanus heralds as a new

277

Fig. 115. Coptic painted cross
(Coptic Museum, Cairo),
resembling cross-carpet pages,
featuring the traditional Coptic
palette of red, green and yellow,
Egypt, 8th or 9th century.
(Photo: Coptic Museum, Cairo)

marvel to these shores. The specialised craft of gilding books was also practised during the early eighth century at Wearmouth/Jarrow, as may be seen from the gold leaf lavishly laid upon the surviving incipit from a Gospelbook now in Utrecht.[14] Gold leaf was also used, along with silver, for the capitals and bases supporting the arcades of the Canon Tables in the Codex Amiatinus, for details in the background to the Ezra miniature and on the curtain-rings in the plan of the Tabernacle. Chrysography seems not to have been widely practised at Wearmouth/Jarrow, however, the Prologues to Amiatinus' Old and New Testaments (ff. IV/3r–IV/3v) employ yellow script on purple pages in order to convey the impression of gold script. One tiny triangle of gold leaf has been noted in the bow of 'Q' in the Lindisfarne Luke incipit (f. 139r, see pl. 21), and the Matthew incipit features a number of delicately applied gold-leaf circles as infills to the Ultimate La Tène spiralwork of the 'Lib' of 'Liber' (f. 27r, see figs 119, 120). Other blank areas on this and the other incipit pages may similarly have been intended to receive gilding, although one would expect the gold to have been laid ahead of the other pigments, as it is a messy process, and this may imply a conscious decision not to proceed with the practice, for aesthetic or economic reasons. Alternatively (and perhaps even more likely), the gilding process may have been left unfinished, like some other details of the decoration, because the artist-scribe was prevented from finishing the final stages of his heroic solitary opus, perhaps by illness or death. True chrysography (unlike the Codex Amiatinus' yellow ink imitation), using powdered or shell-gold applied as ink, is also used for the 'sacred name' rubrics at the head of each Gospel incipit, which link the names of the evangelists and their symbols with that of Christ. Although it dates to around the 840s the Durham *Liber Vitae* (see fig. 47) is another example of practised chrysography from early Anglo-Saxon Northumbria

Fig. 116. The Book of Durrow (Dublin, Trinity College Library, MS 57), f. 1v, carpet page. The red (toasted lead), green (verdigris) and yellow (orpiment) have reacted chemically to one another, causing corrosion. Handling pigments successfully required a degree of chemical skill. (Photo: courtesy of the Board of Trinity College Dublin)

Fig. 117. Lindisfarne Gospels (BL, Cotton MS Nero D.iv), f. 95r, detail of 'd' from the Mark incipit page. This is the only place where the artist-scribe may have experimented with layering pigments, in this case blue and mauve washes of vegetable extracts.

and may indicate a continuing tradition of expertise in the art within the community of St Cuthbert.[15] Gilding never seems to have been practised by Irish scribes, perhaps because in Ireland what gold there was was so valued for use in the production of high-status metalwork (such as the 'Tara' brooch which so resembles Lindisfarne's ornamental repertoire), the working of which was the preserve of specific craftsmen as indicated in the Irish law-codes.[16]

Such technical features distinguish the Lindisfarne Gospels further from its close relatives, the admittedly fragmentary Durham Gospels and the Echternach Gospels. I have always found it difficult to accept the arguments advanced in support of the Durham Gospels being chronologically the later of the three, a difficulty shared by Christopher Verey on textual grounds.[17] Julian Brown also signalled that he could have conceived on palaeographical grounds of Lindisfarne being the later member of the group, had it not been for Rupert Bruce-Mitford's arguments concerning the illumination.[18] These seem to have been partly constrained by his involvement with work on the Sutton Hoo ship burial finds and partly by a misplaced perception of the primacy of figural representation, as seen in the Crucifixion miniature of the Durham Gospels (see pl. 26), which misunderstands the complex abstract symbolism of the Lindisfarne Gospels' cross-carpet pages and the suites of evangelist miniatures and incipits of which they form part. The technical and iconographic arguments summarised here would all indicate to me that the Lindisfarne Gospels is the latest of these volumes and that the most appropriate date for its production lies within the second decade of the eighth century. A later dating for the group would also accord better with Nancy Netzer's work on the Echternach scriptorium, with the Echternach Gospels representing an injection of Northumbrian influence following the initial, Irish-focused foundation stages of the scriptorium.[19] If the Durham Gospels were dated a little earlier than Lindisfarne, it would also help to explain why their text underwent a second correction campaign against that of the Lindisfarne Gospels, conducted by a hand which consulted both books.[20]

The Lindisfarne Gospels represent an outstanding input of resources. The finest vellum was used and was embellished with a wide palette of pigments akin to that encountered in Mediterranean art. Some were made from local vegetable, animal and mineral sources including red lead, orpiment, ochre, verdigris and plant dyes (purples and blues), others have been alleged to be more exotic imports, such as lapis lazuli from the foothills of the Himalayas. H. Roosen-Runge's analysis of the pigments in *Cod. Lind.* was a bench-mark in such studies at the time,[21] but his techniques – essentially the reconstruction of medieval recipes and microscopic visual comparison of the results with the pigments in the Lindisfarne Gospels – have been superseded by more reliable scientific methods.[22] As part of the new facsimile project an examination has been made of the pigments of the Lindisfarne Gospels using a non-destructive Raman laser and this has enabled a secure identification of most of the materials used.[23] Sadly the myth of Lindisfarne being tapped into a trade

route linking it to the Himalayas has to be dispelled, or at least cannot be supported on the grounds of the presence of lapis lazuli within the Lindisfarne Gospels. It does, however, occur in the repainting that was part of the 'modernisation' of an eighth-century Irish pocket Gospelbook (BL, Add. MS 40618) for King Athelstan, and in the late ninth century King Alfred of Wessex is known to have sent alms to the Church in India (thought to have been founded by St Thomas). What Roosen-Runge observed and thought to be ground lapis was in fact the crystalline appearance of an organic blue pigment, indigo or woad, probably occasioned by the behaviour of the binding medium. Those left bereft by such a disappointment can console themselves with what, to my mind, is an even greater wonder, namely the amount of skill in experimental chemistry possessed by the maker(s) of the Lindisfarne Gospels who were able convincingly to emulate and even extend the range of colours available to the artists of the Mediterranean during Antiquity and the early Middle Ages using purely local materials.

For the remarkable colour range achieved and so subtly employed in the Lindisfarne Gospels was produced using a restricted range of pigments: yellow = orpiment (a trisul-phide of arsenic);[24] green = verdigris (a copper corrosion product) or vergaut (orpiment mixed with an organic blue); blue = a plant extract (either indigo or woad, the latter being the more likely as it was more commonly available in north-west Europe at the time, or a purple blue variant, as purple, below); red/orange = red lead; purple = a plant extract (possibly folium, *crozaphora tinctoria*, the appearance of which can be modified like a litmus paper, making it more red or blue according to the amount of acidity or alkalinity introduced – stale urine, for example, is one substance which is known, according to a craftsman named Theophilus, to have been used later in the Middle Ages to increase acidity; other pigment-yielding plants such as the lichen Orchil may also have been used);[25] white = chalk; black = carbon, or the text ink.

The range of blues and purples is remarkable and must have required very careful mixing of ingredients. On f. 14v, in the outer arcades of the Canon Tables, one can see where the artist ran out of the blue he was using in the arcade on the left and that the next batch was rather more purple and more fluid. This should be contrasted with the subtle interplay of blue and lilac areas in the hound interlace at the foot of the 'Liber' on the Matthew incipit page (f. 27r, see pl. 11) where the variation appears intentional for aesthetic purposes, although the zoomorphic interlace in the side-border seems to display the same problems of recipe and viscosity as seen in the Canon Table. A close microscopic examination of the triskeles at the head of the 'Liber' on the same page reveals that a blue/purple and orange mix were used for the background colour. Leaf and powdered gold were also used, but sparingly for important rubrics (the sacred names at the head of each incipit page are written in powdered gold ink) and as fine jewel-like details (applied as gold leaf over gum) in the decoration of the incipit pages (both techniques may be seen in figs 119, 120). The ink appears to have been composed of iron salts suspended in gall, with

Fig. 118. The Book of Kells (Dublin, Trinity College Library, MS 59), f. 290v, detail of the symbol of St Luke from a four-symbols page, showing the ambitious painting technique in which coloured washes of pigment were superimposed, with overlying details in orange to further extend the palette by introducing a measure of optical mixing. Subsequent washing of the leaves may have caused the flaking. (Photo: courtesy of the Board of Trinity College Dublin)

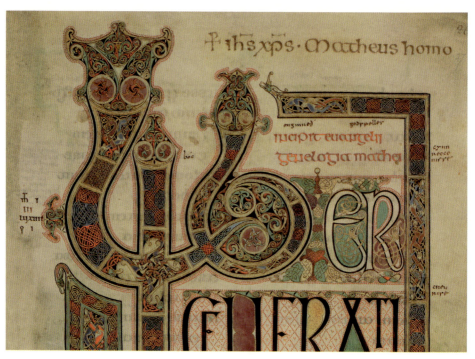

Fig. 119. Lindisfarne Gospels (BL, Cotton MS Nero D.iv), f. 27r, detail of the painting and gilding at the head of the Matthew incipit page.

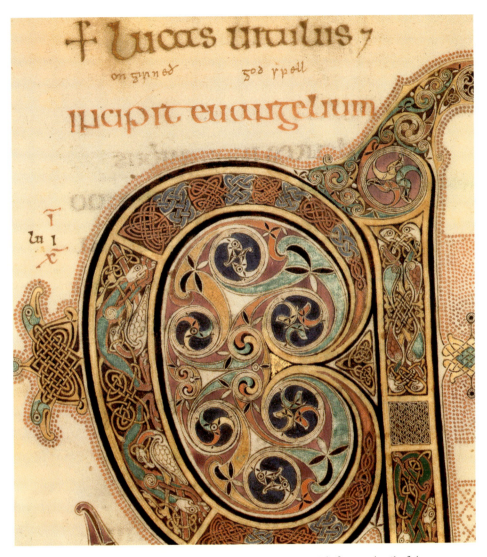

Fig. 120. Lindisfarne Gospels (BL, Cotton MS Nero D.iv), f. 139r, detail of the
painting and gilding at the head of the Luke incipit page.

some added carbon. It has remained remarkably stable and has kept its blackness, rather
than fading to brown as is common with ferous inks. It must have been made using an
extremely good recipe.

A few details of the artwork which give further insights into the design process are
perhaps worth mentioning. The consistency of preliminary layout in leadpoint for both
script and decoration clearly supports the premise that the book was essentially by one
hand, as does the intimate relationship between script and decoration throughout,

283

especially where the initials and decorated incipit pages are concerned. The decoration and painting technique of the latter are the same as those of the carpet pages and the evangelist miniatures, and this, plus the sensitive and sustained application of pigment in relation to the backdrawings, do not suggest the need to postulate assistance from one or more colourists rather than an integrated work on the part of the artist-scribe. The 'Liber' Matthew incipit page (f. 27r, see pl. 11) shows that the display script and the decoration were clearly by the same hand, for the ink line of the second 'a' of 'Abraham' extends continuously to form part of the outside of the border. On the same page the red dots of the background to the display script overlie the ink line of the border, showing that they were painted after the main design had been finished. The calf of St Luke (f. 137v, see pl. 18) has a transparent pigment wash painted over the fine-line delineation of his fur and wing feathers, with no retouching of the ink necessary, but nonetheless the thick black outer lines of the calf's figure have been repeated for clarity after painting. A few particularly discreet touches are worth observing, such as the delicate hidden purple crosses and the extremely fine gridwork in the cornerpieces of the Matthew carpet page (f. 26v, see pls 9a, 10). In the interlace panel to the left of the 'i' of 'Liber' on f. 27r one break of interlace towards the foot is picked out in blue, while the rest is yellow, giving a particularly fine balance (see pl. 11). In the panel of interlace which resembles a delicate eastern silk, below the 'Q' of 'Quoniam' (f. 139r, see pl. 21), the birds actually bite their nails in trepidation in a humorous touch complemented by the well-fed cat on the same page.

A notable aspect generally of the painting technique of the Lindisfarne Gospels is that the materials have remained remarkably stable, unlike the more restricted palette of the Book of Durrow, or the more ambitious over-painting technique of the Book of Kells.[26] The artist, or those who may have assisted in preparing his materials, had achieved expertise in the chemistry involved. A full range of colours, akin to those of high-grade eastern Mediterranean, Byzantine and Italian manuscript art, is used rather than the often restricted Insular 'tricolor' of red, green and yellow with its cultural references to Coptic and Merovingian books.[27] In this respect it may again be related to the orbit of the Ceolfrith Bibles. One particular technical similarity to the Codex Amiatinus is that the latter features a dense pastel blue painted ground to its Tabernacle image (see fig. 121). The Lindisfarne Gospels use a similar thick pink pigment cover for the backgrounds to the evangelist miniatures (see pls 8, 14, 18, 22). In Amiatinus this may have been necessary to cover writing underneath, but this is not the case in the Lindisfarne Gospels where the drawings appear on the other side of the leaf. The effect is reminiscent of the pink bole underlying areas of gilding in eastern and later medieval painting. Perhaps the Lindisfarne Gospels' artist was trying to emulate some such technique, minus the gilding itself. Perhaps it was originally intended to supply the gilding but the process remained unfinished, like other small areas of the incipit pages decoration which may have been intended to receive gilding and other areas which remained unpainted (e.g. the background interlace to the

Fig. 121. The Codex Amiatinus (Florence, Biblioteca Medicea-Laurenziana, MS Amiatino 1),
ff. IIv–III Plan of the Tabernacle, the Temple at Jerusalem from one of the Ceolfrith
Bibles, Wearmouth/Jarrow, before 716. (Photo: Biblioteca Medicea-Laurenziana)

head of the cross in the opening St Jerome carpet page, see pls 2, 23b). Perhaps the allusion
was not to gilding, but to another technique such as encaustic icon painting in which white
and pink wax were painted onto wood or onto plastered walls (as seen in a fifth-century
early Coptic example on display in the Metropolitan Museum, New York (Rogers' Fund
1939, 39.158.1). A curious feature of the Lindisfarne Gospels' pink grounds (which were
probably made by mixing chalk with an organic purple) is that their surfaces appear
polished. This may be the result of a devotional practice of veneration accorded to iconic
images in which their surfaces were rubbed, or to the preparation of the surface to receive
gilding. Alternatively, it may have something to do with attempts by the artist to render
the densely painted surface smoother and more supple and less prone to cracking as the
surface of the membrane cockled over time. In his 'Il Libro dell'Arte' the fifteenth-century
Florentine artist, Cennino Cennini, gives instructions on 'How you should tint kid
parchment, and by which method you should burnish it': having applied the tints, 'If …
the parchment is not smooth enough to suit you … lay it on a walnut board, or on a flat,

Fig. 122. Fresco of the Annunciation, in Byzantine fashion, from the western apse of the church in the Coptic monastery of Deir-el-Suriani, Wadi Natroun, Egypt, 6th century. (Photo: David Jacobs)

smooth slab; then put a sheet of good clean paper [or parchment] over the one which you have tinted; and, with the stone for burnishing and working gold, burnish with considerable strength of hand; and so, in this way, it will get soft and smooth.'[28]

Other than for the modelling of the flesh of the evangelist portraits the Lindisfarne Gospels eschew the classicising painterly technique seen, for example, in the Ezra miniature of the Codex Amiatinus (see fig. 30). The faces of the Lindisfarne Gospels' evangelists have their features, such as eyelids, emphasised by green shadowing, in Byzantine fashion, or by red/pink shading and detailing. The rest of their anatomy and their draperies are expressed by means of linear penwork and by cells of colour reminiscent of cloisonné metalwork and are an extension of the design conception and painting technique of the abstract ornament and zoomorphic interlace elsewhere in the volume, with which they homogenise.

Previous art historical discussion has tended to characterise this as a manifestation of the distinction between the romanising and 'Celticising' camps in Insular art or to dismiss the artist of the Lindisfarne Gospels as incapable of grasping the subtleties of the more naturalistic, illusionistic and painterly methods of Mediterranean and eastern artists and

Fig. 123. Fresco of the Virgin and Child, in Coptic fashion (descended from the Pharaonic iconography of Isis and Horus), flanking the entrance to the chancel of the church in the Coptic monastery of Deir-el-Suriani, Wadi Natroun, Egypt, 6th or 7th century. A similar image occurs in the Book of Kells. (Photo: David Jacobs)

consequently reducing the forms in his models to barbarous patterned linearisations. George Henderson pointed to the fallacy of assuming a naturalistic stylistic primacy even within Mediterranean art of the late Antique and early Christian periods, comparing the Lindisfarne Gospels' figural style to that of art in other media, notably *opus sectile*.[29] It should be remembered that Mediterranean manuscript art also varied greatly. Within the Italian corpus the same stylistic differences might, for example, be commented upon between the 'painterly' Vatican Vergil and the 'linear' Virgilius Romanus. Likewise, the stylised linear figures of Coptic manuscripts and icons bear a similar relationship to their more painterly fresco counterparts (such as the classicising Annunciation or even the flatter painterly Virgin and Child frescoes in the church of the Coptic monastery of Deir-el-Suriani in the Wadi Natroun, see figs 122, 123). Wessel has characterised the Coptic style as 'flatness, two-dimensionalism, reduction of form, and predominance of line'.[30]

This might equally well apply to the art of many eastern Mediterranean regions at this period, and to the Lindisfarne Gospels. Their evangelist miniatures could thus be every bit as exotic and cosmopolitan in their stylistic and technical references to Mediterranean art as the Codex Amiatinus and need not by any means betoken a lack of skill or sources. What

is different is the intent. This may have been due to a wish to allude to different strands and impulses in Mediterranean and eastern art and/or to a wish to harmonise and integrate the figural images with the strongly linear, non-figural components of the rest of the Lindisfarne Gospels' decorative programme. The influence of more indigenous styles of art should also be taken into consideration. The Picts, in particular, long before the injection of Northumbrian influence following King Nechtan's letter (written around 713/14) to Ceolfrith (requesting masons as part of a package of modernisations to the Pictish Church), had evolved an accomplished linear draughtsmanship on their incised stones. The natural-ism apparent in the delineation of animal symbols on these stones, such as the goose and fish on the Class I Easterton of Roseisle stone and the eagle on the Class II Brough of Birsay stone (both National Museum of Scotland), and the confident characterisation of human figures on Class II sculptures, such as the Hilton of Cadboll slab and the Rosemarkie fragment of Daniel in the lions' den (both in the National Museums of Scotland, see fig. 124) are a cogent reminder that the Mediterranean was not the only available source of such traits in Insular art, even of their ultimate point of inspiration.

Another aspect of the Lindisfarne Gospels' programme which may be relevant in this respect is their tendency to combine the iconic and aniconic. Unlike the Durham Gospels and the later Irish St Gall Gospels, the Lindisfarne Gospels do not represent the Cruci-fixion in narrative figural terms but employ stylised cross-carpet pages, redolent of the symbolic *crux gemmata*, to convey the divine – Christ mystically embodied and concealed within Scripture.[31] The evangelist miniatures are treated as stylised icons, especially that of John, in which the character of the individual Gospels and their representation of different aspects of Christ and his ministry are explored through the relationship of human author/ scribes and their mystical symbolic guises, emphasised by their identifying inscriptions, the layout of which is again redolent of the traditions of icon and fresco painting. The Matthew miniature further serves as a 'preface' to the scheme, presenting a *figura* of the relationship between the Old and New Testaments and affirming the relationship between Christ, the Evangelist, the scribe and the reader/viewer: in short, symbolising the process and import of the transmission and reception of Scripture in a manner reminiscent of, yet distinguished from, that contained within the prefatory quire of the Codex Amiatinus. This process of transmission is further explored in the Lindisfarne Gospels via the incorporation of Jerome's prefaces and the Eusebian Canon Tables into an integrated scheme of decor-ation in which they occupy a prominent role. Finally, the iconic/aniconic approach is extended to the Word itself which is celebrated and elevated to iconic status in its own right in the exuberant decorated incipit pages which are adorned with all the visible trappings of status and authority familiar through centuries of ornamentation of valued objects and persons with abstract and zoomorphic art, so beloved of both Celtic and Germanic society.

As we have seen, the Lindisfarne Gospels features a limited amount of gilding. St

Fig. 124. Pictish sculpture, with a mounted noblewoman and her entourage,
and Northumbrian-style vinescroll border, 8th century, Hilton of Cadboll,
Ross and Cromarty, Scotland. (Photo: National Museums of Scotland.
© Trustees of the National Museums of Scotland)

Wilfrid's Gospelbook, which he commissioned for Ripon (probably during the 670s),
perhaps from artists abroad, featured chrysography on purple pages and had been hailed
as a new feature in Britain.[32] That the technique was subsequently learned and practised at
Wearmouth/Jarrow is shown by the gilded initial in the Gospel fragment now bound with
the Carolingian Utrecht Psalter, but the use of actual gilded text script is only evinced in
the North East in the Lindisfarne Gospels and in the Durham *Liber Vitae* (see figs 47, 120).[33]
Gilding became popular in southern England during the eighth century in works such as
the Vespasian Psalter, the Stockholm Codex Aureus and the Royal Bible (see figs 32, 40,
153), and St Boniface requested books written in chrysography (gold script) of Abbess
Eadburh of Minster-in-Thanet in order to impress converts in the Germanic mission
fields.[34] The Lindisfarne Gospels may be more sparing in its use of actual precious metals,

289

although it would have subtly 'glistered' as its touches of gold caught the candlelight, but its allusions to high status metalwork would hardly have been lost upon a contemporary audience. If it was indeed housed, when not on display or in use, in a metalwork book-shrine, or its binding adorned with precious metal plaques, the effect would have been even more resplendent and impressive.

The artist-scribe of the Lindisfarne Gospels was, on the basis of the extant evidence, highly innovative in his design techniques. The possibility of precedents, now lost, obviously cannot by ruled out, but his work certainly stands out technically in many ways from the other Insular manuscripts that have survived. As we have seen, he seems to have developed the use of leadpoint at least three hundred years ahead of what was thought to be its introduction to Europe.[35] This enabled tremendous flexibility and complexity of layout and detail, as it allowed the membrane itself to act as the 'motif-piece' for trying out ornament, rather than the more cumbersome pieces of slate, stone, wood or bone, or indeed wax tablets, used by other Insular artists in the various media (see figs 90, 109).

As we have seen in the discussion of the techniques of layout in the chapter on codicology (chapter four, above), the process of design can be seen clearly in places and changes in thought detected, so that it is rather like observing an authorial editing process in an autograph manuscript (see pl. 9 and figs 63, 88). The artist did not draw his preliminary designs on the side of the membrane to be painted, but on the reverse, so that the details were not lost as soon as the first layers of pigment were applied (in the same way as the modern animator paints on the opposite side to his/her drawing, so that the emulsion does not obscure its detail). Almost every decorative element in the volume has such back-drawings other than the Canon Tables, but here they may have been lost as much of the overall layout is repeated from one side of the page to the other and would have been obscured by over-painting. The overall structure of the Canon Tables arcades seems to have been replicated on both sides of the leaves, with the same prickings and rulings guiding the layout on both sides.[36] The prickings and rulings for their architectural surrounds can be clearly seen on f. 14v at the base of the first column on the left (see fig. 125). Prick-marks and ruled lines (especially those guiding the inscriptions) can also be seen of the reverse of the evangelist miniatures, especially those of Matthew and Luke. The implication of this innovative design process is not only that the drawings had to be conceived and executed back-to-front, prefiguring the intaglio technique to be used in printing and engraving, but that the leaves would have been backlit, perhaps using a transparent horn or glass writing desk or membrane stretched on a frame, rather like designing on a modern light-box. I have been unable, as yet, to locate a parallel for this technique in the medieval corpus, other than the method for painting on both sides of silk outlined in Cennino Cennini's 'Il Libro dell'Arte', which incorporates many earlier practices.[37] Grids, tracing and transfer by means of pouncing (as seen, for example, in an English bestiary made around 1170, British Library, Add. MS 11283, see fig. 126)[38] are all

Fig. 125. Lindisfarne Gospels (BL, Cotton MS Nero D.iv), f. 14v, detail of the base of the column showing traces of the planning of the design of the Canon Tables.

known to have been employed, as are under-drawings upon which the paint was laid and sketches in modelbooks, on motif-pieces or on flyleaves (such as the author portrait sketched in red chalk in a tenth-century copy of Aldhelm, British Library, Royal MS 7.D.xxiv, f. 85v, or on the flyleaves of the Helmingham Orosius, British Library, Add. MS 47967, see figs 127, 128).[39]

Compasses, rulers and dividers were also used to lay out the carpet pages (see pls 9a, 23a), and Lindisfarne's complex animal interlace is worked out on a grid, in the working manner of the sculptor,[40] but the details of the ornament were then worked up free-hand, allowing the playful challenges to symmetry which may be observed throughout (as noted in the descriptions of the carpet pages), which are nonetheless governed by the geometric principles of design by which Creation might be understood.[41] A similar approach to layout, assisted by compass-work, may be seen on the metalwork objects from the Donore hoard (see fig. 129),[42] upon which La Tène spiralwork and zoomorphic interlace are engraved, having been compass-constructed and finished free-hand. The tinned bronze plate from a book-shrine or binding recently found in the Blackwater at Shanmullagh (Co. Antrim) also employs these techniques for the spiralwork which filled the spandrels of a

291

Fig. 126. The pouncing technique (BL, Add. MS 11283), f. 3r, lower half of page, from a Bestiary with prickings used to transfer the design, England, late 12th century. The transfer prickings for the griffin design on the other side of the folio are clearly visible.

cross resembling that on f. 94v of the Lindisfarne Gospels, and probably close to it in date. As Michael Ryan observes, 'together with the 'Tara' brooch and the Lagore buckle, the objects provide strong evidence for the adoption of the style seen in the Lindisfarne Gospels in the east Midlands of Ireland around the beginning of the eighth century'.[43] The same might also be said of sculptures in southern Ireland, notably the Ahenny crosses and the Tullylease slab, which resembles Lindisfarne's Matthew carpet page and which also carries an inscription in half-uncials of the type found in Lindisfarne (see figs 15, 16, 18).[44] This shared tradition should perhaps be seen as something approaching an Insular version of the Romanesque trans-Manche 'Channel School' in terms of the regional diffusion of a style either side of a sea-channel, in accordance with the socio-historical context. This area also embraced the northern British kingdoms, as well as Anglo-Saxon Northumbria, and Pictland. The same principles of design and of layout techniques are again encountered on the Hunterston brooch (National Museum of Scotland, FC8) and on a slate motif-piece for a pseudo-penannular brooch from Dunadd (Naional Museum of

Fig. 127. The Helmingham Orosius (BL, Add. MS 47967), f. 1r, flyleaf drawings trying out designs for evangelist symbols, a runic alphabet and a possible binding motif, Winchester, second half of 10th century.

Fig. 128. Aldhelm, *De virginitate* (BL, Royal MS 7.D.xxiv), ff. 85v–86r, underdrawing, with later retouching in ink, of an author portrait, Wessex, early 10th century.

(a) (b)

Fig. 129. Donore handle assembly (NMI 1985:21a,b,c,d,e): (a) general view as assembled and
(b) the engraved disc, Irish, 8th century, modelled on the lion headed door handles
of late antiquity. They may have functioned as the carrying handles of a shrine.
(Photo: National Museum of Ireland)

Scotland, GP 218), both executed in 'Irish' style in Scotland sometime during the late
seventh to ninth centuries (see figs 90, 130).[45] These exhibit the same underlying layout
technique as parts of the design of the Lindisfarne Gospels (see pls 9, 23a).[46] The design
for areas of spiralwork is based upon a square quartered by two ruled diagonal lines
forming an 'X'; a compass mark is made at the point at which these lines cross, in the centre
of the square, and a circle is drawn; further diagonal lines radiate from the central compass
mark and are further subdivided to pinpoint the location of other compass points from
which spring further arcs integral to the design, the remaining details being hung
apparently free-hand upon this underlying geometric skeleton.

Elizabeth Coatsworth has shown that the layout underlying the design of St Cuthbert's
pectoral cross (see fig. 29c), with its precise geometry based upon grids and compass-
drawn circles (the grid of sixteen units square and the circle with a radius of eight units),
was also used for the central motif of one of the Lindisfarne Gospels' cross-carpet pages
(f. 94v) and has traced the tradition of such cross layouts to items of early Anglo-Saxon
metalwork, such as the Ixworth and Wilton crosses (see fig. 131), observing that 'it is
possible to see a very direct transfer of design technique between goldsmith and
illuminator'.[47] Given that there are references to Insular monks being skilled metalworkers
this is not perhaps surprising. The close stylistic relationship of the Lindisfarne Gospels to
Insular metalwork, along with the technical design links, would suggest that the book's
artist-scribe might himself have been an accomplished metalworker. Other aspects of the

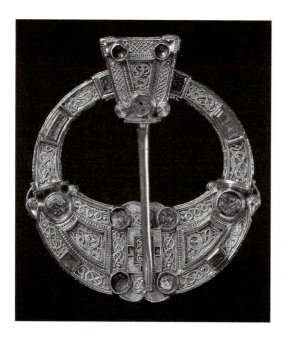

Fig. 130. The Hunterston Brooch (NMS FC8), Irish or Irish style practised in Scotland, late 7th–early 8th century (front). (Photo: National Museums of Scotland. © Trustees of the National Museums of Scotland)

geometry underlying the design of the Lindisfarne Gospels have been discussed in detail by Bruce-Mitford, Guilmain and Stevick.[48] Rosemary Cramp has also drawn attention to the fact that, in other media, the use of geometric aids in layout, such as are encountered in the Lindisfarne Gospels, the pectoral cross and the Lindisfarne sculptures, form part of an ancient British and Celtic tradition.[49] So too does the practice of using panels of ornament, which she suggests may have been connected to the use of motif-pieces (see fig. 90) in the design and transmission of sections of ornament.[50] The design context for much of the Lindisfarne Gospels' ornament therefore lies firmly within a British, Pictish and Celtic tradition which stretched back to the Iron Age and which was actively practised in those areas around and after the time that the volume was made.

Robert Stevick has compared the inter-disciplinary currency of aesthetic, mathematical and technical principles apparent within the arts in various media of the Insular and Anglo-Saxon worlds, including the structure of Anglo-Saxon poetry, with the universality of application to 'all who use measure' favoured by Dürer and others in the late Middle Ages and the Renaissance.[51] He has pointed out that details of layout which have tended to be dismissed as incidental, or not observed at all, are in fact influenced by complex mathematical principles of measurement, such as the Golden Rule (or Golden Mean) governing its page proportions and layout – although later trimming by binders make this difficult to prove – or the intentional disparities in length of what seem at first glance to be truly equal-armed crosses in the carpet pages on ff. 94v and 138v of the Lindisfarne Gospels, or their Jerome and Matthew 4 × 3 cross-pages (ff. 2v and 26v, see pls 2, 10 and

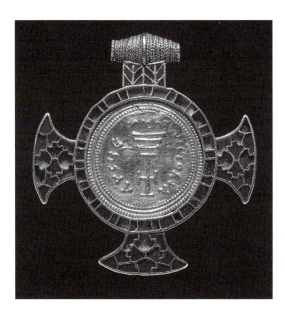

Fig. 131. The Wilton Cross (BM, MME 1859,5-12,1), Anglo-Saxon, early 7th century. The early Christian coin was reset upside down (to face the wearer) in this piece of Anglo-Saxon jewellery from the conversion period. (Photo: courtesy of the Trustees of the British Museum)

fig. 89) which are laid out on the basis of two golden section rectangles (with sides in the ratio 2:φ or its equivalent ($\sqrt{5}$–1):1), their frames being conceived as part of the design ratios, rather than as framing devices.[52]

Placed on the scales against the plethora of received stylistic, formal and iconographic influences and the aesthetic and technical invention of the Insular artist must be not only theological, exegetical and symbolic meaning, but also a desire to explore and recreate anew, in each creation, the divine principles of harmony, measurement and geometry which were believed to order God's Creation. The Creator was sometimes depicted in early medieval art wielding dividers,[53] an iconographic device which continued to exert its relevance many centuries later upon William Blake, who depicted Newton, champion of scientific rationalism, absorbed in a similar geometric exercise, but oblivious to the wonder and divine layout of Creation around him. Geometry and arithmetic, along with music and astronomy, formed the 'quadrivium', a mainstay of classical and early medieval education, which Boethius characterised as providing 'paths through the creation to its source in the incorporeal world wherein lies true wisdom'.[54] Spiritual truths and aesthetic perfection might therefore be sought through numeric and proportional principles and thereby the decorated pages of the Lindisfarne Gospels, especially those involving particularly complex geometric layout such as the cross-carpet pages (but also the words of the incipit pages and the evangelist miniatures and their placing in relation to their frames), can be seen at an even more fundamental level to represent a quest for the understanding, emulation and transmission of the divine rule of time, space and substance.

Asymmetrical components in the natural order are reflected by the Lindisfarne artist not

only in his frequent reversal of elements within the zoomorphic interlace designs, or his occasional pairing of like with unlike (with subtle variations upsetting the game of 'spot the difference', but nonetheless appearing balanced within the overall design to the first glance), but in his intentional proportional inconsistencies of measurement. Thus although the 'Latin' crosses of the Jerome and Matthew carpet pages (ff. 2v and 26v, see pls 2, 10) appear to observe the ratio of 4 × 3, composed of identical units of the design grid, their lowest vertical members do not measure the same as the others (the two lowest squares on f. 2v having their centres placed 46.5mm apart and the rest 52mm, and the two lower medallions on f. 26v being centred apart at 64mm rather than the 59mm of the rest).[55] Only the cross-carpet page of St John (f. 210v, see pl. 24) is entirely regular in its layout and symmetry, reinforcing its exegetical interpretation as the Word transmitted directly from God and the symbolic equation of its evangelist miniature with Christ in Majesty, the fulfilment of the divine order. Thus the geometric layout of Lindisfarne's designs might have been seen as physically embodying and celebrating the Godhead, much as I have suggested the Canon Tables might in their numeric encapsulation of Christ's incarnation, sacrifice and resurrection. To quote Stevick, 'On the St. John cross page alone he composed a small cross at the center of the frame, but too far from it to interact with it perceptually. To say it shortly, Eadfrith knew better than the others the relations between what is conceived by the mind and what is perceived by the senses.'[56] In this aspect, as in so many others, the artist-scribe of the Lindisfarne Gospels emerges as an individual well versed in the traditions of craftsmanship and of literate Christian philosophy, theology and exegesis and able to employ them in innovative, well-planned and supremely well-conducted ways throughout his *opus dei*. He is likely to have been one of the most accomplished, experienced, learned and senior members of his community. Perhaps even its abbot/ bishop.

Because the act of making the Lindisfarne Gospels seems to have been an extremely solitary, eremitic exercise, and as it was not available for close inspection as a model, its technical impact was limited. It might be imagined, however, that the artist-scribe would have had occasion to talk of his work and such oral transmission may account for the possible influence of the Lindisfarne Gospels' painting technique in the Lichfield Gospels and the Book of Kells and the use of lead-point (but not back-drawings) for the layout of one of the incipit pages in the Stowe Missal (f. 12r, which also exhibits the influence of the Lindisfarne Gospels in its adoption of a framing device featuring a cat whose body is filled with birds, see figs 83, 85).[57] It is noteworthy that such technical influence as is exerted occurs primarily in manuscripts associated with Ireland or areas under Irish influence.

Perhaps most remarkable of all the aspects of the making of the Lindisfarne Gospels was, however, the dedication of human resource. For this masterwork was written and illuminated by just one artist-scribe, probably Eadfrith, bishop of Lindisfarne (698–721). The monastic duties of this individual would have been considerable and the work must

have taken many years – probably between five and ten, depending on how much release from other duties was accorded him. There are a number of features which would suggest that his work was incomplete in its final details (gilding, colouring of the Novum Opus carpet page, background highlighting of the Luke carpet page and perhaps the definition of lines of display script in the Chi-rho page and the Luke incipit, see pls 2, 12, 21), perhaps interrupted by illness or death. It was left to the rubricator to finish the text details, including the display incipit/explicit rubrics which had been laid out by the artist-scribe as under-drawings (see pl. 19a) but which were ignored – the rubricator following his own layout and proving thereby that he was no artist. The volume nonetheless remains the masterwork of one gifted individual, an act of *opus dei* which was itself a sustained act of spirituality. No working service-book, this, even if it was used liturgically on certain important feast-days, it was an extraordinary undertaking for an extraordinary purpose – a focal point of the cult of St Cuthbert and a portal of prayer through which the faithful might enter an eternal communion.[58]

The use of decoration to articulate the text: the use of initials

An important feature is that the text is articulated by a programme of hierarchical decoration, with major decorated initials or monograms and display capitals for the Gospel incipit pages, the Chi-rho page and the Novum Opus which formally opens the book; calligraphic minor decorated initials with zoomorphic components for the incipits of the other prefatory sections (Plures Fuisse, Eusebius-Carpiano, the Argumenta, Capitula Lectionum and feasts), the treatment of which resembles that of the display script of the incipit pages. Rubrics are inscribed either in coloured angular display script (to mark the explicits/incipits of Gospels and for most of the liturgical rubrics in the capitulary), or gold (for the sacred names at the head of each Gospel incipit page) or red half-uncials, depending on their purpose. Only those in gold were by the artist-scribe; the others were added by the rubricator, although there are traces of stylus drawings of display rubrics by the original artist-scribe (see pl. 19a).[59] Small minor initials and *litterae notabiliores*, the decoration of which is varied according to function, occur throughout.

Minor initials in the Gospels are used to mark Eusebian sections and *capitula* (chapters): *litterae notabiliores* occur with coloured infill (usually green and yellow) and red dot outline. When the two breaks coincide the *littera notabilior* is given an added contour line.[60] These seem to have a liturgical function, marking pericopes (lections), except in John where they are more common. Likewise, *litterae notabiliores* with whorls are significant in all save Luke where they are common. Some of the lections marked seem to have been quite recent additions to the Roman rite, some incorporated as late as 715. This implies that different models were used for the lections, some being grafted onto the text, which as we heve seen seems to have been copied primarily from one major southern Italian exemplar.

So, by means of a graded system of decorated letters the *capitula*, the Eusebian sections and a specially composed series of lections were marked within the text. This represents a far more sophisticated and integrated approach to textual articulation than that previously encountered in early medieval book production. In Wearmouth/Jarrow books discrete enlarged text letters marked text breaks and lections were indicated by light crosses composed of dots in the adjacent margins. In the Durham Gospels and Durham MS A.II.16 the rubrics saying when a lection was to be read occur as small inscriptions with boxed surrounds in the margins. The Lindisfarne Gospels' response was more advanced and marked a new thoroughgoing approach to the use of ornament to elucidate text which can be detected in an earlier stage of development in the Book of Durrow and which went on to influence later Insular works such as the Book of Kells.[61] This approach to the use of ornament to articulate text was to exert a powerful long-term effect upon medieval book production and was recognised as an invaluable aid to navigation during the act of reading and as an effective form of visual mnemonic.[62] Such a hierarchical approach to ornament was consonant with the Insular perception of script, which embraced similar principles as those which had underpinned the Roman system of scripts.

The Canon Tables, the Jerome Prefaces and the prefatory matter preceding each Gospel

The relationships between the Lindisfarne Gospels and their closest textual relatives as Gospelbooks, Royal I.B.vii, the St Petersburg Gospels and the Gotha Gospels, indicate that there is likely to have been a model at Wearmouth/Jarrow for the Gospels and prefatory texts found in the Lindisfarne Gospels and that this was reflected in these other eighth-century Gospelbooks, but that it did not include Canon Tables. This is intriguing, as it contained both Eusebius-Carpiano and the Novum Opus, both of which deal with the use of Canon Tables, implying that it had probably lost its set of tables before being consulted in Northumbria.[63] Canon Tables were supplied in all three of its Insular 'copies', but drawn from other varied sources. In the Lindisfarne Gospels' case this was a volume containing the 'first larger Latin series',[64] which is generally found in the Greek Gospelbook tradition accompanied by the Eusebius-Carpiano preface.[65] As we have seen, these features are more likely, however, to have been derived from an Italian intermediary – something similar to Codex Fuldensis, a diatessaron made in southern Italy in the mid-sixth century for Victor of Capua (see fig. 66).[66] Thus the available evidence would tend to suggest that the Lindisfarne Gospels' maker was consulting at least two major exemplars of probable Italian origin in order to achieve the desired arrangement.

In his Gospel harmony Victor quoted Eusebius-Carpiano in his preface and prefixed an extract from the Novum Opus to the Canon Tables themselves. An echo of such preoccupations with the relationships between the four Gospels, the role of the Canon Tables and of explicatory introductory matter in clarifying and exploring this relationship,

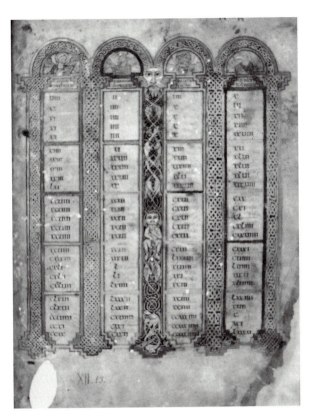

Fig. 132. The Barberini Gospels (Biblioteca Apostolica Vaticana, MS Barb. Lat. 570), f. 1r, Canon Table, with evangelist symbols and human mask recalling the human headed capitals of antiquity. The naked man halfway down the central column protects himself from the encroaching beasts. (Photo: Biblioteca Apostolica Vaticana)

may be heard reverberating throughout the Insular Gospelbook tradition, not least in the Lindisfarne Gospels, where the decorative scheme is also placed at its service. The Lindisfarne Gospels' architectural arcades marked a new departure in Insular Gospelbook production (see pls 6, 7), other probable early examples of which (such as the Book of Durrow and the Echternach Gospels) set their tables within simple grids. The influence of the Mediterranean arcaded genre within the Insular corpus can also be seen in the Codex Amiatinus, Royal 1.B.vii with its linear arcades with human masks and zoomorphic terminals (see fig. 67), the Maaiseik Gospels and the Trier Gospels with evangelist busts in roundels surmounting its arcades, the St Petersburg Gospels with its exuberant and almost Islamic style arches (see fig. 68), the Barberini Gospels with their evangelist symbols in the tympana and its classicising human mask (see fig. 132), the Royal Bible with its elegant triple arcades within an arcade and its lion masks and, in the modified form of the 'beast canon tables' (depicting the evangelist symbols in dialogue) of the Book of Kells.[67] Various Italian and Byzantine models may have been available as sources of inspiration. The placing of larger over smaller arches (Nordenfalk's 'm n' form) is paralleled in a sixth-century Latin Gospelbook (Biblioteca Apostolica Vaticana, Vat. Lat. 3806) and in the Livinus Gospels (Ghent, St Bavo) of around 800, the style of which suggests the influence

of an earlier model.[68] Some earlier arcaded Canons, such as those of southern Italian Codex Beneventanus (British Library, Add. MS 5463, see fig. 133),[69] have birds perching upon their arches, which may have helped to inspire the zoomorphic infill of Lindisfarne's arcades. Lindisfarne's extravagant, easily legible sixteen-page sequence is not reflected in other extant Insular tomes, suggesting once again that it was not available for detailed consultation as an exemplar for other projects, but its distinctive Insular approach of filling the components of the architectural framework with zoomorphic interlace and geometric ornament, rather than adhering to the Mediterranean *trompe-l'œil* imitation of marble columns, capitals and arches, may have helped to inspire some of the subsequent Insular responses.

A 'Christ in Majesty page' comes between the Canon Tables and the Matthew incipit as a Gospels frontispiece in some works, such as the eighth-century volumes Autun MS 3 and Poitiers MS 17, and the slightly earlier Codex Amiatinus.[70] McGurk says that 'they serve the purpose of announcing the unity of the Gospels, as the Insular four symbols page or the Carolingian representation of the Fountain of Life'.[71] The Lindisfarne Gospels handles its opening differently, with the emphasis falling upon the Canons and their explicatory prefaces by St Jerome, which serve to introduce the work and reinforce Jerome's credentials. Its opening emphasis also falls upon the cross-carpet pages (which can be read as a symbolic form of 'Majesty' in the form of the *crux gemmata*), and upon the Matthew miniature which conflates many exegetical aspects of the prefatory quire in the Codex Amiatinus and uses them as a frontispiece to a Gospelbook.[72]

An important feature of the Lindisfarne Gospels' programme of illumination is the manner in which the Jerome prefaces are elevated to occupy a major role in the scheme. The volume opens with a diptych of cross-carpet page in distinctively 'Antique' eastern form with an ultra-traditional palette of red, green and yellow, redolent of Coptic manuscript and textile art and perhaps intended to convey a sense of the antiquity and the exotic eastern nature of Jerome's witness. This faces a decorated incipit page commencing Jerome's 'apologia' in the form of his letter to Pope Damasus, the Novum Opus or 'New Work' (see pls 2, 3). What better way to open a book which celebrated Jerome's place in the process of Scriptural transmission and which was itself in many ways an innovative response to that tradition? Thus the most important of Jerome's explanatory texts is accorded a status approaching that of the beginnings of each of the Gospels themselves, emphasising the relationship between the various transmitters – the evangelists and St Jerome and, by implication, the scribe of the Lindisfarne Gospels himself. The major initials of the 'Novum Opus' page are, however, more modest in scale and quantity of decorative detail than those opening the Gospels themselves, indicating the primacy of the latter.

The other Jerome prefaces, the 'Plures Fuisse' (f. 5v) and the 'Eusebius-Carpiano' (f. 8r) are accorded smaller major decorated initials, enlivened with zoomorphic terminals drawn

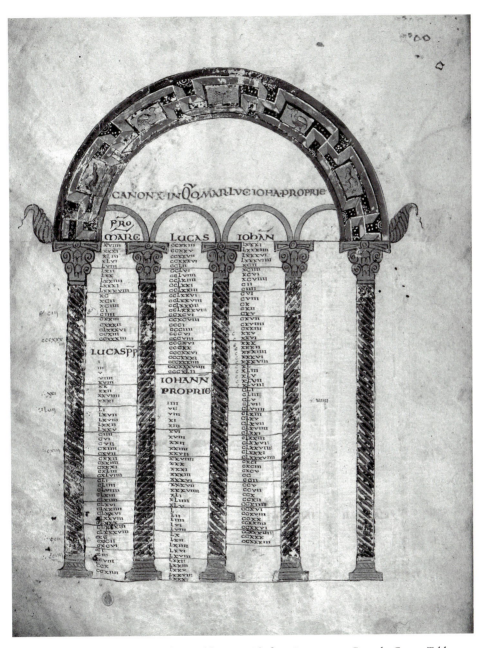

Fig. 133. Codex Beneventanus (BL, Add. MS 5463), f. 3v, Beneventan Gospels, Canon Tables, with birds in the head of the arch. In the Lindisfarne Gospels such birds have become the stylised infill to the bodies of the columns themselves. Benevento, Italy, 8th century.

from the bird and hound menagerie found disporting themselves throughout the volume's illumination, followed by a line of display script. These are similar in scale and occupy the same rung on the hierarchical ladder of decoration to the initials marking the prefatory matter to each Gospel (see pls 4, 5).

Description of the Canon Tables

Canon Tables are a concordance system to the contents of the four Gospels, arranged in tabular form, devised in the fourth century by Eusebius of Caesarea. The Gospel texts were divided into numbered passages which were annotated in the margins of the Gospels themselves (along with the numbers of corresponding passages in the other Gospels) and also arranged in prefatory tables charting which passages occurred in all four Gospels, which in three or two and which were unique to the individual Gospels. The way in which the tables were arranged was variable, and different textual 'families' have been identified.[73]

The Lindisfarne Gospels contain the first extant Insular occurrence of arcaded Canon Tables. Volumes produced in the Mediterranean regions from the fifth century onwards, however, can feature architectural Canon Tables (see fig. 133). In these the columns of numbers are set beneath arcades elaborated with architectural features of classical origins. The bases, columns, capitals and arches can be portrayed quite naturalistically, recalling late Roman and early Byzantine basilicas. Comparisons have been drawn with the arcaded chancels of early Christian churches and the art historian Carl Nordenfalk conceived of them as an architectural atrium through which the mystery of Scripture could be accessed.[74] For the whole of the Gospel texts, symbolising Christ's person and ministry, were here conveyed in a numerical shorthand, as deserving of decorative embellishment and celebration as the Gospels themselves.

In the Lindisfarne Gospels the architectural forms are conveyed symbolically in a flattened, stylised form. There is no attempt at the illusionistic depiction of rounded marble columns or foliate capitals, but the bases and capitals of the five vestigial architectural columns are given stepped profiles. The columns are linked by simple coloured arcades at their heads, the whole set within an outer containing arch resting upon the two outermost columns. The effect is indeed reminiscent of entering an arcaded chancel. The main arch and the columns are filled variously with interlaced, fret or step patterns and the zoomorphic interlace. The entwined forms of stylised birds and beasts are perhaps intended to recall the denizens of early Christian inhabited vine-scrolls (see pls 6, 7 and figs 113, 114) in which Creation partakes of the true vine, the tree of life – Christ's redemptive Passion.

The rhythm of the tables is sustained by the variations in decorative infills to the arcades and of the colours used. The palette is carefully balanced to give each opening an harmonious appearance. The Lindisfarne Gospels are unique in the Insular corpus in employing sixteen pages of tables. This enabled a more leisurely, less compressed arrange-

ment designed for the ultimate ease of cross-reference.[75] The incipit/explicit titles of each Canon Table, stating how many Gospels are included within it, and the headings saying which Gospel is in which column are written in angular coloured display capitals, incorporating runic stylistic features, similar to those used for the Gospel incipits/explicits, having been added by the rubricator. The original artist-scribe planned and painted the Canon Tables but he was prevented from adding their textual contents.

Description of the prefatory carpet page, f. 2v

Although this is the first major decorated folio of the volume and serves as its frontispiece, it is likely to have been one of the last pages to be executed (see pl. 2). The prefatory matter, despite being elevated in the decorative programme of the Lindisfarne Gospels to new heights of importance, was secondary to the text of the Gospels themselves and it is likely that it was left until they were completed. There is ample codicological evidence from throughout the Middle Ages to indicate that a book was seldom written in sequence, from its beginning to its end. The process was much less predictable than that and had much to do with the reactions of the makers to exemplars and to one another. Even in a one-person campaign such as this, one might expect a programming of the workload in which the essential core text, with its special sacred status, took priority and was planned with careful reference to the archetypal exemplar; and the introductory matter, devised with reference to more than one model, followed. This supposition is borne out by the incomplete nature of this important ornamental page which effectively serves as the book's frontispiece.

Some details of the volume's decoration may be 'imperfect', or rather defy the conventions of the overall pattern in which they are included, in order to acknowledge that only the works of the Lord are perfect.[76] Others are blatantly unfinished. The most obviously incomplete passage is at the head of this carpet panel, just to the right of the head of the cross, abutting the frame (see pl. 23b). Here, and immediately above the very head of the cross itself, sections of the interlaced knotwork background which should have been painted orange have been left uncoloured, but the painting has been started in one of the corners and breaks off abruptly. The most likely explanation is that the artist-scribe was never able to return to his work and that it was considered inappropriate for anyone else to complete the body of the work, other than to make the text usable by adding the necessary rubrics and marginal apparatus.

The discolouration of the margins, of the recto of the folio, and the water-staining produced by a thin stream of water penetrating the book at its mid-head and trickling down the page (consistent with a leak whilst the volume was stored upright on a shelf – a library practice not commonly observed until the sixteenth century onwards), indicate the comparative vulnerability of the opening leaves of the book. The orange pigment (red lead) has oxidised more here than elsewhere, acquiring a silver/black veneer in places as a result of its exposure to moisture and air.

This carpet page is the least complex, but it is also the most archaising. Its palette is dominated by the characteristic Insular tricolor of orange, green and yellow (although its outer framing lines and corner-pieces include another shade of green and a mauve). This is the palette of traditional Insular illumination, as seen in the Book of Durrow and the Echternach Gospels, rather than the extensive Italo-Byzantine palette encountered elsewhere in Lindisfarne, in the Codex Amiatinus and the Book of Kells. But this more limited colour-scheme carried deep cultural connotations, summoning forth recollections of early Merovingian art and, even more evocatively, of Coptic Egypt – home of the desert fathers (see figs 115, 175).[77]

The centrepiece of the design is a Latin cross with square terminals, a matching square central panel and an additional matching square panel halfway down its lower leg. It is, essentially, a rectilinear angular version of the cross preceding St Matthew's Gospel (f. 26v, see pl. 10) and similarly has six bosses, one in the centre of each panel. These bosses consist of green squares with unpainted centres, resembling holes. These may be intended to convey the recollection of the bosses used to cover rivet-holes in metalwork processional and reliquary crosses of the early Middle Ages (of the sort similarly 'fossilised' in the stone high-crosses of Ireland and Scotland). Holes in some such bosses may have contained relics. A more symbolic interpretation of these features, especially in the cross-carpet pages, might be that they represent the wounds of Christ (hands, head, side and feet) plus the 'INRI' titulus placed above Christ's head during the Crucifixion.[78] The rectilinear outline also gives the cross something of the appearance of an architectural plan of a cruciform church building, with a square apse, crossing and narthex and porticus chapels alongside parts of the transepts and nave. Martin Werner has suggested similar interpretations for components of the illustrations in the Book of Kells, which may make allusion to the Temple in Jerusalem.[79] Any such allusions are surely symbolic, if they were indeed intended. Given the interest that Arculf's pilgrimage account, utilised by Adomnán in his *De locis sanctis*, inspired upon his arrival in Iona during the late seventh century, and Bede's complex exegetical commentaries upon the Tabernacle and the Temple, along with the diagrams of them introducing the Codex Amiatinus, the possibility of cross-carpet pages fulfilling a simultaneous role as figurae of sacred buildings cannot be excluded, even if only as one of a number of symbolic levels of interpretation.[80] The body of the Church was, after all, a symbolic embodiment of Christ, as was the cross itself.

The outline of the cross is in a blue/green, balancing the brighter green of the square bosses, and its body is filled with a continuous geometric fretwork pattern, resembling a chequerboard of lozenges, in yellow on an orange ground. The cross is set against a ground of fine linear single-strand interlace, formed of 'wheel-headed' knotwork. Each of the knotwork breaks (which are like round wheels with a superimposed 'X') is painted in an alternating sequence of yellow and orange, the whole offset against a black ground which sharpens the pattern and emphasises its fine linearity. Also contained within this interlaced

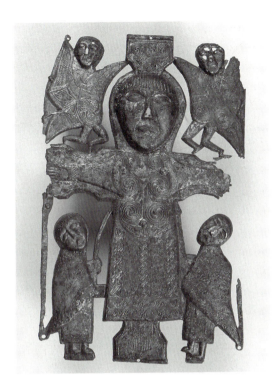

Fig. 134. The Athlone Crucifixion Plaque (NMI R554), Irish, 8th century. The triumphant Christ is flanked by angels and by the sponge and spear bearers, Stephaton and Longinus. (Photo: National Museum of Ireland)

ground are four panels of geometric step patterns, one in each of the angles of the cross. They are contained within mauve frames. The two in the upper quadrants are square and the two in the lower quadrants are rectangular. Their placing calls to mind the mourning figures of the Virgin and St John or of Stephaton and Longinus, the sponge and spear bearers, and of angels or of the sun and moon watching from above, features found in early medieval figural depictions of the Crucifixion (see, for example, fig. 134), or of the placing of the Alpha and Omega ('beginning' and 'end') symbols which often accompany early medieval jewelled crosses. The step patterns in the squares form several further equal-armed crosses, emphasised by the colour disposition of the orange, green and yellow steps, set within an orange outer frame. This pattern is repeated in the same colours, but not exactly the same design, in the rectangular panels, giving one complete pattern and two half-repeats per panel, again contained in an orange outer frame. There are crosses within crosses.[81] The effect produced is highly reminiscent of a woven textile; the sort of elaborate, exotic embroidered silks and woven braids of eastern manufacture in which the incorrupt remains of St Cuthbert were reverently wrapped and which assumed relic status themselves.[82]

The whole design is contained within a rectangular frame with one inner and two outer bounding strips coloured to reflect the similar strips outlining the cross and its flanking

panels. The intervening area is occupied by a continuous frieze of the distinctive bird interlace encountered throughout the decoration of the Lindisfarne Gospels, but here they cease their usual exuberance and are frozen into a solemn, dignified procession, each linked to its neighbour by gripping a graphically outstretched back-turned talon in its hooked beak, and by the tail plumage which interlaces with the lappet (head plumage) of the following bird. Their wing plumage alternates between green and orange striped and multi-celled chequered patterns, like compartments of green and orange cloisonné enamel. The balanced coloristic effect is reinforced by the striking black background. The birds' round, staring eyes and their down-turned mouths convey a sobre expression, as if accompanying their Creator from Cross to Sepulchre, or as if solemnly approaching the Holy of Holies.

The four corner-pieces are identical: pairs of dog or lion heads rest their chins heavily upon the frame, gazing dolefully towards their facing counterparts on the other corners. Their eyes and mouths, like those of the birds, convey sorrow and gravitas: Good Friday anticipating Easter Sunday. The preoccupations of the artist seem here to be following the lines of the dreamer in the near-contemporary Old English poem, the Dream of the Rood: the preparation for death and thereby for new life through the suffering and redemption of the Cross; meditations which might particularly absorb an artist-scribe-priest imminently approaching the end of his own earthly life. The beasts' ears intertwine with the end of the outer purple frame to form, along with their heads, a four-cornered, curvilinear motif, extending at the centre of its top into a double circle with a foliate motif at its centre, drawn delicately in black ink: the four corners of the earth, centred upon the Cross.

Description of the prefatory, Novum Opus, incipit page, f. 3r
Transcription:

> *Incipit prologus x canonum.*
> Nouum
> opus fa-
> cere me cogis ex
> ueteri ut post
> exemplaria scrip-
> turarum toto orbe dispersa quasi quidam arbiter

The 'Novum Opus' is St Jerome's letter to Pope Damasus in which he explains and justifies his work in producing a revised translation of the Bible into the vernacular Latin language of the Roman world – the Vulgate. In the decorative programme of the Lindisfarne Gospels it is accorded a status approaching that of the incipits of the four Gospel themselves (see pl. 3), the similarity serving to emphasise the significance of his role in their transmission. The format of the incipit pages is comparable: a major initial or monogram followed by a diminuendo of display scripts, but whereas the Gospel initials expand across about a third

of the page, that of the Novum Opus occupies less than a quarter. It is followed by five lines of display capitals (the Gospels have between four and six) with a sixth line at the bottom written in the half-uncial script of the main text, its final word, 'arbiter', turning in a calligraphic right-angle, its final letters descending vertically in order to justify the line. The display letters are a mixture of angular Roman square capitals, some adopting stylised rune-like forms (such as the 'bar-gate M' and the the 'dog-legged G', both in line 3, the diamond-shaped 'O' and the 'P' with an additional open lower bow, causing it to resemble a 'B' as in the great John 'INP' monograms in the Lindisfarne and the Durham Gospels, see pls 21, 27a) and more rounded uncials ('u', 'm', 'e', 'f'). They are set upon a ground of red dots, as in the Gospel incipits, the two top lines set against a densely dotted ground, resembling chased metalwork like the inscriptions on the near-contemporary Irish Ardagh chalice (see fig. 97),[83] The initial 'N' is outlined by a double line of dots and set upon a diapered dotted ground of diamonds with central dots. The remaining lines of display capitals are placed between horizontal head- and base-lines of double dots, recalling Roman epigraphic practice on smaller stone and lead plaques, and are outlined with rows of single dots, a feature which Julian Brown ascribed to late Antique practice as observed in manuscripts from northern Africa.[84] The display panels formed thereby are not, however, formalised by bar borders as are the Gospels incipits which accordingly occupy a higher position in the hierarchy of the decorative scheme.

Aldred's Old English gloss is inserted between the lines, and he tries to upgrade his own pointed minuscule script, introducing a greater weight and set formality of aspect and ductus and employing some higher grade letter-forms such as half-uncial 'oc' 'a', in recognition of the formality of this opening page of the text. A later reader, probably not Aldred, has punctuated the *scriptura continua* by adding commas on the base-lines between each of the words, other than those which terminate the end of a line. This page exhibits similar signs of comparative vulnerability and wear, including the water-staining and oxidisation (apparent in the red lead rubric) to the carpet page opposite.

The palette used for this page is particularly bold. The simple but striking crisp black forms of the display capitals are complemented by bold single colour infills in yellow green and mauve, their vibrancy and luminosity bringing to mind stained glass of the sort introduced to Britain by Gaulish glaziers employed at Monkwearmouth and Jarrow (some of their glass still surviving at Jarrow, see fig. 87). These colours, along with the red dots, complement the facing carpet page. The colourful austerity of these letters is softened in places by the use of delicate linear ink contours with pelta-like cusps inside some of their strokes (e.g. the 'M' on the third line and the 'R' on the fourth). The angularity occasionally gives way to more fluid forms, such as the lower additional bows to 'P' on lines 2, 4 and 5, which predict the 'ribbon-style' display scripts which enjoyed increasing popularity throughout the eighth century. The final 'P' on line 5 even sprouts little horned serifs from the end of its lower bow, recalling the 'antenna style' initials of near-contemporary

Southumbrian art (seen, for example, in the Kentish Vespasian Psalter of the 720s–30s).[85] These letters with more curvilinear strokes are often terminated with spirals or sinuous bird heads, as are the 'O' and 'F' of line 2 which feature graceful serif extensions ending in elegant bird heads in black and reserved vellum, resembling Insular silver-niello metalwork.

The metalwork theme becomes even more apparent in the first line. One 'U' is in the form of the black display capitals and serves to link this rather different decorative line to those which follow. The other 'U' enters into ligature with 'M', their black skeletal contours filled with yellow relieved by interlace motifs reserved in vellum on a black ground. The effect recalls Insular metalwork, with burnished gold surfaces broken by intricate details of golden filigree work. The compartments of the 'M' are further adorned by fine interlace strands terminating in bird heads at the foot and in beast heads with gracefully arching attenuated necks, perhaps intended to resemble horses. The fine colour balance of these infills, with their yellow details and bi-partite green and mauve grounds serve once again to link this complex register of ornament with the simpler lines which follow, this theme of decorative diminuendo being picked up by the 'O' in line 2 with its bird heads and bi-coloured infill.

The initial 'N' and the following 'O' form a link between the archaising simplicity and boldness of the rest of the decoration of these paired incipit and carpet pages and the intricate complexity of the corresponding opening diptychs of the Gospels themselves. Blue is introduced into the palette and the black contours of the letter-forms are inhabited by a riotous filigree menagerie of birds and beasts and by a vortex of curvaceous Celtic whorls. The 'N', with its cross-stroke composed of two spiraliform link-strokes, is reminiscent in form of those in the Mark 'INI' monograms in Durham MS A.II.10, the Book of Durrow and the Durham Gospels, in which the cross-stroke takes the form of a reversed 'S' with two trumpet terminals flowing around a central linking boss (see fig. 96 and pls 27, 31d). In this Lindisfarne Gospels' 'N', the boss has disappeared and the two halves of the 'S' have achieved independence, swirling animatedly against one another, like eddies in the tide, and terminating in their interiors in two pairs of hindquarters, each with two legs. These may be intended to form the rear ends of four beasts whose bodies are formed by the letter-strokes of the 'N' itself and whose heads could be either the four interlaced birds at the foot of the first stroke, or the beast heads which occur as interlaced pairs at the heads of the two vertical strokes and also at the foot of the second. These six heads have canine features, although their curved white ears, terminating in a pelta motif, are reminiscent of bovine horns. As there are six of them they are probably not the owners of the four hindquarters, and yet these do not assume bird-like forms (having paws and tails) and therefore do not match the four bird heads. The back-drawings of these further indicate that other heads were originally planned here, with duck-like bills or even muzzles rather than beaked birds (see fig. 88), perhaps indicating that biped beasts were

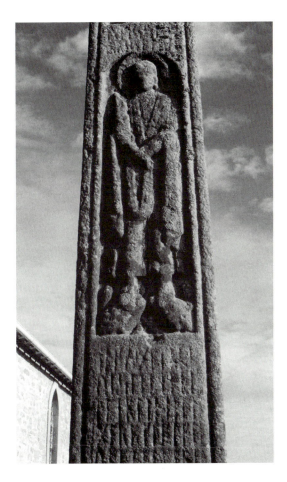

Fig. 135. Christ revealed between two living creatures, with worn runic inscription below detail from the Bewcastle Cross, Northumbrian, 8th century. (Photo: the author)

originally intended but a change in plan resulted in creatures whose rumps did not match their visages – the grotesque hybrid forms of ancient mythology. Such amorphous beasts may have served to symbolise all Creation, in the manner of the creatures at Christ's feet on the Ruthwell and Bewcastle crosses (see fig. 135).[86]

Whatever these creatures are, the interiors of their letter-bodies are filled with a satisfying meal of a procession of interlaced birds. Two further, larger birds insert their bodies into the interstices flanking the spiral cross-strokes, their talons clenched to fit within one angle of the triangular space and their green necks curving into the centre of the cross-stroke spirals where their beaked heads grasp the interlaced tails of the mystery beast hindquarters.

Two delicate opposed pelta motifs serve to link the 'N' to the 'O'. The latter again its letter-stroke filled with interlaced birds, and at head and foot the oval profile is relieved by delicately drawn 'Ultimate La Tène' pelta and trumpet motifs. This classic Celtic abstract art, of Iron Age derivation, finds full exuberant expression in the bow of the 'O', where

Fig. 136. Qur'an (BL, APA Or. MS 7214), ff. 1v–2r, carpet pages from a small portable early Qur'an, made in Iraq in 1036.

spirals emphasised by blue infills form a whirling Trinity flanked by trumpets and peltas. This intricate counterpoint of Celtic abstraction and Germanic zoomorphic interlace is encountered in the other great incipit initials and across the media in metalwork such as the Irish 'Tara' brooch and Ahenny high crosses (see figs 15, 16, 19).[87]

The Gospel carpet pages

Carpet pages, pages of pure decoration serving to divide or introduce texts, take their name from their resemblance to oriental rugs. As we shall see, there may be a previously unperceived validity and meaning to this analogy. Coptic and other eastern manuscripts sometimes feature such pages of decoration, including crosses formed of or set against interlace, as in New York, Pierpont Morgan Library, Glazier Codex 67, f. 215r, and a later Persian copy of an early diatessaron (Florence, Biblioteca Medicea-Laurenziana, Orient 81, f. 127v).[88] They are quite widely represented in Coptic and Christian Arabic manuscripts of the ninth century onwards, and may also have played a role in the development of the great decorated pages of Islamic Qur'ans (see figs 136, 138). Early Coptic bindings also often feature tooled or raised designs resembling carpet pages and may have served as a direct influence, as attested by the binding of the St Cuthbert Gospel (see fig. 17).[89]

Fig. 137. Hebrew Bible (BL, APA, Or. MS 2628), f. 185r, carpet page with micrography, Lisbon, Portugal, 1483.

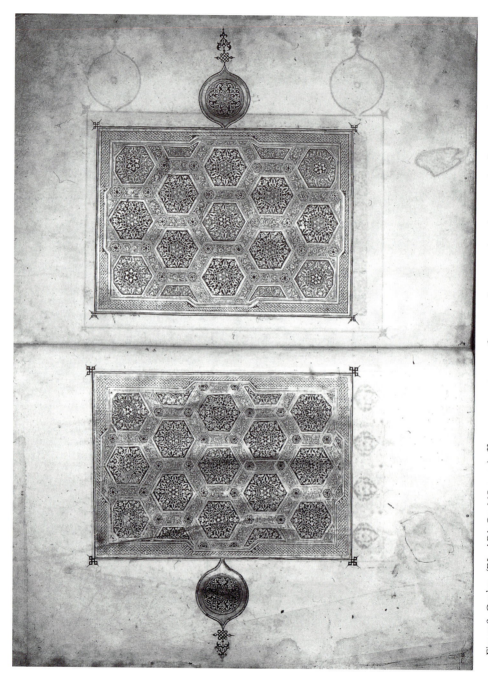

Fig. 138. Qur'an, (BL, APA Or. MS 4945), ff. 1v–2r, carpet pages from a 14th-century (1310) manuscript from Mosul, Iraq. Like the Insular carpet pages, such pages of ornament have been derived from a common earlier source, perhaps Coptic manuscript art.

Another interesting later occurrence of carpet pages is to be found within medieval Hebrew biblical manuscripts (especially those of Iberia which exhibit Islamic influence, see fig. 137) where the threefold division into the Law, the Prophets and the Psalms is marked by groups of carpet pages with geometric, abstract and foliate designs resembling textiles, like the curtains which were lifted to reveal sacred text.[90] The earlier existence of such features has, given the survival rate of manuscripts, often to be deduced from their occurrence in later copies, but one particularly early example of a cross with interlace fill serving as a major text divider is to be seen in Oxford, Bodleian Library, MS Bruce 96, a Gnostic papyrus of the fifth to sixth century (see fig. 110).[91] Similar sources are likely to have inspired the phenomenon in early Insular manuscripts. The Book of Durrow features six carpet pages (see pls 31a–b), at the beginning and end of the book and before each Gospel, most with crosses embedded within their ornament, as well as a four-symbols page in which the evangelist symbols are arranged in the quadrants of a central cross (a feature again paralleled in the Persian diatessaron).[92] The Durrow carpet pages are accompanied by full-page miniatures of the individual evangelist symbols, the four-symbols page facing the first carpet, and decorated incipits with enlarged initials and display script (occupying only part of the page, unlike the Lindisfarne Gospels' full pages). Durrow provides the closest analogy and probable precursor for much of the Lindisfarne programme (even if its evangelist miniatures do not employ the same symbolic ordering). An earlier occurrence of a carpet page is to be found as the frontispiece to the Milan Orosius (Milan, Bibl. Ambrosiana MS D.23.sup., f. 1v), a copy of his *Chronicon* made in the Irish foundation of Bobbio in northern Italy, part of the *parochia* of St Columbanus (not to be confused with St Columba), probably during the early seventh century.[93] This features a rosette or marigold, an Antique symbol of life and rebirth, flanked by four smaller rosettes.

Transmission of the concept of carpet pages to an Insular milieu may therefore have occurred via Italy and Ireland, or from more direct importation of manuscripts from the eastern and southern Mediterranean. They enjoy a limited currency within subsequent Insular book art, the Lichfield Gospels retaining one example (as well as a four-symbols page akin to Durrow's) which is closely related stylistically to those of the Lindisfarne Gospels, and codicology indicating that it probably contained others (see pl. 28).[94] The Maihingen Gospels from early eighth-century Echternach also retain only one carpet preceding St John's Gospel,[95] the Irish St Gall Gospels have a cross-carpet page preceding the genealogy of Christ,[96] and the same position is occupied by the only carpet page in the Book of Kells (in which a double-armed cross like that of Durrow is again embedded, see pl. 32b and fig. 116). The decoration of the Kells page is indebted to the style and zoomorphic ornament of the Lindisfarne Gospels, which it carries to further heights of complexity in its interlace, and exhibits a particular stylistic debt in its inclusion of animal-headed escutcheons on the side of the frame and in its stepped corner-pieces.[97] Other late examples of the genre occur as the frontispiece to the late-eighth- or early ninth-century

Breton St Gatien Gospels,[98] on a single leaf from an Irish Gospelbook of similar date from St Gall,[99] and two cross-carpet pages from an Insular book belonging to Bobbio and now known as the Turin Gospels (the volume was largely destroyed by fire, rendering interpretation of its codicological complexities difficult, but it appears that it may have been a seventh-century volume which was significantly repainted during the ninth century).[100] In Freiburg-im-Breisgau, Universitätsbibliothek, Cod. 702, a Gospelbook probably made at Echternach in the early eighth century, and the Kentish Stockholm Codex Aureus the crosses are liberated from their own pages and are superimposed upon the text itself.[101]

Thus, to judge from the limited surviving evidence, carpet pages could be used by Insular artists to serve as frontispieces to books (and usually reserved for use in Gospelbooks), to mark a particular point in the text (with the interesting phenomenon of the introduction of the genealogy of Christ with a cross-carpet page as well as a 'Chi-rho' initial) and, in a very few of the earlier Gospelbooks, including Lindisfarne, as part of a more ambitious programme to introduce the work and to divide the Gospels, each one having its own dedication cross page.

The inclusion of the practice of physically marking with a cross during the liturgical dedication of church buildings and altars may be relevant in interpreting the meanings of the cross-carpet pages.[102] Columban monks even extended the practice to artefacts associated with their daily labours, such as the quern-stone inscribed with a cross, from Dunadd (Argyll) and now in the National Museum of Scotland. Manuscripts penned in the Wearmouth/Jarrow scriptorium, or those exhibiting its influence like Royal 1.B.vii, likewise have a small cross written in their top left-hand corner, perhaps designed to dedicate and invoke a blessing upon each page of the work for God.[103] I suggest that in the Lindisfarne Gospels the cross-carpet pages, along with the golden rubrics on the facing incipit pages which invoke the name of Christ and of the evangelists, serve a similar dedicatory function. There was also, of course, a long-lived tradition relating to the talismanic function of the cross as a device to ward off evil which may have contributed to its funerary popularity and to its appearance on jewellery found in furnished Anglo-Saxon graves.[104] Such a function may also have been an aspect of its role within Insular books for, as Cassiodorus informed his readers, each word written was 'a wound on Satan's body',[105] and, to quote an inscription on a ninth-century funerary cross from San Vincenzo Al Volturno, 'Crux Xpi: Confusio Diaboli Est' ('The Cross of Christ Confounds the Devil').[106]

The metalwork analogies with the ornament of the carpet pages in both the Book of Durrow and the Lindisfarne Gospels are striking. As we have seen, the palette of Durrow is restricted to green, orange and yellow, the traditional colours of Coptic and Merovingian manuscript painting, as, uncharacteristically, is that of Lindisfarne's introductory Jerome carpet page. A conscious antiquarianism and allusion to the exotic origins of the device

may be intended. In Lindisfarne the palette then expands into a sophisticated range of colours and tones. In the carpet pages the polychromy of Insular and Germanic metalwork is summoned up, with details such as the boss at the centre of the Mark carpet (f. 94v, see pl. 16) incorporating a *trompe-l'œil* three-dimensionality in emulation of a raised metalwork glass boss or stud, of the sort which adorn the Ardagh chalice and the Derrynaflan paten (see figs 97, 139).[107] The suggested inclusion of gilded details within Lindisfarne's carpet designs, as in the Matthew incipit page, would have further heightened this metalwork effect. A more specific analogy is probably being drawn with metalwork processional crosses which are known to have been used in an Insular milieu, as attested by the fragments of gilt copper foil and the bosses which formed one such cross found in Dumfriesshire (in the southern zone administered by Lindisfarne, and now in the National Museum of Scotland) and the Rupertus cross, made on the Continent under Insular influence (see figs 140, 141).[108] The Rupertus cross even features such polychrome glass paste studs set into it as bosses against inhabited vine-scroll ornament on the body of the cross.[109]

The free-standing stone crosses of Britain and Ireland are thought to have imported elements from the design of such metalwork processional crosses into their own designs.[110] The cross erected on Lindisfarne to commemorate Bishop Aethilwald (d. 740) and commissioned by him prior to his death, is the earliest documented example of a free-standing stone cross, although there are some earlier undated examples with cross-shapes tentatively and somewhat crudely emerging from the slabs upon which they are carved at Fahan and the St Patrick's Cross at Carndonagh (see fig. 14), perhaps dating from the seventh or early eighth century and both to be found on Inishowen, Co. Donegal, adjacent to Lough Foyle whence Columba sailed on his *peregrinatio* to Iona, a region therefore enshrined within the Columban federation's collective memory. When painted, as many of them undoubtedly were, the comparison would have appeared even more striking and it is increasingly apparent that some of them carried inset metalwork bosses (some possibly holding relics), such as that which is recorded as being prised out of a cross at Lastingham in Yorkshire.[111]

Sculptured crosses upon slabs may also be related to the cross-carpet pages. They occur, for example, on the aforementioned cross-slabs in Co. Donegal, in a funerary memorial context on the name-stones of Lindisfarne and Hartlepool (perhaps modelled upon Lombardic stones which, as we have seen, also influenced the ninth-century name-stones of San Vicenzo al Volturno), the Tullylease Berechtuine slab in Co. Cork and the recumbent Irish slabs, such as those at Clonmacnoise (see fig. 18). They occur prior to this on Coptic slabs, similar in size and shape to the Northumbrian name-stones, such as those preserved in the Coptic Museum in Cairo and in the British Museum (see fig. 142), and, in a later eastern Mediterranean context (perhaps preserving older traditions) on the memorial stones of Armenia, such as the Khatchk'ar of Aputayli, Sewan, Noraduz Cemetery, 1225 (British Museum, MME 1977, 5–5,1, see fig. 143).[112]

(a)

(b)

Fig. 139. (a) The Derrynaflan paten and stand (NMI 1980:4,5), Irish 8th century; (b) General shot of the Derrynaflan hoard, Irish, 8th–9th century, giving an impression of the sort of metalwork (of late Roman and Byzantine inspiration) that might have been seen alongside the Lindisfarne Gospels on the altar. (Photos: National Museum of Ireland)

318

Fig. 140. The Rupertus Cross (facsimile, Mainz, Römisch-Germanisches Zentralmuseum, original from Bischofshofen parish church, Pongau, Salzburger Raum), Austria, in Continental/Insular style, 8th century, general shot of front. (Photo: Römisch-Germanisches Zentralmuseum, Mainz)

Processional crosses proceeded the Gospelbook during liturgical procession. The ambo (pulpit) from which the Word was preached could also be adorned with a cross embedded within panels of ornament, such as that at Romainmoutiers, an Irish foundation in Switzerland, which strongly resembles a cross-carpet page with its cross embedded in interlace (see fig. 144). Altars might also carry such symbolic decoration, such as the eighth-century altar frontal from Flotta, Orkney, with its central panel containing a cross (now in the National Museum of Scotland).[113] There are therefore compelling analogies with liturgical focal points for the design of Lindisfarne's cross-carpet pages.

A further such analogy, which has previously escaped notice, is that of carpets themselves, for the prayer mat featured in the liturgico-devotional practices of Rome, as well as of the East, as a brief examination of the development of the liturgical veneration of the Cross in Rome will demonstrate.[114] During the first quarter of the seventh century the tradition of the veneration of the Cross on Good Friday was introduced to Rome, under eastern influence from Constantinople. The earliest liturgical text from Rome for the veneration of the Cross in St Peter's, Rome, is the 'Ad crucem salutandum in sancto petro':

> Deus qui unigeniti tui domini nostri iesu christi praetioso sanguine humanum genus redemere dignatus es, concede propitius ut qui ad adorandam uiuificam crucem adueniunt a peccatorum suorum nexibus liberentur. Per dominum.

319

Fig. 141. Processional metalwork cross from Dumfriesshire (NMS), 8th century. (Photo: the author, courtesy of the National Museums of Scotland)

(God, who has deigned to redeem the human race by the precious blood of your only-begotten son our Lord Jesus Christ, grant propitiously we beseech you that those who come to adore the life-giving cross may be freed from the bonds of their sins. Through our Lord.)

This occurs in the Sacramentary of Padua-Paduense,[115] and was celebrated on 14 September (as the finding of the True Cross was celebrated at Jerusalem on that date). In 614 the Persians captured Jerusalem and the relic of the True Cross. Emperor Heraclius recovered it and returned it to Jerusalem in 629, but it was still at risk and so was transferred to Constantinople in 635. Its triumphant entry – the imperial *aduentus* – was the focus of its exaltation there.[116] This developed into the formal veneration of the Cross on Good Friday. By the mid-seventh century, when the earliest Anglo-Saxon clerical pilgrims reached Rome, a mass for the exaltation of the Cross had been composed and was used in many of the churches there. Roman liturgy emphasised the life-giving Cross as an image of Christ (focusing upon John 3.14, the raising up of Christ on the cross, which also symbolises resurrection, for 'when you have raised up the Son of Man then you will realise that I am he' John 8.28). It seems to have escaped notice that the prayer mat (*oratorio*) was used to allow everyone to kneel and kiss the Cross, as shown by a late eighth-century *ordo* adapted

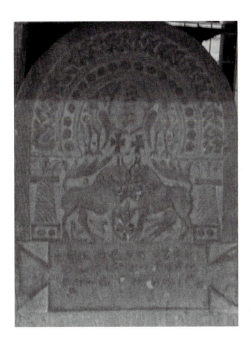

Fig. 142. Coptic funerary slab, resembling the Northumbrian name-stones in shape, Egypt, 5th or 6th century. BM, EA 1801. (Photo: courtesy of the Trustees of the British Museum)

from Roman use for use north of the Alps – Ordo xxiv, pars 29–31.[117] I suggest that carpet pages may indeed be meant to recall such prayer mats, which still feature in the observances of the churches of the Christian Orient and within Islam. The adoration of the Cross was followed by the Eucharist. The zoomorphic decoration on the processional crosses and on the Lindisfarne cross-carpet pages summoned up the Tree of Life, celebrating the eucharistic communion of Creation.

In the Burchard Gospels, at the beginning of the Passion (John 18.1) is an annotation by a Wearmouth/Jarrow scribe: 'in ebd. maiore feria vi ad Hierusalem legitur passio dni' ('in holy week on Friday at Jerusalem the passion of the lord is read'), noting the Good Friday station as part of a list of the stations kept at Wearmouth/Jarrow. They were evidently familar with this liturgical practice in early eighth-century Northumbria. As we have already seen, there is also archaeological evidence for stational crosses within the monastic enclosure on Lindisfarne and references within the anonymous and Bedan lives of St Cuthbert to pilgrims undertaking the 'turas' or pilgrimage round of the 'holy places' there, in accordance with both existing Irish tradition and more recent liturgical observances introduced from Rome.[118]

Pope Symmachus (498–514) provided for a chapel of the Holy Cross at the Vatican a reliquary adorned with gems containing a fragment of the Cross and Emperor Justin II presented another reliquary cross to the Vatican. Lindisfarne's carpet pages with their metalwork resonances might also be intended to symbolise such cross reliquaries. This might account for the varied forms of cross displayed in its various cross-carpet designs.

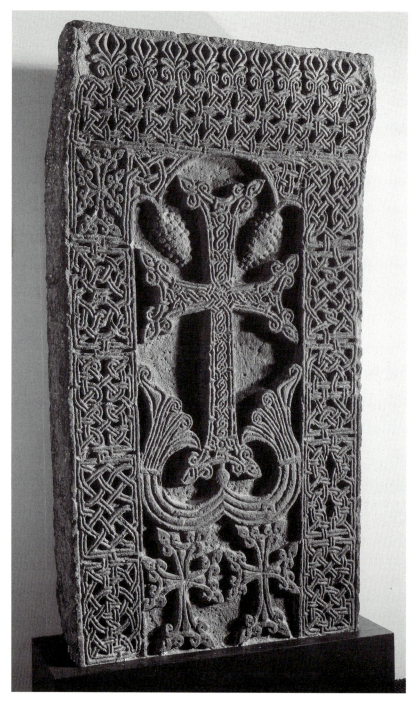

Fig. 143. Khatchk'ar (memorial stone) of Aputayli (BM, MME 1977,5-5,1), Sewan, Noraduz Cemetery, Armenian, 1225. (Photo: courtesy of the Trustees of the British Museum)

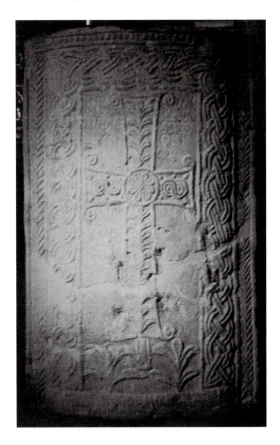

Fig. 144. Ambo (pulpit) with cross and interlace, from Romainmoutiers, an Irish foundation in Switzerland, 7th–8th century. (Photo: the author)

Those preceding the Novum Opus and Matthew's Gospel are of Latin form (see pls 2, 10), with either square or chalice-shaped terminals, these being effectively equal-armed crosses set upon shafts, as the extra terminal midway down the lower leg emphasises, a feature also encountered on the Rupertus cross and on several of the Lindisfarne name-stones (some of which also fill the cross with interlace) and on the Irish Tullylease slab (see figs 18, 91, 140). The cross upon a shaft or column may be of Byzantine derivation. On the churchyard slab at Carndonagh the theme is elaborated further with a Crucifixion set upon a column which in turn rests upon a lower cross.[119] The Lindisfarne Gospels' Mark cross is a Greek, equal-armed cross with a ring-head of Irish fashion.[120] Luke's is also of Greek near equal-armed form, with tau-headed terminals. That preceding John's Gospel is of 'exploded' form with a precisely symmetrical central equal-armed cross flanked by four tau crosses. Bonne has pointed to the influence of a specific relic of the *tabula ansata* inscribed with Christ's title which was nailed to the head of the cross as an explanation for the double-armed cross (as seen in the Book of Durrow and the Book of Kells, see pl. 32b and fig. 116), although the Cross and Crucifixion conjunction of the Carndonagh slab may also be relevant in this respect.[121] Werner has also highlighted the possibility of a connection between the design

of a cross-carpet page in the Book of Durrow and the cult of the True Cross as known at Iona.[122] Perhaps the artist of the Lindisfarne Gospels was paying visual homage to known reliquaries, buildings and/or to the different Christian traditions of East and West as represented by their cross types. Such visual devices would have served to reinforce the Gregorian ideal of diversity within unity, which Bede records was so important to Benedict Biscop and his community.[123] The Cross would therefore stand as a potent symbol of the all-embracing *œcumen*, which transcends all human divisive structures.[124]

Above all, the Lindisfarne Gospels' cross-carpet pages are the embodiment of the *crux gemmata* (the jewelled cross), the symbolic representation of the Godhead by means of abstract, symbolic substitution which had been favoured in the Early Christian tradition. Such substitution had proved especially valuable in the face of the continuing debate concerning iconoclasm and the veneration of images. The *crux gemmata* and the Gospel-book serve as the embodiment of Christ in the fifth-century mosaics of the Orthodox Baptistry in Ravenna, where they occupy the throne and the altar as symbols of orthodoxy (see fig. 39).[125] As already noted, in the 720s the iconoclast party in Constantinople tore down the effigy of Christ on the palace gate and replaced it with a Cross.[126] These were very much live issues and even though a greater tolerance towards images prevailed in the West, they did not go unquestioned, the debate continuing into the Carolingian age. The West took its cue from the letter of Gregory the Great to the iconoclast Bishop Serenus of Marseilles, around 600, in which he urged restraint on the grounds that 'It is one thing to adore a picture, another to learn what is to be adored through the history told by the picture. What Scripture presents to readers, a picture presents to the gaze of the unlearned. For in it even the ignorant see what they ought to follow, in it the illiterate read.'[127] Nonetheless, a residual unease may be detected in the Insular preference for oblique, symbolic meaning rather than direct iconic representation of the Godhead. In 692 the Council *in Trullo*, held in Constantinople, passed a canon (no. 11) rejecting the established symbolic iconography of John the Baptist, the 'Precursor', pointing to the image of Christ as the Lamb in favour of a more literal representation of the Crucifixion as an image of redemption, a move which would contribute to an iconoclastic unease which erupted into the mob which removed the Crucifix from the imperial palace gates in 726.[128]

The Pope refused to subscribe to the Council, perhaps accounting for the prominent retention of the John the Baptist imagery on the Ruthwell and Bewcastle crosses, but there appears to have been an initial Western move in favour of depicting the Crucifixion, as it advocated, seen in the Durham Gospels' Crucifixion miniature, in the sculptures at Carndonagh, Co. Donegal, and the eighth-century Athlone Crucifixion plaque (see pl. 26 and fig. 134). This seems to have been subsequently toned down as tension escalated in the East, resulting in the subtler imagery of the Lindisfarne Gospels.[129] The symbolic resonance and labyrinthine complexity of the carpet pages, which must have served something of the function of prayer labyrinths (akin to those of the later Gothic cathedrals, such as Chartres)

for their maker when he lost himself in meditation during their painting, make them a sophisticated example of such trends.[130] In accordance with a traditional art historical tendency to attribute a primacy to figurative naturalism, discussions of the relationship between the Lindisfarne Gospels and the Durham Gospels have assumed that the figural image of the Crucifixion in the latter represents a later development than the carpet pages in the former. Principles of abstraction would tend, however, to support the opposite conclusion, that the complex abstraction and symbolism of the Lindisfarne carpet pages could be the more sophisticated and later. An icon from the Mediterranean area, or a manuscript miniature such as that in the sixth-century Syrian Rabbula Gospels,[131] may have inspired the artist of the Durham Gospels (and the makers of the other aforementioned early Insular Crucifixion scenes), while the maker of the Lindisfarne Gospels took as his ultimate inspiration a more symbolic, decorative cross motif originating in the Christian Orient or Coptic Egypt and already represented within the Columban tradition in the Book of Durrow.

We have already touched upon the importance of the symbolism of the Cross in Northumbria. It is celebrated above all in the words of that great Anglo-Saxon poem, the 'Dream of the Rood', part of which is inscribed upon the Ruthwell cross.[132] Here the Cross is seen as a living tree, clad in gold and set on its cross-beam with five jewels symbolising the wounds of Christ.[133] On the early eleventh-century Anglo-Saxon Brussels reliquary cross (Treasury, Cathedral of St Michel, Brussels) the relationship is made even more explicit, as it is a 'jewelled' metalwork cross inscribed with a distych, an epitome based upon the Dream of the Rood text and contained a relic of the Cross.[134] On the processional and reliquary crosses, the sculptured crosses and the cross-carpet pages of the Insular world the Cross appears in this guise, proudly displaying its wounds as bosses and covered with the vine-scroll, the *vitis vera* of John 15.1, symbolising the living tree of the Crucifixion and Christ as the true vine nourishing his Church. The birds and beasts inhabiting it signify not only this Church, but all Creation dwelling in a new paradise (Psalm 104.16).[135]

Description of the Matthew carpet page, f. 26v

This is perhaps the most stately and accessible of the Lindisfarne Gospels' cross-carpet pages (see pl. 10). The orange outline of the central Latin cross, its orange, green and yellow colour scheme and its striking circular bosses outlined in blank vellum all serve to distinguish it from its background. This achievement is particularly impressive when one penetrates the mystery of the ornament and discovers that both cross and background are composed of riotous interlaced patterns of birds and beasts. The cross is formed of writhing green and orange quadrupeds, while the ground is filled with sinuous 's' shaped loops of entwined birds and hounds coloured predominantly in pink and blue, with green, orange and yellow details. The black ground upon which they are set forms some distinctive patterns itself, such as the vertical row of black diamonds in the upper quadrants.

The reversal of colouring either side of the cross serves to break and complicate the apparent symmetry, and one particular detail stands out: the vellum hip-spiral of the beast nearest to the right-hand foot of the cross. Like the striped bird in the John carpet page (f. 210v, see pl. 24), this may have been an intentional detail designed to draw attention to the place of the individual creature within the interwoven mass of Creation.

The whole design is contained in a rectilinear double frame of orange and green, the outer green band extending to form stepped corner-pieces filled with fine yellow knot-work. At the centre of each side of the frame are mounts composed of horned interlace with Celtic trumpet-spiral terminals, reminiscent of contemporary Hiberno-Saxon metal-work. Their placing recalls the cardinal points of the Crucifixion, and indeed in the Book of Kells (f. 291v, the St John miniature) they are replaced by the head, hands and feet of the crucified Christ, and also of the four corners of the world, embraced by his redemption. Another feature that may be echoed by these mounts are the decorative projecting ansae, a fossilised recollection of the handles of the classical *tabula ansata* (handled tablets and monumental inscriptions), which also figure in the carpet pages of the earliest decorated Qur'ans of the tenth century onwards (see figs 94, 136, 138).[136]

The shape of the cross is distinctive. Like that facing the 'Novum Opus', it is of Latin type with expanded terminals, including a fifth expansion which serves to lengthen the lower leg of the cross to produce the Latin form. This form is found in several near-contemporary sculptures, such as the 'hoc signum' cross-slab from Jarrow and the Tully-lease slab (see fig. 18).[137] Whereas the 'Novum Opus' carpet-page features an angular cross, this one is curvaceous, with chalice-shaped extensions which it has been suggested might allude to the eucharistic chalice, the receptacle of the blood of the crucified Christ.[138] The centres of these expansions are marked by circles of blank vellum, that at the crossing containing a foliate marigold motif (an early symbol of eternal life) and the others small stepped crosses. These resemble the enamelled bosses of contemporary Irish metalwork and may have been intended to recall the bossed rivet-heads of processional metalwork crosses, signifying the *crux gemmata*.[139] They may also have represented the wounds of Christ, although here there are six bosses, rather than the more usual five, signifying the five wounds (the sixth perhaps, as I have suggested, representing the inscription placed above his head).[140] The use of blank vellum is striking enough, but the bosses may be unfinished. That on the upper expansion of the lower leg has not had its background coloured orange, as in the others. It may be that the circular surrounds were intended to be coloured, or even gilded, for the gilding process was never completed. Any such gilding would have formed a delicate counterpoint to the tiny golden disks on the facing 'Liber' monogram (see fig. 119).

The use of bird and beast forms to articulate the cross may be compared, as we have already seen, to the use of inhabited vine-scrolls, a motif of early Christian Mediterranean derivation, symbolising the partaking of all Creation of the eucharistic Tree of Life.[141]

Such vine-scrolls may be found adorning the shafts of near-contemporary sculptures of 'Northumbrian' workmanship, the Ruthwell and Bewcastle crosses.[142] The cross itself becomes a living organism, as in the contemporaneous Old English poem, the Dream of the Rood,[143] which is itself inscribed upon the Ruthwell cross in Germanic runic characters. In the poem the cross finds voice and tells of its humiliation, agony and glorification in partaking of its Lord's Passion. This cross is equally vibrant, tortured and ennobled, as expressed by the throng of life it contains. Like the opening carpet-page, facing Jerome's 'Novum Opus', the cross is of the Latin form, with a longer lower leg, rather than the virtually equal-armed Greek forms, the Celtic ring-headed cross and the tau crosses explored in the designs of the other carpet pages. The intention may have been, as in other aspects of the conception of this book, to emphasise the inter-relationship of different Church traditions and their integration within the universal Christian ecumen, while signalling a current adherence to the Roman, Latin tradition.

Description of the Mark carpet page, f. 94v
This design is based upon a wheel-headed cross inscribed within a square (see pl. 16), which is filled with a fine, continuous interlaced pattern of double strand wheel-headed motifs with a coloured overlay of yellow, blue and orange. This, in effect, forms the background of the 'carpet', on top of which are laid a series of decorative panels outlined in orange, like the outer containing frame of the whole design. Four panels give form to the central cross, whilst four narrow rectangular panels flank its sides and two more elaborate tripartite panels stand at its head and foot. The overall effect is highly reminiscent of Hiberno-Saxon and Germanic metalwork of the period: the fine interlace resembling chip-carved gold filigree and silver-niello work and the panels gilded plates with filigree and enamelled ornament.[144] The narrow rectangular panels are filled with numerous compart-mentalised crosses, like enamels or millefiori (rods of glass fused into a pattern and cut into slices). The upper and lower panels consist of paired squares filled with Celtic Ultimate La Tène spiralwork of pelta and trumpet motifs, these squares joined by a rectangular link-piece filled with fretwork patterns delicately coloured in orange, yellow and green. The squares are dominated by whirling circles, which, like those in the Luke carpet page, may be intended to symbolise the four evangelists, who are represented in the Apocalypse as four flaming wheels.

The round centre of the cross contains a step-pattern which forms a number of smaller crosses within crosses. The effect strikingly recalls a cloisonné enamel boss of the sort that adorn pieces of contemporary metalwork such as the Ardagh Chalice and the Derrynaflan paten (see figs 97, 139). The jewel-like quality of this boss is increased by the way in which the contours of the crosses abutting the outer edge of the circle are curved, accurately conveying the perspective effect of three-dimensionality, which is so notably absent from the evangelist miniatures, in a sophisticated fashion unusual in such semi-

abstract decoration. This is surely an intentional depiction of the *crux gemmata*, the jewelled cross which is a scriptural symbol of the Godhead.[145]

The symbolism is pursued in the decoration of the frame, which has corner-pieces composed of the interlaced bodies of paired 'dogs' and birds, one of each apiece. Their heads form central mounts placed at the centre of each side of the frame. Their necks form the frame itself and the paired dog heads emerge to face each other at top and bottom, whilst the paired bird heads appear at the sides, squawking at one another across a central pelta motif. Although they bare a generic resemblance to dogs or lions and birds, these are even more stylised and hybrid creatures than usual. The 'dogs' have sharp teeth, but the gaping beaks of the birds also contain rows of teeth. Although the amorphous beasts depicted at the feet of Christ on the near-contemporary Ruthwell and Bewcastle crosses are very different (see fig. 135), they too are not recognisable as a specific genre. On these crosses they form part of an iconography in which Christ is recognised by the beasts in fulfilment of Habakkuk 3.3 (in the Old Latin version) 'between two living creatures shall you know Him'.[146] Perhaps the paired beasts here serve a similar function, with the *crux gemmata* set between them in the way that a figural representation of Christ is on the sculpted crosses. The placing of these zoomorphic escutcheons on the Lindisfarne carpet pages is also reminiscent of the labelling of the cardinal points of North, South, East and West (Arctos, Dysis, Anatol and Mesembria, spelling 'Adam', the first man and a type of Christ) in the plan of the Tabernacle in the Temple at Jerusalem in the Codex Amiatinus (ff. IIv–IIIr, see fig. 121) (see Bayless and Lapidge 1998). There may be an implicit reference to the passages in Revelation/Apocalypse in which the evangelists are presented as 'four living creatures, and they were covered with eyes in front and behind' (Rev. 4.6) and 'four angels standing at the corners of the earth, holding back the four winds', preventing them from harming the land and the sea (Rev. 7.1) until 'we put a seal on the foreheads of the servants of our God' (Rev. 7.3). These beasts, which look in both directions and are placed at the cardinal points, might thus serve the function of recognising the identity of the Lord within the *crux gemmata* and of linking it to the Last Judgement and the redemption of the Just.

Description of the Luke carpet page, f. 138v

The central motif of this carpet page is an angular Greek (near) equal-armed cross, its terminals expanded into a key or fretwork form and its central panel inscribed within a square (see pl. 20). It is set upon a ground of key patterns, forming a continuous design but overpainted to form a diaperwork of diamond shapes in orange, yellow and blue. The orange (red lead) and yellow (orpiment) abut one another and this may have contributed to the greater incidence of blackening (oxidisation) of the orange than that usually found in the volume. A curious detail occurs beneath the upper right-hand rectangular panel, where the diaperwork panel is given added emphasis by the introduction of a black

background. This is rapidly abandoned, however, perhaps because it was realised that it could not be systematically applied across the design without interrupting the pattern, or because the work was unfinished. The overall appearance of the page is one of decorative symmetry, but the closer one penetrates into the ornament, the more one embarks upon a complex game of 'spot the difference'. The creative ability to surprise by variety of detail, while preserving the homogeneity of the whole, becomes increasingly apparent.

The body of the cross is formed of a fine yellow linear interlace pattern set upon a black ground, resembling golden filigree work, contained in a blue frame. At its heart is a square panel filled with four revolving pink circles filled with trumpet spirals. The four circles may, once again, have been intended to represent the four evangelists, recalling their symbolic description as four flaming wheels in the Apocalypse. The triple spokes composed of trumpet spirals may have a Trinitarian meaning. Even these four circles are not identical: two have additional triple yellow crescents. The spandrels and centre of the square are filled with pelta and trumpet motifs set upon a black ground which serves to emphasise the presence of a further cross at the very core of the page.

The large Greek cross is flanked at its corners by four rectangular panels, with two further long, thin panels flanking its head and foot. These are all filled with zoomorphic interlace, but again these do not simply replicate one another. The two upper corner rectangles match one another, each containing four interlaced quadrupeds, two with pink bodies and two with blue. The two lower corner rectangles seem at first glance to match their counterparts, but in fact their four quadrupeds, in similar colours, form a different interlace pattern, more like a figure-of-eight, and those in the left-hand panel are distinguished by their gaping jaws, whereas the other panels have beasts with closed jaws. Even here, one of these fierce beasts is toothless, lacking the sharp canine teeth of its mates, while, as if to compensate, one of the beasts in the lower right-hand panel bares its pointed teeth. Likewise, in the lower thin panel there are two interlaced quadrupeds, while in the upper panel there are four.[147]

The stepped corner-pieces which extend from the outermost purple border of the design (which also has a green inner frame) contain two interlaced birds each, but these occupy the space in two different fashions: those in the bottom corner-pieces grasping their feet, while those in the upper corner-pieces rest their beaks on the frame.

The one element which does maintain a constant duplication is the mount to the outside of the frame. Four of these occur, at the centre of each side of the panel of ornament, and consist of yellow 'horned' interlaced motifs with two dog-headed terminals and a central surmounting yellow orb. These resemble the mounts occasionally found on contemporary Hiberno-Saxon metalwork and serve to suggest the presence of a third cross, underlying the main carpet panel. In the Book of Kells such motifs would be replaced, on appropriate occasion, by the head, hands and feet of the crucified Christ (f. 291v, the St John miniature; see pl. 32d).

Description of the John carpet page, f. 210v

This ambitious design conceals a complex cross motif which is mystically encrypted within the wealth of ornament (see pl. 20). The equal-armed Greek cross has been exploded to form a central cross, the ends of its arms detached to form four tau-headed crosses, all composed of fine yellow interlaced patterns on black grounds contained within orange frames. This entablature is completed by four corner-angles similarly framed in orange but containing Celtic La Tène trumpet-spiralwork. Between these and the tau crosses are set four small square panels, framed in orange, each containing a Greek-key 'swastika' motif (an ancient emblem for life). Four further rectangular panels are contained within the angles of the cross and its panelled surround. These are likewise framed in orange and filled with yellow and orange key patterns on green grounds. As I have suggested with elements of the other carpet-pages, these four panels may have been intended to symbolise the evangelists, flanking Christ in the form of the Cross.

All these panels resemble metalwork plates infilled with filigree and enamelwork. The colour balance of this page is particularly sophisticated and superbly reflects that of the equally complex facing incipit page. The panels are set upon a ground consisting of a lively, writhing interlace of enmeshed bird forms. The rhythm of their contortions is masterly and they are differentiated by the enamel-like patterning of their wing feathers, set off to advantage by the black ground. Some have alternately coloured bands of plumage, others have individually coloured feathers in parti-coloured patterns. The complex interlacing appears symmetrical, but as one penetrates the detail the free-hand nature of the interpretation of the design becomes apparent. The bird-heads bite onto different components of their mates, seldom mirroring the posture of their counterparts. The bird at the centre of the lowest band of the design has an elegant blank vellum spiral detail to its plumage, while one of its mates, to the right of the upper left-hand rectangular key panel, stands out because its feathers are not drawn, leaving it clad in a simple striped wing. This may have been an oversight or may have been deliberate, designed to challenge the apparent symmetry of the design or to convey a deeper meaning. Janet Backhouse suggested that such 'imperfections' may have been included as a gesture of humility acknowledging that only the Lord is perfect.[148] Such a philosophy is attested in later Islamic societies and cannot be ruled out here, although it should be noted that other passages in the decoration of the Lindisfarne Gospels ascribed a similar character are more likely to be unfinished than intentional. Another possibility is that this detail serves to draw attention to the fact that the mass of Creation, symbolised in contemporary iconography by birds and beasts inhabiting the eucharistic vine-scroll or Tree of Life, is composed of mutually interdependent individuals.

The whole design is contained within a double-banded orange frame with stepped corner-pieces filled with fretwork patterns. The outer angles of these terminate in beast-heads viewed from above ('in plan'). They have rounded muzzles and curling yellow ears

or horns, reminiscent of Iron Age Celtic depictions of bull or calf-heads.[149] A reference to the symbol of St Luke may have been intended. At the centre of each side of the frame, emphasising the cardinal points of the main cross, and perhaps linking its form with that of the 'four corners of the earth', are pairs of dog or lion heads, terminating horned interlace designs and surmounted by a central orb, those at head and foot painted green and those at the sides left as blank vellum. As in the other carpet-pages a scriptural reference to Christ, in the form of the *crux gemmata* (signified by the overt metalwork analogies of the design), recognised between two beasts may have been intended.

The Gospel incipit pages and the Chi-rho page

The display script of the Lindisfarne Gospels, and its significance, has been discussed in the consideration of its palaeography in chapter four, above. Suffice it to repeat here that it raises interesting implications for the perception of script as a cultural indicator, the inclusion of Roman, Runic and Greek stylistic features and/or letter-forms serving, along with the mixture of diverse ornamental motifs, to convey a sense of multi-culturalism and multi-ethnic participation in the transmission and reception of the Word.

The relationship of the display script with the contemporary epigraphic context is a considerable factor in identifying Lindisfarne as the place with the most '*in situ*' artefacts which provide a context for the making of the Lindisfarne Gospels, with its inscribed wooden coffin made to contain St Cuthbert's relics at the time of the translation in 698 and its range of funerary name-stones with their bilingual inscriptions in Roman capitals or half-uncials (seen especially on the 'Beanna' stone, Lindisfarne Priory Museum, see figs 9, 91, 'Beanna' top left) and angular runic forms which find their closest counterparts in the Lindisfarne Gospels.[150] Gerald Bonner and John Higgitt have highlighted the similarity between the Roman and runic lettering on the Ruthwell Cross and the display script of the Lindisfarne Gospels, whilst Rosemary Cramp has proposed that Ruthwell's approach to the combination of word and image may have been influenced by the practices of the Lindisfarne 'scriptorium' (or, more precisely, by those of the artist-scribe of the Lindisfarne Gospels and the maker(s) of the Durham Gospels).[151]

It has also been noted, in the discussion of the text and of the programme of textual articulation in chapter four, above, that the incipit pages not only occupy the highest place in the hierarchy of initials which serve to identify text breaks throughout the volume, but that the Chi-rho page additionally serves to mark an ancient Christmas lection and that its curious 'c' of 'Cum esset' is left as blank vellum surrounded by red dots in order to mark decoratively another lection of more modern Roman use.[152]

The scale of the major initials and the way in which the display script has grown to fill the whole page in a formal, framed composition represents an important conceptual advance, probably indebted to the tradition of Roman inscriptions, moving beyond the

more fluid, unframed display script of the Hiberno-Saxon tradition as seen in Durham MS A.II.10, the Book of Durrow and the Durham and Echternach Gospels (see pls 27, 29, 30), although the earlier tradition continued to exert an influence in Ireland and in Insular centres on the Continent. The scale of the display script and the amount of the page that it occupies also grows throughout this sequence of books until it reaches the full-page treatment of the Lindisfarne Gospels. This is perpetuated in subsequent Insular books, where the number of words included diminishes as the amount of decoration increases, notably the Lichfield Gospels and the Book of Kells (see pls 28 and 32a). These volumes go on to perpetuate and develop the Lindisfarne Gospels' distinctive approach; Kells extends the marking of lections to include more major initials and display panels at key points in its text and even elaborates on some of them with its inclusion of full-page miniatures, such as that of the Temptation of Christ.[153]

Description of the Matthew incipit page, f. 27r
Transcription:

> *(Chi-rho symbol) Ih(esu)s (Christus). Matheus homo*
> *Incipit euangelii genelogia mathei*
> Liber
> generati-
> onis ih(es)u
> (christi) filii david filii abraham

> (*Christ. Jesus Christ. Matthew the man.*
> *Beginning of the Genealogy in Matthew's Gospel.*
> A record [or 'the book'] of the genealogy of Jesus Christ, the son of David, the son of Abraham …)[154]

Matthew's Gospel is introduced by a rubric in stately half-uncials penned in powdered gold ink, in which the symbol of Christ, the Chi-rho (the opening letters of his name in Greek), is linked to the name of the evangelist and to that of his symbol, the 'man' (see pl. 11). This is followed by a rubric in red introducing the Genealogy of Christ which opens the Gospel. The number of the passage, its correspondents and the appropriate Canon Table are written in the inner margin adjacent to the 'L'.

The opening word of the Gospel is introduced by a large monogram composed of the major initials 'Lib' which occupy about a third of the page. The letters are contained in an outer frame of yellow, resembling a golden metalwork entablature, filled with colourful panels of knotwork and interlaced birds and beasts, the bow of the 'b' and the head and feet of the letters adorned with panels of Celtic La Tène spiralwork, featuring swirling purple circles and trumpet and pelta motifs. The whole effect is one of chip-carved filigree and enamelwork set within a metal framework. The panels which form the bodies of the letters are filled with blue and orange interlace, which gives them cohesion, interspersed

with panels occupied by pairs of quadrupeds, single dogs grasping birds, a tiny bird squeezed into the tail of the 'b' and four substantial birds enmeshed at the crossing of the 'L' and 'I'. Some small areas of the design are covered with gold leaf: a small triangle at the centre of the mount at the head of the 'b' and tiny circles in the head and foot mounts of the 'L' and 'I'. Other similar areas of blank vellum may also have been intended to receive them, as the gilding process seems not to have been completed.

The remainder of the first line of display script is occupied by an 'ER' in blank vellum outlined in heavy black and with bird-headed terminals at their feet, set against a ground of fine linear single-strand interlace on a multi-coloured ground, with four beast and one bird-headed terminal. The small circle of ink at the head of this panel is rather rough and may have been repaired by a later reader, perhaps Aldred. The monogram is outlined with a double row of red dots which extend to frame the following lines of display script and to from a diapered ground to the second and third lines, resembling chased metalwork such as the Irish Ardagh Chalice and the Pictish St Ninian's Isle bowls (see figs 97, 98).[155]

The remaining display script diminishes elegantly in scale (a feature termed 'diminuendo') and takes the form of square capital and uncial letter-forms, with additional angularity reminiscent of Germanic runic script, and featuring on the final line a number of carefully designed monograms and ligatures. The 'h' and 'p' have hooked serifs drawn from Greek epigraphy, the Greek form of the sacred name 'Christi' is used and on the final line a Greek form of 'f', in ligature with an 'i' as an exotic, cosmopolitan feature.[156] The letters are executed with striking black bodies, some with zoomorphic terminals and surmounted by Celtic scrollwork, and they are filled with bright colours, recalling stained glass of the sort excavated at Jarrow (see fig. 87).

The display panels are framed by two rectilinear bar borders and by a panel of ornament to the left of the descending component of the monogram, shaped to its contours. This panel is framed in knotwork and filled with two interlaced quadrupeds and a tiny single bird. It has a beast-headed terminal, a deer-like creature with long ears. Zoomorphic terminals are likewise used to terminate the bar borders, that at the top having two horns or lappets, perhaps a calf or bull, and that at the foot being a muzzled beast, perhaps a dog or lion, with a single lappet. There may be some allusion intended here to the evangelist symbols and the harmony of the Gospels (see the John incipit, f. 211r). The border on the right is filled with orange and blue knotwork, linking it visually with the monogram, interrupted by panels occupied by a single backwards facing quadruped and by two birds and beasts. The lower border contains a solemn procession of quadrupeds, interlaced but retaining substantial bodies – a less stylised version of the substantial zoomorphic interlace of the Book of Durrow and earlier forms of Germanic zoomorphic interlace (see pl. 31 and fig. 145).

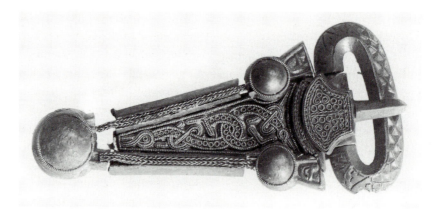

Fig. 145. The Faversham buckle (BM, MME 1097'70, Gibbs Collection), Anglo-Saxon,
early 7th century, showing Salin's Style II animal interlace. (Photo: courtesy of the
Trustees of the British Museum)

Description of the Chi-Rho page, f. 29r
Transcription:

> *Incipit euangelium secundum mattheu(m)*
> (Christi)
> autem gene-
> ratio sic erat cum
> esset desponsata
> mater eius maria ioseph

> (*Beginning of the Gospel according to Matthew.*
> This is how the birth of Jesus Christ came about. His mother Mary was pledged to be married
> to Joseph …)

The great Chi-rho page marks the conclusion of the genealogy of Christ and the
beginning of the passage relating the Christmas story in Matthew's Gospel (see pl. 12). It
is introduced by a red rubric, 'Incipit euangelium secundum mattheu(m)'. The number of
the section, its correspondents and Canon Table number are given in the margin, adjacent
to the head of the first initial.

The upper half of the page is dominated by the the major initials 'XPI', the abbreviated
form of 'Christi', conveyed in Greek characters, the two first letters forming the distinctive
'Chi-rho' (the names of the letters in Greek) which had become an early Christian symbol
for the sacred name. This is one of the most exuberant and masterly pieces of design in the
whole volume. Celtic and Germanic forms of decoration merge in an integrated crescendo
of ornament contained within the contours of these ancient Mediterranean letter-forms.
The 'X' is filled with a writhing, complex mass of enmeshed birds and beasts, forming a
colourful filigree which gives way to a more static, but similarly complicated interlace of

334

alternating double and single knotwork strands. The 'P' terminates at its foot in a lappeted dog or lion head which rests its muzzle upon the base-line of the following row of display script. The interstices of these major initials are filled with a vortex of whirling purple wheels and by spiralwork formed of trumpet and pelta motifs. The heads and left-hand foot of the strokes of the 'X' are adorned with curvilinear mounts filled with Celtic La Tène ornament, that at the top right serving as the abbreviation bar. Behind the crossing of the strokes at the centre of the 'X' are three triangular panels of similar ornament with pelta terminals, which might almost be read as a star lying behind the letter, perhaps an allusion to the star which announced Christ's birth.

The opening initials are surrounded by a double row of red dots. These extend to form the second line of display script, where single rows of red dots not only form the head and base-lines and outline the letters, as they do on subsequent lines, but give substance to the capital letters themselves which are otherwise only articulated by faint, rather rough lines of ink. Several ligatures and monograms feature in this line, the 'EM', 'GE' and 'NE'. The 'G' has the outline of a bird-headed terminal. The manner in which the ink lines are almost hesitantly executed and the way in which some parts of the letter contours are given only in the pale ink and not conveyed by dots, would strongly suggest that the ink represents under-drawing, rather than the finished effect, as does the second line of the Luke 'Quoniam' incipit on f. 139r (see pl. 21). The use of stippling to articulate letter-forms against a plain vellum ground is a pleasing one and is reminiscent of chased metalwork, such as the inscriptions on the near-contemporary Irish Ardagh chalice (see fig. 97). However, if the letters were to be left blank it is likely that their contours would still have received further definition in darker black ink, as in the 'er' of 'Liber' on f. 27r. The letters might then have been given a pale colour wash, as in the top three lines of the Mark 'Initium' incipit on f. 95r. Alternatively, if less likely aesthetically, might they have been intended to receive gilding? This would have produced gilded capitals of the sort favoured in subsequent eighth-century Southumbrian manuscripts, such as the Vespasian Psalter and the Stockholm Codex Aureus (see figs 40, 153), or the fragment of a Gospels from Wearmouth/Jarrow, now bound into the Utrecht Psalter.[157] The small blank vellum circles incorporated into the 'Chi-rho' design, notably that at the centre of the bow of 'P', certainly seem to invite the delicate gilded highlights found in the 'Liber' on f. 27r, suggesting that the programme of gilding was not completed.

The remaining three lines of display script feature Roman square capital and uncial letter-forms, many given an additional angularity recalling runic stylistic features. These are painted black and filled with bright colours, reminiscent of stained glass (see fig. 87). Purple features here and in the 'Chi-rho', the symbolism of this luxurious pigment being appropriate to the narration of the coming of the King of kings. The inner contours of some letters are adorned with pelta or key patterns, an 'R' on the final line has a bird-headed terminal, and hooked serifs are applied to the 'p's, in Greek epigraphic fashion,

giving them a second bow. Most striking of all is the 'c' of 'cum' on the third line, which has been left as blank vellum outlined with red dots, as on the preceding line. As we have seen, this letter was distinguished to mark the Roman lection for the Vigil of the Nativity, as it marks the beginning of the narrative proper of the events surrounding the birth of Christ.

The display script is framed at the foot and on the right by two bar borders, the contours of which echo those of the letters within. They are filled with interlaced patterns of birds and one quadruped (shown biting a bird's leg, just below the bow of the 'P' of the 'Chi-rho'). Each border has a zoomorphic terminal at its head, that at the top a muzzled beast with either double lappets or horns, perhaps a calf, and that terminating the lower border taking the form of a bird head, perhaps an eagle. As elsewhere in the volume, such as the John incipit page (f. 211r), these may represent a conscious allusion to the evangelist symbols and the harmony of the Gospels.

Description of the Mark incipit page, f. 95r
Transcription:

> *Incipit euangelium secundum marcum:*
> *Marcus leo*
> Initium
> euan-
> gelii ih(es)u
> (christi) fili d(e)i sicut
> scribtum [sic] est
> in esaia propheta

> (*Beginning of the Gospel according to Mark:*
> *Mark the lion*
> The beginning of the Gospel about Jesus Christ, the Son of God. It is written in Isaiah the prophet …)

The text is introduced by a rubric in powdered gold ink naming the evangelist and his symbol 'Marcus leo' (see pl. 17). Its placing, inserted as syllables between the components of the major initial and the upper border, along with the absence of an introductory cross or Chi-rho and of any terminating punctuation, would tend to suggest that it was inserted after the rest of the page was completed and with somewhat less care than the corresponding golden rubrics of the other Gospel incipits. The red rubric introducing Mark's Gospel stands at the head of the page, rather than beneath its golden counterpart as elsewhere. The relevant chapter and Canon Table numbers are written in the inner margin adjacent to the top of the monogram.

The page is dominated by a monogram consisting of the major decorated initials 'INI', the two 'I's fused to the upright minims of the 'N', which has an angular cross-stroke with

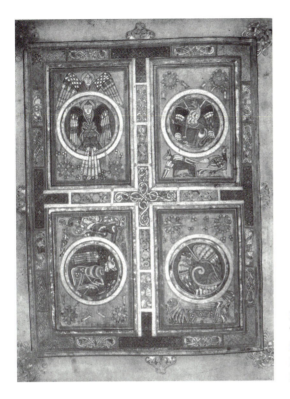

Fig. 146. The Book of Kells (Dublin, Trinity College Library, MS 58), f. 129v, four symbols cross-carpet page in St Mark's Gospel. (Photo: courtesy of the Board of Trinity College Dublin)

a curious bar across it. This angularity is in keeping with that of the square capitals with their angular rune-like adaptations which feature in the display script of the volume. The monogram is outlined in black, with an entablature of yellow inset with panels of fretwork, fine single interlace in orange and blue and zoomorphic interlace. Three of the panels contain interlaced 'dogs' whilst one (that at the foot of the first 'I') is occupied by a hound entwined with two birds and another (that at the foot of the second 'I') by a single dog and bird. The head and feet of the minims culminate in elaborate terminals of Celtic spiraliform ornament, with pelta and trumpet motifs and dominated by two swirling circles apiece. These exuberant patterns terminate in volutes or 'horns' and there is a vestigial recollection of the use of such terminals in Iron Age Celtic art to imply simultaneously the depiction of a calf or bull's head seen from above (i.e. 'in plan'). The analogies with both Celtic and Germanic metalwork are striking.

The monogram is followed by six lines of display script of diminishing scale ('diminuendo'). The top line is occupied by a 'T' with an additional angled foot, an 'I' and a 'U' which forms a monogram with an 'M' consisting of three horizontal bars crossing the final minim of the 'U', in a manner reminiscent of Celtic 'ogam' script in which horizontal and diagonal lines relate to a vertical base-line, this originating as a pre-Christian response by an orally based Irish culture to the Latin alphabet.[158] On the second

337

line are uncial letters, the 'e' terminating in two bird-heads and the thorn-like 'A' entering into ligature with the 'N'. On the third line, again in uncials, the 'e' has a single bird-headed terminal, the tailed 'G' is of the sort favoured in the uncial script of Wearmouth/Jarrow, and the ascender of the 'h' has a hooked serif which may be intended to represent an abbreviation symbol (a more conventional horizontal bar has been added by a later hand, perhaps that of Aldred, above the line), or which, by analogy with the 'h' on the final line, was a purely stylistic convention probably intended to recall Greek inscriptions. The letters of these three lines are filled with pale washes of colour, interrupted in those on the first line, by interlace breaks resembling the coupling links of metal chainwork.

The remaining lines of display script consist of heavy black angular capitals and uncials, the letter-bows filled with vibrant colours. In the bow of the 'd' on the fourth line is the only example of an area in the manuscript which may have been painted in two layers of pigment (see fig. 117), blue with a purple glaze, foreshadowing the technically ambitious painting technique of the Book of Kells. The 'p's, 'b' and 'h' all have additonal hooked serifs, reminiscent of Greek epigraphy. There is an interesting orthographical substitution of 'b' for 'p' in 'scriptum'.

The major monogram is outlined with double rows of red dots, which extend to form a decorative background and linear framework for the display script. The dots form interlaced patterns, as well as diapered grounds, and in the area beneath the cross-stroke of the major initial 'N' they form two elegant interlaced quadrupeds, in a manner highly reminiscent of the punched zoomorphic designs on the Pictish St Ninian's Isle bowls (see fig. 98).[159]

The design is completed and formalised by a bar border which frames the top, right-hand side and bottom of the area of display script. This is filled with panels of interlace and of key patterns and the blue rims terminate in four beast heads. Those at the top are a roaring 'dog', or perhaps a lion, and a bird. There is another 'dog' or lion terminal at the foot and a placid beast head which may be another canine, or perhaps a calf. There may be an intentional interplay here between the evangelist symbols, emphasising their inter-relationships in a fashion more overtly apparent in the Book of Kells and the Book of Armagh (see pl. 32 and fig. 93).[160]

Description of the Luke incipit page, f. 139r
Transcription:

> *(Chi-rho symbol) lucas uitulus:*
> *Incipit euangelium secundum lucam:*
> Quo-
> niam
> quidem
> multi cona-

ti sunt ordina-
re narrationem

(*Christ. Luke the calf:*
Beginning of the Gospel according to Luke:
Many have undertaken to draw up an account …)

Luke's Gospel is introduced by a rubric penned in powdered gold ink which links the sacred name of Christ, expressed by the Chi-rho symbol (the first two letters of 'Christus' in Greek, an 'x' and a 'p'), with the name of the evangelist Luke and of his symbol, the calf (see pl. 21). This serves to reinforce the complex symbolism of the evangelist miniature which simultaneously depicts the evangelist as a human author, as a zoomorphic symbol conveying the individual character of each Gospel, and as a 'type' of Christ.

There then follows a rubric in red ink stating that this is the incipit of the Gospel according to Luke. Both this and the golden rubric are written in stately half-uncials of the same type as the main text script. The chapter number, Eusebian section and the Canon Table number appropriate to this passage are written in the inner margin beside the head of the initial 'q'.

The text proper opens with a major decorated initial 'q' which occupies almost half the ornamental space. The body of the 'q' is emphasised by a heavy black outline and is divided into compartments by a band of yellow. The resulting effect is highly reminiscent, and probably intentionally so, of the entablatures (structural frames, as might be applied, for example, to the rim of a paten dish or the cover of a book-shrine, see figs 79, 139) of contemporary Hiberno-Saxon metalwork, into which would be set panels of intricate gold filigree or enamelwork. The manuscript's golden frames are filled with equally complex and delicate interlaced patterns, four of which feature the distinctive Lindisfarne birds and 'dogs'. The panel at the foot of the descender of the 'q' is filled with two birds whose hooked beaks grasp each other's enormous talons. Their sinuous necks each take the form of fine paired interlaced strands and the counterpoint of the design is highlighted by the alternation in the colours of their bodies: one with an orange wing and blue body and the other with a blue wing and orange body. Above this is a small square panel occupied by a cruciform, wheel-headed interlaced pattern with a small cross at its heart, set against a black ground and resembling filigree or niello work. Above this is a panel in which two lacertine lappeted quadrupeds are entwined in a figure-of-eight. There follows a small square panel of fretwork on a black ground which balances that with the cross below. Above this is a panel of two pairs of opposed birds, in almost heraldic fashion, their talons and lappets plaited together. The bow of the 'q' takes the form of a voluted scroll, resembling a 'C' whose ends meet in spiraliform terminals, rather like a pelta motif. The letter-stroke is composed of three panels, two filled with interlace consisting of fine two-strand orange sections alternating with thicker blue single strand sections. The ends of the orange sections closest to the volutes are expanded and resemble the ends of metalwork

chains. The third panel is occupied by two quadrupeds who seize two affrighted birds who stare back at them in petrified disbelief. These predatory hounds have hip spirals, reminiscent of those commonly encountered in Pictish sculpture in Scotland. Placed slightly upwards of the centre of this panel, on the outer edge of the bow, is an interlaced terminal with two bird-headed terminals and a central surmounting green orb. This motif is once again reminiscent of contemporary metalwork. The space formed at the point at which the volutes of the bow meet is filled with an interlaced triquetra motif on a black ground. The interior of the bow of 'q' is filled with a swirling vortex of Ultimate La Tène ornament, featuring trumpet spirals, pelta motifs and six lilac disks containing trumpet spirals. Four triangular shapes are left as the background to this patterning. One is gilded with gold leaf, set on a flat ground of gum. The other three are left as blank vellum. Some symbolism may have been intended here: the Three in One of the Trinity; the four evangelists? The vellum spaces may have been left intentionally so, or, as elsewhere, it may be that all four were supposed to be gilded, but that the process was left incomplete at the end of the creative campaign. These Celtic designs are balanced by a head and tailpiece to the descender of the 'q', the riot of spiralwork forming flamboyant cusped, curvilinear waves of pure ornament which break onto the vellum, like the motion of the seas.

The 'q' is outlined by two rows of red dots, in late Antique fashion, and these dots multiply to form a stippled background to the succeeding lines of display script, resembling the chased metalwork background to the inscriptions on the near-contemporary Irish Ardagh chalice (see fig. 97). The first line of display script consists of a 'u' and 'o'. The body of the 'u' is filled with two quadrupeds, who contemplate eachother in their shared frustration as they claw against the confines of the letter-form and are restrained from pouncing upon the four interlaced birds who smugly inhabit the central letter-space. The striking yellow 'o' contains a fill of blue and orange step patterns, highly reminiscent of Germanic metalwork, with its garnet and millefiori glass inlays, such as that found at Sutton Hoo.[161] The letters are joined together by fine linear interlaced link-pieces. As so often in the ornament of the Lindisfarne Gospels, a note of asymmetry is introduced by a diamond-shaped panel of interlace at the head of the 'o', rather than the volutes of interlace at its foot and sides. The second line of display script is composed of capital letters simply outlined in pale ink and left as blank vellum offset against the stippled ground (again, in the manner of the Ardagh chalice inscriptions). The effect is striking, but perhaps unintentional, for as in the 'Chi-rho' page (f. 29r) the ink lines of the letters' outlines are somewhat rough and appear unfinished. Perhaps they were intended to be reinforced in a darker black ink, as in the 'er' of the Matthew incipit 'Liber' (f. 27r), or filled with a pale colour wash and ink interlace, as in the first three lines of display script in the Mark incipit (f. 95r), or perhaps even gilded?

The remaining lines of display script continue to diminish in scale ('diminuendo'). They mix Roman square capital, angular runic and uncial letter-forms, all drawn in heavy

black pigment, some with cusped surrounding lines to their bows, and filled with bright colours.

The form and formality of the page is emphasised by the border surrounding the letters. The area beneath the bow of the 'q' and to the left of its descender is filled with one of the most complex passages of ornament in the volume. A subtle weave of interlaced bird forms, single, paired, or in groups of four, is woven into the unusually shaped panel, articulated by a delicate counterpoint of pale colours in which purple, blue, yellow and orange predominate, and in which areas left as blank vellum or coloured black as a background are equally important to the overall effect. This calls to mind an opulent, fine eastern silk fabric, of the sort that St Cuthbert's body was reverently wrapped in at various stages in the early, and subsequent, development of his cult.[162] At the foot of the page the birds squeeze out of this panel into a bordered frieze in which they play 'follow-my-leader' across the page, each biting onto the foot and tail of its predecessor (see fig. 85). They seem oblivious to the danger which awaits them at the right-hand border of the page, the foot of which takes the form of a vigilant cat, ready to pounce. Its head and paw are surprisingly naturalistic in their details – it even has fine whiskers – calling to mind the affectionate references to feline companions in early Irish verse, such as Pangur bán, the pet of a ninth-century Irish poet-scribe, who chased mice as his master chased wisdom across the page.[163] The cat's body takes the form of the bar-border which extends up the page, culminating in its hindquarters at the head of the page. The humour is heightened by the fact that this body/border is full of a similar frieze of birds (although again the symmetry is disrupted by the way in which the birds face in different directions, alternately) which appear to have meekly followed one another into the cat's awaiting stomach. This passage must surely have appeared as funny at the time it was made as it does now, but a darker meaning would probably also have sprung instantly to mind: the ever-present threat of evil, waiting to pounce upon the unwary! This was a theme often explored in Scripture and exegesis, and the cat had a long history of ambivalent symbolism, capable of being imbued with both good and bad meaning.[164]

Description of the John incipit page, f. 211r
Transcription:

> *(Cross) Iohannis aquila:*
> *Incipit euangelium secundum Iohan(nem).*
> IN Prin-
> cipio
> erat uerbum
> et uerbum erat
> apud d(eu)m et d(eu)s

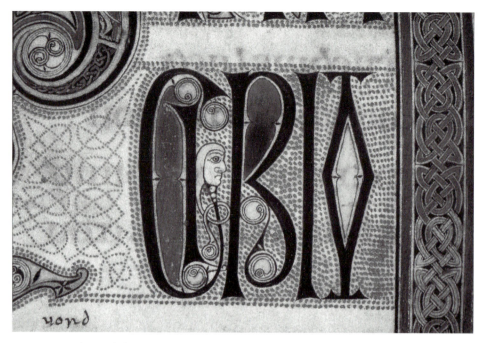

Fig. 147. The Lindisfarne Gospels (BL, Cotton MS Nero D.iv), f. 211r, human-headed initial from the John incipit page, perhaps representing St Matthew's evangelist symbol.

(John the eagle:
Beginning of the Gospel according to John.
In the beginning was the Word, and the Word was with God, and [the Word] was God.)

John's Gospel is introduced by a rubric in powdered golden ink linking a cross, the name of the evangelist 'Iohannis' and of his symbol, the eagle, 'aquila' followed by a 'versus' punctuation symbol, resembling a semicolon (see pl. 25). Beneath this is a red rubric introducing the text 'Incipit euangelium secundum Iohan(nem)'.

The page is dominated by a splendid 'INP' monogram of major decorated initials, occupying about a third of the overall design. It resembles the 'INI' monogram of the incipit of Mark's Gospel and the initials likewise terminate in cusped metalwork mount-like terminals filled with Celtic La Tène ornament with trumpet and pelta motifs and interlaced birds and beasts, dominated by pairs of lilac circles filled with swirling spiral-work. Those at the feet of the initials incorporate small disks of blank vellum which look as if they may have been intended to receive gilding, as in the 'Liber' incipit on f. 27r. The fill of the bodies of the initials is amongst the most complex ornamental passages in the book and complements the complexity and delicate colour balancing of the facing carpet-page. Panels filled with fine linear interlace alternate with those filled with paired or single

342

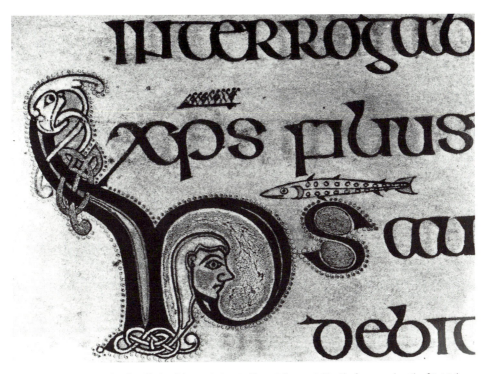

Fig. 148. The Book of Kells (Dublin, Trinity College Library, MS 58), f. 179v, detail of initial,
Ih(esu)s, with human-headed terminal, lion and fish/abbreviation bar.
(Photo: courtesy of the Board of Trinity College Dublin)

birds or quadrupeds. Three large diamond-shaped bosses, filled with step-patterns painted in an unnerving but effective combination of blue and orange, serve to bind the initials together, like ornamental metalwork rivet-heads or cloisonné studs. The cross-stroke of the 'N' assumes a striking angular dog-legged form. Small pelta-shaped mounts alleviate its severity at its head and foot. Its angles are filled with pairs of interlaced quadrupeds. The 'P' has the hooked serif below its bow, borrowed from Greek epigraphy. Its bows are filled with a contorted quadruped and an interlaced triquetra.

The following display script takes the form of capital and uncial letter-forms with heavy black bodies with brightly coloured infills resembling stained glass. Those on the top line have interlaced background panels set upon grounds of red dots, which also surround the monogram and form interlaced backgrounds and borders to the other lines of display script. Many of the letters have spiral, interlace or bird-headed terminals. The 'c' on the second line has an anthropomorphic terminal in the form of a blonde-haired clean-shaven male head in profile (see fig. 147). This is the only occurrence of a human depiction in the volume, other than the evangelist miniatures. It foreshadows the extensive use of human decoration in the Book of Kells (see fig. 148), and in some other Insular books (the

343

Fig. 149. The Book of Cerne (Cambridge, University Library, MS Ll.1.10), f. 91v, detail showing human-headed initial from the Breviate Psalter, Mercian, c.820–40. (Photo: courtesy of the Syndics of Cambridge University Library)

Mercian Book of Cerne, for example, contains a human-headed initial, see fig. 149, and the Barberini Gospels have anthropomorphic line-fillers).[165] This little figure may simply be an extension of the decorative repertoire, or it may have been imbued with some significance. I have suggested that some of the zoomorphic details elsewhere in the volume may allude to the evangelist symbols, and this may be the sole occurrence, outside the Matthew evangelist miniature, of the symbol of Matthew, the Man. If so, the bird-heads of the display script may represent John's eagle. The bi-partite interlace-filled bar border which frames the display script also has two beast-headed terminals, which are somewhat indeterminate but which might conceivably symbolise Mark's lion and/or Luke's calf. If such an iconography were intended it would emphasise the harmony of the Gospels, a theme explored extensively in the decorative programmes of Insular Gospelbooks, and notably in the Book of Durrow (with its four symbols page), the Book of Kells (not only in its four symbols pages but in the animal heads which act as finials to the throne in its Matthew miniature, f. 28v, and which flank the cushion, which are obviously intended to represent the three other evangelist symbols), the Book of Armagh and in a prayerbook, the Book of Cerne (see fig. 150).[166]

344

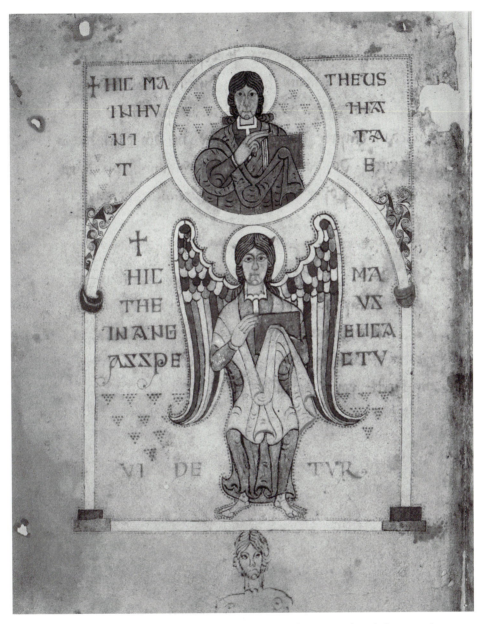

Fig. 150. The Book of Cerne (Cambridge, University Library, MS Ll.1.10), f. 2v, Matthew
miniature, Mercian, c.820–40. The relationships between the symbolic and human guises of
the evangelists are explored in the accompanying inscriptions, which have exegetical contexts.
(Photo: courtesy of the Syndics of Cambridge University Library)

The evangelist miniatures

The Early Christian context and its reception in Insular manuscripts

The perpetual quest for multi-layered meaning, for penetration of spiritual mysteries and their symbolic representation, is a prominent feature in the Insular tradition. It is grounded within the world of late Antiquity and the Apostolic tradition of early Christianity and, in the post-Roman West, paved the transition to a new theocratic scholasticism and structured faith which heralded the Middle Ages. Recent scholarship is revealing some of the complexities of visual reading of Insular monuments in whatever medium, grounded within a ruminative approach within which meditation gradually penetrated the layers of meaning with which individual iconographic elements and their combinations could be imbued.[167] Bede was but one advocate of *ruminatio* as a worthy spiritual discipline and, in his own commentaries on Scripture, built upon a tradition of exploration and explanation of symbolism which he had inherited from Church Fathers such as Augustine and Gregory the Great. Dom Jean Leclercq has characterised the monastic reading of a biblical text as being 'like a meditative prayer' in which the reader 'weighs all of its words to sound the depth of their full meaning' so that 'each word is like a hook, so to speak; it catches hold of one or several others which become linked together and make up the fabric of the exposé'.[168] The same can justifiably be said of visual symbolism.

The tradition of symbolic representation of the evangelists, which came to be that commonly employed in medieval art (after some initial variations favoured by commentators such as Iranaeus and Augustine), in which Matthew is represented by the man, Mark by the lion, Luke by the calf or bull, and John by the eagle stems ultimately from two key biblical passages: the Vision of Ezekiel (Ezekiel chs 1 and 10) and the Apocalypse or Book of Revelation (ch. 4). St Ambrose, in the prologue to his *Expositio Evangelii secundum Lucam*, characterised these symbols as worthy vehicles of meditation, representing different aspects of Christ's being: Matthew – Christ Incarnate; Mark – the King of kings who triumphed over death; Luke – the immolatory victim and high priest of the Passion; John – the triumphant Christ of the Resurrection and Ascension.[169] Gregory the Great expanded this to extend the symbolism to the Just and their aspiration to emulate the virtues of Christ.[170] Bede went on to refer to these metaphors of the nature of Christ in his *Explanatio Apocalypsis* Book I, ch. iv and his *De Tabernaculo*, Book I, ch. 4, where Matthew and Luke are seen as representing the human vulnerability of Christ, and Mark and John his victory.[171] Thus the evangelists serve as a vital link in the eternal chain of the Communion of Saints.[172]

In the Lindisfarne Gospels (see pls 8, 14, 18, 22) the relationship between the evangelists in their human guise and in their symbolic guise is made more explicit by the accompanying monumental inscriptions which stress the symbolism by labelling the man, the lion, the calf and the eagle as 'imago ...', the 'image of', and the human figures with the

evangelists' names, executed in Latin lettering in accordance with Greek formulae, laid out syllabically in accordance with Byzantine iconic practices ('Ó Agios Mattheus', etc.). The 'imago' formula can also be found accompanying the independent full-length evangelist symbols without attributes (nimbus, book or wings), known as 'terrestrial' symbols, in the Echternach Gospels and the Cambridge-London Gospels. In an early ninth-century Mercian prayerbook, the Book of Cerne (which also exhibits some influence, direct or otherwise, from the Lindisfarne and the Book of Kells in its initials and its display panels), the practice of inscribing evangelist miniatures is extended further to incorporate scriptural references in vocabulary which tie in with the exegetical interpretations of Gregory and Bede outlined above (see fig. 150).[173] The labelling of the evangelist scribes with their names is perpetuated, in purely Latin convention ('sanctus matheus evangelista', etc.) in the Barberini Gospels, a complex work, thought to date to the late eighth-century, which exhibits significant stylistic affinity with both the Northumbrian and Mercian traditions. The Trier Gospels from eighth-century Echternach and the early ninth-century Irish Book of Armagh simply label the evangelist symbols of their four-symbols pages with the terms 'homo', 'leo', 'uitulus' and 'aquila'. The former also gives the four evangelists' names ('Mattheus evang', etc.), to the quadrants of its Tetramorph page and inscribes its Matthew evangelist miniature with the legend 'imago sancti mathei evang' and its remaining miniatures with 'incipit evangelium secundum marcum', etc. Other Insular evangelist miniatures dispense with inscriptions altogether. This inscriptional tradition therefore seems to have been developed with an exegetical sophistication of allusion in the Lindisfarne Gospels and to have been reflected, in varying measure, on the Continent at Echternach, and in later Irish works and books from Mercia reflecting Northumbrian and Irish influence.

Whence did the artist of the Lindisfarne Gospels derive his complex approach to depicting the evangelists?[174] The practice of depicting the Gospel writers as authors was based upon the classical author portrait, which might be interpreted either as standing figures carrying books, as on the throne of Archbishop Maximian, Ravenna, or as seated figures holding their works, a type for which classical models existed, such as the Roman Calendar of Filocalus of 354 (Biblioteca Apostolica Vaticana, Barb. Lat. 2154, seventeenth-century copy). The latter type was imported into England during the early stages of conversion, in the pages of the Augustine Gospels (Cambridge, Corpus Christi College, MS 286, f. 129v, Luke miniature; see fig. 151) from sixth-century Italy, wherein St Luke meditates upon the words contained in the book he holds and is identified by a bust of his symbol, the calf, in the arch above. Such 'accompanied' portraits with half-length symbols also occur in the early fifth-century apse mosaics of Sta Pudenziana, Rome, in the Mausoleum of Galla Placidia, the Archbishop's Chapel and S. Apollinare in Classe, Ravenna. Busts of the Evangelists are balanced by those of their symbols, with a full complement of attributes (haloes, wings and Gospelbooks), on the fifth-century covers of

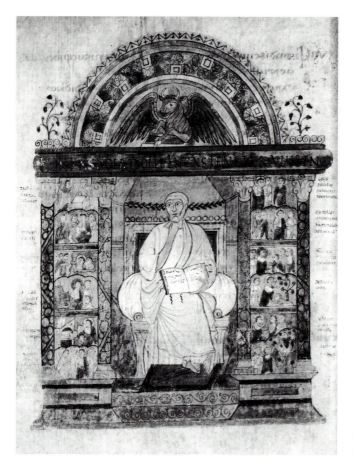

Fig. 151. The St Augustine Gospels (Cambridge, Corpus Christi College, MS 286), f. 129v, Luke miniature, Italy, late 6th century. This book was in England during the Insular period. (Photo: courtesy of the Master and Fellows of Corpus Christi College, Cambridge)

a Gospelbook preserved in the Treasury of Milan Cathedral (Inv. No. 1385), where they accompany scenes from the life of Christ (like the St Augustine Gospels) arranged around central plaques depicting the *agnus dei* and the *crux gemmata*, the latter unveiled by flanking curtains. The availability of such diverse early Christian models may help to account for the variety of approach apparent in the Insular depiction of the evangelists, sometimes even within the same book, but some aspects were perhaps Insular developments. Probably the earliest extant depictions, in the Book of Durrow and the Echternach Gospels, eschew author portraits and present the evangelists symbolically as full-length symbols without the 'attributes' of halo, wings and book. No earlier examples of such images survive, but their existence has been adduced from later manuscripts thought to have been copied from Early Christian sources, notably a sixteenth-century Persian copy of Tatian's Diatessaron (Florence, Bibl. Medicea-Laur., Orient. 81, f. 128v). Fusion of these types produced a 'mixed' type, full-length symbols with full or partial attributes, which may have been an Insular development (although their occurrence upon the seventh-century eastern

Mediterranean Grado throne would again suggest Mediterranean models).

The Cuthbert Coffin, made on Holy Island in 698, is incised with standing figures holding books and with full-length symbols with full sets of attributes, the name of each evangelist being inscribed above in angular display capitals (similar to those of the Lindisfarne Gospels) flanking Christ in Majesty (see fig. 29). The human and symbolic guises are shown together, accompanying one another, full-length, and again flanking a Maiesta, in the Codex Amiatinus (pre-716, f. 796v, see fig. 155), the author figures holding books, and the symbols winged but lacking other attributes. The core of this programme may be traced from at least as early as the sixth century in the apse mosaic of Osios David in Thessaloniki, depicting the vision of Ezekiel in the form of a youthful Christ seated within a mandorla and surrounded by half-length symbols with attributes.[175]

The Lindisfarne Gospels introduce a further development: accompanied portraits with mixed symbols, with the evangelists depicted not as authors but as scribes (except St John who holds a scroll without writing upon it, and who, as we shall see, also symbolically represents Christ in Majesty). There is a long-lived tradition of depicting the Gospel writers as scribes within Byzantine art, which may have been known this early (although their presence in the pre-iconoclastic period is adduced perforce from numerous later examples of the genre), but we may be witnessing in its pages the introduction to northern Europe of the iconography of the evangelist-scribe. In the discussion of the Matthew miniature, below, it will be suggested that the iconography was developed with reference to the miniature depicting Ezra the Scribe in the Codex Amiatinus (see fig. 30), the theme being adapted from a complete Bible to use in a Gospelbook and being designed to emphasise the role of the scribe (the evangelists themselves and subsequent scribal trans-mitters) in the transmission and reception of the Word of God.

The Lindisfarne evangelist-scribes thereby form a vital link between Christ himself, with the various guises of his ministry, the transmitters of his Word and his people. The symbolism is heightened by the use of inscriptions, by the conflation of the full-length terrestrial symbols with the accompanied type, by the iconographic distinctions of the introductory Matthew miniature, by (as we shall see) the depiction of the two evangelists equated with Christ's resurrection to immortality as youthful types (Mark and John) and the two 'mortal' evangelists (Matthew – incarnation; Luke – immolation) as ageing bearded types. As we shall also see, the incorporation of trumpets or scrolls, redolent of the Last Judgement, issuing from the mouths of the symbols of Matthew and Mark is another Insular innovation, perhaps designed to signify the connection between the Incarnation and the Resurrection of Christ. Variations in detail within the Lindisfarne evangelist miniatures may therefore be less the result of visual reference to several sources (although this undoubtedly occurred), than of conscious iconographic planning with reference to exegetical reading.

The evangelist miniatures thus form an important part of the Lindisfarne Gospels'

programme of illumination. They also occupy a central place in the discussion of the depiction of the Evangelists in the Insular world and shed valuable light upon how they may have been interpreted. The absence of any such component from Royal 1.B.vii and the St Petersburg Gospels would tend to suggest that there were no evangelist pages in the archetypal model for their, and the Lindisfarne Gospels', text. This assumption is further supported by the mixed, composite nature of the Lindisfarne Gospels' miniatures. Matthew and Mark are of the bearded Byzantine type, while Mark and John are of youthful, clean-shaven 'Roman' type. It is not unusual for John to be distinguished in this fashion, within the western tradition, as a means of emphasising both his identification with the young disciple beloved of his Lord, and in order to reinforce the exegetical equation of this non-synoptic Gospel writer with the Christ of the Last Judgement, for whom there was an early Christian iconographic tradition of depiction as a youthful type.[176] There is no such immediate explanation for the youthful Mark, unless it was to reinforce the analogy with his symbolic interpretation: that of the triumphant, risen Christ of the Resurrection. If such a meaning were intended, there would be an alignment between the two ageing, bearded types, representative of Christ incarnate (Matthew) and Christ the Paschal sacrifice (Luke), and the two youthful, immortal types of the resurrected Christ.[177]

The Early Christian traditions of visual representation of the evangelists, upon which the artist of the Lindisfarne Gospels drew, were grounded in a literal representation of biblical themes. Within the Insular world images which initially appear quite minimalist and decorative could be imbued with a complex symbolism, geared towards a well-read, exegetically versed element in the ecclesiastical establishment and to oral explication through preaching and formal teaching contexts, such as the ceremony of *apertio aurium* in the course of which the symbolism of the evangelists, the character of their Gospels and their Christological interpretation were explained to the adult cathechumen seeking entry to the Church.[178]

The place of the Lindisfarne evangelist miniatures within the Insular tradition

Accompanied evangelist miniatures, in which the Gospel authors are depicted as humans accompanied and identified by their symbols, occur in the Lindisfarne Gospels, the St Augustine Gospels (Cambridge Corpus Christi College MS 286), the Lichfield Gospels (Lichfield Cathedral, s.n.), the Trier Gospels (Trier, Cathedral Treasury, MS 61), the Harley Golden Gospels (BL, Harley MS 2788), the Rawlinson Gospels (Bodleian Lib., Rawlinson G.167), the Stockholm Codex Aureus (Stockholm, Kungl. Bibl., MS A.135), the St Gall Gospels (St Gall, MS 51), Perugia MSS 2 and 90, Abbeville MSS 4 (St Riquier Gospels, made at Charlemagne's Court School) and 49, Autun MSS 3 (Gundohinus Gospels) and 51, and the Cutbercht Gospels (Vienna, Österreichische Nationalbibl., MS 1224) (see pl. 28 and figs 151, 152, 153).[179] As we have seen, the Lindisfarne Gospels is the earliest surviving Insular volume to employ them, and to depict the evangelists as scribes. The extant evangelist

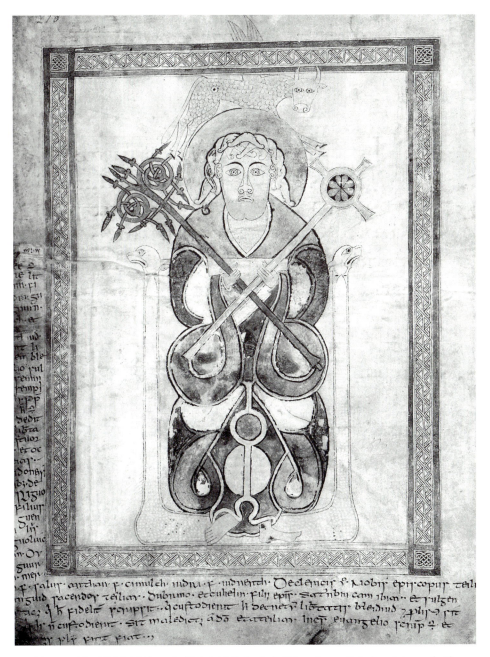

Fig. 152. The Lichfield Gospels (Lichfield Cathedral, MS s.n.), p. 218, Luke miniature (with mid-9th-century inscription recording its donation to Llandeilo Fawr in Wales), Northumbrian, mid-8th century. (Photo by kind permission of the Dean and Chapter of Lichfield Cathedral)

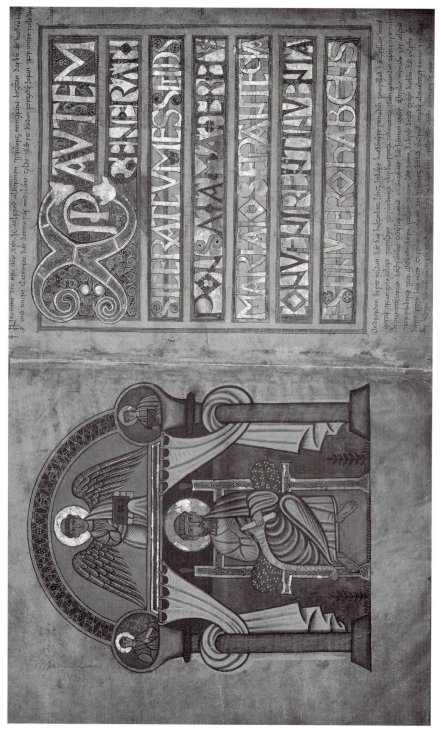

Fig. 153. The Stockholm Codex Aureus (Stockholm, Kungl. Biblioteket MS A.135), ff. 9v–11, Matthew miniature and incipit (with mid-9th-century inscription recording its ransom from Vikings and donation to Christ Church, Canterbury, Kent), mid-8th century. (Photo: Stockholm, Kungl. Biblioteket)

352

miniatures in what are commonly considered to be the other earliest Insular Gospelbooks, the Book of Durrow, the Echternach Gospels and the Cambridge-London Gospels, all consist of full-page terrestrial symbols (the evangelist symbols depicted as single beasts, or on one occasion in the Book of Durrow of all four symbols flanking the cross; see pls 30a, 30d, 31c and fig. 22). These lack the 'attributes' of their more sophisticated early Christian counterparts, also represented in the Lindisfarne Gospels, which carry Gospelbooks and are winged and nimbed. The Lindisfarne Gospels pick up on an early Christian convention of depicting the evangelists as human authors, sometimes identified by their symbols, as in the sixth-century Italian St Augustine Gospels (see fig. 151), and conflate them with the Insular full-length symbols imbued with the 'attributes' of their Mediterranean cousins. It is noteworthy that the form of inscriptions accompanying the symbols in the Lindisfarne Gospels takes the form 'imago ...' ('[symbolic] image of'), which was also applied to the terrestrial symbols of the Echternach Gospels (see pl. 30).

Another indication that the evangelist miniatures were compiled with reference to several visual sources, rather than copied directly from one model, is provided by the fact that only the symbols of the Man/Angel and the Lion have trumpets or scrolls issuing from their mouths.[180] The ambiguous form of these details may be intentional, perhaps intended to refer to a scriptural passage, such as Revelation/Apocalypse 1.10–11, 'On the Lord's Day I was in the Spirit, and I heard behind me a loud voice like a trumpet, which said, "Write on a scroll what you see and send it to the seven churches".' The inference would be that the evangelists were, like St John in his apocalyptic vision, inspired orally by the Holy Spirit to spread the Word in preparation for the Second Coming and Judgement. The closest stylistic analogy is a mould, presumed to be of near-contemporary date, excavated at Hartlepool, a daughter-house of Lindisfarne (see fig. 154).[181] This does not explain why only the Matthew and Mark symbols have such a feature, with its resonance of the apocalyptic trumpeting angels of the Second Coming. In the description of these pages I have suggested that some exegetical link between the Christ Incarnate and the Resurrected Christ might be intended, emphasising the means by which the salvation of humankind was secured. The symbol accompanying St Matthew in the Lindisfarne Gospels, as well as being a symbol of the 'man' with attributes including wings, is also palpably an angel. I have discussed elsewhere the intentional multivalence of the form as a visual reference to Christ as the 'Angel of great counsel', in the Mercian Book of Cerne (see fig. 150).[182] I shall discuss another possibility relating to a Cassiodoran verse, below (p. 363). Another pertinent analogy is with the two cherubim who, along with the evangelists, accompany the Christ in Majesty of the Codex Amiatinus (see fig. 155) and who call to mind the two cherubim surmounting the Ark of the Covenant at the centre of the Temple and Tabernacle of Jerusalem, acknowledging thereby Christ as the new, eternal Temple.

One piece of evidence in particular had been advanced in support of the suggestion that the Lindisfarne Gospels copied its complex evangelist symbols from a pre-existing

Fig. 154. Hartlepool mould with symbol of St Luke (Hartlepool Museum Service, Cleveland, Inv. Nos HAPMG 27'89'91/91), Northumbrian, early 8th century. This remnant from metalwork manufacture at one of Lindisfarne's daughter-houses provides a parallel for the trumpeting evangelist symbols in two of the Lindisfarne Gospels' miniatures. (Photo: Hartlepool Museum Service)

exemplar. The Copenhagen Gospels (Copenhagen, Royal Library, GKS 10 2°) contains a Matthew miniature (f. 17v, see fig. 156) which is closely iconographically related to the Lindisfarne Gospels' corresponding image (see pl. 8).[183] The basic elements, the bearded scribal evangelist, the trumpeting angel and the bearded figure peeping from behind the curtain, are indeed present, but there are also some important differences. The angel swoops downwards from an illusionistic cloud-burst, in Carolingian fashion, the evangelist writes in a book placed upon a circular writing desk rather than resting upon his knee, and the figure, drapery and border style are reinterpreted in more fashionable Anglo-Saxon 'Winchester style'. The volume is thought to have been written before 1000 in a centre associated with St Aethelwold of Winchester, but to have been decorated and completed by an artist-scribe associated both with Peterborough and Christ Church Canterbury.[184] Its other surviving evangelist miniature of St Luke (f. 82v) features a bearded evangelist, as in the Lindisfarne Gospels, but he writes upon a draped lectern, a later iconographic feature, and his symbol, the calf, has acquired a trumpet which is absent in the Lindisfarne Gospels' image. These differences have led some commentators to propose that the artist of the Copenhagen Gospels did not refer directly to the Lindisfarne Gospels, but to another,

Fig. 155. The Codex Amiatinus (Florence, Biblioteca Medicea-Laurenziana, MS Amiatino 1), f. 796v, Christ in Majesty, from one of the Ceolfrith Bibles, Wearmouth/Jarrow, before 716. (Photo: Florence, Biblioteca Medicea-Laurenziana)

earlier shared exemplar.[185] I would suggest, however, that the differences have more to do with the attempts of the later artist to update images which he had seen in the Lindisfarne Gospels, in accordance with early eleventh-century iconographic and stylistic conventions, and to render its scheme of depiction more consistent by giving all the symbols trumpets (although he has in fact disrupted the consistency as well by omitting to supply the calf with a book). The Matthew miniature's changes in fact lend support to such a theory, for the circular writing desk with its curious misinterpreted perspective which leaves it facing full-frontally rather than sloping at all, is a direct quote from the Mark miniature in the Lindisfarne Gospels (see pl. 14). Likewise, the Matthew border, which has been 'modernised', contains a most unusual feature in the form of an almost superimposed cross in the form of chalice-shaped terminals midway along each side of the frame. The impression conveyed is of the distinctive Matthew carpet page of the Lindisfarne Gospels (see pl. 10) having been superimposed upon its Matthew miniature. It therefore seems likely that the artist of the Copenhagen Gospels had in fact consulted the Lindisfarne Gospels and chose to weave several visual references to its decorative scheme into his own work.[186] The fame of the Lindisfarne Gospels was evidently such that a leading artist from southern England saw fit to perpetuate its influence some three centuries after its creation.

Fig. 156. The Copenhagen Gospels
(Copenhagen, Royal Library, GKS
10 20), f. 17v, Matthew miniature,
S. England, early 11th century.
(Photo: Copenhagen, Royal Library)

The enigmatic 'Polonius' figure peeping from behind the curtain in the Matthew miniature (see pl. 8) has been compared by some previous commentators to the inspiring muses of late Antique author portraits, preserved in the early Christian tradition in volumes such as the Rossano Gospels (Rossano, Diocesan Museum of Sacred Art, s.n., f. 121r),[187] and to another convention of early Christian origin which endured throughout the early Middle Ages of depicting the evangelist either as a scribe receiving dictation as part of the process of transmission of the New Testament, or of being given a volume/text (see fig. 158).[188] One such image is preserved in Oxford, Bodleian Library MS Copt. Huntington 17, a Coptic/Arabic Gospelbook of AD 1173 which includes a striking image at the beginning of Matthew's Gospel in which a full-page cross with interlace infill is flanked by Matthew as a scribe and a seated figure of Christ dictating his Gospel (thereby conflating several of the elements of the Matthew cross-carpet page and Matthew miniature in the Lindisfarne Gospels, see fig. 157).[189] Within this tradition, each evangelist stood in a direct line of transmission either from Christ, in the case of Matthew, the Holy Spirit, in the case of John, or from an apostolic precursor (Peter for Mark and Paul for Luke). Aldred's colophon on f. 259r contains a reference to this tradition (perhaps included in order to draw the parallel

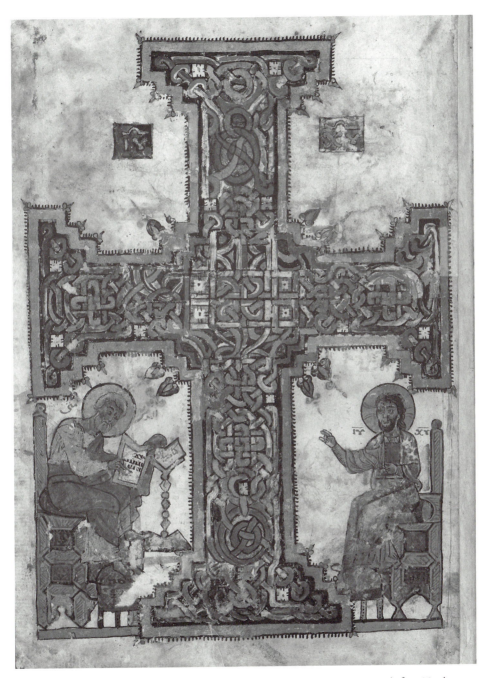

Fig. 157. Coptic Gospels (Oxford, Bodleian Library, MS Copt. Huntington 17), f. 1r, Matthew miniature depicting Matthew and Christ, inspiring or dictating to him, flanking a cross, Coptic Egypt, 1173. (Photo: The Bodleian Library, University of Oxford)

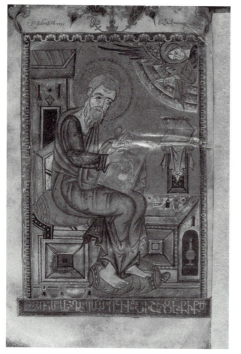

Fig. 158. Armenian Gospelbook (BL, APA Or. MS 5626), f. 1v, Matthew evangelist miniature and incipit page, monastery of Drazark, 1282.

Fig. 159. The St Bavo Gospels (St Bavo's Cathedral, Ghent, Inv. 741), f. 183v, St John miniature and incipit page, Carolingian, first half of 9th century. (Photo: St Bavo's Cathedral, Ghent)

between the four evangelists and their 'inspirations' and the four makers of the Lindisfarne Gospels, in which Aldred included himself, thus extending the line of transmission of Scripture to include himself):[190]

> God, three in one, these Gospels have since [the dawn of] the age consisted of:
> Matthew, who wrote what he heard from Christ;
> Mark who wrote what he heard from Peter;
> Luke, who wrote what he heard from the Apostle Paul;
> John who willingly thereupon proclaimed and wrote the Word given by God through the Holy Spirit.

This text, known as the 'Five Sentences', is of uncertain origin but may derive in part from the Plures Fuisse prologue, included in the Lindisfarne Gospels, commencing at f. 5v.[191]

The Perugia Gospels (Perugia, Biblioteca Capitolare, MS 2), made in ninth-century Italy, also contains images of Christ, enthroned, receiving Gospelbooks from the presenting evangelists and their symbols. This interpretation has been extended to include images in the Carolingian Ghent Gospels (Church of St Bavo, s.n., see fig. 159),[192] although an

alternative suggestion is that the seated figures represent not Christ, but the evangelists, and that the standing figures presenting books represent their inspirers/transmitters.[193] In either case, these analogies for seated figures approached by other figures presenting books would reinforce the case for an interpretation of the figure behind the curtain in the Lindisfarne Gospels' Matthew miniature as Christ, even at a simple or primary level of meaning.[194] The Matthew miniature also lends itself, however, to a more complex reading.

The 'Matthew' miniature (see pl. 8) features a scribe, identified by an inscription of Greek formula and written in Roman capitals with Germanic runic stylistic features, as St Matthew ('Ó AGIOS MATTHEUS'). He is additionally identified by the figure of an angel (who might again be intended to recall the cherubim who surmounted the Ark), the 'man' ('imago hominis') or symbol of St Matthew and of the Incarnate Christ, who sounds a trumpet redolent of the Second Coming as foretold in Ezekiel and Revelation. In these texts Christ is accompanied by the four beasts or images of the evangelists, which were interpreted by exegetes such as Augustine, Gregory and Bede and which usually take the form of: Matthew – the Man/Angel (symbolising the Incarnate Christ); Mark – the lion (symbolising the triumphant resurrected Christ); Luke – the calf/bull (symbolising the immolatory victim of the Crucifixion); John – the eagle (symbolising the ascended Christ of the Second Coming).

I have discussed elsewhere that such 'accompanied' evangelist portraits, found here and in the Mercian Book of Cerne (see fig. 150), simultaneously symbolise Christ, the Gospel writers, the scribe who faithfully transmits the Scriptures and the aspirations of the faithful.[195] But what of the mysterious figure who peeps from behind the curtain? He has been variously interpreted as Christ, God the Father (the Ancient of Days), or Moses and has been thought perhaps to have been modelled upon the inspiring muse of late antique author portraits.[196] A striking feature is the curtain, which hangs from its prominent rings. The immediate reference which comes to mind is the curtain of the Tabernacle, discussed at length in Bede's commentaries. Such looped-back curtains are used elsewhere to 'reveal', as with the contents page of the seventh-century Ashburnham Pentateuch where it is drawn aside to reveal the titles of the five books of the Law.[197] Might the Lindisfarne curtain similarly reveal the *figura* of the Old Testament which informs and helps to interpret the Gospels? The bearded male figure who reverently holds a sacred book in his draped hand, recollecting the deacon who was responsible for conveying Scripture, might thus fulfil a similar iconographic function to that proposed by O'Reilly for the bookcase (*armarium*) in the Amiatinus Ezra miniature (see fig. 30).[198] The drawn-back curtain which is a relatively common feature of many later Coptic, Byzantine and Carolingian evangelist miniatures might similarly have been intended to imply a revelatory function, if in less complex a manner.[199] One relevant example in this respect which, although of sixteenth-century date, probably derives its iconography from an earlier Byzantine exemplar, is a Bulgarian Gospelbook now in Sofia (Bibl. Nat., inv. BNCM 65), the non-figural decoration

of which suggests that its model was of quite an early date. In this manuscript the evangelist Mark is depicted as a bearded figure in the act of writing in very similar fashion to the Amiatinus Ezra figure, with his writing implements and materials strewn around him upon his table and with his feet set upon an apparently floating footstool (articulated in the same mistaken perspectival fashion as in Amiatinus and in the Lindisfarne Matthew miniature). Behind him is a church building (the Holy of Holies, the new Temple) with a curtain drawn aside at its entrance. The curtain recalls that in the Lindisfarne Matthew miniature and the church itself is somewhat reminiscent of the bookcase accompanying Ezra in Amiatinus.

Some such early Christian archetypal iconography might underpin the approaches of both of the Northumbrian artists, but if so they have both adapted it to suit their communities' own exegetical and iconographic purposes.[200] There has, of course, been a great deal of debate concerning whether the Amiatinus Ezra miniature was a copy of an image in a Cassiodoran manuscript. Paul Meyvaert has advanced the judicious interpretation that Cassiodorus' Codex Grandior contained a portrait of a seated figure which formed the basis for the Amiatinus Ezra, but that this represented not the Prophet but Cassiodorus himself. The Northumbrians, ignorant of this, reinterpreted the figure as the prophet responsible for preserving and transmitting Scripture and who thereby served as a 'type' of Christ.[201] Meyvaert's carefully balanced argument indicates that there was indeed a connection between the Codex Grandior and the Codex Amiatinus, but that the independence of the latter in other components of its overall iconography, as well as its choice of text type and layout (the Codex Grandior is thought not to have been laid out *per cola et commata*) and iconography was also strongly marked and that it was not a copy of the former per se. Whether or not a Cassiodoran depiction of a scribe was the immediate source of inspiration for these images in Amiatinus and Lindisfarne (and the Lindisfarne artist may have been basing his Matthew image directly upon the Amiatinus Ezra) or whether they are effectively innovative, their artists both seem to be responding to an ultimately early Christian model for a seated scribe and transforming it to suit their purposes. This model may have been in book form, although the visual influence of icons and panel paintings of the sort known to have been imported to Northumbria should not be discounted, and to judge from perspectival distortions in both of the Northumbrian miniatures (as well as later examples of the same phenomenon, such as the aforementioned Gospelbook in Sofia) any such exemplar was probably itself far from achieving 'classical' (or naturalistic) perfection itself in its spatial representation.

Whatever the stylistic and iconographic starting point, it is the way in which the two Northumbrian artists treated their subjects and the meaning with which they imbued them that remains of greatest interest. As O'Reilly discusses, Matthew 5.17 emphasises that Christ came not to dissolve the Law but to fulfil it. Belief in Christ entails keeping the Law: the Ark contains that hidden Wisdom and the Gospels reveal it. The Tabernacle, as Bede's

commentaries, *De Tabernaculo* and *De Templo,* so eloquently convey, is, for Christians, a *figura* of Christ.[202] Exegetes, from Iranaeus to Bede, stressed the need to imitate Christ, who draws from his treasure both Testaments, and in his *De Tabernaculo* Bede warns against bringing forth only old treasure (the literal meaning of the Law) and exhorts the scribe to seek the spirtual meaning of Scripture and practise it. As George Brown has highlighted, such symbolism is very definitely not representative of merely antiquarian and romanising trends or agendas: it lies at the heart of the life of the faithful in the present.[203] As Origen pointed out (commenting on Psalm 1.2), the scribe who meditates on the Law day and night (in the sustained, focused scribal campaign witnessed in the Lindisfarne Gospels, for example) and who lives and teaches the Gospel, becomes the Tabernacle or dwelling-place of the Lord.[204] Cassiodorus, in his *Commentary on the Psalms,* extends the Psalm passage (Ps. 14/15.1–2) which says that the righteous who keep the Law shall dwell in the Tabernacle of the Lord, to Christ who fulfilled the Law by entering the Tabernacle of human flesh. The Gospels, and Matthew in particular, recount the virtues of the Incarnate Christ, which the faithful must emulate in order to become Tabernacles themselves. Cassian and Gregory the Great applied this teaching specifically to the lives of teachers/ preachers, and by implication to hermits, hence the revelation of similar preoccupations in works of hagiography, such as the *Lives* of St Cuthbert. Both Scripture and hagiography thereby urge the living out of the message, to instruct the faithful, by imitation, to make of themselves God's sanctuary.[205]

The Lindisfarne miniature could thus be interpreted as a multivalent image: depicting the author of the Gospel; exploring the symbolic witness of his Gospel; and emphasising, at the opening of a Gospelbook, the harmony of the Old and New Testaments. The book held by the figure behind the curtain represents the Law, contained within the Tabernacle, which is integrated with the New Testament being written by the evangelists, the two Testaments being harmonised in the Incarnate and Risen Christ, who is the new Temple. A further layer of meaning may be adduced, again with reference to O'Reilly's reading of the Ezra miniature, in which the scribe and the reader, by studying, interiorising and living out the two Testaments, make of themselves an Ark, a Tabernacle – the sanctuary and dwelling-place of the Lord. The reader vests as a priest to enter the sanctuary of Scripture, thereby becoming the sanctuary of the Lord. A relevant passage in this respect is also 2 Corinthians 3.7–18, especially verses 15–18:[206]

> Yes, to this day whenever Moses is read a veil lies over their [the Israelites'] minds; but when a man turns to the Lord the veil is removed. Now the Lord is the Spirit, and where the Spirit of the Lord is, there is freedom. And we all, with unveiled face, beholding the glory of the Lord, are being changed into his likeness from one degree of glory to another; for this comes from the Lord who is the Spirit.

The peeping figure thus becomes every righteous believer, a symbol of the Church/ Communion of Saints, and of the scribe/teacher/preacher, also symbolised by the writing

evangelist whom he so resembles.[207] O'Reilly has pointed out that Bede described Ezra the Scribe as 'typus Christi', a 'type' of Christ, hence his similarly nimbed depiction in the Amiatinus miniature.[208] So, in Lindisfarne, the two nimbed figures are both *figurae* of Christ and it becomes possible for the believer to be simultaneously represented. As Hebrews 10.12–22 says:

> We have, then, complete freedom to go into the Most Holy Place by means of the death of Jesus. He opened for us a new way, a living way, through the curtain – that is, through his own body. We have a great high priest in charge of the house of God. So let us come near to God with a sincere heart and a sure faith, with hearts that have been purified from a guilty conscience and with bodies washed with clean water.

To recap, the two nimbed figures in the Lindisfarne miniature simultaneously symbolise the Old and New Testaments, the Incarnate and Risen Christ, the Evangelist, the scribe, the teacher/preacher and every believer. The Matthew miniature fulfils something of the function of the quire of *figurae* which introduces the Codex Amiatinus. It reacts to the complex theological and iconographic preoccupations contained therein and adapts them to the needs of a Gospelbook. This is no mere copy of or garbled reaction to a Cassiodoran or Wearmouth/Jarrow exemplar, as previously thought, the Lindisfarne Gospels even having been described by one author as 'an Italian Gospelbook in disguise'.[209]

I also propose another reading of this image (which in no way negates the foregoing), which is that it is the visual embodiment of a pair of couplets which accompanied the diagrammatic summary of scriptoral division according to St Augustine. Their source may have been Cassiodorus' Codex Grandior but knowledge of them probably came via Wearmouth/Jarrow. The Codex Amiatinus (f. VIIIr) contains the first couplet (perhaps, as suggested by Paul Meyvaert, actually in Bede's handwriting), but there is evidence (a quotation from the Anglo-Saxon author Milred of Worcester) to suggest that at least one of the other two Ceolfrith Bibles – that subsequently at Worcester – may have contained both (perhaps representing development in Bedan exegetical thought after the Codex Amiatinus had departed in 716). The couplets deal with the inspirational nature of Scripture and its transmission and read:

> Eloquium Domini quaecunque uolumina fundunt, / spiritus hoc sancto fudit ab ore Deus. / Esaias domini cecinit miracula uates / atque euangelicis concinit ore tubis. /

This may be translated as:

> In those volumes that display the Lord's eloquence, / the Holy Spirit has poured it forth from the mouth of God. / Isaiah sang of the Lord's miracles / and sounded forth [/ bore witness] from his mouth with angelic trumpets.

In this context the Lindisfarne Gospels' Matthew miniature depicts the inspiration of the Lord (the figure revealed by the curtain of the Holy of Holies) at work in the witness borne by Isaiah, the Old Testament prophet who foretold the coming of the Messiah and who symbolised the priestly calling, by the evangelist Matthew and by subsequent scribes of

Scripture (including that of the Lindisfarne Gospels), all represented by the scribal figure. The trumpeting angel represents the sounding forth of their message across time and space.

What we have here is then a new visual response (going beyond the diagrammatic representation found in the Codex Amiatinus) to Cassiodoran texts, diagrams and images (the couplets, Bedan exegesis, the Augustine diagram and the Ezra miniature of Amiatinus). This was perhaps stimulated by contact with Bede and developing thought at Wearmouth/Jarrow and underpinned by a Columban tradition in which the role of the scribe as a conduit of the Spirit was well recognised.

Bruce-Mitford and Cramp have rightly cited stylistic evidence to indicate that Lindisfarne's evangelist miniatures were composed from more than one source.[210] The Matthew scribe may be modelled upon that of the Amiatinus Ezra or its exemplar,[211] but this is only one component of its scheme. These are coherent, synthetic images rather than copies, which are responding to varied material (visual and ideological). A gloss may be added concerning the trumpeting symbols for Matthew and Mark. In the eighth century, before 716, Bede wrote his *Commentary on Luke*. The letter from Bishop Acca of Hexham, included in its preface, asks Bede to justify his 'new interpretation', given in his *Commentary on Apocalypse*, of the meaning of the evangelist symbols. Bede's interpretation was not new, but was based upon the writings of Augustine rather than Jerome. His audience was not well-read enough to discern the sources unaided. Bede had therefore attracted criticism for this work, as he did for his groundbreaking treatment of chronology. Acca was keen that he vindicate his theories by explaining to the less erudite the scriptural and exegetical precedents upon which such discussion was founded.[212] Such debate would form an appropriate backdrop for the sort of experimentation with evangelist imagery that we witness in the Lindisfarne Gospels. Linking symbols of Matthew and Mark by apocalyptic trumpets, may become explicable when it is considered that Bede favoured the less usual association, promoted by Iranaeus, of the lion with Matthew and the man with Mark. Lindisfarne adopts the more orthodox ordering of the symbols, but may be acknowledging this pairing.

The Lindisfarne evangelists have usually been considered as author/scribe depictions. The details of the writing implements and Gospels which they are making, or in the case of John holding, differ in a number of significant respects. The distinction calls to mind Bede's apologia addressed to Bishop Acca of Hexham, in which he says that, in accordance with the bonds of monastic servitude, he had himself undertaken the roles of author, notary and scribe.[213] Matthew writes in a bound codex, possibly symbolising the role of author; Mark appears to draft a text on a sheet, whilst clutching a bound codex in his left hand, perhaps engaged in the role of note-taker; Luke writes upon a scroll, the formal scribal fair copy of a text; John also has a scroll but does not inscribe it, but rather gestures to it as if indicating that its text has come directly from the throne of God, as explained in exegesis.[214]

Description of the Matthew evangelist miniature, f. 25v

The evangelist Matthew is depicted as a scribe, of the classical author variety (see pl. 8). There is an obvious stylistic connection between his figure and that of Ezra the Scribe in the Codex Amiatinus (see fig. 30), and it has long been thought that they were both indebted to the same Cassiodoran exemplar. But, unlike Ezra, Matthew is not accompanied by a writing desk and implements, nor by the *armarium* (book cupboard) containing the books of Scripture, but is shown writing in a fully bound book which he holds on his knee. His script is invisible, but it may be that the scribe of the volume intended to return to pen the opening words of the Gospel on its blank pages, as in the Barberini Gospels. Each of the Lindisfarne evangelists relates differently to their 'books' and, as discussed with reference to the Mark miniature, this may refer to the distinction between the roles of author, notary and scribe, as outlined by Bede in his *apologia* to Bishop Acca of Hexham, and to the revelatory role of John (see the John miniature, f. 209v).

Matthew is clad in a green pallium, in Mediterranean fashion, its stylised drapery folds shaded in orange, over a purple tunic with an embroidered golden yellow trim. He is bearded, in Byzantine fashion, and his long straight hair and beard are painted a pale blue/grey. His brow is furrowed in concentration and his eyes given a complementary green shading, a Byzantine stylistic convention. His bowed head is silhouetted against a large yellow ochre nimbus with an orange rim. It is noteworthy that his nimbus is a different yellow to the paler haloes, outlined in blank vellum, of his accompanying symbol and of the enigmatic figure who watches from behind a curtain. In the other evangelist miniatures the haloes of evangelist and symbol share the same central colour, serving to link them, while here they serve to tie together the symbol of the angel/man and of the peeping figure.

Matthew is identified by a large epigraphic-style inscription: 'Ó Agios Mattheus', a Greek formula transliterated in Latin characters of stylised angular capital form, reminiscent of Germanic runic inscriptions. The 'G', however, is of rounded uncial form, of the sort favoured in the uncial script of Rome and of southern England. The 'O' carries a stress-mark, as if for oral recitation, and the words are divided and disposed around the figure in a manner reminiscent of Byzantine icons and Italian frescoes, such as those of Sta Maria Antiqua.

Matthew sits upon an elaborate throne, inset with marquetry-like patterns, upon a plump orange cushion. His feet, shod in the insubstantial thongs of vestigial antique sandals, rest upon a footstool which floats ethereally, the perspectival depiction of these furnishings being even more distorted than in the Amiatinus Ezra miniature. Matthew's figure is surmounted by his identifying evangelist symbol, labelled in half-uncials 'imago hominis', 'the image of the man'. As exegetical sources tell us, the man symbolised the nature of Matthew's Gospel, stressing the Incarnation of Christ.[215] Here, however, the symbol is in celestial guise, as a trumpeting angel, recalling the heralds of the Last

Judgement and thereby linking Incarnation and Resurrection. The Echternach Gospels make the same point in a different fashion. Their 'imago hominis' (f. 18v, see pl. 30) takes the form of a seated, fully frontal youthful evangelist (with a Roman tonsure), enthroned against a cross-shaped background. Here the Matthew terrestrial symbol is a man, not an angel, but depicted in a way that recalls both the enthroned Christ of the Second Coming and the Incarnate Christ of the Crucifixion.[216] The angelic symbol finds subsequent parallels in the Book of Kells and in the early ninth-century Mercian prayerbook, the Book of Cerne (see fig. 150), where the implications of this iconography are explored in the accompanying inscriptions, and may include a reference to Christ as the 'Angel of great counsel'.[217] The Lindisfarne angel is shown in profile, a trumpet or speech scroll emanating from his mouth, has two wings with finely detailed plumage, and wears a tunic and pallium which is draped over his left hand in which is reverently held a book, recalling the manner in which the deacon held the Gospels during the liturgy (a feature again echoed in the Book of Kells and the Book of Cerne).

A figure peeps from behind a curtain. The elegantly draped orange fabric, with its tasselled yellow trim, is suspended from a rail by seven striking black rings. The figure revealed is a nimbed male bust, his elegantly curled hair and beard coloured blue/grey, like that of Matthew, and set against a pale yellow nimbus like that of the angel symbol. He wears a yellow trimmed orange garment, draped over his hand in which he holds a green and yellow book, its colours and the reverent manner in which it is held recalling that clasped by the angel. There are obviously some conscious links being made here. The Insular mindset was predisposed to multivalence, or multi-layered meaning, so more than one interpretation is possible, and some readings have been suggested above.

The role of the evangelist is set within the context of transmission, his depiction as a scribe perhaps extending the analogy to the scribe engaged in producing the Lindisfarne Gospels who similarly entered into that process. The relationship between the Incarnate and Risen Christ, which the Gospelbook itself symbolised, as Christ hidden beneath the letters of Scripture (1 Corinthians 1.24 and 2.6–7),[218] is explored through the relationship of evangelist, symbol and 'inspiring' figure and the viewer is invited to participate in that relationship by contemplating this iconic image. The effect of an icon is completed by the unusual thick pink grounds of the Lindisfarne evangelist miniatures, which appear to have been polished or burnished. This may have been intended to allude to the encaustic pink wax icons of the East,[219] or to the pink grounds to many Coptic frescoes, or to the bole grounds underlying the gilded backgrounds of Byzantine icons. Perhaps the Lindisfarne grounds were themselves intended to be gilded, as I have already suggested. Perhaps the evangelist miniatures were unfinished in this respect, although on balance it seems more likely, given the finished state of the figure painting and the messiness that major retrospective laying on of gold leaf would have occasioned, that a stylistic reference to icons and frescoes was intended. The effect of a panel painting or icon placed upon

the page is further emphasised by the rectilinear frame with its horned interlaced terminals.

Description of the Mark evangelist miniature, f. 93v

Mark is depicted as a youthful, clean-shaven author figure, of Italianate rather than bearded Byzantine type (see pl. 14). The residual influence of Italo-Byzantine art may nonetheless be detected in the facial modelling, with the green-tinged complementary shading to the eyes of both evangelist and symbol. His brow is furrowed and his mouth down-turned with the solemnity of his task. He wears a purple pallium, edged in yellow, the folds of its drapery represented by stylised blue lines. This colour scheme is reversed for the underlying tunic, which also has an elaborate yellow hem-line and cuffs. His feet are shod in the sandals appropriate to the Mediterranean, vestigially delineated by fine linear thongs. His toe- and finger-nails are delicately conveyed by areas of blank vellum. The outlines of the figure and of the evangelist symbol are reinforced in heavy black ink. Mark's carefully rolled curls are set against a striking nimbus of yellow with a green rim. He sits upon a throne with a plump blue cushion and his feet rest upon a footstool inset with four coloured surfaces that serve to distort further its mistaken perspective. Fortunately its two little feet anchor it to the floor and prevent it from completely floating away.

Realistic perspective has again been sacrificed, but to greater decorative effect, when depicting Mark's writing desk, which faces frontally as a striking circle of blank vellum with a yellow rim and black outline. Although it leaves no writing behind it, Mark's pen moves across a large single sheet of vellum – or could the frame around the sheet be intended rather to suggest a wax tablet? If so, one might have expected him to write with a stylus. Either way, there is a marked distinction between this and the bound codex in the St Matthew miniature and the scrolls of Sts Luke and John. This variation could have been merely an artistic convention, stimulated by the iconographic model or models, or may perhaps be more significant.

Mark is accompanied by his evangelist symbol, the lion, interpreted in said exegesis as a symbol of the triumphant risen Christ of the Resurrection. This may explain why a scroll or trumpet of blank vellum issues from its mouth, recalling the trumpeting angels who, according to the Apocalypse, will attend Christ at the Second Coming. This may have been intentional or due to an exemplar. The closest stylistic analogy for the trumpeting lion (if indeed it is a trumpet rather than a speech scroll) is a metalwork mould excavated at Hartlepool (see fig. 154).[220] The lion is a benign-looking creature. Unlike Mark, it gazes towards the viewer, as if extending an invitation to partake in the resurrection to eternal life made possible by Christ's own Passion and Resurrection. The lion holds a book in his front paws, is winged and nimbed, the yellow nimbus echoing that of the evangelist and, with consummate design-sense, being placed to frame the lower face, rather than the top

of the head, thereby emphasising the turn of the face to engage the viewer. The delicate way in which fine lines are employed to delineate the fur and feathers is reminiscent of the fine hatching of Visigothic manuscript art and, more significantly, of the related Echternach Gospels (see pls 29, 30 and fig. 21).

The lion is labelled 'imago leonis' in half-uncials, whilst Mark is surrounded by the inscription 'Ó Agius [sic] Marcus', a 'u' being substituted for 'o' in 'Agios'. The 'O' is given a stress-mark, inviting an oral recitation, and the formula of the inscription is Greek, although transliterated and written in angular capitals. It is divided into syllables disposed either side of the figure.

The whole composition is set, as in the other miniatures, upon a thick pink ground which appears to have been burnished or polished in some way, perhaps as a conscious allusion to encaustic icon painting with wax, or to the bole which would have underlain Byzantine gilded grounds. What an amazing difference gilding would have made to the overall effect, if it was originally intended. That the pink ground was added late in the painting process is indicated by the fact that it intrudes above the heavy black outlining of the figure of St Mark, at the point where the stand of the writing desk coincides with his leg.

A frame of blue with 'horned' interlace motifs at its corners contains the scene and, set as it is upon a plain vellum ground, gives the impression of literally framing the image as an icon or panel painting.

Description of the Luke evangelist miniature, f. 137v

The evangelist Luke is depicted as a scribe in the act of writing upon a scroll (see pl. 18). His pen produces no marks, but once again it may be the case that the artist-scribe intended to add the opening words of the Gospel later. Luke is of the Byzantine bearded type, his beard and hair elegantly curled in late Antique fashion, his eyes and nose moulded with green complementary shading, again in Byzantine fashion, his brow furrowed and his mouth set in concentration as he is inspired to his task. This is no veristic attempt at a scribal portrait, however, unlike some early Byzantine and Italian examples, or even as in the Ezra miniature of the Codex Amiatinus, for there are none of the accoutrements of the scribe, no ink horn or writing desk (see fig. 30). This Luke appears frozen in an abstract time and space, totally absorbed in the inspirational spontaneity of his task.

He wears a purple pallium, its folds delineated by stylised orange lines, as it drapes elegantly across torso and arm but cascades confusedly towards its golden tasselled hem line. Beneath is an orange tunic, its drapery lines articulated in green, with an embroidered trim of golden concentric circles at neck, cuffs and hem. His feet are shod with the flimsiest of sandal thongs – a residual reference to Mediterranean visual convention rather than to the footwear requirements of a denizen of the northern seaboard. His toe-nails are carefully rendered in blank vellum, offset against the pink flesh tones and his feet float

etherally above a stylised footstool. He is seated upon an Antique throne, a minimal affair reduced to the mere essential elements to convey its structure rather than any attempt at perspectival realism. Its luxurious status is conveyed, however, by the marquetry insets embellished with circular motifs which adorn its bars, by its sturdy green feet and by its plump orange cushion, adorned with yellow foliate-like dots in the manner of the Durham Cassiodorus.

The saintly status of the evangelist-scribe is conveyed by his shining golden halo (conveyed by the use of bright yellow orpiment), outlined by fine double bounding lines which are echoed by another pair of lines inside its rim. This nimbus is echoed by that of the identifying symbol which hovers above, borne aloft on a pair of blue wings, the plumage of which is articulated by the use of a myriad of very fine ink lines, each feather carefully drawn. This fine linear work is continued on the calf's body to depict its hair. These features, coupled with the way in which it is shown in profile but turns its head to stare dolefully at the viewer through piercing, graphically drawn almond-shaped staring eyes, are highly reminiscent once more of the treatment encountered in the Echternach Gospels and in early Visigothic illumination (see pls 29, 30 and fig. 21). The calf has a muzzle formed of a pelta motif, little curved green horns, a tail which clings to its hindquarters and dark black hooves, the front of which clasp the Gospelbook, a stylised affair with green covers and yellow foredges.

The whole composition is again set upon a ground of thick, slightly polished pink pigment, contained within a rectilinear orange frame (which has oxidised in places), which extends into simple but elegant horned interlaced corner-pieces, like the frame of a panel painting. The boldness of the effect is softened by the way in which the fine lines which outline the interlace extend to form a key motif just inside the corner of the frame and into little scrolls abutting the straight outer lines of the frame.

The strong resemblance to an icon set within its frame against the blank vellum of the page (marred only slightly by some water staining at the top left) is increased by the way in which the identifying inscriptions are written. That for the calf symbol is inscribed in the half-uncials of the text: 'imago uituli' ('image of the calf/bull'), and that of the evangelist-scribe in angular display capitals: 'Ó AGIOS LUCAS' ('O holy Luke'). The latter employs a Greek formula and words transliterated in Latin script.

Description of the John evangelist miniature, f. 209v
The evangelist John is depicted enthroned, facing frontally, as a youthful clean-shaven type in accordance with the early Christian convention for delineating the features of the young apostle who so loved his Lord (see pl. 22). Both the pose and the facial type call to mind an immediate, intentional, analogy with the youthful Christ who is often the type enthroned as the apocalyptic Judge of the Second Coming foretold by John in the other major work ascribed to him, the Apocalypse/Book of Revelation. Through such sym-

bolism and its intertextual exegetical interpretation, a link was established between God, the evangelist and the faithful. As near contemporary commentaries, such as that preserved in the eighth-century Frankish Gelasian Sacramentary, point out in relation to Psalm 102.5, 'David says of the person of Christ: your youth will be renewed like the eagle's, that is, like that of Jesus Christ our Lord who rising from the dead ascended into heaven.'[221] This correspondence is further emphasised by the fact that, unlike the other evangelists, John is not engaged in the act of writing but holds a scroll, which could symbolise both his Gospel and the Book of Life held by Christ the Judge, and also his role as a prophet foretelling the Apocalypse. John gestures towards the scroll, his hand also drawing the viewer's attention towards his symbol, the eagle, discussed in exegesis as representative of the Risen Christ of the Last Judgement, with a sermon falsely attributed to St Ambrose declaring that 'Christ, after the venerated Resurrection by which he taught that human kind can return to life after death, flew back to the Father like an eagle.'[222] The eagle clutches a book in its talons, as it flies in profile towards the top right-hand corner of the frame. This dynamic representation graphically embodies the exegetical premiss that John, the eagle, soared directly to the Throne of God for the Word, its Gospel, which was therefore considered particularly inspired and inspirational. Its lections featured in the offices for the sick and dying. It was this Gospel, which speaks of the things that work 'by love', that Cuthbert and his master, Boisil, studied together at Melrose, and that Bede was engaged in translating into the English language, for the good of his soul and those of others, upon his death bed.[223]

John fixes the viewer with his compelling frontal stare, his eyes and face carefully modelled and coiffed in Italo-Byzantine style. He invites the onlooker to partake in the inspiration of the Gospel and thereby to ensure their claim to divine mercy before the Judgement Seat. John's enlarged throne, with its contorted misunderstood perspective and its plump blue cushion, recalls the Mercy Seat from which Christ dispenses justice and judgement in many depictions of the Last Judgement. Chist is depicted similarly enthroned and facing the viewer face-on in the Book of Kells (f. 32v, see pl. 32d) and in the late eighth-century Carolingian Godescalc Evangeliary. The Lindisfarne Gospels' St John/Christ figure wears a purple pallium (emphasising the divine *imperium* by the use of the purple cloth which betokened imperial rule since Antiquity), its folds shaded blue, trimmed with a yellow tasselled hem probably intended to convey gold thread. His underlying tunic is blue with orange folds, trimmed with yellow braid elaborated with circles. His right foot is shod in a flimsy version of the Antique sandal, whilst the left, shown frontally, lacks thongs. His striking orange nimbus, with its yellow rim, is reflected in the orange nimbus of the eagle, whose eye and beak are set firmly upon their purpose and whose brown plumage is intricately delineated with fine lines and white highlights. The eagle is accompanied by a half-uncial inscription 'imago aequilae', while the evangelist is flanked by an elaborate epigraphic inscription in Roman square capitals incoporating stylised angular

runic elements. Its yellow letters are set upon a continuous orange ground, echoing his nimbus and reminiscent of stained glass (see fig. 87) or *opus sectile*.

The image is set upon the usual burnished thick pink ground, within a frame with horned interlaced corner-pieces. More than any other this uncompromising frontal, engaging image invites comparison with the Byzantine icon tradition.

In conclusion, the Lindisfarne Gospels' decorative programme is essentially new, even if it its designer consciously drew upon exemplars, styles and motifs intended to summon up and acknowledge a wide range of cultures. An important part of this agenda was that the volume should enshrine and celebrate the *auctoritas* of Jerome's Vulgate edition, as one of a number of valued participants in the process of scriptural transmission. In its visual and textual allusions the volume simultaneously exhibits respect to certain other scholars and books (notably from Italian and Columban traditions) also involved in this process. A great deal of effort was expended in establishing layout to ensure that the Lindisfarne Gospels also enshrined aspects of the liturgical tradition, as celebrated at an earlier period in parts of southern and northern Italy (some elements of which probably figured in the liturgy practised at Wearmouth/Jarrow around 700) and as remodelled in Rome around 715. Even if the volume was not designed to be used extensively in the public worship of the Church it was evidently important that it should be able to function as a working liturgical book and as a commemoration of the cumulative liturgical tradition, both as currently used and as symbolically preserved. The Lindisfarne Gospels' illumination was also conceived against a background of exegetical reading and learned theology and designed to explore issues of Scriptural transmission, ecumenism, cultural integration and, fundamentally, the relationships of the author, transmitter and 'reader' with the Divine.

The artefactual stylistic context of the Lindisfarne Gospels

Abstract and zoomorphic ornament: the menagerie of the Lindisfarne Gospels and the vortex of Creation

The contorted, writhing mass of living creatures which adorns the major decorated pages and some of the major initials of the Lindisfarne Gospels are one of their most distinctive and influential features. They have evolved generically from a form of Germanic animal ornament known as Salin Style II, the origins of which are debated but which enjoyed widespread currency amongst the Germanic peoples who came into contact with the Roman world and who subsequently occupied its western territories.[224] Their responses to the naturalistic and decorative art forms and motifs of Late Roman provincial art featured a robust stylisation of animal forms and a taste for interlace, which could be found adorning the mosaic floors and stone and wood architectural details of the late Roman world, from Egypt and Syria to Cologne and Bath. The beasts of Germanic metalwork

move ever further from the recognisable species of their ancestors, evolving into long-limbed, long-snouted amorphous forms with a marked tendency to bite their own and the limbs of their fellows and to adopt contorted poses, including a characteristic pose in which they rotate their heads and look back along their own bodies. Their feet often dissolve into feathered elements and their heads can sprout manes or plumage known as lappets, such features offering further potential for interlacing.

This Style II animal ornament is now known not to have been exclusively Germanic, but to have been practised throughout the Celtic and British areas of Britain and Ireland, as well as in those areas settled by the Anglo-Saxons. The art historical discussion by Bruce-Mitford in *Cod. Lind.* tended to over-emphasise the Germanic ethnic focus of these elements, which was not surprising in the wake of the momentous finds from the Sutton Hoo ship burial, with which he was involved, and their stylistic parallels with aspects of the Lindisfarne Gospels' ornament. Its zoomorphic interlace resembles that on the great Sutton Hoo buckle and shoulder clasps, and its carpet pages with their step and fret patterns are very like the cloisonné garnet metalwork of the latter (see fig. 112). Bruce-Mitford also, however, drew attention to equally striking analogies with the decoration of the Sutton Hoo hanging-bowl mounts, of Celtic manufacture and identified both ethnic strands at play in the Lindisfarne Gospels.

Subsequent archaeology has retrieved from earth and water many other artefacts and their manufacturing debris which have told us more about the Scandinavian, German, N. Italian and Frankish backgrounds to Anglo-Saxon metalwork, and also that during the seventh century craftsmen at the Dalriadic ceremonial centre of Dunadd in Argyll (see fig. 90) and the Mote of Mark in Dumfriesshire were mixing styles, combining Germanic interlace and Celtic La Tène abstract ornament (which was native to Britain as well as to Ireland).[225] The concept of interlacing patterns is, in general, an extremely ancient one which achieved widespread currency throughout the Roman Empire. Its route into the British Isles and Ireland was not achieved exclusively via the medium of Germanic metalwork and its use in the manuscript art and in the sculpture of Lombardic Italy, Switzerland, Gaul, Coptic Egypt, Syria, Armenia and Palestine is also likely to have influenced the Insular artist. Thus the Khatchk'ar ('sign of God' or 'wood of life', memorial prayers in stone) of Aputayli from thirteenth-century Armenia presents us with a cross, replete with eucharistic and baptismal, salvation symbolism, embedded with a framework of diverse interlace panels, highly reminiscent of the carpet pages of the Book of Durrow and the Lindisfarne Gospels (see fig. 143).[226] The same might be said of the seventh- or eighth-century stone ambo (pulpit) at the Irish foundation of Romainmoutiers in Switzerland (see fig. 144). Such comparisons would be even more striking had these stone monuments retained their original polychrome paintwork. Such similarities may betoken cultural parallelism rather than direct stylistic influences, but the possibility of common ultimate points of reference cannot be excluded.

Fig. 160. Fragment of a cross shaft, Lowther 2, from Lowther, Cumbria, 8th century. A procession of Style II long-snouted, lappeted, interlaced animals (the jaws of one appear as the first strong diagonal element on the left). (Photo: Coleen Batey)

Generic interlace and its Style II animal interlace derivatives were gradually imported, along with Celtic abstraction, into the early extant witnesses to Insular manuscript production. The Cathach of Columcille (see fig. 37), thought to date to the early seventh century, but perhaps to the lifetime of Columba himself (d. 597),[227] builds pelta and trumpet motifs into its enlarged initials, as well as the crosses and fish of the uncial manuscripts made in Gregory the Great's Rome.[228] Durham MS A.II.10, a Gospelbook thought to have been made in seventh-century Northumbria, features two bold Style II serpents in the cross-stroke of its major initial N ('Initium', f. 2r, see fig. 96) and interlace in the 'D'-shaped arcaded frame to its incipit/explicit (f. 3v).[229] The Book of Durrow, a hotly debated volume for which consensus favours a later seventh-century date and a Columban origin and the prefatory matter of which is closely related to that of the later Book of Kells, carries the process of conflation of Germanic, Celtic, Pictish and Eastern artistic elements to new heights in its enlarged incipits, its carpet pages and its evangelist miniatures (see pl. 32).[230] The solemn, sinuous processions of Style II long-nosed beasts which progress through these pages find their relatives in the surviving incipit page of the Durham Gospels (Durham MS A.II.17, see pls 26, 27) where they are again combined with La Tène motifs and a Crucifixion miniature. This has moved beyond the symbolic cross page of Durrow, with the four evangelist symbols in its spandrels, to portray an icon of the Crucified Christ with angels and the spear and sponge bearers, Stephaton and Longinus.[231] Their counterparts can also be seen in stone, in the northern sculptures at Wamphray (near Moffat), Lowther 2 (Cumbria; see fig. 160), which bears a particular stylistic affinity to the animal ornament of the Durham Gospels, and to sculptures at Monkwearmouth (the porch and nos 656, 677, 81, 83 and '4'; see figs 28, 161).[232]

Style II animal ornament continued to enjoy currency into the eighth century and can be seen as far afield as the northerly Pictish centre of Tarbat (Ross and Cromarty) on the accomplished dragon stone (Tarbat Discovery Centre) and on the cross-head from

Fig. 161. Fragment, perhaps from an altar screen, with Style II animal ornament, Monkwearmouth, sculpture no. 4, late 7th century. The long scissor-like snouts reappear here on the upper right. (Photo: Bridget Heal, courtesy of the Vicar and Churchwardens of St Peter's, Monkwearmouth)

Lasswade, near Edinburgh (Nat. Mus. Scotland). It is noteworthy that, whilst following the Book of Durrow and the Durham Gospels in combining interlace, fretwork and La Tène abstract ornament, the Echternach Gospels eschew the use of animal ornament except for the evangelist symbols themselves on their individual symbol pages (see pls 29, 30). This omission has been attributed to speed in manufacture, it having been suggested in the Urs Graf facsimile commentary volume that the Echternach Gospels were made in a hurry, around 698, so that a visitor from Echternach could take them back with him as a gift to the new foundation. In other respects the ornament is carefully executed and features a fine linear penwork hatching and detailing reminiscent of chased metalwork and of Visigothic illumination (seen, for example, in BL, Add. MS 30850, ff. 5v–6r, see fig. 21). Similar penwork is encountered in the Durham Gospels and in the articulation of the fur and feathers of the evangelist symbols in the Lindisfarne Gospels' miniatures. Other less carefully executed Insular manuscripts exhibit no such qualms in their inclusion of ill-formed zoomorphic ornament and it remains a possibility that the reticence in depicting living creatures may have had a more intellectual or theological motivation, perhaps related to the continuing debate concerning images, or to a difference in the stylistic and social context in which the book was to function and the audience to which it was to appeal. In either case, the Echternach Gospels stands apart from other of the more prestigious Insular Gospelbooks such as the Durham Gospels, the Lindisfarne Gospels, the Lichfield Gospels

Fig. 162. Mould and glass stud from Lagore Crannog (NMI E.14:1572 a,b), Irish 8th century. This strongly resembles the central boss of the Lindisfarne Gospels' Mark carpet page. (Photo: National Museum of Ireland)

and the Book of Kells in this respect, perhaps adding to the impression that it was made in a different orbit. The Book of Durrow provides something of a context, for although it employs Style II animal ornament in its carpet pages it likewise does not apply it to the letters of its decorated incipits.

The regional spread of the Style II animal ornament which forms the background to the zoomorphic decoration of the Insular manuscripts in question was, nonetheless, a wide one, as was that of the Celtic abstract ornament with which it was fused and which had enjoyed a widespread currency throughout Britain and Ireland from the Iron Age onwards.

Attempts to localise a manuscript by identifying a stylistic link with a specific work of art in another medium is further complicated by the portability of smaller objects, the travels of craftspeople and the complex patterns of landholdings, gift exchange and affiliations within extensive monastic federations and expansive bishoprics and kingdoms. This renders the evidence of manufacturing debris at sites such as Dunadd, the Mote of Mark, Lagore Crannog and Moynagh Lough in Co. Meath and Garranes ringfort in Co. Cork extremely valuable in locating sites of production (see figs 90, 103, 109, 162). Thus a sculpture in Cumbria, such as that at Lowther, might have been made for a dependency of Lindisfarne, which had significant landholdings in the region, centering upon Carlisle to the North and Cartmel to the South. A centre to the far North, the major monastic and Pictish settlement site which is being excavated at Tarbat above Inverness, exhibits

Fig. 163. Inscribed stone from Tarbat (now in National Museums of Scotland, 1B 286) with angular display capitals resembling those of the Lindisfarne Gospels, Pictish/Columban, 8th century. (Photo: National Museums of Scotland. © Trustees of the National Museums of Scotland)

affiliations in its sculpture to those of Iona and Ireland, Pictland and Northumbria in its interlace and fretwork, its animal ornament and its figure style (the Apostles stone in the Tarbat Discovery Centre exhibiting a linear figural style akin to that of the Lindisfarne Gospels and the Book of Kells). One of the Tarbat stones, now in the National Museum of Scotland, even features a lengthy inscription carved in a form of Lindisfarne's angular display capitals (see fig. 163). The deep relief of its carvings (even those closest to Pictish style, such as the beautiful calf-stone), rather than the shallow incisions of earlier Pictish art, also speaks of other cultural affiliations. A specific historical link is suggested, although by no means proven, by the dedication of the church there to St Colman, who may be the bishop of Lindisfarne who left after the Synod of Whitby, taking with him some of the relics of St Aidan. Communications with Lindisfarne, as well as with other Columban centres, may have continued in the house or houses which were his subsequent homes and the resting place(s) of Lindisfarne's founder, whose other relics stayed with the community of St Cuthbert.

An important contribution of the artist-scribe of the Lindisfarne Gospels was his

Fig. 164. Drawing of the
Bamburgh beast, Style II animal
ornament from a small gold filigree
panel excavated at Bamburgh,
Anglo-Saxon, 7th century.
(Photo: Bamburgh Castle)

adaptation of Style II, of which a pertinent example is the Bamburgh beast which adorns
a tiny gold plaque found at the royal site of Bamburgh close to Lindisfarne (now on display
in Bamburgh Castle, see fig. 164), into a new species. Its menagerie consists of recognisable
birds, hounds, stylised calf or bull-heads and a remarkably naturalistic cat head whose
stylised attenuated body has ingested a whole flock of birds on the Luke incipit page. As
we have seen in the foregoing discussion of the decorated incipit pages, the exegetical
symbolism of the cat and of the evangelist symbols extend the theological complexities
of the evangelist miniatures into the very ornament of the decorated text pages of the
Lindisfarne Gospels, a trend which was to be developed par excellence in the Book of
Kells.[233]

The innovative and gifted artist of the Lindisfarne Gospels is, on the basis of the
evidence that survives, adapting Style II to a new naturalism.[234] This would accord with
other aspects of Mediterranean influence apparent in the book's text, script and evangelist
miniatures. The inhabited vine-scrolls, invested in the Early Christian tradition with the
symbolism of the Eucharist and of Christ's sacrifice and triumph over death, which are
amongst the late seventh-century sculptured friezes of Jarrow and Hexham and which
are subsequently echoed on eighth-century sculptures such as the Bewcastle Cross and
the Pictish Hilton of Cadboll stone (Hilton of Cadboll, base, and National Museum of
Scotland, main stone), are populated by naturalistic figures, human, bird and beast (see figs
124, 165, 166).[235] A particularly elegant example is that now preserved at Jedburgh Abbey
(see fig. 114).[236] Jedburgh was a ninth-century Lindisfarne foundation and the vine-scroll
(altar-screen?) slab with its deeply carved birds and mouse is accordingly dated to that
century. However, its analogies are with the earlier works cited above, raising the question
of whether it might have come from an earlier Lindisfarne context or from another of its
daughter-houses.[237] Unlike these 'naturalistic' and almost three-dimensional sculptural
counterparts, the Lindisfarne Gospels' menagerie is more stylised in its two-dimensional
ornamental articulation, which demands that the forms are contorted into interlace. Its
menagerie may consist largely of readily distinguishable birds and beasts, but these are not
generally from identifiable species. The quadrupeds could be inspired by either the hounds
or lions of eastern hunting scenes and the birds combine the long beaks of the seabirds

Fig. 165. Vine scroll inhabited by an archer, from Hexham Abbey (now at Durham Cathedral), late 7th century. (Photo: by kind permission of the Dean and Chapter of Durham Cathedral)

which are such a dominant feature of the Northumbrian coastal landscape with the long-toed talons of eagles and the lappet-plumage of the parrots of Coptic and Byzantine textiles. There may be an exegetical purpose at work here, akin to that which led the sculptors of the Ruthwell and Bewcastle Crosses to depict the two beasts which acknowledge Christ, who stands upon them, as ambiguous, amorphous forms (Habbakuk 3.3 in the Old Latin version),[238] the eagle being a well-known symbol of resurrection (see the discussion of the St John evangelist miniature, above) and of the perpetual recollection of salvation through partaking of the Eucharist.[239] However, what we may be witnessing is the logical consequence of the adaptation of naturalistic forms to the exigencies of Style II interlace. The long-beaked birds fulfil the linking, biting function of the Style II long-snouted beasts, while their talons function like the feathered feet of their Style II counterparts.

Another remarkable achievement of the Lindisfarne Gospels' artist is that he has grafted his zoomorphic forms onto true interlace patterns laid out on a grid, in the same manner as the Insular sculptor and metalworker would do.[240] Perhaps his skills also included mastery of working in one of these media? The use of grids in laying out designs is an ancient one, found from at least as early as the second century BC on an Egyptian pattern-piece (Berlin, Staatliche Museen Preussischer Kulturbesitz, Ägyptisches Museum, Papyrussammlung Inv. No. P 13558) and was well-known in the Insular and Viking worlds.[241] The

Fig. 166. Coptic inhabited vine scroll, 5th or 6th century. BM, EA 1611.
(Photo: courtesy of the Trustees of the British Museum)

closest stylistic analogies for this sort of 'naturalistic' zoomorphic interlace, which is thought to have originated in the calligraphy of the scriptorium, are to be found on sculptures dating from the eighth century from the Lothian area, which came under Lindisfarne's aegis, notably the interlaced birds on the cross-shaft from Aberlady (National Museums of Scotland; see fig. 167), the interlaced quadrupeds and the independent birds on their vine-scroll on the tall, slender cross shaft at Abercorn (which, along with the Acca cross at Hexham, is the closest we can come to an idea of the appearance of Bishop Aethilwald of Lindisfarne's cross; see fig. 168),[242] the cross-shaft from Coldingham (a double daughter-house of Lindisfarne's) with its double-contoured zoomorphic interlace (National Museum of Scotland) and the later eighth- or ninth-century cross shaft from Lindisfarne (Lindisfarne Priory Museum; see fig. 169). It is also to be found adorning many of the highest quality examples of Christian Celtic metalwork from Ireland and Scotland. These include the Tara brooch, the Ardagh chalice, the Derrynaflan paten and the Donore hoard metalwork (all in the National Museum of Ireland; see figs 129, 139) and the Hunterston and Dunbeath brooches (National Museum of Scotland; see fig. 130).[243] Other examples of the new style have also been found in England, including the bird ornament on a glass stud recently found at Freckenham, (BM, MME 2002, 5–2.1; see fig. 170) and the opposed interlaced birds on the mid-eighth-century Brandon pin head (Suffolk Co. Council, Archaeological Unit, Inv. No. BRD O18 0602). A particular detail of the

Fig. 167. The Aberlady cross shaft (now in the National Museums of Scotland), with interlaced birds resembling those of the Lindisfarne Gospels, from a daughter-house of Lindisfarne's on the southern shore of the Firth of Forth. (Photo: National Museums of Scotland. © Trustees of the National Museums of Scotland)

Lindisfarne Gospels' animal ornament, the elegant interlaced quadrupeds with their sinuously arching, equine necks, which are executed in red dots as part of the background to the display lettering of the Mark incipit page (f. 95r, see pl. 17), finds its closest analogy on the eighth-century Pictish silver bowls from the St Ninian's Isle treasure (particularly National Museum of Scotland, FC269, which also features quadrupeds, see fig. 98),[244] the stippling recalling the punching of the metalwork, a technique practised in the Near East (for example, a silver bowl punched with marigolds and a cross from eighth- or ninth-century Iran, British Museum OA 1981-3-5.1)[245] and on Roman metalwork (such as the bowls from the third- to fourth-century Helmsdale hoard in the National Museum of Scotland).[246]

The new style of animal ornament that reached a creative peak in the Lindisfarne Gospels therefore exerted considerable influence upon the sculpture and metalwork of eighth-century northern Britain and Ireland and, to a lesser extent, upon other parts of Britain. It is a style which seems to have originated in the calligraphic penwork of the scriptorium, partly under the influence of design and layout techniques practised by the sculptor and metalworker and subsequently re-imported into their milieux. Its influence soon became widespread within the Insular manuscript tradition, with the animal-headed

379

Fig. 168. The Abercorn cross shaft (shown recumbent) with two interlaced beasts (left panel, their bent heads meeting in the middle at the bottom) and plant scroll reminiscent of the layout of the zoomorphic interlace of the Lindisfarne Gospels and the cover of the St Cuthbert Gospel. From a Pictish bishopric on the southern shore of the Firth of Forth, subsequently administered by Lindisfarne, 8th century. (Photo: the author)

lettering of the Durham Gospels and the Lindisfarne Gospels being echoed in works from such diverse backgrounds as the Columban Book of Kells, the Irish Stowe Missal, Macregol and Rawlinson Gospels, the Welsh Hereford Gospels, the Continental Trier Gospels from Echternach and the Cutbercht Gospels, the Kentish Vespasian Psalter and Stockholm Codex Aureus, and the Mercian Book of Cerne. Zoomorphic terminals to elements of decoration had, of course, featured earlier within Celtic, Germanic, classical and eastern art, as had the human head. The single human-headed initial encountered on the Lindisfarne Gospels' John incipit page (f. 211r, see pl. 25), which may be intended to represent the Matthew evangelist symbol, the man, can be found recurring in the Insular corpus in the Book of Kells, the Book of Armagh and the Book of Cerne (see figs 148, 149). The Lindisfarne Gospels themselves may not have been available for detailed study to many, even if visible as a source of inspiration at the shrine and on the altar on special feast days, but their style was certainly an influential one, perhaps because of their iconic status and because of the currency of the style in other more widely circulated books made within its immediate orbit.

The closest analogy to the intricate bird and beast interlace of the Lindisfarne Gospels is, however, the Lichfield Gospels. In its surviving cross-carpet page (p. 220, see pl. 28), the latter transposes the dense bird interlace of the Lindisfarne's Matthew and John carpet pages onto the Latin cross with square terminals of the Lindisfarne Jerome carpet page.

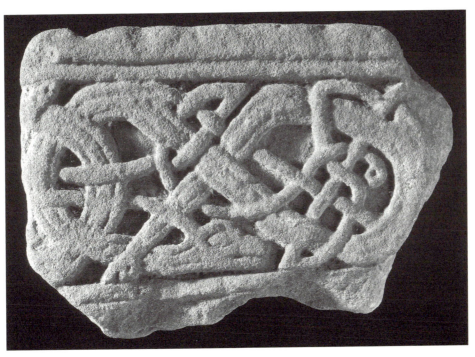

Fig. 169. Cross shaft with animal interlace (Lindisfarne Priory Museum, 81077047), late 8th or 9th century, Lindisfarne. The design still recalls the zoomorphic interlace of the earlier Lindisfarne Gospels. (Photo: courtesy of English Heritage)

As in Lindisfarne's Matthew carpet page the subtlety of the design is further complicated by both cross and background consisting of rhythmic patterns of bird interlace, but in Lichfield these patterns have become simpler and more strident, the lacertine forms composing themselves into sinuous double-stranded figure-of-eight loops, 'chi's ('x' shapes) and swastika-like patterns (the swastika being an ancient symbol of life frequently encountered in Egyptian and Roman art). These interlace patterns are more akin to those of eighth-century sculpture, such as the Aberlady shaft (see figs 152, 167).[247]

Here, as in its display script and in the overall design of its incipit-page monograms, as well as in the style of its display script and its half-uncial text script, the Lichfield Gospels presents itself as the closest stylistic heir of the Lindisfarne Gospels. Its two surviving evangelist miniatures (Mark and Luke) despite adopting the 'accompanied' form of human evangelist (identified by an accompanying symbol above), as found in Lindisfarne, depart from it in depicting the evangelists as enthroned authors, rather than scribes (see pl. 28). Mark's lion may have a vestigial trumpet or scroll issuing from its mouth, here more resembling a lolling tongue, and it has remembered to carry its Gospelbook, but it lacks its other attributes, halo and wings, while Luke's calf has forgotten all its trappings

381

Fig. 170. Stud with a spiral of bird ornament (BM, MME 2002.5-2,1) recalling that of the Lindisfarne Gospels, 8th century, found at Freckenham, Suffolk. (Illustrator: James Farrant, courtesy of the Trustees of the British Museum)

and stares out boldly at the viewer in emulation of its evangelist figure below, who sits brandishing the rod and cross-headed staff as he stares full-frontally at the viewer in an attitude midway between that of the Lindisfarne St John/Christ in Majesty and the corresponding image in the Book of Kells (f. 291v, see pl. 32d). The stylised drapery conventions in Lichfield are also closer to those of the Echternach Gospels' Matthew symbol (see pl. 30a), the Durham Gospels' Crucifixion (see pl. 26) and later Irish evangelist miniatures, such as those of the Macregol Gospels (see fig. 95). This over-emphatic stylisation, the drapery swags resembling large tear-drops in part, may have been indebted to a tradition which began earlier in Mediterranean areas such as Coptic Egypt and of which a pertinent example is to be found in the West in the drapery enveloping the enthroned figure on a textile which became part of the cult of St Kunibert and which is now preserved in the treasury of the Church of St Kunibert in Cologne.

The Lichfield Gospels thus appears to have looked backwards towards stylistic and iconographic elements of the Echternach, Durham and Lindisfarne Gospels and forwards to those of the Book of Kells and later Irish works. We do not know where it was made, but in the early ninth century it was redeemed and given to the church of St Teilo at Llandeilo Fawr in Wales by Gelhi, son of Arihtiud in return for his best horse. We know not with whom he traded, but given the obvious analogy with a similar fate having befallen the Stockholm Codex Aureus, which was ransomed from the Vikings by an English ealdorman and his wife, the possibility that Lichfield had also been seized somewhere as Viking loot is a strong one (see the inscriptions recording these transactions in

figs 152, 153). The impression gained is that it too was a product of an ultimately Columban network of foundations which shared a pool of artistic traditions and references. That it was made in Anglo-Saxon territory, rather that in Ireland, Scotland or Wales, would seem to me to be confirmed by its use of full runic characters in its display script.

The Lindisfarne Gospels would appear to have been an influential part of such a shared tradition, but not to have served as the immediate, closely examined exemplar for many subsequent works. This would be in keeping with a scenario in which it served as an inspirational but relatively inaccessible focal point (probably as part of a cult focus) within a tradition of which it was still a part and which extended to later Columban and Irish works, as well exerting a more limited influence upon Insular art in general, as practised in centres on the Continent and in those elsewhere in England which also retained a recollection of Celtic participation in the evangelisation process and perhaps of origins as part of the Lindisfarne *parochia*.

The animal interlace is combined, in the Lindisfarne Gospels and related works already cited, with a swirling vortex of abstract spiralwork and curvilinear trumpet and pelta forms derived from Celtic La Tène art. The movement implicit in these designs is reminiscent of the flow of water and air and the burgeoning of plant life (some of the Iron Age designs being ultimately abstracted from Mediterranean foliate decoration). An analogy with the creatures and forces of Earth, Air and Water in Genesis 1 is suggested. If such connotations were understood by those responsible for such designs, the decoration of the Lindisfarne Gospels might be seen as a celebration of all Creation partaking of the Word. Like Style II, the Celtic ornament enjoyed too wide a currency to be region-specific. Nor are the Irish and Pictish/Scottish contexts the only possible source, as the La Tène style was also prevalent in the British enclaves of England and Scotland, as artefacts such as the ball from Walston, the silver sheet from Norrie's Law and the engraved mount from Balmaclellan (all National Museum of Scotland) show.[248] The corpus of seventh-century hanging-bowls and brooches of Celtic and British manufacture found in English contexts should be borne in mind here too, as should the occurrence of a number of British names within the benefactors recorded on the pages of the Durham *Liber Vitae*.

The spiralwork often terminates in the Lindisfarne Gospels in zoomorphic terminals, as do many of its display letters and decorated initials. These can also be found in the Durham Gospels and, in the form of three beast or bird heads terminating a spiraliform pattern, on a plethora of works as diverse as the Irish Ahenny crosses and the Kentish Vespasian Psalter. Likewise, the fret and step patterns of the Lindisfarne Gospels (widely encountered around the Mediterranean as a legacy from Graeco-Roman art) can be observed on metal-work from the Sutton Hoo excavations, and other masterpieces of seventh-century Anglo-Saxon art such as the Kingston Down brooch (Liverpool Museum, Inv. No. M 6226, see fig. 171), the Wickhambreux stud from Kent (BM, MME 1905, 4–18, 16, see fig. 172) on Irish studs such as those adorning eighth-century Irish masterpieces, such as the 'Tara'

Fig. 171. Kingston Down brooch (Liverpool Museum, National Museums and Galleries on Merseyside, Inv. No. M 6226), Anglo-Saxon, early 7th century. The central roundel of the Lindisfarne Gospels' Mark carpet page (f. 94v) is drawn perspectively to simulate a boss such as the central one here, and in fig. 172). (Photo: courtesy of the Board of Trustees of the National Museums and Galleries on Merseyside: Liverpool Museum)

brooch (Nat. Mus. Ireland, R 4015, see fig. 19), the Derrynaflan paten (Nat. Mus. Ireland, 1980:4–5, see fig. 139) and the Ardagh Chalice (Nat. Mus. Ireland, 1874:99, see fig. 97), the Deer Parks Farm stud from Co. Antrim (Ulster Museum, DPF 2401), the Lagore Crannog glass stud mould from Co. Meath (Nat. Mus. Ireland, E14:1572,a,b, see fig. 162) and the late seventh- to early eighth-century Hunterston brooch (National Museum of Scotland, FC8, see fig. 130) from Scotland.[249] Such patterns can also be found adorning sculptures (often along with interlace and La Tène ornament) from sites as diverse as the Ahenny high-crosses (near Cashel, see figs 15, 16),[250] the sculptures at St Maelrubha's monastery at Applecross on the west coast of Scotland, the sculptures at Tarbat and elsewhere in Pictland (e.g. the Nigg, Shandwick and Rosemarkie slabs), the Lothians (Abercorn, see fig. 168), Rheged (Hoddom) and Northumbria (including those at Lindisfarne itself).

The Lindisfarne Gospels did not begin the trend of artistic cultural fusion (as we have seen, the phenomenon can be observed in the seventh-century metalworking material from Dunadd and the Mote of Mark and in the Book of Durrow and the Durham Gospels). However, it certainly refined the process and combined it with an informed approach to script as a cultural signifier in its display fusions of Roman, runic and Greek letter-forms. It synthesised all of its varied ethnic ingredients, some of which were born of a century or more of cultural, religious and political regional interaction, expansionism and alliance, and unified them in an homogenous whole. This effectively became a new artistic style and rapidly assumed a widespread currency, accelerating an existing process of diffusion, throughout much of the Insular world. Such an approach can also be observed in the David miniature of the Vespasian Psalter (see fig. 40), a near-contemporary book from Kent,

Fig. 172. The Wickhambreux stud
(BM, MME 1905.4-18.16), Kent,
7th century. (Photo: courtesy of the
Trustees of the British Museum)

wherein La Tène spiralwork infills an architectural arcade supported on interlace-filled columns with capitals/bases/roundels containing independent birds and beasts, supported on a base containing fretwork and terminating in animal interlace, this architectural frame containing human figures in Mediterranean style and flanked by Byzantine foliate motifs. Here all the cultural and ethnic stylistic indicators can be readily isolated; in the Lindisfarne Gospels they are fully integrated and transformed into a new statement of combined identity.

In terms of its ornament, as is also the case with its scripts and text, the Lindisfarne Gospels therefore finds their proper context in early eighth-century north-eastern Britain. This was an area where ancient Celtic, Roman and Post-Roman artistic traditions flourished and were interwoven with the Germanic tastes of its Anglo-Saxon overlords and the Columban and Mediterranean strands of its Church tradition. The context for cultural fusion has been seen to have been an extended one, regionally and chronologically, and does not betoken exclusivity. Nonetheless, the closest *in situ* sculptural analogies for the more innovative aspects of its decoration, notably its distinctive new brand of animal interlace (which merged Style II with a new naturalism gleaned from the more 'romanising' stylistic elements of the English Church), its distinctive display script with its epigraphic context, and its linear figure style (for which the closest comparison remains the Cuthbert coffin of 698), lie within the area of 'Islandshire', 'Norhamshire' and the Lothians, a region administered by the bishopric of Lindisfarne for most of the period in question, and, more precisely, on Holy Island itself. The prestigious and resource-rich nature of the Lindisfarne Gospels speak of a powerful and well-endowed foundation which was probably the home of a major cult (by analogy with the Book of Durrow and the Book of Kells) and which

had built up a complex web of cultural, historical and ecclesiastical affiliations. Lindisfarne presents itself as the logical candidate for the likeliest place of origin.

Like the distinctive zoomorphic repertoire of the Lindisfarne Gospels, their organic spirals and geometric motifs, and even their figural forms, are derived from a widespread vocabulary which had already been enjoying quite widespread currency, having been inherited from the artistic styles of the classical world and northern European prehistory. The trend towards uniting them had begun prior to the making of the Lindisfarne Gospels, but within their pages these various forms achieved new heights of accomplishment, carried forward by the flexibility of the quill and by the mastery of what seem to have been new techniques and fuelled by a structured intellectual agenda. The ingredients were thereby successfully synthesised into a seamless weave which was to form the underlying fabric of Insular art throughout the eighth century, and beyond.

Notes

1 O'Meara 1982, ch. 37. M. P. Brown 2002a.
2 For overviews of Insular illumination, see Nordenfalk 1977; Henry 1964; Alexander 1978; G. Henderson 1987; M. P. Brown 1991.
3 Campbell and Lane 1993; Lane and Campbell 2000; Youngs 1989.
4 Laing 1973, 1975; Longley 2001.
5 Wright 1967; G. Henderson 1987.
6 M. P. Brown 1996, 1998 and 2000; O'Reilly 1998 and 2001.
7 On carpet pages in general, see Calkins 1983, p. 42.
8 Henry 1964; Wilson 1984; Ryan 1983; G. Henderson 1987; Youngs 1989; Fox *et al.* 1990; Meehan 1994 and 1996.
9 Bonne 1995; Pirotte 1994; Stevenson 1981–2; Webster and Brown 1997, pp. 211–12, 234–5; M. P. Brown 2000.
10 Nordenfalk 1938.
11 This aspect of numeric symbolism provides an interesting link with the geometric principles underlying much of the design, as discussed below.
12 M. P. Brown 1996a.
13 Bede, *De Tabernaculo*, Bk II. See M. P. Brown 1996, pp. 123–4; for the general context, see Henderson 1999.
14 These fragments now form part of the Utrecht Psalter in Utrecht University Library (f. 102 carries the gilded incipit), see Van der Horst 1996, p. 31, fig. 6.
15 I am indebted to David Ganz for raising this example in this context with me.
16 Ó Floinn 1989.
17 Coatsworth in Verey *et al.* 1980, and Bruce-Mitford in *Cod. Lind.*, although see also Bruce-Mitford 1989. See also Verey 1989 and 1999.
18 T. J. Brown 1982.
19 Netzer 1994 and 1989.
20 See n. 128, p. 270, above.
21 *Cod. Lind.*, pp. 263–72.
22 Brown 1996a.
23 Results of the recent Raman laser analysis of the pigments used in the Lindisfarne Gospels appear in Appendix 2, along with a discussion of the technique used. The joint British Library, University College London Pigment Project headed by David Jacobs, a senior conservator at the British Library, conducted the pigment analysis. I acknowledge the valuable assistance of Professor Robin Clarke, of the Christopher

Ingold Laboratories Department of Chemistry of University College London for loan of the Raman instrument and his support which allowed the Lindisfarne Gospels and a number of manuscripts from both the western and oriental collections to be examined. The analysis was conducted by Katherine Brown, a member of that project, and David Jacobs and took place in the conservation laboratory of the British Library under the auspices of myself as the Curator of Illuminated Manuscripts. This team was also assisted by David French, another member of the British Library's conservation department, and the work was authorised by Helen Shenton, Head of Conservation and Preservation, and Alice Prochaska, Head of Special Collections at the British Library. I should like to express my thanks to all those concerned with this project. It is hoped that the project may benefit further in the future from a symbiosis with research currently under way at the Natural History Museum, London, into the identification of the geographical locations of mineral deposits, allowing the Raman spectra for individual areas of pigment in any manuscript to be assigned to specific regions.

24 Arsenic deposits do occur in Britain, for example in Cornwall, but imported orpiment has also been found in archaeological contexts, from the Sculptor's Cave at Covesea near Inverness where a small lump of the pigment imported from the Mediterreanean was found in a third- to fourth-century context, and a similar fragment from seventh-century Dunadd, both of which are exhibited in the National Museum of Scotland. See Lane and Campbell 2000, pp. 212, 243, 247 and 254.

25 It should be noted that the specific laser required for more precise identification of organic pigments is not portable and could not, therefore, be used in the analysis of British Library manuscripts. The amount of fluorescence observed did, however, allow the conclusion that a plant extract, rather than an animal extract such as the molluscs which yielded Tyrian purple, was used in the Lindisfarne Gospels, and also in other Insular and Byzantine manuscripts tested by this and other projects. The back-drawings did not produce a Raman spectrum, which suggests the use of a silver or lead-point, rather than carbon or graphite which would be expected if a modern pencil had been used. Silver and lead occur together geologically. The implement used may, of course, have included traces of both.

26 See the pigment analysis in Fox *et al.* 1990; Fuchs and Oltrogge 1994.

27 M. P. Brown 1996 and 2000.

28 Thompson 1960, pp. 10–11.

29 G. Henderson 1993. *Opus sectile* is essentially like a mosaic or jigsaw technique, using larger pieces of stone or clay.

30 Wessel 1965, p. 170. For a fuller discussion of Late Antique and Early Christian styles, see Kitzinger 1977.

31 On this symbolism and the context of the iconoclasm debate, see the discussion of the cross-carpet pages, below.

32 M. P. Brown 2000.

33 Van der Horst 1996.

34 Whitelock 1979, no. 154; Levison and Tangl 1968.

35 *Cod. Lind.*, pp. 263–72; Backhouse 1981; Scheller 1995. For recent research on the design processes and materials of the Lindisfarne Gospels, see M. P. Brown 2000.

36 For a ninth-century continental example of the same phenomenon, with stylus drawings guiding the painting of Canon Tables on either side of the leaf, see Hahn 1988, p. 82, n. 10.

37 Thompson 1960, discussed in 'layout' in chapter four, above.

38 Kauffmann 1975, no. 105. I am indebted to Alixe Bovey for drawing my attention to the pouncing therein.

39 For a discussion of working methods, see Scheller 1995 and Alexander 1993.

40 See the discussion of the zoomorphic ornament, below.

41 Stevick 1994; see the discussion below.

42 Youngs 1989, nos 63–6 and discussion therein by Michael Ryan, p. 127.

43 On the Shanmullagh plate, see Bourke 1998. See Ryan in Youngs 1989, p. 67. On a similar connection with Irish filigree metalwork, see Whitfield 1987. On the cultural background, see, for example, Cramp 1986; Hamerow and MacGregor 1999.

44 Youngs 1989, p. 127, fig. 3; Henderson and Okasha 1992.

45 Youngs 1989, nos 69 and 155; on the Hunterston brooch see Stevick's forthcoming paper in *Medieval Archaeology*, and for the layout of the 'Tara' brooch see Stevick 1998; for a full discussion of the layout

technique, and a comparison with those of the Lindisfarne Gospels, see Whitfield 1999, where she also discusses the use of a 9mm unit of measurement which may have been influenced by Roman systems of measurement.

46 This was fully discussed by Bruce-Mitford in *Cod. Lind.*, pp. 226–31 and is summarised in the introduction to Alexander 1978, fig. 3.

47 Coatsworth 1989, pp. 293–4; Coatsworth and Pinder 2002.

48 Bruce-Mitford in *Cod. Lind.*, pp. 226–30; Guilmain 1987; Stevick 1983, 1986 and 1994.

49 Stevick 1994; Cramp 1989.

50 Cramp 1989; O'Meadhra 1979.

51 Stevick 1994, p. 4.

52 Stevick 1994, pp. 90–1 and 102–7.

53 As in the early eleventh-century English scientific miscellany, British Library, Cotton MS Tiberius B.v.

54 Based upon Boethius, Proemium to the first book of *De institutione arithmetica*, transl. Masi 1983, p. 73; Stevick 1994, p. 13.

55 For a detailed discussion of the underlying mathematical principles and of the details of layout in the Lindisfarne Gospels, see Stevick 1994, pp. 102–15, 140–50, 197–200. See also Stevick 1983.

56 Stevick 1994, p. 200.

57 For the Stowe Missal (Dublin, Royal Irish Academy, MS D.II.3, f. 12 onwards), an Irish manuscript of late eighth- or early ninth-century date, see Alexander 1978, no. 51, pl. 217.

58 For a discussion of the spiritual context for production, see Brown 2000 and O'Reilly 2001.

59 Discussed under layout in chapter four, above.

60 *Cod. Lind.*, p. 38. They occasionally sprout 'whiplash' penwork tails (e.g. the penultimate line of f. 211v a) of the sort found in the Echternach Gospels, the Augsburg Gospels and in parts of the Cambridge-London Gospels.

61 For the Insular context and the beginnings of the use of decoration for textual articulation from the time of the earliest extant Irish manuscripts, such as the Codex Usserianus Primus and the Cathach onwards, see Farr 1997, especially pp. 15–17, 42–3, 46–50, 80–6, 117 and 120.

62 In medieval cathedral schools and universities, from the twelfth century onwards, masters would exhort their pupils to memorise texts by using the visual appearance of the page as a prompt.

63 See chapter three on 'Text' in the present volume.

64 Nordenfalk 1938; Alexander 1978, no. 9.

65 Nordenfalk 1938; *Cod. Lind.*, p. 33.

66 This copy was possibly made for Victor himself, perhaps at Capua where he was bishop (541–54), and subsequently belonged to the Anglo-Saxon missionary St Boniface. It contains a Gospel harmony (or diatessaron, not generally influential in the West until central Middle Ages) and an essentially Vulgate Gospel text, similar to the prototype for the Ceolfrith Bibles and the Lindisfarne Gospels; see McGurk 1955, p. 12). CLA 8.1196.

67 Netzer 1994a.

68 Alexander 1978, p. 37.

69 Or those in the sixth-century Syrian Rabbula Gospels; Nersessian 2001, no. 108. See also the Golden Canon Tables, British Library, Add. MS 5111.

70 Although in Amiatinus there is some possibility that the Majesty miniature was once part of the prefatory quire of tables and images.

71 McGurk 1955, p. 16.

72 M. P. Brown 2000; O'Reilly 2001. The themes manifest in Amiatinus' Tabernacle diagram, the process of transmission of sacred text embodied in its Ezra miniature, and its 'Majesty' page in which Christ, flanked by cherubim and evangelists, becomes the Ark, are also explored in Lindisfarne's Matthew miniature.

73 Nordenfalk 1938; McGurk 1955; Netzer 1994. See discussion of the Text in chapter three of the present volume, above.

74 Nordenfalk 1938.

75 See the discussion in chapter three, above.

76 Backhouse 1981. There may be some evidence for this approach to craftsmanship in the Islamic tradition,

but it does not seem to have enjoyed currency within the western exegetical corpus.

77 M. P. Brown 1996, 1996a and 2000.

78 Bonne 1995; Pirotte 1994 and 2001.

79 Werner 1994.

80 Bede, *De Tabernaculo*; Farr 1999.

81 Stevenson 1981/2.

82 Battiscombe 1956; Bonner 1989; Calkins 1983.

83 Ryan 1983; Youngs 1989.

84 T. J. Brown 1984.

85 Wright 1967.

86 Ó Carragáin *et al.* 2001 and forthcoming.

87 Henry 1964; Ryan 1983; Youngs 1989.

88 Illustrated in Alexander 1978, figs 12–13.

89 For the former, and for such patterned bindings, see for example, Cramer 1964 and for the latter, Avrin 1991, who also points to a resemblance between the 'tabula ansata' projections from the sides of such designs with the zoomorphic 'escutcheons' of the Lindisfarne Gospels carpet pages. For a comparison of a Coptic binding of the seventh–eighth century (New York, Pierpont Morgan Library, MS 569) with the St Cuthbert Gospel, see Avrin 1991, p. 310.

90 See, for example, De Hamel 2001, pp. 44–5, pl. 27, British Library, Or. MS 2628, a Hebrew Bible from Lisbon 1483.

91 Cramer 1964, pl. 31.

92 Illustrated in Alexander 1978, fig. 14 and no. 6, pls 11, 12, 13, 20, 21, 22. A seventh, preceding Matthew's Gospel, may have been lost.

93 Alexander 1978, no. 3, pl. 6 and, for a discussion of the origins of carpet pages, see p. 11.

94 Alexander 1978, no. 21, pl. 77.

95 Alexander 1978, no. 24, pl. 119.

96 Alexander 1978, no. 44, pl. 200.

97 Alexander 1978, no. 52, pl. 245. Kells also features several four-symbols pages.

98 Alexander 1978, no. 56, pl. 273.

99 Alexander 1978, no. 58, pl. 282.

100 Alexander 1978, no. 61, pls 277–8.

101 Alexander 1978, nos 25, pls 117–18 and no. 30, pls 138–9.

102 Farr 1989.

103 This feature was adopted from earlier Italian manuscript production, see discussion in chapter four, above.

104 Mitchell 2001; see also Stevenson 1981–2 and M. P. Brown 2000.

105 Cassiodorus, *Institutiones*, see Migne 1844–64, LXX, cols 1144–5; M. P. Brown 2001, p. 14.

106 Mitchell 2001, pp. 164–5.

107 Moulds for such glass bosses have also been excavated on Iona; Susan Youngs, pers. comm.

108 See Bailey 1996, fig. 12 for the former and Webster and Backhouse 1991, no. 135, and also no. 133 for the latter.

109 Polychrome studs also occur on the 'Tara' brooch and the Moylough belt shrine and a mould for them has been excavated at Tarbat.

110 See, for example, Mac Lean 1995.

111 Bailey 1996, pp. 10–11 and 1996a. For Lastingham, see Lang 1991, pls 582–3.

112 Nersessian 2001, no. 14.

113 It was the practice to dedicate altars with a cross, as, for example, those inscribed on the wooden core of the portable altar which is one of St Cuthbert's relics. See, for example, some of the Ordines in Andrieu 1948.

114 For a full discussion of this subject, see Ó Carragáin forthcoming. I am deeply indebted to Professor Ó Carragáin for kindly granting access to his text, prior to publication, and for much valuable discussion. On the cross in art and liturgy, see Raw 1990. See also Stevens and Cook 1977.

115 Mohlberg 1927, no. 665, p. 54; text from Deshusses 1979, I, p. 271 (= Introit, Hadrianum no. 690).

116 Van Tongeren 1998, pp 243–5.

117 Andrieu 1948, III, p. 293.

118 See Ó Carragáin 1987, 1994 and forthcoming. On early Irish pilgrimage rounds see Herity 1989. On the archaeological and textual evidence, see the discussion in chapter one, above.

119 This is thought to date from the seventh century and belongs to a region in Co. Donegal with strong Patrician and Columban traditions.

120 With some intentional disparities in measurement, as noted by Stevick 1994, pp. 90–1 and 102–7.

121 Bonne 1995.

122 Werner 1990. On a similar theme in relation to the Book of Kells, see Werner 1994.

123 Ó Carragáin 1994, pp. 26–7.

124 Ó Carragáin 1994 and forthcoming. On the principle, see Angenendt 2000, pp. 295–303 and Ó Carragáin 1999b, pp. 201–3.

125 Chrysos 1999.

126 M. P. Brown 2000, p. 2.

127 Ayerst and Fisher 1977, pp. 101–2; Chazelle 1990; M. P. Brown 2000, p. 4.

128 DACL, p. 3083; see also the general discussion here on the Cross.

129 DACL, p. 3083, fn. 4–5; Millet 1910; Ó Carragáin et al. 2001.

130 Pirotte 1994; Bonne 1995.

131 Nersessian 2001, no. 108.

132 Ó Carragáin forthcoming.

133 Swanton 1970.

134 See the full discussion in Ó Carragáin forthcoming; Backhouse et al. 1984, no. 75.

135 Hauck 1974.

136 Avrin 1991.

137 Henderson and Okasha 1992; M. P. Brown 1989.

138 Karkov 1993.

139 M. P. Brown 2000.

140 Bailey 1996, p. 2.

141 See also the discussion in Ryan 1991, pp. 122–6.

142 Ó Carragáin forthcoming.

143 Ó Carragáin forthcoming.

144 Niamh Whitfield informs me, pers. comm., that she only perceives the dotted motifs in the Lindisfarne Gospels, such as the 'Autem' on f. 29r and the interlace on f. 95r, as having a direct link with filigree metalwork. There is very little niello work in the Irish and 'Hiberno-Saxon' metalwork corpus, although it does occur on the Steeple Bumpstead boss and in southern English metalwork, especially of the later eighth century onwards. On the techniques used to produce black backgrounds in examples of Insular metalwork such as the 'Tara' brooch, see Whitfield 1997.

145 M. P. Brown 2000; Chrysos 2000.

146 Ó Carragáin et al. 2001.

147 Whitfield 1997a, pp. 235–7.

148 Backhouse 1981.

149 Niamh Whitfield informs me, pers. comm., that she sees these more as a 'Celtic' version of the classical lion mask.

150 Battiscombe 1956; Page 1956, pp. 316–17, 321–4.

151 For Bonner and Higgitt, see Cramp 1989, p. 225, and on the relationship of text and image on the Ruthwell Cross, the Cuthbert coffin and the portable altar, the Lindisfarne name-stones and the Lindisfarne Gospels, see Cramp 1989, p. 221, where she says that 'it is, then, a tradition clearly established in the first or second phase of Lindisfarne life'. Nonetheless, whenever the ecclesiastical affiliations and stylistic affinities of the Ruthwell are discussed there is a tendency to favour an association with Wearmouth/Jarrow. Given the text/image relationship and the historical context of Lindisfarne's 'vice-regency' of northern Bernicia and neighbouring areas, perhaps Lindisfarne should be considered as a viable alternative focal point for Ruthwell's designers. Ó Carragáin, for example, would see it as an expression of the same 'eirenic'

tendencies which underpinned the suggested collaboration between Wearmouth/Jarrow and Lindisfarne, see Ó Carragáin, forthcoming.

152 See the discussion of the use of ornament to articulate the text, above, and of the liturgical component of the text in chapter three, above.

153 For a discussion of this, and for the interpretation of the Temptation miniature as a multivalent image simultaneously representing the Communion of Saints, see Farr 1997.

154 Translations from the Gospels taken from the *The Holy Bible, New International Version* (London 1980).

155 Youngs 1989, nos 97 and 98.

156 Berschin 1980.

157 Alexander 1978, nos 29 and 30; Van der Horst 1996.

158 For a brief contextual introduction see, for example, Brown 1998a, p. 10.

159 Youngs 1989, nos 97 and 98.

160 Alexander 1978, nos 52 and 53; M. P. Brown 1996 and 1998.

161 Webster and Backhouse 1991, nos 14–15, for example.

162 Battiscombe 1956.

163 The Pangur bán poem is translated by Greene and O'Connor 1967, pp. 82–3 as follows:

'Myself and White Pangur are each at his own trade; he has his mind on hunting, my mind is on my own task.

Better than any fame I prefer peace with my book, pursuing knowledge; White Pangur does not envy me, he loves his own childish trade.

A tale without boredom when we are at home alone, we have – interminable fun – something on which to exercise our skill.

Sometimes, after desperate battles, a mouse is caught in his net; as for me there falls in my net some difficult law hard to comprehend.

He points his clear bright eye against a wall; I point my own clear one, feeble as it is, against the power of knowledge.

He is happy and darts around when a mouse sticks in his sharp claw, and I am happy in understanding some dear, difficult problem.

However long we are like that, neither disturbs the other; each of us loves his trade and enjoys it all alone.

The job he does every day is the one for which he is fit; I am competent at my own job, bringing darkness to light.'

The text may be partly inspired by the injunctions to appropriate labour of Thessalonians 2. It was written in the margins of a book from the monastery of St Paul in Carinthia in the early ninth century. The title is often translated as 'White Pangur' but 'bán' is more properly the term for excrement. Cats were highly valued in Celtic society, to judge from the provisions of the law-codes, and featured in mythology, such as the three monstrous cats who guarded the Cave of Cruachan, the entrance to the otherworld. The Pictish territory of Caithness took its name from the ancient province of Cat, named after the founder of the Tuatha Cruithne. See Berresford Ellis 1987, p. 56; Watson 1926, p. 30.

164 For a discussion of the Christian use of cat iconography, see Lewis 1980.

165 See M. P. Brown and E. Rynne in O'Mahony 1989; M. P. Brown 1996.

166 M. P. Brown 1996. The Lindisfarne head might also, less convincingly, be a word play on principio/princeps alluding to royalty (divine and/or secular) or 'principia', the (spiritual) front-line.

167 For examples of this approach, see O'Reilly 1993, pp. 110–11, and O'Reilly 1998 and 2001; Ó Carragáin *et al.* 2001 and forthcoming; Farr 1997 and forthcoming; M. P. Brown 1996 and 1998. On biblical commentaries and the Insular context see, for example, Bischoff and Lapidge 1994, Stansbury 1999 and McNally 1971.

168 Leclercq 1961, pp. 78–9; Bailey 1996, p. 2.

169 Migne 1844–64, xv, ed. 1532.

170 Verses 1–2 of his Homily iv, Book 1, Homiliae in Ezechielem, Migne 1844–64, LXXVI, col. 815.

171 Migne 1844–64, XCIII, col. 144 and XCI, col. 403; M. P. Brown 1998, p. 120.

172 M. P. Brown 1994, 1996 and 1998, p. 120.

173 M. P. Brown 1996 and 1998.

174 On the early history of evangelist imagery see, for example, Nordenfalk and Grabar 1957; Nordenfalk 1968; Schapiro 1973; G. Henderson 1987, *passim*, but especially pp. 115–22.

175 M. P. Brown 1996, p. 108; Papagiannopoulos 1981, pp. 57–9.

176 M. P. Brown 1996 and 1998.

177 See the discussion of the miniature of St John, below.

178 On the *apertio aurium*, and its continued relevance during the seventh and eighth centuries, see Ó Carragáin 1987; see also M. P. Brown 1996, pp. 109–15 and 1998, p. 126.

179 M. P. Brown 1996 and 1998.

180 *Cod. Lind.*, p. 142–61; Cramp 1989.

181 See Cramp 1989.

182 M. P. Brown 1996, pp. 107–8.

183 Temple 1976, no. 47, pl. 154. See also Farr in G. H. Brown and C. Karkov forthcoming.

184 T. A. M. Bishop 1967, 33–41; Temple 1976, p. 69.

185 *Cod. Lind.*, pp. 142–61; Temple 1976, p. 69.

186 For evidence of a hardpoint drawing of the Copenhagen Gospels' Matthew figure on the preceding folio which may be a tracing, possibly taken from the Lindisfarne Gospels, see Farr in G. H. Brown and C. Karkov forthcoming.

187 *Cod. Lind.*, pl. 32a.

188 *Cod. Lind.*, pls 31c (ivory depicting St Peter, with angel, dictating to St Mark; Victoria & Albert Museum, London), 32b (St Mark receiving his Gospel from St Peter; Paris, Institut Catholique, MS Copte-Arabe 1) and 32d (St Mark inspired by St Peter; Mt Athos, Kutlumusi 1, f. 112v). Discussed in *Cod. Lind.*, pp. 161–4.

189 Cramer 1964, pl. XI.

190 See Nees forthcoming.

191 Discussed further in chapter three on 'Text' in the present volume, above. The five sentences are quoted by Aldred introducing his colophon on f. 259r. They are written in a script heavily influenced by Insular half-uncial and may have been copied from an Insular volume, perhaps even the Lindisfarne Gospels themselves on a now missing leaf.

192 This identification first advanced by Koehler 1923, p. 11 onwards.

193 Argued by Williams 1965, pp. 76–9, and 1980, pp. 203–7, in respect also of several Spanish Beatus images. For a summary of the discussion, see Netzer 1994, pp. 100–2, pls 101–2.

194 See the discussion in chapter one, above.

195 M. P. Brown 1996, pp. 82–114.

196 M. P. Brown 1996, pp. 88–9; G. Henderson 1987, pp. 120–2.

197 O'Reilly 2001 and Farr 1999.

198 O'Reilly 2001.

199 For a range of such images of inspired evangelist scribes, with curtains as part of the design, from medieval Coptic art, see Cramer 1964, pp. 76–92.

200 See Lozanova *et al.* 2002, no. 99 (illustrated). It is also possible, of course, that the model for the Sofia manuscript had conflated these components from separate sources.

201 Meyvaert 1996, esp. pp. 870–82. Prior to this Bruce-Mitford 1967, pp. 11–14, had argued that Cassiodorus had depicted himself in the guise of Ezra to emphasise their shared 'achievements in the matter of holy writ'. The association with Cassiodorus was challenged by Corsano 1987, who viewed the Amiatinus Ezra, and other of its images, as Northumbrian inventions. G. Henderson 1993, defended the Cassiodoran association. For a survey of the debate, and detailed bibliography, see Marsden 1995, pp. 119–22. Nees has also recently summarised the argument and has added his own conclusion concerning these images in Amiatinus and Lindisfarne: 'They are likely overlapping contemporaries, likely drawing upon a shared source, rather than one the copy of the other', 1999, p. 157, n. 104.

202 See Bede, *De Templo* and *De Tabernaculo*, ed. D. Hurst, CCSL vol. 119A, 'Bedae Opera', Pars II 'Opera Exegetica', 2A, 1969. For English translations, see Bede, *On the Temple* and *On the Tabernacle*, Connolly and O'Reilly 1995 and Holder 1994.

203 G. H. Brown 1999, and 1996; O Carragàin 1994.

204 O'Reilly 2001.

205 *Ibid.*

206 I am grateful to Christopher Verey for drawing my attention to the relevance of this passage in respect of my suggestions here. George Henderson implied some association with the theme of Moses unveiled, 1987, p. 122.

207 The figure which has been interpreted as a deacon, bearing a book in his veiled hands, at the head of the Matthew incipit (f. 29r) in the Book of Kells may serve a similar iconographic function, descended from that of the Lindisfarne Matthew miniature and its figure behind the curtain. See Farr 1997.

208 O'Reilly 2001.

209 Michelli 1999, pp. 345–58. There remains much to recommend other aspects of this piece.

210 Cramp 1989; Bruce-Mitford in *Cod. Lind.*

211 The evident connection between these images means that, if the artist of the Lindisfarne Gospels copied his scribal evangelists from an existing earlier Italian Gospelbook, then the Amiatinus Ezra was likewise lifted from such a source rather than from a Cassiodoran image. Conversely, the Lindisfarne artist derived his Matthew figure from Amiatinus or its Cassiodoran source and adapted it for use in a new evangelistic context. I would tend to favour the latter, given the composite nature of Lindisfarne's evangelist miniatures, as discussed above.

212 Stansbury 1999, pp. 70–1. For discussions of the depictions of the evangelists in Insular art see, for example, M. P. Brown 1996, pp. 82–114 and 1998; O'Reilly 1998; G. Henderson 1987.

213 Farmer 1983, p. 128; Brown 2000.

214 M. P. Brown 1996 and 1998; O'Reilly 1998.

215 On the exegetical background to the evangelist miniatures, see M. P. Brown 1996 and 1998, and O'Reilly, 1998.

216 The Echternach Gospels thus display a similar set of exegetical concerns and employ an equally symbolic, if less complex, iconography to convey them. The recurrence of the 'imago …' formula of accompanying inscriptions in the evangelist miniatures of the Lindisfarne Gospels, the Echternach Gospels and the Cambridge-London Gospels is a noteworthy aspect of the similarities between these works and might suggest that they stem from a shared artistic and theological tradition. That this was also represented on the Continent is demonstrated by the Matthew miniature of the Trier Gospels, f. 18v) which adopts the same formula for image and inscription as the Echternach Gospels for this miniature alone.

217 M. P. Brown 1996.

218 M. P. Brown 2000.

219 See, for example, the encaustic painting on display in the Coptic gallery of the Metropolitan Museum, New York, or the sixth-century Coptic casket illustrated in Wessel 1965, pp. 170–1, pls XI and XII, or the sixth-century Coptic tempera painting on wood, see *ibid.*, pp. 172–3, pl. XIII, which feature human busts against a pink ground. A thick pink ground is likewise used in many Coptic frescoes, such as that depicting the saints from Saqqara, *ibid.*, p. 168, pl. X.

220 Cramp 1989.

221 For this, and interpretation in Irish commentary, see McNally 1971; Bailey 1996, p. 4.

222 Migne 1844–64, XVII, col. 694.

223 For a discussion of the significance of St John's Gospel in Insular thought, see M. P. Brown 2000.

224 For a full discussion of Style II, see Speake 1980; Marx 1995 gives an account of the body-shapes of quadrupeds in the Lindisfarne, Lichfield and St Gallen Gospels, pointing to a particularly close relationship between the two former.

225 On Dunadd, see Campbell and Lane 1993 and Lane and Campbell 2000; on the Mote of Mark, see Laing 1973, 1975, 1993 and Longley 2001; on the British background and the historical context for cultural fusion in Dumfries and Galloway, see Brooks 1991; Cramp 1995, for the implications for the debate concerning English or Irish origins of manuscripts displaying such mixed styles, see Ó Cróinín 1984. For an overview of the metalwork of the period, see Youngs 1989.

226 British Museum, MME 1977, 5–5, 1; see Nersessian 2001, no. 14, p. 111.

227 Dumville 1999; Schaumann 1978/9.

228 Petrucci 1971; McGurk 1961; Alexander 1978, no. 4.

229　Alexander 1978, no. 5.

230　*Ibid.*, no. 6.

231　*Ibid.*, no. 10.

232　A generic stylistic connection between sculptures at Monkwearmouth and the zoomorphic ornament of the Book of Durrow and the Lindisfarne Gospels was first noted by Miles 1898. The Style II analogy is actually much closer to Durrow and to the Durham Gospels than to Lindisfarne. See Cramp 1984, nos 9A, 17, 18, 19, 21); for Wamphray see Bailey 1996; on Lowther and Monkwearmouth, see the forthcoming Ph.D. thesis (Durham University) by Gwen Adcock, to whom I am deeply indebted for valuable discussion and access to drawings prior to submission of her thesis.

233　See, for example, discussions in O'Mahony 1994.

234　Wright 1967a. Other intermediaries may, of course, have been lost, but this aspect of creative response to new Mediterranean models is consistent with other aspects of stylistic, technical and textual innovation or development apparent in the Lindisfarne Gospels

235　At Jarrow bird heads are also incorporated into a straighforward interlacing pattern as part of a narrow architectural frieze (fragments preserved in the Bede's World Museum). During the seventh century some more independent and recognisable animal forms begin to emerge from their Style II background, such as the hound which prances along the bone handle from Fishergate, York (Yorkshire Museum, Inv. No. 198645.4618).

236　Webster and Backhouse 1991, no. 114.

237　Webster and Backhouse 1991, no. 114.

238　Ó Carragáin *et al.* 2001, p. 141.

239　See Bailey 1996, p. 4. See, for example, Gregory the Great's commentary on Ezekiel 17, 3–4, 'a great eagle … which … came to Lebanon and took the highest branch of the cedar' which he interprets as prophesying the Lord soaring heavenward, see Migne 1844–64, LXXVI, cols 815–16; see also Pseudo-Ambrose, 'Christ, after the venerated resurrection by which he taught that human kind can return to life after death, flew back to the Father like an eagle', see *ibid.*, XVII, col. 694.

240　On the use of grids in sculpture, see, for example, Bailey 1980 and Bailey 1978. For a useful summary explanation of some of the basic design principles underlying the construction of interlace, fretwork and zoomorphic decoration in Insular Gospelbooks, drawing upon earlier studies by J. Romilly Allen and George Bains, see Van Stone 1994.

241　See Scheller 1995, pp. 91–3.

242　The panel of two interlaced quadrupeds on the Abercorn cross not only relates to the design principles of the Lindisfarne Gospels' zoomorphic interlace but finds a very close, and previously unnoticed, parallel in a panel at the top of the frame of the Matthew miniature in the Barberini Gospels (f. 11v).

243　Youngs 1989, see especially the discussion by Michael Ryan, pp. 125–30.

244　Youngs 1989, no. 98.

245　Buckton 1994, no. 77.

246　The punched technique can also be observed on British Museum, Dept. of Islamic Antiquities, inv. 1981.3–5.1, a silver gilt repoussé bowl with marigolds and a central 'cross' motif from Iran, eighth to ninth century.

247　See the juxtaposition in G. Henderson 1987, p. 125.

248　See Cramp 1995; O'Sullivan 1993; Laing 1993.

249　All discussed and illustrated in Youngs 1989.

250　See Edwards 1985, on the origins of the Irish high-crosses.

CONCLUSION

Preaching with the pen in the scribal desert: the meaning and making of the Lindisfarne Gospels

After this protracted voyage of discovery, in which we have attempted to get to know the Lindisfarne Gospels and to explore their life and times, where does the jury stand? Who made them, where and when? In any detective story, not least an academic one, the denouement is a crucial factor and the evidence can now be reviewed. However, the true key to unlocking the mystery lies in answering the question 'Why?'

I have argued that an obvious debt to Wearmouth/Jarrow in terms of the mutual availability of the Lindisfarne Gospels' main textual exemplar, of the influence of its stately bilinear script and of its symbolic approach to iconographic figurae needs to be balanced judiciously against the wealth of evidence pointing to a context of manufacture other than in the Wearmouth/Jarrow scriptorium. This included the following:

The reliance upon different and not ostensibly Wearmouth/Jarrow sources for other textual and decorative components (the canon tables and the various evangelist miniatures).

Traces of a residual Columban background in the Gospels' textual variants; the use of half-uncial script which finds its closest parallels within the Columban tradition, both prior and subsequent.

The refinement of traditional Insular codicological methods of membrane preparation and arrangement (as opposed to the experimentation with late Antique or Continental methods encountered in Wearmouth/Jarrow products).

A divergent response to Wearmouth/Jarrow practices of dedicating the page and marking lections.

An unusual and innovative drafting technique which finds its closest parallels within Celtic metalworking traditions; a painting technique which, although indebted to Mediterranean art, finds its closest responses within the subsequent Columban tradition.

A stylistic contextual raft for the illumination in which elements of Irish, Pictish, Northumbrian and other Germanic and Mediterranean cultures are synthesised and which bears no relationship in its entirety to surviving books from Wearmouth/Jarrow, although some of its works served among the many visual and exegetically based sources consulted by the artist-scribe of the Lindisfarne Gospels.

Likewise, attempts to relocate the origins of books (notably the Echternach Gospels) which have in the past been thought to be closely related to the Lindisfarne Gospels stylistically (and by implication thereby the Lindisfarne Gospels themselves) to Ireland or Echternach, by locating the impetus for Willibrord's misson at the English colony of Ráth Melsigi in Ireland and by identifying continuing echoes of a relationship with subsequent products of the Echternach scriptorium such as the Augsburg Gospels, is but one element in the picture. A continuing dialogue with Ireland is already well evinced in a Columban context, one within which the monastery at Lindisfarne was firmly embedded, and in the close relationship of the Lindisfarne Gospels with examples of eighth-century Irish metalwork and sculpture, no less than with other Pictish material, and should not be considered as surprising historically as it has tended to be. However, the proximity of the relationship with Wearmouth/Jarrow and with other Anglo-Saxon monuments in a variety of media, and the stylistic integration of Anglo-Saxon runic features into its distinctive display script, would tend to preclude any idea of the Lindisfarne Gospels having been made in Ireland.

On balance, I favour Lindisfarne as the most likely venue for such a fusion of influences in the making of a major manuscript which, by the very nature of the care and resources lavished upon its production, is likely to have been planned as a cult object. This is most likely to have occurred during a period in which St Cuthbert's community on Holy Island, led by Bishop Eadfrith, is known to have been engaged in collaboration with Wearmouth/ Jarrow, and in direct communication with Bede, during the first quarter of the eighth century (rather than the final decades of the seventh century as traditionally thought). Considerable time and resource would have had to be allocated to the project and this does not accord with the account of the translation in 698, the celebrations surrounding which seem to have been 'stepped up' only after the discovery of the incorrupt status of Cuthbert's corporeal relics at that time. That the opening of the tomb occurred in Lent, and its results had to be relayed to the bishop whilst he was in retreat, argues against a major planned event which would have had to include at least a five-year period in which to make the Lindisfarne Gospels. Other factors also tend to support a probable date of production during the second decade of the eighth century: contemporaneous attempts to establish a cult of St Wilfrid at Ripon, with a book as a major focal point; manufacturing features, including the unavailability to finish the work of its remarkably dedicated single artist-scribe (who is likely to have been a very senior and important member of the monastic community and who there is reason to suspect, even without the colophon, could

have been Bishop Eadfrith); the inclusion of liturgical features which were being integrated into, and promoted as part of, the Roman rite around 715. The stylistic context would favour a date within the first half of the eighth century, with the relationship between the Lindisfarne Gospels and the Ceolfrith Bibles, known to have been made before 716 when Ceolfrith set off for Rome taking the Codex Amiatinus with him, and with the figural engravings and inscriptions on the St Cuthbert coffin, known to have received his relics at the translation of 698, providing the only fixed chronological points of reference and reinforcing a dating for the Lindisfarne Gospels within the first quarter of the eighth century, rather than the second. The dating for the planning, making, completion and binding of the Lindisfarne Gospels therefore sits most convincingly somewhere within the span 710–25, with the work of the artist-scribe falling around 715–20. The final stages of his work were not completed and Eadfrith's death in 721 may have had something to do with this.

More significant than the who, where and when remains the importance of the Lindisfarne Gospels as an outstanding and innovative monument of book production and of art, and its place within the history of the dissemination of the Gospels and within the formation of a fully integrated, synthesised Insular culture which was confidently sited within the broader Christian ecumen.

What might it actually have meant to those who dedicated their lives to God's service to be entrusted with the transmission of his Word, as preachers and as scribes? I would propose the extension of the metaphor of the scholar-priest to that of the scribe-priest. In a letter to Bishop Acca of Hexham concerning his commentary on Luke, Bede says that 'I have subjected myself to that burden of work in which, as in innumerable bonds of monastic servitude which I shall pass over, I was myself at once dictator, notary, and scribe' ('ipse mihi dictator simul notarius et librarius existeren'; note the use of the term *librarius* for 'scribe', or preserver).[1] This revealing passage shows that he regarded such work as an expression of monastic humility, an act of *opus dei*, and that he differentiated between the functions of author, note-taker and formal scribal transmitter. Cassiodorus, in his *Institutiones*, said that each word written by the monastic scribe was 'a wound on Satan's body', thereby ascribing to the scribe the role of *miles Christi*, or soldier of Christ. In the same work he says that in those who translate, expand or humbly copy Scripture the Spirit continues to work, as in the biblical authors who were first inspired to write them. Indeed, as Jennifer O'Reilly has pointed out, Scripture lends the scribal analogy to the Lord himself (see Jeremiah 31.33; Hebrews 10.16; Psalms 44/45.1–2). Cassiodorus also says (in his Commentary on Psalm 44/45.1–2 and in the *Institutiones*) that the scribe could preach with the hand alone and 'unleash tongues with the fingers', imitating the action of the Lord who wrote the Law with his all-powerful finger (bringing to mind the pointing hand of God which features in later Anglo-Saxon evangelist miniatures).[2] Bede pursues this theme in relation to Ezra the Scribe, who fulfilled the Law by restoring/writing its destroyed books,

thereby opening his mouth to interpret Scripture and teach others. The act of writing is therefore presented as an essential, personal act for the scribe/preacher/teacher.[3]

Such scriptural resonances have a bearing upon the circumstances of production of the Lindisfarne Gospels. As we have seen, this amazingly complex and elegant book is surprisingly the work of a single artist-scribe who (from the evidence of his preparatory designs) intended to undertake all the work himself but who was prevented from completing the final stages, the textual aspects of which were completed by the rubricator, with the final touches to the artwork remaining unfinished.[4] Modern scribes estimate that at least two years of full-time work in optimum physical conditions would be required to produce such a work and that, given the physical demands of the task, only three hours or so of good quality work is likely to have been sustained each day.[5] A basic time and motion assessment of the time needed to undertake such a task alongside the other monastic duties of the Divine Office, prayer, study and manual labour, would suggest that something more like five to ten years would actually have been required, depending on how much exemption was granted from other duties, such as would be accorded to an anchorite. The only other Insular illuminated manuscripts which favoured such solitary working patterns are the Book of Durrow and the Echternach Gospels (the damaged state of the Durham Gospels prevents comment).[6]

I have suggested elsewhere that this might have represented a recollection of a distinctive 'Celtic' scribal response to such injunctions to *meditatio/contemplatio*. The act of copying and transmitting the Gospels was to glimpse the divine and to place oneself in its apostolic service and this may have been seen as a solitary undertaking on behalf of the community, rather than a communal collaboration, as with many aspects of Celtic eremitic monasticism. As such these books are portals of prayer, during the acts both of making and studying. I would propose an analogy between the work of the artist-scribe on such an exceptional, spiritually charged project with that of the hermit or anchorite, the physical endurance and deprivation and the levels of meditation and prayer required to produce a book such as the Lindisfarne Gospels equating to the hermit's 'desert'. As St Cuthbert struggled with his demons on the Inner Farne hermitage on behalf of all humanity, so the monk who produced the Gospelbook which was to serve as a major visual representation of his cult may also have embodied in his work a sustained feat of spiritual and physical endurance as part of the Apostolic mission of bringing the Word of God to the furthest outposts of the known world and enshrining it there within the new Temple of the Word and embodiment of Christ – the Book.

In an insightful discussion of the Ezra miniature in Ceolfrith's Codex Amiatinus, Jennifer O'Reilly has drawn attention to the patristic concept of the 'inner library' and the necessity for each believer to make him or herself a library of the divine Word, a sacred responsibility which Cummian referred to as 'entering the Sanctuary of God' by studying and transmitting Scripture.[7] Books are the vessels from which the believer's ark, or inner

library, is filled. They are the enablers of direct, contemporary Christian action, channels of the Spirit, and gateways to revelation, for 'In the beginning was the Word, and the Word was with God, and the Word was God' (John 1.1).

O'Reilly's discussion suggests that Wearmouth/Jarrow was adapting material drawn from sixth-century exemplars from the Vivarium to produce an illustrated prefatory quire for its single-volume Bibles and that this represented a process of informed choice and conscious adaptation. The interpretation of the intriguing Matthew evangelist miniature of the Lindisfarne Gospels which I have proposed, and which was suggested to me by her discussion of the Codex Amiatinus Ezra miniature,[8] would imply that, rather than relying upon the same Cassiodoran exemplar for the figures in these images, Lindisfarne's iconographic response postdated Amiatinus. This, and its companion pandects, were the result of a major editorial and scribal campaign which must have occupied a number of years sometime during Ceolfrith's abbacy of both houses (689–716). Bede probably played a leading role in this programme, and, as Jennifer O'Reilly, Carol Farr and others have demonstrated,[9] the concerns manifest in editing and in 'illustration' by means of complex *figurae* tie in with the preoccupations which Bede exhibits in his commentaries, written during the early eighth century.

Such an exegetical context would again suggest a somewhat later date than the traditional 698 for the production of the Lindisfarne Gospels. So too would the inclusion of a number of lections, marked within its carefully planned decorative programme, which were papal additions to Roman usage at the end of the seventh century and in 715. These may, of course, have enjoyed an earlier circulation, but their prominence in papal liturgical initiatives is likely to have drawn significant attention to them. Those planning the Lindisfarne Gospels were evidently taking pains to devise a layout in which lections from several sources were synthesised into a new decorative programme designed to articulate the text and to enshrine not only an authoritative version of Jerome's own 'Vulgata' rescension of the Gospels but also the liturgy, probably as represented at the time of manufacture and perhaps including some of the most up-to-date papal thought on the subject. Unity and the avoidance of issues suggestive of schism seem to have been a major consideration, not only textually but in the careful balancing within the decoration of iconic and aniconic features – an impressive feat of tightrope walking at a time when iconoclasm was definitely a live issue in both East and West.

If Wearmouth/Jarrow was attempting something of a programme of textual dissemination, such as it subsequently employed for the works of Bede from the 740s and such as was developed by Charlemagne and his circle, culminating in the 'publication' of the great Tours Bibles in the second quarter of the ninth century,[10] it may have exerted a somewhat different impact in the centre which produced the Lindisfarne Gospels than the one it intended. The finest, costliest materials were assembled. One of this centre's senior members produced a remarkably beautiful, painstaking and accurate copy of Jerome's Vulgate,

copied from an exemplar obtained from Wearmouth/Jarrow (probably a southern Italian original or one of a number of Wearmouth/Jarrow copies, perhaps even the one which is preserved as a fragment and was bound with the damaged Durham Gospels at Chester-le-Street during the tenth century). He supplemented it with a generous set of Canon Tables, carefully assimilated into the main text with reference to another possibly Capuan or northern Italian source, and with symbolic evangelist miniatures, carpet pages and decorated incipit pages, composed with reference to a variety of models and according to a pre-determined iconographic and synthesising decorative agenda. He also devised a sophisticated and unparalleled hierarchy of decorated initials in order to articulate textual divisions, including lections.

All of this was assisted by his probable invention of new methods and materials of design, including chemical experimentation with pigments to provide an extensive palette which achieved the range available to Mediterranean artists but using local materials, the pioneering of the leadpoint, of backlighting and of an 'intaglio' (or reversed) design process, all well ahead of their time, in order to achieve the maximum flexibility and sophistication of integrated word and image.

The resulting volume, the Lindisfarne Gospels, was a stunning object and a faithful textual embodiment of the Word of God as transmitted by the evangelists and St Jerome and as adapted for contemporary use in the liturgy, the public prayer-life of the community, but it appears to have been consulted and used only on special occasions. It was a focal point, an enshrinement of ideals and a tabernacle of the Word which is divinity itself, designed to be seen, to be contemplated as a portal of prayer by the viewer in the way that its making had been to its creator, immersed in meditation in his eremitic desert and rewarded with a glimpse of revelation – that all-consuming, all-transforming glimpse of the presence of God and the awesome profundity of the sense of joy and completion to come. Its presence on the altar, or in its metalwork shrine, symbolically evoked the very presence of God and celebrated the tradition of transmission of the Gospels and their use in preaching and prayer. Just as the *Liber Vitae* mystically embraced all those to be remembered during the liturgy, without the necessity of the recitation of names, so the Gospels evoked the relationship between God, those who spread his Word in written and oral form throughout the ages and the nations, and those who had eyes to see and ears to hear. This was a Gospelbook to be seen, to celebrate, to enshrine and to inspire.

What it was not was an exemplar itself. The impact of the decoration and script of the Lindisfarne Gospels, and a limited response to its technical innovations, can be detected, mainly in manuscripts, metalwork and sculpture made in Ireland, Scotland, parts of Northumbria and Mercia (in which many daughter-houses of the Lindisfarne *parochia* were established). Those who saw it or discussed its manufacture seem to have absorbed its impact, especially those involved in making the Cambridge-London Gospels, the Lichfield Gospels, the Stowe Missal, the Book of Kells and the Book of Cerne. It was still evoking

an artistic response in the early eleventh century when a southern English artist incorporated visual references to its Matthew miniature and cross-carpet page in the Copenhagen Gospels.

Either its main textual exemplar, or another Wearmouth/Jarrow copy, seems to have been available subsequently to those producing Royal 1.B.vii (probably in Northumbria), the Gotha Gospels (probably in Northumbria, or possibly in the Echternach area) and the St Petersburg Gospels (probably in Mercia). The Burchard Gospels, annotated at Wearmouth/Jarrow, also exerted an influence on the Continent. The impact of the Lindisfarne Gospels themselves were primarily exerted, over the course of the next century and beyond, in areas with 'Celtic' affiliations, even if only during the earlier stages of their initial foundation. It did not, however, supplant the earlier, mixed textual tradition of those areas. Indeed, its makers probably never intended it to be viewed as an 'authorised' version, but rather as an 'authoritative' version, recording and celebrating St Jerome's important contribution to the process of transmission alongside representatives of other traditions. Some Gospelbooks thought to have been made in Northumbria subsequently, such as Durham MS A.II.16 and the Cambridge-London Gospels, appear to have employed exemplars from different textual traditions for the individual Gospels – and the programmes of correction in the Echternach and Durham Gospels – the latter being corrected against the Lindisfarne Gospels themselves, further indicates the possibility of a comparative textual environment. In the Columban heartland scribes remained faithful to the tradition of their founding father, continuing to employ the established Columban prefatory matter, even when varying the version of the Gospels themselves. The Vulgate was available within these circles, as represented by the Book of Durrow and perhaps the Echternach Gospels, but in a different form to that circulated by Wearmouth/Jarrow and preserved in the Lindisfarne Gospels. It is possible to see the stylistic similarities between the Book of Durrow, the Echternach Gospels, the Durham Gospels and the Lindisfarne Gospels stemming from their common ultimately Columban background, and indeed those features that Lindisfarne shares with the Lichfield Gospels and the Book of Kells as reflecting their continued communication as recipients of a shared heritage. However, I find it difficult to conceive of the Lindisfarne Gospels having been made in a centre which possessed the variant Vulgate texts used in the Book of Durrow or the Echternach Gospels. The latter contains a copy of a colophon attesting to the authority of its text by identifying it as the copy of a book belonging to Eugippus, Abbot of Lucullanum near Naples, in turn copied from a book owned by St Jerome himself. It is extremely unlikely that such an authority would have been discarded in favour of another version of the Vulgate, received via Wearmouth/Jarrow, if it were available.

The proximity of the stylistic relationship between the Lindisfarne and Durham Gospels, and the fact that they were corrected by the same hand (which seems to have corrected the Durham Gospels, then the Lindisfarne Gospels, and then returned for a

second correction of Durham with reference to the text of Lindisfarne), incline me to the view that they were in the same place when Lindisfarne was completed and that they may well both have been made there, with Durham representing an earlier phase of development and remaining closer to its Columban roots. Durrow is also likely to represent this earlier stage, its closest stylistic analogies lying within the corpus of late seventh-century metalwork and sculpture. It, or its textual exemplar, was subsequently available to the team who produced the Book of Kells and this may suggest that these two books were made in the same place (perhaps Iona or another Columban house). However, this is the case, not necessarily the case, as Durrow or its exemplar could have travelled to another house within the *parochia*. The Echternach Gospels, with their distinctive colophon, reflect but stand aside from the tradition, perhaps supporting the idea that their artist-scribe came from the same background but was working elsewhere, perhaps at Echternach itself.

The picture which emerges is of the Lindisfarne Gospels having been made in a centre which valued its Columban origins and which remained in communcation with the *parochia*, but which was textually independent and open to the influence of 'romanising' centres such as Wearmouth/Jarrow and to contemporary papal innovations to the liturgy, and which was sensitive to 'live' ecclesiastical debates on matters which threatened schism. This would certainly accord with what we know of the monastery at Lindisfarne and its historical context. It may never have possessed an actual scriptorium. The pattern of work in the Lindisfarne Gospels, and indeed in the Book of Durrow (and what remains of the Durham Gospels), suggests that the labour of copying Scripture was a solitary, eremitic exercise. In this sense the community or communities which produced them may even have reflected something of the semi-eremitic *lavras* of the Syro-Palestinian monastic tradition, with some of their members (for part of their lives) coming together with the community for communal worship but living separately as quasi-anchorites. Conversely, if Julian Brown and Tom McKay were correct in seeing the Vatican Paulinus as a Lindisfarne product, there may have been an element of communal, coenobitic, work in the scriptorium to copy study texts; but the additionally spiritually charged work of transmitting Scripture was entrusted to senior members of the community (as suggested by the Columban practice at Iona as recorded by Adomnán) who effectively approached their labours as anchorites, the highest monastic calling. Their Gospelbook thus became their scribal desert (Old Irish 'disert', see figs 173–176).

Under such circumstances it is not surprising that each book should be an intensely personal work, reflecting the training and influences operating upon the individual as much as that of the community. People travelled as well as books and other stylistic models. When considering the relationships between the tiny proportion of books that have survived it is unwise to adopt a magnet-theory, grouping them all around known centres. The only places in Anglo-Saxon England to which extant books can be securely ascribed in any number are Wearmouth/Jarrow and Canterbury. That does not mean that they were

Fig. 173. *The Life of St Cuthbert*
(BL, Yates Thompson MS 26), f. 24r,
St Cuthbert praying in the sea, with his
feet subsequently dried by otters (bottom
right), Durham, late 12th century.

all made there. The subtle balance of similarities and dissimilarities have to be carefully assessed in each case and the possibility of artists and scribes from different backgrounds operating in the same place at the same time considered, especially in centres which are less inclined by their rules of life to favour coenobitic scriptorium practices, such as Lindisfarne. Books which are closely related stylistically could have been made in Lindisfarne, in Melrose, in Norham, in Hartlepool, to name but a few candidates within the *parochia*.

However, for an exceptional input of resource and energy such as that expended upon the Lindisfarne Gospels, a cult association remains likely and is borne out by subsequent provenance and use. It seems perverse to insist that this should have been one of the other houses, rather than Lindisfarne itself, given the historical context and its known associations with Wearmouth/Jarrow. The best artefactual context for materials known to have been in a certain place at a certain time remain the coffin and relics of St Cuthbert and the name-stones, all of which were at Lindisfarne itself. We know that, in addition to the epigraphic tradition, book-writing was strongly advocated within the Columban form of monastic life that it embraced (even after Cuthbert's reforms) and that such a monastic duty

Fig. 174. The Nitrian Desert, Egypt, site of outlying hermitages, seen from the early Christian monastery of Deir-el-Suriani (Fr Bigoul, the librarian, in the foreground). (Photo: David Jacobs)

was certainly practised at Lindisfarne: an anonymous monk of the house wrote the first life of St Cuthbert; Bede's name is inscribed in its roll of life (the contents of which may be fossilised within the ninth-century Durham *Liber Vitae*); Bishop Aethilwald wrote an abridgement of the Psalter and probably also a hymnal. To deny the possibility, and indeed the likelihood, of manuscript production there can only be the product of academic or political iconoclasm of the most injudicious variety. Those who might question why little else can be attributed to the same centre would do well to recall that the same is true of almost every other Insular centre and to ponder the fate of the library of eighth-century York, the extent and quality of which was described (and no doubt exaggerated) by Alcuin in laudatory verse. No surviving books have been securely attributed to York.

During the tenth century Aldred had sustained access to the great cult book in order to add the English language to the enshrined tradition of transmission of the Gospels, and Farmon, priest of Harewood,[11] and Owun may have been permitted to consult it (or another copy of Aldred's gloss) when preparing the English gloss to the Macregol Gospels, an early ninth-century Irish manuscript.[12] Aldred, like Symeon of Durham after him, had his own purposes and the contemporaneous concerns of the community of St Cuthbert in mind when recording the circumstances of production and preservation of this remarkable book. He exhibits concerns consistent with the early stages of the reforming camp within the tenth-century English Church and may have been encouraged to join the Chester-le-

404

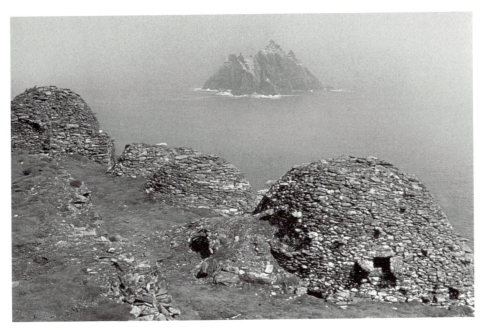

Fig. 175. Early monastic settlement with beehive huts, 7th–9th century,
Skellig Michael, Co. Kerry, Ireland.

Street community in order to foster such reform and to promote the use of the vernacular as an agent of English identity in the re-unification of England, as well as a means of promoting and popularising the cult of St Cuthbert. The colophon cannot be taken at face value as an historical record, any more than Symeon's account of its wanderings and miraculous retrieval from the deep. If Aldred chose to preserve the name of Bishop Eadfrith in connection with its manufacture as a tribute to a contemporary namesake, and to include himself in an evangelistic quartet of makers, this does not mean that he could not have taken advantage of a pre-existing community tradition of manufacture, perhaps preserved as a dedication inscription on its metalwork shrine (for which there are Irish analogues) and have converted it into a book's dedication inscription in accordance with more recent Continental and West Saxon practice. Likewise, he may have lifted it from another written source of the sort known to have been preserved subsequently at Durham and contained within earlier manuscripts such as the Lindisfarne Gospels themselves.

The Book of Cerne, a Mercian prayerbook of the second quarter of the ninth century, provides a precedent in its probable adaptation of texts associated with Bishop Aethilwald of Lindisfarne (to whom Aldred ascribes the binding of the Lindisfarne Gospels) in respect of a contemporary bishop, Aethelwald of Lichfield. Yet, as we have seen, an attribution to Lindisfarne does not by any means rely upon an acceptance of the veracity of Aldred's colophon, or an earlier nucleus to it. The fact of the ownership of the volume by the mid-

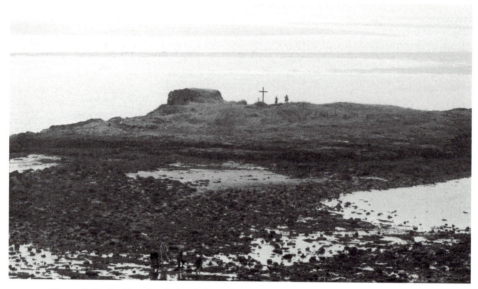

Fig. 176. St Cuthbert's Isle (Hobthrush), an eremitic retreat in the bay adjacent to
Lindisfarne monastery. (Photo: the author)

tenth century by the community of St Cuthbert would in any case be a reputable piece
of early provenance evidence (although it had, by that time, also absorbed the properties
of Wearmouth/Jarrow). The powerful affiliations with the Columban tradition, manifest
prior and post its production, the assimilation of strong Wearmouth/Jarrow influence
(but avoidance of other of its methods), the stylistic contextual material which points to
northern Bernician territory and to Holy Island in particular as the best source of in situ
artefacts exhibiting a close relationship to the volume, the exceptional quality of manu-
facture and subsequent retention as a prestigious focal point of the cult of St Cuthbert all
concur in supporting Lindisfarne as the most likely place of production of the Lindisfarne
Gospels. The title, in my opinion, stands.

Some individuals were allowed access to the Lindisfarne Gospels during the Middle
Ages and added an occasional discreet inscription, in hardpoint, some marking lections
(including some of the feasts of St Cuthbert). Offsets of ink, pigment and metalwork
corrosion features visible upon careful observation of the manuscript indicate that it was
once interleaved with other documents and objects. This leads me to conclude that it was
probably either the 'liber de reliquiis' (recorded as attached to the shrine of St Cuthbert at
Durham) or the 'Liber Magni Altaris', kept chained to the High Altar of Durham Cathedral
throughout the Middle Ages, if indeed they were not in fact one and the same, and that it
was still present there at the end of the sixteenth century, according to the author of the
Rites of Durham writing in 1593. There remains some possibility that it was at Lindisfarne

during the fourteenth century, a time when there was considerable building activity at what remained an important pilgrimage centre (and it was certainly removed there for safe-keeping during the Norman harrowing of the north after the Conquest), but on balance the reference in a Lindisfarne inventory of 1367 to a 'book of St Cuthbert which fell into the sea' probably refers to another book. The medieval cult of St Columba possessed some thirty such tomes which had miraculously survived trial by water. In the sixteenth century John Joscelyn, Laurence Nowell and an unidentified scholar who transcribed the Gospel of John were granted study access. By the early seventeenth century the volume was in the hands of Robert Bowyer, Keeper of Records in the Tower of London and Clerk of Parliament, son of a known bibliophile, William Bowyer (who also owned a copy of the Anglo-Saxon Chronicle) and passed from him to Sir Robert Cotton, one of the nation's greatest book collectors and a key figure in the foundation of a library which was to form the core of the newly established British Museum in 1753 and which has subsequently become part of the British Library.

This outstanding book has been the meeting place of faith and politics since its inception and it continues to fulfil that delicate role today. It was made in an age when there was no perception of an imposed division between spiritual and secular, between work and prayer, as still remains the case in many modern societies. In its making it was conceived as an intercessory endeavour on behalf of all Creation, celebrating its reconciliation and union with its Creator. It remains a powerful, energised symbol of that perpetual human quest.

To summarise, I would suggest that the Lindisfarne Gospels represent a fusion of earlier traditions of Lindisfarne, with its Irish components and its Columban background (the earlier traditions of which are represented by works such as Durham MS A.II.10, the Book of Durrow, and the Durham and Echternach Gospels, whether or not any of them were also actually made at Lindisfarne), with the subsequent importation of Italian stimuli via Wearmouth/Jarrow in the service of a recognisable agenda. These developments could have been protracted, as indeed was the early development of the cult of St Cuthbert, and grouping of the manuscripts around the fixed point of the translation of 698 has been misleading. The context for cultural fusion seems to lie best within the period of formalisation of the cult in the first quarter of the eighth century. This allows it to be viewed alongside Bede's commission to rework the first *Life* of Cuthbert at the behest of Bishop Eadfrith of Lindisfarne, who was recorded in the tenth-century community's tradition as the maker of the Lindisfarne Gospels, Bede's commentaries (the influence of which is reflected in the book's iconography) and his composition of the *Historia Ecclesiastica* which was dedicated to King Ceolwulf, a leading patron of Lindisfarne who may already have taken up residence there 'in clericatu'. In many respects the Lindisfarne Gospels are the visual equivalent of the *Historia Ecclesiastica,* in terms of presenting a fully integrated, inclusive image for an emergent state formed of disparate cultural groups.

In 716 Iona finally conformed and Ceolfrith set off for Rome to impress upon the Pope the orthodoxy of the Insular Church – the Lindisfarne Gospels were begun around this time to celebrate this unity.

The three communities – Lindisfarne, Jarrow and Monkwearmouth – should be seen as working together to establish a new identity for Northumbria, and thereby for England, one which acknowledged the components which had established its Christian culture and which was as implicitly romanising as that promoted by Wilfrid, and symbolised by the purple codex which was the focus of his cult at Ripon, but which was intrinsically orientated towards displaying cultural synthesis and reconciliation within the Christian ecumen, interlacing and co-celebrating the Celtic, British, Anglo-Saxon, Germanic, Roman, Coptic, Byzantine and Syro-Palestinian traditions. The apostolic mission had indeed reached and embraced the far ends of the earth. The material and literary culture of these extremities proclaims that they were no provincial outpost, but a vibrant, integrated part of that universal, eternal communion.

Notes

1 D. Hurst, ed., *Bede, Expositio in Lucam*, Corpus Christianorum Series Latina 120 (Turnhout 1960), prol. 93–115; Stansbury 1999, p. 72.

2 Cassiodorus, *De Institutione Divinarum Litterarum*, ch. 30; see Fridh 1973; Migne 1844–64 LXX, 1847, cols 1144–5; Ayerst and Fisher 1977, p. 14. See also O'Reilly 2001. Some of the foregoing is discussed further in connection with the Matthew miniature in chapter five, above.

3 See O'Reilly 2001.

4 M. P. Brown 1989, p. 155.

5 I have spoken to a number of contemporary scribes on this matter, including some of the team currently working with Donald Jackson on a complete hand-produced Bible for the Benedictine monastery of St John's, Collegeville, Minnesota.

6 Alexander 1978, nos 6, 10, 11.

7 See Walsh and Ó Cróinín, eds, *Cummian's Letter De Controversia Paschale*, 1988, pp. 15–18, 57–9. See O'Reilly 2001.

8 O'Reilly 2001.

9 O'Reilly 2001; Farr 1997 and 1999.

10 Similar attempts to establish an 'authorised version' by commissioning a series of approved copies of sacred text, which were then disseminated to key centres for further copying, may be observed in the Emperor Constantine's ordering a number of complete Bibles for important churches, as part of an attempt to introduce Christianity as a state religion in the fourth century, and in the codification of the Qur'an in 653 under the third Caliph 'Uthman the Prophet, Muhammad's son-in-law, as a result of which four copies were sent to the four main regions of the Islamic world to be used as exemplars. See De Hamel 2001, p. 63 and Holt *et al.* 1970.

11 The identification of Harewood in the West Riding of Yorkshire is possible, as well as that near Ross-on-Wye advanced by Alexander 1978, no. 54, although Farmon and Owun's gloss is in the Mercian dialect, which might support the latter identification. Skeat 1871–87 proposed that in order to construct their gloss, Farmon and Owun would have needed access to the Latin texts of both the Macregol and the Lindisfarne Gospels, but it is perhaps wiser to see their work as relying partly upon Aldred's gloss, whether observed directly from the Lindisfarne Gospels or from another copy of the English gloss, and partly upon the original Latin text of the Irish Gospelbook they were glossing.

12 Oxford, Bodleian Library, MS Auct. D.2.19, see f. 168v re Farmon and Owun's gloss; Alexander 1978, no. 54.

Fig. 177. The Lindisfarne Gospels (BL, Cotton MS Nero D.iv), ff. 209v–210r, miniature of St John and back drawings for the John carpet page.

Bibliography

Account Rolls = 'Extracts from the Account Rolls of the Abbey of Durham', II, *Surtees Society* 100, Durham, 1899

Adomnán, *De Locis Sanctis*, ed. D. Meehan, *Scriptores Latini Hiberniae*, 3, Dublin, 1958

Adomnán, *Life of St Columba*, ed. and transl. W. Reeves, Edinburgh, 1874

Aethelwulf, *De Abbatibus*, ed. and transl. A. Campbell, Oxford, 1967

Aird, W. M., 1991. 'The Origins and Development of the Church of St Cuthbert, 635–1153', unpubl. PhD thesis, University of Edinburgh

Aird, W. M., 1998. *St Cuthbert and the Normans in the Church of Durham, 1071–1153*, Woodbridge

Alexander, J. J. G., 1978. *Insular Manuscripts, 6th to the 9th Century*, London

Alexander, J. J. G., 1978a. *The Decorated Letter*, London

Alexander, J. J. G., 1993. *Medieval Illuminators and Their Methods of Work*, New Haven and London

Andrieu, M., 1948. *Les Ordines Romani du Haut Moyen Age, II, Les Textes*, Louvain

Angenendt, A., 1994. *Heilige und Reliquien die Geschichte ihres Kultes vom frühen Christentum bis zur Gegenwart*, Munich

Angenendt, A., 2000. *Der Memorial-und Liturgiecodex von San Salvatore/Santa Giulia in Brescia*, Hanover

Anon., 1851. *Protestant Aggression. Remarks on the Bishop of Durham's Letter to the Archdeacon of Lindisfarne*, by a Catholic clergyman resident within the diocese of Durham (identified in a MS note in the British Library's copy as Revd McRogerson of Minsteracre), pamphlet published by G. B. Richardson, Newcastle-upon-Tyne

Arnold, T., 1882–5. See Symeon of Durham, below

Astle, T., 1784. *Origin and Development of Writing*, London

Atchley, E. G. C. F., ed. and transl. 1905. *Ordo Romanas Primus*

Atiya, A. S., 1967. *History of Eastern Christianity*, South Bend, Indiana

Autenrieth, J. and F. Brunholzl, eds, 1971. *Festschrift Bernhard Bischoff zu seinem 65*, Stuttgart

Avrin, L., 1991. *Scribes, Script and Books*, London and Chicago

Ayerst, D. and A. S. T. Fisher, 1977. *Records of Christianity*, II, Oxford

Backhouse, J. M., 1981. *The Lindisfarne Gospels*, Oxford (reptd 1992)

Backhouse, J. M., D. H. Turner and L. Webster, eds, 1984. *The Golden Age of Anglo-Saxon Art 966–1066*, London

Backhouse, J. M., 1995. *The Lindisfarne Gospels: a Masterpiece of Book Painting*, London

Badawry, A., 1978. *Coptic Art and Archaeology*, Cambridge, MA

Bailey, R., 1978. *The Durham Cassiodorus, The Jarrow Lecture 1978*, Newcastle-upon-Tyne

Bailey, R., 1978a. 'The Chronology of Viking-age Sculpture in Northumbria', in Lang 1978, pp. 179–85

Bailey, R., 1980. *Viking Age Sculpture in Northern England*, London

Bailey, R., 1989. 'St Cuthbert's Relics: Some Neglected Evidence', in Bonner *et al.* 1989, pp. 231–46

Bailey, R., 1996. 'Ambiguous Birds and Beasts: Three Sculptural Puzzles in South-West Scotland', *Fourth Whithorn Lecture*, Whithorn, 1995

Bailey, R., 1996a. 'What mean these stones?', *Bulletin of the John Rylands Library* 78, 21–46

Bailey, R., 1996b. *England's Earliest Sculptors*, Publications of the Dictionary of Old English 5, Toronto

Baldwin Brown, G., 1921. *The Arts in Early England*, v, London

Bataillon, L. J., B. G. Guyot and R. H. Rouse, eds, 1988. *La Production du livre universitaire au Moyen Age*, Paris

Bately, J., M. P. Brown and J. Roberts, eds, 1993. *A Palaeographer's View: Selected Papers of Julian Brown*, London

Battiscombe, G. F., ed., 1956. *The Relics of St Cuthbert*, Oxford

Bayless, M. and M. Lapidge, eds, 1998. *Collectanea Pseudo-Bedae*, Scriptores Latini Hiberniae 14, Dublin

Bede, *De Templo* and *De Tabernaculo*, ed. D. Hurst, Corpus Christianorum Series Latina 119A, 'Bedae Opera', Pars II 'Opera Exegetica', 2A, Turnhout, 1969

Bede, *Expositio in Lucam*, ed. D. Hurst, Corpus Christianorum Series Latina 120, Turnhout, 1960

Bede, *Historia Abbatum*, ed. C. Plummer, Oxford, 1896

Bede, *Historia Ecclesiastica* (HE), ed. D. H. Farmer, transl. L. Sherley-Price, revd R. E. Latham, *Bede, Ecclesiastical History of the English People*, London, 1990; ed. B. Colgrave and R. A. B. Mynors, *Bede's Ecclesiastical History of the English People*, Oxford, 1969; ed. C. Plummer, *Bedae Opera Historica*, Oxford, 1956

Bede, *Lives of the Abbots of Wearmouth and Jarrow*, ed. D. H. Farmer, *The Age of Bede*, revd edn, Harmondsworth, 1983

Bede, *Opera Homiletica*, ed. and transl. D. Hurst, Corpus Christianorum Series Latina 122, Turnhout, 1955

Bede, *Vita Cuthberti*

Bede, Prose *Life of St Cuthbert*, ed. and transl. D. H. Farmer, Harmondsworth, 1983; also ed. and transl., along with the Anonymous *Life*, B. Colgrave, 1940, reptd 1985

Bede, Metrical *Life of St Cuthbert*, ed. W. Jaegar, 1935

Bede, *On the Tabernacle*, transl. A. G. Holder, Liverpool, 1994

Bede, *On the Temple*, transl. S. Connolly, with intro. by J. O'Reilly, Liverpool, 1995

Beissel, S., 1907. 'Entstehung der Perikopen des römischen Messbuches: zur Geschichte der Evangelienbücher in der ersten Hälfte des Mittelalters', *Ergänzungshefte zu den 'Stimmen aus Maria-Laach'*, bd. 24, Ergänzungshefte 96, Freiburg im Breisgau, pp. 401–620

Belting, H., 1994. *Likeness and Presence: a History of the Image before the Era of Art*, transl. E. Jephcott, Chicago

Berresford Ellis, P., 1987. *A Dictionary of Irish Mythology*, London

Berschin, W., 1980. *Griechisch-Lateinisches Mittelalter*, Berne

Berschin, W., 1989. 'Opus deliberatum ac perfectum: why did the Venerable Bede write a Second Prose Life of St Cuthbert?', in Bonner *et al.* 1989, pp. 95–102

Bhreathnach, E., 2001. 'Abbesses, Minor Dynasties and Kings in Clericatu: Perspectives of Ireland, 700–850', in Brown and Farr 2001, pp. 113–25

Bischoff, B., 1966–81. *Mittelalterliche Studien*, 3 vols, Stuttgart

Bischoff, B. and M. Lapidge, 1994. *Biblical Commentaries from the Canterbury School of Theodore and Hadrian*, Cambridge Studies in Anglo-Saxon England 10, Cambridge

Bishop, E., 1918. *Liturgica Historica*, Oxford

Bishop, T. A. M., 1967. 'The Copenhagen Gospel Book', *Nordisk Tidskrift for Bok- och Biblioteksvasen*, pp. 33–41

Bodden, M. C., 1988. 'Evidence for the Knowledge of Greek in Anglo-Saxon England', *Anglo-Saxon England* 17, pp. 217–46

Bonne, J-C., 1995. 'De l'ornemental dans l'art médiéval (viie–xiie s.). Le modèle insulaire', in M. Pastoureau, ed., *Cahiers du Léopard d'Or*, v, Paris, pp. 185–219

Bonner, G., D. Rollason and C. Stancliffe, eds, 1989. *St Cuthbert, His Cult and His Community to AD 1200*, Woodbridge

Bonner, G., 1989. 'St Cuthbert at Chester-le-Street', in Bonner *et al.* 1989, pp. 387–97

Bourke, C., 1993. *Patrick: the Archaeology of a Saint*, Belfast

Bourke, C., ed., 1995. *From the Isles of the North. Early Medieval Art in Ireland and Britain*, Belfast

Bourke, C., 1998. 'Fine Metalwork from the River Blackwater', *Archaeology Ireland* 45, vol. 12, no. 3, Autumn, 30–31

Boyd, W. J. P., 1975. *Aldred's Marginalia. Explanatory Comments in the Lindisfarne Gospels*, Exeter

Boyd, W. J. P., 1975a. 'Aldrediana xxv: Ritual Hebraica', *English Philological Studies* 14, pp. 1–57

Bray, D., 1992. *A List of Motifs in the Lives of the Early Irish Saints*, Helsinki

Breeze, A., 1996. 'The Provenance of the Rushworth Mercian Gloss', *Notes and Queries* 241, pp. 394–5

Brooks, D., 1991. 'The Northumbrian Settlements in Galloway and Carrick: an Historical Assessment', *Proceedings of the Society of Antiquaries of Scotland* 121, pp. 295–327

Brown, G. H., 1996. 'Bede the Educator', *The Jarrow Lecture* 1996, Newcastle-upon-Tyne

Brown, G. H., 1999. 'The Church as Non-Symbol in the Age of Bede', in Hawkes and Mills 1999, pp. 359–64

Brown, G. H. and C. Karkov, eds, forthcoming. *Anglo-Saxon Styles*, New York

Brown, M. P., 1989. 'The Lindisfarne Scriptorium', in Bonner *et al.* 1989, pp. 151–63

Brown, M. P., 1990. *A Guide to Western Historical Scripts from Antiquity to 1600*, London and Toronto, 2nd edn 1999

Brown, M. P., 1991. *Anglo-Saxon Manuscripts*, London

Brown, M. P., 1991a. 'Continental Symptoms in Insular Codicology: Historical Perspectives', in P. Rück, ed., *Pergament*, Sigmaringen, pp. 57–62

Brown, M. P., 1993. 'Paten and Purpose: the Derrynaflan Paten Inscriptions', in Spearman and Higgitt 1993, pp. 162–7

Brown, M. P., 1994. 'Echoes: the Book of Kells and Southern English Manuscript Production', in O'Mahony 1994, pp. 333–43

Brown, M. P., 1994a. 'The Role of the Wax Tablet in Medieval Literacy: A Reconsideration in Light of a Recent Find from York', *British Library Journal* xx, no. 1 (Spring, 1994), pp. 1–15

Brown, M. P., 1994b. *Understanding Illuminated Manuscripts. A Guide to Technical Terms*, Malibu and London

Brown, M. P., 1996. *The Book of Cerne. Prayer, Patronage and Power in Ninth-Century England*, London and Toronto

Brown, M. P., 1996a. 'Pigments and Their Uses in Insular Manuscripts', in J. Sharpe, ed., *The Compleat Binder: Studies in Book-making and Conservation in Honour of Robert Powell*, Bibliologia 14, Turnhout, pp. 136–45

Brown, M. P., 1998. 'Embodying Exegesis: Depictions of the Evangelists in Insular Manuscripts', in A. M. Luiselli Fadda and E. Ó Carragáin, eds, *Le Isole Britanniche e Roma in Età Romanobarbarica*,

Rome, pp. 109–28

Brown, M. P., 1998a. *The British Library Guide to Writing and Scripts*, London

Brown, M. P., 2000. '"In the Beginning was the Word": Books and Faith in the Age of Bede', *The Jarrow Lecture 2000*, Newcastle-upon-Tyne

Brown, M. P., 2001a. 'The Life of St Fursey. What We Know; Why it Matters', *Fursey Occasional Paper No. 1*, Norwich

Brown, M. P., 2001b. 'Mercian Manuscripts? The "Tiberius" Group and its Historical Context', in Brown and Farr 2001, pp. 278–91

Brown, M. P., 2002. *The Lindisfarne Gospels, British Library, Cotton MS Nero D.iv. Description of the Manuscript*, Luzern

Brown, M. P., 2002a. 'Gerald of Wales and "the Marvels of the East": the Role of the Author in the Development of Medieval Illustration', in A. S. G. Edwards, ed., *Decoration and Illustration in Medieval English Manuscripts*, English Manuscript Studies x, London, pp. 34–59

Brown, M. P., forthcoming a. 'Insular Script: Display Scripts', 'Insular Scripts: Uncial', 'Insular Scripts: Half-uncial' and 'Insular Scripts: Minuscule', in R. Gameson, ed., *The History of the Book in Britain*, 1, Cambridge

Brown, M. P., forthcoming b. 'House-Style in the Scriptorium: Scribal Reality and Scholarly Myth', in G. H. Brown and C. Karkov

Brown, M. P., forthcoming c. 'The Tower of Babel: the origins of the early western written vernaculars' (submitted for a volume in memory of Leonard Boyle. B. Bolton and A. Duggan, eds)

Brown, M. P. and C. Farr, eds, 2001. *Mercia: An Anglo-Saxon Kingdom in Europe*, Leicester

Brown, M. P. and D. H. Wright, forthcoming. *The Barberini Gospels*, London

Brown, P., 1981. *The Cult of the Saints*, Chicago

Brown, T. J., ed., 1969. *The Stonyhurst Gospel of St John*, Roxburghe Club, Oxford

Brown, T. J., 1969a. *The Durham Ritual*, Early English Manuscripts in Facsimile 16, Copenhagen

Brown, T. J., 1971. 'Northumbria and the Book of Kells', *The Jarrow Lecture 1971*, Newcastle-upon-Tyne; reptd in *Anglo-Saxon England* 1, 1972, pp. 219–46

Brown, T. J., 1974. 'The Distribution and Significance of Membrane Prepared in the Insular Manner', *Colloques Internationaux du Centre National de la Récherche Scientifique*, no. 547, 'La Paléographie Hébraique Médiévale', Paris, pp. 127–35; reptd in Bately *et al.* 1993

Brown, T. J., 1982. 'The Irish Element in the Insular System of Scripts to circa AD 800', in H. Loewe, ed., *Die Iren und Europa im früheren Mittelalter*, 2 vols, Stuttgart, 1, pp. 101–19; reptd in Bately *et al.* 1993

Brown, T. J., 1984. 'The Oldest Irish Manuscripts and their Late Antique Background', in P. Ní Chatháin and M. Richter, eds, *Irland und Europa: die Kirche im Frühmittelalter*, Stuttgart, pp. 311–27; reptd in Bately *et al.* 1993

Brown, T. J. and T. Mackay, 1988. *Codex Vaticanus Palatinus Latinus 235, an Early Insular Manuscript of Paulinus of Nola*, Turnhout

Brubaker, L., 1995. 'The Sacred Image', in R. Ousterhout and L. Brubaker, eds, *The Sacred Image, East and West*, Illinois Byzantine Studies 4, Urbana, pp. 1–24

Bruce-Mitford, R., 1965. 'The Lindisfarne Gospels in the Middle Ages and Later', *British Museum Quarterly* 29 (3–4), pp. 98–100; reptd in *Journal of the British Archaeological Association*, 32, 1969, 1–25

Bruce-Mitford, R., 1967. 'The Art of the Codex Amiatinus', *The Jarrow Lecture 1967*, Newcastle-upon-Tyne

Bruce-Mitford, R., 1967a. 'The Reception by the Anglo-Saxons of Mediterranean Art Following their Conversion from Ireland and Rome', *Settimane di studio del Centro italiano di studi sull'alto medioevo*, Spoleto 14, pp. 799–818

Bruce-Mitford, R., 1967b. 'The Lindisfarne Gospels', *Great Books of Ireland (Thomas Davis Lectures)*, pp. 26–37

Bruce-Mitford, R., 1989. 'The Durham-Echternach Calligrapher', in Bonner *et al.* 1989, pp. 175–88

Brunner, A., 1947–8. 'A Note on the Distribution of the Variant Forms of the Lindisfarne Gospels', *English and Germanic Studies* 1, pp. 32–52

Bruno, V., 2001. 'The St Petersburg Gospels and the Sources of Southumbrian Art', in Redknap *et al.* 2001, pp. 179–90

Bruun, J. A., 1897. *An Enquiry into the Art of the Illuminated Manuscripts of the Middle Ages*, 1, Celtic *Illuminated Manuscripts*, Edinburgh

Buckton, D., 1994. *Byzantium. Treasures of Byzantine Art and Culture*, London

Budny, M. O., 1985. 'London, British Library, MS Royal 1.E.vi: the Anatomy of an Anglo-Saxon Bible Fragment', unpubl. PhD thesis, University of London

Bullough, D., 1993. 'What has Ingeld to do with Lindisfarne?', *Anglo-Saxon England* 22, 93–126

Bullough, D., 1998. 'A Neglected Early-Ninth-Century Manuscript of the Lindisfarne *Vita S. Cuthberti*', *Anglo-Saxon England* 27, 105–38

Calendar of State Papers = *Calendar of State Papers of the Reign of King James I. Domestic, 1603–1610*, ed. M. A. E. Green, London, 1857

Calkins, R., 1983. *The Medieval Illuminated Book*, London

Cambridge, E., 1984. 'The Early Church in County Durham: a Reassessment', *Journal of the British Archaeological Association* 137, pp. 65–85

Cambridge, E., 1988. *Lindisfarne Priory and Holy Island*, English Heritage, London (reptd 2000)

Cambridge, E. and C. Stancliffe, eds, 1995. *Oswald: Northumbrian King to European Saint*, Stamford

Camden, W. (published anonymously), 1605. *Remaines of a Greater Work concerning Britaine*, London

Campbell, E. and A. Lane, 1993. 'Celtic and Germanic Interaction in Dalriada: the 7th-Century Metalworking site at Dunadd', in Spearman and Higgitt 1993, pp. 52–63

Casley, D., 1734. *A Catalogue of the Manuscripts of the King's Library. An Appendix to the Catalogue of the Cottonian Library*, London

Cassiodorus, *Institutiones* = *De Institutione Divinarum Litterarum*, see Fridh 1973; Migne, *Patrologiae Cursus Completus* LXX, Paris, 1847; R. A. B. Mynors, ed., *Institutiones*, Oxford, 1937; transl. L. W. Jones, *An Introduction to Divine and Human Readings*, New York, 1946

Cecchelli, C., ed., 1959. *The Rabbula Gospels*, Olten and Lausanne

Chadwick, D. E., C. B. Judge and A. S. C. Ross, 1934. 'A New Collation of an Extract from the Old English Gloss to the Lindisfarne Gospels', *LSE* 3, pp. 10–16

Chadwick, N., 1961. *The Age of the Saints in the Early Celtic Church*, Oxford

Chadwick, N., ed., 1963. *Celt and Saxon: Studies in the Early British Border*, Cambridge

Chapman, J., 1908. *Notes on the Early History of the Vulgate Gospels*, Oxford

Charles-Edwards, T. M., 2000. *Early Christian Ireland*, Cambridge

Chavasse, A., 1958. *Le Sacramentaire Gélasien (Vaticanus Regimensis 316)*, Bibliothèque de Théologie, IV, Paris and Tournai

Chavasse, A., 1989. 'Évangéliaire, épistolier, antiphonaire et sacramentaire: les livres romains de la messe aux VIIᵉ e VIIIᵉ siècles', *Ecclesia Orans* 6, pp. 177–225 (reptd in his *La Liturgie de la Ville de Rome, du Vᵉ au VIIIᵉ siècle*, 2 vols (Rome, 1993), pp. 153–229)

Chavasse, A., 1993. *Les Lectionnaires Romains de la Messe au VIIe et au VIIIe Siècle: sources et derivés* (Spicilegii Friburgensis, 'Subsidia', 22), 2 vols, Fribourg-en-Suisse

Chazelle, C., 1990. 'Pictures, Books and the Illiterate: Pope Gregory I's Letters to Serenus of Marseilles', *Word and Image* 6, no. 2, pp. 138–53

Chrysos, E., 1999. 'The Gospels on the Throne', in A. Dierkens, ed., *Le Saint et le Sacré*, Brill

CLA = E. A. Lowe, *Codices Latini Antiquiores*, 11 vols and suppl., Oxford, 1934–72

Clanchy, M., 1993. *From Memory to Written Record*, 2nd edn, Cambridge, MA and Oxford (reptd 1998)

Clayton, M., 1990. *The Cult of the Virgin Mary in Anglo-Saxon England*, Cambridge

Coates, R., 1997. 'The Scriptorium of the Rushworth Gospels: a Bilingual Perspective', *Notes and Queries* 44, pp. 453–8

Coatsworth, E., 1989. 'The Pectoral Cross and Portable Altar from the Tomb of St Cuthbert', in Bonner *et al.* 1989, pp. 287–302

Coatsworth, E. and M. Pinder, 2002. *The Art of the Anglo-Saxon Goldsmith, Fine Metalwork in England, its Practice and Practitioners*, Woodbridge

Cod. Lind. = T. D. Kendrick, T. J. Brown, R. L. S. Bruce-Mitford, H. Roosen-Runge, A. S. C. Ross, E. G. Stanley and A. E. A. Werner, eds, *Evangeliorum Quattuor Codex Lindisfarnensis*, facsimile, 2 vols, Olten and Lausanne, 1956–60

Colgrave, B., ed., 1927. *Life of Bishop Wilfrid by Eddius Stephanus*, Cambridge

Colgrave, B., 1940. *Two Lives of St Cuthbert*, Cambridge, reptd 1985

Colgrave, B. and R. A. B. Mynors, 1969 (see Bede, above)

Cook, A. S., 1894. *A Glossary of the Old Northumbrian Gospels (Lindisfarne Gospels or Durham Book)*, Halle

Connolly and O'Reilly, 1995 (see Bede, above)

Corsano, K., 1987. 'The First Quire of the Codex Amiatinus', *Scriptorium* 41, pt 1, pp. 3–34

Courcelle, P., 1948. *Les Lettres Grecques en Occident. De Macrobe à Cassiodore*, Paris; transl. H. E. Wedeck, *Late Latin Writers and their Greek Sources*, Harvard, 1969

Cox, B., 1995. 'The Book as Relic: the Lindisfarne Gospels and the Politics of Sainthood', unpubl. PhD dissertation, Stanford University

Craig, D. J., 1991. 'Pre-Norman sculpture in Galloway: some territorial implications', in R. D. Oram and G. P. Stell, eds, *Galloway: Land and Lordship*, Edinburgh, pp. 45–62

Craig, D. J., 1992. 'The Distribution of Pre-Norman Sculpture in South-West Scotland: Provenance, Ornament and Regional Groups', unpubl. PhD thesis, Durham University

Cramer, M., 1964. *Koptische Buchmalerei*, Recklinghausen

Cramp, R. J., 1969. 'Excavations at the Saxon Monastic Sites of Wearmouth and Jarrow: An Interim Report', *Medieval Archaeology* 13, pp. 24–66

Cramp, R. J., 1975. 'Window-glass from the Monastic Site of Jarrow', *Journal of Glass Studies* 17, pp. 88–96

Cramp, R. J., 1983. 'Anglo-Saxon Settlement', in J. C. Chapman and H. Mytum, eds, *Settlement in North Britain 1000 BC to AD 1000*, British Archaeological Reports, British Ser., 118, 273–97

Cramp, R. J., ed., 1984. *Corpus of Anglo-Saxon Stone Sculpture, I, County Durham and Northumberland*, Oxford

Cramp, R. J., 1986. 'Northumbria and Ireland', in P. Szarmach and V. D. Oggins, eds, *Sources of Anglo-Saxon Culture*, Kalamazoo, pp. 185–201

Cramp, R. J., 1989. 'The Artistic Influence of Lindisfarne Within Northumbria', in Bonner *et al.* 1989, pp. 220–1

Cramp, R. J., 1994. 'Monkwearmouth and Jarrow in their European context', in K. Painter, ed., *'Churches Built in Ancient Times': Recent Studies in Early Christian Archaeology*, Society of Antiquaries of London, Occasional Papers, n.s. 16, pp. 279–94

Cramp, R. J., 1995. 'Whithorn and the Northumbrian Expansion Westwards', Third Whithorn Lecture, 1994

Cramp, R. J., 2001. See Hamerow and MacGregor

Cramp, R. J. and R. Bailey, eds, 1988. *Corpus of Anglo-Saxon Sculpture, II, Cumberland, Westmoreland and Lancashire North of the Sands*, Oxford

Cramp, R. J. and J. Cronyn, 1990. 'Anglo-Saxon Polychrome Plaster and Other Materials from the Excavations of Monkwearmouth and Jarrow: An Interim Report', in S. Cather *et al.*, eds, *Early Medieval Wall Painting and Painted Sculpture*, British Archaeological Reports 216, Oxford, pp. 17–30

Craster, H. H. E., 1925. 'The Red Book of Durham', *English Historical Review* 40, pp. 504-32

Craster, H. H. E., 1954. 'The Patrimony of St Cuthbert', *English Historical Review* 69, pp. 177–99

Crawford, B., 1987. *Scandinavian Scotland*, Leicester

Cubitt, C. R. E., 1995a. *Anglo-Saxon Church Councils, c.650–c.850*, Leicester

Cubitt, C. R. E., 1995b. 'Unity and Divinity in the Early Anglo-Saxon Liturgy', *Studies in Church History* 32, pp. 45-57

DACL = F. Cabrol and H. Leclercq, *Dictionnaire d'Archéologie Chrétienne et de Liturgie*, III, Paris, 1914

Damico, H., ed., 1998. *Medieval Scholarship: Biographical Studies on the Formation of a Discipline*, II, *Literature and Philology*, New York

Day, J., 1571. *The Gospels of the Fower Evangelistes*, London

De Bruyne, D., 1914. *Sommaires, divisions et rubriques de la Bible latine*, Namur

De Bruyne, D., 1920. *Préfaces de la Bible latine*, Namur

De Bruyne, D., 1931. 'Notes sur la Bible de Tours au ixe Siècle', *Göttingische gelehrte Anzeigen* 193, pp. 321–59

De Hamel, C., 2001. *The Book. A History of the Bible*, London

De Rossi, G. B., 1888. *La Bibbia offerta da Ceolfrido Abbate al Sepolchro di S. Pietro. Al Sommo Pontefice Leone XIII omaggio giubilare della Biblioteca Vaticana*, Vatican, pp. 1–22

Deshusses, J., 1979. *Le Sacramentaire Grégorien*, Fribourg

Drogin, M., 1980. *Medieval Calligraphy, its History and Technique*, Montclair, (reptd NY, 1989)

du Bourguet, P., 1971. *Art Copte*, transl. C. Hay-Shaw, London

Duffus Hardy, T., ed., 1973. *Registrum Palatinum Dunelmense*, I, Rolls Series, London

Duke, J. A., 1932. *The Columban Church*, Oxford (reptd 1957)

Dumville, D. N., 1972. 'Liturgical Drama and Panegyric Responsory from the 8th Century. A Re-examination of the Origin and Contents of the 9th-Century Section of the Book of Cerne', *Journal of Theological Studies* n.s. 23, pt 2, pp. 374–406

Dunville, D. N., 1984. 'Some British Aspects of the Earliest Irish Christianity', in P. Ní Chatháin and M. Richter, eds, *Irland and Europa: die Kirsch in Frühmittelalter*, Stuttgart, pp. 16–24

Dumville, D. N., 1993. *Britons and Anglo-Saxons in the Early Middle Ages*, Aldershot

Dumville, D. N., 1993a. *English Caroline Script and Monastic History, Studies in Benedictinism, AD 950–1030*, Woodbridge

Dumville, D. N., 1997. 'The Churches of North Britain in the First Viking-Age', Fifth Whithorn Lecture, 1996

Dumville, D. N., 1999. *A Palaeographer's Review*, Osaka

Edwards, N., 1985. 'The Origins of the Free-standing Stone Cross in Ireland: Imitation or

Innovation?', *Bulletin of the Board of Celtic Studies* 32, pp. 393–410

Ehwald, R., 1919. *Aldhelmi Opera*, Monumenta Germaniae Historica, Auctores Antiquissimi xv

Ekwall, E., 1936. *The Concise Oxford Dictionary of English Place-Names*, Oxford

Farmer, D. H., ed., 1983. *The Age of Bede*, revd edn, Harmondsworth

Farmer, D. H., 1987. *The Oxford Dictionary of Saints*, 2nd edn, Oxford

Farr, C., 1989. 'Lection and Interpretation: the Liturgical and Exegetical Background of the Illustrations in the Book of Kells', unpubl. PhD dissertation, University of Texas at Austin

Farr, C., 1991. 'Liturgical Influences on the Decoration of the Book of Kells', in R. T. Farrell and C. Karkov, eds, *Studies in Insular Art and Archaeology*, American Early Medieval Studies 1, Oxford, OH, pp. 127–41

Farr, C., 1994. 'Textual Structure, Decoration and Interpretative Images in the Book of Kells', in O'Mahony 1994, , pp. 437–49

Farr, C., 1997. *The Book of Kells, its Function and Audience*, London and Toronto

Farr, C., 1999. 'The Shape of Learning at Wearmouth-Jarrow: The Diagram Pages in the Codex Amiatinus', in Hawkes and Mills 1999, pp. 336–44

Farr, C., forthcoming a. 'Style in Late Anglo-Saxon Art: Questions of Learning and Intention', in G. H. Brown and C. Karkov forthcoming

Farr, C., forthcoming b. 'The Sign at the Cross-roads: the Matthean Nomen Sacrum in Gospelbooks before Alfred the Great', in L. Webster and M. O. Budny, eds, *Shaping Understanding: Form and Order in the Anglo-Saxon World, 400–1100* (forthcoming publication of the proceedings of a colloquium held at the British Museum, 7–9 March 2002)

Fischer, Bonifatius, 1962. 'Codex Amiatinus und Cassiodor', *Biblische Zeitschrift*, N.F.vi (Paderborn), pp. 57 ff

Fischer, Bonifatius, 1985. *Lateinische Bibelhandschriften im frühen Mittelalter*, Freiburg im Breisgau

Fischer, Bonifatius, 1988–91. *Die lateinischen Evangelien bis zum 10. Jahrhundert* (*Aus der Geschichte der lateinischen Bibel*, 13, 15, 17, 18, Matthew 1988, Mark 1989, Luke 1990, John 1991), Freiburg im Breisgau

Fisher, D. J. V., 1973. *The Anglo-Saxon Age c.400–1042*, Harlow

Florence of Worcester, ed. B. Thorpe, *English Historical Society*, 1, 1848; see also McGurk and Darlington 1995

Forbes-Leith, W., 1896. *The Gospel Book of Saint Margaret*, Edinburgh

Fowler, J. T., ed., 1899. *Durham Ancient Rolls*, 11, Surtees Society C

Fox, P., ed., 1990. *The Book of Kells, MS 58, Trinity College Library Dublin*, 2 vols, facsimile and commentary, Lucerne

Frere, W. H., 1930–5. *Studies in Early Roman Liturgy*, Alcuin Club Collections nos 28, 30, 32

Fridh, A., ed., 1973. *Magni Aurelii Cassiodori Variarum Libri XII*, Corpus Christianorum Series Latina 96, Turnhout

Fuchs, R. and Oltrogge, D., 1994. 'Colour Material and Painting Technique in the Book of Kells', in O'Mahony 1994, pp. 135–71

Gabra, G., 1993. *Cairo and the Coptic Museum and Old Churches*, Cairo

Gamber, K., 1963. *Codices Liturgici Latini Antiquiores*, Freiburg (2nd edn, 1968)

Gameson, R. G., 1994. 'The Royal 1.B.vii Gospels and English Book Production in the Seventh and Eighth Centuries', in R. G. Gameson, ed., *The Early Medieval Bible*, Cambridge, pp. 24–52

Gameson, R. G., 1996. 'The Gospels of Margaret of Scotland and the Literacy of an Eleventh-Century Queen', in J. Taylor and L. Smith, eds, *Women and the Book. Assessing the Visual Evidence*,

London and Toronto, pp. 149–71

Gameson, R. G., ed., 1999. *St Augustine and the Conversion of England*, Stroud

Gameson, R. G., 2001. 'Why Did Eadfrith Write the Lindisfarne Gospels?', in *Belief and Culture in the Middle Ages: Studies Presented to Henry Mayr-Harting*, ed. R. Gameson and H. Leyser, Oxford, pp. 45–58

Gameson, R. G., 2001a. 'The Scribe Speaks? Colophons in Early English Manuscripts', *H. M. Chadwick Memorial Lectures* 12

Gameson, R. G., 2002. *The Stockholm Codex Aureus*, Early English Manuscripts in Facsimile XXVIII, Copenhagen

Ganz, D., 1990. *Corbie in the Carolingian Renaissance*, Sigmaringen

Ganz, D., 1994. 'Mass Production of Early Medieval Manuscripts: the Carolingian Bibles from Tours', in R. G. Gameson, ed., *The Early Medieval Bible*, Cambridge, pp. 53–62

Ganz, D., 2002. 'Roman Manuscripts in Francia and Anglo-Saxon England', in *Roma fra Oriente e Occidente, Settimane di Studio del Centro Italiano di Studi sull'Alto Medioevo*, XLIX, Spoleto, 607–47

Gasquet, F. A. and Bishop, E., 1908. *The Bosworth Psalter*, London

Gerchow, J., 1987. 'Die Gedenküberlieferung der Angel-sachsen', unpubl. PhD thesis, Albert-Ludwigs-Universität, Freiburg

Giraldus Cambrensis, see O'Meara 1982, below

Grabar, A. and C. Nordenfalk, 1957. *Early Medieval Painting from the 4th to the 11th Century*, Lausanne

Grafton, A., 1997. *The Footnote: a Curious History*, Cambridge, MA

Graham, T. and A. G. Watson, 1998. *The Recovery of the Past in Early Elizabethan England: Documents by John Bale and John Joscelyn from the Circle of Matthew Parker*, Cambridge Bibliographical Society Monograph 13

Graham, T., 2000. 'John Joscelyn, Pioneer of Old English Lexicography', in T. Graham, ed., *The Recovery of Old English: Anglo-Saxon Studies in the Sixteenth and Seventeenth Centuries*, Kalamazoo, pp. 83–140

Graham-Campbell, J., 2001. 'National and Regional Identities: the "Glittering Prizes"', in Redknap *et al.* 2001, pp. 27–38

Green, R., 1974. 'Marginal Drawings in an Ottonian Manuscript', in U. McCracken, L. M. C. Randall and R. H. Randall, eds, *Gatherings in Honour of Dorothy E. Miners*, Baltimore, pp. 129–38

Greene, D. and F. O'Connor, eds, 1967. *A Golden Treasury of Irish Poetry AD 600–1200*, Dingle

Guilmain, J., 1987. 'The Geometry of the Cross-Carpet Pages in the Lindisfarne Gospels', *Speculum* 62, pp. 21–52

Haddan, A. W. and W. Stubbs, 1871. *Councils and Ecclesiastical Documents Relating to Great Britain and Ireland*, 3 vols, Oxford

Hahn, C., 1988. *Kommentarband, Killians und Margaretenvita, Passio Kiliani, Ps. Theotimus, Passio Margaretae, Orationes* (Hanover, Niedersachsische Landesbibliothek, Ms. L 189), Codices Selecti LXXXIII, Graz

Hall, D. J., 1983. 'The Community of St Cuthbert – its Properties, Rights and Claims from the Ninth Century to the Twelfth', unpubl. PhD thesis, University of Oxford

Hamerow, H. and A. MacGregor, eds, 2001. *Image and Power in the Archaeology of Early Britain. Essays in Honour of Rosemary Cramp*, Oxford

Hamilton Thompson, A., 1923. *Liber Vitae Ecclesiae Dunelmensis*, Durham

Hamilton Thompson, A., 1949. *Lindisfarne Priory, Northumberland*, HMSO

Harbison, P., 1994. 'High Crosses and the Book of Kells', in O'Mahony 1994, pp. 266–9

Harmer, F. E., ed. and transl., 1914. *Select English Historical Documents of the Ninth and Tenth Centuries*, Cambridge (for Aldred's colophon, see no. xxii)

Harmon, J. A., 1984. *Codicology of the Court School of Charlemagne: Gospel Book Production, Illumination and Emphasized Script*, European Studies ser. 28, History of Art 21, Frankfurt

Hart, C., 1975. *The Early Charters of Northern England and the North Midlands*, Leicester

Hauck, K., 1974. 'Das Einhardkreuz: mit einem Anhang zu den Problemen des Rupertus-Kreuzes', *Frühmittelalterliche Studien* 8, pp. 105–15

Hawkes, J., 1996. *The Golden Age of Northumbria*, Morpeth

Hawkes, J. and S. Mills, eds, 1999. *Northumbria's Golden Age*, Stroud

Hawkes, J., 2001. See Ó Carragáin 2001

HE = Bede, *Historia Ecclesiastica* (see Bede, above)

Heinzelmann, M., 1979. *Translationsberichte und andere Quellen des ReliquienKultes*, Turnhout

Henderson, G., 1987. *From Durrow to Kells, the Insular Gospel-books 650–800*, London

Henderson, G., 1993. 'Cassiodorus and Eadfrith Once Again', in Spearman and Higgitt 1993, pp. 82–91

Henderson, G., 1999. *Vision and Image in Early Christian England*, Cambridge

Henderson, G., 1980. 'Bede and the Visual Arts', *The Jarrow Lecture* 1979, Newcastle-upon-Tyne

Henderson, G., 2001. 'The Barberini Gospels (Rome, Vatican, *Biblioteca Apostolica Barberini* Lat. 570) as a Paradigm of Insular Art', in Redknap *et al.*, pp. 157–68

Henderson, I., 1982. 'Pictish art and the Book of Kells', in D. Whitelock, R. McKitterick and D. Dumville, eds, *Ireland and Early Medieval Europe, Studies in Memory of Kathleen Hughes*, Cambridge, pp. 79–105

Henderson, I., 1987. 'The Book of Kells and the Snake Boss Motif on Pictish Cross-slabs and the Iona Crosses', in Ryan 1987, pp. 56–65

Henderson, I. and E. Okasha, 1992. 'The Early Christian Inscribed and Carved Stones of Tullylease, Co. Cork', *Cambridge Medieval Celtic Studies* 24 (Winter 1992), pp. 2–36

Henry, F., 1950. 'Les débuts de la miniature Irlandaise', *Gazette des Beaux-Arts*, 6e pr. 37

Henry, F., 1960. 'Remarks on the decoration of three Irish Psalters', *Proceedings of the Royal Irish Academy* 61, section C no. 2, 23–40

Henry, F., 1963. 'The Lindisfarne Gospels', *Antiquity* 37, pp. 10–110

Henry, F., 1964. *L'Art Irlandaise*, Yonne

Henry, F., 1965. *Irish Art in the Early Christian Period*, London

Henry, F., 1974. *The Book of Kells*, London

Herbert, M., 1988. *Iona, Kells and Derry: The History and Hagiography of the Monastic Familia of Columba*, Oxford

Herity, M., 1983. 'The buildings and layout of early Irish monasteries before the year 1000', in L. Freeman, ed., *Celtic Monasticism*, Monastic Studies 14, pp. 247–84

Herity, M., 1989. 'Early Irish Hermitages in the Light of the Lives of Cuthbert', in Bonner *et al.* 1989, pp. 45–63

Higgitt, J., 1994. 'The Display Script of the Book of Kells and the Tradition of Insular Decorative Capitals', in O'Mahony 1994, pp. 209–33

Higgitt, J., K. Forsyth and D. N. Parsons, eds, 2001. *Roman, Runes and Ogham. Medieval Inscriptions in the Insular World and on the Continent*, Donington

Higham, N. J., 1986. *The Northern Counties to AD 1000*, Harlow

Higham, N. J., 1993. *The Kingdom of Northumbria*, Stroud

Hill. P., 1992. *Whithorn 4. Excavations 1990–1991. Interim Report*, Whithorn

Hill, P., 1994. *The Whithorn Dig*, Whithorn

Historia de Sancto Cuthberto, see R.S.1 and Johnson-Smith 2002

Hist. MSS Comm. = Historical Manuscripts Commission

Hohler, C., 1956. 'The Durham Services in Honour of St Cuthbert', in Battiscombe 1956, pp. 155–91

Holder, 1994 (see Bede, above)

Holt, P. M., A. K. S. Lambton and B. Lewis, 1970. *The Cambridge History of Islam*, Cambridge

Howlett, D., 1998. 'Hellenic Learning in Insular Latin: an Essay on Supported Claims', *Peritia* 12, pp. 54–78

Howlett, D., 1998a. 'Vita I Sanctae Brigitae', *Peritia* 12, pp. 1–23

Hull, J. E., 1927. 'Pseudo-history', *The Vasculum* 13, pp. 132–7

Hurst, 1960 (see Bede, above)

Jaager, W., ed., 1935. *Bedas metrische Vita sancti Cuthberti*, Palaestra 198, Leipzig

Johnson-South, T., 1992. 'The Norman Conquest of Durham: Norman Historians and the Anglo-Saxon Community of St Cuthbert', *Haskins Society Journal* 4, 85–95

Johnson-South, T., 2002. 'The "Historia de Sancto Cuthberto"', *Anglo-Saxon Texts* 3, Cambridge

Karkov, C., 1993. 'The Chalice Cross in Insular Art', in Spearman and Higgitt 1993, pp. 237–44

Karkov, C., 1999. 'Whitby, Jarrow and the Commemoration of Death in Northumbria', in Hawkes and Mills 1999, pp. 126–35

Kauffmann, C. M., 1975. *Romanesque Manuscripts 1066–1190*, London

Kelly, E. P., 1994. 'The Lough Kinale Shrine: the Implications for the Manuscripts', in O'Mahony 1994, pp. 280–9

Kendrick, T. D., 1938. *Anglo-Saxon Art to AD 900*, London, reptd 1972

Ker, N. R., 1941. *Medieval Libraries of Great Britain*, Royal Historical Society

Ker, N. R., 1943. 'Aldred the Scribe', *Essays and Studies* xxviii, pp. 7–12; reptd in A. G. Watson, ed., *N. R. Ker, Books, Collectors and Libraries. Studies in the Medieval Heritage*, London and Ronceverte, 1985, pp. 3–8

Ker, N. R., 1957. *Catalogue of Manuscripts Containing Anglo-Saxon*, Oxford

Ker, N. R., 1985. 'The Migration of Manuscripts from the English Medieval Libraries', in A. G. Watson, ed., *N. R. Ker, Books, Collectors and Libraries. Studies in the Medieval Heritage*, London and Ronceverte, pp. 459–70

Keynes, S., 1985. 'King Athelstan's Books', in M. Lapidge and H. Gneuss, eds, *Learning and Literature in Anglo-Saxon England*, Cambridge, pp. 143–201

Kirby, D. P., 1974. *St Wilfrid at Hexham*, Newcastle

Kitzinger, E., 1975. *The Place of Book Illumination in Byzantine Art*, Princeton

Kitzinger, E., 1977. *Byzantine Art in the Making*, Harvard and London

Knowles, D. and R. N. Hancock, 1953. *Medieval Religious Houses: England and Wales*, London

Kockelhorn, E., 2000. *Evangeliorum Quattuor Codex Petropolitanus (Lat.F.v.I. N 8)*, Luxembourg

Koehler, W., 1923. 'Die Denkmäler der karolingischen Kunst in Belgien', in P. Clemen, ed., *Belgische Kunstdenkmäler*, Munich, pp. 1–26

Köllner, H., ed., 1976. *Die Illuminierten Handschriften der Hessischen Landesbibliothek Fulda*, I, Stuttgart

Laing, L., 1973. 'The Angles in Scotland and the Mote of Mark', *Transactions of the Dumfriesshire and Galloway Natural History and Antiquarian Society*, 3rd ser., 50, pp. 39–52

Laing, L., 1975. 'The Mote of Mark and the Origins of Celtic Interlace', *Antiquity* 49, pp. 98–108

Laing, L., 1993. *A Catalogue of Celtic Ornamental Metalwork in the British Isles c.AD 400–1200*, British

Archaeological Reports, British Ser. 229

Lampe, G. W. H., ed., 1969. *The Cambridge History of the Bible. 2, The West from the Fathers to the Reformation*, Cambridge

Lane, A. and E. Campbell, 2000. *Dunadd. An Early Dalriadic Capital*, Cardiff Studies in Archaeology, Oxford

Lang, J., ed., 1978. *Anglo-Saxon and Viking Age Sculpture*, British Archaeological Reports, British Ser., 49

Lang, J., ed., 1991. *Corpus of Anglo-Saxon Stone Sculpture, III, York and Eastern Yorkshire*, Oxford

Lapidge, M., 1989. 'Bede's Metrical *Vita S. Cuthberti*', in Bonner *et al.* 1989, pp. 22–96

Lapidge, M. and D. N. Dumville, eds, 1984. *Gildas: New Approaches*, Woodbridge

Lapidge, M., ed., 1995. *Archbishop Theodore: Commemorative Studies on his Life and Influence*, Cambridge

Lapidge, M., 1996. 'Aediluulf and the School at York', in M. Lapidge, *Anglo-Saxon Literature 600–899*, London and Rio Grande, OH, pp. 381–98

Lawlor, H., 1916. 'The Cathach of St Columba', *Proceedings of the Royal Irish Academy* 33, pp. 241–443

Leclercq, J., 1961. *The Love of Learning and the Desire for God*, New York

Leland, J., 1774. *Collectanea*, ed. T. Hearne, 2nd edn, IV, London

Leaker, U., 1997. *Die westsächsische Evangelienversion und die Perikopenordnungen im angelsächsischen England*, Munich

Levison, W. and M. Tangl, eds, 1968. *Bonifatii Epistulae . . .*, Darmstadt

Lewis, S., 1980. 'Sacred Calligraphy: the Chi Rho Page in the Book of Kells', *Traditio* 26, pp. 139–59

Liber Pontificalis, LXXXVI (Sergius), xiv, ed. L. Duchesne, Paris, 1886–92, I, p. 376; transl. R. Davis, *The Book of Pontiffs ('Liber Pontificalis')*, Translated Texts for Historians 5, Liverpool, 1989

Lindsay, W. M., 1963. *Notae Latinae*, 1st edn (Cambridge, 1915), 2nd edn, Hildesheim, 1963

Longley, D., 2001. 'The Mote of Mark: the Archaeological Context of the Decorated Metalwork', in Redknap *et al.* 2001, pp. 75–89

Lowe, C. E., 1991. 'New light on the "Anglian minster" at Hoddom. Recent excavations at Hallguards Quarry, Hoddom, Annandale and Eskdale District, Dumfries and Galloway Region', *Transactions of the Dumfriesshire and Galloway Natural History and Antiquarian Society*, 3rd ser., 77, pp. 11–35

Lowe, E. A., see also CLA, above

Lowe, E. A., 1928. 'More Facts about our Oldest Latin Manuscripts', *The Classical Quarterly* 22, pp. 43–62 (reptd in L. Bieler, ed., *Palaeographical Chapters*, I, 251–74, Oxford, 1972)

Lowe, E. A., 1960. *English Uncial*, Oxford

Lozanova, R., ed., 2002. *Icones et Manuscrits Bulgares*, Europalia

Luce, A. A., G. O. Simms, P. Meyer and L. Bieler, eds, 1960. *Evangeliorum quattuor Codex Durmachensis*, facsimile and commentary, 2 vols, Olten

Mac Lean, D., 1995. 'Technique and Contact: Carpentry-constructed Insular Stone Crosses', in Bourke 1995, pp. 167–75

Madden, F. and H. Shaw, 1833. *Illuminated Ornaments of the Middle Ages*, London

Marckwardt, A. H., 1948. 'The Sources of Laurence Nowell's Vocabularium Saxonicum', *Studies in Philology* XLV, p. 24

Marckwardt, A. H., 1952. *Laurence Nowell's Vocabularium Saxonicum*, University of Michigan Publications, Language and Literature, xxv

Marner, D., 2001. *St Cuthbert, His Life and Cult in Medieval Durham*, London

Marsden, R., 1995. *The Text of the Old Testament in Anglo-Saxon England*, Cambridge Studies in Anglo-Saxon England 15, Cambridge

Marsden, R., 1995a. 'Job in his Place: The Ezra Miniature in the *Codex Amiatinus*', *Scriptorium* 49, pp. 3–15

Marsden, R., 1998. 'Manus Bedae: Bede's Contribution to Ceolfrith's Bibles', *Anglo-Saxon England* 27, 65–86

Marshall, T., 1665. *Observationes in Evangeliorum Versiones perantiquas duas, Gothicas scil. et Anglo-Saxonicas*, Dort, 1665; Amsterdam, 1684

Marx, S., 1995. 'The Miserable Beasts – Animal Art in the Gospels of Lindisfarne, Lichfield and St Gallen', *Peritia* 9, pp. 234–45

Masai, F., 1947. *Essai sur la Miniature Dite Irlandaise*, Brussels

Masi, M., 1983. *Boethian Number Theory: A Translation of the De Institutione Arithmetica*, Amsterdam

MacAlister, R. A. S., 1913. 'The Colophon in the Lindisfarne Gospels', in E. C. Quiggin, ed., *Essays and Studies Presented to Sir William Ridgeway*, Cambridge, pp. 299–305

Mayr-Harting, H., 1972. *The Coming of Christianity to Anglo-Saxon England*, London

McGurk, P., 1955. 'The Canon Tables in the Book of Lindisfarne', *Journal of Theological Studies* 6, pp. 192–8

McGurk, P., 1961. *Latin Gospel Books from AD 400 to AD 800*, Les Publications de Scriptorium, v, Paris-Brussels, Anvers-Amsterdam

McGurk, P., 1993. 'The Disposition of Numbers in Latin Eusebian Canon Tables', in R. Gryson, ed., *Philologia Sacra*, I, Freiburg, pp. 242–58

McGurk, P., 1994. 'The Oldest Manuscripts of the Latin Bible', in R. G. Gameson, ed., *The Early Medieval Bible*, Cambridge, pp. 1–23

McGurk, P., and R. Darlington, 1995. *The Chronicle of John of Worcester*, Oxford

McKitterick, R., 1985. 'Knowledge of Canon Law in the Frankish Kingdoms Before 789: The Manuscript Evidence', *Journal of Theological Studies* n.s. 36, pp. 97–117

McKitterick, R., 1989. *The Carolingians and the Written Word*, Cambridge

McKitterick, R., 1991. 'Frankish Uncial: A New Context for the Echternach Scriptorium', in P. Bange and A. Wieler, eds, *Willibrord, zijn wereld en zijn werk*, Nijmegen, Centrum voor Middeleeuwse Studies 1990, pp. 374–88

McKitterick, R., 1995. 'Essai sur les representations de l'ecrit dans les manuscrits carolingiens', *Révue française d'histoire du livre*, nos 86–7, pp. 37–64

McKitterick, R., 2000. 'Le Scriptorium d'Echternach aux huitième et neuvième siècles', in M. Polfer, ed., *L'évangélisation des régions entre Meuse et Moselle et la fondation de l'abbaye d'Echternach (Vᵉ–IXᵉ siècle)*, P. S. H. CXVII, Publications du CLUDEM, 16, Luxembourg, pp. 501–22

McNally, R. E., 1971. 'The evangelists in the Hiberno-Latin tradition', in Autenrieth and Brunzholzl, 1971, p. 116

McNamara, M., 1973. 'Psalter Text and Psalter Study in the Early Irish Church (AD 600–1200)', *Proceedings of the Royal Irish Academy* 73, section C no. 7, pp. 201–98

Meehan, B., 1994. *The Book of Kells*, London

Meehan, B., 1996. *The Book of Durrow*, Dublin

Meyvaert, P., 1964. 'Bede and Gregory the Great', *The Jarrow Lecture* 1963, Newcastle-upon-Tyne

Meyvaert, P., 1976. 'Bede the Scholar', in G. Bonner, ed., *Famulus Christi: Essays in Commemoration of the 13th Centenary of the Birth of the Venerable Bede*, London, pp. 40–69

Meyvaert, P., 1979. 'Bede and the Church Paintings at Wearmouth/Jarrow, *Anglo-Saxon England* 8, pp. 63–77

Meyvaert, P., 1996. 'Bede, Cassiodorus and the Codex Amiatinus', *Speculum* 71, pp. 827–83

Michelli, P., 1996. 'The inscriptions on pre-Norman Irish reliquaries', *Proceedings of the Royal Irish Academy* 96c, pp. 1–48

Michelli, P., 1999. 'What's in the Cupboard', in Hawkes and Mills 1999, pp. 345–58

Migne, J. P., ed., 1844–64. *Patrologiae Cursus Completus*, 221 vols, Paris

Miles, G., 1898. *The Bishops of Lindisfarne, Hexham, Chester-le-Street, and Durham AD 635–1020*, London

Millar, E. G., 1973. *That Noble Cabinet*, London

Millar, E. G., 1923. *The Lindisfarne Gospels*, London and Oxford

Millar, R. M., 2000. *System Collapse System Rebirth. The Demonstrative Pronouns of English 900–1350 and the Birth of the Definite Article*, Berne

Millet, G., 1910. *Les Iconoclastes et la Croix*, Paris

Mitchell, J., 2001. 'Script about the Cross: the Tombstones of San Vicenzo al Volturno', in Higgitt *et al.* 2001, pp. 158–74

Mohlberg, P. K., 1927. *Die älteste erreichbare Gestalt des Liber Sacramentorum anni circuli der römischen Kirche*, Münster

Morin, G., 1891. 'La Liturgie de Naples au Temps de Saint Gregoire', *Revue Bénédictine* 8, pp. 481–93, 529–37

Morin, G., 1892. 'Le Recueil Primatif des Homélies de Bede sur l'Evangile', *Revue Bénédictine* 9

Morin, G., 1893. 'Les notes liturgiques de l'Evangélaire de Burchard', *Revue Bénédictine* 10, pp. 113–26

Morin, G., 1911. 'Liturgie et basiliques de Rome au Milieu du VIIe siècle d'après les listes d'évangiles de Würzburg', *Révue Bénédictine* 28, pp. 296–330

Mostert, M., ed., 1999. *New Approaches to Medieval Communication*, Turnhout

Mynors, R. A. B., ed., 1937. *Cassiodori Senatoris Institutiones*, Oxford

Mynors, R. A. B., 1939. *Durham Cathedral Manuscripts to the End of the Twelfth Century*, Durham

Needham, P., 1979. *Twelve Centuries of Bookbindings*, New York

Nees, L., 1978. 'A Fifth-Century Book Cover and the Origin of the Four Evangelist Symbols Page in the Book of Durrow', *Gesta* 17, pp. 3–8

Nees, L., 1993. 'Ultán the Scribe', *Anglo-Saxon England* 22, pp. 127–46

Nees, L., 1999. 'Problems of Form and Function in Early Medieval Illustrated Bibles from Northwest Europe', in J. Williams, ed., *Imaging the Early Medieval Bible*, Pennsylvania, pp. 122–77

Nees, L., forthcoming. 'Reading Aldred's Colophon for the Lindisfarne Gospels', *Speculum*, Spring 2003

Nennius, *Historia Brittonum*, ed. T. Mommsen, Monumenta Germaniae Historica AA XIII, Berlin, 1898; transl. A. W. Wade-Evans, *Nennius's 'History of the Britons'*, 1938

Nersessian, V., 2001. *Treasures from the Ark, 1700 Years of Armenian Christian Art*, London

Netzer, N., 1989. 'Willibrord's Scriptorium at Echternach and its Relationship to Ireland and Lindisfarne', in Bonner *et al.* 1989, pp. 203–12

Netzer, N., 1989a. 'The Early Scriptorium at Echternach: The State of the Question', in G. Kiesel and J. Schroeder, eds, *Willibrord, Apostel der Niederlande*, Luxembourg, pp. 127–34 and 312–18

Netzer, N., 1994. *Cultural Interplay in the Eighth Century, the Trier Gospels and the Making of a Scriptorium at Echternach*, Cambridge

Netzer, N., 1994a. 'The Origin of the Beast Canon Tables Reconsidered', in O'Mahony 1994, pp. 322–32

Netzer, N., 1995. 'Cultural Amalgamation in the Stuttgart Psalter', in Bourke 1995, pp. 119–26

Netzer, N., 1999. 'The Book of Durrow: the Northumbrian Connection', in Hawkes and Mills, pp. 315–26

Neuman de Vegvar, C., 1987. *The Northumbrian Renaissance: a Study in the Transmission of Style*, London and Toronto

Nilgen, U., 1981. 'Maria Regina – ein politischer Kultbildtypus?', *Römisches Jahrbuch für Kunstgeschichte* 19, pp. 1–33

Noel, W. G., 1995. *The Harley Psalter*, Cambridge

Nordenfalk, C., 1932. 'On the Age of the Earliest Echternach Manuscripts', *Acta Archaeologica* 3, pp. 57–62

Nordenfalk, C., 1938. *Die Spatantiken Kanontafeln*, 2 vols, Goteborg

Nordenfalk, C., 1942. 'Eastern Style Elements in the Book of Lindisfarne', *Acta Archaeologica* 13, pp. 157–69

Nordenfalk, C., 1951. 'The Beginning of Book Decoration', in O. Goetz, ed., *Essays in honor of Georg Swarzenski*, Chicago

Nordenfalk, C., 1968. 'An Illustrated Diatessaron', *Art Bulletin* 50, pp. 119–40

Nordenfalk, C., 1977. *Celtic and Anglo-Saxon Painting*, London

Nordenfalk, C., 1992. *Studies in the History of Book Illumination*, London

Nordenfalk, C. and A. Grabar, 1957. *Early Medieval Painting from the Fourth to the Eleventh Century*, Skira

Nordhagen, P. J., 1977. 'The Codex Amiatinus and the Byzantine Element in the Northumbrian Renaissance', *The Jarrow Lecture* 1977, Newcastle-upon-Tyne

Ó Carragáin, E., 1987. 'A Liturgical Interpretation of the Bewcastle Cross', in M. Stokes and T. C. Burton, eds, *Medieval Literature and Antiquities. Studies in Honour of Basil Cottle*, Cambridge, pp. 15–42

Ó Carragáin, E., 1994. 'The City of Rome and the World of Bede', *The Jarrow Lecture* 1994, Newcastle-upon-Tyne

Ó Carragáin, E. 1994a. '"Traditio Evangeliorum" and "Sustenatio": the relevance of liturgical ceremonies to the Book of Kells', in O'Mahony 1994, pp. 398–436

Ó Carragáin, E., 1999. 'The Necessary Distance: *Imitatio Romae* and the Ruthwell Cross', in Hawkes and Mills 1999, pp. 191–203

Ó Carragáin, E., J. Hawkes and R. Trench-Jellicoe, 2001. 'John the Baptist and the *Agnus Dei*: Ruthwell and Bewcastle Revisited', *Antiquaries Journal* 81, pp. 131–53

Ó Carragáin, E., forthcoming. *Liturgical Thought and 'The Dream of the Rood', Communal Rituals and Meditative Reading in Anglo-Saxon England*, London and Toronto

Ó Cróinín, D., 1982. 'Pride and Prejudice', *Peritia* 1, pp. 352–62

Ó Cróinín, D., 1984. 'Rath Maelsigi, Willibrord and the Earliest Echternach Manuscripts', *Peritia* 3, pp. 17–49

Ó Cróinín, D., 1988. *Evangeliarium Epternachense (Universitätsbibliothek Augsburg Cod. 1.2.4°2), Evangelistarium (Erzbischöfliches Priesterseminar St. Peter, Cod. Ms 25): Colour Microfiche Edition*, Munich

Ó Cróinín, D., 1989. 'Is the Augsburg Gospel Codex a Northumbrian Manuscript?' in Bonner *et al.* 1989, pp. 189–201

Ó Cróinín, D., 1989a. 'Early Echternach manuscript fragments with Old Irish glosses', in G. Kiesel and J. Schroeder, eds, *Willibrord, Apostel der Niederlande*, Luxembourg, pp. 135–43 and 319–22

Ó Cróinín, D., 1995. *Early Medieval Ireland 400–1200*, Harlow

Ó Floinn, R., 1989. 'Secular metalwork in the eighth and ninth centuries', in Youngs 1989, p. 72

Ó Floinn, R., 1994. *Irish Shrines and Reliquaries of the Middle Ages*, Dublin

Okasha, E., 1999. 'The Inscribed Stones from Hartlepool', in Hawkes and Mills, 1999, pp. 113–25

Okasha, E. and K. Forsyth, 2001. *Early Christian Inscriptions of Munster, a Corpus of the Inscribed Stones*, Cork

O'Loughlin, T., 1992. 'The Exegetical Purpose of Adomnán's De Locis Sanctis', *Cambridge Medieval Celtic Studies*, 24 (Winter), pp. 37–53

O'Loughlin, T., 2000. *Journeys on the Edges, the Celtic Tradition*, London

O'Loughlin, T., 2000. *Celtic Theology, Humanity, World, and God in Early Irish Writings*, London

O'Mahony, F., ed., 1994. *The Book of Kells. Proceedings of a Conference at Trinity College Dublin, 6–9 September 1992*, Aldershot

O'Meadhra, U., 1979. *Early Christian, Viking and Romanesque Art. Motif-pieces from Ireland*, N. European Archaeology, 7, Stockholm

O'Meara, J. J., ed., 1982. *Giraldus Cambrensis, Topographia Hibernia*, revd edn, Portlaoise

O'Reilly, J., 1993. 'The Book of Kells, folio 114r', in Spearman and Higgitt 1993, pp. 110–11

O'Reilly, J., 1998. 'Patristic and Insular Traditions of the Evangelists: Exegesis and Iconography', in A. M. Luiselli Fadda and E. Ó Carragáin, eds, *Le Isole Britanniche e Roma in Età Romanobarbarica*, Rome, pp. 49–94

O'Reilly, J., 2001. 'The Library of Scripture: Views from the Vivarium and Wearmouth-Jarrow', in P. Binski and W. G. Noel, eds, *New Offerings, Ancient Treasures. Essays in Medieval Art for George Henderson*, Stroud

O'Sullivan, D., 1989. 'The Plan of the Early Christian Monastery on Lindisfarne: a Fresh Look at the Evidence', in Bonner *et al.* 1989, pp. 125–42

O'Sullivan, D., 1993. 'Sub-Roman and Anglo-Saxon finds from Cumbria', *Transactions of the Cumberland and Westmoreland Antiquarian and Archaeological Society*, n.s. 93, pp. 25–42

O'Sullivan, D. and R. Young, 1995. *English Heritage Book of Lindisfarne, Holy Island*, London

O'Sullivan, W., 1994. 'The Palaeographical Background to the Book of Kells', in O'Mahony 1994, pp. 175–82

Pächt, O., 1962. *The Rise of Pictorial Narrative in Twelfth-Century England*, Oxford

Page, R. I., 1989. 'Roman and Runic on St Cuthbert's Coffin', in Bonner *et al.* 1989, pp. 257–66

Page, R. I., 1995. *Runes and Runic Inscriptions*, Woodbridge

Palaeographical Society, 1873–83. *Facsimiles of Manuscripts and Inscriptions*, Series 1, ed. E. A. Bond, E. M. Thompson and G. F. Warner, London

Papagiannopoulos, A., 1981. *Monuments of Thessaloniki*, Thessaloniki

Parkes, M. B., 1982. 'The Scriptorium of Wearmouth-Jarrow', *The Jarrow Lecture* 1982, Newcastle-upon-Tyne

Parkes, M. B., 1987. 'The contribution of Insular Scribes of the Seventh and Eighth Centuries to the "Grammar of Legibility"', in A. Maierù, ed., *Grafia e interpunzione del latino nel medioevo*, Rome, pp. 15–30

Parkes, M. B., 1992. *Pause and Effect, an Introduction to the History of Punctuation in the West*, Aldershot

Parkes, M. B., 2000. '*Rædan, areccan, smeagan*: how the Anglo-Saxons read', *Anglo-Saxon England* 26, pp. 1–22

Petrucci, A., 1971. *L'Onciale Romana, Studi Medievali* 3rd ser., 12

Piper, A. J., 1978. 'Libraries of the monks of Durham', in M. B. Parkes and Andrew G. Watson, eds, *Medieval Scribes, Manuscripts & Libraries. Essays presented to N. R. Ker*, London, pp. 213–49

Pirotte, E., 1994. 'Le signe de la Croix dans les manuscrits insulaires: camouflages et apparitions', *Annales de l'histoire de l'art et d'archéologie* 16, pp. 23–45

Pirotte, E., 2001. 'Hidden Order, Order Revealed: New Light on Carpet Pages', in Redknap *et al.*, pp. 203–8.

Plummer, C., 1925. *Irish Litanies*, London

Raine, J., 1838. *Catalogi Veteres Librorum Ecclesiae Cathedralis Dunelm.*, Surtees Society, VII

Raine, J., 1852. *The History and Antiquities of North Durham*, Durham

Raw, B. C., 1990. *Anglo-Saxon Crucifixion Iconography and the Art of the Monastic Revival*, Cambridge

Redknap, M., N. Edwards, S. Youngs, A. Lane and J. Knight, eds, 2001. *Pattern and Purpose in Insular Art*, Oxford

Regul, J., 1969. *Die Antimarcionitischen Evangelienprologe*, Freiburg

Ritchie, A., 1993. *Viking Scotland*, London

Rites of Durham, ed. J. T. Fowler, Surtees Society, CVII, 1902

Roberts C. H. and T. C. Skeat, 1987. *The Birth of the Codex*, London

Rollason, D. 1989. *Saints and Relics in Anglo-Saxon England*, Oxford

Rollason, D. 1989a. 'St Cuthbert and Wessex: the Evidence of Cambridge, Corpus Christi College MS 183', in Bonner *et al.*, pp. 413–24

Rollason, D. 1992. 'Symeon of Durham and the Community of Durham in the Eleventh Century', in C. Hicks, ed., *England in the Eleventh Century*, Stamford, pp. 183–98

Ross, A. S. C., 1932. 'The Errors in the Old English Gloss to the Lindisfarne Gospels', *Review of English Studies* 8, pp. 385–94

Ross, A. S. C., 1933. 'Notes on the Methods of Glossing Employed in the Lindisfarne Gospels', *Transactions of the Philological Society*

Ross, A. S. C., 1937. *Studies in the Accidence of the Lindisfarne Gospels*, Leeds School of English Language Texts and Monographs 2, Kendal

Ross, A. S. C., 1979. 'Lindisfarne and Rushworth One', *Notes and Queries* 224, pp. 194–8

Ross, A. S. C., 1981. 'The Use of Other Latin Manuscripts by the Glossators of the Lindisfarne and Rushworth Gospels', *Notes and Queries* 226, pp. 6–11

R.S. = Rolls Series

Roth, C., 1953. 'Antecedents of Christian Art', *Journal of the Warburg and Courtauld Institutes* 16, pp. 1–2

Ryan, M., ed., 1983. *Treasures of Ireland. Irish Art, 3000 BC–1500 AD*, Dublin

Ryan, M., ed., 1987. *Ireland and Insular Art AD 500–1200*, Dublin

Ryan, M., 1991. 'Links Between Anglo-Saxon and Early Irish Medieval Art. Some Evidence of Metalwork', in C. Karkov and R. Farrell, eds, *Studies in Insular Art and Archaeology, American Early Medieval Studies* 1, Oxford, OH, pp. 117–26

Ryan, M., 1994. 'The Book of Kells and Metalwork', in O'Mahony 1994, pp. 270–9

Sanz, S. M. P., 2001. 'Adredian Glosses to Proper Names in the Lindisfarne Gospels', *Zeitschrift für Englische Philologie* 119, pp. 173–92

Schapiro, M. and Seminar, 1973. 'The Miniatures of the Florence Diatessaron', *Art Bulletin* 55, pp. 528

Schaumann, B. T., 1978/9. 'Early Irish Manuscripts: the Art of the Scribes', *Expedition* 21, pp. 33–47

Scheller, R. W., 1995. *Exemplum. Model-Book Drawings and the Practice of Transmission in the Middle Ages (ca.900–ca.1450)*, Amsterdam

Schipper, W., 1994. 'Dry-point compilation notes in the Benedictional of St Æthelwold', *British Library Journal* 20, no. 1 (Spring)

Schipper, W., forthcoming. 'Vernacular layout style in Anglo-Saxon England', in G. H. Brown and C. Karkov forthcoming

Selden, J., 1652. *Historiae Anglicanae Scriptores* x, London

Sheldrake, P., 1995. *Living Between Worlds. Place and Journey in Celtic Spirituality*, London

Shetelig, H., 1940–54. *Viking Antiquities in Great Britain and Ireland*, 6 vols, Oslo

Skeat, W. W., 1871–87. *The Holy Gospels in Latin, Anglo-Saxon, Northumbrian and Old Mercian Versions, Synoptically Arranged*, Cambridge

Skene, W. F., 1886–90. *Celtic Scotland*, 3 vols, Edinburgh

Smith, I. M., 1983. 'Brito-Roman and Anglo-Saxon: The Unification of the Borders', in P. Clack and J. Ivy, eds, *The Borders*, Durham, pp. 9–48

Smith, T., 1696. *Catalogue of the Manuscripts in the Cottonian Library, 1696*, ed. C. Tite, Cambridge, 1984

Smyth, A. P., 1984. *Warlords and Holy Men, Scotland AD 80–1000*, London

Speake, G., 1980. *Anglo-Saxon Animal Art and its Germanic Background*, Oxford

Spearman, M. and J. Higgitt, eds, 1993. *The Age of Migrating Ideas, Early Medieval Art in Northern Britain and Ireland*, Stroud

Stalley, R., 1994. 'Scribe and Mason: The Book of Kells and the Irish High Crosses', in O'Mahony 1994, pp. 257–65

Stancliffe, C., 1989. 'Cuthbert and the Polarity between Pastor and Solitary', in Bonner *et al.* 1989, pp. 21–44

Stansbury, M., 1999. 'Early Medieval Biblical Commentaries, Their Writers and Readers', in K. Hauck, ed., *Frümittelalterliche Studien, Herausgegeben von H. Keller und C. Meier*, Berlin and New York, pp. 50–82

Stansbury, M., 1999a. 'Source-marks in Bede's Biblical Commentaries', in Hawkes and Mills 1999, pp. 383–9

Stenton, F. M., 1971. *Anglo-Saxon England*, Oxford

[Eddius] Stephanus, *Life of Wilfrid*, ed. and transl., D. H. Farmer, *The Age of Bede*, Harmondsworth 1983, pp. 105–84

Stevens, W. O. and A. S. Cook, 1977. *The Anglo-Saxon Cross*, Hamden, CT

Stevenson, J. and G. Waring, 1854–65. See Surtees Society

Stevenson, R. B. K., 1981–2. 'Aspects of Ambiguity in Crosses and Interlace', *Ulster Journal of Archaeology*, 44/45, pp. 1–27

Stevick, R., 1983. 'The Design of Lindisfarne Gospels Folio 138v', *Gesta* 22, pp. 3–12

Stevick, R., 1986. 'The 4 × 3 Crosses in the Lindisfarne and Lichfield Gospels', *Gesta* 25, pp. 171–84

Stevick, R., 1994. *The Earliest Irish and English Bookarts. Visual and Poetic Forms Before AD 1000*, Philadelphia

Stevick, R., 1998. 'The Form of the Tara Brooch', *Journal of the Royal Society of Antiquaries of Ireland* 128, pp. 5–16

Stokes, W., 1890. *Lives of the Saints from the Book of Lismore*, Anecdota Oxoniensia, Oxford

Strutt, J., 1775–6. *Horda Angel-cynnan; or a Compleat View of the Manners, Customs, Arms, Habits, Etc. of the inhabitants of England*, 3 vols, London

Surtees Society, 1854–65. *The Lindisfarne and Rushworth Gospels, Now First Printed from the Original Manuscripts in the British Museum and the Bodleian Library*, pt I, Matthew, ed. J. Stevenson (1854), Surtees Society vol. 28; pt II, Mark, ed. G. Waring (1861), vol. 39; pt III, Luke, ed. G. Waring (1863), vol. 43; pt IV, John, ed. G. Waring (1865), vol. 48

Symeon of Durham, *Historia Dunelmensis*, ed. T. Arnold, *Symeonis Monachi Opera Omnia*, 2 vols, Rolls Series, I, London, 1882–5

Swanton, M., 1970. *The Dream of the Rood*, Manchester

427

Sweet, H., 1887. *A Second Anglo-Saxon Reader*, Clarendon Press Series, Oxford; 2nd edn revd by T. F. Hood, Oxford, 1978

Talbot, C. H., ed., 1954. *The Anglo-Saxon Missionaries in Germany*, London and New York

Talley, T. J., 1986. *The Origins of the Liturgical Year*, New York

Telepneff, Fr. G., 1998. *The Egyptian Desert in the Irish Bogs. The Byzantine Character of Early Celtic Monasticism*, Etna

Temple, E., 1976. *Anglo-Saxon Manuscripts, 900–1066*, London

Thacker, A., 1989. 'Lindisfarne and the Origins of the Cult of St Cuthbert', in Bonner *et al.* 1989, pp. 103–24

Thomas, C., 1992. 'Whithorn's Christian Beginnings', *First Whithorn Lecture*, 1992, Whithorn

Thompson, A. H. (ed.), 1923. 'Liber Vitae Ecclesiae Dunelmensis', I, *Surtees Society* 136, Durham

Thompson, D. V., 1957. *The Materials and Techniques of Medieval Painting*, New York

Thompson, D. V., ed., *Cennino d'Andrea Cennini, The Craftsman's Handbook*, New York

Tite, C. G. C., ed., 1984. See Smith, T., 1696

Tite, C. G. C., 1993. *The Manuscript Library of Sir Robert Cotton*, The Panizzi Lectures, British Library, London

Tite, C. G. C., 1997. 'Sir Robert Cotton, Sir Thomas Tempest and an Anglo-Saxon Gospel Book: a Cottonian paper in the Harleian Library', in J. P. Carley and C. G. C. Tite, eds, *Books and Collectors, 1200–1700: Essays Presented to Andrew Watson*, London

Toulmin-Smith, L., 1907. *The Itinerary of John Leland*, I

Tudor, V., 1989. 'The Cult of St Cuthbert in the Twelfth Century: the Evidence of Reginald of Durham', in Bonner *et al.* 1989, pp. 447–68

Van der Horst, K., W. Noel and W. C. M. Wüstefeld, eds, 1996. *The Utrecht Psalter in Medieval Art*, MS't Goy

Van Stone, M., 1994. 'Ornamental Techniques in Kells and its Kin', in O'Mahony ed., 1994, pp. 234–42

Van Tongeren, L., 1998. 'Vom Kreuzritus zur Kreuzestheologie: die Entstehungsgeschichte des Festes der Kreuzerhöhung und seine erste Ausbreitung im Westen', *Ephemerides Liturgicae* 112, pp. 215–45

VCH = Victoria County History, *Co. Durham*, London, 1905

Verey, C. D., ed., 1980. *The Durham Gospels*, Early English Manuscripts in Facsimile 20, Copenhagen

Verey, C. D., 1989. 'The Gospel Texts at Lindisfarne at the Time of St Cuthbert', in Bonner *et al.* 1989, pp. 143–50

Verey, C. D., 1999. 'Lindisfarne or Rath Maelsigi? The Evidence of the Texts', in Hawkes and Mills, 1999, pp. 327–35

Verzone, P., 1967. 'From Theodoric to Charlemagne', in Methuen's *Art of the World*, transl. P. Waley, London

Walker, R., 1998. *Views of Transition. Liturgy and Illumination in Medieval Spain*, London and Toronto

Walsh, J. and T. Bradley, 1991. *A History of the Irish Church 400–700 AD*, Dublin

Walsh, M. and D. Ó Cróinín, eds, 1988. *Cummian's Letter De Controversia Paschale*, Toronto

Wamers, E., 1983. 'Some Ecclesiastical and Secular Insular Metalwork Found in Norwegian Viking Graves', *Peritia* 2, pp. 277–306

Ward, B. (SLG), 1989. 'The Spirituality of St Cuthbert', in Bonner *et al.* 1989, pp. 65–76

Warner, G. F. and Gilson, J. P., 1921. *Catalogue of Western Manuscripts in the Old Royal and King's Collections in the British Museum*, I, London

Watson, A. G., 1987. *Medieval Libraries of Great Britain. Supplement to the Second Edition*, London

Watson, W. J., 1926. *The History of the Celtic Placenames of Scotland*, Edinburgh (reptd 1986)

Webster, L. and M. P. Brown, eds, 1997. *The Transformation of the Roman World*, London

Webster, L. and J. M. Backhouse, eds, 1991. *The Making of England: Anglo-Saxon Art and Culture AD 600–900*, London

Weitzmann, K., 1977. *Late Antique and Early Christian Book Illumination*, London

Werner, M., 1990. 'The Cross-Carpet Page in the Book of Durrow: The Cult of the True Cross, Adomnan and Iona', *Art Bulletin* 72, pp. 174–223

Werner, M., 1994. 'Crucifixi, Sepulti, Suscitati: Remarks on the Decoration of the Book of Kells', in O'Mahony 1994, pp. 450–88

Wessel, K., 1965. *Coptic Art*, London

Westwood, J. O., 1843–5. *Palaeographia Sacra Pictoria*, London

Westwood, J. O., 1868. *Facsimiles of the Miniatures and Ornaments of Anglo-Saxon and Irish Manuscripts*, London

Whitelock, D., ed., 1979. *English Historical Documents* I, revd edn, London

Whitfield, N., 1974. 'The Funding of the Tara Brooch', *Journal of the Royal Society of Ireland* 104, pp. 120–42

Whitfield, N., 1987. 'Motifs and Techniques of Celtic Filigree. Are they Original?', in Ryan 1987, pp. 75–84

Whitfield, N., 1997. '"Corinthian Bronze" and the "Tara" brooch?', *Archaeology Ireland* no. 30, vol. 11, no. 1 (Spring), pp. 25–8

Whitfield, N., 1997a. 'Filigree Animal Ornament from Ireland and Scotland of the Late-Seventh to Ninth Centuries', in C. Karkov , R. Farrell and M. Ryan, eds, *The Insular Tradition*, New York, pp. 211–43

Whitfield, N., 1999. 'Design and Units of Measure on the Hunterston Brooch', in Hawkes and Mills, 1999, pp. 296–314

Wilkinson, J., 1977. *Jerusalem Pilgrims Before the Crusades*, Warminster

Williams, J., 1965. 'A Castillian Tradition of Bible Illumination, the Romanesque Bible from San Millan', *Journal of the Warburg and Courtauld Institutes* 28, pp. 66–85

Williams, J., 1980. 'The Beatus Commentaries and Spanish Bible Illustration', *Actas del simposio para el estudio de los Codices del commentario al Apocalypsos de Beato de Liebana* I, Madrid

Wilson, D. M., 1961. 'An Anglo-Saxon Bookbinding at Fulda (Codex Bonifatianus I)', *Antiquaries Journal* 41, pp. 199–217

Wilson, D. M., 1984. *Anglo-Saxon Art*, London

Wood, I., 1995. 'The Most Holy Abbot, Ceolfrid', *The Jarrow Lecture* 1995, Newcastle-upon-Tyne

Wordsworth, J. and H. J. White, 1889–98. *Nouum Testamentum … secundum editionem Sancti Hieronymi: pars prior – Quattuor Euangelia*, Oxford

Wright, D. H., 1967. *The Vespasian Psalter*, Early English Manuscipts in Facsimile 14, Copenhagen

Wright, D. H., 1967a. 'The Italian Stimulus on English Art around 700', Stil und Überlieferung. Akten des 21. Internat. Kongress für Kunstgeschichte. Bonn, 1964, I, 91

Youngs, S., ed., 1989. *'The Work of Angels', Masterpieces of Celtic Metalwork, 6th–9th Centuries AD*, London and Austin

Zimmermann, E. H., 1916. *Vorkarolingische Miniaturen*, Berlin

Analysis of the pigments used in the Lindisfarne Gospels

Katherine Brown, Michelle P. Brown and David Jacobs

An introduction to The British Library and University College London Raman Microscopy Project

The scientific analysis of materials used in the making and for the conservation of manuscripts, incunabula, works of art, and artefacts

A substantial amount of our cultural heritage for the period *c.*500–1500 has been preserved in illuminated manuscripts and incunabula. The identification, analysis and interpretation of materials used in the manufacture of such artefacts can give us an insight into the development and spread of artistic styles, materials technologies, social changes and advances in global commerce, trade and the exchange of ideas. The study of pigments and inks is a subject at the interface of art and science, and one that attracts the interest of librarians, curators and archivists, historians, conservators, research and museum scientists.

University College London and the British Library's project for the analysis of materials used in the making and for the conservation of manuscripts and incunabula is now in its fifth year. A major development occurred in December 2000 when, with the support of the British Library and the EPSRC, the Christopher Ingold Laboratories at University College London purchased a Renishaw Raman System 1000 configured with a Nikon microscope, three laser wavelengths and two remote probes. The sources are a 514.5 nm Spectra-Physics argon ion laser, a 632.8nm helium-neon laser and a 780 nm near infrared laser.

The project is presently based in the conservation studios of the British Library and the Christopher Ingold Laboratories. The project has initiated collaborative research programmes with other major institutions including Cambridge University, The Victoria and Albert Museum, The Wellcome Institute and The Tate Gallery. Raman analysis has also been conducted for the Yale Centre for British Art, the Beinecke Rare Books and Manuscript Library, The Museum of London, The Petrie Museum, the Museum of East Asian Art, major auction houses and private collectors.

At the time of writing the joint Raman project consists of Professor Robin Clark, Dr Stephen Firth, Miss Katherine Brown and Dr Tracy Chaplain of University College London and David Jacobs, Senior Conservation Officer of the British Library. Previous recent project staff include Dr

Lucia Bergio (Victoria and Albert Museum), Dr Greg Smith (National Gallery Washington DC), and Dr Peter Gibbs (University College London).

The project staff work closely with the curators of the collection items involved and the work on Anglo-Saxon manuscripts and the Lindisfarne Gospels was carried out with Dr Michelle Brown, who guided the selection of areas of the painting to be observed with a view to answering some specific questions and to permit an assessment of the accuracy of Roosen-Runge *et al.*'s earlier discussion in *Cod. Lind.*

1 The aims of the Raman project

The main aim of the Raman project is to analyse materials used for the manufacture and conservation of artefacts. This involves the identification of the original materials and possible degradation products and the determination of related conservation problems. This leads to a greater understanding of the object and the identification of future conservation strategies.

Raman microscopy is particularly suited to the analysis of fragile material, such as illuminated manuscripts, incunabula and works of art on paper where sampling is not possible. Raman microscopy is a non-destructive, non-invasive and extremely specific technique.

1.1 A historical perspective

The information gathered in these studies also helps to define the historical perspective of the object by providing new information, or confirming or disproving long held suppositions about the materials used in the manufacture of an artefact. As not all materials were available to all peoples at all times, the movements of materials, and hence people, can be seen in the objects that they create. The presence of non-indigenous materials on objects of known origin indicates that communications existed with the source of the material. If patterns of communication change, that change is often reflected in the materials available.

Information can also be obtained about the environment in which the object was created. Valuable materials indicate a wealthy patron or establishment, a change in material during the construction of a object may indicate a change in circumstance or workmanship, later alterations in other materials may be demonstrate a change in ownership and so forth. Where the origin of an object is not known it can sometimes be placed into a context according to the materials used in its construction; it may be possible to propose an origin and date of construction for some objects.

While some of this information may be surmised from other sources, evidence from Raman microscopy can provide confirmation or, in many cases, serve to contradict what was previously believed.

1.2 Applications to conservation

Many materials used in the construction of library objects interact with one another and some may interact with materials used for conservation treatments. Conclusive identification can enable the selection of appropriate materials for use in conservation removing any risk of future damage to the object. In addition, some earlier conservation treatments that have been used and not recorded can be identified by this technique.

Future care

The future care requirements of materials can be predicted to a large extent if their composition is known. Many materials are light and moisture sensitive, some are even poisonous, all of which should be taken into account in the planning of their exhibition, storage and handling.

Degradation

A lot of older material in any library does suffer from degradation. This is particularly common with, for example, lead, arsenic or copper based pigments. Analysis by Raman microscopy identifies the initial materials and degradation products, in many cases establishing the nature of the degradation process and allowing its progress to be monitored. With this information it may be possible to eliminate the causes to prevent worsening or recurrence of the problem. Through laboratory simulations and further analysis the potential exists to reverse some of these processes and restore the material to original appearance. Where this is not possible, accurate identification of the original material makes 'virtual restoration' of a digital image a possibility.

This unique collaboration between libraries, museums, art galleries and a major research university offers the opportunity to create a database of pigments, inks and binders and their associated degradation and conservation problems. This database could then be directly linked to digital images of collections and historical reference information. It is hoped that the Raman project will become the primary reference and advice source for institutions and individuals throughout the United Kingdom concerned with the materials used in the creation and conservation of historic artefacts.

2 Studies in progress

The British Library conservation department first became aware of Raman microscopy in 1992 when it was used for 'Mass Spectrometry on Ancient Paper and the Analysis of Ancient Dyed Chinese Paper', a collaborative project between Queens University, Belfast and the British Library Conservation Department. Prior to this, Raman microscopy had been used by other groups to study the pigments of the artist's palette for art historical research. This analysis of a specific conservation problem showed how such a sensitive analytical tool could be used in practical conservation. A Raman spectroscopic library of over sixty natural and synthetic pigments (pre-1850) has now been compiled and can be downloaded from http://www.ucl.ac.uk/chem/resources/Raman/speclib.html, and will assist the future identification of pigments.

Following the publication of the results the study of a Byzantine/Syriac Lectionary, curators at the British Library requested that the conservation department should develop the project, to cover other areas of the collections, where they had observed degradation of pigments or wished to extend their knowledge of ink and pigment manufacture, origin, chemistry and application.

Material from a number of British Library collections was studied in a pilot project to establish the effectiveness of this technique from the conservation, curatorial and historical standpoints. Although a number of different collections are involved the majority of the study is currently focussed on illuminated western manuscripts, decorated incunabula, illuminated material from the Oriental and India Office collections and the philatelic collections.

2.1 The first study of a British Library manuscript

In 1997, at the request of Mark Barnard and Dr Vrej Nersessian, Professor Clark and Dr Gibbs used Raman microscopy to examine the pigments on a rare early thirteenth century Byzantine/Syriac Gospel in the British Library Oriental and India Office collections (Clark and Gibbs, *Chem. Commun.* 1997, 1003–4). The manuscript had developed a dramatic discolouration to black of the white pigment used on nearly all of its sixty illuminations. The product of the degradation was identified and safeguards imposed to ensure safe future conditions for the manuscript; showing the potential of such an analytical tool in practical conservation.

2.2 Western Manuscripts

A number of Anglo Saxon manuscripts have been studied with the following aims:

• To establish the palette of each manuscript as an exemplar
• To establish the insular palette and observe any changes
• To consider these results in terms of the conservation of the manuscript
• To look for evidence of patterns of pigment use that can be attributed to particular illuminators or schools

Although still in progress, this fundamental study is already adding to our understanding of western manuscripts. Eventually it will be possible to assist in the identification of the point of origin of a number of manuscripts of unknown schools from the consideration of the materials used in their construction.

2.3 Oriental and India Office collections

A large study of manuscripts from the Oriental and India office collection of the British Library, including Persian, Turkish, Indian, Mogul, Chinese and Tibetan material from the tenth to the nineteenth centuries, are being examined.

A principle part of this area of the project is the study of a Persian Shahnama, dated 1483. Although a standard Persian text, the illustrations are not in the typical Persian style. It is hoped that a survey to establish the palette of oriental material from this period will enable a fingerprint for each different region to be defined in terms of the materials used in the construction and decoration of the manuscripts. This may enable us to properly establish the origin of the 1483 Shahnama.

3 Summary

From a conservation and preservation perspective, the project is of tremendous value in assisting in the delicate balancing act of ensuring due care for the long term preservation of rare and often fragile materials and the desire for wider public access through exhibition, publication and digitisation. The research benefits for the science and humanities alike are significant.

The continuing programme of research is being framed to ask and answer questions of broad cultural, economic and scientific interest. For example, where and how were new ideas or materials shared by different cultural groups? What impact did the growth in urban economies and experimental science have on later medieval trade and communications? The project is a note worthy example of the benefits of expert collaboration between the library and university sectors, science and the arts.

David Jacobs, Senior Conservation Officer, The British Library

Pigment Analysis by Raman Microscopy

Katherine Brown

It is increasingly being recognised that the analysis of materials by scientific methods is significant to both the conservation and preservation of an object and the understanding of its origins within a historical context. Until recently this has not been achievable by non-destructive methods, however, new studies by Raman microscopy are now concentrating on such diverse materials as archaeological skin and bone, pigments and archaeological artefacts.[1-4]

1 Pigment analysis in conservation and history

A full identification of the materials used in the production of any object of cultural significance has considerable impact upon the plans and processes in place for its long-term preservation. Decorated manuscripts particularly benefit from the analysis of the pigmentary materials used in the production of their decoration. For the conservator, an accurate description of the pigments used is essential not least because it is generally known that certain materials are far more inclined to suffer detrimental degradation processes than others. Identification of substances already present allows appropriate materials to be selected for the conservation of the object, avoiding unfortunate interactions between modern materials used in the conservation process and those already on the page. An appropriate care plan can be constructed that takes full account of the likely effects of light, humidity and environmental contaminants, for example, on the materials. Potential interactions between materials already present, such as that between white lead and orpiment, can be assessed and monitored, and perhaps prevented or reversed.

From a historical point of view a great deal can be learnt about the technological capabilities of the society that produced the artefact, their trading links with other groups and the wealth and status of the individuals who commissioned the object. Evidence for all of these things can be found in the materials used, particularly in comparison with other artefacts from similar periods or geographical regions. For example, abrupt changes in the pattern of pigment use in the illustrations of a single manuscript can be indicative of periods of socio-economic change. Perhaps new materials became available during production, or some form of upheaval prevented completion until a later date or a move to a different location. It is hoped that, in due course, it may be possible to ascribe the palette of a manuscript to particular artists or particular schools, allowing provenance to be assigned to manuscripts whose origin is in doubt, through scientific means.

1.1 Previous results

The original pigment analysis of the Lindisfarne Gospels was conducted on the basis of visual comparisons between in situ pigments and samples made up as far as possible in accordance with contemporary instructions.[5] Using this method a number of pigments were identified: red lead, kermes, orpiment, yellow ochre, yellow gall, lazurite, indigo, folium saphireum, rubeum and purpureum, murex (shellfish) purple, verdigris, and white lead. A number of these cannot be identified by Raman microscopy – particularly folium. One that is identifiable, lazurite, is particularly of interest. Given the date and origin of the Lindisfarne Gospels, the presence of lazurite in the palette would provide irrefutable evidence of trade routes (however indirect) between one of

the furthest outposts of Christianity and the only working source of lazurite at this period – the mines in what is now Afghanistan.

However, subsequent studies by Raman microscopy of other manuscripts originally analysed by the visual comparison method has cast doubts over the accuracy of the results.[6] In particular, the identification of the pigments on British Library Arundel 155 has been shown to be in error especially where the blue and green pigments are concerned.

1.2 Why Raman microscopy?

In recent years, interest has been growing in the use of Raman microscopy as a technique for the analysis of fragile or valuable materials for a number of key reasons. Perhaps most important of these is its application *in situ*. Samples do not need be taken from an object to conduct a Raman analysis; an important consideration for delicate and fragile objects such as manuscripts, that can be irreparably damaged by the removal of surface materials. Further, the technique is entirely non-destructive; laser irradiation at suitably low power does not damage the object under analysis.

In addition, Raman microscopy is unambiguous and extremely specific. Each Raman active molecule has its own spectrum, which may be identified explicitly. With a database of spectra for comparison a form of fingerprinting is possible. Where more than one pigment is present in admixture it is possible to separate them in one of two ways. By focusing exclusively on crystals of each pigment, one at a time, easily identified Raman spectra are produced that are separately indicative of each component of the mixture. Where the pigments are too finely mixed to allow this, a Raman spectrum from the mixture will contain peaks attributable to all of the materials. These can be separately identified, allowing the individual elements of the mixture to be identified.

To aid this fingerprinting process, a number of databases of inorganic and organic pigments, binders and other archaeological materials such as horn and bone have been prepared. These generally consist of spectra and tables of band wave numbers for comparison.

In addition, modern equipment is relatively portable. The ability to conduct analysis on site is particularly attractive to curators of valuable collections that cannot be removed from their home institutions without prohibitive expense and inconvenience.

2 The Raman effect

In 1921 the Indian scientist Chandrasekhara Raman began the investigations for which he would win the Nobel Prize in 1930. He had become interested in the phenomenon of light scattering through liquids whilst observing the intensely blue colour of the Mediterranean Sea.[7] He proposed that the sunlight was being scattered by the molecules of water and began experiments to test this assertion. Following a discussion on the recently discovered Compton effect at the British Association Meeting in 1924, Raman published a quantitative theory of the Compton effect, in 1927 that convinced him that an optical analogue of the effect must exist. In 1928, using only natural light and, by modern standards, very rudimentary equipment, Raman and his student, K. S. Krishnan, discovered that it was possible for liquids and gases to scatter light at both the incident wavelength and at a modified one. A note to the journal *Nature* followed[8] and the apparent simplicity of the effect and ease with which it could be seen soon engendered contributions form around the world.

Fig. 1. Mechanisms of light scattering from a molecule.

2.1 Theory of the Raman effect

To observe the Raman effect, a sample is illuminated by a monochromatic beam of light (most frequently from a laser) with photon energy E. The majority of the incident light is scattered by elastic collision with the molecules comprising the sample, with no change in the energy (Rayleigh scattering). However, a very small percentage is scattered inelastically (Raman scattering) and the incident photons gain or lose a small amount of energy, e, through interactions with the interatomic vibrations of the sample molecules (fig. 1). Raman spectroscopy is the measurement of the energy $(E - e$ or $E + e)$ of these photons.

Every material is composed of a unique set of atoms bound together in a characteristic way, distinguishing it from any other material. The atoms in a specific material vibrate around their equilibrium positions in particular ways and with energies that are related to the mass of the constituent atoms and the geometry and strength of the bonds. The change in energy of an inelastically scattered photon corresponds to the energy of a vibration in the material. By measuring the energy changes of scattered photons we can determine the characteristic vibrational frequencies of the sample. The Raman spectrum produced by the scattered photons can be treated as a fingerprint for each material, allowing the rapid characterisation and identification of a sample by comparison with pre-constructed databases from a variety of sources.[2,3]

2.2 The Raman microscope and the experimental technique

The development of lasers and sensitive detectors within the last thirty years or so has made Raman spectroscopy a fast and effective technique for the analysis of many different materials. Within the last fifteen years this technology has been applied to work with small samples through the development of the Raman microscope.

Light from a monochromatic laser is directed down an optical microscope onto a sample on the microscope stage. The light is absorbed and some of it re-emitted by the Raman scattering process. This emitted light, and some reflected light, is collected through the microscope. The reflected light

Fig. 2. The Renishaw System 1000 Raman microscope.

Fig. 3. The Raman microscope.

is filtered out and the Raman scattered light fed to a spectrometer where a spectrum, a plot of scattered photon energy against intensity, is recorded and displayed on a computer.

In the case of large or particularly delicate objects it is not possible to place them directly onto the microscope stage for analysis. Instead a remote fibre optic probe may be used. The fibre couples directly to the laser, feeding the monochromatic light to the probe head, where it is focused onto the sample by a lens. The returning light passes through the same lens into another optical fibre which is coupled to the microscope, at the microscope stage. In this way the returning light is directed through the spectrometer as before.

The analysis of the Lindisfarne Gospels was conducted at the British Library using a Renishaw System 1000 micro-Raman spectrometer. Due to the size and weight of the manuscript, no attempt was made to place it under the microscope. Instead, a remote fibre optic probe was coupled between the laser and the microscope, allowing the manuscript to be safely situated in a specially constructed book cradle. To record Raman spectra, a 632.8 nm red laser was used at powers of up to 1 mW at the sample over accumulation times of up to 1200 seconds in total.

In addition, sweepings were taken from the gutter between f. 93v and 94 for analysis with the Raman microscope using the 514.5 nm green laser. Laser powers of up to 4mw were used over accumulation times of up to 350 seconds in total.

Fig. 4. Folio 93v, the evangelist miniature of St Mark. Numbered sample areas are indicated.

438

3 The results of the Raman Project

Areas of a number of folios were selected for analysis, with a view to ascertaining the general palette. Specific areas were also selected that were unusual in appearance or to answer particular questions. The results are presented here in page, rather than sample, order.

3.1 Folio 93v, the evangelist miniature of St Mark

Table 1 The pigments found on f. 93v – British Library Cotton Nero D iv. Spectra were not obtained from those areas indicated by a dash. Indigo denotes indigo or woad.

Area	Colour	Pigment
1	Orange	Red Lead
2	Blue	Indigo
3	Blue	Indigo
4	Blue	–
5	Blue	Indigo
6	Red	Red Lead
7	Pink	–
8	Yellow	Orpiment
9	Yellow	–
10	Yellow	–
11	Dark Green	Indigo, Orpiment
12	White/Plain Parchment	–
13	Green	Verdigris
14	Blue	Indigo
15	Pink	–
16	Red	Red Lead
17	Dark Red	–
18	Yellow	Orpiment
19	Black	Weak Carbon
20	Green	Verdigris
21	Yellow	–
22	Green	Indigo, Orpiment
23	Pink	–
24	Black	–

Fig 5. The Raman spectrum of red lead from area 1 of f. 93v.

Fig. 6. The combined spectra of indigo and orpiment from area 22 of f. 93v.

The analysis of the sweepings on the glass slide was conducted in a more random manner since assorted detritus was collected. The principle purpose was to confirm the identification of the green pigments, which are harder to identify with the red laser. To that end particles with a greenish appearance and sufficient size were selected. The identification of verdigris made with the red laser was confirmed – the gutter sweepings did contain fragments of verdigris, the most likely source of which is minimal flaking from pigment used in the illustration.

Fig. 7. The Raman spectrum of verdigris recovered from the gutter between f. 93v and 94.

3.2 Folio 95, the Initial page of the Gospel of St Mark

Table 2 The pigments found on f. 95 – British Library Cotton Nero D iv

Area	Colour	Pigment
90	Blue	White Lead, Indigo
91	Blue	Indigo
92	Purple/Blue	Indigo
93	Pink	–
94	Blue	Indigo

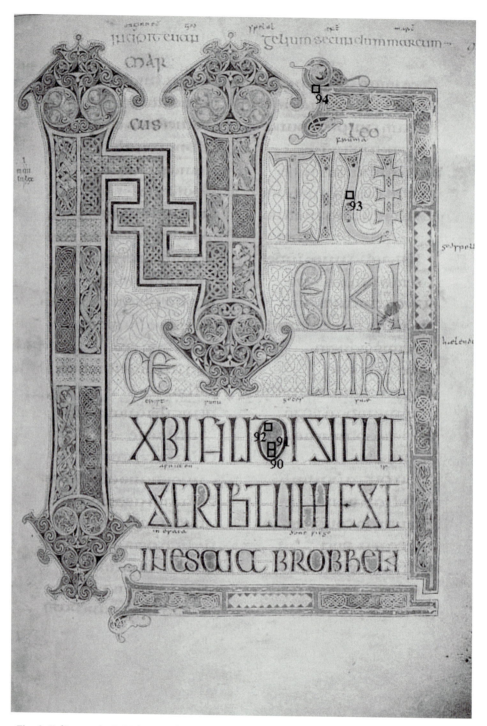

Fig. 8. Folio 95r, the Initial page of the Gospel of St Luke. Numbered sample areas are indicated.

3.3 Folio 137v, the evangelist miniature of St Mark

Table 3 The pigments found on f. 137v – British Library Cotton Nero D iv

Area	Colour	Pigment
60	Blue	Indigo
61	Yellow	Orpiment
62	Yellow	Orpiment
63	Red	–
64	Green	Verdigris
65	Beige	Chalk
66	Beige	Chalk
67	Brown	Indigo
68	Brown	Indigo
69	Blue	Indigo
70	Blue	Indigo
71	Orange	Red Lead
72	Blue/Green	Indigo, Orpiment
73	Green	Verdigris
74	Dark Red	–
75	White/Plain Parchment	–
76	White/Plain Parchment	–
77	Yellow	Orpiment
78	Orange/Red	Red Lead
79	Pink	White Lead
80	Pink	–
81	Pink	Chalk
82	Dark Pink	–
83	Green	Verdigris
84	Purple	–
85	Dark Red	Red Lead
86	Black	–
87	Red	Red Lead
88	Dark Red	–
89	Yellow	Orpiment

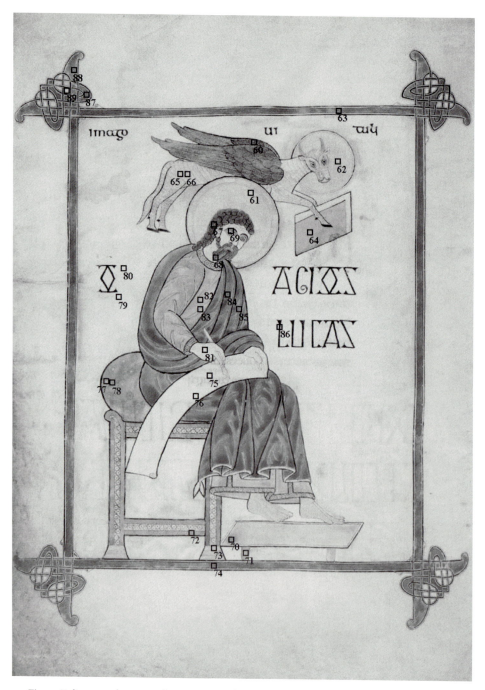

Fig. 9. Folio 137v, the evangelist miniature of St Luke. Numbered sample areas are indicated.

Fig. 10. The Raman spectrum of white lead from area 79 of folio 137v.

Fig. 11. The Raman spectrum of chalk from area 81 of folio 137v.

445

3.4 *Folio 138v, the cross-carpet page of the Gospel of St Luke*

Table 4 The pigments found on f. 138v – British Library Cotton Nero D iv

Area	Colour	Pigment
48	Green	–
49	Blue	Indigo
50	Dark Red	–
51	Blue	Indigo
52	Orange	Red Lead
53	Yellow	Orpiment
54	Yellow	Orpiment
55	Pink	–
56	Black	Weak Carbon
57	Dark Red	–
58	Black	–
59	Green	Verdigris

3.5 *Folio 139, the Initial page of the Gospel of St Mark*

Table 5 The pigments found on f. 139 – British Library Cotton Nero D iv. Verdigris is notoriously hard to identify with a red laser. Area 34 is assigned as 'Possibly Verdigris' since the spectra quality is too low to make a conclusive identification.

Area	Colour	Pigment
25	Blue	Indigo
26	Yellow	Orpiment
27	Red	Red Lead
28	Green	Verdigris
29	Blue	Indigo
30	Blue	Indigo
31	Purple	–
32	Gold	–
33	Gold	–
34	Dark Green	Possibly Verdigris
35	Black	–
36	Brown-Black	–
39	Yellow	–
40	Yellow	Orpiment
41	Red	Red Lead
42	Red	–
43	Black	Trace Carbon
44	Purple	–
45	Blue	Indigo
46	Red/Orange	Red Lead
47	Yellow	Orpiment

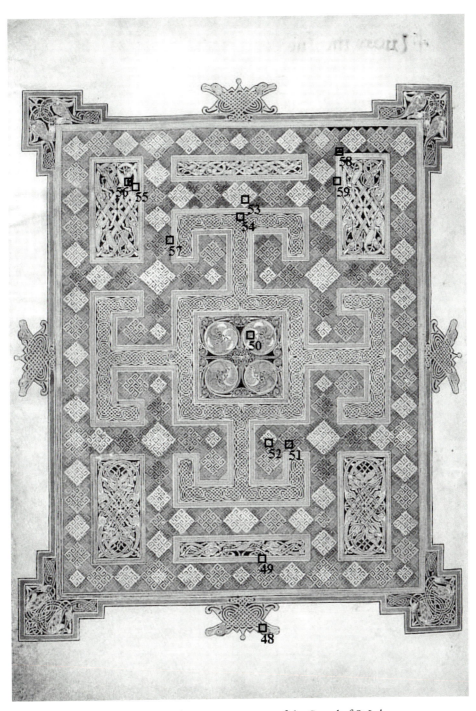

Fig. 12. Folio 138v, the cross-carpet page of the Gospel of St Luke.
Numbered sample areas are indicated.

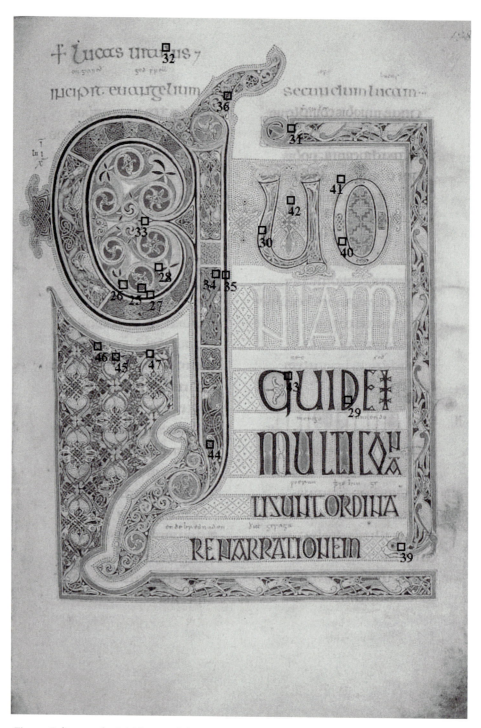

Fig. 13. Folio 139, the Initial page of the Gospel of St Luke. Numbered sample areas are indicated.

Fig. 14. The Raman spectra of lazurite, indigo and the blue pigment from area 29, Cotton Nero D iv.

3.6 Other areas

Selected areas of a number of other folios were also examined. The Evangelist Miniature of St. John (f. 209v) was not amenable to Raman analysis although this was attempted. Only chalk was found, identified in a white coloured area. The blue pigments of folios 13v and 14v of the Eusebian canon tables were also examined as they represented a range of different hues. All of the blue areas were found to have been pigmented with indigo. Areas of the rubric of folio 239v were also analysed but did not easily give Raman spectra. There was some evidence of lead degradation, suggesting that the rubric may have been written in red lead.

Folio 26 is on the opposite side of the vellum to the cross-carpet page preceding St. Matthew's Gospel. Details of the design on the subsequent page have been marked out on f. 26 and can still clearly be seen. An area of these markings was examined and found to have no Raman spectrum. Disagreement exists over the nature of the implement used to create these marks. However the absence of a Raman spectrum suggests a silver or lead point and conclusively precludes the use of any form of carbon or graphite.

4 Discussion and conclusions

A number of interesting points arise from this analysis, the most striking of which is the complete absence of lazurite in any of the areas analysed. The only blue pigment found in any of the differently coloured blue regions was indigo or woad (referred to here generically as 'indigo'). Unfortunately Raman microscopy cannot distinguish between home-grown woad and imported indigo as the chromophore, the cause of the colour, is the same. However, since woad production was known in England it is likely that this is the source. Interestingly a range of colours has been produced from the same material. This may be explained in a number of ways. It is possible that the manufacture of indigo pigment from the plant was an imprecise process thereby generating a range of colours. Conversely, the pigment may have had its appearance altered by mixing or glazing with another material. Finally, the colour of the pigment itself may have been deliberately adjusted during the process of manufacture, perhaps using an acid/alkaline technique, as has been suggested for folium.[9] No other pigments were detected in combination with indigo in the blue areas, but it is possible that a poor Raman scatterer had been used, and so would not be detectable by Raman microscopy.

The other particular point of interest is the use of two distinct and separate green pigments in different areas. Firstly the traditional verdigris is found in at least two different shades, which commonly occurs. In addition however vergaut, produced by the combination of a blue and a yellow pigment, was found. In this case the combination was indigo and orpiment, although both lazurite and azurite have been found in this combination on other material.[6]

Also worthy of note is the black ink used for the outlining and emphasis in the illustrations. It contains some, but very little, carbon, indicating that it is not a carbon-based or graphite ink and yet it is extremely dark and consistent in colour, particularly when compared to the ink used for the interlinear gloss only a few centuries later. The most likely source for both is an iron gallo-tannate ink, which is almost impossible to detect by Raman microscopy. The artist-scribe in this instance had access to exceptionally good supplies of ink or an exceptionally stable recipe given that it has neither faded nor eroded the substrate, as is commonly found.

A number of materials did not give Raman spectra for various reasons. A gold material has been used in a very few areas of the decoration of the Lindisfarne Gospels, particularly on folio 139 where it was analysed. Although gold itself does not have a Raman spectrum, all of its common imitators, such as lead tin yellow, orpiment and mosaic gold, do.[3] The gold coloured material used on the Lindisfarne Gospels did not produce a Raman spectrum, strongly suggesting that the decorations are highlighted in genuine gold.

The other materials that did not give spectra could not be so easily identified. These are composed of two main groups. Firstly, some mineral materials, particularly ochres, are very weak Raman scatterers or are not Raman active at all. The weak scatterers can sometimes, but only rarely, be identified. The other materials are pigments that are organic in origin, extracted from plants or animals. These may well be Raman active but their spectra are often swamped by intense fluorescence which obscures the data. Indigo and woad are such pigments, but respond well to the 632.8 nm laser available for this study. Other organic pigments have been shown to be responsive to FT-Raman techniques[3] but the difficulties in moving these instruments makes them unsuitable for performing on-site analyses.

However, a range of pigments were identified, that have much in common with other Insular manuscripts.[6] Orpiment is the most commonly found of the yellow mineral pigments and features here heavily. Red lead is also a traditional part of the Insular palette. Both white lead and chalk have

been used in mixtures with other pigments. Usually, where the artist has wanted a white coloured area he has left the parchment plain. The only exception to this that was found is the use of chalk on f. 209v. Indigo is the only blue pigment identified on the manuscript and has been used on its own and in combination with orpiment to make green. The other green pigment was identified as verdigris.

The somewhat restricted range of pigments used in the decoration of this manuscript have produced a range of colours, with different blues, greens and yellows selected for specific purposes suggesting a high level of sophistication in the design and execution. The variation in shade and hue produced from a very few initial pigments is both rare and subtle.

References

1 Edwards, H. G. M. *et al.*, 2001. *Journal of Raman Spectroscopy* 32, pp. 17–22.

2 Bell, I. M., R. J. H. Clark and P. J. Gibbs, 1997. *Spectrochimica Acta Part A* 53, pp. 2159–79.

3 Burgio, L. and R. J. H.. Clark, 2001. *Spectrochimica Acta Part A* 57, pp. 1491–21.

4 Clark, R. J. H., M. L. Curri and C. Laganara, 1997. *Spectrochimica Acta Part A* 53, pp. 597–603.

5 Kendrick, T. D. *et al. Evangelium Quattuor Codex Lindisfarnensis*, Volume 1, (facsimile) Urs Graf Verlag (1956), Volume 2, (commentary), Olten and Lausanne (1960).

6 Brown, K. L., 2002. 'Raman spectroscopic and computational studies of artists' pigments and other inorganic compounds', PhD thesis, University of London.

7 Long, D. A. 1988. *International Reviews in Physical Chemistry* 7, pp. 317–49.

8 Raman, C. V. and K. S. Krishnan, 1928. *Nature* 121, p. 501.

9 de Hamel, C., 2001. *Manuscript Illumination*, The British Library, London.

Index of Manuscripts Cited

General Index